Tradigital Maya

Tradigital Maya

A CG Animator's Guide to Applying the Classic Principles of Animation

Lee Montgomery

Focal Press
Taylor & Francis Group

NEW YORK AND LONDON

First published 2012
This edition published 2013 by Focal Press
70 Blanchard Road, Suite 402, Burlington, MA 01803

Simultaneously published in the UK
by Focal Press
2 Park Square, Milton Park, Abingdon, Oxon OX14 4RN

Focal Press is an imprint of the Taylor & Francis Group, an informa business

Notices
Practitioners and researchers must always rely on their own experience and knowledge in evaluating and using any information, methods, compounds, or experiments described herein. In using such information or methods they should be mindful of their own safety and the safety of others, including parties for whom they have a professional responsibility.

Product or corporate names may be trademarks or registered trademarks, and are used only for identification and explanation without intent to infringe.

To the fullest extent of the law, neither the Publisher nor the authors, contributors, or editors, assume any liability for any injury and/or damage to persons or property as a matter of products liability, negligence or otherwise, or from any use or operation of any methods, products, instructions, or ideas contained in the material herein.

Library of Congress Cataloging-in-Publication Data
Montgomery, Lee, 1973-
 Tradigital Maya: a CG animator's guide to applying the classic principles of animation / Lee Montgomery.
 p. cm.
 Includes bibliographical references and index.
 ISBN 978-0-12-385222-9 (pbk.)
 1. Computer animation. 2. Maya (Computer file) I. Title.
 TR897.7.M648 2011
 006.6'96—dc23
 2011038124

British Library Cataloguing-in-Publication Data
A catalogue record for this book is available from the British Library.

ISBN: 978-0-123-85222-9 (pbk)
ISBN: 978-0-080-96960-2 (ebk)

Typeset by: diacriTech, Chennai, India

For all those new animators struggling to hone their craft, this book is dedicated to their endeavor and to the fellow professionals and academics who commit their time to supporting their dreams.

I hope that you have as much enjoyment in reading the book as I had in writing it and that it stands up next to the other great references on animation out there.

Special mention should also go to my friends and family who've supported me throughout my career and particularly during the last 12 months as I worked on the book. Without the love and support of my parents I would be nowhere in my life and I hope they're as proud of me as I am of them.

Contents

Contents

Contents

Contents

Contents

Acknowledgments

First, I'd like to thank the team at Focal Press for their dedication, support, and patience as I worked on this book over the last year. In particular, thanks to Katy Spencer, for her professionalism as we worked through the technical review and editing process and to Sarah Binns who has guided the project through to final publication.

Thanks should also go to Mike Gasaway for his input during the technical edit for Focal Press. Mike's understanding of the book's focus and the commitment he showed in providing detailed input during the edit were invaluable.

Without Laura Lewin and the rest of the team at Focal's belief in the initial proposal and outline the book would not have been such a success.

I'd also like to acknowledge all of the people I've been inspired by professionally within the animation industry over the last 10 years. This book is for the people who have the passion and skill to create the illusion of life through their craft.

The book would also not be possible without the vision of those who work tirelessly to define, create, and improve the software and tools we take for granted in our daily toil as animators. The dedicated product design and development teams at Autodesk should be commended for their commitment to improving the tools and workflows we use every day.

Introduction –
Traditional to Digital

Many of the principles of traditional animation were developed in the 1930's at the Walt Disney studios. These principles were developed to make animation, especially character animation, more realistic and entertaining. These principles can and should be applied to 3D computer animation.
– John Lasseter - Pixar, "Principles of Traditional Animation Applied to 3D Computer Animation", Computer Graphics, pp. 35–44, 21:4, July 1987 (SIGGRAPH 87).

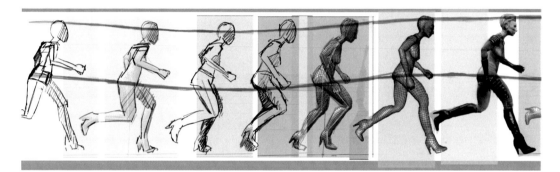

FIG 0.0.1 Run cycle animation – animation arcs and key poses.

Welcome to *Tradigital Maya*! – The source for Maya animators to expand both their technical and creative skills with reference to the fundamental principles of animation. Please also visit this book's Web site at **www.tradigitalmaya.com**!

Where Do the Fundamental Principles of Animation Come From?

The fundamental principles of traditional animation are as applicable today in 3D animation as they were almost 80 years ago when they were first applied at the Walt Disney Studios. The 12 principles of animation were originally taught at Disney as the basis for animators to create convincing and believable animation. Although the principles were first applied to cell animation, they are equally as applicable today in 3D animation as they are to traditional animation media including clay-animation, stop-motion, and cell animation.

The 12 principles were originally outlined by Frank Thomas and Ollie Johnson in their book *The Illusion of Life, Disney Animation*. The book is considered a standard text for animators, and it is recommended that the reader of Tradigital Maya considers purchasing this title alongside other traditional animation reference guides.

Note

Other recommended reference texts for both traditional animation practice and 3D animation are provided in the final chapter of the book.

What Are the 12 Fundamental Principles of Animation?

The 12 principles of traditional animation are a series of fundamentals, which animators need to consider in practice. The principles were conceived primarily as a framework for animation based on the need to mimic natural weight, gravity, and mass as seen in movement in the real world. The art of creating believable motion in animation is a dark art requiring an understanding of how things move in the real world. Creating sequential frames of motion, both in traditional media and through computer animation that creates the illusion of life and vitality is the key to the animator's job.

The principles can also be considered as a more general framework for creating engaging performance through animation. A number of the principles, such as anticipation, staging, appeal, and exaggeration, are less rooted in the technical practice of imitating real-world motion and are more directly related to creating drama or characterization. These are analogous to theatre, cinema practice, or acting.

The principles are covered in detail in individual chapter sections throughout this book. Understanding each fundamental principle is critical in creating animations that are believable and engaging for the viewer. Each chapter will provide an introduction to the animation principle that will be covered in the chapter tutorials that follow. As the traditional principles are applied together throughout the book, reference will also be made in each chapter introduction to how the principle has been applied alongside the other animation principles in other chapter tutorials.

FIG 0.0.2 Principles in practice – arcs, anticipation, timing & spacing, and ease out.

 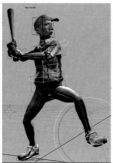 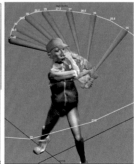

Summary of the 12 fundamental principles that are covered throughout the book are as follows:

>Arcs – Arcs naturally occur in most motion in the real world because of the effect of gravity, inertia, and the hinged arc motion of animal limbs (see Fig. 0.0.2, first screenshot from left).
>Anticipation – An action should be preceded by anticipation; this is both a theatrical device and a fundamental of motion in the real world when objects and people gather energy before action (see Fig. 0.0.2, second screenshot from left).
>Timing & Spacing – Effective timing & spacing of animation underpins all the other animation principles; understanding the intervals between major motions and how to edit keyframe timing to effectively convey the action is a key fundamental (see Fig. 0.0.2, third screenshot from left).
>Ease In & Ease Out – Objects and people do not move at a constant speed or velocity. There should be a build up or acceleration to motion and a deceleration that follows. This can only be achieved through effective timing & spacing (see Fig. 0.0.2, fourth screenshot from left).

FIG 0.0.3 Principles in practice – staging, follow-through, secondary action, and pose to pose.

 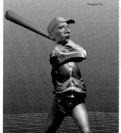 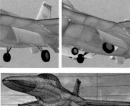 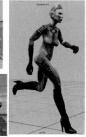

>Staging – Staging is a general concept that can be applied throughout animation. It is similar to framing in film practice and is the ability to communicate ideas with clear and readable framing (see Fig. 0.0.3, first screenshot from left).
>Follow-Through and Overlap – Objects do not move at the same time; there should be a natural follow-through or overlap in motion, think of an arm swinging a bat or a flowing cape, the motion overlaps after the body (see Fig. 0.0.3, second screenshot from left).
>Secondary Action – Secondary action is motion that supports the main animation. Think background elements, characters props, or mechanisms that add interest and believability to motion (see Fig. 0.0.3, third screenshots from left).
>Pose to Pose and Straight Ahead – Pose to pose and straight ahead are two different methodologies that can be applied when creating animation. Pose to pose is the most commonly used methodology and requires the animator to "block in" the major poses for the animation before refining the in-between frames. Straight ahead is more spontaneous and is a less-planned approach (see Fig. 0.0.3, right screenshots).

xxi

FIG 0.0.4 Principles in practice – solid drawing, appeal, squash and stretch, and exaggeration.

Solid Drawing and Design – Skills in traditional arts including drawing, sculpting, and design are important in computer animation; without the ability to create believable forms and pleasing shapes in animation, the illusion will break (see Fig. 0.0.4, first and second screenshots from left).

Appeal – Appeal is a general animation principle that can also be applied to production design. Appealing character design and performance requires an understanding of characterization and performance as well as effective application of the other principles in tandem to convey mood (see Fig. 0.0.4, third screenshot from left).

Squash and Stretch – Squash and stretch is a principle that is required when animating the natural change in volume or shape in organic or soft-bodied objects. In 3D animation, this can be mimicked through simulation such as Maya's nCloth and muscle systems (see Fig. 0.0.4, fifth screenshot from left).

Exaggeration – Exaggeration is another general principle that should be applied across all areas. Readability in animation is key and can only be achieved through strengthening or exaggerating the animation, so that it is engaging for the viewer (see Fig. 0.0.4, right screenshot).

Each fundamental principle should be considered not just in isolation but alongside the other principles to create a unified statement. For example:

- Effective timing & spacing of animation is required to create both believable ease in and ease out or follow-through.
- Without strong framing or staging of an animation sequence, the anticipation or build up to the action will not be readable or effective.
- Strong secondary animation on background characters or other elements alongside overlapping motion and follow-through will help enhance a sequence as additional elements add appeal to the overall mood being created.

Applying the Principles in Maya

To get started, you'll obviously need either a fully licensed version of the software or a trial version to work through the tutorials. The tutorials were put together primarily in Maya 2012; a fully functional 30-day trial version of the latest release can be downloaded from – www.autodesk.com/maya-trial.

xxii

The tutorials in the book cover the full range of technical and creative skills that you'll need to apply the traditional animation principles effectively in Maya.

Maya Tutorial Scene Files

The Maya tutorial scene files referenced throughout the book can be downloaded from the book's Web site, **www.tradigitalmaya.com**. Please refer to the instructions on the book's Web site regarding installation of the Maya tutorial scene files and media. The scene files are organized by chapter section and should be downloaded prior to working through each chapter tutorial.

- *Technical fundamentals* – the Maya interface, navigating the scene and edit (see Fig. 0.0.5).

Basics of how to navigate the Maya user interface to select and modify scene elements will be covered in the initial chapter tutorials. Being comfortable with the user interface and able to select and modify the elements whilst animating is essential for getting great results with less frustration.

- Scene organization and selection and modification through Maya's display layers, Outliner, Channel Box, and Attribute Editor will be covered throughout.
- Accessing specific elements for edit from the Maya Attribute Editor will also be used throughout to change properties while animating. Different display modes and toggles to speed up scene selection, preview and edit will also be covered.

FIG 0.0.5 Technical fundamentals – The Maya user interface.

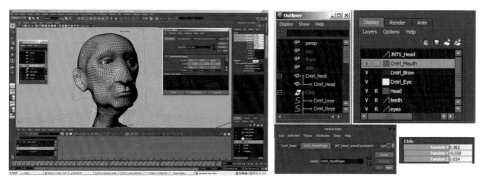

- *Technical fundamentals* – keyframing and editing motion (see Fig. 0.0.6).

Initial tutorials will introduce you to the fundamental tools and workflows used to animate within Maya. Understanding the basics of how to set keyframes for animation in Maya on the timeline and how to edit motion timing and position is a key.

Technical workflows for further editing motion timing and keyframe interpolation through the Maya Dopesheet and Graph Editor will also be covered throughout.

xxiii

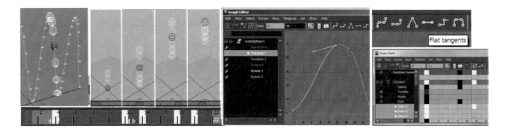

FIG 0.0.6 Keyframing and editing motion – Motion Trails, Ghosting, Graph Editor, and Dope Sheet.

- **Traditional media and reference** (see Fig. 0.0.7)

Usage of traditional media and reference, including thumbnailing and storyboarding, will be encouraged throughout the book. The principles of solid drawing and staging are required to effectively pose characters for animation that are naturally weighted and move correctly. Solid draughting skills are also required to create effective layouts for storyboards and plan out revisions to the animation whilst working.

Thumbnail pose reference will be provided for the majority of the character animation tutorials. Pose break downs for the extended tutorials will be provided either at the start of the tutorial or as the tutorial progresses. Creating iterative thumbnails to plan out specific body posing will also be encouraged as will creating your own reference thumbnails and revisions during the projects. The reader is also encouraged to consider other reference sources such as photography, video reference, and life study to assist in understanding how the character should move; additional guidance around where to apply thumbnailing and reference is provided in Chapter 5.

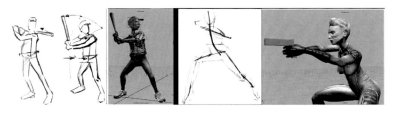

FIG 0.0.7 Thumbnails and character posing.

- **Character animation – inverse kinematics, control rigs, human IK, and posing** (see Fig. 0.0.8).

The main focus for the tutorials within the book is character animation. Basics of working on isolated areas of character posing will be introduced in initial chapters alongside explanation of the fundamentals of inverse kinematics for character posing.

Full character control rigs will be provided for you to work through the full animation exercises in the later chapters. Both standard Maya character Control Rigs and Maya human IK Rigs will be provided. Both the technical process of posing characters for animation and creative workflows to create believable motion will be explored.

xxiv

FIG 0.0.8 Character animation – control rigs, human IK, and posing.

- **Technical setup – character skeleton rigs, inverse kinematics, control rigs, constraints, and connections** (see Fig. 0.0.9). These techniques are also covered in the online chapters, so please see the Web site for more information.

Although the main focus of the book is applying traditional creative skills in analyzing and refining animation, we will also be looking at the technical tools and workflows within Maya to create great animation controls and rigs.

Tutorials focusing specifically on Character Rigging, Blend Shapes Setup, and Maya Muscle are included as additional online tutorials available for download from the book's Web site, **www.tradigitalmaya.com**.

FIG 0.0.9 Technical setup – connections, character rigging, and detail controls.

Understanding the fundamental technical strengths and limitations of how your character or object control rig has been put together will help to provide a broader understanding of how the controls work for animation when posing and keying.

- **Dynamics – rigid body dynamics (collisions) particle simulation (nParticle) cloth simulation (nCloth), and Maya muscle** (see Fig 0.0.10).

Workflows for technical setup and refinement of dynamics and simulation will also be a focus for the book. Although these areas are considered more the domain of a technical animator or Visual Effects Technical Director (VFX TD),

their effective application to create believability to the viewer still requires a firm understanding of how to create natural weight, timing, and gravity through application of the traditional principles. As the effects are directed by the artist, creative decisions and choices are available to refine the results to enhance your animations and effects.

FIG 0.0.10 Dynamics setup – rigid bodies, nParticles, nCloth, and Maya muscle.

Additional Resources and Reference

Additional Media and Online Book Tutorials

Reference media, along with a number of additional online chapter tutorials, are also included on the book's Web site for download: **www.tradigitalmaya.com**.

The additional online chapter tutorials complement the main book tutorials and cover technical rigging, setup, and cameras.

The book is not intended as an exhaustive guide to either all areas of traditional animation practice or technical application in Maya. As such, the reader should consider additional technical and creative resources as they look to expand their skills as an animator.

Maya Documentation and Tutorials

The documentation and tutorials included with Maya provide a solid basis for working with the software. Please refer to the Maya documentation as you work through the tutorials in the book, especially if there are any technical areas of the interface or tools you are not comfortable with. Additional reference guides and tutorials for Maya are also available in both print and online, and it is encouraged that the reader considers purchasing these if they are looking to expand their skills in a specific area of the software.

Animation and Industry Reference

Additional creative reference for traditional animation practice is also encouraged as the reader works through this book and looks to further their skills as an animator. A thorough understanding of both the media of computer animation and the current industry practice is also encouraged for any animator, whether they're new to the industry or experienced.

Included in the final chapter of the book are a number of additional recommendations for further study, which the reader should consider as they work through this book.

Please be sure to visit this book's Web site, **www.tradigitalmaya.com**, for online chapters covering more animation techniques, as well as the Maya scene files referred to throughout the book.

Arcs – Organic Movement/ Natural Motion

Very few living organisms are capable of moves that have a mechanical in and out or up and down precision.

The Illusion of Life: Disney Animation – Frank Thomas and Ollie Johnston

In this chapter, we'll be looking at the basis of natural movement – arcs. Arcs are present in the majority of motions in the natural world; this is due to the effects of mass, weight, and inertia on objects, whether living or not. Think of an object traveling through the air, such as a ball being thrown; although the ball may follow a straighter line at the start of the throw, it will naturally follow more of an arc, as it loses speed and gravity takes hold. The natural phenomenon of arced motion needs to be replicated convincingly in animation to add believability, if the motion is not arced or the timing is even, it will look unnatural and the illusion will be lost.

Natural arcs can be seen in the animation exercises throughout this book. The following are some examples where you would see arcs in motion in the other tutorials exercises:

Bat Swing – In the baseball bat swing animation that we'll look at in later chapters, a clear arced motion can be seen on the swing; this is because the bat swings from the wrist, which is a fixed pivot on the hand. This pendulum type motion is typical in human or organic motion and also applies to the limbs on the body (see Fig. 1.0.1, left screens).

Jump Landing – In the jump animation that we'll look at in Chapter 11, there are natural arcs on the body throughout the animation, from the start through the motion in the air and on the landing. At the landing phase of the sequence, the body pivots around the foot that's planted on the ground, with natural arcs visible on the hips and torso (see Fig. 1.0.1, third screen from left).

FIG 1.0.1 Arcs – bat pendulum swing, hip rotation, and body pose.

Character Posing – Organic arcs are also visible in the body's form and shape in real life, even when the body is not in motion. This is due to the curvature of the spine and weight distribution on the body. Typically, the body distributes weight off center, which creates natural arced shapes running across the body (see Fig. 1.0.1, fourth screen from left).

If the body is posed with purely straight lines or blocky square shapes, the pose will look unnatural and robotic. This is something, which is common in many novice animations. Throughout the book, we will look at how to pose the body with natural arcs that give the animation weight and balance. We will look in detail at character posing specifically in Chapter 9.

Arcs in Object Motion

In the first two tutorials in this chapter, we'll look specifically at arced motion for object animation. As in the jump animation example that we touched on, objects moving through the air should have a natural fluid arced motion due to momentum, inertia (or loss of speed), and the effect of gravity.

Ball Bounce – In the first tutorial, we'll look at a ball bounce animation. Arcs are apparent in the motion in both the timing of the animation as the ball's momentum is lost and in the motion as the ball bounces across the ground (see Fig. 1.0.2, left screens).

Plane Trajectory – In the tutorial of Chapter 2, we'll look at a takeoff animation for an F16 fighter plane. Although the F16 fighter is being driven into the air by the rocket jets on the plane, there are still natural arcs that should be apparent on both liftoff (due to momentum and gravity) and flight as the plane maneuvers (see Fig. 1.0.2, right screens).

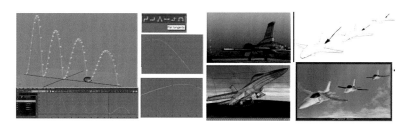

FIG 1.0.2 Arcs – object trajectory.

Localized Arcs – Human Motion

The third and fourth tutorials in this chapter will focus specifically on arcs in human motion. For these exercises, we will look at arcs on a couple of localized areas on the body. These tutorials will introduce common character animation concepts including posing and Inverse Kinematics.

- In the arm swing tutorial, we will look at the pendulum swing on the arm; in addition to analyzing the arc on the arm swing, we will also touch on a couple of other principles of animation including follow-through and Ease In & Ease Out to mimic real-world motion through animation (see Fig. 1.0.3, left).
- In the run cycle tutorial, we will look specifically at the arc on the hip trajectory in the animation. The natural arc of the hips during the weight shifts and foot plants on the run is key in creating believability in the run cycle (see Fig. 1.0.3, right).

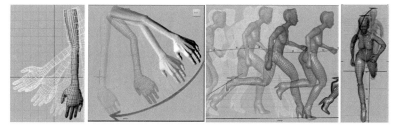

FIG 1.0.3 Arcs – localized human motion.

Chapter 1.1 – Animation Test – Bouncing Ball

The bouncing ball animation test was originally used at Disney as a test of skill for new animators joining the studio. The test is still in use today at studios including Pixar:

> no matter how seasoned you are, this is the first thing that an animator would do when they come into Pixar, because it shows timing, spacing, squash and stretch, anticipation, etc.
> Andrew Cordon, Senior Animator, Pixar – 3D World Issue 130, June 2010, p. 24.

In this tutorial, we'll be focusing initially on creating fluid blocked in movement for the ball bounce through the standard manipulation and hand-keying tools in Maya. The tutorial will first introduce you to the fundamentals

of creating and editing animation in Maya including the following: Animation Preferences, the Channel Box (for viewing motion values) Transformation tools for manipulation, keyframing, and playback controls (see Fig. 1.1.01).

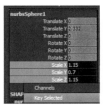 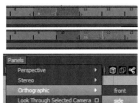

FIG 1.1.01 Animation basics – Transform Tools, Channel Box, Keyframes, and Orthographic View.

Other key animation principles including Ease In & Ease Out, Squash and Stretch, and Timing & Spacing will also be introduced with the use of key edits using the Time Slider, Channel Box, and Maya Graph Editor to edit motion timing. The Maya Motion Trail feature will also be utilized alongside display ghosting to validate the final arc on the ball bounce as well as the timing intervals (see Fig. 1.1.02).

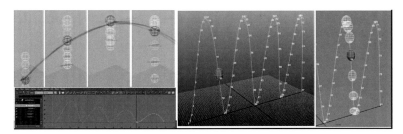

FIG 1.1.02 Animation ghosting, the Graph Editor, and Motion Trail.

Animation Preferences

For our animation of the bouncing ball, we'll work on an initial bounce cycle that can be looped. For a ball bouncing, this would be less than 1 second, with the time varying based on the height of the bounce and mass of the ball.

For the length of the animation sequence and playback rate, this can be set from Maya's animation preferences. Let's take a look at how to set up animation and playback range within Maya:

- Open a new session of Maya or select File > New Scene to clear the current scene.
- The preferences for Maya's frame range can be set from a few different places:
 - Animation Preferences button – This is at the bottom right corner of the user interface; it is the small white icon with figure in red beside the key icon (see Fig. 1.1.1, top left screenshot). Clicking the "Animation Preferences" button will automatically open Maya's "Preferences" window to display the "Time Slider" options (see Fig. 1.1.1, middle screenshot).
 - Window > Settings/Preferences > Preferences (see Fig. 1.1.1, bottom left screenshot) – Selecting this option (from Window menu at the top of the UI) will open the Maya Preferences window; from here, select the "Time Slider" category from the left pane (see Fig. 1.1.1, middle screenshot).

4

- In the Preferences window, under the "Time Slider" section, set the animation and playback range to 20 frames, which is just less than 1 second at 24 frames per second (fps):
 - Playback start/end = 1/20.
 - Animation start/end = 1/20.

Note

The "Playback" and "Animation start/end" can also be set interactively from the input fields underneath the "Time Slider" in Maya (see Fig. 1.1.1, right screenshots). The gray box between the input fields can also be dragged left and right to increase or decrease the playback range.

- In the Preferences window, under the "Playback" section, set the following:
 - Playback Speed: = real time [24 fps].

Note

Setting playback to real time will force Maya to attempt to maintain a constant playback rate of 24 fps. This setting is critical in evaluating the animation in real time in the Viewport.

FIG 1.1.1 Animation preferences.

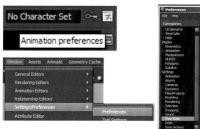 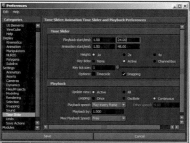 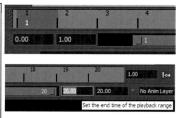

Maya Grid Display

For the ball bounce, we'll be working on animating the ball bouncing across the scene. While working, it is useful to have the Grid display in Maya setup appropriately for the scene to preview the animation. As we'll be animating the ball traveling a fair distance across the ground plane, let us set up the grid, so that it is larger and extends across more of the Viewport:

- From the top of the user interface, select the Display menu and select:
 - Display > Grid [] Options.

Note

To select options within Maya from any of the menus, click the small square-shaped icon at the right of the menu item (see Fig. 1.1.2, top left screenshot).

- The "Grid Options" window will open (see Fig. 1.1.2, bottom left screenshot). From here, the display of the Grid in the Viewport can be customized. Set the following: Size > Length and width = 40.00 units (see Fig. 1.1.2, bottom left screenshot).
- Hit "Apply and Close" at the bottom of the window to apply the change and close the dialog window. The size of the Grid displayed in the scene view will be larger (see Fig. 1.1.2, middle screenshot).

Note

The background color in the Maya Viewport can be toggled from the default blue color to gray/black with the following shortcut key:

Alt + B = Viewport background color.

The Grid display can be toggled on/off from either of the following:

- The Viewport panel icons at the top of the panel window. Toggle on/off the Grid icon (see Fig. 1.1.2, top right screenshot).
- The "Show" menu from the panel drop-down menus above the panel. Toggle on/off "Grid" from here (see Fig. 1.1.2, bottom right screenshot).

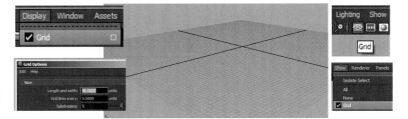

FIG 1.1.2 The Maya grid options and show toggle.

Creating the Bouncing Ball

We'll use a primitive NURBS sphere for the bouncing ball animation.

- From the top row of menus at the top of the Maya User Interface, select the "Create" menu and select:
 - Create > NURBS Primitives > Sphere.

This will activate the create tool, click and drag near to the origin of the scene (intersection of the grid) to create a new NURBS sphere (see Fig. 1.1.3, left screenshot).

The Maya Channel Box

Maya's Channel Box can be used to set the position of the ball and scaling:

- With the NURBS sphere still selected, toggle on display of the Maya Channel Box with Ctrl + A shortcut toggle (see Fig. 1.1.3, second screenshot from left).

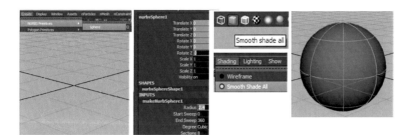

Note

The Channel Box displays the following by default:

- Name of the selected object listed at top – "nurbsSphere1."
- Transform channels – Translate/Rotate and Scale X/Y/Z.

The values shown here correlate with the position (Translate X/Y/Z), rotation (Rotate X/Y/Z), and scaling (Scale X/Y/Z) of the object (or node) in the scene view (or Viewport), and the values update automatically when the object is transformed in the Viewport.

The Channel Box can be used to numerically position, rotate, or scale objects in the scene:

- With the sphere selected, click with the left mouse button in the first numeric input field in the Channel Box for "Translate X." With the left mouse button still pressed down, drag downward to the "Rotate Z" numeric input field for the object and then release the left mouse button.

Note

The selected channel input fields will be highlighted in blue to show that they are selected. The last selected input field (Rotate Z) will show the number selected and highlighted.

- From the numeric keypad on your computer, hit 0 and Enter – this will set all of the selected attributes in the Channel Box to value = 0 (see Fig. 1.1.3, second screenshot from left). The sphere will be positioned at the global origin (Translate X/Y/Z = 0.0).

At the bottom of the Channel Box is a heading titled "INPUTS"; this is the input attributes for the sphere.

- Under INPUTS, click on "makeNurbSphere1" to display the input attributes and double-click in the "Radius" section and type 2.4 to set the Sphere's radius to 2.4 units (see Fig. 1.1.3, second screenshot from left).
- Shading in the viewport panel can be toggled between Wireframe and Shaded display from either the shading toggle buttons at the top of the panel, the Shading menu at the top of the panel, or shortcut keys 4 (wireframe) or 5 (shaded) (see Fig 1.1.3, right screens).

7

Animation Preferences – Key Tangents

For the animation of the bouncing ball, we start by blocking out the motion in this initial phase. Keyframes for animation in Maya can have different interpolation types, and these types will create different motion between the keyframes on playback. "Stepped" interpolation between keyframes will create a blocking jump in motion on playback, which is useful when validating the overall timing.

The default interpolation type that Maya uses when setting new keyrfames can be set from the Animation Preferences window:

- From the top of the Maya User Interface, select the following to open the Preferences window: Window > Settings/Preferences > Preferences.
- From the Preferences window, select the following category from the left pane: Categories > Settings > Animation (see Fig. 1.1.4).
- On the main part of the window, scroll down to the "Tangents" section and set the following from the drop-down menus:
 - Default in tangent = Linear.
 - Default out tangent = Stepped.

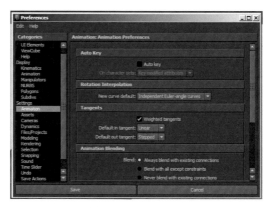

FIG 1.1.4 Animation preferences – key tangents.

Linear Tangency creates straight line motion between the keyframes. The object will move at constant velocity when using Linear Tangency. "Stepped Tangency" will create a jump between the motions at the keyframes, as the motion is flat and then jumps to the next value. Do not worry about the technicalities too much right now; the key interpolation can be viewed later in Maya's Graph Editor, which we'll cover later (see Fig. 1.1.12).

- Scene file with the Ball model setup is included with the project files as **1.1_00_BallBounce_00_Ball.ma**.

Note

The preferences as set here will apply to all keys set while working on the scene and any other scenes. Remember to set this option back to "Clamped" when working on the refining stage of the animation.

Selection and Transformation Tools and Settings

While animating, you should be aware of the different transform tools and options.

Maya's Toolbox on the left of the interface includes the buttons to select whether you are in selection or transform mode in the scene. When interacting with your scenes to animate, you will mainly be either selecting the objects or transforming them to animate (Transform = Move/Rotate/Scale). The icons are fairly self-explanatory and each mode can also be accessed from shortcut keys (see Fig. 1.1.5, left screenshot).

Tool Settings

The different modes for the selection and transform tools can be set from the Tool Settings window (see Fig. 1.1.5, middle screenshot). Double-click any of the tools in the Toolbox to open the Tool Settings. From here, you can set whether you will be moving, rotating, or scaling objects in the scene in Local or World modes. Generally, these options should be set as the default, although there may be instances where you want to, for example, to move objects in Local or Gimbal modes instead of the default World modes. The transform Gizmo icon will update in the scene view depending on which mode is selected.

Transform Marking Menu

Tool Settings for the transform tools can also be accessed quickly from the Maya Marking menu in the Viewport by downing the following:

* With the mouse cursor over the Viewport, press and hold the shortcut key (i.e., Q = Select or W = Move).
* With the shortcut key depressed, click and hold the left mouse button to display the marking menu (see Fig. 1.1.5, right screenshot).
* From the marking menu, select the option required (see Fig. 1.1.5, right screenshot – "Local" mode enabled).

FIG 1.1.5 The Maya Toolbox and Tool Settings window.

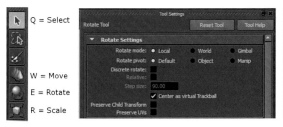
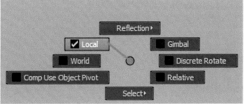

Animating the Ball Bounce

To animate the ball, we'll use Maya's standard transform tools to position and keyframe the ball at different positions during the animation:

First, set the Panel display to display Single Pane as Side Orthographic View:

* Make sure that the Maya Panel Layout is set to Single Pane view from the Panel menu (at the top of the Panel): Panels > Layouts > Single Pane.

Note

You can use the shortcut toggle of pressing the Spacebar on the Keyboard quickly to toggle between the default Four Panes layout and Single Pane layout.

The Single Pane that is maximized is the pane the mouse cursor is over when hitting Spacebar quickly.

- In the Single Pane view, press and hold the Spacebar on the Keyboard. This displays the default Maya Marking menu. Click the left mouse button on the "Maya" box in the center and drag the mouse cursor to the right to select and highlight "Side View" option (see Fig. 1.1.6, top left screenshot).

Note

The different orthographic views for the pane can also be set from the Panels menu: Panels > Orthographic > Side at the top of the pane (see Fig. 1.1.6, bottom left screenshot).

In the Side View, select the Sphere and hit "F" shortcut key to frame the Sphere.

Note

The F shortcut frames selected objects in the current view, whereas A shortcut frames all the objects in the view. The Shift + A and Shift + F shortcut keys will frame in all active panes.

- With the sphere selected, enable the Move Tool (W shortcut).

Note

The Move Tool will display in the Viewport as an arrow icon. The three arrows represent the different transform axes. Green arrow represents Y-axis, blue represents Z-axis, and red arrow represents X-axis. Selecting either axis handle will change the display to yellow.

- Select the Y-axis (pointing up) to enable Y-axis translation; the axis handle will change to yellow (see Fig. 1.1.6, second screenshot from left).
- Drag the Y-axis move handle upward, so that the sphere is positioned with base at the origin (the thick black line at Y = 0) (see Fig. 1.1.6, third screenshot from left).

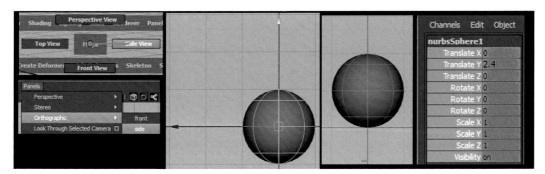

- Make sure that the current frame is frame 1, and with the sphere still selected, hit "S" shortcut key on the keyboard.

FIG 1.1.6 Moving and setting key for the sphere at frame 1.

Note

When setting keyframe on selected objects, a small red "tick" will display on the Time Slider to show that there is a key set when the object is selected. The "Key tick size" can be modified from:

Window > Settings/Preferences > Preferences > TimeSlider > Key tick size.

Note

The S shortcut key will set a keyframe on all channels for the currently selected object. From the Channel Box, keyed attributes display as highlighted in red (see **Fig. 1.1.6**, fourth screenshot from left). Although we are only currently animating the Y-axis animation on the sphere (up and down bounce), we have keyed every channel for the sphere.

When keying animation, it is worth being aware which channels are being keyframed. Keyframing with the S shortcut key can create a lot of unnecessary keyframes in the scene for attributes that are not animated. In a later section covering Squash and Stretch, we will look at workflow for keying selected attributes in the Channel Box (see Fig. 1.1.19).

For now, be aware of the following additional shortcut keys that allow keying for separate individual Translation/Rotation/Scaling channels on objects:

Shift + W = keyframe Translate X/Y/Z only.
Shift + E = keyframe Rotate X/Y/Z only.
Shift + R = keyframe Scale X/Y/Z only.

Note

Alternate workflow to set keys manually with these shortcuts can also be used. Maya's "Auto Keyframe toggle" accessible from the small key icon at the bottom of the interface will set key on the selected object anytime a change is made to the objects transforms or other modified channels.

11

Copying and Pasting Keys and Setting Height Key

For the key blocking for the ball bounce, the start position is keyed at frame 1 with the ball on the ground. At the end of the animation, the ball will be in the same position on the ground to create the loop from frames 1 to 20; the ball will bounce from the ground (at frame 1) to full height (at mid-point of the animation) and then comes back to ground (at frame 20). Let's look at copy/pasting the key for the ground position at frame 1/20 and setting a mid-point key:

- With the ball selected, right-click on the "key tick" at frame 1 and choose > Copy. This copies the key at frame 1 (see Fig. 1.1.7, first screenshot from left).
- Scrub the Time Slider with the left mouse button to frame 20.
- With the ball selected, right-click at frame 20 and choose > Paste > Paste. This pastes the copied key at frame 20 (see Fig. 1.1.7, second screenshot from left).

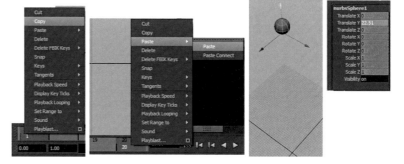

FIG 1.1.7 Copy/pasting keys and setting the mid-point for the Y-translation.

For the ball bounce, the mid-point for the animation will be around frame 10; this is where the ball will be at full height. We can use the Move Tool to position the ball in Y-axis in the Viewport for this key:

- Select the ball in the Viewport and scrub the Time Slider to frame 10.
- At frame 10, enable the Move Tool (W) and grab the Y-axis handle (up/down) and pull the sphere upward in Y-axis, so that it is far off the ground (see Fig. 1.1.7, third screenshot from left).
- Hit S shortcut key to key all channels on the selected object.

Note

The height here is a matter of personal preference and the overall scene scaling for the bounce. In final example, Translate Y = 50.

The translation set here can be modified later from the Graph Editor in Maya during the editing phase of the animation if you feel that the bounce is too short or too long.

- Scene file with the ball bounce blocked in is included with the project files as – **1.1_01_BallBounce_01_Blocked.ma**.

Playback the Animation

Playback the animation to get a feel for the overall timing:

- Either Scrub the Time Slider to frame 01 (by clicking the left mouse button at frame 01 or drag the Time Slider back to frame 01) or use the Alt + Shift + V shortcut key (Windows) to return to the start frame of the animation.
- Hit the play button in the Playback controls (bottom right of the interface) or hit Alt + V shortcut key (Windows) to start playback.

Note

Make sure that you are familiar with the Maya Playback controls. The "Step Forward/Back Frame" buttons allow you to cycle forward and backward one frame at a time by continuously pressing the shortcut key. The "Step Forward/Back Key" buttons allow you to quickly cycle through the keyframes that are set on the currently selected object.

While animating, you'll probably find it quicker to use the Maya shortcut keys to control playback (see Fig. 1.1.8).

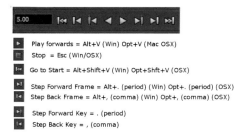

FIG 1.1.8 Maya playback controls and shortcuts.

On playback, the animation should loop continuously (if not, check the Animation Preferences > Playback > Looping option is set to "Continuous").

On playback, the animation will jump from frame 01 to 09 (ball on the ground) to frame 10 (ball in the air); this is due to the "Stepped" interpolation option that we set up for new key tangents earlier (see Fig. 1.1.4). This interpolation mode will show the animation as "blocked in" during playback, which is ideal for validating the overall timing.

Editing Key Timing

For a ball bounce, the full height of the ball on the bounce would not be exactly at the mid-point of the animation (frame 10 as we keyed earlier; see Fig. 1.1.7, third screenshot from left).

When a ball bounces, it will slow, as it reaches full height before it accelerates toward the ground.

Therefore, the full height we keyed for the Translate Y for the ball should actually be set a few frames later in the animation; this will accelerate the fall toward the ground, as there are less frames from the full height key to the ground key at frame 20.

Note

This type of edit is referred to an animation practice as editing the "Timing & Spacing" intervals between the animated elements. This creates more believable motion, as the objects will appear to have more convincing weight, mass, gravity, and acceleration.

Timing & Spacing will be covered throughout this book with reference to the other principles; the principle is covered in detail in Chapter 3.

We can edit the timing of our ball bounce animation from the Time Slider as follows:

- With the ball selected, scrub the Time Slider with the left mouse button to around frame 10 to validate the position. The red key tick for the key that we set at frame 10 should be visible (see Fig. 1.1.9, top screenshot).
- Hold down the Shift key on the Keyboard and click the left mouse button at frame 10 and then with both the Shift key and left mouse button still pressed drag to frame 9.

Note

Using Shift + left mouse drag on the Time Slider allows selection of frame range for edit. The selected frame range and keys will be highlighted in red (see Fig. 1.1.9, middle screenshot).

There are three icons within the selected range that can be used to select and move or scale the frame range.

- The < arrow at the start of the selected range can be selected and dragged left/right to scale the start frame of the range.
- The > arrow at the end of the selected range can be selected and dragged left/right to scale the end frame of the range.
- The <> arrow handle in the middle of the selected range can be selected and dragged left/right to move the selected keyframe range earlier or later in time (see Fig. 1.1.9, middle screenshot).

- Select the <> arrows in the middle of the range with the left mouse button and drag the range forward two frames, so that the key is now at frame 12 (see Fig. 1.1.9, bottom screenshot).

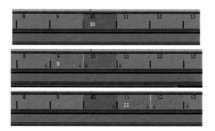

FIG 1.1.9 Selected and editing frame ranges on the time slider.

Note

Key timing can also be edited from the Graph Editor or Dope Sheet in Maya.

Editing from the Time Slider is a fast and an easy way to make edits. However, you should be aware that editing the key timing from the Time Slider only works for selected objects; keys that are shown on the Time Slider are restricted to the keys on the current object.

The Maya Graph Editor

In the Maya Graph Editor, we can see a visual graph representation of motion for scene objects. From here, refinements can be made to the key interpolation and timing for the ball bounce animation. Let's take a look at the Graph Editor:

- With the ball selected, go to the Panel Layouts shortcut buttons at the left of the user interface – displayed under the Toolbox (see Fig. 1.1.10, left screenshot).

Note

The Panel Layouts shortcuts allow you to quickly toggle between a few standard preset layouts for the software. You can also set the layout scheme from the "Panels" menu at the top of the panel view, from: Panels > Panel and Panels > Layout menus.

- From the Panel Layouts shortcut icons, change the Panel Layout for the scene to Persp/Graph layout by selecting the icon, which is split horizontal/vertical with Grid (top)/Graph (bottom) (see Fig. 1.1.10, left screenshot).

FIG 1.1.10 Layout preset – perspective/Graph Editor.

Two panels will be shown. The Perspective Panel at top for preview and edit of objects and the Graph Editor in bottom panel for key edit (see Fig. 1.1.10, right screenshot). Selecting the handle at the intersection between both the panels will allow the size of the Graph Editor relative to the size of the Perspective View to be scaled.

With the scene objects selected, the animated channels should be shown in the left pane for selected object.

Note

If the animated channels do not display, select the "Show" menu at the top of the Graph Editor and ensure that either the "Attribute" checkboxes are enabled or "Show All" option is selected to show all the channels. Select the "Translate Y" channel from the left pane of the Graph Editor window to display the motion graph [or "function curve" as it is called in some other applications (F-Curve)].

Note

Displaying the Graph Editor alongside the Perspective Viewport in this Layout Preset is a great scheme for editing animation keys while working. The Graph Editor can also be displayed as a floating window within Maya, which can be minimized or moved to a secondary monitor (if you have dual-monitor setup). To display the Graph Editor in its own window:

- From the top of the Maya interface, select the Window menu, then Window > Animation Editors > Graph Editor (see **Fig. 1.1.11**).

FIG 1.1.11 Graph editor, displayed as floating window.

The Grid section of the Graph Editor (main panel in gray in the Window) shows a graph of the key motion of the selected channel for the object through time (see Fig. 1.1.11, right screenshot).

The values along the bottom of the window show the time in the scene, while the values running from top to bottom along the left side represent the attribute values for the selected channels. For our motion graph for the Translate Y value, we can see the green line representing the motion for the keys that are set:

At frame 01 – Keyframe is a set for Translate Y = 0 – the line for the motion graph starts at zero.

At frame 12 – There is a keyframe set for Translate Y = +50 units (or whichever value you set personally) – the line for the motion graph suddenly jumps up.

At frame 20 – Keyframe is set for Translate Y = 0 – the line for the motion jumps back down to zero. The stepping in the motion graph is due to the "Stepped" interpolation mode we set earlier.

Note

The standard Viewport navigation shortcut keys and transform tools can be used while working in the Graph Editor.

- Dolly (Alt + LMB)/Track (Alt + MMB) – This can be used to Dolly and track around the Graph Editor to change the view of the scenes motion graphs.

Note

You can also use the standard Viewport shortcuts to frame selected keys (F) or frame all keys (A) in the Graph Editor.

- Move (W) – This can be used to move keyframes up/down (increase/ decrease value) and left/right (increase/decrease time setting).
- Scale (E) – This can be used to scale selected keyframes up/down – scale value range or scale timing of keys (left/right).

When scaling keys, the selected position of the mouse is used as the point the keys will scale from; this is useful if, for example, you wanted to select all keys and scale toward the origin (Y = 0) or scale all toward the start frame (frame = 01).

Breakdown Key (In-between)

For the animation, keys are blocked in for the major poses of the sequence; the ball on the ground (frames 01 and 20) and the ball at full height of bounce. For the animation, the ball would accelerate faster near the end of the animation, as gravity pulls it toward the ground. The animation on the rise from the ground (frame 01) to full height (frame 12) has already been slowed by offsetting the key from frames 10 to 12 (see Fig. 1.1.9, bottom screenshot).

For the second major phase of the animation, to slow the mid-point of the animation and create more motion in the end phase (to frame 20 – ball land), we can add a breakdown or in-between key. The animation phase of adding

breakdowns or in-betweens is sometimes referred to as "Blocking Plus." This allows us to change the timing and create more refinement in the motion.

- Scrub the Time Slider to frame 14 of the animation.
- With the ball selected, enable the Move Tool (W) and move the ball downward slightly in Y-axis, so that at frame 14, the ball drop is delayed. This will create faster motion from frames 14 to 20.
- With the ball still selected, set key with the Shift + W (set translation key) shortcut.

With the Maya Graph Editor open, the new key for Translate Y should be visible, playback the sequence (Alt + V) to validate the blocked in motion (see Fig. 1.1.12).

Note

Select and move the key up/down in the Graph Editor if the translation does not look right with the timing.

FIG 1.1.12 Graph editor, breakdown key added.

- Scene file with the Timing Edit and Breakdown key added for the ball bounce animation is included with the project files as – **1.1_01_BallBounce_02_Blocking_Plus.ma**.

Playblast

Although Maya's Playback through the Viewport should play the sequence at the actual frame rate for the scene (real time [24 fps]), it can be difficult to validate the overall timing of the scene. This is more noticeable with complex scenes with more elements where playback rate will be impacted, but may also be noticeable even on simple scenes where the system may skip frames on playback even when Maya is attempting to maintain real-time [24 fps] playback as setup from the Animation Preferences.

While animating, it is a good idea to get into the habit of making quick preview renders to appraise the animation edits. Fortunately, Maya includes the Playblast tool, which will create quick hardware renders of the animation from the current Viewport:

- Right-click on the Time Slider and choose Playblast [] Options (see Fig. 1.1.13, top left screenshot).

Tip

Make sure to select the square [] box icon beside Playblast in the menu to open the Options Window.

FIG 1.1.13 Playblast options and render settings.

- The Playblast Options window will display (see Fig. 1.1.13, bottom left screenshot).
 From the Playblast Options window, set the following:
 - Display size: = "From Render Settings."

Note

Setting the Playblast render to use the "Display Size" from Maya's "Render Settings" will keep the render size and framing consistent with any final offscreen renders you make.

- Hit the "Apply" button at the bottom of the Playblast Options window to apply the settings.
- Select the "Window" menu at the top of the user interface and choose:
- Window > Rendering Editors > Render Settings (see Fig. 1.1.13, top right screenshot).
- From the Render Settings window, select the "Common" tab at the top to display the Common Render Settings and scroll down to the "Image Size" heading and set the following:
 - Presets = 640 × 480.

Note

This sets the render size to 640 pixels (horizontal) × 480 pixels (vertical), the same image size will be used for Playblast (see Fig. 1.1.13, middle right screenshot).

- Select the "Maya Software" tab at the top of the Render Settings window and set the following:
 - Quality = Production Quality (see Fig. 1.1.13, bottom right screenshot).
- Hit the "Close" button at the bottom of the Render Settings window to apply the settings.

19

Create a Playblast of the animation by doing the following:

- Right-click on the Time Slider, from the menu choose "Playblast."

The Playblast will render quickly and Maya's FCheck window will open and play the animation looped (see Fig. 1.1.14, left screenshot). The playback controls in FCheck are shown along the top; these are similar to the Playback Controls in the Maya UI, although the shortcut keys are slightly different. In FCheck, choose Help > Animation Controls to display the list of shortcut keys.

The stepped motion that is blocked in for the animation allows us to quickly validate the overall timing. The major key timings are clearly visible at the following frames:

- Frames 01–11 = Ball travels upward from the ground to full height extension (see Fig. 1.1.14, second to fourth screenshots from left).
- Frames 12–14 = Ball at full height extension and delayed drop to the ground (gravity) (see Fig. 1.1.14, fourth to sixth screenshots from left).
- Frames 14–20 = Ball drops from delayed drop position to the ground (see Fig. 1.1.14, sixth to seventh screenshots from left).

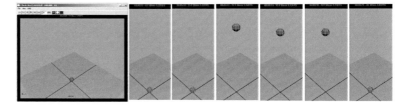

FIG 1.1.14 Playblast render of the animation.

Changing Key Tangent Type

With the Key tangent set to "Stepped," we've blocked in the major timing of the motion. Stepped interpolation can be used to set up major keys for animation to validate major timing edits. To make additional edits to the animation, the key tangent type should be changed, so that we can edit the animation close to final state.

- With the ball selected and Graph Editor visible, select the Translate Y Channel to display the motion graph for the ball's up/down (Translate Y) animation.
- Enable the select tool (Q) and select all the Translate Y keys in the Graph Editor window.

Tip

The keys will be highlighted in yellow and the graph will be highlighted in white to show selection (see Fig. 1.1.15, top left screenshot).

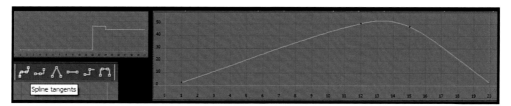

- With the keys for Translate Y selected, hit the "Spline tangents" button at the top of the Graph Editor window to change the tangent type for the keys.

Note

The Spline tangents button is the second tangent option from left of the six option buttons (see Fig. 1.1.15, bottom left screenshot).

The graph for the motion should update in the main Graph Editor window; there should now be smooth Spline line drawn between each of the keys that are set at frames 01, 12, 14, and 20 (see Fig. 1.1.15, right screenshot); the smooth line between each of the keys creates a smooth "interpolation" between the major keys.

Note

In 3D Animation, key interpolation is a fundamental concept as the tangent type used for the key has a major effect on how the computer automatically interpolates the motion between the keys to create the animation.

Scene file with key tangency changed to spline for the ball bounce animation is included with the project files as – **1.1_01_BallBounce_03_Blocking_SplineCurve.ma**.

Ghosted Playblack

If you playback the animation, the motion of the ball should now be smooth due to the change in key tangent and interpolation. The timing should look roughly right with the ball slowing, as it bounces into the air (frames 01–12), hanging in the air briefly (frames 12–14), and then accelerating quickly to the ground (frames 14–20).

Note

When working on looped animation, set the Animation Playback range for last frame to one frame before the final frame (in this animation, it is frame 19). Setting the last playback frame to this frame will make the animation loop smooth during playback. This is because the extreme pose at the start and end of the animation (frames 1 and 20, respectively) is identical. If this frame is played twice during playback, it will cause slight pause as the animation loops. For info on setting the Animation Playback range from the Maya Animation Preferences or Range slider see the preceding section (see Fig. 1.1.1, right screenshot).

When previewing animation, another useful tool in Maya is "Ghosting" – Ghosting will show a ghost of the object during playback with the object being shown at position in the immediately preceding and following frames. Ghosting allows you to validate the timing as the spacing between the object "Ghost" appears to form a "trail" effect; this is also referred to as "Onion Skinning."

- Ensure that the "Animation" menu set is enabled from the status line drop-down at the top of the UI (shortcut key = F2).
- With the ball object selected, go to the Animate menu at the top of the interface and select "Ghost Selected" (see **Fig. 1.1.16**, left screenshot).

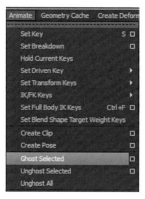
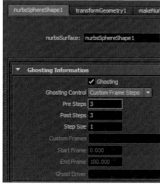

FIG 1.1.16 Ghost selected and ghosting information.

Note

After validating the timing with Ghosting, the effect can be disabled by selecting Unghost Selected from the same menu.

Tip

The [] options for "Ghost Selected" can be set before applying the effect. The effect can also be modified from the Maya Attribute Editor as follows:

- With the object selected (to which Ghosting is applied), open the Attribute Editor (with Ctrl + A toggle or open from Window > Attribute Editor).
- From the Attribute Editor, select "Shape" tab at the top (for our sphere, this tab is named "nurbsSphereShape1" (see Fig. 1.1.16, right screenshot).
- From the "nurbsSphereShape1" tab, scroll down and expand the "Object Display" rollout. Under here is the "Ghosting Information" heading, expand this section to view the options (see Fig. 1.1.16, right screenshot).
- The default global option is to display three Pre-Steps and three Post-Steps for the object's animation, with the animation Step being one frame. This can be changed from the "Ghosting Control" drop-down, with "Custom Frame Steps" allowing you to select the step interval. The "Keyframes" option is useful as it will only display ghost on the keyframes that have been set.

Note

Ghosting will display whichever display mode is currently active. For preview, it is usually easier to validate the timing in Wireframe display mode (Shortcut = 4).

By default, the Ghost effect will display in the Viewport as follows (see Fig. 1.1.17):

- Object Wireframe color = default = Navy blue>
 - This is the object's current position at the current frame.
- Object wireframe color = light blue to white>
 - This is the object's position shown as it will be at the following three frames in the sequence.
- Object wireframe color = dark orange to light orange>
 - This is the object's position shown as it was at the preceding three frames in the sequence.

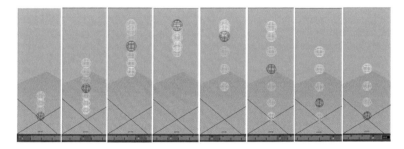

FIG 1.1.17 Ghosting displayed in Perspective Viewport.

On playback or during scrub of the Time Slider, the Ghosting helps us validate the range of motion of the ball between frame intervals:

- At the start of the animation, we can see that the ghosts are displayed more closely together when the motion of the ball is slow in the scene. This is because the ball is traveling less distance between these frames at this phase of the animation (see Fig. 1.1.17, screenshots from left to middle).
- When the ball's motion is at its slowest in the animation (frames 12–14 when the motion graph is at a plateau and the ball at full height before gravity acceleration), the wireframe ghost display for the balls shows them bunched up, showing that the ball is traveling a very short distance over the frames the ghost display is showing (see Fig. 1.1.17, third and fourth screenshots from left).
- Once the ball has reached full height, it accelerates toward the ground. The spacing between the ghosts displayed for the ball's motion increases when cycling through the animation between frames 14 and 20 (with Alt + . (period) shortcut (Windows) or Option + . (period) shortcut (Mac OSX)) (see Fig. 1.1.17, screenshots from middle to right).

Scene file with the ball bounce animation with ghosting enabled is included with the project scene files as – **1.1_01_BallBounce_04_Ghost.ma**.

23

Refining the Animation Timing – Key Tangents

The Animation timing can be refined a bit more by making a couple of quick additional edits to the key tangents for the animation:

- With the ball selected, open the Graph Editor and ensure that the motion graph for Translate Y is displayed.
- Marquee – Select (Q) the first keyframe at frame 01 on the graph. The key should highlight in yellow to show that it is selected.
- From the "tangent-type" shortcut buttons at the top of the Graph Editor, hit the "Flat tangents" button to set the tangent for the key to "flat."

Tip

Icon button for "Flat tangents" is the straight horizontal line icon (see Fig. 1.1.18, top left screenshot).

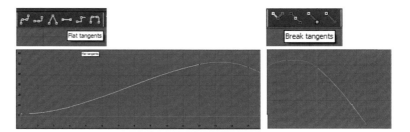

FIG 1.1.18 Editing the key tangents to refine the timing.

Tip

Flat tangent for key will flatten the two tangent handles for the key (shown in brown). This mode is ideal when creating an "Ease In" for the animation as tangency for the key will go from flat state (value = Y = 0) slowly rising from the key to the next key on the curve. This creates "Ease In" or "Slow In" right at the start of the animation, as the ball rises from the ground after the bounce toward the high point on the bounce.

Note

Ease In & Ease Out are covered in more depth in Chapter 4.

In addition to creating more of an "Ease In" at the start of the animation, we can also add more acceleration (or fast out) at the end of the animation (from frames 14 to 20).

If you look at the current motion graph at the end of the animation, the curve appears to "bow" or flatten, as it reaches the end of the animation (see Fig.

1.1.15). Similar to the "Ease In" at the start, this bow effect creates what can be called "Ease Out." As the ball reaches the end of the animation, the amount of change in Translate Y (vertical value on curve) slows across each successive frame.

In animation, you'd typically want to use "Ease In" in conjunction with "Ease Out" in a lot of instances. For a ball bouncing, this isn't appropriate and should be changed. As the ball travels toward the ground (frames 14–20), the acceleration of the ball should be constant or increasing. The values for the change in translation across the end frames should not be decreasing or slowing. Modifying the tangency for the key can help us get the motion graph for the translation to more naturally match what would happen in real life due to the effect of weight and gravity:

- With the ball selected, open the Graph Editor and ensure that the motion graph for Translate Y is displayed.
- Marquee select (Q) the last keyframe at frame 20 on the graph. The key should highlight in yellow to show that it is selected.
- From the "tangent-type" shortcut buttons at the top of the Graph Editor, hit the "Break tangents" button to break the tangent handles for the keyframe.

Tip

Icon button for "Break tangents" is the blue/red icon that is in V shape (see Fig. 1.1.18, top right screenshot).

- With the tangent handles broken for the key, you should see that the two handles either side of the key are displayed as blue (left of key)/brown (right of key).

Note

Breaking tangency for key allows you to set the tangent handles differently, moving the handles will change the interpolation for the motion graph spline that allows the motion at the key to be very sharp between extreme tangency on either side.

- With the key tangent broken, select the key and then select the Blue Key Tangent handle at the left of the key to modify the shape of the input curve coming into the key
- With the tangent handle selected, enable the Move Tool (W) and change the position of the tangent handle, so that the curve interpolates as a straight line into the key at frame 20 (see Fig. 1.1.18, bottom right screenshot).

Playback the animation and render Playblast:

- Scrub the Time Slider to frame 01 or hit the "Go to Start Frame" button on the Playback Controls (Alt + Shift + V (Windows)/Option + Shift + V (OSX)).

- Hit Play from the Playback controls (Alt + V (Win)/Option + V (OSX)).
- Right-click on the Time Slider and choose "Playblast" to render quick Playblast of the scene view.

The animation timing should look more fluid and believable. The ball eases into the motion when traveling upward in the air then accelerates fast toward the ground. At each phase of the animation, the timing is relative to the gravity being exerted on the ball, with the curve edits to key tangency re-enforcing this.

Spend some time making further edits to the keys and tangents for the ball's Translate Y Channel (up/down travel). When working on refinements to timing, it is advisable to work on individual channels through the Graph Editor to fix the timing.

Scene file with the ball bounce animation refined with the curve edits is included with the project scene files as – **1.1_01_BallBounce_05_CurveEdit.ma**.

Squash and Stretch

For the ball bounce, we can add in some additional Squash and Stretch to re-enforce the animation. Squash and Stretch is a fundamental animation principle and is covered in more depth in Chapter 11. Basically, Squash and Stretch in animation is used to show the change in an object's volume, as it reacts to forces in the real world; typically, the effect is applied to character or organic motion in animation where an object can visibly deform.

For our ball, we can apply the effect at the phases where the ball connects with the ground and travels upward/downward in space.

- At the connection frame to the ground, the ball should compress due to gravity; the amount of compression is dependent on the flexibility of the ball. This is the "Squash" in the animation.
- As the ball travels upward and downward through the air, the ball's shape will elongate to an egg-type shape due to the gravity being exerted. This is the "Stretch" in the animation.
- When the ball is at it is full height, it appears to float in the air (at around frame 12); at this phase of the animation, gravity is hardly affecting the ball, so both squash and stretch are not applied and the ball shape should be keyed at the default.

Note

In our example, we'll assume that the ball is pretty bouncy; you can modify the amount of bounce in the animation by changing the channel values that we'll key in the next section if you want more pronounced or less pronounced bounce in the ball.

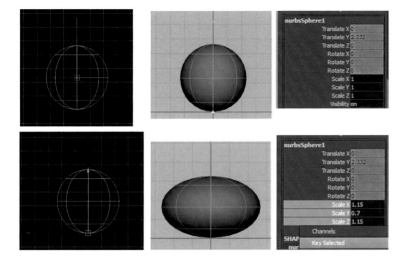

FIG 1.1.19 Modifying pivot and scaling the ball – squash.

To create the Squash and Stretch, we'll use scaling for the ball object. For this to work, the object's pivot needs to be moved downward, so that the ball will scale to the ground as it makes connection:

- With the ball selected, go to frame 1 (Alt + Shift + V) and then go to a Side View and enable the Move Tool (W).
- Frame the ball in the Side View (F shortcut) and Dolly (Alt + MMB) out a bit, so that it is visible along with the ground plane.
- With the ball selected, activate the Move Tool (W) then enter "Edit Mode" to modify the Pivot position for the ball (shortcut for Edit Pivot is the "INSERT" key (Windows) or "HOME" key (OSX) on the Keyboard) (see Fig. 1.1.19, top left screenshot).

Note

You may want to toggle wireframe view (4) from shaded view (5) to help in the placement. The background color for the Side view can be toggled with Alt + B shortcut to change the color if the wireframe model and pivot gizmo are not clearly visible.

- With Pivot mode active, pull the Pivot down toward the ground plane, at the base of the ball.

Tip

Hold the X shortcut key while moving to snap to the Grid.

- Toggle Edit Pivot mode back off ("INSERT" key (Windows) or "HOME" key (OSX)).

With the Move Tool (W) now active, the gizmo to move the ball should now be positioned at the modified pivot (see Fig. 1.1.19, bottom left screenshot).

- With the ball selected, enable the Scale Tool (R) and scale the ball downward in Y-axis. The ball should scale toward the new pivot point that we set (see Fig. 1.1.19, middle screenshot). This is ideal for the squash effect that we'll add. Undo any changes to the scaling (Z shortcut).

As we used S shortcut to key the animation earlier, we've set the keyframe on every channel (Translation, Rotation, and Scaling) for the object. This can be undesirable for a couple of reasons. First, we have additional keys for the scaling that we don't need, and second, the interpolation that is already been set for these keys is clamped. To resolve this, do the following:

- With the sphere selected, open the Graph Editor from Window > Animation Editors > Graph Editor.
- Select the Scale X/Y/Z channels from the left pane in Graph Editor by click + Dragging with the left mouse button.
- Hit F shortcut in the right pane to frame all the keys, then marquee select all the keys and hit delete to delete the keys.

Note

If you check from the Channel Box with the sphere selected, the Scale X/Y/Z channels should no longer be highlighted in red. This is because they no longer have key data.

For the keys that we'll set for the scaling, we'll want these to use a standard tangent type. The "Stepped" interpolation type is fine for initial keying for object motion, although it is not fine for the scaling.

- Open the Maya Preferences from Window > Settings/Preferences > Preferences.
- Select the following category heading in the left pane – Settings > Animation.
- Scroll down to the "Tangents" section and set the following:
 Default in tangent = Clamped.
 Default out tangent = Clamped.

For the scaling, we'll use the Channel Box to set the values exactly to key:

- Scrub the Time Slider to frame 01 or hit the "Go to Start Frame" button on the Playback Controls (Alt + Shift + V (Windows)/Option + Shift + V (OSX)).
- With the ball selected, make sure the Channel Box is visible (Ctrl + A) to view the Scale X/Y/Z channels (see Fig. 1.1.19, top right screenshot).
- Double-click in each of the numeric inputs fields and set the following values (see Fig. 1.1.19, bottom right screenshot):
 - Scale X = 1.15.
 - Scale Y = 0.7.
 - Scale Z = 1.15.

Note

This will scale the object downward in Y-axis (70% or 0.7 scaling) while maintaining the volume of the object. As the other scale channels (X/Z) are scaled outward a bit, the volume is maintained. The default scale values are 1.0/1.0/1.0, which is 100% scaling in each channel. As the Y channel is scaled to 70%, the X/Z channels need to be scaled to 115% to maintain the volume; the total values for X/Y/Z should equal 3.0 (or 3 × 100%) when added.

- With the values set, select the "Scale X" channel name to highlight blue with the left mouse button and then drag downward with the mouse still depressed to also select and highlight the "Scale Y" and "Scale Z" channels.
- With the three Scale channels selected and highlighted, right-click on any of the highlighted channels and choose "Key Selected" from the menu (see Fig. 1.1.19, bottom right screenshot).
- Scrub the Time Slider to frame 20 and repeat the final step to set the same scale key at frame 20 of the animation.

Note

"Key Selected" will set a key on only the selected channels; the rest of the unselected object's channels are not keyed. This method of keying is useful when you want to reduce the amount of extraneous keys being set on the object while animating.

Similar workflow can be used to key the "Stretch" on the ball during the animation.

- Scrub the Time Slider to frame 04 or use the Step Forward Frame/Step Backward Frame buttons on the Playback Controls to move to frame 04 (Alt + . (period)/Alt + , (comma) – Windows/Option + . (period)/Option + , (comma) – (OSX)).
- With the ball selected, make sure that the Channel Box is visible (Ctrl + A) to view the Scale X/Y/Z channels.
- Double-click in each of the numeric inputs fields and set the following values (see Fig. 1.1.20, right screenshot):
 - Scale X = 0.9
 - Scale Y 1.2
 - Scale Z = 0.9

This will stretch the ball 120% (Scale Y = 1.2) of its default size while compressing it 90% (Scale X/Z = 0.9) in the other axes to maintain the volume (see Fig. 1.1.20).

- Use the same process as before to select the Scale X/Y/Z channels and Key Selected to set keyframe (see Fig. 1.1.20, right).

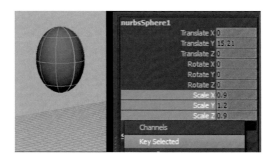

FIG 1.1.20 Modifying scaling for ball – "stretch" pose.

For the "Stretch" animation on the ball, this should be repeated at later phase in the animation. The transitions for the ball going from Squash > Stretch should be as follows to match the bounce animation:

- Frame 01 – Squash.
- Frame 04 – Stretch (Frame 01 >> 04 = Squash to Stretch).
- Frame 12 – Default Scaling (Frame 04 >> 12 = Stretch to default).
- Frame 18 – Stretch (Frame 12 >> 18 = Default to Stretch).
- Frame 20 – Squash (Frame 18 >> 20 = Stretch to Squash).

To copy the Stretch scale keys from frame 04 to frame 18, you can use the same workflow as before to Copy/Paste the key from the right-click context menu on the Time Slider. There's also another trick you can use to quickly copy and paste keys on the Timeline:

- With the ball selected, use the "Step Forward Key" or "Step Backward Key" to cycle to frame 04 (where the stretch scale key is set).

Note

You can also use the shortcut keys step the Time Slider through the keys on selected object (see Fig. 1.1.8):

- Step Forward Key = . (period)
- Step backward key = , (comma)

- With the ball selected and displayed in Viewport at frame 04, move the mouse cursor over frame 18 and click with the middle mouse button.

Note

Although the current animation frame will update on the Time Slider to frame 18, the animation in the Viewport for the ball will not update and the Channel Box will still show the scaling as: Scale X = 0.9, Scale Y = 1.2, and Scale Z = 0.9. This allows us to easily copy or paste poses or keys for objects at different points in the Timeline.

- After shifting the Time Slider to frame 18 with the middle mouse button, confirm that the Scale channels are correct and then hit Shift + R shortcut to key all the Scale Channels for the ball.

Playback the animation to see the effect; the ball should now be naturally squashing and stretching at the correct phases of the contact and motions. For the mid-point in the animation (frame 12), we can add an in-between key for the scaling. At this point, the ball should be at the default scaling:

- With the ball selected, scrub the Time Slider to frame 12 and input the following values in the Channel Box for scaling:
 - Scale X = 1.0.
 - Scale Y = 1.0.
 - Scale Z = 1.0.
- Use Shift + R shortcut to key the scale channels at frame 12 or use "Key Selected" to key the Channels in the Channel Box.

Scene file with the squash and stretch keys added for the ball bounce animation is included with the project scene files as –
1.1_02_BallBounce_01_SQnST01.ma.

With the ball selected, check the motion curves for the scaling from the Graph Editor.

If you select the Scale X/Z channels from the left pane, the curves will be overlaid; this is because both the Scale X/Z channels are keyed with identical values. The Scale Y channel has values (highlighted in green) opposite to that of Scale X/Y. Select all the three scale channels in the Graph Editor, so we can make edits (see Fig. 1.1.21).

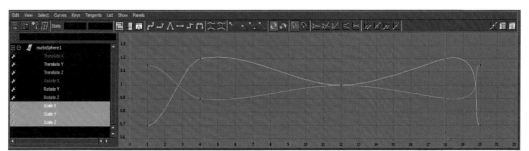

FIG 1.1.21 Graph editor – default curve for the squash and stretch scale keys.

As with the Translate Y keys, we can make some edits to the key tangency for the scale keys in the Graph Editor to better match the motion in the animation.

- In the Graph Editor, marquee select (Q) all the scale keys at frame 04. With the keys selected, hit the "Flat Tangents" button to change the tangency type (see Fig. 1.1.22, left)
 - This better suits the motion at frame 04; the curve is less bowed at this frame than it was before (see Fig. 1.1.21), but is still slightly curved (see Fig. 1.1.22, left).
- In the Graph Editor, marquee select (Q) all the scale keys at frame 18. With the keys selected, hit the "Flat Tangents" button to change the tangency type.
 - This change is so that the input tangency better suits the lead into this key.

- With the scale keys still selected at frame 18, hit the "Break Tangents" shortcut key then pull down the right tangent handles for the keys, so that the motion graph from frame 18 to frame 20 for the scaling is more of a straight line (see Fig. 1.1.22, middle screen).
 - This changes the "out motion" from frame 18, so that the scaling motion is at constant acceleration, instead of eased out as it was earlier. This matches the type of curve interpolation that we set up previously for the translation and suits the ball motion (see Fig. 1.1.22, right screen).

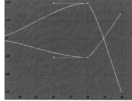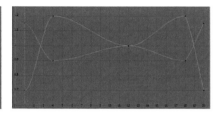

FIG 1.1.22 Graph editor – modifying the scale key tangency.

Scene file with the key tangent edits for the squash and stretch keys is included with the project scene files as – **1.1_02_BallBounce_02_SQnST02.ma**.

Looping the Animation

The animation loops as the playback loops, to further edit the animation and to get the ball bouncing across the ground plane, we need to add duplicate bounce and squash and stretch keys –

- From the numeric input field at the right of the Range Slider, just under the Time Slider, set the End Time of the Playback Range to 80.00 (see **Fig. 1.1.23**).

FIG 1.1.23 End time of playback changed – for loop copy keys.

The keys that we've set for the ball bounce (scale and translation) can be quickly copied and pasted on the Time Slider to loop the animation.

- With the ball selected, click the left mouse button at frame 4 on the Time Slider and then with Shift key depressed drag the left mouse button past frame 20.

The selected keyframe range text should highlight in red with the keys highlighted in yellow (see **Fig. 1.1.24**, top left screen).

- With the key range selected and highlighted, right-click on the range and choose "Copy" (see Fig. 1.1.24, top left screen).
- Scrub the Time Slider to frame 23 and right-click at frame 23 and choose "Paste > Paste" (see Fig. 1.1.24, top right screen).

This creates a perfect loop between frames 1 and 39; the first key at frame 1 was not copied, as it is looped again at frames 20 and 39 (see Fig. 1.1.24, top right screen).



FIG 1.1.24 Copying and pasting the keys for loop.

- Scrub the Time Slider to frame 42 and right-click at frame 42 and choose "Paste > Paste" (see Fig. 1.1.24, lower left screen).
- Scrub the Time Slider to frame 61 and right-click at frame 61 and choose "Paste > Paste" (see Fig. 1.1.24, lower right screen).

Note

The second and third paste operations should work correctly as long as the copied keys are still in the buffer. If you have performed some other operations in-between, you may need to copy the keys again from the first step.

- Set the end key for the animation and playback range to frame 77. This is the last key of the animation (see Fig. 1.1.25).

FIG 1.1.25 End time of playback – edited for Loop.

Loop Animation – Curve Edit

- Select the ball and open the Graph Editor from Window > Animation Editors.
- Select the Translate Y Channel and hit F shortcut to frame the whole of the curve.

The curve should be looped, as the animation has been copy/pasted from the last step. Additional edits can be made by multi-selecting the duplicated keys (with Shift +) that sit at the same intervals then editing the key tangency handles to smooth out the curve. For example, on the keys at the top of the ball bounce, some minor edits were made to the tangency to give a smoother ease in on the bounce (see Fig. 1.1.26).

FIG 1.1.26 Viewing and editing the looped Curve in the Graph Editor.

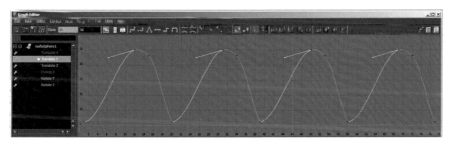

Scene file with the looped animation and key tangent edits for the bounce is included with the project scene files as – **1.1_03_BallBounce_01_Loop01.ma**.

Loop Animation – Bounce Across Ground

For the ball to bounce across the ground, we need to animate the ball moving along the X-axis, Z-axis, or both (which would be diagonal). For simplicity, we'll animate it bouncing across the Z-axis in a straight line. First, we need to remove the existing keys that were set on the Translate Z Channel that were set earlier using Shift + W (Key Translation = All) or S (Key all) shortcuts earlier:

- Select the ball from the Outliner or Perspective View.
- From the Channel Box (Ctrl + A), select and highlight the Translate Z Channel (see Fig. 1.1.27, top screen).
- Right-click in the Channel and choose "Break Connections" (see Fig. 1.1.27, middle screen).
- The keys will be deleted and the channel will no longer highlight in red to show that keys are active on the channel (see Fig. 1.1.27, lower screen).

FIG **1.1.27** Channel Box – Translate Z – "break connections."

- Scrub the Time Slider back to frame 1.
- From the Perspective View, select the ball and enable the Move Tool.
- Grab the Translate Z handle on the Move Tool and pull the sphere back in −Z-axis to the edge of the grid (see Fig. 1.1.28, top screen).
- Hit Shift + W shortcut to key the translation at frame 1.
- Scrub the Time Slider to the end frame (frame 77) and with the Move Tool (W) still active, pull the ball forward in +Z-axis to the opposite edge of the grid (see Fig. 1.1.28, lower screen).
- Hit Shift + W shortcut to key the translation at frame 77.

FIG **1.1.28** Setting two keys for start/end position of ball across grid.

If you check from the Graph Editor, the Translate Z Channel will show two keys, one at start and the other at end of the ball motion. The curve will be a straight line, as there are no breakdown or in-between keys, which indicates constant velocity or speed as the ball moves (see Fig. 1.1.29).

Scene file with the looped ball bounce animation across the Grid plane is included with the project scene files as –
1.1_03_BallBounce_02_Loop02_GroundBounce01.ma.

FIG 1.1.29 Graph editor – translate Z.

Viewing and Editing the Trajectory Arc

- Open the scene file from the Project directory
 1.1_03_BallBounce_02_Loop02_GroundBounce02.ma.

The scene file includes a visual aid, called Motion Trail, to view the ball's trajectory or arc as it bounces across the ground plane. Setup of Maya's MotionTrail and updated Editable Motion Trail feature are covered in more detail later in this chapter, but it is included here solely for illustration purposes (see Fig. 1.1.30).

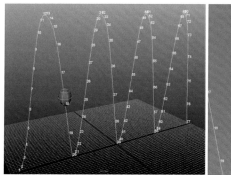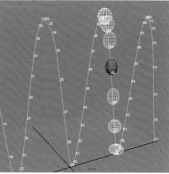

FIG 1.1.30 Ball trajectory – Motion Trail.

We can make some final edits to the ball's height, as the loop animation progresses to make the trajectory of the bounce look more natural. As a ball bounces, energy is dissipated or lost on each bounce, as the ball loses momentum. This would be visible, as the ball bounce being less high on each successive bounce across the ground. We can mimic this effect by simply scaling down the translate Y keys for each bounce:

- With the ball selected, open the Graph Editor, and select the Translate Y Channel from the left pane.

- Marquee select the keys for the top height values for the three bounces after the initial bounce (frame 30 onward).
- With the keys selected, enable the Scale Tool (E) and then click and hold the middle mouse button with the shift keyboard key held at the lowest value on the curve (Y = 0) and drag downward.

> **Tip**
>
> Holding the Shift key while modifying key position or scale in the Graph Editor will constrain the edit to up/down (value) or left/right (time).

- The curve will scale down, lowering the height on the ball bounce for the second to fourth bounce (see Fig. 1.1.31, left screen).

Repeat the process to successively scale the curve down as the bounce progresses:

- Marquee select the keys for the top height values for the last two bounces (frame 40 onward).
- With the keys selected, enable the Scale Tool (E) and then click and hold the middle mouse button with the shift keyboard key held at the lowest value on the curve (Y = 0) and drag downward.
 - The curve will scale down, lowering the height on the ball bounce for just the third and fourth bounces (see Fig. 1.1.31, right screen).

FIG 1.1.31 Graph editor – scaling the curve to create more natural bounce arc.

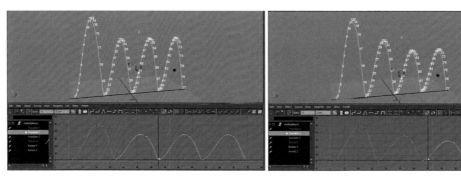

Repeat the above steps to scale down only the last height keys for translate Y, so that the curve is getting successively smaller right at the end of the bounce animation.

The height (Translate Y) should be scaled just a bit each time for the trajectory arc to look convincing (see Fig. 1.1.32). With each edit, the Motion Trail should update in the Viewport to help visualize how the animation will look.

Scene file with the arc trajectory edited on the bounce is included with the project scene files as – **1.1_03_BallBounce_02_Loop02_GroundBounce02.ma**.

Validating the Animation and Additional Edits to Refine the Motion

- Render a Playblast or hit Alt + V shortcut to playback the animation in the Viewport.

On Playback, the animation looks reasonably convincing:

- The trajectory arc of the animation adds to the animation, as there is a nice variation in the bounce that would mimic what you'd see in real life (see Fig. 1.1.32).
- The initial edits made to the timing to "Ease In" the bounce adds gravity to the initial bounce.
- The edits to the scaling of the ball add convincing squash and stretch to the sequence.

On Playback, you'll also notice a couple of things that break the illusion of the bounce. Although these refinements are not covered here, take some time to explore how to finalize the animation through the following edits:

- *Bounce Rotation* – The ball is not rotating at all during the bounce animation; this looked fine when the ball bounced straight up and down, but looks unconvincing when the ball is traveling across the ground. The ball's rotation in local X-axis could be animated to follow the arc trajectory.
- *Timing & Spacing* – Although the ball's height has been modified for the bounce cycle, no edits have been made to the Timing or Spacing. If you look at the Motion Trail, the keyframes are bunched up further as the animation progresses. The spacing intervals are less between each frame, the ball slows significantly on each bounce. This looks unconvincing and edits to the key timing would improve the animation.

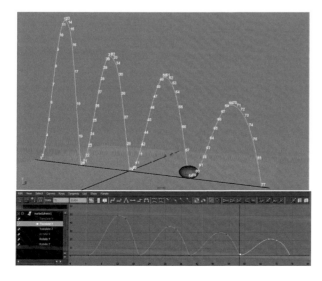

FIG 1.1.32 Validating the final animation.

Chapter 1.2 – F16 Fighter Flight Path

Motion Paths in Maya are a great way to create natural arced movement by constraining object movement along a path. In this tutorial, we'll take a look at working with Motion Paths for an F16 Fighter takeoff sequence.

Technical areas of the software covered in this tutorial will include the following:

1. Modeling and editing – Creating/editing curve with CP Curve tool,
2. Basic object hierarchy and setup for animation (plane model and NURBS Control objects),
3. Working with Display Layers/Outliner/Hypergraph Connections,
4. Motion Path Options,
5. Viewing animation timing with Motion Trail, and
6. Refinement of Motion Path animation timing through Set Motion Path Key and the Graph Editor.

Introducing the Asset

Open the scene file from the project scene files directory – **1.2_00_F16_Setup.ma**.

The scene file includes the F16 fighter model and environment models for the sky, ground, and runway (see Fig. 1.2.1).

FIG 1.2.1 F16 fighter model and environment for sequence.

With the scene open, open the Outliner from – Window > Outliner. The elements in the scene are organized as follows:

F16_Master_Ctrl – This is the red star-shaped NURBS Control Object sitting on the ground plane beneath the F16 (see Fig. 1.2.1, Viewport screenshot); this is the Master Control Object that is parent of the F16 fighter plane model and all the additional controls for the plane. The additional controls are hidden in the F16_Ctrl display layer. We will be working with the additional controls for secondary animation in Chapter 7.1.

Selecting the Master Control Object (F16_Master Control) also highlights all the children objects in green wireframe (see Fig. 1.2.2, left screenshot), Moving the Master Control Object (with Move Tool, W shortcut) controls the movement of the F16 and all other parts that inherit the transformations (see Fig. 1.2.2, left screenshot).

F16_Pivot_Ctrl – This is the yellow circular-shaped object sitting on the ground plane beneath the F16 (see Fig. 1.2.1, Viewport screenshot). This object is a child of the Master Control Object, rotating this object controls the rotation of the F16 model and all other object parts that are children and inherit the rotation (see Fig. 1.2.2, right screenshot). The Pivot Control has been added, as it will not be possible to rotate the Master Control Object once it is constrained to the Motion Path.

FIG 1.2.2 F16 fighter Master Control Object (left) and pivot Control Object (right) selected.

Ground/Runway/Sky – These are the separate model parts used for the desert ground plane, runway, and sky dome. These are separate to the F16 control and model hierarchy, and these should not be moved in the scene. Add the environment model parts to a new display layer, so that we can prevent them being selected:

- With the start scene open, open the Outliner from – Window > Outliner.
- In the Outliner Window, click left mouse button and select "Ground," then hold the Shift key and left mouse button and select "Sky"; this will select all objects listed in the Outliner from "Ground" to "Sky." "Ground," "Runway," and "Sky" models should be selected and highlighted in blue in the Outliner (see Fig. 1.2.3, left screenshot). They should also be highlighted in the Viewport as white or green Wireframe. Objects that are selected last in Maya are highlighted as green, with the first selected objects being highlighted in white wireframe (see Fig. 1.2.3, left screenshot).
- Open the "Channel Box/Layer Editor" with Ctrl + A toggle.

Note

Ctrl + A toggles between "Channel Box/Layer Editor" Display and the "Attribute Editor" at the right of the Maya Interface. Ensure that the "Display Layers" tab is selected in the bottom half of the "Channel Box/ Display layers" window to show the current display layers in the scene.

- Create New Display Layer, either by hitting the * button on the right or selecting "Layers > Create Empty Layer." Name the layer as Environment_ Geo (see Fig. 1.2.3, middle screenshot). With the Ground/Runway/Sky objects still selected, right-click on the new layer and choose "Add Selected Objects."

- With the environment models added to the new display layer, test toggling visibility by un-checking the V checkbox on the layer. In addition, the V checkbox can control whether the objects in the Display Layer are templated or shown in Referenced display mode. Toggle this to R for Reference display mode. This will set the objects to be visible in the scene but not selectable.
- With the three environment objects still selected, hit Ctrl + G shortcut; this will create a new Group for the Objects, which is visible from the Outliner. Organizing objects into groups helps keep the scene well organized while working (see Fig. 1.2.3, right screenshot).

Note

The F16 model and additional controls are already added to existing display layers in scene. The F16 model is also referenced, so that it is un-selectable and the additional controls are currently hidden as we won't be working with them in this lesson.

FIG 1.2.3 Scene organization, adding background objects to reference layer and grouping in outliner.

Scene file with the environment models added to reference display layer and grouping is included with the project scene files as – **1.2_01_F16_Setup.ma**.

EP Curve – Motion Path

Let's take a look at creating and editing the curve that we want the F16 to fly along on takeoff. Work from the existing scene file you have open or open the project scene file – **1.2_01_F16_Setup.ma**:

- At the top of the Maya interface, go to Create > EP Curve Tool (see Fig. 1.2.4, left screenshot).
- With the tool still active, go to a Front Orthographic View. To do this, either hold down the Spacebar and select "Front" from the marking menu or go to the "Panels" menu at the top of the Viewport and select "Orthographic > Front." The F16 should be shown in side on view (see Fig. 1.2.4, middle screenshot).
- Hold down the X shortcut key to enable "Grid Snapping" Icon showing magnet and grid will be highlighted from the status line at the top of the interface to show that the mode is active.
- With the tool still active and Grid Snapping enabled, click the left mouse button at the origin (just below where the plane is sitting at Y = 0 units).

- Dolly out by scrolling the middle mouse wheel or holding Alt + right mouse button until the F16 is shown from the distance. Place another point for the EP curve further along the runway by clicking the left mouse button eight grid units from where the F16 is sitting on the ground. Make sure to click at Y = 0 on the grid.

> **Tip**
>
> Y = 0 is shown as a slightly darker gray line on the grid.

- Continue placing points with the EP Curve tool – Place the next point another eight grid units along the −X-axis and at further two units higher (in Y-axis) place another two or three points with the tool to create an S-shaped curve for the flight takeoff (see Fig. 1.2.4, right screenshot).
- Hit Enter or the Q (select) shortcut key to complete the curve and exit the tool. From the Outliner, Double-click Curve 1 and type in F16_MotionPath to rename the Curve.

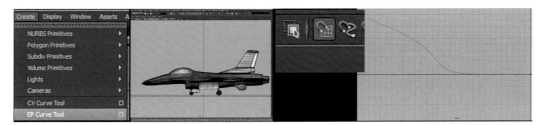

FIG 1.2.4 Creating the EP curve for the F16 Motion Path takeoff.

Note

Once complete, the EP Curve can be edited at Control Point level by selecting the Curve and hitting F9 shortcut to enter Control Vertex Component selection mode. In the component selection mode, the CV's (Control Vertices) can be selected and moved in the Viewport (with Move Tool = W shortcut).

If editing the Curve CV's, stick to a side view for ease of edit. Editing CV's in Perspective View can be tricky unless the edits are restricted to X-/Y-axis with the Move Tool.

Further editing of the curve can be done after the F16 model is constrained to the curve with the Motion Path.

Motion Path – Connecting the Model to the Curve

We'll attach the F16 to follow the Curve flight path by using Maya's Motion Path. The flight takeoff would take a few seconds; first let's set the Maya Animation preferences to set the timeline to 100 frames; 100 frames are roughly 4 seconds at 24 frames per second (fps). Open the Animation Preferences window by hitting the red/white icon button at the bottom right of the Maya interface, it's the button just right of the key icon (see **Fig. 1.2.5**, left screenshot).

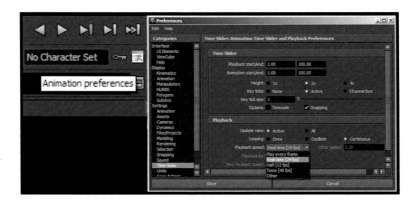

FIG 1.2.5 Animation preferences – setting animation start/end and Playback Speed.

From the preferences window, set the Time Slider as follows:

- Playback Start/End: 1.00/100.00.
- Animation Start/End: 1.00/100.00.
- Under Playback, set Playback Speed to Real-time (24 fps), setting to real time will force Maya to attempt to playback the scene in Real-time (see Fig. 1.2.5, right screenshot).

Note

The Animation Preferences can also be opened from Window > Settings/ Preferences > Time Slider.

Let's attach the F16 to follow the Curve through Maya's Motion Path.

- From the Outliner, select with left mouse button the F16 Master Control object named F16_Master_Ctrl then hold Ctrl + left mouse button to select the curve object named F16_MotionPath. The F16_Master_Ctrl object and F16 plane model should be highlighted white wireframe in the Viewport while the curve object (F16_MotionPath) will be highlighted green in the Viewport to show that it was selected last (see Fig. 1.2.6, left screenshot).

Note

The order of selection for constraints is important in Maya. Object selected first is constrained to the object that is selected last when applying the constraint.

- With both objects selected, ensure that the Animation Menu Set is active (F2 shortcut key) then go to the Animate menu at the top of the Maya interface and select:
 - Animate > Motion Paths > Attach to Motion Path [] Options (see Fig. 1.2.6, right screenshot).

> **Tip**
>
> To open the options, ensure that the [] box is selected, which is beside the menu item.

- With the Attach to Motion Path Options window open, set the following:

Time Range = Time Slider – This sets the object to follow the curve path from time range the same as we set for Time Slider in previous step, so first frame will be frame 1 and end frame (when the object is at end of the path) will be frame 100 (or end of animation range).

Front Axis = X – This sets the axis the object will be facing when following along the path. The plane object is facing –X-axis in the Viewport, so this needs to be set to X.

Inverse Front = Enabled – This sets the front axis to be inverted or reversed. The F16 model is facing negative X-axis in the Viewport, so we need to enable this; otherwise, the F16 will be taking off backward. Leave the rest of the options at default and hit "Attach" button at the bottom left of the Window to attach the F16 to the Motion Path and close the dialog window (see Fig. 1.2.6, right screenshot).

FIG 1.2.6 Selecting object and curve and attach to Motion Path Options window.

The Motion Path Options can be edited after connecting the model to the curve. To edit the options after creating the Motion Path node; from the Outliner, select the F16 Master Control object (F16_Master_Ctrl), open the Maya Attribute Editor (Ctrl + A toggle), then from the Attribute Editor, select the "motionPath1" tab to view the attributes (see Fig. 1.2.7, left).

To view the connections, select the F16 Master Control object (F16_Master_Ctrl) and at the top of the Maya interface, go to Window > Hypergraph: Connections; this will show that the curve object is an input node to the motionPath1 node that is constraining the F16 along the curve (see Fig. 1.2.7, right).

FIG 1.2.7 Motion path attributes
and connections visible in the
hypergraph: connections window.

Scrub through the Time Slider at the bottom of the interface with the left
mouse button to test that the F16 is following the Motion Path of the Curve.
Hit Alt + V shortcut to playback or stop the Animation.

The position of the F16 plane on the curve at different stages of the animation
can be previewed in the Perspective Viewport (see **Fig. 1.2.8**).

> ### Tip
>
> From the Outliner, select the Main Master Control Object for the F16
> (F16_Master_Ctrl) and hit F shortcut (frame selected) to frame the F16 in
> the Viewport.

Previewing the motion, you'll see that the velocity or speed of the motion is
constant. The F16 travels at constant speed while traveling along the ground,
on initial takeoff and when rising into the air (see Fig. 1.2.8).

At frame 1 – The F16 is at start point of the curve (0% along length).
At Frame 25 – The F16 is 25% along the length of the curve.
At Frame 50 – The F16 is 50% along the length of the curve.
At Frame 75 – The F16 is 75% along the length of the curve.

Scene file with the F16 connected to Motion Path with default timing options
is included with the project scene files as – **1.2_02_F16_Path_Attach.ma**.

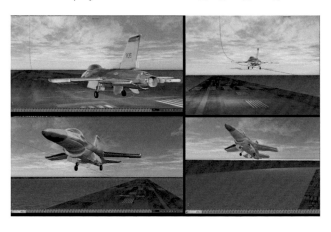

FIG 1.2.8 Previewing the motion
of the F16 along the curve using the
Motion Path.

We can visualize the speed and velocity of the motion along the curve by using a Motion Trail. Maya's new Editable Motion Trail feature will be covered in more detail in the following chapter sections.

For this tutorial, the non-Editable Motion Trail feature from Maya 2011 is used for illustration purposes:

- Open the scene file with Motion Trail added for the F16 flight from the project scene files folder – **1.2_03_F16_Path_MotionTrail.ma**.
- Frame numbers are displayed with show position the object at each frame in the animation. As mentioned earlier, the timing is even and the F16 is moving at constant velocity along the path. The spacing between the frame numbers on the Motion Trail is even when seen in the Viewport, which acts as a visual cue (see Fig. 1.2.9, bottom left screenshot).
- The Motion Trail and frame number icons display as dark green in the Viewport (see Fig. 1.2.9, left screenshot). We can edit the color of the Motion Trail and frame numbers, so that it is more clearly visible in the Viewport. From the Outliner, select "motionTrail1Handle" and open the Attribute Editor (Ctrl + A toggle). Select the "motionTrail1HandleShape" tab at the top and expand the following rollouts – Object Display > Drawing Overrides. Turn on Enable Overrides and change the color with the slider, so that the swatch shows a bright yellow color (see Fig. 1.2.9, top right screenshot). The Motion Trail and frame icons will update to display as bright yellow in the Viewport (see Fig. 1.2.9, bottom right screenshot).

FIG 1.2.9 Motion trail added to scene to preview timing. Editing Motion Trail color display in viewport.

Note

Motion Trails are not Visible when the Renderer is set to Viewport 2.0 or when Show > Locators is turned off from the Panel Menu in Maya.

When editing the timing of objects that have Motion Trail created, the Motion Trail and frame icons will update automatically, which helps us to visualize the edits being made to the timing & spacing of the animation.

Editing Motion Path Timing

As we can see during playback of the scene, the motion timing of the F16 along the path is unnatural. This is confirmed by viewing the spacing of the frame timing icons on the Motion Trail.

A plane does not move at a constant speed during takeoff. Gravity and inertia act on the plane to slow the movement as it lifts of the ground. We'll take a more in-depth look at editing timing for animation in later chapters.

For now, let's take a look at some basic edits to the timing of the F16 along the Motion Path.

- Select the F16 Master Control object, named – F16_Master_Ctrl.
- Scrub the Time Slider with the left mouse button to around frame 20.
- Hit the F shortcut key to frame the F16_Master Ctrl object and the F16 model in the Perspective Viewport.
- With the "F16_Master_Ctrl" object still selected, open the Channel Box (Ctrl + A toggle).
- Expand the INPUTS section to show the attributes for motionPath1.
- Select the U Value heading with left mouse button, so that it highlights blue (see Fig. 1.2.10, top left screenshot).

Note

The U Value attribute for the Motion Path is equivalent to the percentage that the object is along the path at the current frame. From frames 1 to 20, it is just under one-fifth of the total animation (20/100 frames). Therefore, when the object is moving at the default constant velocity, it will be at approximately one-fifth of 100% in U Value; the value displays as 0.192 – attribute value of 1.0 is 100%, which is what the U Value shows at frame 100.

- With the U Value attribute selected, we can see that there are two keys displayed as red lines currently shown on the Timeline – one at frame 1 and the other at frame 100.
- We can add additional keys to modify the timing by enabling Auto Keyframe and modifying the U Value attribute. Turn on Auto Keyframe by hitting the red icon shaped like a key at the bottom right of the interface (see Fig. 1.2.10, bottom left screenshot).
- With the U Value input still highlighted in the Channel Box, move the mouse over the Viewport, hold the Ctrl key, and drag with the middle mouse button held down.

Tip

Dragging with the middle mouse button will modify any highlighted Channel Box attribute interactively while selected. This can be used to modify other attributes interactively within Maya.

- Holding the Shift Key while modifying the attribute with middle mouse button will modify the attribute more quickly.
- Holding the Ctrl Key while modifying the attribute with middle mouse button will modify the attribute more slowly.
- Modify the attribute, so that the U Value is less, at about 0.15 instead of 0.19; this will move the F16 backward along the Motion Path, so it will have traveled less in the same time (frame 1–frame 20, it will have traveled 15% along the path instead of 19%). The new Motion Path key will show as green frame number on the path.

Tip

The Motion Trail that has been added to the scene will also update to reflect the changes in timing of the Motion Path; this helps validate the edits but can also be confusing to view. If necessary, select the "motionTrail1Handle" element from the Outliner and choose – Display > Hide Selection/Display > Show Selection to toggle visibility while working.

We've slowed the initial speed of the plane on takeoff. The initial part of the animation where the plane travels along the runway prior to lift off has been slowed by 5%. The plane's speed would also slow considerably in the phase immediately after it leaves the ground due to the weight and mass of the plane relative to the power needed to get in the air.

We'll set some additional U Value keys for the Motion Path to slow the plane between frames 20 and 50.

- Open the Channel Box/Layer Editor and turn off visibility for the "Environment_Geo" layer; this will make it easier to view and edit the Motion Path keys (see Fig. 1.2.11, left screenshot).

47

- Scrub the Time Slider to around frame 30 and use the same workflow to modify the U Value, so that it is less; set at around 0.25% or 25% of the time. As before, reducing the value will move the F16 backward, so that it has traveled less along the path at the current frame.
- Scrub to frame 40 to repeat the process. The distance between frames 30 and 40 should be roughly the same as between frames 20 and 30. You can slightly increase the distance between frames 30 and 40 to suggest that the plane is increasing in speed slightly.

FIG 1.2.11 Adding and editing further Motion Path keys to modify timing.

Tip

After setting the Motion Path keys, you can edit the placement of the key by selecting the frame number in the Viewport, enabling the Move Tool (W) and dragging left/right with the middle mouse button held down (see Fig. 1.2.11, middle screenshots).

Make sure the "motionTrail1Handle" is hidden from the scene if selection of the Motion Path key is difficult.

- Scrub to frame 50 to repeat the process and slow the motion. You can increase the distance between frames 40 and 50, so it is a bit more than between frames 30 and 40 to suggest that the plane is increasing in speed slightly (see Fig. 1.2.11, top right screenshot).

Playback the animation, the motion is more convincing as the F16 lifts off. The velocity is slowed, as it arcs off the ground. We can accelerate or speed up the motion, as the plane arcs into the sky to make the animation more convincing:

- Make sure that the F16 control object, F16_Master_Ctrl, is selected and that the INPUT node > motionPath1 > U Value is selected and highlighted in the Channel Box. The keyframes should be visible as red ticks in the Time Slider.
- Hold down the Shift key and then drag with the left mouse button from frame 99 to 100. The frame range will be highlighted in red to show that it is selected.

- On the highlighted frame range, there are a couple of yellow <> arrows. Click the left mouse button on the arrows and drag the highlighted frame range and key at frame 100 back to frame 85 (see Fig. 1.2.11, bottom right screenshot).

Drag the Range Slider beneath the Time Slider to set the end of the playback range to frame 85, and then playback the animation. The sequence between frames 50 and 85 will be faster, as the last key on the Motion Path is now at frame 85 instead of frame 100.

Scene file with additional Motion Path keys added and timing edited is included with the project scene files as – **1.2_04_F16_Path_Key.ma**.

In this tutorial, we've had a look at basic scene organization and selection through the Outliner and Display Layers. We've covered editing attributes through the Channel Box and Attribute Editor. These tools and processes are critical in navigating your Maya scene files while animating and speeding up workflow.

In the tutorial, we covered creating motion paths with Maya's curve drawing tools and attaching objects to follow motion paths. Creating and editing Motion Path keys allow us to edit the animation timing and create more convincing timing to match the elements we're animating. The timing of the shot was edited, so that the plane takeoff was more convincing and matched the weight and gravity of the F16.

In the following chapters, we'll be looking in more detail at the additional tools available in Maya for editing animation timing as well as the other animation principles that can be applied to the F16 flight sequence.

Chapter 1.3 – Character IK Arm Swing

Arcs are naturally apparent in all organic motion. This is particularly true for human motion due to the construction of the body's limbs that drive the motion.

As the limbs are appendages of the body, when they swing to create movement, natural fluid arcs should be apparent. The motion of the limbs can be considered as similar to a basic pendulum swinging motion as the limb swings from a fixed pivot.

On the human body, the most obvious pivot points on the body that create the pendulum swing and natural arced motions are the ball sockets at the hips (for legs) and shoulder sockets at the end of the clavicles (for the arms).

In this section, we'll take a look at animating a basic character arm swing. The aim of the tutorial is to give the reader a complete understanding of how to analyze organic arced motion and how to edit and refine the animation through the tools in Maya.

Understanding how to apply effective timing and posing for an arm swing to create weight and balance will also be covered in the tutorial. The tutorial will cover the following main technical and creative areas in Maya:

Maya Joint Chains, Forward & Inverse Kinematics, and Additional Controls

The tutorial will introduce the technical setup and different display modes for Skeleton Joint hierarchies in Maya. The different tools for animating skeleton joint chains with Forward & Inverse Kinematics will be covered with the additional features and controls for the Rotate Plane Solver and Pole Vector Constraint (see Fig. 1.3.1).

FIG 1.3.1 Maya joint chain, FK/IK control, and Pole Vector Constraint.

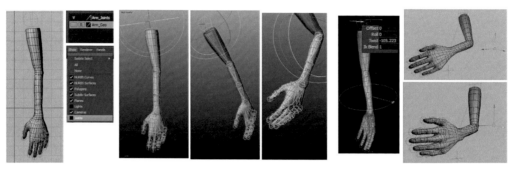

Pose Blocking, Timing & Spacing, and Motion Arcs

The main body of the tutorial will cover pose blocking for an arm swing as well as editing timing to create natural weight and follow-through on the motion. Maya's Motion Trail feature will be used to analyze and refine the motion arc in 3D space (see Fig. 1.3.2).

FIG 1.3.2 Pose blocking, timing, follow-through, and motion trails.

Joint Rig and Mesh

Open the start setup scene for this section – **1.3_01_Arm_FK_JointBind00.ma**.

The scene file includes a character arm mesh skinned to a basic arm joint chain with Maya's Smooth Bind (see Fig. 1.3.3). Open the Outliner to view the skeleton hierarchy and elements in the scene (see Fig. 1.3.3, left screenshots). The joints are in a basic hierarchy, with the J_Larm joint, the root joint, and the other children joints.

Display Modes –When working with characters setup with skeleton joint rigs, there are a few default display settings and toggles that are worth being aware of:

- Display Layers – With the Channel Box/Layer Editor active (Ctrl + A toggle), you'll see that there are a couple of Display Layers added in the scene (see Fig. 1.3.3, third screenshot from left top). The joint hierarchy has been added to its own layer (Arm_Joints) with the arm mesh also in its own layer (Arm_Geo). The Display Layers include toggles for whether the objects in the Layer are

Visible (V) or Referenced (R = Un-selectable). This allows you to toggle whether the mesh is visible (V) while working. Having the mesh on a "Referenced" layer means that it is visible but cannot be selected while animating.

- Show > Joints – The "Show" menu in the Panels menu (top menu above the Viewport panel) includes drop-down for which objects are currently visible. This allows you to toggle whether all the joints in the scene are currently visible (see Fig. 1.3.3, third screenshot from left-bottom).
- Shading > X-Ray Joints – Also in the Panels menus is the "Shading" mode menu; from here, "X-Ray Joints" can be enabled, which will display the joints through the model (see Fig. 1.3.3, second screenshot from left).

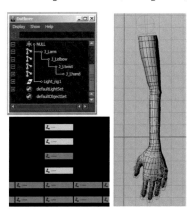

FIG 1.3.3 Joint chain hierarchy, skinned mesh, and display modes.

Note

When working with joint animation, it can be useful to toggle wireframe (4)/shaded (5) display modes. Also consider switching the Viewport background color (Alt + B shortcut) to a darker color to see the joints more clearly while working.

Animating with Forward Kinematics (FK)

On a basic joint chain, each joint needs to be animated in turn to pose the character. This is the basics of character animation, termed Forward Kinematics (FK). Kinematics is the study of motion, so Forward Kinematics basically means forward motion.

For forward kinematic animation on our arm joint chain, each joint would need to be rotated to pose and animate the character's arm.

Note

Forward Kinematics always uses rotations for animation. Translation, or scaling, of the joints in the arm chain would scale and deform the arm unrealistically.

Test out the rig using Forward Kinematics:

- From the Outliner or Side view, select the upper arm joint – J_Larm.

> **Tip**
>
> In the Outliner, the element is a child of the NULL object – expand the NULL group by clicking on the + icon with shift held down to expand the whole hierarchy.

- With the rotate tool active (E), rotate the joint in local Y-axis to swing the arm back, also test rotating round a bit in local X-axis to pitch the arm (see Fig. 1.3.4, second screenshot from left); all the other joints in the joint chain hierarchy follow the rotation.

Note

The mesh will display in purple wireframe if wireframe on shaded display is active; this shows that the mesh is accepting input (Smooth Bind (SkinCluster)).

- From the Outliner or Side view, select the elbow joint – J_Lelbow. With the rotate tool active (E), rotate the joint in local Y-axis to rotate the forearm toward the upper arm (see Fig. 1.3.4 – third screenshot from left).

Note

Some joints, such as the elbow, are referred to as hinge joints and would normally rotate only around one or two axes (like a hinge).

As it is a hinge joint, the elbow should normally rotate only around the local Y-axis in this example; however, rotation around the other axis is also possible. This can be prevented by setting up Rotation Limits for the Joint from the Attribute Editor.

> **Tip**
>
> When animating on a hierarchy, use the Up/Down arrow keys on the keyboard to move selection up and down the hierarchy quickly.

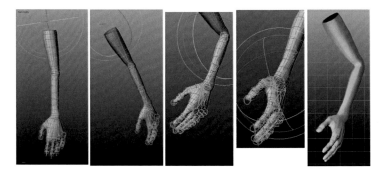

FIG 1.3.4 Animating with Forward Kinematics.

Note

Disregard the LTwist joint in the middle of the joint chain; this joint is set up to provide automated rotation in the full setup. For further info on roll joint setup, see online Chapter 9.1.

From the Outliner or Side view, select the hand joint – J_Lhand. With the rotate tool active (E), rotate the joint in Z-/Y-/X-axis to pose the hand (see Fig. 1.3.4, fourth screenshot from left).

Joints such as the wrist would have a full range of movement or rotation in all axes.

As you can see, Forward Kinematics and basic joint rotation can be a laborious way to animate. If your main aim while animating the arm was to pose the hand in space, you need to go through several steps in rotating all the joints to get the pose. However, FK rotation can sometimes produce more natural results, as it allows the animator to feel out the force and intent on each individual joint on the arm.

However, in some instances, it can be unworkable; for example, let us say you want to lock the hand to a table while animating the body motion; you would need to constantly try to match all the rotations on the arm chain to get the hand to exactly match the position.

Scene file with the arm chain pose animated with FK is included with the project files as – **1.3_01_Arm_FK_JointBind01_TEST.ma**.

Animating with Inverse Kinematics (IK)

Inverse Kinematics (IK) provides more control and flexibility for character animation. As the term suggests, IK is the opposite of FK.

In all 3D animation and in Maya, an IK setup is created from a basic joint chain, with a handle or null being created to control the rotation of the joint chain. In Maya, this is created by using the "IK Handle tool" to create the handle after selection of the root joint and end joint.

For our arm setup, an ikHandle has been created linking the root of the upper arm (J_Larm) to the wrist (J_Lhand). The ikHanlde is visible, linked under the NULL object in the Outliner; with the ikHandle selected, attributes specific to the IK Solver are visible from the Attribute Editor (see Fig. 1.3.5, first screenshot from left).

Note

IK setup is covered in more depth in the Character Rigging section in online Chapter 9.1.

- Open the scene file from the Project directory – **1.3_02_Arm_IK_Pole_00.ma**.
- From the Outliner or Scene view, select the ikHandle – named – ikHandle1.

The ikHandle is displayed in Maya as a small Null object (small cross-shaped object at the wrist on the setup file). The display size for the ikHandle can be modified from – Display > Animation > IK Handle Size.

The ikHandle is a child of the NULL hierarchy in the Outliner; expand the hierarchy by clicking the small + icon beside the name to view the element.

- With the handle selected, the joints will display as purple wireframe; this shows that there is an input constraint or connection from the IK Handle controlling their animation (see Fig. 1.3.5, third screenshot from left).
- With ikHandle1 selected, enable the Move Tool (W) and move the handle about, the arm joints rotate in position automatically to match the position. This is referred to as IK solving, with the joints solving their rotation based on the IK Handle position (see Fig. 1.3.5, screenshot on far right).

FIG 1.3.5 IK basics.

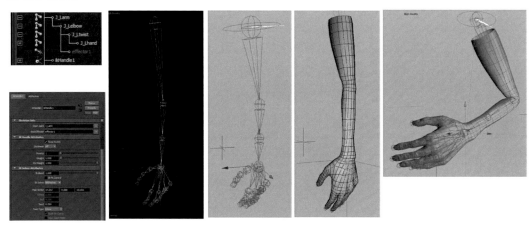

IK Rotate Plane Solver

The IK setup in the example scene uses Maya's ikSPsolver – this is a rotate plane solver, which also provides control for the rotation of the joint chain across a plane.

- With the ikHandle selected, enable the Show Manipulator Tool from the Maya toolbox (shortcut = T).
- A green line will be visible in the Viewport drawn from the root of the arm joint (J_Larm) to a bit behind the arm chain. A move icon will be visible that can be moved in space to rotate the arm; imagine that a flat plane extends from the arm chain to this point (see Fig. 1.3.6, first screenshot from left).
- Moving this control across the red local X-axis will rotate the chain, as if moving the chain's rotate plane. The position for this control can be viewed from the Channel Box when the ikHandle is selected; the position is shown as "Pole Vector X/Y/Z" (see Fig. 1.3.6, second screenshot from left).
- With the Show Manipulator tool active, a yellow circle will also be visible in the Viewport; clicking with the mouse on this manipulator will allow you to also change the rotation of the arm and elbow by dragging left/right with the mouse. This is shown as "Twist" from the Channel Box (see Fig. 1.3.6, second screenshot from left). This has the same effect as modifying the Pole Vector position to modify the rotation of the arm and position of the elbow.

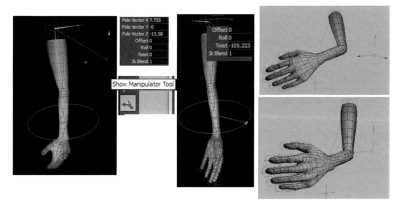

FIG 1.3.6 IK rotate plane solver, twist attribute, and Pole Vector Constraint.

In Maya, an object can be used to control the elbow position. This is set up using the Pole Vector Constraint in Maya. Setup for this is covered in further detail in online Chapter 9.1. Using an object to control the Pole Vector is more straightforward to animate on, as you do not need to constantly toggle on the Show Manipulator tool to animate the twist on the arm.

- Select the cross-shaped object behind the elbow (named Locator 1) – (see Fig. 1.3.6, top screenshot on far right).
- Enable the Move Tool (W) and move the locator; the arm chain will rotate to modify the elbow position, with the ikHandle position staying in place (see Fig. 1.3.6, bottom screenshot on far right).

Scene file example with the IK Handle (ikHandle1) and Pole Vector object animated (Locator1) is included with the project scene files as – **1.3_02_Arm_IK_Pole_01_TEST.ma**.

Blocking in the Poses for the Arm Swing

Open the setup scene as – **1.3_03_Arm_IK_Rig00.ma**.

The rig in the setup scene is the same as the one we'll work with later in Chapter 7.1. For simplicity, the joints are hidden from the Show > Joints menu. The green circular control at the wrist is set up to control the ikHandle's position through a simple constraint. Simply select, rotate, and move the control to pose the arm and rotate the wrist. Let us block in the three main poses for an arm swing.

- Switch to a side view from – Panels > Orthographic > Side or from the Maya Marking menu (Spacebar).

The playback range for the animation is set to 24 frames from the Time Slider (1 second at 24 fps).

Make sure that the "Playback Speed" is set to "Real-time [24 fps]" from the "Animation Preferences" window if it is not already (see Fig. 1.2.5 in previous chapter section).

- Scrub the Time Slider to frame 12 of the playback range, select the green circular control object (named Ctrl_Hand), and hit Shift + W then Shift + E

shortcut to set a key for Translation and Rotation for the control (see **Fig. 1.3.7**, middle screenshot). The channels should highlight in red to show that they are keyed and red tick should display on the Time Slider for the key.

- Scrub the Time Slider to frame 1 and use the Move Tool (W) to position the wrist in an upright pose swung out to the left, with the elbow still slightly bent. Activate the rotate tool (E) and rotate the hand in local Y-axis, so that it is almost parallel to the forearm (see Fig. 1.3.7, left screenshot).

FIG 1.3.7 Blocking in the major poses for the arm swing.

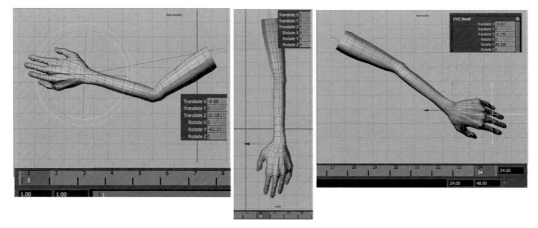

Note

The rotation of the wrist is controlled by the rotation of the circular control object, with the control needing to be rotated separately.

- With the control object still selected (Ctrl_Hand), set a key for the position and rotation at frame 1 (Shift + W/Shift + E).
- With the control object still selected, scrub the Time Slider to the last frame (frame 24) and use the same process to position the wrist, rotate the hand and set key. The angle of the arm should be around 45° (or half way between 3 and 6 o'clock on a clock's hands; see Fig. 1.3.7, right screenshot).

If you playback the animation (Alt + V – Windows/Opt + V – Mac), it should look pretty stiff and robotic. This would not only be more noticeable if using Linear interpolation for the keys, but should also be apparent if you're using the default Clamped Tangent for keys from Animation Preferences > Tangents.

If you scrub the Time Slider at four-frame intervals and check the position of the arm (0, 4, 8, 12, 16, and 20), the spacing between the hand poses should be fairly consistent (see Fig. 1.3.8). The timing & spacing between frames 0 and 12 (mid-point) should be almost identical, with the spacing a bit closer on the second phase of the swing, between frames 12 and 24 (mid-point to end).

FIG 1.3.8 Previewing the timing & spacing – blocking.

Scene file with the three key poses for the arm swing keyed at frames 1, 12, and 24 is included with the project scene files as – **1.3_04_Arm_IK_Swing01_Block.ma**.

In-between Pose – Ease In

At the start of the animation, the arm is falling toward the ground, with the wrist dropping. At this phase of the animation, the swing is gathering momentum, as gravity takes control. To make the motion believable, the intervals between the phases at the start of the swing should be slowed. This is similar to the initial in-between pose that we used for the ball bounce to slow the motion and create an "Ease In" to the animation.

- Scrub the Time Slider to frame 6.
- With the wrist control selected (Ctrl_Hand), enable the Move Tool (W) and pull the wrist up and back a bit, so that it has fallen less along the swing (see Fig. 1.3.9, left screenshot – mesh position shown in purple wireframe).
- With the wrist control still selected (Ctrl_Hand), enable the rotate tool (W) and rotate the wrist up a bit, so that the hand is angled slightly upward (see Fig. 1.3.9, left screenshot – mesh position shown in purple wireframe). Set a key for the control's Translation and Rotation at frame 6 (Shift + W/Shift + E).

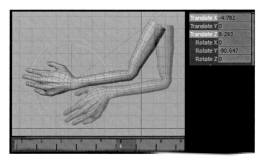

FIG 1.3.9 In-between pose – motion slowed at start (ease in)

Note

The reason the hand should be rotated upward is that it is falling after the arm; this is called "Follow-Through" in the animation. The hand and fingers are traveling after the wrist due to gravity and inertia. This creates more believable motion in the animation.

Scene file with the in-between pose keyed at frame 6 is included with the project scene files as – **1.3_04_Arm_IK_Swing02_EaseIn.ma**.

Validating the Timing and Motion

As with the bouncing ball animation from the first section, the timing can be validated by enabling ghosting for the model:

- From the Outliner, select the arm mesh (named Arm_Mesh).

Note

The object is added to the Arm_Geo display layer, which is set to "Reference" mode (E) meaning it is un-selectable from the Viewport scene view. Toggle "R" Reference mode to select from the scene or use Right-Click > Select Objects to select the object from the Display Layer.

- With the mesh selected, open the Attribute Editor (Ctrl + A); the "Arm_MeshShape" tab should be displayed by default. From here, scroll down and expand the "Object Display" rollout > "Ghosting Information" and turn on "Ghosting."
- Scrub the Time Slider slowly forward from the start frame:
 - At frame 1 – The intervals between the ghosts on the next three frames (shown in orange wireframe) are close together, showing that the arm is not traveling far over those frames (1–4) (see Fig. 1.3.10, top left screenshot).
 - At frame 6 – The intervals between the ghosts on the next three frames (frames 7–10) are spaced out a bit further, showing that the arm is accelerating to move over further distance (see Fig. 1.3.10, bottom left screenshot).
 - At frame 12 – The interval between the ghosts on the preceding three frames (frames 9–12) are spaced even further apart, showing that the arm is moving faster during this phase of the animation (see Fig. 1.3.10, middle screenshot).

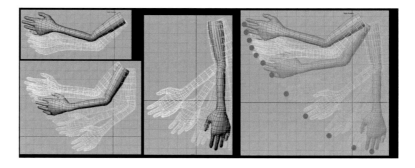

FIG 1.3.10 Validating the timing, ghosting enabled.

If you take screenshots of the arm at different frames, you can also create a contact sheet showing the timing & spacing (see Fig. 1.3.10, right screenshot).

This can be done in most image editing programs that support layers/opacity. In the above example, a red mark has been placed at the middle finger position on each frame between frames 1 and 12 to show the timing & spacing.

Motion Trail

As in the previous exercise, Maya's Motion Trail feature can be used to further validate the timing. The Motion Trail is also ideal to check the arc of the arm swing and make real-time edits to refine and smooth the path.

- Open the scene file from the Project Directory with the Motion Trail already set up – 1.3_04_Arm_IK_Swing03_MotionTrail.
- Select the Motion Trail from the side view or from the Outliner (it is named motionTrail1Handle).

With the Motion Trail selected, the attributes can be modified from the Attribute Editor to change the display and update.

- With the Motion Trail selected, open the Attribute Editor (Ctrl + A) to check the settings:

 MotionTrail1 – This tab includes the options for the frame range and update; these are listed under the "Snapshot Attributes" section (see Fig. 1.3.11, top left screen).

 Snapshot Attributes – Start Time = 1.00/End Time = 24 – The Trail is displayed for the full range of the animation; this can be modified to show only a range of the animation.

 Snapshot Attributes – Update = animCurve – The Motion Trail updates whenever the animation is modified on the object the trail is displayed for; whenever a keyframe is set or edited, the trail will update.

 Snapshot Attributes – Motion Trail = Ctrl_Hand – The Motion Trail is set to display trail for the hand control object that is animated in the scene; the trail updates when keys are set or modified.

 motionTrail1HandleShape – This tab lists the properties of the shape node for the Motion Trail (see Fig. 1.3.11, lower left screen). From here, the following is set:

 Object Display – Drawing Overrides – Drawing Overrides are enabled and the Motion Trail has been set to a bright green color for clear illustration.

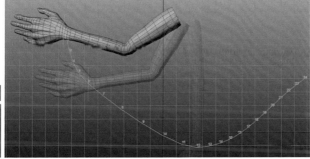

FIG 1.3.11 Motion trail display.

With the Motion Trail displayed, you can see that the trajectory the arm is following on the swing looks a bit off. The in-between key added at frame 6 improves the timing, but pushes the arm off a natural arc. The spacing between the keys at frames 12–24 is also too close and constant, and there is an odd kink at the end of the animation (see Fig. 1.3.11, Side Viewport screen).

Editing the Arc on the Swing

As the Motion Trail is set to update on animation edit (Update = animCurve), edits can be made to the animation to refine the arc on the swing.

For this, enable the "Auto Keyframe toggle" by toggling on the Key icon from the bottom right of the user interface; with Auto Keyframe enabled, edits to the position and rotation of the wrist controller will automatically set key and update the Motion Trail curve in Real-time in the Viewport. Let's start by working from a side view to refine the shaping on the curve.

- At frame 8, the hand control (Ctrl_Hand) should be pulled downward slightly to improve the shape of the curve; this in-between key will also improve the timing & spacing between frames 16 and 12 (see Fig. 1.3.12, left screenshot).

Note

Ensure that key is set with Auto Keyframe after edit and curve updates.

- At frame 12, the hand control should be pulled back a bit along the curve; this will improve the spacing between frames 12 and 24, which were previously "bunched up" with each frame being placed close together (see Fig. 1.3.12, middle screenshot).
- At frame 16 another in-between key can be set. At this frame, the wrist control (Ctrl_Hand) should be pulled slightly further along its natural trajectory. This will improve the spacing between frames 12 and 16 (wrist travels further) and frames 16 and 24 (wrist swings less, as it rises; this creates "Ease Out" in the motion). The arm should also follow more of a straight line at this frame to follow the hinge swing of the elbow (see Fig. 1.3.12, right screenshot).

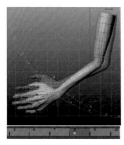

FIG 1.3.12 Editing the arc and spacing.

As mentioned previously, the angle of the hand should also be modified to add follow-through to the motion. At the new keyframes, rotate the wrist control back slightly in local Y-axis to suggest that the weight of the hand is carried after the elbow (see Fig. 1.3.12).

While adding and editing the in-betweens to modify the arc shape and timing, continually review the motion on playback (Alt + V) and by scrubbing the Time Slider. Minor edits to the posing at in-between keyframes such as frame 16 may be necessary to create a smooth arc (see Fig. 1.3.13, left screenshots). The arc should follow a flatter, more bowed shaped at the end of the arm swing, as the arm is more fully extended than at the start frame (frame 1).

For the timing at the end, additional in-between keyframe can be added at around frame 20 to pull the wrist further along the arc and add additional follow-through for the hand (see Fig. 1.3.13, right screenshots).

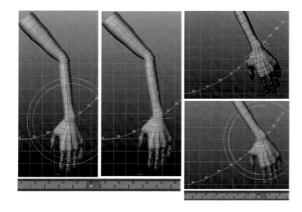

FIG 1.3.13 Refining the arc and basic edit to timing on arm up-swing.

Shifting and Scaling Keyframes

If you check the timing & spacing between the keys on playback or by checking the frame numbers on the Motion Trail, you should notice that it looks inconsistent. The spacing between the keys on the second half of the swing (frames 12–24) are still bunched up looking and the timing fairly regular.

To resolve this, we can shift and scale the keys on the Time Slider to make the timing more consistent, mirroring the "Ease In" and acceleration from frame 1 to frame 12 with a consistent fast out and "Ease Out" on the up-swing (frames 12–24):

- With the hand control object selected (Ctrl_Hand), click the left mouse button at frame 16 on the Time Slider.
- With the mouse button clicked at frame 16, hold shift and drag right to select range from frame 16 to frame 21 – the selected frame range will highlight red on the Time Slider (see Fig. 1.3.14, left screenshot).
- With the range selected and highlighted red, click the middle <> handle on the range and drag left to shift the keys back 1 frame (keyframes 16–20 shifted to frames 15–19) (see Fig. 1.3.14, right screenshot).

FIG 1.3.14 Shifting keys back in time.

The overall timing of the down swing section (frames 12–24) should also be shortened by a few frames to make the spacing more consistent with the first half of the animation:

- Select the key at frame 12 and shift back to frame 11.
- Select the keys between frames 11 and 24, so that the range is highlighted red (see Fig. 1.3.15).
- Grab the arrow handle > at the right-hand side of the selected range and drag the handle to the left to scale the selected key range. The end key should be moved to around frame 20 to scale the range and speed up the overall motion (from frame 11–24 to frame 11–20 – just over a quarter) (see Fig. 1.3.15).

Note

When scaling keys on the Time Slider, frames will be offset and can end up sitting on non-whole frame numbers. This can be validated by using the "Step forward/back one key" button on the Playback controls to see where the keys sit. To resolve this, select the key range and use Right-Click > "Snap" to snap the keys to whole frames (see Fig. 1.3.15, right screenshot).

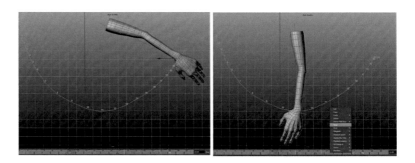

FIG 1.3.15 Scaling selected key range to adjust timing.

Scene file with the motion arc and timing edited is included with the project scene files as – **1.3_04_Arm_IK_Swing04_MotionTrail_Edit.ma**.

Camera Bookmarks

So far, the edits to the arm swing have all been done from a side view. Working from an orthographic view is simpler when blocking in animation, as you are only validating and editing the animation in two dimensions. Always switch between the different orthographic and perspective views at different stages while animating to check the timing & spacing.

With the basic swing of the arm from the side refined through using the Motion Trail, we can move on to refining the swing and adding additional side-to-side motion on the arc.

When working in a Perspective View to make edits to character animation, it can be useful to set up camera bookmarks; camera bookmarks in Maya allow you to save a bookmark of different views showing the animation from different angles.

- Go to a Perspective View (from Spacebar > Hotbox > Perspective or Panels > Perspective).
- Use the camera tools to tumble (Alt + LMB), track (Alt + MMB), or dolly (Alt + RMB) the view, so that the arm is shown from roughly the same view as the side view (see Fig. 1.3.16, right screenshot).

> ### Tip
> You can also use the Maya view cube (top right of the Viewport) to quickly orbit the view or switch to side view (Perspective).

It is fairly straightforward to save and edit the camera bookmarks:

- Once you're happy with the side view from the Perspective camera, go to the Panels menu at the top of the panel and select:
 - View > Bookmarks > Edit Bookmarks (see Fig. 1.3.16, left screenshot).
- From the Bookmark Editor, type a descriptive name for the view (SIDE) and hit "New Bookmark" (see Fig. 1.3.16, top middle screenshot).
- Once the bookmark has been stored, it can be returned to from:
 - View > Bookmarks – the names should be listed from here (see Fig. 1.3.16, bottom middle screenshot).

FIG 1.3.16 Creating and returning to camera bookmarks.

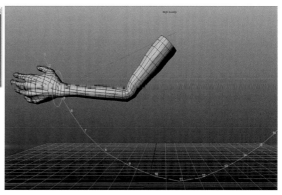

For edits to the motion in 3D, several different views should be used to validate and refine the animation. The following camera bookmarks are ideal for the additional edits that we'd need to finalize the arm swing (see Figs 1.3.16 and 1.3.17):

SIDE – Side view.
SIDE_FRONT – Three-quarter view of the arm from the front side.
FRONT – Almost straight on view of the arm from the front.
SIDE_BACK – Three-quarter view of the arm from the back side.
BACK – Almost straight on view of the arm from the back.

Note

Although the camera bookmarks are a great aid when validating and refining the animation, more experienced animators may find that they prefer the ease and flexibility of modifying the view angle directly from within the Viewport while editing.

Scene file with the camera bookmarks setup for the Perspective View is included with the project scene files as –
1.3_04_Arm_IK_Swing05_Cam_bookmarks.ma.

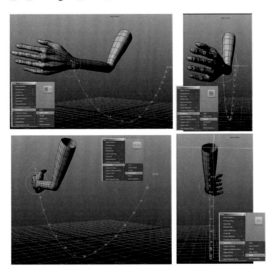

FIG 1.3.17 Camera bookmarks setup to validate and refine the arm swing.

If you playback the animation from the BACK or FRONT camera view, you can see that the arm is only arcing from left to right currently. This is unnatural for an arm swing; an arm doesn't swing like a pendulum on a clock, from a fixed hinge. The shoulder joint the arm is connected to also allows the arm to pivot in more than one axes. On an arm swing, the arm and hand would also naturally swing in across the body at the start and end of the swing and out away from the body at the mid-point of the swing (frame 11 in our animation). Part of this additional arc to the motion would be controlled by the rotation of the shoulders. Although we are only animating the arm swing, we can mimic some of the additional arc motion that would be distributed from the shoulder rotation.

Editing the Arm Swing – Out/In

With the hand control selected (Ctrl_Hand), open the Channel Box (Ctrl + A toggle).

In the Channel Box, we can see that all the translation and rotation channels for the control have been animated; the values are highlighted in red to show that there are keys set.

For the Translate Y Channel, the value is at Translate Y = 0 throughout the animation, the channels that are animated with value change are Translate X (side-to-side swing from side view) and Translate Y (up/down motion on swing from side view). Translate Y is the local translation channel for the wrist motion Inward/Outward toward the viewer when viewing from the side (see Fig. 1.3.18, left screenshot – local Translate Y Channel selected and highlighted yellow on Move).

Occasionally, keys may be set on a channel throughout an animation even though the motion has not been animated (as Shift + W or S shortcuts used). To clean up the scene and remove extraneous keys, right-click on the selected channel in the Channel Box and choose "Break Connections" option; the values for the channel will no longer be shown in red, showing that key connections have been removed (see Fig. 1.3.18, right screenshot).

FIG 1.3.18 Removing animation connections – translate Y.

- At frame 1, select the hand control (Ctrl_Hand) and, from the Channel Box, right-click on the Translate Y Channel and choose "Key Selected."
- At frame 11, select the hand control (Ctrl_Hand) and, from the Channel Box, right-click on the Translate Y Channel and choose "Key Selected" (see Fig 1.3.19, left screenshot)
- Scrub the Time Slider to frame 1 and set the Perspective View to the SIDE_FRONT view from: View > Bookmarks > SIDE_FRONT (see Fig. 1.3.19, middle screenshot).
- At frame 1, select the hand control (Ctrl_Hand), enable the Move Tool (W), and pull the hand in slightly toward the imaginary body (in Global X-axis/local Y-axis).
- Set key for the translation edit at frame 1 by hitting S (key All Channels).

Note

The value for the local Translate Y Channel for the control should update to show negative value, around −1.6 to −1.65 (see Fig. 1.3.19, right screenshot).

The green Motion Trail curve in the Perspective Viewport will update automatically to sync with the edit made to the hand position. The curve should now arc outward from left to right of the Viewport between frames 1 and 11 (see Fig. 1.3.19, right screenshot).

FIG 1.3.19 Keying the wrist swinging inward at frame 1 then outward at frame 11.

The pose at frame 11 can also be strengthened by pulling the wrist control out slightly (see **Fig. 1.3.20**, second screenshot from left).

Note

When posing the control outward, be aware that the arm joint chain may lock if the IK control is pulled too far outward (set Translate Y Channel to maximum 2.1).

At frame 14, the wrist should continue along an out-swing trajectory, edit the pose, so that the control continues to swing out at frame 14 (set Translate Y Channel to maximum 2.0) (see Fig. 1.3.20, fourth screenshot from left). Make sure that you hit S shortcut to key the channels after the edits.

FIG 1.3.20 Keying the wrist swinging out further at frames 11 and 14.

At the end of the swing (frame 20), the arm should swing back inward again to a similar pose to the one keyed at frame 1.

- Scrub the Time Slider to frame 20 and set the Perspective View to the SIDE_BACK view from: View > Bookmarks > SIDE_BACK (see Fig. 1.3.21, left screenshot).
- At frame 20, select the hand control (Ctrl_Hand), enable the Move Tool (W), and pull the hand in slightly toward the imaginary body (in Global X-axis/local Y-axis). Check the value for Translate Y from the Channel Box; it should be set to around Translate Y = −0.338 (see Fig. 1.3.21).
- Set key for the translation edit at frame 20 by hitting S (key all channels).

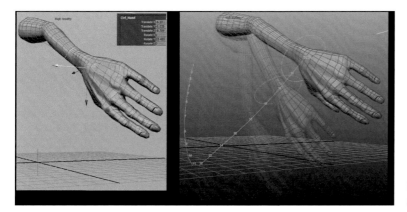

FIG 1.3.21 Finalizing the arc for the arm swing.

Check the shape of the curve from different angles by orbiting around the Viewport (Alt + LMB) or switching between the camera bookmarks that are set up for the scene. The arc on the Motion Trail should be fluid with it swinging in noticeably at the start of the sequence (frame 1), out to full extension around frames 11–14, and then back in to the body (see Fig. 1.3.21).

Scene file with the arc edited to include the additional inward and outward swing motion on the arm is included with the project scene files as – **1.3_04_Arm_IK_Swing06_MotionTrail_Edit2_SIDE.ma**.

Looping the Arm Swing

For the animation, the arm swings from left to right (from frame 1 to frame 20), stopping at the pose with the hand back out behind where the body would be on the character. For the sequence, we can loop the motion to get the hand to swing back in the opposite direction to where the start frame is. You can quickly preview this by changing the Playback option to "Oscillate."

- Open the Animation Preferences from the shortcut button at the bottom right of the user interface (see Fig. 1.3.22, left screenshot).
- From the Preferences window, set the following (see Fig. 1.3.22, right screenshot):
 - Playback > Looping > Oscillate.

Note

Oscillate will loop playback – forward from frame 1 to frame 20, then backward from frame 20 to frame 1 repeatedly. This is also sometimes termed as "ping-pong" playback. The default option is continuous, which will continuously loop frame 1–20/20–1/1–20, etc.

- Hit save to save the change from the Preferences window and playback the scene.

FIG 1.3.22 Playback options – oscillate.

Although the animation loops with the arm swing backward, forward, and backward continuously, the motion looks unnatural; the hand poses do not look right on the swing back and the wrist is following the same trajectory (Motion Trail) as the animation is identical. Re-open the Animation Preferences window and set Playback > Looping back to "Continuous" – Copying and reversing the animation keys will allow us to edit and refine the motion for the swinging backward and forward loop animation, instead of having it loop back and forwards automatically.

First, increase the number of frames in the animation, so that there's more frames to work with in copy/pasting and editing the keys. Set the End Time of both the Animation and playback to 65.00 frames (see **Fig. 1.3.23**).

Note

Both these values can be set at the right side of the Range Slider, just beneath the Time Slider.

FIG 1.3.23 Setting the end animation and end playback range.

To create the loop, we need to copy and reverse the keyframes set on the hand control object. The range that should be copied is from frame 1 to frame 17. Frame 20 does not need to be copied, as this frame is the mid-point on the original left/right swing and new right/left swing that we'll create by reversing the motion.

- With the hand control object selected (Ctrl_Hand), click and hold the shift key at frame 1 and then drag to around frame 18 to select all the keys from frame 1 to frame 18 (the selected range should highlight red on the Time Slider).
- With the key range selected, right-click on the Time Slider and choose > Copy to copy the keys to the buffer (see Fig. 1.3.24, left screenshot).
- Scrub the Time Slider to frame 40. Right-click at frame 40 and choose Paste > Paste option (see Fig. 1.3.24, right screenshot). The keyframe ticks that were copied from frame 1 to frame 17 should be pasted and visible between frames 40 and 58.

FIG 1.3.24 Copy/pasting the keys for the swing.

With the control selected (Ctrl_Hand), open Maya's Dope Sheet Editor from Window > Animation Editors > Dope Sheet (see Fig. 1.3.25, left screenshot).

FIG 1.3.25 The Maya Dope Sheet window.

Maya's Dope Sheet Editor can be used to modify key timing, copy/paste keyframes, and scale frame ranges. The Dope Sheet provides a simplified graphical interface for selecting and modifying all keyframes for a selected object or individual channels. From the left pane of the Dope Sheet, the selected object is listed, with the keyframes shown on the main right pane (see Fig. 1.3.25, top right screenshot). From the left pane, selecting + icon will expand the object connections and show animated channels and associated keyframes in the main right pane of the Window (see Fig. 1.3.25, bottom right screenshot).

- With the select tool active (Q), select the keyframes between frames 40 and 65.
- With the keyframes selected and highlighted in yellow, enable the Scale Tool (R).

Note

After the Scale Tool is enabled for a range of keys selected in the Dope Sheet, a white marquee box will display around the selection. Each corner handle of the white marquee box selection can be used to scale the keyframes in toward the frame on opposite side (to compress the frames) or outward to increase the frame range the keys are placed on.

- With the keys selected and the Scale Tool active, grab the right corner handle on the white marquee selection box and drag the handle toward the left.
 - This will scale the keyframe range in time in toward the frames 1–40 (see Fig. 1.3.26, first three screenshots from top to bottom).
- Continue dragging the scale handle beyond the first frame (frame 40) to scale the key range in negative value. This will effectively reverse the motion. Scale the end key to around frame 23, just after the end key on the original sequence (see Fig. 1.3.26, bottom screenshot).

FIG 1.3.26 Scaling keys to reverse motion in the Dope Sheet.

Note

When scaling key ranges through the Dope Sheet, keys may not fall on whole frames after edit. To resolve this, use Edit > Snap Keys from the Dope Sheet window or select and "Snap" the keys from the right-click context menu on the Time Slider.

After reversing the motion, additional edits to the key spacing may be needed to match the reverse motion (frame 20–40) with the original motion that was copied and reversed (from frames 1–20).

Edits to the key spacing can be made by selecting and dragging key ranges from either the Time Slider or through the Dope Sheet (see Fig. 1.3.27, top two screenshots).

Some people prefer to make the majority of edits to timing & spacing through the Time Slider, as it is more immediate and easier to make edits than through a separate window.

The frame spacing for the new copied and reversed keys (20–24) should exactly be the opposite of the original keys (frames 1–20).

Key at frame 23 (same as original key copied from frame 17).
Key at frame 26 (same as original key copied from frame 14).
Key at frame 29 (same as original key copied from frame 11).
Key at frame 33 (same as original key copied from frame 08).
Key at frame 35 (same as original key copied from frame 06).
Key at frame 40 (same as original key copied from frame 01).

Note

You could also use copy/paste option to copy the individual keys from their original frames (1–20) to the reversed section (20–40).

With the animation looped, set the End of both the Animation Range and "Playback Range" to frame 40 from the input boxes at the right side of the Range Slider (beneath the Time Slider) (see **Fig. 1.3.27**, bottom screenshot).

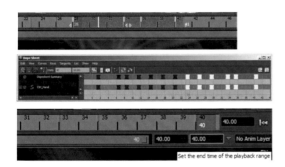

FIG 1.3.27 Fixing the reversed/ looped key timing and setting animation range.

Note

The Motion Trail that we added to the scene earlier will only update based on the original Time Slider settings used when creating the Motion Trail (frames 1–20).

To view the Motion Trail for the new section (20–40), select the Motion Trail object, then

- From Channel Box, expand the INPUTS > motionTrail1 section.
- Set End Time = 40.

Scene file with the animation on the arm swing looped with back swing is included with the project scene files as – **1.3_05_Arm_IK_SwingLoop01.ma**.

If you playback the new looped animation, the effect should be identical to the playback previously using the "Oscillate" playback option. The animation from frame 1 to frame 20 is exactly reversed from frame 20 to frame 40. Although this looks unnatural, we can now make additional edits to the motion on the reversed section (20–40) to create a natural backward swing motion from right to left (when seen from Side View).

Editing the New Motion – Arm Swing Back

On playback of the animation, the hand follows exactly the same trajectory, as it swings from left to right (frames 1–20) and back from right to left (frames 20–40). This looks unnatural; the wrist appears to move along a rail, as it swings back and forward.

If you look closely at the Motion Trail in the scene view, the frame numbers displayed are overlaid for the original forward motion and reversed motion; showing that the position for the keys is on identical frames on the looped/ reversed section (see Fig. 1.3.28, top screenshot).

With the Control Object selected (Ctrl_Hand), open the Graph Editor and select the Translate Y Channel to display the motion graph (see Fig. 1.3.28, top screenshot). This is the swing outward and inward we keyed originally for the wrist; the curve looks like two identical mountains (see Fig. 1.3.28, top screenshot).

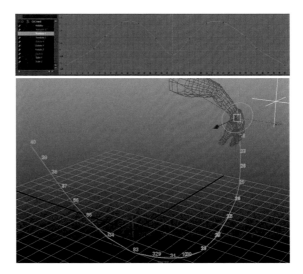

FIG 1.3.28 Validating the motion curve from the Graph Editor.

We can offset the motion on the swing, as the arm comes back (frames 20–40):

- With the hand control object selected (Ctrl_Hand), open the Graph Editor and select the Translate Y Channel to display the motion graph.
- With the select tool active (Q), select the following key range:
 - Frames 23–35.

Note

We don't want to edit the key at frame 20 or 40, as both these keys are at the mid-point (frame 20) and loop point (frame 40) on the original animation.

• With the key range selected in the Graph Editor, enable the Move Tool (W), hold the Shift key on the Keyboard, and then click and drag downward with the middle mouse button pressed down.

Note

Holding shift key while modifying key position will allow you to restrict the edits in the Graph Editor to either time (left/right drag with mouse) or value (up/down drag with mouse).

Dragging the selected keys down in value changes the position of the wrist at these frames (see Fig. 1.3.29). When viewed from the Camera Bookmark > FRONT, the wrist should appear shifted over to the left during the second half of the animation when the arm is swinging back (frame 20–40). Offsetting the motion creates a more natural curve and the arm is no longer swinging as if it is "on rails." While making edits to the key position, validate the curve shape on the Motion Trail, as it updates in the scene view.

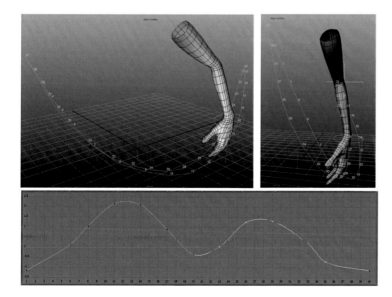

FIG 1.3.29 Editing the translate Y channel (wrist swing out) on the back swing (frame 20–40).

You can take this further by creating an overlapping loop or "figure eight" type motion on the swing (see Fig. 1.3.30) – with the arm swinging in further to the body between frames 23 and 26 (Translate Y decreased) then crossing over at

73

frame 29 (to same as frame 11 position) to swing outward in opposite direction away from the body (at frame 33/35 Translate Y increased) (see Fig. 1.3.30).

FIG 1.3.30 Editing the translate Y channel (wrist swing out) on the back swing (frames 20–40).

Scene file with the curve trajectory edited for the arm swing back (frames 20–40) is included with the project scene files as – **1.3_05_Arm_IK_SwingLoop02_Fig8.ma**.

Follow-through on the Wrist

On playback, the wrist motion for the new swing-back section (frames 20–40) looks unnatural. The wrist rotation and hand position are the same as they are in the first section of the animation (frames 1–20). This is because the keys have been copied and reversed.

If you remember from the earlier section, we offset the rotation on the wrist, so that the hand appeared to follow-through, as the arm swung from left to right (see Fig. 1.3.12).

For the reversed section and swing back, the wrist rotation should be reversed to provide natural follow-through and weight to the motion.

- Select the hand control (Ctrl_Hand) and with the rotate tool active (E), step through the following keys (Step Forward/Backward Key = . (period)//, (comma)) and rotate the wrist control backward, so that the fingers are trailing behind, or following the wrist motion. Set keyframe after making each edit to the rotation.
 Frame 23/Rotate Y = 50 (see Fig. 1.3.31, first screenshot from left).
 Frame 26/Rotate Y = 40 (see Fig. 1.3.31, second screenshot from left).
 Frame 29/Rotate Y = 25 (see Fig. 1.3.31, third screenshot from left).
 Frame 33/Rotate Y = −25 (see Fig. 1.3.31, fourth screenshot from left-top).
 Frame 35/Rotate Y = −45 (see Fig. 1.3.31, fourth screenshot from left-bottom).

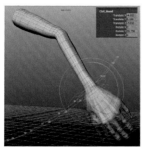

FIG 1.3.31 Follow-through on the wrist-arm swing-back (frames 20–40).

The edited animation should look more natural, weighted, and fluid.

- On the upward back swing (frames 11–20), the hand is slightly angled behind the wrist with the fingers following the motion (see Fig. 1.3.32, left).
- On the downward forwards swing (frames 20–40), the angle of the hand is now reversed, again following the line of travel of the forearm (see Fig. 1.3.32, right).

If you look at the posing of the hand at the extreme points on the swing (frames 0, 20, and 40), the wrist angle does not reach the extreme pose for the follow-through until a few frames after reaching the extreme point in the swing; this offset on the motion creates a more natural weight, as the objects in the chain react to the motion on trajectory and weight at different times. The wrist action follows the forearm.

Scene file with the wrist/hand posing edited to add weight and follow-through (frames 20–40) is included with the project scene files as –
1.3_05_Arm_IK_SwingLoop03_WristWeight.ma.

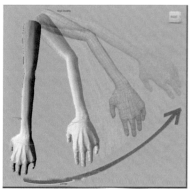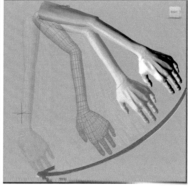

FIG 1.3.32 Visualizing the wrist/hand follow-through (up – frames 11–20; down – frames 20–29).

Elbow Angle (Pole Vector)

The animation now looks more fluid and natural with the timing and pose edits that we've made to the wrist. However, if we look at the arm swing animation from the front, the elbow posing doesn't appear to follow the angle of the arm and wrist (see Fig. 1.3.33).

As the arm swings downward, the elbow is pushed inward, which looks unnatural (see Fig. 1.3.33, middle screenshot).

FIG 1.3.33 Elbow angle on swing — un-edited.

Earlier in the chapter section, we covered the ikSPsolver and Pole Vector Constraint that are set up on the arm (see Fig. 1.3.6). The Pole Vector Constraint allows control over the arm posing through animating the yellow cross-shaped Locator object named Ctrl_Elbow that's visible behind the arm. Let's take a look at editing the Pole Vector to make the posing on the elbow look more natural:

- Scrub the Time Slider to the start frame (frame 1).
- Tumble around the Perspective View to view the arm swing from 3/4 front view (see Fig. 1.3.34, left screenshot).

By viewing the arm pose from the front, the elbow is pushed in quite far and doesn't match the angle the wrist is swinging in (as seen on the Motion Trail) (see Fig. 1.3.34, left screenshot).

- From the Outliner or Perspective View, select the yellow cross-shaped locator object for the elbow Pole Vector Control (named Ctrl_Elbow).
- With the Move Tool (W) active, pull the locator out to the right-hand side to change the elbow pose. The elbow should be posed, so that the plane of the arm more naturally follows the swing (see Fig. 1.3.34, middle and right screenshots).
- With the Control object still selected (Ctrl_Elbow), hit Shift + W shortcut to key the translation. The value for Translate Y in the Channel Box (Ctrl + A) should be around 6.05.

FIG 1.3.34 Editing elbow angle on swing with Pole Vector Control, frame 1.

- Scrub the Time Slider to frame 20; at this frame, the arm is fully back on the swing.
- Tumble around the Perspective View to view the arm swing from 3/4 front view or 3/4 back view (see **Fig. 1.3.35**, first and second screenshots from left).

Viewing the arm pose from the front, the elbow is pushed out quite far and doesn't match the angle the wrist is swinging in (as seen on the Motion Trail (see Fig. 1.3.35, first and second screenshots from left)).

- With the control object still selected, enable the Move Tool (W) and pull the locator in toward where the body would be to change the elbow pose. The elbow should be posed, so that the plane of the arm more naturally follows the swing (see Fig. 1.3.35, third and fourth screenshots).
- With the Control object still selected (Ctrl_Elbow), hit Shift + W shortcut to key the translation. The value for Translate Y in the Channel Box (Ctrl + A) should be around −1.731.

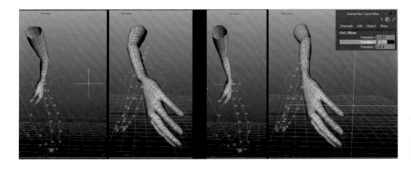

FIG 1.3.35 Editing elbow angle on swing with Pole Vector Control, frame 20.

- Scrub the Time Slider to frame 40; at this frame, the arm is fully forward on the swing, at the same pose as frame 01.
- Tumble around the Perspective View to view the arm swing from the top view or 3/4 front view (see **Fig. 1.3.36**, first and second screenshots from left).

Keying the Pole Vector control at frame 20 has pushed the Pole Vector Control and elbow in at this frame. The elbow pose looks unnatural and doesn't follow the angle of the arm or swing (see Fig. 1.3.36, first and second screenshots from left).

The pose at frame 40 should be the same as at frame 1.

- Scrub the Time Slider to frame 1 and, with the elbow control selected (Ctrl_Elbow), open the Channel Box (Ctrl + A toggle).
- From the Channel Box, check the Pole Vector controls translation in local Y axis at this frame. In the example, we used value of:
 - Translate Y = 6.05.
- Double-click the Translate Y numeric input field to select and highlight the value.

- With the number displayed and selected, hit Ctrl + C to copy the number and then scrub to frame 40 and past the value in the numeric input field for Translate Y.
- Hit Shift + W shortcut to key the translation for the control object (Ctrl_Elbow).

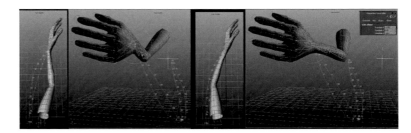

FIG 1.3.36 Editing elbow angle on swing with Pole Vector Control, frame 40.

Scene file with the Pole Vector Control animated to create more natural posing on the elbow on the swing is included with the project scene files as – **1.3_05_Arm_IK_SwingLoop04_Pole_Elbow.ma**.

Chapter 1.4 – Character – Run Rhythm

In the preceding tutorial, we took a look at animation arcs for a basic arm swing. Fluid motion arcs are naturally apparent when analyzing human motion and can be applied across all phases and elements of character animation.

In this tutorial, we'll take a look at the arcing rhythm of the body in motion during a run cycle. Fluid motion arcs can be seen on the body during the run and are particularly apparent on the height of the body in motion.

As with other areas of animation, the study of video or photo reference should be encouraged along with thumbnailing. Thumbnailing is covered in more detail in Chapter 5 and can be used for project work such as this, where you need reference to determine the motion arc of the human body.

If we take a look at motion arc overlaid for the character's hip and head height during a run, we can see considerable movement in the height of the hips during different phases of the run (see **Fig. 1.4.1**).

FIG 1.4.1 Thumbnail – character arc on run – height.

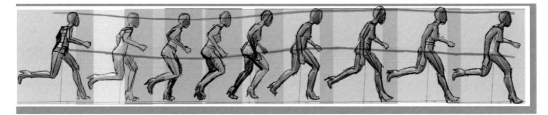

The hips dip considerably during the run after each major foot plant, as the weight on the hips is transferred downward. The hips are at their highest during the run when the legs are fully extended, as the weight is transferred upward and forward.

As with the preceding tutorial, we will work with the Motion Trail feature in Maya to appraise the arcing motion on the run and make edits to the motion to create more fluid and natural animation. The tutorial will also cover some of the additional tools available in the Maya Graph Editor to smooth the curve tangency as well as to loop the motion in space (see Fig. 1.4.2).

FIG 1.4.2 Motion trail editing and Maya Graph Editor.

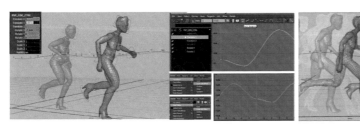

Scene Setup and Animation

Open the start setup scene for this section – **1.4_00_RUN_Arc00.ma**.

The scene file includes a character mesh bound to skeleton with Control Rig (see Fig. 1.4.3, left screenshot). As in the previous exercises, Display Layers are setup to control visibility of the following elements:

- Skeleton – This layer includes the character skeleton that the mesh is bound to with Smooth Bind.
- Curve_CNTRLS – This layer includes the Control Objects for the rig; visible as the color-coded wire objects in the Viewport (see Fig. 1.4.3, left screenshot).
- Geometry – This layer includes the character model; the layer is set to "Reference" mode, so that the model is not selectable while working.

Ensure that the Playback Speed is set to Real-time [24 fps] from Maya's animation preferences and hit play (Alt + V).

- The animation on the character is a run cycle. We'll cover the process for blocking out the run cycle animation for the character in Chapter 8.1, where we'll look at a pose-to-pose workflow for animation. For this exercise, we'll work specifically on just the animation arc for the character's hip height during the run.
- The Control Rig setup will also be covered in online Chapter 9.1. For this exercise, we'll work with the main animation control for the character's center of mass (or hips) to create a more convincing arc on the run.

On playback, you'll notice that the character's hips do not move during the run cycle. This makes the animation appear unnatural and unrealistic. The run cycle is animated with the character "on the spot."

An additional parent control for the character rig hierarchy has been added and animated to visualize the run across the ground. This element is the large cross-shaped locator at the base of the character at the origin (at 0, 0, 0 – named PARENT). The translation for the character parent is animated on a layer. This allows the run across space to be toggled on and off from the animation layer.

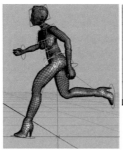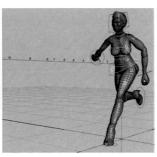

- Open the Channel Box/Layer Editor and select the "Anim" tab (see Fig. 1.4.3, middle screenshot).
- Select and highlight the "Anim_Run_DIST" layer; it should highlight in blue.
- The small icon that looks like a "Stop Sign" in the layer toggles Mute/Un-Mute for the layer (third icon from left).
- Toggle off "Mute" for the Layer, so that the animation for the PARENT control is active.

When the Layer is active, the Locator object is animated moving across the ground on playback, turning the static "on the spot" run cycle into a run across the ground plane.

A Motion Trail is also visible in the Perspective View showing the trajectory of the character's hips (see Fig. 1.4.3, right screenshot).

As you can see, the trajectory is a straight line that allows us to visualize and assess the unnatural hip motion in space.

Orbit around to the side of the character. If you scrub the Time Slider, you should be able to see that the motion looks unnatural and rigid. Enabling Ghosting for the character mesh (from the Attribute Editor) can help visualize this more clearly. For illustration, I've composited some screenshots showing the character run between frames 0 and 8 with overlaid line showing the hip trajectory (see Fig. 1.4.4).

Check the major poses at the keyframes for the run:

> Frame 00 – The character's left outstretched leg is connecting with the ground plane.
> Frame 02 – The character's hips are beginning to pass over the planted left foot.
> Frame 05 – The character's weight is transferring across the right leg, which is outstretched.
> Frame 08 – The character's right outstretched leg is connecting with the ground plane.

The pose at frame 08 is exactly a mirror of the pose at frame 00. The leg, torso, and arm poses are exactly mirrored. The animation from frames 08 to 16 is also an exact mirror of frames 00 to 08 except that the leg, torso, and arm poses are exactly mirrored.

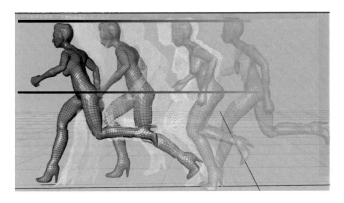

FIG 1.4.4 Visualizing character motion trajectory on run.

The height of the hips during the run cycle should follow a natural arc when viewed from the side. The character's hip should naturally rise up and down in a fluid arc as the character's weight is transferred during the weight shifts onto either foot and push off from the ground.

The Motion Trail included in the start setup scene is created in a previous version of Maya; this is the same type that we worked with in the preceding Chapter sections, with the trail curve updating when edits are made to the animated object.

For this exercise, we'll take a look at working with the newer Editable Motion Trail introduced in Maya 2012.

Note

If you are using Maya 2011 or older version, you can still work through this tutorial using the older Motion Trail object included in the scene.

- Select the Motion Trail object from the Viewport or Outliner. The object is the line showing the trajectory of the hips and is named motionTrail1Handle in the Outliner (see Fig. 1.4.5, left screenshot).
- With the Object selected, go to the Display menu at the top of the Maya UI and choose:
 - Hide > Hide Selection (see Fig. 1.4.5, right screenshot).

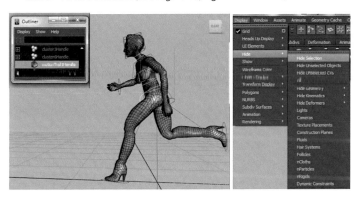

FIG 1.4.5 Hiding Motion Trail from scene.

Create the new Editable Motion Trail in Maya following the below steps:

- From the Outliner, expand the "PARENT" hierarchy by clicking on the + sign beside the name.

Tip

Use Shift + Click to expand the full hierarchy.

- Select the main center of mass control object named FSP_COG_CTRL (see Fig. 1.4.6, top left screenshot).

Note

The control object is the red wire cube-shaped object that is visible in the Viewport around the characters' hips, selecting the control will highlight the object itself green in the Viewport along with the child control objects. The character mesh will appear highlighted purple when Wireframe (4) or Wireframe on Shaded Display modes are active; this indicates that the model is accepting input from the control object and underlying skeleton (see Fig. 1.4.6, bottom left screenshot).

- With the control object still selected, enable the Animation Menu Set (F2) and go to the Animate menu at the top of the UI and select:
 - Create Editable Motion Trail [] Options (see Fig. 1.4.6, top middle screenshot).

Use the default options as is except for the toggle for "Show Frame Numbers," which should be enabled (see Fig. 1.4.6, bottom middle screenshot).

The Editable Motion Trail will be visible in the Viewport as a red line; the line shows the trajectory of the objects' motion with the keyframes displayed as small white boxes. The frame numbers for the keyframes should also be displayed using the option as set in the last step (see Fig. 1.4.6, right screenshot).

FIG 1.4.6 Creating Editable Motion Trail.

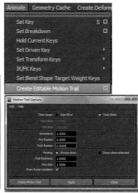
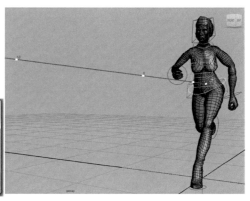

The display options for Editable Motion Trail are accessible from the Attribute Editor:

- Either select the Motion Trail in the Viewport or select the element from the Outliner named – motionTrail2Handle.
- With the object selected, open the Attribute Editor (Ctrl + A toggle) and ensure that the motionTrail2HandleShape tab is selected (see Fig. 1.4.7, first screenshot).
- From here, the keyframe, Active Keyframe, trail color, and thickness display can be set (see Fig. 1.4.7).
- The keys on the Editable Motion Trail can be selected and manipulated directly from the Viewport; select any of the Keyframes (small cube icon and trail) and enable the Move Tool (W) and move the Active Keyframe up in global Y-axis (see Fig. 1.4.7, third and fourth screenshots).

FIG 1.4.7 Editing keys on Editable Motion Trail.

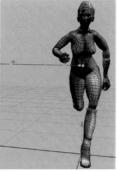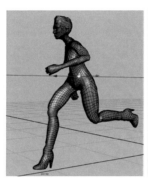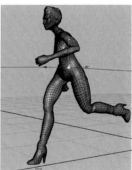

After selecting the key, the color will change as specified in the Active Keyframe attribute. Modifying the position of the keyframe in the Viewport will also change the position of the object in space at the given keyframe (see Fig. 1.4.7, third and fourth screenshots).

Editing the key position directly in the Viewport is an enhancement to the original Motion Trail in Maya that we looked at earlier and allows for a more visual workflow while animating. The previous workflow that we used in selecting the object itself and animating to change position will also update the Motion Trail as with the previous implementation. A direct relationship exists between the key placement on the Motion Trail and the objects placement in the Viewport.

We can use the standard workflow of keying the control object to modify the animation and validate the changes with the Editable Motion Trail:

- From the Toolbox at the left side of the user interface, toggle on Perp/Graph from the Panel shortcut layout buttons to switch the Panels to display Perspective Panel above Graph Editor Panel.
- Select the hip control object from the Perspective Panel or Outliner (named FSP_COG_CTRL).

83

- From the Graph Editor, select the objects Translate Y Channel to view the Graph.
- Scrub the Time Slider to frame 05.

At this frame, the character's hips are too low (see Fig. 1.4.8, left screenshot); they should be raised as the weight is beginning to transfer onto the planted right leg:

- With the Control Object still selected, open the Channel Box and set the following value for the translation – Translate Y = −0.032.
- Hit Shift + W shortcut to key the translation.

Note

If the Auto Keyframe Toggle is active, the key will be set automatically after changing the attribute.

The shape of the Motion Trail will update to reflect the change. The new key for the height (Translate Y) will also be visible from the Graph Editor (see Fig. 1.4.8, right screenshot).

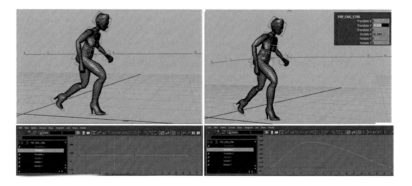

FIG 1.4.8 First key pose – hips raised.

Scene file example with the key modified for the hip height at frame 05 is included with the project scene files as – **1.4_00_RUN_Arc01_01.ma**.

You'll notice that adding the new key for translation has also modified the shape of the curve later on in the animation. At frame 08, the hips are raised to follow the change in trajectory, as key is not set for Translate Y at this frame (see Fig. 1.4.9, first screenshot).

At frame 08, the height of the hips should be the same as at frame 00, as it is an identical mirror of that at frame 00 with the legs swapped.

- Scrub the Time Slider to frame 08.
- With the hips control object still selected (FSP_COG_CTRL), open the Channel Box and type in the following value for Translate Y:
 - Translate Y = −0.092.

- Hit Shift + W shortcut to key the translation for the hips (see Fig. 1.4.9, second screenshot).

The Curve should update in the Curve window to reflect the change. In addition, the Editable Motion Trail's shape should change (see Fig. 1.4.9, second screenshot).

Note

For this step, you could also have copied the key for translate Y from the Curve window or used Right-Click > Key Selected in the Channel Box to key only the Translate Y Channel.

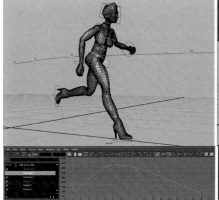 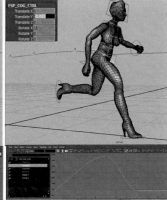

FIG 1.4.9 Copying the hip height pose at frame 08.

Scene file example with the key modified for the hip height at frame 08 is included with the project scene files as – **1.4_00_RUN_Arc01_02.ma**.

The shape of the Editable Motion Trail and hip translation should now look more natural to reflect the weight shift on the hips during the foot plants. The hips naturally rise to full height at frame 05 and then start to dip, as the weight forces downward onto the leading leg. At frames 00 and 08, the weight is starting to push downward and the trajectory should continue down in the next couple of frames. The low point for the hips pose should be around two frames after frames 00 and 08 (at around frame 02 and frame 10 respectively); set this pose next:

- Scrub the Time Slider to frame 02.
- With the hips control object still selected (FSP_COG_CTRL), open the Channel Box and type in the following value for Translate Y:
 - Translate Y = −0.105.
- Hit Shift + W shortcut to key the translation for the hips (see Fig. 1.4.10, second screenshot).

85

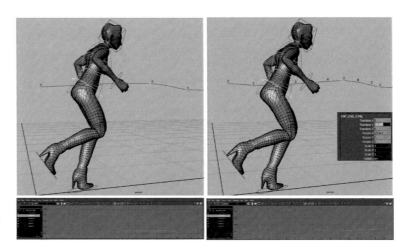

FIG 1.4.10 Setting hip height key at frame 02 – low point on run.

Scene file example with the key modified for the hip height for the low dip at frame 02 is included with the project scene files as – **1.4_00_RUN_Arc01_03.ma**.

If we look at the Curve for the Y Translation in the Curve Window, the curve now follows a smooth trajectory that fits the motion for the run (see Fig. 1.4.11).

The motion dips at frame 02, as the hips push down and as the weight transfers over the left foot. At frame 05, the hips raise to full height, as the weight is transferred forward, and at frame 08, the hips begin to push downward (the same pose at frame 00).

FIG 1.4.11 Viewing the motion in the Graph Editor.

If you scrub the Time Slider, the posing for the character can be validated. Turning on Ghosting for the character mesh helps to check whether the pose and weight shifts are working correctly. With Ghosting enabled, we can see that the height of the hips and head is correct for the run, and that the overall trajectory and action line are fluid and natural.

Using Photoshop or other video editing software, you can take incremental screenshots of the run and overlay these on layer to validate the pose. Action line can be drawn to check the trajectory and arc of the hips during the run (see Fig. 1.4.12).

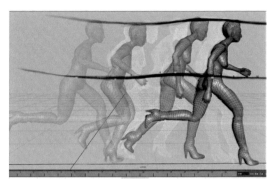

FIG 1.4.12 Checking the motion and arc – ghosting enabled (frames 00, 02, 05, and 08).

Taking incremental screenshot at each individual frame and compositing these together sequentially can help to further validate that the motion arc for the character is working correctly for the run (see Fig. 1.4.13).

FIG 1.4.13 Validating motion arc for hip/head – frames 00–07.

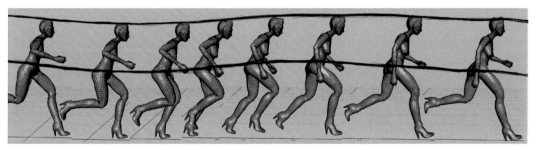

Looping the Motion

Scrub the Time Slider slowly from frame 00 to frame 08, then from frame 08 to frame 16. The motion is exactly looped on the run. At frame 00, the left leg is extended on run, which then switches to right leg extended (mirrored) at frame 08. The leg posing switches again back to the right leg extended at frame 16. The hip height from frames 08 to frame 16 should be identical to frame 00 to frame 08:

- Scrub the Time Slider to frame 05.
- With the hips control object selected (FSP_COG_CTRL), open the Channel Box and check the height for the hip control (Y translation) (see Fig. 1.4.14, left screenshot):
 Translate Y = −0.032.
- Scrub the Time Slider to frame 13; at this frame, the posing on the legs/body for the character is exactly mirrored from the pose at frame 05. Therefore, the hip height should be the same.
- With the hips control object selected (FSP_COG_CTRL), open the Channel Box and set the following for translate Y (see Fig. 1.4.14, right screenshot):
 Translate Y = −0.032.
- Hit Shift + W shortcut to key the translation for the hips (see Fig. 1.4.14, second screenshot).

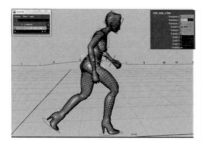

FIG **1.4.14** Hip height looped (full height – frame 05 = frame 13).

Scene file example with the hip height looped at frame 05/13 is included with the project scene files as – **1.4_00_RUN_Arc02_01.ma**.

If we look at the original arc from frame 00 to frame 08, the hips dip to lowest point at frame 02, just after the foot connects with the ground (at frame 00). This pose is mirrored on the run at frame 10 (with right foot planted).

Use the same process as in previous step to copy the height key from frames 02 to 10 –

- Scrub the Time Slider to frame 02.
- With the hips control object selected (FSP_COG_CTRL), open the Channel Box and check the height for the hip control (Y translation) (see Fig. 1.4.15):
 Translate Y = −0.105.
- Scrub the Time Slider to frame 10; at this frame, the posing on the legs/body for the character is exactly mirrored from the pose at frame 02. Therefore, the height should be the same.
- With the hips control object selected (FSP_COG_CTRL), open the Channel Box and set the following for translate Y (see Fig. 1.4.15):
 Translate Y = −0.105.
- Hit Shift + W shortcut to key the translation for the hips (see Fig. 1.4.15).

FIG **1.4.15** Hip height looped (lowest dip height – frame 02 = frame 10).

Scene file example with the hip height looped at frame 02/10 is included with the project scene files as – **1.4_00_RUN_Arc02_02.ma**.

As before, the arc and posing can be validated by enabling ghosting and compositing screenshots of the animation at the key poses (frames 00, 02, 05, 08, 10, 13, and 16).

The Editable Motion Trail is a great visual indicator of the height arc for the hips. Checking the arc and animation, the motion should be fluid and the arc looped perfectly at the key poses (see Fig. 1.4.16).

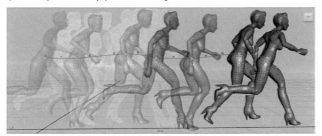

FIG 1.4.16 Validating the motion arc – ghosting enabled – key poses.

Hip Sway

The motion arc for the run now looks fluid when viewed from the side of the character. The hips naturally rise and fall to match the weight shifts between the foot plants and trajectory of the run.

If we tumble around to a front view of the character, we'll notice that there is no motion on the hips in the X-axis (side-to-side) (see Fig. 1.4.17, second screenshot from left).

- From the Outliner or Viewport, select the hip control object (FSP_COG_CTRL).
- From the Channel Box, check the value for Translate X; it is Translate X = 0 (see Fig. 1.4.17, first screenshot from left).
- Scrub the Time Slider from frame 00 to frame 16; the value is the same throughout the animation, with no discernible motion from side-to-side on the hips.

This is unnatural looking and doesn't match the natural hip sway you see when walking or running.

When you walk or run, there is typically a weight shift on the hips from side-to-side, which matches the foot plants.

The hips typically sway to the side to distribute the body weight over the planted foot. The sway on the hips from side to side can also be refined using the same tools as before and the edited final motion should also be visible as a smooth arc using the Motion Trail in Maya.

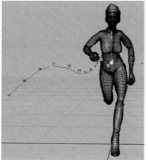

FIG 1.4.17 Modifying hip pose, frame 00.

89

- From the Channel Box/Layer Editor (Ctrl + A), go to the Display tab and turn off display of the Control Object layer named Curve_CNTRLS (see Fig. 1.4.15, first screenshot from left).
- Scrub the Time Slider to frame 00 and tumble around in Perspective Viewport to view character from front.
- Select the key on the Editable Motion Trail at frame 00 and enable the Move Tool (W) (see Fig. 1.4.17, second screenshot from left).
- Pull the key out to the side in Global + X-axis, so that the hips are roughly directly above the left heel (see Fig. 1.4.17, third screenshot from left).

Note

Editing position of a key on the Editable Motion Trail will automatically edit the keyframe regardless of whether or not you specifically key the modification with S (key all channels) or Shift + W (key Translation) shortcut keys. Beware of this when making modifications to key position on the Editable Motion Trail.

For the hip sway, the motion will be mirrored during the run, as the hips sway from left to right on the foot plant. At frames 00 and 16, the hips should shift in +X-axis to weight over the right foot, while at frame 08, the hips shift in –X axis to weight over the left foot. The values for Translate X should be exact opposites as the character's hips shift over the left and right foot. This is because the character has been animated centered at the scene origin (X = 0).

- After modifying the key position at frame 00 in previous step, switch back on display of the Curve Controls from the Display Layer tab (see Fig. 1.4.17, fourth screenshot from left top).
- Select the main Hip Control named FSP_COG_CTRL and open the Channel Box (Ctrl + A).
- From the Channel Box, check the value for Translate X. In the example, I've set this to:
 - Translate X = 0.050 (see Fig. 1.4.17, fourth screenshot from left).

Note

You don't need to use exactly the same value as in the example, but you need to note what this is set to as the key for Translate X needs to be mirrored and copied at frames 08/frame 16 in next step.

- Scrub the Time Slider to frame 08 (see Fig. 1.4.18, left screenshot).
- With the control object still selected, open the Channel Box (Ctrl + A) and double-click in the numeric input field for Translate X.
- Set this to the same value as noted from frame 00 and add – (negative) at front. In our example, this is Translate X = –0.050 (see Fig. 1.4.18, middle screenshot).
- Set key for the translation with Shift + W shortcut.

Note

The value at frame 08 should be the negative value of frame 00, as the hips sway to exactly the same position at opposite side of X-axis (from X = 0). In the example, I have set Translate X = −0.05 at frame 08 to mirror Translate X = 0.05 at frame 00 (see Fig. 1.1.18, middle and right screenshot).

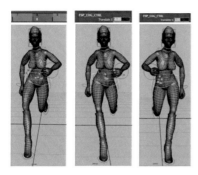

FIG 1.4.18 Mirrored hip pose at frame 08.

At frame 16 of the animation, the pose on the character is exactly the same as at frame 00 (this creates the loop); therefore, the hip position for the sway should be exactly the same as at frame 00.

- Scrub the Time Slider to frame 00.
- With the hip control object selected (FSP_COG_CTRL), open the Channel Box and check the value for Translate X.

In the example scenes, I've used the value of +0.5 for translate X at frame 00. This value should be copied to frame 16 and then key set with Shift + W hotkey (see Fig. 1.4.18, right screenshot).

Scene file example with the hip sway looped is included with the project scene files as – **1.4_00_RUN_Arc03.ma**.

As before, the arc can be validated by viewing the Motion Trail in the Viewport and sketching over screen captures of the animation at key points in the motion (see Fig. 1.4.19). The hips sway naturally from side to side following a smooth arc from right to left as the weight distributes from left leg to right.

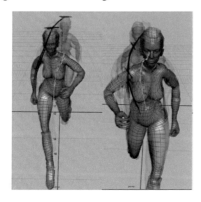

FIG 1.4.19 Validating the motion arc.

91

The hip sway looks more pronounced when the character is running on the spot, test muting the Animation Layer – Anim_Run_DIST – to validate the hip sway.

Looping Curves and Fixing Tangency

When working on looped animations, it is important to be aware of the key tangency at the start and end of the animation. As these keyframes are identical, any issues in the key tangency can create unnatural looking motion. Editing the keys with the Graph Editor can help finalize the animation.

- From the Outliner or Viewport, select the main hip control (FSP_COG_CTRL).
- In the Graph Editor Window, select the Translate Y Channel from the left pane to show the Graph for the up/down motion on the hips.
- With the select tool (Q) active, click and drag to marquee select all the keyframes on the Curve in the Graph Editor Window. The Graph should highlight in white and the keys in yellow to show that they're selected.
- With the keys selected, go to the Tangents menu at the top of the window and select:
 - Tangents > Auto.

This will set all the selected Keyframes to use Auto Tangency type; this can also be toggled from the shortcut icon buttons at the top of the Graph Editor (see **Fig. 1.4.20**).

FIG 1.4.20 Graph editor – setting auto tangents for keys.

Although the curve tangency looks smooth before frame 00 and after frame 16, there would be a slight imperceptible kink in the loop animation, as the keys and tangency are not identical.

Maya includes a couple of tools in the Graph Editor that can be used to cycle the curve and fix the tangency:

- With the Curve for Translate Y still displayed in the Graph Editor, go to the View menu at the top of the Graph Editor and select:
 - View > Infinity (see **Fig. 1.4.21**, first screenshot from left).
- From the Curves menu in the Graph Editor, we can set the Curve to cycle into infinity. Go to the Curves menu and select the following (see Fig. 1.4.21, second and third screenshots from left):
 - Curves > Pre Infinity > Cycle.
 - Curves > Post Infinity > Cycle.

If you look at the Curve in the Graph Editor window, the curve for Translate Y now cycles to infinity before and after the original keys. The cycle is visible as dotted line before the first key (frame 00) and after the last key (frame 16) (see Fig. 1.4.21, right screenshot).

FIG 1.4.21 Graph editor – turning on pre- and post-infinity cycles for the curve.

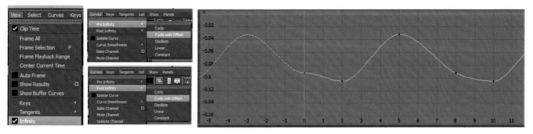

Note

The Infinity toggle setting from the View menu is not stored with the scene file when saving; if you wish to view the infinite curve from the Graph Editor, you need to toggle the option on for each new session.

Along with cycling the motion for the channel, the infinite curve highlights any kinks in the key tangency before and after the first and last keys.

- With the Curve for translate Y still displayed in the Graph Editor, enable the select tool (Q) and select the first key at frame 00 (see Fig. 1.4.22, left screenshot).

The flattened tangency for the keyframe creates a kink in the curve that is not smooth:

- With the select tool still active, select the tangency handle at the right side of the key.
- Activate the Move Tool (W) and pull the key tangent handle downward to smooth out the curve and create a natural transition between the curve before and after the key (see Fig. 1.4.22, right screenshot).

FIG 1.4.22 Graph editor – fixing key tangency, infinite curve displayed and looped.

Use the same process to fix any kinks in the key tangency for the key at frame 16 for the Translate Y Channel.

Scene file example with the pre- and post-cycles for the Translate Y curve enabled and tangency fixed is included with the project scene files as – **1.4_00_RUN_Arc04_Inf_edit01.ma**.

Note

The Infinity toggle setting from the View menu is not stored with the scene file after saving; if you wish to view the curve from the Graph Editor with infinity after opening the example scene, you'll need to toggle the option back on from – Graph Editor > View > Infinity.

For the hip sway motion that we worked on in the last section (see Fig. 1.4.19), we can use the same process to check and validate the curve and key tangency:

- From the Outliner or Viewport, select the main hip control (FSP_COG_CTRL).
- In the Graph Editor window, select the Translate X Channel from the left pane to show the Graph for the left/right motion on the hips.
- With the Curve for Translate X still displayed in the Graph Editor, go to the View menu at the top of the Graph Editor and select:
 - View > Infinity.
- From the Curves menu in the Graph Editor, set the Curve to cycle into infinity. From the Curves menu, select the following:
 - Curves > Pre Infinity > Cycle.
 - Curves > Post Infinity > Cycle.

As before, the pre- and post-infinity shapes for the curve will be shown as dotted line before frame 00 and after frame 16 (see Fig. 1.4.23, top screenshot).

If you look at the curve, you can see that there is a sharp "in" angle at frame 00 and a sharp "out" angle to the curve at frame 16. This is unnatural and will make the motion appear fast; there will not be any natural ease in and out to the motion when playing back the animation. The curve angle should look the same at frame 00/16 to the shape at frame 08.

FIG 1.4.23 Graph editor – fixing key tangency (translate X) infinite curve displayed and looped.

- With the Translate X curve still visible in the Graph Editor, enable the select tool (Q) and marquee select all three keys at frame 00/08/16.
- With the keys still selected, hit the "Flat tangents" button at the top of the Graph Editor or go to the Tangents menu at the top of the Graph Editor and select:
 - Tangents > Flat.

Flat tangents produce a smooth ease in & ease out to the motion curve when the key is at extreme point or value (see Fig. 1.4.23, middle screenshot).

The shape of the motion curve for the X Translation is now smoother and will look correct when the animation is looped. The curve shape can be confirmed when you dolly out in the Graph Editor (see Fig. 1.4.23, bottom screenshot).

Scene file example with the pre- and post-cycles for the Translate X curve enabled and tangency fixed is included with the project scene files as – **1.4_00_RUN_Arc04_Inf_edit02.ma**.

The curve shape for Translate X is similar to what you'd see if you view the Editable Motion Trail for the hips from the top.

Looping and Extending the Run Animation

Using cycle and infinity for curves can also allow you to loop a full character animation. This would be useful if you needed to have the run loop animated in a longer sequence. The process for this is fairly straightforward, with each of the animated objects for the run loop being selected and cycle enabled from the Graph Editor. For the character running across space, we need to use different mode to cycle the motion:

- Open the provided project scene file – **1.4_00_RUN_Arc05_InfCycle_Offset00.ma**.

The scene file has the motion cycled for all the control objects for the character run. The animation playback range is set from frame 00 to frame 160.

- From the Playback controls, go to the first start frame (Alt + Shift + V shortcut) and then hit play (Alt + V).

The run cycle animation loops "on the spot," and the character run animation loops 10 times from frame 00 to frame 160 on playback.

The reason the animation loops on the spot is that the animation layer for the translation across the ground on the Locator object is muted (named PARENT (see Fig. 1.4.3, from start section, and Fig. 1.4.24, left screenshot)).

- Open the Channel Box/Layer Editor (Ctrl + A toggle) and, from the Animation layers tab, un-mute the layer named Anim_Run_DIST (see Fig. 1.4.24, right screenshot).
- Go to the start frame and hit play again (Alt + V).

Between frames 00 and 16, the character runs across the ground (as the Locator is animated on layer), and after frame 16, the motion stops and the character again runs on the spot. This is because the curve for the locator translation has not been cycled.

FIG 1.4.24 Muted and un-muted animation layer – run loop translation.

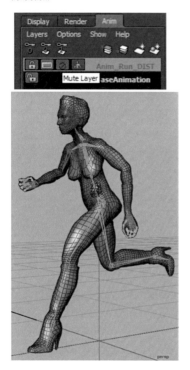

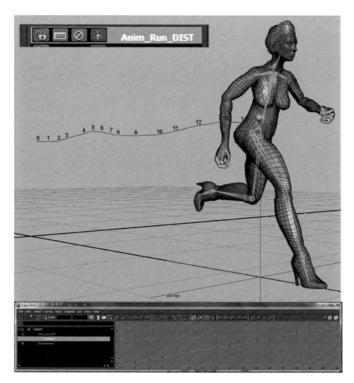

- Select the large cross-shaped locator, named PARENT – either from the Viewport (under the characters feet) or from the Outliner.
- Open the Graph Editor, select the Translate Z Channel from the left pane and set the following:
 View > Infinity.
 Curves > Pre Infinity > Cycle.
 Curves > Post Infinity > Cycle.
- Go to the start frame (frame 00) and hit play again (Alt + V).

The animation for the locator is looped but doesn't look right; the character runs across the ground from the origin (0, 0, 0) but, after every 16 frames, jumps back to the start point. This is because the animation curve has been cycled without any offset. If you check the Graph Editor and dolly out (Alt + RMB), you can see that the motion curve for Translate Z matches the motion on playback (see Fig. 1.4.25).

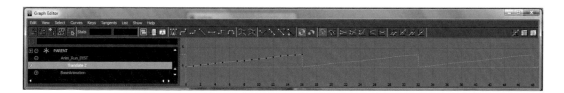

Scene file example with the locator translation cycled with default setting is included with the project scene files as – **1.4_00_RUN_Arc05_InfCycle_Offset01.ma**.

Let's take a look at another mode for cycling that allows the motion to be cycled with an offset:

- With the Locator object still selected (PARENT), go to the Graph Editor.
- Ensure that the Translate Z Channel is selected from the left pane of the Graph Editor.
- From the Curves menu in the Graph Editor, select:
 - Curves > Post Infinity > Cycle with Offset (see Fig. 1.4.26, left screenshot).

If you view the curve in the Graph Editor (with Infinity enabled), you can see that the curve now extends in straight diagonal line (see Fig. 1.4.26, right screenshot).

Using the previous mode (default cycle), the motion in the curve was repeated without offset. The animation for the locator moving out from the origin was looped with the character jumping backward at start of each loop.

Using the Cycle with Offset mode cycles the curve, but adds an offset so that the looped motion starts correctly at the value on the last keyframe.

FIG 1.4.25 Graph editor – curve cycled for translation locator (PARENT).

FIG 1.4.26 Graph Editor – curve cycled with offset for translation locator (PARENT).

- Scrub the Time Slider to the start frame 00 (shortcut Alt + Shift + V).
- Hit play on the playback controls (Alt + V).

The animation is looped correctly for the run. After each cycle, the motion for the PARENT Locator starts at the end point for the previous cycle, creating a smooth transition (see Fig. 1.4.27).

Note

The Pre-Infinity option can also be used to extend the animation before frame 00 for the sequence.

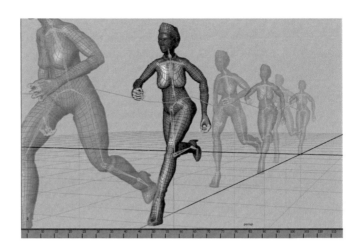

FIG 1.4.27 Playing back the looped run animation – Cycle with Offset enabled.

Scene file example with the locator translation cycled with offset to loop the run correctly is included with the project scene files as – **1.4_00_RUN_Arc05_InfCycle_Offset02.ma**.

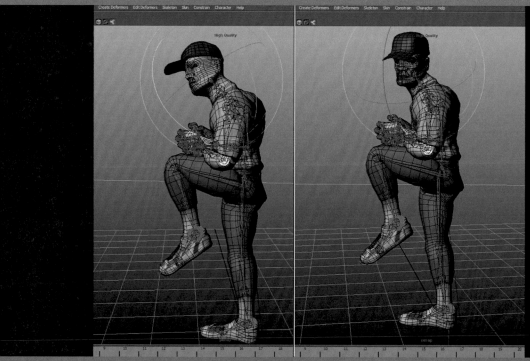

Anticipation – Building the Action

People in the audience watching an animated scene will not be able to understand the events on the screen unless there is a planned sequence of actions that leads them clearly from one activity to the next… This is achieved by preceding each major action with a specific move that anticipates for the audience what is about to happen.

The Illusion of Life: Disney Animation – Frank Thomas and Ollie Johnston

Anticipation in animation is critical in both creating natural motion and building audience expectation. As such, it can be considered both an animation principle and a theatrical device. For example:

Human motion – A character leading up to a strong physical motion will normally lead up to the motion by coiling his body in the opposite direction to build energy; this can be seen clearly in many sports including boxing where the boxer will coil his body and arm backward prior to releasing a punch.

Theater – A device commonly used in film or theater is to build audience anticipation by providing cues to the viewer of what will happen next.

For example, a hushed telephone conversation offscreen or character reacting to action offstage will precede the action and create anticipation.

Anticipation is used alongside the other animation principles throughout the other tutorial examples in this book. It should be considered when working on the majority of sequences, for example:

F16 Fighter – Takeoff and Fight Sequence

In Chapter 1, we worked on motion path animation for an F16's takeoff (see Fig. 2.0.1). As part of a longer sequence, this animation would set the scene and mood of the shots that follow. The shot could be extended to show longer buildup to the flight takeoff; for example, ground crew could be animated or the sequence could be intercut with shots of the enemy pilot in flight. This would exaggerate the anticipation and build audience expectation.

FIG 2.0.1 Anticipation – F16's takeoff.

In the online chapters 5.1 and 5.2, we'll take a look at storyboarding and animatic assembly for an F16 fight sequence (see Fig. 2.0.2). The sequence builds up from slow wide angle intro shots of the F16's in flight; the enemy fighter is introduced and the timing of the shots and action increases to build to climatic dogfight.

FIG 2.0.2 Anticipation – F16's fight sequence.

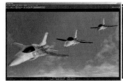

Head Turn Animation/Animation Appeal

In Chapter 4, we'll take a look at creating ease in for a character head turn animation using the standard keying tools and Graph Editor to modify the key tangency (see Fig. 2.0.3, left).

In Chapter 10, we'll look at how the head turn animation's timing & spacing can be edited to create character appeal in facial animation (see Fig. 2.0.3, right). As part of a longer facial animation sequence, the timing edits will create different mood, with the anticipation turn at the start of each sequence building anticipation during the shot.

FIG 2.0.3 Anticipation – head turn and facial animation (appeal).

VFX – Dynamics Rocket Smash

In Chapter 8, we'll work on a dynamics rocket smash. The breakable dynamic elements in the scene increase in size and impact as the animation progressess. Smaller elements are smashed at the start, building anticipation up to main smash on military compound building (see **Fig. 2.0.4**).

FIG 2.0.4 Anticipation – dynamics sequence buildup.

In Chapter 12, we will work on the same sequence but exaggerate the overall animation through ramping up the animation principles that are applied.

Additional breakable elements will be added to the sequence that help to enhance the anticipation through added overlap, follow-through, and secondary motion. The buildup of the sequence is also enhanced through delayed timing to climatic explosion on the building roof that is added at end (see **Fig. 2.0.5**).

FIG 2.0.5 Anticipation – dynamics sequence exaggeration.

Character Animation

For character actions or motion, effective application of anticipation in the animation is key in creating believability in the animation.

The first tutorial in this Chapter will focus on creating anticipation for a baseball pitcher throwing the ball to the batter. Corresponding animation of

the batter striking the ball is also covered in the other tutorials throughout the book.

In Chapter 12, we will use exaggeration to ramp up the anticipation in the animation through both extending the lead-in time to the motion and exaggerating the poses, so that the coil back on the batter swing is more pronounced. Creating contrast between posing and timing for character animation can help increase anticipation for the viewer (see Fig. 2.0.6).

FIG 2.0.6 Anticipation – character lead into action.

 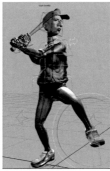

In the jump animation in Chapter 11, anticipation is applied at several phases of the sequence (see Fig. 2.0.7). At the start, there is an extended lead in as the character goes to ready pose to gather energy. This pose is held for several frames to build the anticipation.

Later in the sequence, anticipation builds for the land to ground as the character travels through the air. The viewer is led to anticipate the landing through the angle of the character's body and posing on the leg, which extends in anticipation of the landing.

FIG 2.0.7 Anticipation – character builds energy and anticipates jump landing.

As we see, anticipation can be applied to both character animation and dynamics simulation, which are covered in more detail in the two tutorials in this chapter.

Chapter 2.1 – Baseball Pitcher Throw

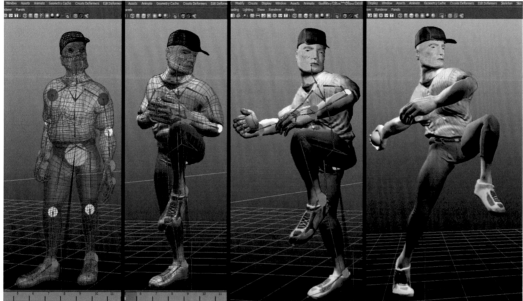

FIG 2.1.0 Baseball pitcher throw – key anticipation poses.

Study of the body's movement in sports and athletics is a great opportunity to appraise the principles of animation from real life. In sports, the body will typically show great anticipation before each major motion or action.

The act of anticipation can be considered a theatrical device as well as an organic motion in the body itself to build energy. The physical motion in the body in anticipation of physical action can also be seen as a buildup of energy. Typically, the body and limbs will coil backward in the opposite direction from action to build energy before motion. Examples of this from the sports world would include the following:

1. Soccer player composing himself then running from distance before swinging leg back in preparation for free kick.
2. Golfer spending time to compose himself before shot. Corkscrew motion in body coiling round from shoulder and arms behind ball before follow-through on shot.
3. Boxer swinging arm and upper torso back and round in a corkscrew motion before launching haymaker punch.
4. American Football quarterback looking downfield for receiver with ball closed in toward body in anticipation. Swing of throwing arm and body backward before the release of ball.

5. Baseball pitcher composing himself for throw. Raising of left leg up and in toward coiled body to build energy for throw. Corkscrew motion of upper torso around to build energy pre-throw.

In this tutorial, we'll work on the pre-anticipatory moves for a baseball pitcher throwing the ball at batter (see Fig. 2.1.0, key poses).

Reference and Thumbnailing

As with any animation sequence, you should pre-plan out the work through looking at reference and thumbnailing out the major poses. An online image search will return lots of pictures you can use as reference; you could also use video reference for this to study the timing of the motion.

If we look at photo reference, we can see the major poses the pitcher will make before throw.

The first major pose would be the idle; the pitcher is in relaxed stance prior to throw and may be readying the ball by cupping it toward the glove and adjusting footing (see Fig. 2.1.1, left) extending the length of time the pitcher is in the idle pose would increase the scene of anticipation and drama. This could include preparing the ball, finding footing, gaining composure, etc.; this would all be prior to the pitcher actually stepping back before the throw.

The next major pose would be the coiled ready pose. The pitcher goes from the idle pose to a coiled pose with the ball clenched inward; the left leg is raised and hips shift backward in space. The pitcher will normally hold this pose for a while to build energy and compose himself (see Fig. 2.1.1, right).

FIG 2.1.1 Idle pose to coiled ready pose.

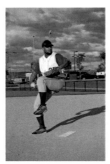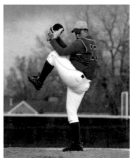

In preparing to throw, the pitcher's arms will open out and the body will rotate round from the coiled pose to a more open preparatory pose, this pose would be similar to the coiled readiness pose and could be described as a moving hold (see Fig. 2.1.2, left).

The next major pose would be the weight shift of the hips forward in anticipation of the throw. The arms would be fully open and extended to build

energy for the pitch. The upper torso would be coiled backward as the hips coil forward in the opposite direction (see Fig. 2.1.2, right).

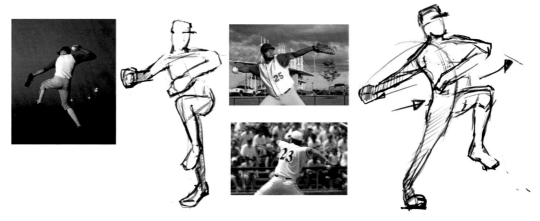

The hips will lead the motion with the left foot planting before the ball is released from the outstretched right arm. The upper torso will follow last in the motion after the hips and feet and will coil round like a corkscrew before release. For the pre-anticipation sequence, we will work on pose blocking to block in the major anticipatory poses prior to the feet plant and subsequent throw and follow-through of the arms. The actual release of the throw and follow-through actions for the sequence will be covered in Chapter 6.

Refer to the photo reference and thumbnails shown above while working through this tutorial. In addition, feel free to use your own reference or thumbnails while working on the pose blocking for the sequence.

Character Asset and Display Modes

- Open the setup scene from the Project Directory – **2.1_00_Rig_TPose.ma**

The character model for this tutorial is similar to the type of asset currently used within game development. The model detail has been sculpted in Mudbox and baked down to a Normal Map, which is assigned as a texture to the low-poly model in Maya. The Normal Map can be viewed in the Viewport when the display mode is set to High-Quality rendering or Viewport 2.0. Both these display modes are dependent on whether you have a video card with the necessary hardware capabilities. Both display modes can be set from the Renderer drop-down in the Panel menu at the top of the Viewport (see Fig. 2.1.3). The Panel Toolbar icons at the top of the Viewport in Maya allow you to quickly toggle whether High-Quality rendering is enabled and also to set whether the model is displayed in Wireframe, shaded, or Wireframe on shaded modes (see Fig. 2.1.3).

FIG 2.1.3 Renderer drop-down and Panel tool bar icons.

Note

In Maya 2011, when Viewport 2.0 is enabled, it does not allow display to be set to X-Ray Joints from Panel menu > Shading > X-Ray Joints. Therefore, the Viewport 2.0 mode is not best suited to animator's posing and keying with character control rigs in Maya 2011; it is mainly intended for visual fidelity for preview. Please note: This limitation has been addressed in Maya 2012.

For posing the character with the Full Body IK rig, you should work in X-Ray joints, Wireframe, or Wireframe on Shaded display modes. This will allow easy preview, selection, and manipulation of the Full Body IK effectors and skeleton. For preview of final shaded model with normal maps, High-Quality rendering or Viewport 2.0 can be enabled. The different Viewport modes are shown in **Fig. 2.1.4.**

FIG 2.1.4 Viewport display modes.

Viewport 2.0 / High-Quality Rendering-
Joints & IK Handles hidden.
(Preview mode)

High-Quality Rendering -
X-Ray Joints mode enabled
(Animation editing/preview)

Default Rendering -
Wireframe Shading Mode -
Full Body IK Effectors are visible.

Full Body IK

In this tutorial, we'll be working with a character setup with Full Body IK control rig in Maya.

Note

The methodology and controls for the Full Body IK control rig are similar to the HumanIK rig we will be working with in Chapter 12. The features of both systems are very similar, with a lot of the marking menus and keying modes being the same.

Full Body IK and HumanIK rigs in Maya provide full IK/FK blending as well as additional attributes to control Effector Pinning and IK reach. As the system is fully integrated in Maya, the controls are accessible both through the standard marking menus and through shortcut keys when working with the control rig effectors. The system is easy to work with, although provides a high level of control for animators.

Posing and Keying Modes

At a basic level, simple selection and translation of the spherical effectors on the rig is done for the majority of the character posing and keying. The Control Rig Effectors can be selected from either shaded (5) or Wireframe (4) display modes. Toggling between wireframe and shaded modes aids in posing of the underlying skeleton.

For keying, the shortcut to set keys for Full Body IK in Maya is Ctrl + F, Keys are set on the Control Rig based on the currently enabled keying mode. This can be set to All or Selected Body Part from the Full Body IK marking menu. The Marking menu can be accessed from right-mouse click when Full Body IK elements are currently selected (see Fig. 2.1.5).

FIG 2.1.5 Full Body IK Marking menu – keying modes.

Effector Pinning

Effector Pinning allows you to temporarily pin any of the control rig effectors in space while posing the character. An example where you would use Effector Pinning would be when you need to pin a character's hand to an object while you pose the rest of the body. It would also commonly be used when you need to keep the feet position consistent when modifying the pose of the hips. Figure 2.1.6 shows character with pinning enabled for the feet and wrist effectors with the body position modified on the right.

FIG 2.1.6 Effector pinning enabled for wrist/feet. Torso positioned while wrist/feet placement maintained.

107

The Effector Pinning can be set to lock Translation (T), Rotation (R), or both. Effectors that are pinned in Translation or Rotation will show T or R icon over the effector in the Viewport.

Effector Pinning can be set after selection of the effector, either from the Channel Box (Ctrl + A) or from the Full Body IK marking menu that is accessible from Right-Click when effector is currently selected (see Fig. 2.1.7).

Above: Right-Click >
Marking Menu for Full-Body IK>Pinning

Right: Pinning drop-down in Channel Box

FIG 2.1.7 Effector pinning can be set from the Full Body IK marking menu or Channel Box.

Full Body IK – Effector Pinning in Action

Let's take a look at how the Pinning works on the example scene:

- Open the scene file named – **2.1_00_Rig_TPose.ma**.

Note

For illustration purposes, the "Skel_" Display Layer is hidden, so that only the Full Body IK Effectors are visible in the screenshots.

- Look at both feet effectors, a small TR icon shows that both Translation and Rotation Pinnings are enabled (see Fig. 2.1.8, left screen).
- Select the Hip control object, the large sphere at the hips, named "HipsEffector."
- With the Move Tool (W) active, pull the control down in global Y-axis.
- The feet remained pinned; they do not rotate or translate as you move the hips and the rest of the body moves along with the hips (see Fig. 2.1.8, middle screen).
- Select the right wrist control object, the large sphere, named "RightWristEffector."
- With the right wrist control object selected, right-click with the mouse in the Perspective Viewport and choose – "Pin Translate" option (see Fig. 2.1.8, right screen).

FIG 2.1.8 Pinning in action.

- With Pinning enabled for the right wrist control, select the Hip control object again ("HipsEffector") (see Fig. 2.1.9, left screen).
- Enable the Move Tool (W) and pull the control down in global Y-axis.
- The right wrist remains in the same place, locked in space (see Fig. 2.1.9, middle screen). Although locked in position, the wrist still rotates, so that the angle matches the new angle on the arm; this is because Pin Rotate was not activated.
- Select the left wrist effector (named LeftWristEffector) and with the Move Tool (W) pull it far over and down in global X- and Y-axes (see Fig. 2.1.9, right screen).

FIG 2.1.9 Pinning in action.

Notice how the rest of the body, including the spine, stretches to follow the motion?

Note

The right wrist effector is pulled beyond the position it was pinned at, this is similar to working with standard IK Effectors in a full control setup.

Reach – T/R

Effector Pinning is used to quickly pose the character while maintaining position or rotation of the effector. Enabling Effector Pinning does not lock the effector in space during playback; it is only intended as a quick way to pose the character.

The Translation and Rotation Reach settings for the control rig effectors set whether the effector is keyed in IK mode (reach = 1) or FK mode (reach = 0). If an effector needs to be locked in space during playback, it has to be keyed in IK mode (Reach Translation = 1). As with Pinning on effectors, the current Reach setting for effectors can be set from the Full Body IK marking menu or from the Channel Box (see Fig. 2.1.10).

FIG 2.1.10 Reach T/R can be set from the Full Body IK marking menu or Channel Box.

Note

Keyboard shortcuts are also available to quickly toggle the Pinning and Reach modes for the current selection. The shortcuts are as follows:

Alt + S = Pin Both (T/R)
Alt + W = Pin translation (T)
Alt + E = Pin rotation (R)
Alt + 3 = IK Key (reach = 1)
Alt + 1 = IK Key (r\each = 0)

Character Pose Blocking Part 1 – Idle Pose to Coiled Readiness Pose

FIG 2.1.11 Pose blocking – idle (left screen – frame 0) to coiled ready pose (right screen – frame 5).

In the first phase of the sequence, we'll block out the posing from the idle pose to a coiled ready pose prior to the throw. To achieve this, we'll use the different Pinning and Reach modes on the Full Body IK rig along with the standard translation and rotation manipulators in Maya to pose the character. Refer to the photo reference and thumbnails in the introduction when posing the character.

• Open the start scene file from the project directory – **2.1_01_Start_Pose.ma**.

The scene file includes the Full Body IK rig and character mesh. The character is in the idle pose at frame 0 (see **Fig. 2.1.11**, left screenshot).

In the idle pose, the character is posed with weight shifted onto his left foot, the hips are also off center above the left foot and we want to shift the weight on the character onto his right leg.

• Scrub the Time Slider to frame 5 to start work on the Coiled pose.
• From the Perspective View, select the LeftAnkleEffector and then Shift + Select the RightAnkleEffector.

Note

Toggle Wireframe display or enable Shading X-Ray from the panel, so that the effectors are visible to aid selection (see **Fig. 2.1.12**).

• With both effectors selected, right-click in the Perspective Viewport and choose the "Pin Both" option (see Fig. 2.1.12).

FIG 2.1.12 Pinning enabled for both feet prior to hips posing.

• From the Tool Box on the left of the user interface, double-click the Move Tool to open the Tool Settings Window, set Move Axis to World if it is not set to World by default. This will ensure that the Hips and other effectors can be manipulated easily within world space with the Move Tool (see **Fig. 2.1.13**, left screen).

- With the Move Tool (W) active, select the large spherical Hip control object named HipsEffector (see Fig. 2.1.13, middle screen).
- In the Perspective Viewport – Tumble around to a front view of the character (Alt + LMB) to view the character face on.
- Translate the hips to the left of the Viewport and up slightly (negative X-axis and positive Y-axis) to position the hips above the right foot (see Fig. 2.1.13, right screen).
- Set a key for the effector with Cltr + F shortcut (see Fig. 2.1.13, right screen).

FIG 2.1.13 Move tool set to world, hips effector selected and translated to pose above right foot.

With the weight shifted on the character's hips, let's work on the pose blocking for the left leg that needs to rise up toward the body for the coiled readiness pose.

- Still at frame 5 – Orbit around the character in the perspective view (Alt + left mouse button), so that you're viewing the character from the side to pose the left foot.
- Select the left ankle effector (LeftAnkleEffector).
- Enable the move tool (W) and pose the foot in a raised position by moving up in Y-axis and forward slightly in Z-axis. Set Full Body IK Key with Ctrl + F shortcut.

Tip

Ctrl + click the X-axis on the move tool to restrict movement to the Y-/Z-axis only during manipulation. This will allow movement along a 2D plane that is useful when posing.

- Once the position for the foot looks balanced, modify the rotation of the foot with the rotate tool (E shortcut), so that it is tilted slightly downward for the pose. Set the rotate tool to local rotation mode from the tool settings for ease of manipulation (see Fig. 2.1.14, left screenshot).

FIG 2.1.14 Posing the leg raise and hip balance.

After posing the foot, take some time to re-pose the hips, so that the pose weighting looks balanced (see Fig. 2.1.14, middle and right screenshots). For this, you can select both the hips and left ankle effector to translate before setting key (Ctrl + F).

> **Tip**
>
> Remember to set Full Body IK key at each step with Ctrl + F Shortcut; this will key all the effectors that are posed at the same time when "Key Mode = All" from the right-click marking menu (see Fig. 2.1.10).

- Still at frame 5, tumble around to the character's right side to work on the arm posing (see Fig. 2.1.15).
- Select the left wrist effector – LeftWristEffector and with the Move Tool (W) pull it in toward the body above the left thigh in Global X-/Y-/Z-axis (see Fig. 2.1.15, left screenshot).
- Set Full Body IK Key with Ctrl + F shortcut.
- Still at frame 5, select the right wrist effector – RightWristEffector and with the Move Tool (W) pull it in toward the body level with the left thigh in Global X-/Y-/Z-axis (see Fig. 2.1.15, right screenshot).
- Set Full Body IK Key with Ctrl + F shortcut.

FIG 2.1.15 Posing the arms Pt. 1.

To edit the poses, incremental edits can be made while enabling pinning for selected elements, for example, the right elbow pose looks right that we've just keyed after moving the right wrist up (Y-axis) and forward (Z-axis). Let's say as in this example: we want to pose the wrist in closer to the body in a more clenched pose for the hands but still retain the pose position on the elbow – Pinning is ideal for this:

- Still at frame 5, select the right elbow effector (named RightElbowEffector).
- With the effector selected, right-click in the Perspective Viewport and choose Pin Translate option from the marking menu (see Fig. 2.1.16, left screenshot).
- With Pin Translation enabled for the right elbow, select the right wrist effector (named RightWristEffector) and with the Move Tool (W) pull the effector in closer to the body in X-axis (see Fig. 2.1.16, right screenshot, shaded).
- Make any further adjustments to the pose position by moving the effector slightly in global Y-/Z-axis until it looks like the hands are clasped slightly.
- Set Full Body IK key when the pose is finalized (Ctrl + F).

FIG 2.1.16 Refining the hand and elbow pose.

The major blocking for the pose is pretty much there, with the hips, hand, and feet placement and posing looking solid. When viewed from the side, the character pose still looks a bit blocky with the back looking poker straight (see Fig. 2.1.17, left). To resolve this, we can rotate the torso in on itself slightly to match the coiled in posing of the hands.

For this step, we need to retain the poses we have blocked in already for the hips, wrist, and ankle effectors while we're modifying the rotation of the torso. To do this,

- Still at frame 5, select the hips and right/left wrist effectors with Shift + left mouse button in the Viewport. Named – HipsEffector//LeftWristEffector//RightWristEffector.
- With the effectors selected, right-click in the Perspective view to open the marking menu and set "Pin Both" or use "Alt + S" shortcut key to toggle pinning (see Fig. 2.1.17, left screenshot).

FIG 2.1.17 Coiling the torso inward.

- With the hip, wrist, and ankle effectors pinned, select the effector at the top of the torso under the neck named ChestEndEffector (see Fig. 2.1.17, middle screenshot).
- With the ChestEndEffector selected, enable the rotate tool (E shortcut) and rotate the effector inward in local Z-axis to bend or coil the spine inward toward the thigh (see Fig. 2.1.17, right screenshot). In addition, rotate the control round slightly in local X-axis, so that the left shoulder is forward slightly.
- With the effector still selected, set Full Body IK key (Ctrl + F) at frame 5 once you are happy with the posing.

In posing the spine with this effector, the neck and head posing will be pushed out with the head rotated to the side and downward. This makes the character look off balanced and almost half asleep (see Fig. 2.1.18, left screenshot).

A more natural pose would be for the head to be rotated upright without the tilt to the side in local Y-axis. For character animation, the head should typically remain in more balanced pose to keep the character poised during the motion. To fix this:

- Still at frame 5, select the spherical head control effector (named HeadEffector).
- With the Control selected, enable the Rotate Tool (E) (see Fig. 2.1.18, left screenshot).
- Tumble around to the left side of the character and rotate the head round in local X-axis, so that the character is looking toward the action line at 3/4 face on. In addition, rotate the head round in local Y-axis, so that the head is more upright (see Fig. 2.1.18, right screenshot).
- Set Full Body IK key (Ctrl + F) at frame 5 once you're happy with the modified pose.

115

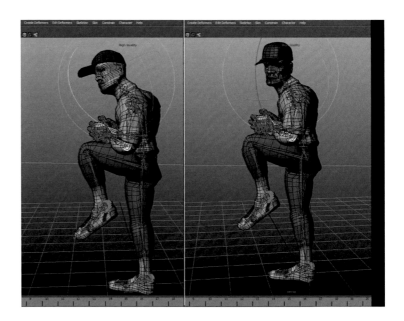

FIG 2.1.18 Strengthening the
posing of the head.

Scene file with the finalized Idle Pose (frame 0) to Coiled Readiness
Pose (frame 5) is included with the Project Scene files as –
2.1_02_Start_Pose_Rise_Pose.ma.

Character Pose Blocking Part 2 – Readiness Pose to Moving Hold

Baseball pitcher will normally pause in this pose for a few frames before
readying to throw the ball. This adds to the anticipation before the throw.
Thumbnail reference for this next pose is provided in the introduction to the
chapter (see Fig. 2.1.2, left).

Continue from the existing scene file you're working on or open the example
scene file included with the project scene files that includes the idle to coiled
ready pose we've already blocked out – **2.1_02_Start_Pose_Rise_Pose.ma**.

• Scrub the Time Slider to frame 10, select any one of the control effectors,
and set a Full Body IK key (Ctrl + F shortcut).

We want to add a moving hold between frames 5 and 10. For this, we'll rotate
the upper torso round slightly. To do this, we need to deactivate pining on the
hand effectors and left foot, as we want these to rotate back along with the
hip; the right foot should still be pinned, so that it does not move while we're
posing the character.

• From the Perspective View or Outliner, select LeftAnkleEffector/
LeftWristEffector/RightWristEffector/RightElbowEffector and do Right-
Click > Unpin to unpin the effectors (see Fig. 2.1.19).

FIG 2.1.19 Unpinning the effectors to rotate the body.

- With the wrist and left ankle effectors un-pinned, select the hip effectors (HipsEffector) and rotate it back slightly in local X-axis and also move it back and up slightly (in X-/Y-axis) with the move tool to exaggerate the pose (see Fig. 2.1.20, first and second screenshots).
- With the hips effector still selected, set Full Body IK key (Ctrl + F) at frame 10 once you're happy with the posing.

We can also coil the upper torso back more to strengthen the posing and add to the anticipation for the move:

- Select the effector beneath the neck (ChestEndEffector) and rotate it back slightly in local Y-axis. This pushes the head off balance, so select the head effector and rotate it the other way to balance the pose (see Fig. 2.1.20, third screenshot).

The pitchers' elbows would also be raised slightly at this pose in preparation for the throw and the hands would un-cusp slightly.

To raise the elbows:

- First, select the wrist effectors (LeftWristEffector/RightWristEffector) and enable pinning from Right-Click > Pin Both.
- Select the elbow effectors (LeftElbowEffector/RightElbowEffector) and pull them up slightly, so that they follow a strong action line across the body.

Note

The elbow effectors may appear to move away from the joint – this is natural as they are moved beyond limit because the wrists are pinned.

With effector selected, set Full Body IK key (Ctrl + F) at frame 10 once you're happy with the posing for the elbows (see Fig. 2.1.20, third screenshot).

117

To finalize the pose:

- Pull the pitcher's right hand out in preparation for throw (RightWristEffector). You will also need to rotate round the wrist effector to maintain the poise of the character and make final adjustments to keep the pose strong (see Fig. 2.1.20, fourth screenshot).
- With effector still selected, set Full Body IK key (Ctrl + F) at frame 10 once you're happy with the overall posing.
- In addition, rotate the LeftWristEffector round slightly in local X-/Y-axis, so that the hand follows a straighter action line with the forearm (see Fig. 2.1.20, fourth screenshot). Hit Ctrl + F to key.

The final scene file, going from the idle pose (frame 0) to the coil pose (frame 5) to the readiness pose (frame 10), is included with the project scene files as – **2.1_03_Rise_Pose_Pre_Throw.ma**.

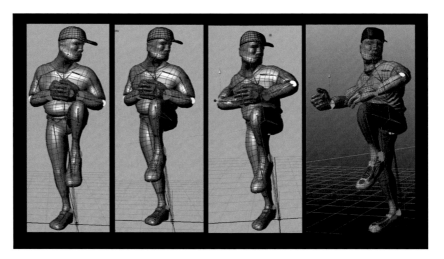

FIG 2.1.20 Posing the character in readiness for the throw (moving hold).

Character Pose Blocking Part 3 – Readiness Pose to Pre-Release Pose

Let us review the pose blocking we have done so far (in project file – **2.1_03_Rise_Pose_Pre_Throw.ma**):

- The first pose we have blocked in at frame 5 has raised the character from the idle pose into a coiled ready pose where he's hunched inward to build energy.
- We have added a moving hold pose at frame 10, with the character in similar pose, but with the arms opening out slightly and the torso rotating back more in preparation.

The next major pose we'll work on will have the arms opened out more, with the right arm coiled back in pose immediately preceding release of the ball. For this pose, we'll pose the hips and left leg moving forward into the throw.

The leg and hips are moving forward first, while the right arm is still coiling back to build energy for release. The upper arm releasing the ball will follow through last. This pose has the character at full extension and is the most exaggerated pose in anticipation of the move – reference for the pose is provided in the thumbnail image in introduction to the chapter (see Fig. 2.1.2, right).

First, let us start by posing the arms and upper body:

- Work from the existing scene file you're working on, or open the project file with the existing poses blocked in – **2.1_03_Rise_Pose_Pre_Throw.ma**.
- Scrub the Time Slider to frame 15 to block in the next pose (see Fig. 2.1.21, left screen).
- Select the right wrist control (RightWristEffector) and with the Move Tool (W) active, pull the effector back in the Global X- and Z-axes.

> Tip
>
> If you Ctrl + click on the Y-axis, it will constrain the movement with the translate tool to the X-/Z-axis plane (see Fig. 2.1.21, second screenshot).

Use the rotate tool (E) to rotate the wrist round to match the angle of the forearm. Orbit round the character to the side to check the pose running from the clavicle down to the wrist is a straight line (see Fig. 2.1.21, third screenshot).

While posing, make any necessary adjustments to the posing of the elbow and shoulder as needed to finalize the arm pose. As before, use the pinning tools to pin the wrist effector if you need to modify the elbow position or shoulder.

- With effector still selected, set Full Body IK key (Ctrl + F) at frame 15 once you're happy with the arm pose.

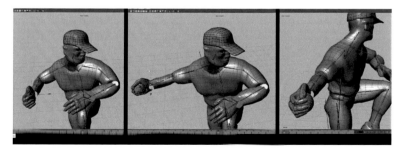

FIG 2.1.21 Posing the arm for pre-throw pose.

For the pre-release pose, we also want to rotate the upper torso round further and raise the opposite right arm higher; this will create a more dynamic angle to the pose and coil to the torso on the pre-throw.

- Still at frame 15, first select both wrist effectors (LeftWristEffector/ RightWristEffector) and turn off pinning from the right-click marking menu.

With pinning turned off, we can rotate round the torso with the wrist's following the rotation of the upper body.

- Select the effector beneath the neck (see **Fig. 2.1.22**, left screenshot – ChestEndEffector selected).
- With the rotate tool active (E), rotate the effector back in X- and Y-axis to coil the body further back (see Fig. 2.1.22, middle screenshot).
- To finalize the upper torso pose, select the head effector and rotate it back round to counter the motion and maintain a solid pose (see Fig. 2.1.22, right screenshot).
- Raise the left wrist effector and shoulder to create a strong action line running across the body (see Fig. 2.1.22, right screenshot).
- With effector still selected, set Full Body IK key (Ctrl + F) at frame 15 once you're happy with the upper torso and left arm pose.

FIG 2.1.22 Coiling back the upper torso for pre-throw.

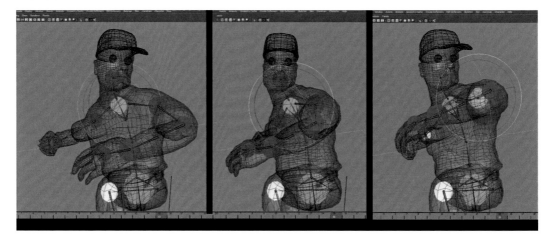

Let's work on the hips and legs for the pose.

We want the hips and leg posing to lead the torso and arms. The torso and arms are still coiling and rotating *backward* in anticipation of the throw. At this section of the animation, the hips should be rotating round *forward* and traveling in the opposite direction. If you think of the motion, it is similar to a corkscrew action – the hips rotate round first and are carrying the weight of the body to the top of the corkscrew that would be the shoulders and the arms.

For the leg pose edits, we want to maintain the rotation edits we made to the upper torso in the last edit; for this, we can use Rotation Pinning on the chest effector to lock the pose:

- Still at frame 15, select the spherical effector at the top of the chest – ChestEndEffector.
- From the right-click marking menu, choose Pin Rotate option (see Fig. 2.1.23, left screenshot).
- Select the hips effector (HipsEffector) and rotate it forward in X-axis, so that the hips are rotating round at this frame.

Note

As you rotate the hips forward to counter the upper torso rotation, the chest rotation will stay "as is" because Rotation Pinning is still enabled from previous step (see Fig. 2.1.23, middle screenshot). The planted right foot on the ground should also stay locked as Pinning is active for the right ankle (RightAnkleEffector). The left leg should follow the rotation as pinning is not active for LeftAnkleEffector.

- With the Move Tool active (W) and with the hips effector still selected, move the hips forward in X-axis to shift the weight. The posing should have a strong diagonal action line running from the right foot, through the spine up to the left shoulder (see Fig. 2.1.23, right screenshot).
- With effector still selected, set Full Body IK key (Ctrl + F) at frame 15 once you're happy with the hips position and rotation.

FIG 2.1.23 Counter rotation and motion for the hips pose – hips lead.

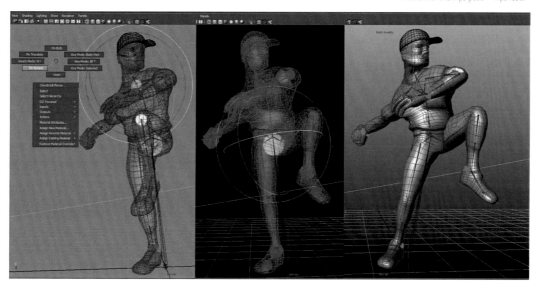

To finalize the pose, we need to refine the foot placement and angle of the knee. The right foot that is planted on the ground should also be raised, so that the pitcher is weighted on ball of the foot instead of heel.

- Still at frame 15, select the right ankle effector (RightAnkleEffector) that is currently pinned and choose Right-Click > Unpin.
- Then, select the effector on the ball of the foot (RightFootEffector) and choose Right-Click > Pin Both (see Fig. 2.1.24, left screenshot). The icon will change to TR for the effector to show that translation and rotation are pinned.
- Next, select the hips effector (HipsEffector) and raise it up slightly, so that the right leg is fully extended. The effector on the ball of the foot will remain pinned in space and the heel effector (RightAnkleEffector) will

121

raise, as the hips are raised in Y-axis (see Fig. 2.1.24, middle screenshot). Hit Ctrl + F to set Full Body IK key.

We also want to shift the weight onto the ball of the foot by pulling the heel back and rotating the toe round:

- Select the right ankle effector (RightAnkleEffector) and pull it back slightly in global X-axis (see Fig. 2.1.24, right screenshot). Hit Ctrl + F to set Full Body IK key.
- Select the effector on the ball of the foot (RightFootEffector) and rotate it back round, so that the angle of the foot looks more natural (see Fig. 2.1.24, right screenshot). Hit Ctrl + F to set Full Body IK key.

The right knee effector should also be pulled forward to more closely match the angle the hips are traveling in (see Fig. 2.1.24, right screenshot):

- Select the right knee effector (RightAnkleEffector) and pull it forward slightly in global X-axis (see Fig. 2.1.24, right screenshot). Hit Ctrl + F to set Full Body IK key.

Once you're happy with the weight and balance in the pose set Full Body IK key (Ctrl + F) at frame 15.

FIG 2.1.24 Pinning the ball of the foot and shifting weight balance on right leg.

While working on the character and keying the poses, check the weight shifts and angles of the limbs from different angles in the Viewport to ensure that the poses are balanced and solid. In addition, check the action lines of the underlying skeleton to ensure that there are solid lines of movement across the spine, shoulders, hips, and limbs (see Fig. 2.1.25).

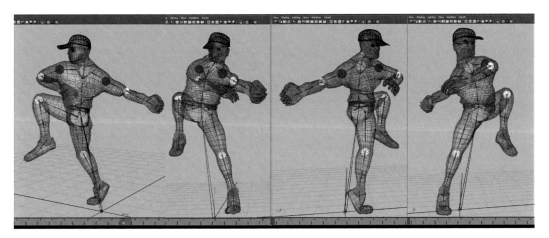

FIG 2.1.25 Validating the character pose from different angles in the Viewport (Alt + Left Mouse Button to Orbit).

The final scene file with the four major anticipation poses blocked in is included with the project scene files as – **2.1_04_Pre_Throw_Pre_Release.ma**.

In this tutorial, we've covered thumbnailing and reference for animation, working with the Full-Body IK control rig in Maya, and the process of pose blocking for animation. We've seen how an understanding of how the body moves in anticipation of action can be applied to animation and we've worked on posing the character in several dynamic poses to build anticipation of motion.

We've blocked in the pre-moves for a full-character action–based animation sequence. We will continue working with the same scene file asset in Chapter 6 where we'll finalize the sequence as we cover follow-through and overlapping action.

Chapter 2.2 – nParticle – Rocket Launch

Maya includes a robust Dynamics system to simulate rigid-body and soft-body dynamics. For simulation of fluid or particle effects, the included Dynamics and newer nDynamics systems allow a great degree of flexibility and control.

nParticles were introduced in Maya 2008 Ext.2 and largely replace the standard Particles setup. nParticles are part of the nDynamics system and take advantage of the Nucleus (n) Physics solver, which is also used by the nCloth system. We'll be using both nParticles (nDynamics) and Fluid Effects (Dynamics) in combination in this tutorial.

In this tutorial, we'll first take a look at blocking in some mechanical motion for a rocket's pre-launch before we work on the nParticles and Fluid Effects setup for the rocket flame and smoke.

Introducing the Asset

Open the start scene from the Project scene files directory named –
2.2_01_Rocket_Launch_Start.ma

The scene file includes a model setup for the Rocket launch. The rocket itself is linked to the arm on the base that moves up and down by using the yellow arrow control shape (RK_ArmRaise_CTRL). The base rotates through rotation of the red circular control object at the base (RK_BasePivot_CTRL) (see **Fig. 2.2.1**, left screenshot).

The control objects are setup using Maya's set driven key setup. We'll be looking at setup for control objects in more depth in Chapter 9 and online Chapters 7.1 and 11.1.

FIG 2.2.1 Rocket launch – model setup and control objects. Animation preferences.

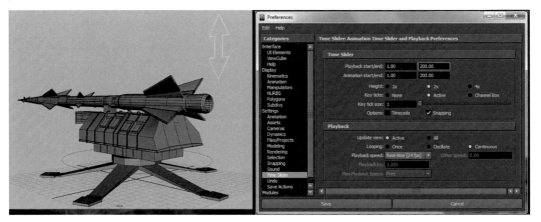

Animating the Mechanical Motion for the Rocket

For the pre-launch sequence for the rocket, we'll animate the base of the rocket mechanism craning round, then the arm mechanism rising in readiness.

First, let's set the Timeline to around 10 seconds for this shot.

- Open the Animation Preferences window from – Window > Settings/Preferences > Time Slider (see Fig. 2.2.1, right screenshot). Set the following:
 - Playback start/end = 1.00 / 200.0.
 - Playback Speed = Real-time [24 fps].
 - Hit the Save button to save the settings.

Base Pivot for Pre-rocket Launch

From the Outliner or Viewport, select the red circle-shaped control at the base of the rocket (RK_BasePivot_CTRL). The base of the rocket will also highlight in green wireframe to show that it is also selected (as it is a child of the control) (see **Fig. 2.2.2**, left screenshot).

FIG 2.2.2 Animating the base pivot.

- With the control selected, scrub the Time Slider to frame 1 and hit Shift + E to set key for rotation of Y-axis = 0 (see Fig. 2.2.2, left screenshot).
- With the control selected, scrub the Time Slider to around frame 75.
- Enable the rotate tool (E shortcut) and rotate the control in local Y-axis to rotate the rocket base toward the Viewport (around Rotate Y = 118 (third of full revolution)). Hit Shift + E shortcut to set key for rotation (see Fig. 2.2.2, right screenshot).

Arm Crane for Pre-rocket Launch

The motion for the pivot rotating we've blocked in is around 3 seconds (75 frames). We could animate the arm that is holding the rocket craning upward at the same time. As we're working in blocking in anticipation for the shot, we'll key the craning motion slightly after the pivot rotation to add to the anticipation and make the motion more mechanical looking.

From the Outliner or Viewport, select the yellow arrow-shaped control at the back of the rocket itself (RK_ArmRaise_CTRL). The arrow will highlight green to show that it is selected, and the rocket arm and rocket itself will also highlight in purple wireframe, which shows that it is constrained through Set Driven Key setup (see Fig. 2.2.3, left screenshot).

FIG 2.2.3 Animating the rocket arm rising.

- With the control still selected, scrub the Time Slider to frame 100 and hit Shift + W shortcut to set a key for translation at Y-axis = 0. This is the pose where the rocket arm is at default rest pose (see Fig. 2.2.3, left screenshot).
- With the control still selected, scrub the Time Slider to around frame 170.
- Enable the translate tool (W shortcut) and translate the arrow control up in local Y-axis to around Y = 3.0. Hit Shift + W shortcut to set key for translation (see Fig. 2.2.3, right screenshot).

This keys the animation for the arm rising to around 3 seconds (frames 100–170 = 70 frames). There is slight pause between this motion and the preceding motion of the base pivoting that we keyed before (from frames 1 to 75, pause between frames 75 and 100). The timing of the motion can be edited from the Dope Sheet if you want to extend the anticipation or make it more punchy.

Scene file including the default timing used above is included with the project scene files as – **2.2_02_Rocket_Pre-Launch.ma**.

Emitter Setup for nParticles

The animation we have setup is building anticipation for the rocket launch. After readying position for the launch, the rocket jets would fire, with flames and smoke billowing out before release. We'll use the nDynamics system in Maya to create nParticles for the flames.

- First, switch to the nDynamics menu set in Maya. This can be done from the drop-down menu at the top left of the Maya user interface (see Fig. 2.2.4, left screenshot). Switching to the nDynamics menu set changes the main menus at the top of the user interface, so that all the nDynamics tools and features are accessible.
- Go to the nParticles menu at the top of the interface and select nParticles > Create nParticles > Balls (see Fig. 2.2.4, middle screenshot). This sets the nParticle shape type to balls for any newly created nParticles.
- From the same nParticles menu at the top of the interface, open the options for creating a new nParticle emitter from nParticles > Create nParticles > Create Emitter [] Options (see Fig. 2.2.4, bottom middle screenshot).
- From the options window, give the new Emitter an appropriate name – EM_Rocket_Flame (see Fig. 2.2.4, right screenshot).
- Set Basic Emitter Attributes > Emitter Type = Volume (see Fig. 2.2.4, right screenshot).
- Set Volume Emitter Attributes > Volume Shape > Cylinder (see Fig. 2.2.4, right screenshot).

FIG 2.2.4 nDynamics menu set and emitter options

Hit Create from the Create Emitter Options Window. This creates a new Emitter object, which emits the nParicles into the scene. The Emitter is by default placed at the scene origin (X/Y/Z = 0.0). The Emitter is setup with the basic options used, the Emitter is a cylindrical object that fits the shape we need for the rocket and the nParticle type emitted is the basic Balls type we set above. If you scrub the Time Slider to frame 1 and hit play (Alt + V shortcut), you can see the nParticle balls emitted into the scene with the default options we have used (see Fig. 2.2.5, left screenshot).

We can tweak how the nParticles are emitted from the Attribute Editor to fit the effect we are looking for. If you check playback, the nParticles are emitted from the Emitter outward in all directions. For the rocket flame effect, we want the nParticles to be emitted directly from back of the Rocket in a straight line.

- With the emitter object selected from the Outliner or Viewport (EM_Rocket_Flame), open the Attribute Editor (Ctrl + A toggle) (see Fig. 2.2.5, middle screenshot).
- In the EM_Rocket_Flame1 tab, expand the Volume Speed Attributes rollout and set Along Axis = −20. This sets the nParticles to emit downward from the Emitter. Setting this attribute changes the shape of the Emitter object in the Viewport, with an arrow object pointing downward from the center of the emitter (see Fig. 2.2.5, middle and right screenshots).

FIG 2.2.5 Setting volume speed attribute, so that nParticles are emitted straight down.

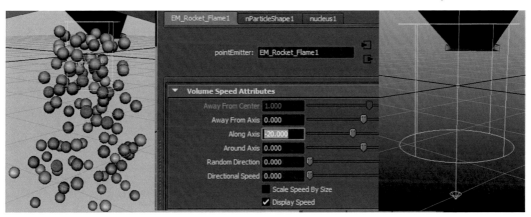

If you scrub the Time Slider and hit play (Alt + V), you should see that the nParticle balls are emitted in straight line downward. We'll tweak the other attributes for Emitter and nParticles in following steps. First, we need to position the Emitter object in the right place, so that the nParticles are emitted from the back of the rocket:

- Scrub the Time Slider to frame 1. At this frame, the rocket arm is at the default horizontal pose, which is easier for us to position and link the Emitter object.
- With the Emitter object selected (EM_Rocket_Flame1), open the Channel Box (Ctrl + A) and double-click in the Rotate Z field and input 90 to rotate the emitter object round, so it is parallel to the rocket.

- With the mouse pointer over the Perspective panel, hit the Spacebar on the keyboard quickly to toggle to 4 × Panes layout. Enable the Move Tool (W shortcut) and, from the top and side view panels, position the emitter, so that it is placed at the back of the rocket (see Fig. 2.2.6, left screenshot).
- From the Outliner or Viewport, select the Emitter object (EM_Rocket_Flame1) then select the Rocket object (EM_Rocket_Geo) (see Fig. 2.2.6, middle screenshot).
- The Emitter should highlight in white and the rocket in green to indicate that it was selected last (see Fig. 2.2.6, right screenshot). Hit the P shortcut key; this parents the Emitter object to the Rocket. The object selected last is the object being parented to. Parenting the Emitter object to the Rocket means that it will follow the motion.

FIG 2.2.6 Positioning and linking the emitter to the rocket.

For the particle emission, you would not really want the nParticles (flames) to start firing from the back of the rocket until it is in the ready position. We can control when and how many particles are emitted by keyframing the Rate Attribute for the emitter.

Emitter Rate

The pre-launch animation for the arm that holds the rocket rising was keyed to end at around frame 170. We want the nParticles not to start emitting until after this frame:

- Make sure that the emitter object is still selected (EM_Rocket_Flame1).
- Scrub the Time Slider to frame 174.
- With the Emitter Still Selected, open the Channel Box (Ctrl + A toggle).
- Listed in the Channel Box is the rate attribute. Double-click on the number and change it from 100 (default) to 00 – this means that no particles are emitted. Right-click on Rate in the Channel Box, so that it is highlighted blue and choose Key Selected; this keys the attribute at the current value. The value box should highlight red, which shows that keys are set (see Fig. 2.2.7, left screenshot). If you scrub the Time Slider back to frame 1 and hit play (Alt + V), no nParticles are emitted.

- Set the current time on the Time Slider to frame 175 (1 frame after frame 174). Repeat the steps above but set the value for rate to 80 before setting key. Repeat the process and set another key at frame 190 for rate at 250.
- If you scrub the Time Slider back to frame 1 and hit Play (Alt + V), the particles do not start emitting until frame 175; between frames 175 and 190, the particle rate increases from 80 to 250 from the keys we set.

When playing back the animation, you may notice the particle emitter intersects with the rocket geometry; to fix this Hold Ctrl key, enable the scale tool (R shortcut), and click on Y- axis scale to constraint the scaling to X-/Z-axis-scale the emitter in a bit, so that it is smaller than the rocket funnel at the back (EM_Rocket_Flame1).

Scene file with the emitter setup and basic attributes set is included with the project scene files as – **2.2_03_Rocket_EmitFlame01.ma**.

FIG 2.2.7 Keying the rate attribute for the emitter.

Nucleus Solver – Ground Plane Setup

When you playback the animation, you'll notice that when the nParticles are emitted they float downward to infinity through the ground. For the setup, we want to create a ground plane, so that the nParticles can roll off the ground when they hit the floor.

- At the top of the user interface, go to Create > Polygon Primitives > Plane and drag out a plane in the Viewport. Scale it appropriately in the Viewport with the scale tool (R shortcut).

Note

The plane model is only there as a visual queue; we'll use the Ground Plane setup on the Nucleus Solver to create a ground object for the nParticles in next step.

- With the Emitter selected from the Viewport or Outliner (EM_Rocket_Flame1), open the Attribute Editor (Ctrl + A toggle) and go to the nucleus1 tab (see Fig. 2.2.8, left screenshot).

129

Note

The Nucleus solver is the solver that is used for all nDynamics elements in the scene (including nParticles and nCloth). The attributes for the solver include the overall attribute settings for the nucleus physics including attributes such as Gravity and Wind, Solver quality, and Ground Plane.

- From the nucleus1 tab in the Attribute Editor, go to the Ground Plane roll-out and turn on "Use Plane" from the check-box (see Fig. 2.2.8, left screenshot).
- At the top of the interface, go to Window > Settings/Preferences > Time Slider and set End Frame to frame 400. This is set so that we can preview the effect of the nParticle emission for a longer period.

Scrub the Time Slider back to frame 1 or hit Alt + Shift + V (go to first frame shortcut) and then hit play (Alt + V). When the nParticles start emitting; you'll see that they now bounce off of the Ground Plane, which looks more natural (see Fig. 2.2.8, right screenshot).

Note

Playback *needs* to be set back to the start frame. This is so that the simulation is evaluated correctly – this is true for both nDynamics and standard Dynamics in Maya.

FIG 2.2.8 Nucleus solver attributes, enabling ground plane.

Scene file with the Ground Plane enabled for the Nucleus solver is included with the project scene files as – **2.2_04_Rocket_EmitFlame02_GroundPlane.ma**.

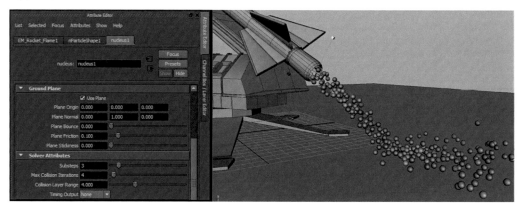

Tweaking the Effect on the nParticles

We can further tweak the effect by modifying the behavior of the nParticle objects that are emitted. Currently, the nParticles collide with one another when they're emitted like ping-pong balls. They also have an infinite lifespan, which means that, after being emitted, they remain in the scene. For a flame effect, we'd want the nParticles to intersect with one another and disappear after a set length of time. We can set this up, by modifying the nParticleShape attributes:

- Playback the simulation from the start, so that some of the nParticle Ball objects are visible in the Viewport. Select the nParticle balls from the Viewport or from the Outliner (nParticle1).
- Hit Ctrl + A shortcut to toggle the Attribute Editor on and go to the nParticleShape tab at the top of the window (see Fig. 2.2.9, left screenshot).
- Go to the Collisions roll-out and turn off "Self-Collide" (see Fig. 2.2.9, left screenshot).

Scrub the Time Slider back to frame 1 and playback the simulation (Alt + V). The nParticle objects still collide with the ground plane, but will not collide with one another and will produce a stream-like effect after bouncing off the ground (see Fig. 2.2.9, middle screenshot).

The nParticle lifespan attribute controls the duration the nParticles remain in the scene from the moment they are first released by the Emitter. For the flame effect, we can set the nParticle lifespan, so that they disappear (or die) from the scene shortly after hitting the ground:

- Select the nParticle balls from the Viewport or from the Outliner (nParticle1).
- Hit Ctrl + A shortcut to toggle the Attribute Editor on and go to the nParticleShape tab at the top of the window (see Fig. 2.2.9, third screenshot).
- Go to the Lifespan roll-out and switch Lifespan Mode to "Constant" from the default "Live Forever" (see Fig. 2.2.9, third screenshot).
- Set the Lifespan attribute to 0.65, so that they die after 0.65 (see Fig. 2.2.9, third screenshot).

On re-play of the simulation, the nParticle objects will disappear right after they hit the ground (see Fig. 2.2.9, far right screenshot).

FIG 2.2.9 nParticleShape Attributes – Collision and Lifespan.

Shading and Texturing the nParticles

The nParticles are currently represented in the Viewport as the default Ball shapes. These are great for previewing and tweaking the effect of the simulation and attributes such as the rate and lifespan. The Viewport display can be toggled from the "Attribute Editor > nParticleShape1 tab > Shading roll-out." This default nParticle "ball" type display is termed "Particle Render Type = Blobby Surface (s/w)."

You can also convert the nParticle objects to a mesh that is useful for texturing the model:

- Select the nParticle balls in the Viewport or from the Outliner (nParticle1) (see Fig. 2.2.10, left screenshot).
- Go to the Modify menu at the top of the user interface and choose Modify > Convert > nParticle to Polygons.

If you set the current time to frame 1 and then re-play the simulation, the nParticle objects are replaced by a single mesh object, with the shapes intersecting to produce continuous flow of particles (see Fig. 2.2.10, right screenshot).

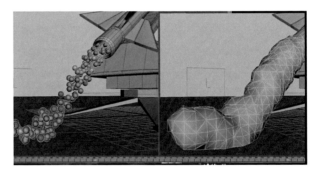

FIG 2.2.10 Converting nParticles to mesh.

The default mesh that replaces the nParticles is pretty coarse; the quality can be improved by increasing the attributes for the Output Mesh.

- With the nParticlesShape tab displayed in the Attribute Editor, expand the Output Mesh roll-out to see the attributes (see Fig. 2.2.11, left screenshot).
- Set the following to increase the quality:
 - Mesh Method = quad Mesh.
 - Mesh Smoothing Iterations = 4.

FIG 2.2.11 Refining the output mesh display.

The mesh display will update in the Viewport and should look smoother (see Fig. 2.2.11, right screenshot).

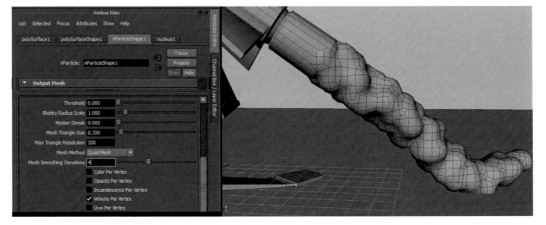

Note

Although increasing Mesh Smooth Iterations will improve the display quality, it may also affect playback performance of the simulation if set too high.

nRigid – Mesh collision

The nParticle Mesh is larger than the previous default balls we used. If you playback the simulation, the mesh intersects slightly with the base of the Rocket model (see Fig. 2.2.11, right screenshot). To partially resolve this, you can scale down the size of the emitter slightly in X-/Z-axis to around X = 0.42/Y = 0.42 (see **Fig. 2.2.12**, left screenshot).

For nParticle simulation, we can also add nRigid objects to the Nucleus solver. nRigid objects that are included in the same Nucleus solver as nParticles will interact with nParticles and other nDynamics effects (such as nCloth). This means that nParticle objects will collide realistically with the nRigid objects when running the simulation. The Ground Plane that we added earlier for the Nucleus solver produces a similar effect.

For the simulation, we can create nRigid from the Rocket model; this will mean that the nParticles will collide realistically with the end of the rocket when the particles are emitted:

- From the Outliner or Viewport, select the Rocket model (RK_Rocket_GEO).
- With the Rocket model still selected, from the top of the user interface, go to the nMesh menu and select nMesh > Create Passive Collider [] Options (see Fig. 2.2.12, middle screenshot).
- From the Options window, the Solver is set to the current nucleus1 solver used in scene by the other nParticles elements. This means that the nRigid will be added to same Nucleus solver. If you had other nucleus solvers setup in scene, you'd need to add the elements to correct solver to interact. As it is, choose the default and select Make Collide option.

This creates a new nRigid element in the scene for the Rocket. If you playback the simulation, the nParticle mesh should collide realistically with the rocket model (see Fig. 2.2.12, right screenshot).

FIG 2.2.12 Scaling emitter and adding nRigid to scene for the rocket.

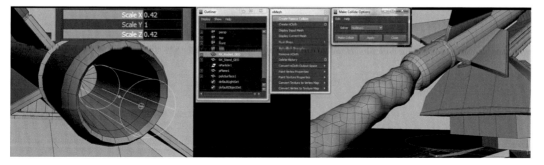

Scene file with the tweaks made to the nParticle shape and nRigid added to scene is included with the project scene files as – **2.2_05_Rocket_nParticleShapeEdit_nRigid.ma**.

Shading – 3D Texture

Work from the existing scene file you have setup or open the project scene file – **2.2_05_Rocket_nParticleShapeEdit_nRigid.ma**.

For the flame effect, you can texture the nParticle mesh in the scene to simulate the fire. As we converted the nParticles to a standard mesh earlier, it can be textured the same way as any other standard model in Maya.

For a flame effect, Maya's 3D procedural textures are a great way to create organic textures that mimic natural effects.

With the scene file open (**2.2_05_Rocket_nParticleShapeEdit_nRigid.ma**), choose the File > Import option and import the following Maya scene file from the project scene files directory – **2.2_06_Fire_3D_Texture01.ma**.

The scene is only 2K as all it includes is material setup with the 3D procedural textures:

- Open the Hypershade window from Window > Rendering Editors > Hypershade.
- Select the _06_Fire_3D_Texture01:Flame_mat from the top pane, and click on the [>>] Input and Output Connections button (see **Fig. 2.2.13**, left screenshot) at the top to see how the textures are connected in the material (see Fig. 2.2.13, middle screenshot):
 - The Main Flame_mat material is a standard Lambert material with a Maya 3D Stucco texture as incandescence input.
 - The 3D Stucco Texture has two color channels – both channels have separate Maya 3D Solid Fractal Setup as input.
 - You can select the nodes from the Hypershade and make any necessary adjustments to the properties from the attribute editor to tweak the effect. You could also look at refining the material or changing the setup by connecting other shaders or textures within the Hypershade. For further information on working with Maya's Hypershade, refer to the included Maya documentation.
- Set the Time Slider back to frame 1 and replay the simulation until the nParticle Mesh object is visible in the scene.
- Select the nParticle mesh from the Viewport or Outliner (polySurface1).
- With the Hypershade window open, right-click over the Flame_mat material and choose "Assign Material to Selection" option.
- With the nParticle mesh framed in the Viewport, hit the "Render the current frame" button (small clap-board icon) at the top of the user interface to test the effect (see Fig. 2.2.13, right screenshot).

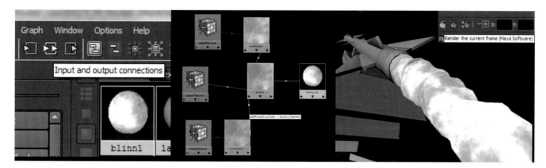

FIG 2.2.13 Maya's 3D procedural textures used for flame effect.

Scene file with the nParticle mesh textured with the 3D procedural texture is included with the project scene files as – **2.2_07_Rocket_nParticle_Texture.ma**.

No Smoke without Fire

In nature, there's no smoke without fire. Conversely, fire doesn't normally exist in nature without smoke. The simulation for the rocket flame is taking shape with the work we've done on the nParticles setup and procedural 3D textures we've used.

To further refine the simulation and create a more realistic effect, we can add smoke through Maya's Fluid Effects.

Maya's Fluid Effects are part of the standard Dynamics set in Maya. To create the smoke effect we'll set up the nParticle flame model as an emitter for a Fluid container:

- Scrub the Time Slider back to frame 1 where the Rocket model is at the default position.
- First, go to the menu drop-down at the top of the Maya user interface to switch the menu set to Dynamics (see **Fig. 2.2.14**, first screenshot).
- With the Dynamics menu set active, go to the top of the interface and choose Fluid Effects > Create 3D Container [] Options. From the options window, choose Edit > Reset and make sure X/Y/Z resolution and scale are set to the default = 10.0. Hit Apply and Close to create the new container (see Fig. 2.2.14, second screenshot).
- The container will display as green box (when selected) in the Viewport. It will be placed at the origin beneath the rocket after being created. With the container selected, open the Outliner and rename it to Smoke_RocketFlame (see Fig. 2.2.14, third screenshot).
- We need to position and link the 3D Container the same way as we did for the nParticle emitter earlier:
 - With the container still selected, enable the move tool (W shortcut) and move the container in X-/Y-axis to position over the end of the rocket. The container should also be scaled to around a third

(see Fig. 2.2.14, fourth and fifth screenshots). You can type the values from the channel box to get this exactly right:
- Translate X = 10.353.
- Translate Y = 9.066.
- Scale X/Y/Z = 0.336.

With the Container object (Smoke_RocketFlame) still selected Ctrl + Select the Rocket model (RK_Rocket_GEO) from the Outliner and hit P shortcut key to link the container as child to the Rocket model parent. This means that the container will follow the Rocket's motion during the simulation.

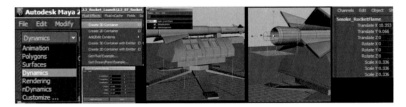

FIG 2.2.14 Dynamics – creating a 3D fluid effects container and linking to the rocket.

Fluid Emission

We want the Flame model (the nParticle Mesh) to emit the smoke from its surface; set this up next:

- From the Outliner, select the 3D Container (Smoke_RocketFlame), then Ctrl + Select the nParticle Mesh (polySurface1), the nParticle mesh will highlight green to show that it was selected last (see Fig. 2.2.15, left screenshot).
- Go to the Fluid Effects menu, at the top of the Maya interface and select Fluid Effects > Add/Edit Contents > Emit from Object [] Options (see Fig. 2.2.15, middle screenshots).
- From the Emit from Object Options window, set Emitter type to Surface and name it as Emit_Flame_SM (see Fig. 2.2.15, middle screenshots). Hit apply and close.

If you go back to frame 1 (Alt + Shift + V) and then replay the simulation (Alt + V), you can see the effect. As the nParticle mesh passes through the container, the Fluid Effect (Smoke) is emitted from the model (see Fig. 2.2.15, right screenshot).

FIG 2.2.15 Emit from Object – fluid effect (smoke) emitting from the nParticle mesh.

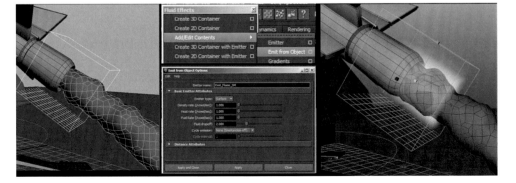

Note

If there are issues during playback, such as errors in the Script Window or elements not simulating correctly, it is probably due to playback skipping, which is causing problem with the dynamics evaluation. To resolve this, set "Playback Speed = Play Every Frame" from the Maya Animation Preferences; this will force every frame to be played during the simulation, which will increase accuracy. Please note that the Play Every Frame option may cause the animation to play slower or faster depending on the speed of the system, if this is an issue, consider doing a test render to validate the effect.

The effect is starting to take shape. On playback, the Fluid Container cube is only covering part of the Flame nParticle mesh (see Fig. 2.2.15, right screenshot). This means that the fluid (smoke) is only emitted from the nParticle mesh when it passes through the cube-shaped container. We can resolve this by setting the Fluid Container object to Auto Resize:

- Select the cube-shaped Fluid Container from the Outliner or Viewport (Smoke_RocketFlame) (see Fig. 2.2.16, left screenshot).
- Open the Attribute Editor (Ctrl + A), then go to the Smoke_RocketFlameShape tab and expand the Auto Resize roll-out – turn on Auto Resize from the check-box (see Fig. 2.2.16, left screenshot).
- When you playback the simulation, the Fluid Container will now Auto-Resize to the size of the emitter object as it passes through, so the fluid (smoke) is always emitted from the nParticle flames (see Fig. 2.2.16, right screenshot).

FIG 2.2.16 Auto-resize option for the fluid container.

We can modify the Shading Attributes for the fluid (smoke) to get a more realistic effect:

- With the Fluid Container still selected (Smoke_RocketFlame), open the Attribute Editor and go to the Smoke_RocketFlameShape tab and expand the Shading roll-out.
- From the Shading roll-out, do the following:
 - **Color** – Click the Selected Color swatch and set to a pinkish brown color from the Color wheel window (see Fig. 2.2.17, left screenshot).
 - **Incandescence** – Create a color ramp going from a dark brown color to red to yellow from the color wheel. To do this, click at interval points on the ramp display (rectangle shape) to create new key values; once the values are set, click on the color swatch to set color (see Fig. 2.2.17, left screenshot).
 - **Opacity** – Click on the ramp to create several new key points for the ramp. Set these to go from 00 to 100 at end. Set Opacity Input to Density; this will mean that the Opacity of the Fluid (smoke) will change gradually based on the density of the Fluid (smoke) (see Fig. 2.2.17, left screenshot).
- The fluid (smoke) color will now display differently in the Viewport during playback of the simulation. The modifications we've made have changed the appearance (see Fig. 2.2.17, middle screenshot).
- Hit the Render Current Frame button at the top of the user interface (small clap-board) to see the effect more clearly (see Fig. 2.2.17, right screenshot).

FIG 2.2.17 Modified color, incandescence, and opacity attributes for the fluid (smoke) effect.

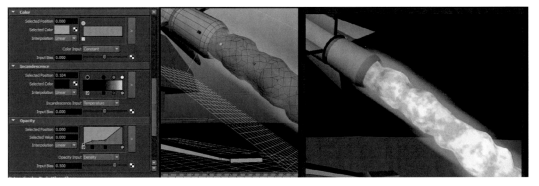

Enhancing the Quality of the Smoke Effect

The effect looks a bit more convincing, but it still does not really look like smoke. This is due to some of the quality settings and other attributes for the fluid (smoke). We can get something a lot better looking by doing some more tweaking:

- With the Fluid Container still selected (Smoke_RocketFlame), open the Attribute Editor and go to the Smoke_RocketFlameShape tab and expand the following roll-outs to make the right changes:
 - **Container Properties** – Set the Base Resolution to 60 from the default 10.

Note

This increases the quality of the fluid simulation, but will also cause slow playback performance on slower systems. Reduce this number if performance is an issue (see **Fig. 2.2.18**, top left screenshot).

- · **Dynamic Simulation** – Set High Detail Solve to All Grids (see Fig. 2.2.18, middle left screenshot).
- · **Lighting** – Turn on Self Shadow and Hardware Shadow (see Fig. 2.2.18, bottom left screenshot); this will make the smoke look a lot more convincing, as it will naturally cast shadows on itself.

Note

Turning on Hardware Shadow will display the shadows in the Viewport. This can seriously impact performance on slower systems. If necessary turn this off for Viewport display and preview the effect by producing a small offscreen test render.

FIG 2.2.18 Increasing quality for the fluid (smoke effect) and turning on self-shadowing.

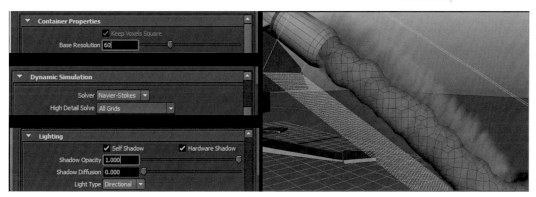

Scrub the Time Slider to frame 1 and playback the simulation (Alt + V); the smoke will gradually increase in the Viewport as soon as the nParticle shape (flames) starts passing through the Fluid Emitter. Further tweaks can be made to enhance the effect and create even more dynamic and natural results.

While tweaking the attributes, be sure to make incremental test renders of single frames to assess the edits (see **Fig. 2.2.19**). In addition, use the Batch render command in Maya to produce small test renders while working from Rendering Menu Set (F6) > Render > Batch Render [] Options.

The final scene file with the setup is included in the project scene files directory along with small test render:

2.2_08_Rocket_Smoke_FluidEffect.avi

2.2_08_Rocket_Smoke_FluidEffect.ma

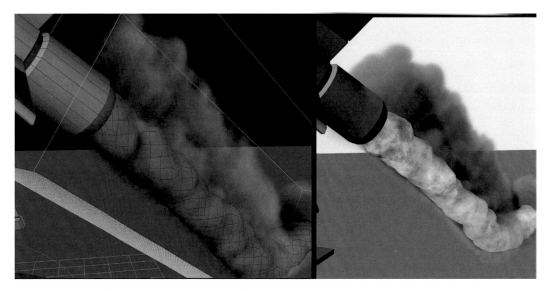

FIG 2.2.19 Final smoke effect previewed in Viewport and rendered.

Animation Editing –
Timing & Spacing

The number of drawings used in any move determines the amount of time that action will take on the screen
 The Illusion of Life: Disney Animation – Frank Thomas and Ollie Johnston

A firm grasp of timing for animation is a key principle to understand. Timing can have a strong impact on both the pacing of an animation sequence and the believability of physical motion.

With regards to physical motion or character animation, if the timing is off, it will be immediately noticeable to the viewer that the animation is wrong, the sense of physical weight, mass, and inertia will be lost. With regards to pacing of a sequence, object animation as well as camera sequencing is also key in creating strong pacing that matches the mood of the shot.

Effective use of Timing & Spacing needs to be applied throughout animation. Without effective timing & spacing, none of the other principles can be applied effectively.

Timing & Spacing – Anticipation to Follow-through and Overlap

In Chapter 2, we looked at the baseball pitcher sequence; minor edits were required to the key Timing & Spacing through the Time Slider to provide contrast between the pre-lead in and build up to start of action. In Chapter 6, we'll be looking at follow-through and overlapping action on the second half of the sequence. Again, the effective use of Timing & Spacing will be required to create believability in the motion. Analyzing the spacing and timing intervals and difference among the overall body motion, upper torso motion, and arms is key to creating believability in the animation (see Fig. 3.0.1).

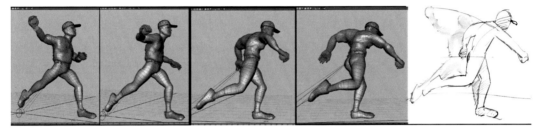

In Chapter 7, we'll be working on secondary animation with a hand animation rig (see Fig. 3.0.2). Again, effective edits of the keyframe Timing & Spacing on the hand controls are critical to create believability in the hand motion and gesture. Elements do not move at the same time – root joints lead the motion with appendages or secondary joints following the motion – the wrist leads with the main finger joints then finger tips following through. The timing intervals need to make sense.

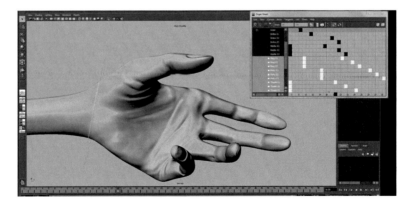

FIG 3.0.2 Timing & Spacing – secondary animation with follow-through and overlap.

Timing & Spacing – Appeal – Mood & Characterization

Differences between timing & spacing intervals in animation can also significantly change the mood or tone of the animation. Contrasts in the timing beats can make character animation appear subdued, lively, bright,

evil, or angry; in fact, any number of different moods can be created through effective use of Timing & Spacing. Knowing what type of timing your character should move on is critical in creating characterized performances with appeal. Effective use of Timing & Spacing to create appeal for character performance is discussed in more detail in Chapter 10 (see **Fig. 3.0.3**).

FIG 3.0.3 Timing & Spacing – bright/lively.

Timing & Spacing – Framing the Action – Camera Cuts and Action

For longer animation sequences, pre-planning of the Timing & Spacing intervals through both the storyboard and Animatic is key to creating engaging shots. In Chapter 5, we'll be looking at layout for the F16 fighter sequence where effective use of Timing & Spacing is required to create both anticipation of the action and engagement during the main dogfight (see **Fig. 3.0.4**). Planning the Timing & Spacing intervals between the animated elements and the timing on the camera shots themselves is a necessity at the pre-production phase of the animation.

FIG 3.0.4 Timing & Spacing – storyboard layout – action.

As you can see, Timing & Spacing can be applied to character animation, object animation, camera animation, and pre-production. In fact, it needs to be considered throughout this book when working through the exercises.

For the tutorials that follow in this chapter, we'll focus on Timing & Spacing for character animation. In the first tutorial, we'll analyze the Timing & Spacing intervals used on some of the other character animations covered in the book. Two of the key areas to understand how to apply timing and spacing are on walk cycles and run cycles, which we'll look at.

In the second tutorial, we will focus specifically on overall timing & spacing edits for a single animation sequence of a baseball batter, which will also be a focus in the next chapter when we look at ease in & ease out.

Chapter 3.1 – Timing & Spacing – Analysis

Timing & Spacing Pt. 1 – Jump Animation – Spacing Contrast

Contrast in Timing & Spacing on character animation is critical when creating dynamic and fluid animation.

For action or athletic motion, the contrasts should be broader and more defined. This helps to make the action more readable and the animation punchier.

Exaggerated Timing & Spacing can also help to heighten or exaggerate several of the other key animation principles, including: anticipation, ease in & ease out, and follow-through.

Using effective Timing & Spacing for broad athletic action will also help to give the character more mass and weight while in motion and increase the believability of the animation for the viewer.

- Open the scene file from the project directory named – **3.1_01_Spacing_Jump.ma**

The scene file includes a character jump animation (see Fig. 3.1.1).

We will work on creating the pose blocking for the jump animation in detail in Chapter 11.

- Playback the animation (Alt + V) to appraise the overall timing & spacing on the jump.

Note

The animation plays from right to left of the Perspective Viewport, which is the same as the screenshots used as illustration here, which also read from first pose at right to end pose at left. (see Fig. 3.1.1).

The overall spacing on the jump animation is pretty broad. The contrasts between the poses are quite broad, with the character going from upright pose to coiled pose at start, to elongated outstretched poses at mid-point of the jump (see Fig. 3.1.1, right to left screens).

There is broad contrast between the overall timing & spacing on the main shape or silhouette of the body as well as contrast between the timing & spacing on the body parts (arms and legs).

FIG **3.1.1** Jump spacing – overall contrast.

If we take a look at specific sections of the Jump sequence, we can see how the timing & spacing enhances the animation:

Start Section – Stance to Pre-Jump (see **Fig.** 3.1.2.1, right to left screens)

- Frames 0–8 – "Fast In" Stance Pose to crouch one-third second (see Fig. 3.1.2.1, right screen)
- Frames 8–14 – "Anticipation" – Pause before coil back (see Fig. 3.1.2.1, middle screen)
- Frames 14–24 – "Ease-In" Coil back to gather energy (see Fig. 3.1.2.1, left screen)

FIG **3.1.2.1** Jump timing & spacing – ease in and anticipation.

Jump Section 1 – Pre-Jump to Mid-Point (see **Fig.** 3.1.2.2, right to left screens)

- 7 Frames (24–31) = "Ease In" starting to accelerate to stance/jump (see Fig. 3.1.2.2, right screen)
- 5 Frames (31–36) = Accelerating into air (see Fig. 3.1.2.2, middle screen)
- 3 Frames (36–39) = Broad spacing as momentum increases at mid-point of jump (see Fig. 3.1.2.2, left screen)

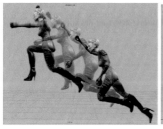

FIG **3.1.2.2** Jump timing & spacing – acceleration and momentum.

Contrast between the timing & spacing intervals on the jump animation is critical in creating weight, mass, follow-through, anticipation, and ease in & ease out in the animation. Effective spacing ensures that the animation does not look even or mechanical, which can be one of the pitfalls of computer animation.

Using ghosting or cycling through the animation frame by frame can help to evaluate and modify the spacing and timing to refine the motion. For acceleration, spacing intervals should get gradually broader, before slowing as gravity takes effect (see the bouncing ball animation from Chapter 1 and Fig. 3.1.2.2).

Timing & Spacing Pt. 2 – Walk Spacing

Let's take a look at the overall timing & spacing for a walk cycle.

- Open the scene file from the project directory named –
 3.1_02_Spacing_Walk.ma
- The scene file is retargeted Motion Capture data of a character walk.

Note

The process of remapping the Motion Capture data onto the character is discussed in detail in Chapter 12.

The Playback start time/Playback end time frames are framed on a portion of the animation (frames 70–143 – see **Fig. 3.1.3**).

During this portion of the animation, the character does a full walk cycle, going from what we call the "passing pose" weighted on the right leg through two steps back to similar "passing pose" on right leg (see Fig. 3.1.3). The sequence is a full cycle.

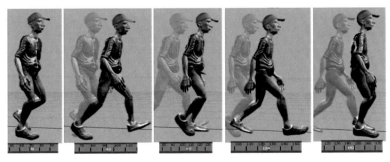

FIG 3.1.3 Walk spacing – even stride.

Playback the animation (Alt + V) and scrub the Time Slider to appraise the Timing & Spacing on this part of the walk. If you look at the spacing on the walk, you'll notice that:

- The spacing on the stride length when hitting what we call the "Contact Pose" on both strides is fairly even at:
 - Frame 93 Contact Pose 1 – Left leg leads (see Fig. 3.1.3, second screen from left).
 - Frame 124 Contact Pose 2 – Right leg leads (see Fig. 3.1.3, fourth screen from left).

- The timing intervals between the passing poses is fairly even:
 - Frame 70 – First Passing Pose.
 - Frame 107 – Second Passing Pose (107 – 70 = 37 frames).
 - Frame 143 – Third Passing Pose (143 – 107 = 36 frames).
- The distance traveled by the hips between the major Contact Poses and Passing Poses is also fairly consistent (shown by the faded ghost on the screenshots – see Fig. 3.1.3).

As the timing & spacing of the major poses at this phase of the animation (frames 70–143) is fairly even, the walk looks balanced and even.

Let's take a look at another part of the overall walk animation in the scene:

- From the active Panel, select the Panels menu at the top and choose:
 - Panels > Perspective > persp1 (see Fig. 3.1.4).
- From the Range Slider, or numeric input fields for Start/End Playback range, set the following:
 - Start Time = 126.00; End Time = 201.00 (see Fig. 3.1.4).

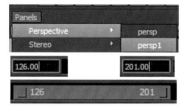

FIG 3.1.4 Framing the uneven walk animation.

- Playback the framed section of the animation (Alt + V).

The spacing between the main contact poses and passing poses are quite different from the previous example (see Fig. 3.1.5).

FIG 3.1.5 Walk spacing – uneven stride.

- The distances between the leg strides on the main contact poses at frames 126, 160, and 201 are uneven.
- The second step onto the left leg (at frame 160) is shorter than the stride length on the start and end frames of the sequence (see Fig. 3.1.5, middle screen).

- On the contact pose at the end, the right leg strides more to the side (character's right), which counters the unevenness of the short middle stride (see Fig. 3.1.5, screen at far right).

The character appears to shuffle due to the unevenness of the stride length. Although this section of the animation could not be used as source for a walk loop animation, the unevenness is natural looking and fits the overall walk animation in the scene (when Playback framed from frames 1 to 488).

Overall Timing for Walks

Go back to the original Playback framing for the scene (frames 70–143) and switch back to Perspective > persp from the Panel menu. Alternately, just reopen the scene file.

You'll notice that the walk is pretty slow for this part; overall, the walk animation for the whole scene looks labored.

- The Playback Speed is set to 60 fps (from the Animation preferences).

Note

60 fps is a common recording rate used when recording Motion Capture.

- There are 73 frames on the walk cycle (from start passing pose (frame 70) to end passing pose (at frame 143) (see Fig. 3.1.3).
- 73 frames at 60 fps is around 1.2 seconds.

This timing in this Playback section is suited to a slow strolling walk cycle.

An even natural walk cycle at "march time" would be a bit faster, with full cycle (two steps) taking exactly 1 second.

When working on walk or run cycle animations, you only really need to concentrate on creating half of the loop animation. If you think of a walk, there are two full steps in a loop cycle and, as we saw from the previous section, the spacing between the steps should be the same.

For a walk cycle animation, the animation from the start- to mid-point of the walk can effectively be duplicated or mirrored to create the full loop, this ensures that the walk is evenly spaced and cycles correctly. Therefore, you only need to concentrate on creating step from start contact pose to mid-point to opposite contact pose (see Fig. 3.1.6).

Note

If you are working on a longer walk sequence animation, you may consider breaking up the cycled walk poses, so that they are more uneven and the walk looks less mechanical.

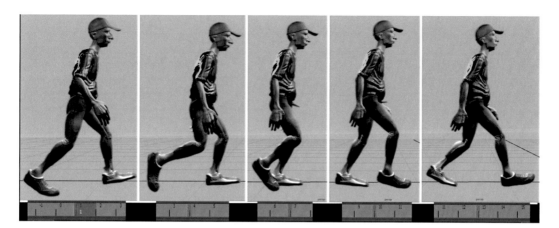

When working at standard 24 fps, a standard "march time" 1 second walk cycle can be keyed on "threes" – with each step taking 0.5 seconds (12 frames at 24 fps).

FIG 3.1.6 Walk cycle – key spacing.

- Frame 1 (Contact Pose 1 – legs at full extension) (see Fig. 3.1.6, first screen).
- Frame 4 (Down Pose – hips dip) (see Fig. 3.1.6, second screen).
- Frame 7 (Passing Pose – weight transfers over foot) (see Fig. 3.1.6, third screen).
- Frame 10 (Up Pose – hips rise) (see Fig. 3.1.6, fourth screen).
- Frame 13 (Contact Pose 2 – legs at full extension – mirrored from frame 1) (see Fig. 3.1.6, fifth screen).

Timing & Spacing Pt. 3 – Run Spacing – Overall Spacing

The overall timing & spacing on a run cycle animation is a lot broader than a walk cycle. Let's take a look at the timing & spacing on the run cycle animation that we worked with in Chapter 1.

- Open the scene file from the project directory named –
 3.1_03_Spacing_Run.ma

The Playback Speed is set to 24 fps (from the Animation preferences).

- The run cycle is looped and is 16 frames long (two steps = complete cycle).
- Each step has eight frames (1/3 of a second). The run speed is a jog (see Fig. 3.1.7, single step).
- A faster run or sprint would be quicker at: six frames (run) or four frames per step (very fast sprint).

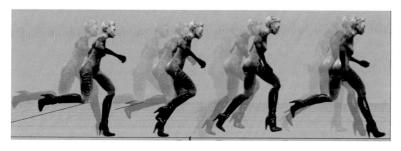

FIG 3.1.7 Run cycle – overall pose spacing – single step – frames 0–8.

If we look at the pose spacing on the run step, the main difference on a run cycle is:

- The character does not have both feet in contact with the ground at same time at any point in the run cycle (at start/end contact pose).
- Only single foot is planted at the start point (see Fig. 3.1.7, screen on far left), mid-point (see Fig. 3.1.7, final screen on right), and end points of the cycle.
- The stride length on the legs is a lot broader than on the walk cycle (see Fig. 3.1.7, screens on far left/right).
- At a couple of points in the cycle, the feet are off the ground, with the hips raised (see Fig. 3.1.7, third screenshot from left). At this point, the feet are switching before contact.
- The passing point is earlier in the cycle (see Fig. 3.1.7, second screenshot from left).
- At frame 3, the hips have passed over the planted foot and there is an extended distance traveled from the passing pose to get back to the next foot plant (see Fig. 3.1.7, second to fourth screens from left).

Overall, the posing for a run cycle is more dynamic than a walk cycle. The more exaggerated the angle of the body pose and longer the stride length are, the broader the spacing should be (the timing should also be faster). It is important to appraise the timing & spacing while blocking the animation to make sure that it fits.

As with a walk cycle, the run cycle still needs to have matching mirrored poses at the main passing/contact poses in the animation. The process of blocking and mirroring the poses for the run cycle is discussed in detail in Chapter 8.

Timing & Spacing Pt. 4 – Run Spacing – Foot/Hip Spacing

If you look at the walk and run examples, there is contrast in the timing & spacing between the separate body parts. In particular on the run, there is broad contrast between the timing & spacing on the hip and foot poses; this is due to both the transfer of weight and the follow-through on the elements during the stride (see Figs 3.1.8 and 3.1.9). Scrub the Time Slider to check the timing and spacing intervals on the run:

- From frame 00 (contact pose) to frame 03 (passing pose), there is broad spacing on the right leg swing. As the leg is quite long on the character, this is exaggerated (see Fig. 3.1.8, left screen).
- From frame 03 (passing pose) to frame 06 (pre-contact pose), there is even more contrast on the leg swing distance when compared with the hips travel, as it swings forward to plant (see Fig. 3.1.8, middle screen).
- From frame 06 (pre-contact pose) to frame 09 (contact pose), the spacing is reversed – the foot plants and stops for a few frames and the hips begin to follow-through (see Fig. 3.1.9, right screen).

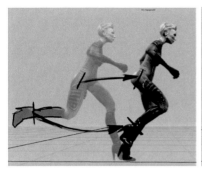
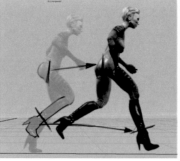
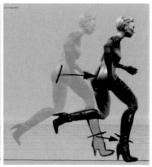

FIG 3.1.8 Run cycle – leg swing spacing/hips.

If you look at the spacing intervals on the leg after the foot plant, the spacing is quite different:

- From frames 11 to 16 – the right leg trails the leading left leg and hips, which are striding forward (see Fig. 3.1.9, left screen).
- From frames 16 to 19 – the right leg swings forward quickly to the next stride (as the hips move forwards through space to the next step on the run (see Fig. 3.1.9, right screen). The leg trails the hip motion during the initial phase (up to frame 16) with the follow-through motion happening on the leg after. Each element does not move at the same time.

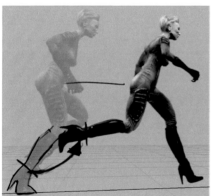
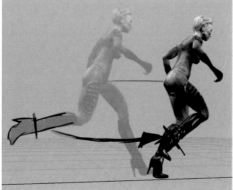

FIG 3.1.9 Run cycle – leg swing spacing/hips – follow-through.

Chapter 3.2 – Re-timing Action – Character Baseball Swing

Introducing the Character Asset

The character asset that we'll be working with in this section is similar in resolution and detail to the baseball pitcher character mesh that we worked with in Chapter 2.1 (see Fig. 3.2.1).

- Open the start file for the tutorial – **3.2_00_Start_Timing.ma**

The control setup for the character is the same setup used on the female character that we worked with in Chapter 1.4. The full setup for the character rig, skinning, and control setup is discussed in Chapter 9.3, which can be viewed on the Web site.

Note

We will not be working in detail with all the separate controls for the character in this section; instead we will be focusing on re-timing the animation.

However, as we'll be working with this character asset in later chapters, let's take a look at the setup for display and preview of the rig in Maya.

Display Layers

From the Channel Box/Layer Editor (Ctrl + A Toggle), there are a couple of Display Layers setup that can be toggled while working. Effectively managing what's displayed in the scene in Maya is critical while animating and reviewing the animation (see Fig. 3.2.1).

Three separate Display Layers are set up for the following elements:

1. The Control Objects (the colored wire objects for animation, Display Layer named-Bball_02_RIG_Curve_CNTRLS).
2. The underlying character skeleton (Layer named-Bball_02_RIG_Skeleton).
3. The character mesh (Layer named BBall_02_GEO).

Note

The skeleton and character mesh Display Layers should be set to Reference (R) or Template (T) display modes to prevent selection.

FIG 3.2.1 Character rig Display Layers and Viewport display modes.

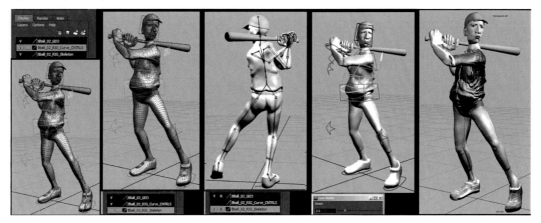

Note

Display of Joints and NURBS curves (Control Objects) can also be toggled globally on and off for the scene from the Panels menu > Show menu.

Maya's Shading menu has a couple of options to toggle whether:

1. The Joints are displayed in X-ray mode (Shading > X-Ray Joints), which is useful for preview.
2. Option to modify the thickness of lines (Shading > Thicker Lines). Increasing the thickness of lines can help in display and selection of the Wire Control Objects (see Fig. 3.2.1, fourth screenshot from left).

When animating and previewing work, it can also be useful to toggle the shading modes in the Viewport (from Shading menu or 4/5/6 shortcut keys).

- Displaying the model as "Smooth Shade" (5) with Wireframe on Shaded mode can help when posing, as the wireframe lines help describe the form as well as help identify any breakages in the character mesh when posing with the rig (see Fig. 3.2.1, first and second screenshots from left).
- Toggling whether the lights are used in scene can help describe the form on the mesh more clearly while animating (toggle between 5 and 7, to "Use Default Lighting" (5) or "All Lights" (7)).
- The character mesh also includes normal and specular maps for additional detail. Toggle the Viewport Renderer to Maya's "Viewport 2.0" or "High quality Rendering" modes from the Panel > Renderer menu to view these on the model (see Fig. 3.2.1, fifth screenshot from left).

Timing & Spacing

With the scene file open, ensure that "Playback Speed" is set to "Real-Time [24 fps]" from Maya's "Animation Preferences," and Playback the animation in the scene (Alt + V shortcut).

From frames 15 to 40 – The baseball batter swings from a coiled readiness pose to hit the ball and then follow-through with the bat across opposite shoulder (see Fig. 3.2.2, left to right screenshots).

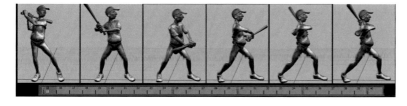

FIG 3.2.2 Baseball swing – timing & spacing – key poses.

The pose blocking for the baseball swing animation is covered later in this book in Chapter 6.3.

By previewing the animation, you'll notice that the motion does not look realistic, as the timing is too slow.

This is common when starting an animation or blocking out key poses. On the sequence, the animation Control Objects are keyed at regular five-frame intervals (see Fig. 3.2.2).

When blocking out animation, you should typically only be focusing on the overall posing and checking the transitions between the key poses through scrubbing the Maya Time Slider.

In this section, we'll look at the process to make overall edits to the timing between the key poses to make the animation more fluid and believable. We will work on global edits to the timing & spacing on the animation and then make iterative timing changes to selective elements to get the animation closer to final.

Object Selection Masks

When working on character animation in Maya, it can be useful to utilize the selection masks available from the Maya Shelf. Setting selection mask can help when you are only working on animating a specific group of similar objects.

Note

Using Maya's Display Layers and Show options can also be used as either an alternative to aid selection or in combination with the selection masks.

For the character setup in the scene, the only elements that are animated in the scene are the NURBS curve control objects (colored wireframe objects around the character). Set the selection mask to only select these elements:

- From the Maya Shelf, press the left mouse button on the pop-up menu icon to the left of the selection mask and select – All objects off (see Fig. 3.2.3, top screenshot).
- Click the "Select curve objects" icon (small squiggle icon) on from the shelf to select only Curve objects from scene (see Fig. 3.2.3, bottom screenshot).

FIG 3.2.3 Setting object selection mask – curve objects.

- Set the current Panel to Perspective View (Panels > Perspective > persp) and frame the character in the Viewport (see Fig. 3.2.4, left screenshot).
- Click the left mouse button in the top left corner of the Panel and drag a marquee selection over the whole screen.

All of the NURBS curve Control Objects should be selected and highlighted in white, except for single object, which will be highlighted in green, as it was selected last (see Fig. 3.2.4, middle screenshot).

FIG 3.2.4 Selecting curve objects (with selection filter) and modifying Key Tick Size.

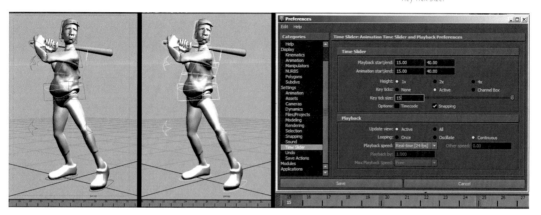

FIG 3.2.4 Selecting curve objects (with selection filter) and modifying Key Tick Size.

Note

Be aware that the current set selection mask will remain active while working. If required, turn off the selection mask if you are working on scene and need to select other elements from the Panel.

With the NURBS curve Control Objects selected, the keys will be visible as red ticks on the Time Slider. The size of the Key Ticks can be modified to aid the selection and edits made in this chapter section.

• Go to "Window > Settings/Preferences > Time Slider > Key Tick Size" and set the Key Tick Size = 15 (see Fig. 3.2.4, right screenshot).

Editing Timing & Spacing – First Half of Swing Animation

In Chapter 1.3, we looked at the different methods for editing key timing on a character arm swing, both through editing keys directly on the Time Slider and through the Dope Sheet.

With all the Control Objects selected, we can make global edits to the overall timing through editing the keys on the Time Slider. On Playback, the sequence is far too slow with the current timing, let's look at re-timing the first half of the swing animation (frames 15–25).

• Make sure that all the Control Objects are still selected from the previous step (see Fig. 3.2.4).
• On the Time Slider, click, at frame 20 with the left mouse button, then hold the shift key and click and drag right with the left mouse button to expand the selection to select from frame 20 to past frame 40 (see Fig. 3.2.5, top screenshot).

- With the keys from frames 20 to 40 selected and highlighted, click the left mouse button on the small <> arrow icon at the middle of the highlighted selection and then drag left with the mouse button to shift the keys back three frames – the keys on frames 20–40 should be moved earlier by three frames (see Fig. 3.2.5, second screenshot from top).
- On the Time Slider, click at frame 22 with the left mouse button, then hold the shift key and click and drag right with the left mouse button to expand the selection to select from frames 22 to 38 (see Fig. 3.2.5, third screenshot from top).
- With the keys from frames 22 to 38 selected and highlighted, click the left mouse button on the small <> arrow icon at the middle of the highlighted selection and then drag left with the mouse button to shift the keys back two frames – the keys on frames 22–38 should be moved earlier by two frames (see Fig. 3.2.5, fourth screenshot from top).

FIG 3.2.5 Shifting keys to re-time first half of swing.

The edits have shifted the keys from frames 20 and 25 to frames 17 and 20, respectively. Instead of 11 frames between the start of the swing (frame 15) and the mid-point of swing (frame 25), there are now only six frames (frames 15–20). The time between these poses has been reduced by about half, so the motion is twice as fast.

- Playing back the animation validates that the timing is a lot punchier on the down swing to the mid-point of the swing at the start frames.
- Scrubbing the Time Slider can help to validate the timing and spacing intervals between the poses.
- Using the Step Forward/Step Backward One Frame buttons on the Playback Controls (Alt +, /Alt +.) is also a useful workflow to use to check the pose difference between each frame. Stepping through each frame from frames 15 to 20 shows that there is a lot of motion or spacing between the poses at each frame, creating faster motion on Playback (see Fig. 3.2.6).

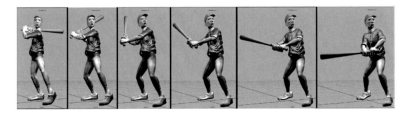

FIG 3.2.6 Validating timing intervals – step forward one frame (frames 15–20).

Scene file with the timing modified for the start frames is included with the project scene files as – **3.2_01_Re-Time_StartSwing(IN).ma**.

Editing Timing & Spacing – Second Half of Swing Animation

If we Playback the animation to check the overall timing, we can see that, although the timing looks right for the first part of the swing, the second part of the swing from frame 20 still looks too slow.

Stepping forward a frame at a time through the shot shows that the bat swings from frames 15 to 20 considerably, almost 180° from behind the head to the side of body (see Figs 3.2.6 and 3.2.7, screenshots on left). From frames 20 to 25, the bat only swings around 90° across the body, over the same period of time. The spacing between the poses is less on each successive frame, slowing the motion (see Fig. 3.2.7, screenshots on right).

FIG 3.2.7 Validating timing intervals – frames 15–25.

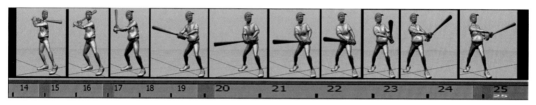

If we look at the timing and spacing on the final part of the swing, from frames 25 to 35, we can see that there is even less motion between each successive frame when cycling through the animation (see Fig. 3.2.8, screenshots from left to right). Over the 10 frames, the character swings the bat only around 45° from full extension to across the shoulder.

Although there would be some slow out (or ease out) at this phase of the animation, the pose intervals between each frame are so slight that the character appears to be moving in slow motion at the end of the animation (see Fig. 3.2.8).

FIG 3.2.8 Validating timing intervals – frames 25–35.

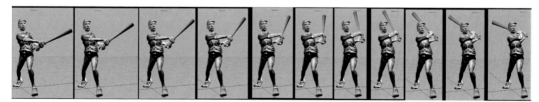

Let's take a look at editing the timing intervals between frames 25 and 35 to make the animation punchier:

- Use the same workflow as before to select all the Animated Curve Control Objects (see Fig. 3.2.4).
- With the Control Objects selected, click the left mouse button at frame 25, and then with the shift key de-pressed drag to frame 36 to select the keys between frames 25 and 35 (see Fig. 3.2.9, top screenshot).

- With the keys from frames 25 to 35 selected and highlighted, click the left mouse button on the small < > arrow icon at the middle of the highlighted selection and then drag left with the mouse button to shift the keys back 1 frame (see Fig. 3.2.9, second screenshot from top).
- Click the left mouse button at frame 29 and then with the shift key de-pressed drag to frame 35 to select the keys between 29 and 34 (see Fig. 3.2.9, third screenshot from top).
- With the keys from frames 29 to 34 selected and highlighted, click the left mouse button on the small <> arrow icon at the middle of the highlighted selection and then drag left with the mouse button to shift the keys back two frames (see Fig. 3.2.9, fourth screenshot from top).
- Finally, select the key at frame 32 and shift it back to frames to frame 30 (see Fig. 3.2.9, bottom screenshot).

FIG 3.2.9 Shifting keys to re-time second half of swing.

On Playback (Alt + V), the timing edits make the animation looks more natural. The overall timing of the second half of the sequence is more realistic and fits the first half edits.

Using the same process as before, we can step through the frames to validate the timing edits (Playback Controls = Step Forward/Step Backward One Frame (Alt +, /Alt +).

Frames 24–30

At the end of the swing, there are now only six frames (1/4 second) between the character swinging the bat around 45° from full extension to across the shoulder (see **Fig. 3.2.10**, left to right). The spacing between the poses at each frame is fairly even – meaning that the motion does not noticeably speed up or slow down. Compare this with the previous timing, where the motion was spread over 10 frames from frames 25 to 35 (see Fig. 3.2.8, left to right) – the motion has been speed up.

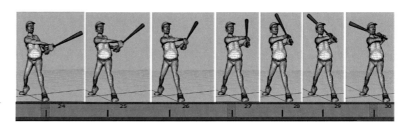

FIG 3.2.10 Validating timing edits – frames 24–30.

158

Frames 20–24

At the contact point on the swing, there are now only four frames on the motion (frames 20–24 – see Fig. 3.2.11, left to right). The key previously at frame 25 has been shifted to frame 24 – although this only reduces the timing by one-fifth, there is contrast between the poses as there is an in-between key at frame 22. The pose at frame 22 is closer to the pose at frame 20 – this effectively slows the motion between frames 20 and 22 and conversely makes the spacing between the poses at frames 22 and 24 broader. The broader motion between the poses at frames 22 and 24 creates punch in the animation and a "fast out" as the wrist swings in contact with the ball (see Fig. 3.2.11, screenshots on right).

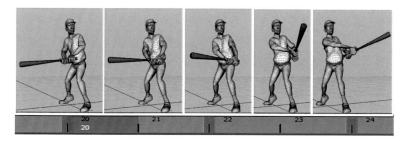

FIG 3.2.11 Validating timing edits – frames 20–24.

Scene file with the timing modified for the second half of the swing is included with the project scene files as – **3.2_02_Re-Time_EndSwing(OUT).ma**.

Timing & Spacing – Isolated Elements

Similar workflows can be used to analyze and edit the timing intervals on isolated elements of the animation. In fact, the most common workflow when animating is to block out the overall timing and then make itterative selected edits to timing of detail areas in the animation. This refinement process will typically require looking at the posing and timing on selected body parts as the animation is polished.

If we take a look at the timing of the feet on the edited animation (**3.2_02_Re-Time_EndSwing(OUT).ma**), we can see that the motion on the trailing planted right foot looks off. As soon as the left foot is planted (at frame 17), the right foot begins to pivot and roll from the toe and ball of the foot. This motion is twinned with the rotation on the hips that are twisting into the swing (see Fig. 3.2.12). This is unnatural looking, as the foot is moving at the same time as the hips – it also makes the motion look "soft" or a bit "spongy."

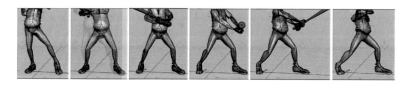

FIG 3.2.12 Validating timing – frames 15–30 – right foot turn.

We can make a couple of quick edits to the motion, so that it looks more natural. For this, we'll use the Dope Sheet to appraise and modify the timing for the elements:

- Using the same workflow as before, select all the wire Curve Control Objects in the scene.
- Open the Dope Sheet Window from:
 - Window > Animation Editors > Dope Sheet (see **Fig. 3.2.13**, left screenshot).
- Expand the Dope Sheet window to show all the selected Control Objects and keyframes (see Fig. 3.2.13, right screenshot).

FIG 3.2.13 Maya Dope Sheet Editor – overall timing.

In addition to an overview of all the animated elements and timing, the Dope Sheet also provides a benefit in that it allows us to see all the separate animated channels on the object. For the foot control that we want to edit, attribute is set up to control the foot roll. Setup for this is covered in the Character Rigging section in Chapter 9.3 and we'll be working on animating with this control through the Channel Box in a couple of other chapters; for now, let's take a look at the keys from the Dope Sheet:

- Make sure that the right foot control is selected and listed in the Dope Sheet Editor.

Note

You may need to scroll the left pane of the Dope Sheet Editor to see it listed, it's named as BBALL02_RIG_BASE_FSP_Foot_R_CTRL.

FIG 3.2.14 Maya Dope Sheet Editor – viewing animated channels – foot control.

- With the left mouse button, click the small + icon beside the object name to expand the animated channels (see **Fig. 3.2.14**).
- The following animated channels should be visible:
- Roll/Heel Rool/Toe Roll/Heel Pivot/Toe Pivot (see Fig. 3.2.14).

For the foot pivot and roll, the animated channels are Ball Roll and Toe Roll. To make the animation look more natural, the keys should be offset a few frames, slightly after the hips start to twist on the swing. This will look more natural, as the hips are leading the motion and forcing the foot to rotate and pivot as the body turns. This edit will also add natural "Follow-through" to the animation to create more believability.

- With the object still selected and Dope Sheet Editor open, select and highlight the following channels from the left pane: Ball Roll/Toe Roll.

Note

Use Ctrl + LMB to multi-select the two channels.
When channels are first selected, all the keys are also selected and highlighted in the Dope Sheet.

- Activate the Move Tool (W) and pull the keys + three frames, so that the animation starts slightly later, at frame 20 instead of frame 17 (see **Fig. 3.2.15**).

FIG 3.2.15 Maya Dope Sheet Editor – offsetting keys – foot roll and pivot.

If you scrub the Time Slider, you'll see that the foot pivot and roll is now delayed, which looks more natural when compared with the timing on the hips.

At around frame 20, you'll notice that the knee looks twisted and doesn't match the edited angle of the foot (see **Fig. 3.2.16**, left screenshot). This is due to the timing being un-modified on the knee Control Object:

- Make sure that the right knee control is selected and listed in the Dope Sheet Editor.

Note

You may need to scroll the left pane of the Dope Sheet Editor to see it listed, it's named – BBALL02_RIG_BASE_FSP_Leg_R_Pole.

- Click the + icon beside the Control Object name in the left pane of the Dope Sheet window to expand the channels and select the Translate Channel (see **Fig. 3.2.16**, left screenshot).

- With the Select Tool, marquee select the keys between frames 17 and 27. The keys should highlight in yellow (see Fig. 3.2.16, left screenshot).
- Activate the Move Tool (W) and shift the keys + two frames, so that the motion now starts at frame 19 instead of frame 17 (see Fig. 3.2.16, right screenshot).

FIG **3.2.16** Maya Dope Sheet Editor – offsetting keys – knee control animation.

Scrub the Time Slider and cycle through the frames using the Step Forward key on the Playback Controls to check and validate the timing edits.

The twist on the knee and foot is now delayed to follow the rotation of the hips more naturally. The foot does not start to pivot until the hips are already in motion, and the heel does not push out fully until the hips and knee are at full extension. Although the knee does not begin to turn until after the hips, it still leads the foot turn by a single frame, which could be extended. Overall, the motion timing is more believable, as there is overlap and follow-through added to enhance the selected elements timing (see Fig. 3.2.17).

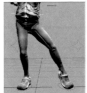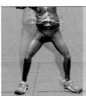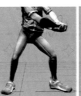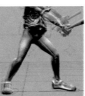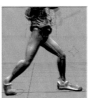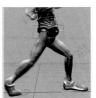

FIG **3.2.17** Validating timing edits – frames 15–30 – foot and knee, pivot and roll.

Scene file with the timing modified for the foot roll and pivot and knee is included with the project scene files as – **3.2_03_Re-Time_Foot_Pivot.ma**.

Animation Editing –
Ease In & Ease Out

Ease In & Ease Out (or Slow In & Slow Out as it was originally known) is the one animation principle that can most clearly be seen in human and organic movements in the real world. Objects do not naturally reach a critical speed in the real world unless purely mechanical – Even mechanical objects such as vehicles or planes require momentum before building speed gradually.

Gravity and inertia also act to slow the momentum of objects, both when beginning motion or halting.

In earlier chapters, we touched on the use of Ease In & Ease Out as a fundamental principle of animation:

- Ease In & Ease Out was used in the Bouncing Ball animation to make the ball bounce more convincingly. Through key edits and the Curve Window, the motion of the ball was slowed as it reached full height on the bounce, realistically mimicking the effect of gravity (see Fig. 4.0.1).
- Ease In & Ease Out was also applied on the IK Arm Swing in Chapter 1. A similar workflow was used to slow the motion of the arm as the wrist reached the full extension on the swing. As with the Bouncing Ball animation, Ease In & Ease Out was applied to effectively mimic the

FIG **4.0.1** Ease in & ease out –
Bouncing ball and arm swing.

effect of gravity and momentum on the arm as it moved through space
(see Fig. 4.0.1, right screenshots).

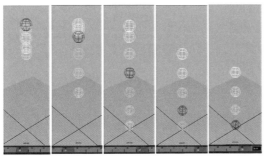

As an animation principle, Ease In & Ease Out can be applied both as an effect
to realistically mimic the natural forces in the world and as a dramatic device
to frame action through effective timing and spacing. For the F16 animatic
we'll work on in Chapter 5.1 and online Chapter 5.1, Ease In & Ease Out in the
timing is utilized to frame the action. This is apparent in the overall cut timing,
as well as the timing of specific shots (see **Fig. 4.0.2**).

FIG **4.0.2** Ease in – F16 fight
sequence – Hit shot to fall, framing
successively closer and faster.

To convey action through the camera, Ease In & Ease Out can be applied
through framing the action with either:

- Ease In – Wide-angle shots with slow timing going to close POV (Point of View)
 shots with fast timing. The timing beats and framing speed up on lead in.
- Ease Out – Close-cropped camera framing with fast cuts slow out to wider
 angle shots with slower timing. The timing beats and framing slow on the
 lead out (see **Fig. 4.0.3**).

FIG **4.0.3** Ease out – F16 fight
sequence – Lead out at end of
sequence.

For full body character motion, significant Ease In & Ease Out can be seen especially on exaggerated or athletic motion.

For both the baseball pitcher and the batter animations, we looked at in the preceding chapters, Ease In was applied alongside anticipation to build the animation to the main motion. The buildup of energy or intent in both sequences is the most obvious example of Ease In to the main motion.

At the end of a full character motion, there should typically be a corresponding Ease Out to the motion as the momentum dissipates. This should both match the loss of physical energy and act as a theatrical lead out to the motion.

This can be seen clearly in the second half of the baseball pitcher animation that we will work on in Chapter 6. After swing to full extension with the arm, the character will follow through with the motion for a few frames before very slowly easing out to end the animation (see **Fig. 4.0.4**).

The difference between the timing and the spacing on the poses determines how pronounced the Ease Out is in the pose. For some animations, such as this, it can be advantageous to add several keys of very slight motion with less variation between the poses – this creates what is called a Moving Hold, which is a short sequence where the character is in largely the same pose, but is idle or only moving very slightly.

In the first of the tutorials in this chapter, we will work on edits to posing and frame spacing to refine Ease In and Out on the baseball batter animation. For the second animation, we will look at how to achieve similar results using edits to the key timing and tangency through the Graph Editor for isolated elements on a head turn animation.

FIG 4.0.4 Ease out after follow-through on baseball pitch (Chapter 6).

Chapter 4.1 – Ease In & Ease Out – Character Baseball Swing

In this section, we will continue working with the baseball batter animation that we looked at in the preceding chapter. We will use the previously introduced workflows to edit key timing and spacing to apply overall Ease In & Ease Out to the animation.

- As with the IK Arm Swing animation, we will once again utilize the Motion Trail feature in Maya to visualize timing & spacing on the motion to effectively apply Ease In & Ease Out to the baseball bat swing.
- We will be working with edits to selected elements on the character control rig such as the wrist posing and timing on the bat. Modifying the pose intervals will enhance the Ease In & Ease Out on the swing.

We will not be covering the full posing for the animation on the full character control rig or all of the associated controls. These will be covered in more detail in Chapter 6.3.

Note

Please refer to Chapter 3.2 for information on the scene setup and Display Layers for this character rig while working through the exercise.

Overall Timing Edit – Ease In & Ease Out

- Open the start scene file for the tutorial – **4.1_00_Start_EaseInOut.ma**.
- The scene file includes the baseball bat animation we worked on in the preceding chapter section. We will work on refining the animation in this section to add Ease In & Ease Out to the motion.
- From the Range Slider at the bottom of the Maya user interface, set the start and end time of the playback range from the numeric input fields on either side as follows (see **Fig. 4.1.1**):
 - Start time of the playback range = 0.00.
 - End time of the playback range = 40.00.

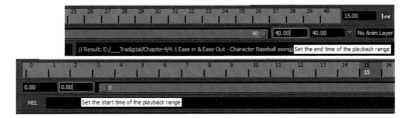

FIG 4.1.1 Setting the overall timing for playback of the sequence.

- Playback the animation (Alt + V).

On playback, you'll notice that there is a pre-animation of 15 frames added to the sequence (original start time was frame 15).

From frame 0 to frame 15, the character goes from an idle ready pose with the bat upright (frame 0 – see Fig. 4.1.2, first screen from left) to a more coiled ready pose with the bat over the shoulder (at frame 15 – see Fig. 4.1.2, fifth screen from left).

The addition of the 15 frames and animation at the start adds an overall lead in to the action before the fast swing. This lead in could also be classed as anticipation in the animation. The additional 10 frames at the end of the animation do not include any animation, but are intended to block out the overall timing for the sequence for the animation that'll be added for overall lead out.

FIG 4.1.2 Lead into action, frames 0–15.

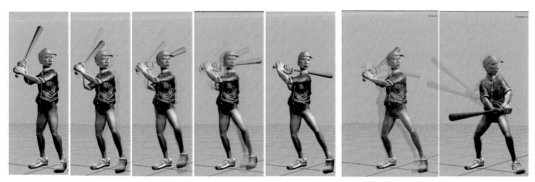

The scene file with the additional lead in/out frames added at the start and end of the sequence is included with the project scene files as – **4.1_01_EaseInOut_Overall.ma**.

Viewing Timing & Spacing – Motion Trail

With the scene file still open (**4.1_01_EaseInOut_Overall.ma**), open the Outliner (Window > Outliner) and select the following element (listed under the cameras at the top of Outliner – see Fig. 4.1.3, left screen).

• motionTrail1Handle.

Go to the Display menu at the top of the Maya interface and select the following:

• Display > Show > Show Selection (see Fig. 4.1.3, right screen).

FIG 4.1.3 Selecting and showing motion trail.

The MotionTrail will display in the Perspective Panel. The frame numbers marked on the Motion Trail allow us to see the timing intervals on the bat swing. The Motion Trail follows the motion of the bat (see Fig. 4.1.4).

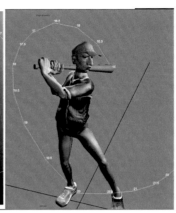

FIG **4.1.4** Viewing timing/spacing – Motion trail.

If we tumble around to a ¾ top perspective view (see Fig. 4.1.4, middle screen), we can see that the timing intervals at the start of the swing (frames 15–19) look fairly even. At frames 20–22, the spacing of the frames on the Motion Trail are close together, showing that the motion is slowed.

We can apply similar methodology as we used with the arm swing animation in Chapter 1 to refine the timing.

The spacing intervals should be closer together at the start of the swing (slower) and then open out with broader spacing between the frames as the bat gathers momentum. This will add a natural "ease in" to the animation and make the animation look more natural, weighted, and fluid.

In the following section, we'll take a look at editing the timing & spacing while validating the edits through checking the Motion Trail update and Playback Timing.

We'll work specifically on the Ease In & Ease Out of the main bat swing animation (frames 15–30).

The overall lead in from frames 00 to 15 will not be edited in this section. We'll work on enhancing the overall lead out animation (frames 30–40) at the end of the tutorial when we focus on creating an additional "Moving Hold for the animation."

First, set the playback frame range and Motion Trail Display for the Ease In section we're working on:

- From the Range Slider at the bottom of the Maya user interface, set the start time of the Playback range from the numeric input fields on the left side as follows (see **Fig. 4.1.5**): start time of the playback range = 15.00.

FIG **4.1.5** Range Slider – setting start time for playback and edit.

Editing Motion Trail Display

For the edits, we can set the Motion Trail to display only the frame range we're working on (see Fig. 4.1.6). This will help simplify the view while animating. The first section we'll work on editing is the "Ease In" for the bat swing animation (frames 15–24).

- Select the Motion Trail, from the Perspective View or Outliner (named motionTrail1Handle).
- Open the Channel Box (Ctrl + A) and, from the INPUTS section at the bottom, click the heading motionTrail1 to show the settings.
- Set the following by double-clicking in the numeric input fields:
 - Start time = 15.
 - End time = 24.

FIG 4.1.6 Selecting and editing motion trail start/end.

The scene file with the Motion Trail unhidden and set to dispaly the frame range for edit is included with the project scene files as – **4.1_02_EaseInOut_CurveEdit01.ma**.

Editing Timing & Spacing – Ease In on Swing

To edit the timing & spacing intervals, we can use a combination of editing the key timing and modifying the poses. First, let's add an additional frame at the start to ease into the swing. For the timing edits, we'll use the same workflow as in the preceding chapter section to select all of the animated elements and modify the keys globally on the Time Slider.

- Select all of the wire Control Objects from the Perspective View (they should be highlighted in white/green to show that they're selected).

Note

The mesh and skeleton are set to Reference/Template in the Display Layer, so that they cannot be selected. The Motion Trail curve does not need to be selected for this step.

- From the Time Slider, click the left mouse button with the mouse pointer on frame 17, and then with the shift key depressed, click and drag right to expand the selected key range past frame 29. The selected range should be highlighted in red and the selected keys in yellow (see Fig. 4.1.7, left screen).

169

- With the key range still selected, click the left mouse button with the mouse pointer on the <> icon at the middle of the selection and drag the key range forwards +1 frame, so that the key at frame 17 is now at frame 18 (see Fig. 4.1.7, right screen).

FIG 4.1.7 Modifying timing – Ease in.

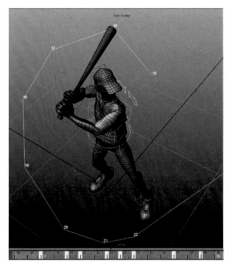 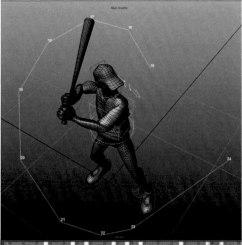

Shifting the keys has added additional frame at the start. If we look at the timing intervals on the Motion Trail, the intervals on the poses for the bat at the frames between frames 15 and 18 are slower, as the spacing intervals are less. This slows the motion at the start and adds Ease In (see Fig. 4.1.7, right screen).

If we look at the timing intervals on the rest of the first half of the swing, we can see that the spacing between the frames between frames 18 and 21 looks fairly natural and correct. The spacing is opened out as the bat accelerates into the swing. However, between frames 21 and 23, we can see that the spacing is bunched up between the frames. There isn't much movement between the pose intervals at these frames. This slows the motion unaturally at the mid-point in the swing (see Fig. 4.1.7, bottom of Perspective View).

We can fix this using a combination of editing the key timing and posing:

- Select all of the wire Control Objects from the Perspective View (they should be highlighted in white/green to show that they're selected).
- From the Time Slider, click the left mouse button with the mouse pointer on frame 23, and then with the shift key depressed, click and drag right to expand the selected key range past frame 31. The selected range should be highlighted in red and the selected keys in yellow (see **Fig. 4.1.8**, first screen from left).
- With the key range still selected, click the left mouse button with the mouse pointer on the <> icon at the middle of the selection and drag the key range backwards −1 frame, so that the key at frame 23 is now at frame 22 (see **Fig. 4.1.8**, second screen from left).

FIG 4.1.8 Modifying timing – Faster out (frame 22).

This removes the additional frame interval that was visible previously on the Motion Trail. If we look at the spacing interval, the spacing between the bat at frames 21 and 22 is still fairly tight, which slows the motion at this frame. The spacing interval doesn't look appropriate compared to the preceding and following frames. We can fix this by modifying the position of the bat at frame 22.

- Scrub the Time Slider to frame 22.
- From the Perspective View or Outliner, select the Blue Circular control object for the left hand (named BBALL02_RIG_BASE_FSP_Hand_L_CTRL).
- With the control selected, enable the rotate tool and rotate the wrist around the local Y-axis, so that the bat swings forwards slightly further (see Fig. 4.1.8, third screen from left).

Note

If the right arm hyper-extends too far, use the Move Tool (W) to pull the wrist back in toward the body slightly (in the Global X-axis – see Fig. 4.1.8, third screen from left).

Note

Tumble around the Perspective View to ensure that the action line and curve look consistent from different angles.

- Hit the Shift + W (key translation) and the Shift + E (key rotation) shortcuts to set key at frame 22.

The Motion Trail will update once the key is set to reflect the change.

Iterative changes can be made to the key poses at the frame intervals to fix any issues in timing and spacing.

Any edits to spacing at the mid-point in the animation should create more regular broad spacing at the full extension of the swing when the bat is at full speed.

Pose Edits – Ease In

Further edits can be made to the posing at the start of the swing animation to create a more natural Ease In. The spacing intervals should go from small to

large as the bat accelerates into the swing. The change in spacing should be gradual to make the motion look fluid. To add additional Ease In at the poses, we can pose the bat backwards slight, the opposite of what we did in the last step to accelerate the bat (at frame 22).

- Scrub the Time Slider to frame 16 and tumble around to view the character from a ¾ top view (see Fig. 4.1.9, left screen).
- From the Perspective View or Outliner, select the Blue Circular control object for the left hand (named BBALL02_RIG_BASE_FSP_Hand_L_CTRL).
- With the control selected, enable the rotate tool and rotate the wrist around the local X-axis, so that the bat is swung slightly back from the pose it's at (see Fig. 4.1.9, middle screen).
- Hit the Shift + E shortcut to set rotation key at frame 16.

Note

This sets in-between key, as there was no existing key at this frame.

The Motion Trail should update to reflect the change after the key is set (see Fig. 4.1.9, right screen).

FIG 4.1.9 Modifying pose/spacing – Ease in (Frames 15–16).

The edit has decreased the spacing interval between frames 15 and 16, effectively slowing the motion at the start.

 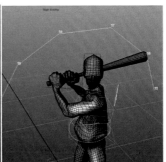

Iterative adjustments can be made to the other keys and posing at the start of the swing to slow the animation. The poses for the bat at the frames between frames 16 and 19 can also be pulled back slightly to "slow in" the animation. The distance interval between each pose should get slightly larger as the bat progresses and accelerates through the swing:

- Scrub the Time Slider to frame 17 and tumble around to view the character from a ¾ top view (see Fig. 4.1.10, first screen from left).
- From the Perspective View or Outliner, select the Blue Circular control object for the left hand (named BBALL02_RIG_BASE_FSP_Hand_L_CTRL).
- With the control selected, enable the rotate tool and rotate the wrist around the local X-axis, so that the bat is swung slightly back from the pose it's at (see Fig. 4.1.10, second screen from left).

- Hit the Shift + E shortcut to set rotation key at frame 17.
- Scrub the Time Slider to frame 18 and tumble around to view the character from a ¾ top view (see Fig. 4.1.10, third screen from left).
- With the control selected, enable the rotate tool and rotate the wrist around the local X-axis, so that the bat is swung slightly back from the pose it is at (see Fig. 4.1.10, fourth screen from left).
- Hit the Shift + E shortcut to set rotation key at frame 18.

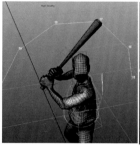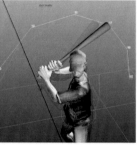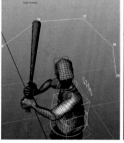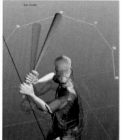

Make additional edits to the posing and keys for the angle of the bat between frames 19 and 22. The spacing should gradually increase from the start as the bat swing accelerates.

FIG 4.1.10 Modifying pose/spacing– Ease in (Frame 17 (Left Screens) to frame 18 (Right Screens)).

At the start of the swing (frames 15–18), the spacing should be tight as the motion slows and then accelerates (see Fig. 4.1.11, left screenshot). At the mid-point of the animation, the spacing should be at maximum (around frames 20–23 – see Fig. 4.1.11, right screenshot).

As edits are made to the posing and spacing at one frame, the timing and spacing will change on the preceding and the following frames. Additional edits may be needed to get the pose intervals correct for the timing on the swing (see Fig. 4.1.11).

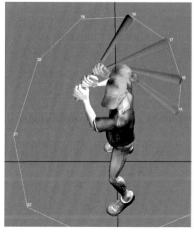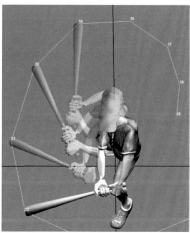

FIG 4.1.11 Modifying pose/spacing – Ease in – Frames 15–18 left screen, to frames 19–22 right screen.

173

When validating the timing & spacing for the Ease In on the swing, check the Motion Trail and posing from a few different angles in the Perspective View. In addition, playback the animation regularly and make occasional Playblasts to check the progress of the edits.

The line of the curve on the swing should still look fluid when viewed from the side during playback, with the arc of the curve running in a diagonal line from behind the shoulder to in front of the body. Additional edits to the wrist position as well as the shoulder rotation may be required to ensure that the posing at each key frame looks fluid and consistent (see Fig. 4.1.12).

FIG 4.1.12 Validating posing and timing intervals – Ease in – Frames 15–22.

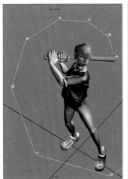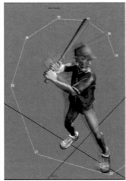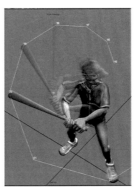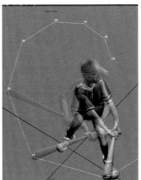

The scene file with the editied timing and spacing for the swing Ease In is included with the project scene files as – **4.1_03_EaseInOut_CurveEdit02_IN.ma**.

Editing Timing & Spacing – Ease Out on Swing

For the Ease Out on the main swing section (frames 23–30), we can use a similar process to edit the key timing and posing. The Timing & Spacing on the Ease Out on the swing should be the opposite of the Ease In, with the spacing on each successive frame getting smaller as the animation progresses to slow the motion. First, set the Motion Trail display to the range we're working on (see Fig. 4.1.13):

- Select the Motion Trail, from the Perspective View or Outliner (named motionTrail1Handle).
- Open the Channel Box (Ctrl + A) and, from the INPUTS section at the bottom, click on the heading motionTrail1 to show the settings.
- Set the following, by double-clicking in the numeric input fields:
 - Start time = 20.
 - End time = 40.

FIG 4.1.13 Selecting and editing motion trail start/end – Ease out range.

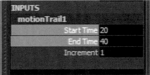

With the Motion Trail Displayed, we can see that the pose spacing already eases out slightly at the end (frames 25–30).

The Timing/Spacing looks a bit inconsistent, as the intervals go from broad/fast (frames 23–24) to consistent slow between frames 26 and 30 (see Fig. 4.1.14).

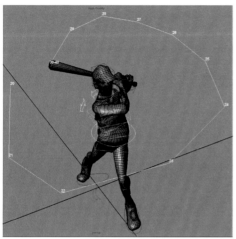 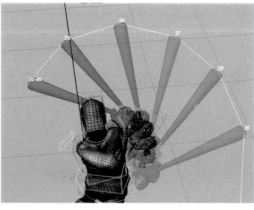

- Select all of the wire Control Objects from the Perspective View (they should be highlighted in white/green to show that they're selected).
- From the Time Slider, click the left mouse button with the mouse pointer on frame 29, and then with the shift key depressed, click and drag right to expand the selected key range past frame 30. The selected range should be highlighted in red and the selected keys in yellow (see Fig. 4.1.15, left screen).
- With the key range still selected, click the left mouse button with the mouse pointer on the <> icon at the middle of the selection and drag the key range forwards +1 frame, so that the keys at frame 29/30 are now at frame 30/31, respectively (see Fig. 4.1.15, right screen).

FIG 4.1.14 Viewing unedited timing/spacing – Motion trail – Frames 23–30 (Ease Out).

FIG 4.1.15 Modifying overall timing – Ease out.

 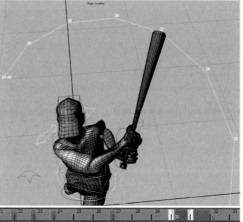

The edit has effectively added an additional frame for the Ease Out. There are now four frames between frames 27 and 31 instead of the previous three frames (frames 27–30) (see Fig. 4.1.15, right screen). The additional frame has modified the timing at the end, bunching up the posing or spacing between these frames adding Ease Out, although the spacing is better, we'd still need to make some small adjustments as before on the posing to make the Ease Out look more fluid:

- Scrub the Time Slider to frame 30 (see **Fig. 4.1.16**, first screenshot).
- Rotate (E) the left wrist control around slightly (BBALL02_RIG_BASE_FSP_Hand_L_CTRL), so that the end of the bat is moved closer to the pose at frame 31 (see Fig. 4.1.16, second screenshot).
- Hit the Shift + E shortcut to key the rotation.
- Scrub the Time Slider to frame 29 (see Fig. 4.1.16, third screenshot).
- Rotate (E) the left wrist control around slightly (BBALL02_RIG_BASE_FSP_Hand_L_CTRL) so that the end of the bat is moved slightly closer to the pose at frame 30 (see Fig. 4.1.16, fourth screenshot).
- Hit the Shift + E shortcut to key the rotation.

FIG 4.1.16 Modifying posing and spacing intervals, frames 30 and 29.

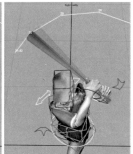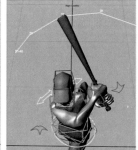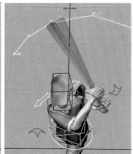

Use the same process to modify the poses at frames 28 and 27 (see **Fig. 4.1.17**, fourth screenshot).

The intention in modifying the posing on the wrist control is to "bunch up" the poses gradually nearer the end of the swing to increase the Ease Out. As before, make sure that the swing and Motion Trail look right from different angles in the Perspective View.

FIG 4.1.17 Modifying posing and spacing intervals, frames 28 and 27.

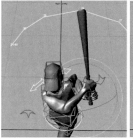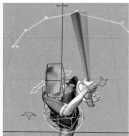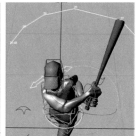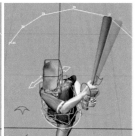

The same process should be used to modify the posing and spacing on the preceding frames of the Ease Out (frames 22–27).

The spacing between frames 22 and 23 can be increased slightly by pushing the bat further along the trajectory at frame 23 to increase momentum at the full extension on the swing (see **Fig. 4.1.18**, right screenshot).

Likewise, the poses can be pushed slightly further forwards at frames 24 and 25, which has the effect of increasing the spacing on the preceding frames and reducing the spacing on the following section (frames 25–26 – see Fig. 4.1.18, right screenshot).

When making edits to the pose spacing and timing, validate the pose intervals from a ¾ top view of the character while also scrubbing the Time Slider and periodically playing back the full animation.

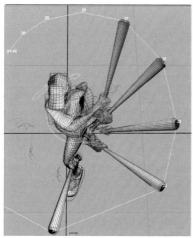 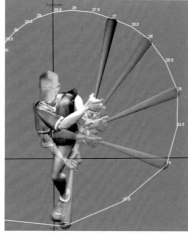

FIG 4.1.18 Modifying posing and spacing intervals, frames 23–27 (Pre-edit (Left screen)).

As with the Ease In animation, the arc and spacing edits should be validated from a few different angles in the Perspective Viewport – the posing on the wrist and bat may need to be edited slightly to keep the curve of the Motion Trail fluid and natural looking (see **Fig. 4.1.19**).

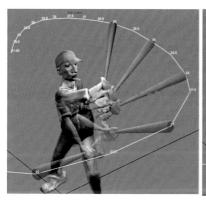 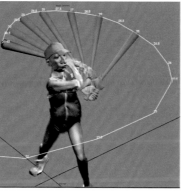

FIG 4.1.19 Validating and finalizing the arc and overall spacing on the swing.

The scene file with the edited timing and spacing for the swing Ease Out is included with the project scene files as –
4.1_04_EaseInOut_CurveEdit03_OUT.ma.

Post Ease Out (Lead Out) & Moving Hold

For the end of the animation, you'll remember from the start of the tutorial we added 15 frames at the end of the swing animation (frames 30–45). Currently, this section is static without any keys set, with the additional frames used as a visual guide for the additional lead out. For this section, we can add a few additional frames of Ease Out as well as a slight moving hold to the animation to finish off the sequence.

- Scrub the Time Slider to frame 33 (two frames after the last key at frame 31 on the swing (see **Fig. 4.1.20**, left screenshot)).
- Select the left wrist control object – BBALL02_RIG_BASE_FSP_Hand_L_CTRL.
- Rotate the wrist downwards slightly around the local X-axis to extend the follow-through and Ease Out (see Fig. 4.1.20, middle screenshot).
- Set rotation key with the Shift + E shortcut.
- This adds an additional couple of frames of Ease Out to the animation, as the bat rests to a settled pose over the shoulders (see Fig. 4.1.20, middle and right screenshots).

FIG 4.1.20 Additional ease out rest pose – Frames 31–33.

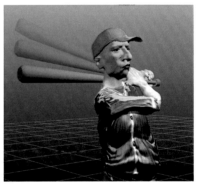

For the end of the sequence, we can use a couple of "Moving Hold" poses. A "Moving Hold" is an animation where there is no significant difference between the poses at the key intervals.

It is typically used where you'll want to reduce the movement in the animation to provide contrast to the preceding action.

A "Moving Hold" can be a slight shift in weight or poise on the character and is often used in animation to create a character idle, where the character is at rest but still appears "alive."

For a Moving Hold, the motion should be reduced, for our example, we can move the body very slightly through adding additional keys for the hip

translation as well as rotation on the head. This can suggest that the character is regaining balance at the end of the animation or moving to relaxed state.

The final sequence provided with the project scene files has the Moving Hold poses keyed at frames 33, 36, 40, and 45. It's a matter of preference how these poses would be keyed or the amount of movement between the transitions.

- From the Project Files, open the scene file with the additional lead out and Moving Hold poses to review the edits –
 4.1_05_EaseInOut_CurveEdit04_OUT_MOVEHOLD.ma.
 - At frame 33 (see Fig. 4.1.21, left screenshot), the head control object is rotated downwards slightly, as the batter acknowledges the ball strike (BBALL02_RIG_BASE_FSP_Head_CTRL). The hips are also lowered very slightly as the body rests (BBALL02_RIG_BASE_FSP_COG_CTRL).
 - At frame 36 (see Fig. 4.1.21, middle screenshot), the body rises slightly, as the hips rise. The head also rotates upwards very very slightly, as the body tenses.
 - At frame 40–45 (see Fig. 4.1.21, right screenshot), the wrist rotates back round very slightly, in the opposite direction it came from initially; this suggests that the character is relaxing toward idle and possibly dropping the bat across the shoulder to get ready for the next swing.

When keying "Moving Hold" poses, it is important to be aware of the transitions and spacing. If the spacing is too broad, it will suggest another action.

For example, the hips translation in the example is very slight and suggests minimal movement on the hold while still indicating that the character is alive (see Fig. 4.1.21, bottom screenshot – Graph Editor, Translate Y).

The slight rotation on the head between frames 31 and 45 suggests a slight nod or acknowledgement from the batter and creates an illusion of life in the character while not being so overt that the character looks like a nodding dog.

FIG 4.1.21 Moving hold – Frame 33/Frame 36 and transition between frames 40 and 45.

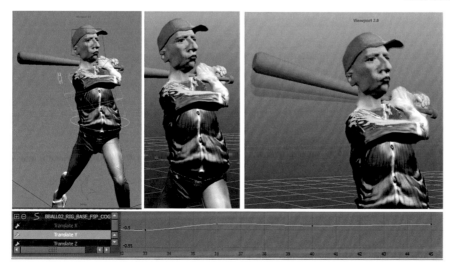

Chapter 4.2 – Ease In & Ease Out – Head Turn

Rig Setup

- From the project files, open the start file for the tutorial – **4.2_00_Head_Rig.ma**.

The scene file includes a character head mesh and rig.

The mesh is skinned to a couple of joints for the neck and head (see Fig. 4.2.1, first screen from left). The joints deform the mesh and should be hidden from either the Display Layer or Panel – Show > Joints (see Fig. 4.2.1, second and third screen from left).

For posing the neck and head, the red and yellow wire-shaped control objects (Cntrl_Head/Cntrl_Neck) are used, as these constrain the joint rotation (see Fig. 4.2.1, fourth screen from left). The joints can therefore be hidden from view, as the animation controls are used for manipulation while animating.

Additional controls for posing the facial shapes are also included, though hidden from view for ease of selection while working (see Fig. 4.2.1, fifth screen from left).

Note

We will be working with the facial animation controls in later chapters, in this section; we will be focusing solely on animating the main neck and head posing with the Neck and Head controls.

FIG 4.2.1 Head rig setup.

- With the scene file Open, go to Window > Settings/Preference > Preferences.
- From the Preferences Window, set the following:
 - Settings > Animation > Tangents > Weighted Tangents = off (see Fig. 4.2.2, top screenshot).
 - Settings > Animation > Tangents > Default in tangents = Linear/ Default out tangents = Linear (see Fig. 4.2.2, top screenshot).
 - Settings > Time Slider > Playback start = 1.00/Playback End = 30.00 (see Fig. 4.2.2, lower screenshot).

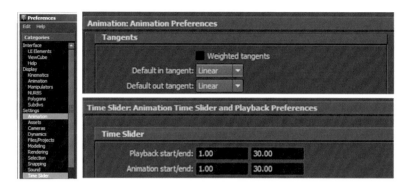

FIG 4.2.2 Preferences – Tangents and playback range.

Head Turn Animation – Blocking

- Select the neck control object (Cntrl_Neck).
- Scrub the Time Slider to frame 1 and, with the Rotate Tool (E), rotate the neck around slightly in the negative–Y-axis. The value in the Channel Box (Ctrl + A) should be around Rotate Y = −27.0 (see Fig. 4.2.3, left screen). Right-click on the Rotate Y channel and choose Key Selected.
- Still at frame 1, select the head control object (Cntrl_Head) and with the Rotate Tool (E) rotate the head around slightly in the negative Y-axis, so that it rotates round slightly further than the neck. To around Rotate Y = −25.0 (see Fig. 4.2.3, middle screen). Right-click on the Rotate Y channel and choose Key Selected.
- Scrub the Time Slider to frame 30 and rotate both the neck and head control objects around the same amount in the opposite direction (Rotate Y+). As before, the head should be rotated slightly further than the neck control. The head should be posed as if looking to the character's left side. After posing each control, right-click on the Rotate Y channel and choose Key Selected (see Fig. 4.2.3, right screen).

FIG 4.2.3 Head turn – Pose blocking.

181

- With only the Neck Control object selected, open the Graph Editor window (from Window > Animation Editors > Graph Editor).
- If you look at the Rotate Y graph for both the head and neck control objects, you'll see that the graph is a straight line between both keys (see Fig. 4.2.4). This is because weighted tangents were turned off from the preferences (see Fig. 4.2.2). The straight line graph shows that the object rotates at constant speed as time progresses.

FIG 4.2.4 Graph editor – Rotate Y channel – Constant acceleration.

- Hit the Alt + V shortcut to playback the animation.

FIG 4.2.5 Validating spacing/timing on playback – Constant speed on head turn.

The animation appears robotic and unattural. The timing & spacing on the head and neck is constant throughout the animation, with the head turning by the same amount between each frame (see Fig. 4.2.5).

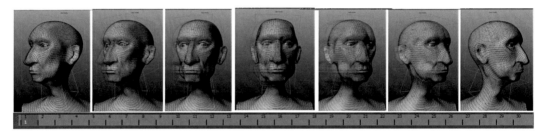

The scene file with the head turn blocked in with linear timing is included with the project scene files as – **4.2_01_Head_Turn_Linear.ma**.

Adding In-between Key – Linear Ease In

- Scrub the Time Slider to around frame 10.
- Select the Neck Control object (Cntrl_Neck) and from the Graph Editor enable the Add Keys Tool (from icon at the top left of the Graph Editor Window – see Fig. 4.2.6, top left screen).
- Select the curve with the Select Tool (Q) and with the Add Keys Tool, click the middle-mouse button with the mouse pointer on frame 10.
- Select the new key at frame 10, and with the Move tool active (W), hold down the shift key on the keyboard and drag the key downwards.

Tip

Holding the shift key while moving key in the Graph Editor allows you to constrain the key movement to the vertical (up/down = key value) or the horizontal direction (left/right = key time).

FIG 4.2.6 In-between key – Linear ease in.

Tip

With the key selected, the value can also be set from the numeric input field boxes at the top where it says "Stats" (see Fig. 4.2.6, lower left screen).

Repeat the above steps to add a linear Ease In key for the head animation at frame 10 (similar key for rotation Y).

On playback (Alt + V) – The animation has been slowed at the start of the animation. The in-between key at frame 10 has lower value than previously, which means that the neck and head are now rotating less between frames 0 and 10. As the angle of the graph line between frames 10 and 30 is sharper, it shows that the objects are rotating more in this range.

Note

The motion is still mechanical looking as the curve is still using the linear in & out key tangency.

The scene file with in-between key added to create linear or flat Ease In to the head turn is included with the project scene files as – **4.2_02_Head_EaseIn_Linear.ma**.

Smooth Ease In – Weighted Tangency

- Re-open the previous scene file without the in-between key added for ease in – **4.2_01_Head_Turn_Linear.ma**.
- From Perspective View, select the Head control object (Cntrl_Head), and then with the Shift key depressed, select the Neck control object (Cntrl_Neck) to add to the selection.

Note

Both objects should be highlighted in green in the viewport.

- Open the Graph Editor from Window > Animation Editors > Graph Editor.

Note

Both objects should be listed in the left pane of the Graph Editor window to show that they're selected. Both of the Rotate Y curves should be shown in the right pane of the Graph Editor.

- From the Graph Editor, go to the Curves menu at the top and choose Curves > Weighted Tangents (see Fig. 4.2.7, left screen).
- From the Graph Editor, go to the Keys menu at the top and choose: Keys > Free Tangent Weight (see Fig. 4.2.7, top right screen).

Note

The free tangent weight shortcut button along the top can also be used (see Fig. 4.2.7, lower right screen).

FIG 4.2.7 Setting the curves to use weighted tangents and enabling free tangent weight.

Note

As no keys have been selected on either curve, both these options have been applied to all keys on the curve. Weighted Tangents needs to be enabled on the curve to use free tangents.

- From the right-pane of the Graph Editor, select the keys at the start frame (frame 1) with Q shortcut:

Note

The key can be selected for Rotate Y channel for both objects if both objects are selected; otherwise, select each object in turn and repeat the following steps.

- With the key selected, the curve will be highlighted in white and the yellow key tangency handle will also be displayed (see Fig. 4.2.8, left screen).

As Weighted Tangency and Free Tangent Weight is enabled, the angle and influence of the key tangent handle can be modified to change the shape of the curve.

- Select the yellow key tangency handle at the right of the key and with the move tool (W) active, pull the tangent handle down, so that it is flat.
- With the yellow key tangency handle still selected, pull the tangent handle to the right to increase the weighting (or influence) (see Fig. 4.2.8, right screen).

Changing the angle of the tangency flattens out the curve at the start, creating automatic "Ease In" to the animation. The Rotate Y values for both the neck and head control objcets increase more gradually as the frames progress.

Increasing the weighting on the tangency handle pronounces the effect of the tangent influence, enhancing the "Ease In."

FIG 4.2.8 Modifying key tangency and weight – "Ease-in."

- With both objects still selected and Graph Editor open, select the last keyframe (Frame 30).
- Select the tangent handle to the left of the key and pull the handle downwards, so that the curve shape changes to a more diagonal 45° toward the end (see Fig. 4.2.9, right screen).

Changing the tangent angle at the end changes the curve shape, so that there is no longer an "Ease Out" at the end of the animation. The angle is similar to the previous unedited curve at the end with the animation changed, so that the speed of the motion is roughly constant at the end. This creates a "fast out" to the head turn.

FIG 4.2.9 Modifying key tangency and weight – "Fast out."

- From the Perspective Panel's View menu, select the following View > Bookmarks > L_SIDE_3_4 (see Fig. 4.2.10).

FIG 4.2.10 Camera bookmarks – ¾ side view.

Note

Setup for Camera Bookmarks was covered in Chapter 1.3. For this animation, the L_SIDE_3_4 bookmark is used as the main camera view to animate to.

- Playback the edited animation from the L_SIDE_3_4 camera bookmark (Alt + V shortcut).

The camera bookmark views the head from the character's left side. In the edited animation, the head starts looking to the character's right side (see Fig. 4.2.11).

The motion at the start is very gradual with a slow "Ease In" due to the edits made to the key tangency. The head turns very gradually at start and then turns around more quickly near the end of the frame range to face the camera view (Bookmark = L_SIDE_3_4).

FIG 4.2.11 Playback (Bookmark = L_SIDE_3_4) – Validating the "Ease In" on the head turn.

The scene file with smooth Ease In and fast out added to the head turn with the key tangent edits is included with the project scene files as – **4.2_03_Head_Turn_EaseIn_FastOut_Tangent.ma**.

Smooth Ease In Pt. 2 – Double Take on Turn

- Reopen the scene file with the linear Ease In set with Linear key – **4.2_02_Head_EaseIn_Linear.ma**.
- Select both control objects (Ctrl_Neck/Ctrl_Head) and open the Graph Editor window.
- Select the key at frame 10 for both objects and hit the "Flat Tangents" shortcut button from the top row of the Graph Editor (see Fig. 4.2.12, bottom screenshot).

Note

The Key tangent type can also be set from the "Tangents" menu in the Graph Editor.

FIG 4.2.12 Setting flat tangent for key (Frame 10).

Setting flat tangency for the key sets the tangent handles flat. The start of the animation (frames 00–10) has a fairly constant acceleration, while the second part (frames 10–30) now has a slower Ease In on the turn.

- Open the Animation Preferences from the shortcut at the bottom right of the interface or from:
 - Window > Settings/Preferences > Preferences > Settings > Animation (see Fig. 4.2.13, left screenshot).
- From the Animation Preferences > Tangents section, set the following (see Fig. 4.2.13, right screenshot):
 - Default in tangent = Clamped.
 - Default out tangent = Clamped.
 - Weighted tangents = off.

Note

The defaults set from here control which tangency type is used only for newly created keys. The tangency type can still be modified from the Graph Editor later. Some animators may prefer to use Linear Tangency when blocking animation (as it was set previously in the tutorial) and then control tangency on a key by key basis when making edits. Using non-weighted tangency for new keys will mean that the tangent handle length or weight cannot be modified for the new key, unless it is explicitly enabled (see Fig. 4.2.7, lower right screen).

FIG 4.2.13 Setting default tangency.

- Scrub the Time Slider to frame 15 to set additional in-between key (see Fig. 4.2.14, left).
- Select each of the control objecst in turn and rotate back around slightly in the local Y-axis then set key. Values should be around – Ctrl_Neck – Rotate Y = −24 // Ctrl_Head – Rotate Y = −27.

FIG 4.2.14 Setting additional rotate Y key (Frame 15) double-take.

The head and neck should rotate back round between frames 10 and 15 (see Fig. 4.2.14, right). The animation should now look as if the character is doing a "double-take" reaction in response to something that is going on. It looks as if the character has heard something (frames 00–10) and then turns back before turning fully round to respond and face the camera.

If we look at the Graph Editor with the new key added, we can see that the key tangency for the new key is "Clamped"; this is due to the default we set in the Preferences. Clamped tangency sets the tangency, so that the tangency handles are "clamped" and will automatically follow the angle of the curve.

The scene file with the additional in-between key set for the double-take is included with the project scene files as – **4.2_04_Head_EaseIn_Double Take.ma**.

Softening the Ease In – Additional Edits

If you playback the animation so far (**4.2_04_Head_EaseIn_Double Take.ma**), the motion still looks fairly robotic. This is because only single channel (Rotate Y) has been animated on the head turn. Often when blocking in animation, it can be a good idea to work on isolated areas or single animation channels before refining the effect. For our head turn animation, additional rotation in the other two channels (Rotate X/Z) will help soften the Ease In on the head turn and make the motion look more fluid and natural.

- Work from the previous scene file (**4.2_04_Head_EaseIn_Double Take.ma**) making edits at the following frames:
 - Frame 1 – Head and Neck rotated slightly further around in the local Z-axis, and rotation keyed (Shift + E), so that the head tilts slightly to the character's left side (see Fig. 4.2.15, second screen from left).
 - Frame 1 – Head and Neck rotated slightly further downwards in the local X-axis and rotation keyed (Shift + E), so that the head tilts slightly downwards toward the character's chest (see Fig. 4.2.15, second screen from left).

At Frame 10, the head and neck will still be tilted slightly downwards (due to the key edit on Rotate X at frame 1 – see Fig. 4.2.15, third screen from left).

- At frame 10, rotate the neck and head back up slightly in the local X-axis and set key. In addition, rotate both controls back around slightly in the local Z-axis, so that the head looks less tilted to the side (see Fig. 4.2.15, fourth screen from left).

FIG **4.2.15** Key edits – Frames 1 and 10.

- Frame 15 – Make similar minor edits to the Rotate X and Rotate Z channels for both control objects, with the head and neck straightening up more (see Fig. 4.2.16, second screen from left).
- Frame 30 – Make more obvious edit to the neck and head's rotation in the local X and the local Y-axes; the neck should be craned forwards and the head should be raised at this frame, so that the character looks more engaged or poised at the end of the head turn (see Fig. 4.2.16, fourth screen from left).

FIG 4.2.16 Key edits – Frames 15 and 30.

- Open the edited animation from the proejct scene files – **4.2_05_Head_EaseIn_Double Take_Refined.ma** – and playback the animation (Alt + V) from the L_SIDE_3_4 camera bookmark.

The animation looks a lot more natural and fluid because of the minor offsets made in the other rotation channels (Rotate X and Rotate Z).

From the camera bookmark angle, the head is naturally tilted away and slightly downward at the start of the Ease In phase of the animation. As the head reacts and does double-take around frame 15, the head tilts upwards (Rotate X), as it turns (see Fig. 4.2.17).

FIG 4.2.17 Validating the edits – Ease in (Frames 1–15).

On the main phase of the animation, when the head turns fully round (frames 15–30), there is a more obvious craning extension on the neck because of the Rotate X edits and, although the head straightens more, it is still slightly off axis (in Rotate Z), which looks natural (see Fig. 4.2.18).

189

FIG 4.2.18 Validating the edits –
Head turn (Frames 15–30).

Re-Timing the Motion – Fast Turn

If you playback the animation (from the project file –
4.2_05_Head_EaseIn_Double Take_Refined.ma), the animation still looks
fairly soft. Although the Ease In now looks fairly refined and natural (frames
1–15), the actual head turn, from frames 15–30 looks a bit too slow. The
spacing intervals between the ease-in and action should have more contrast
to grab the viewer's attention. Both the Ease In (Frames 1–15) and head turn
(Frames 15–30) are 15 frames.

Halving the head turn length will create contrast with the Ease In and make
the animation snappier:

- With the scene file open (**4.2_05_Head_EaseIn_Double Take_Refined.ma**),
 select both control objects (Ctrl_Neck/Ctrl_Head) and open the Dope Sheet
 editor (from Window > Animation Editors > Dope Sheet).
- Select the keys for both control objects at frame 30 (see **Fig. 4.2.19**, top
 screenshot).
- With the keys selected and highlighted yellow, enable the Move Tool (W)
 and, with the middle mouse-button depressed, drag the keys back in time,
 to frame 22 (see Fig. 4.2.19, lower screenshot).
- Playback the animation (Alt + V) – the motion should look a lot snappier.

FIG 4.2.19 Dope Sheet – Re-timing
the motion.

The scene file with the motion retimed to be snappier on the head
turn is included with the project scene files as –
4.2_06_Head_EaseIn_Re-Time_FastTurn.ma.

Ease Out on Head Turn

The animation currently stops at frame 22, with the playback range running on a
few frames to frame 30 (on – **4.2_06_Head_EaseIn_Re-Time_FastTurn.ma** – see

Fig. 4.2.20, top screenshot). The frame range can be extended and a similar workflow to what we used for the Ease In is used to add an extended Ease Out to the sequence.

- With the scene file open – **4.2_06_Head_EaseIn_Re-Time_FastTurn.ma** – set the "end time of the playback range" from the numeric imput field at the right of the Range Slider to 45.00 (see Fig. 4.2.20, lower screenshot).

FIG 4.2.20 Extending animation range.

- At frame 28, select each of the control objects in turn and extend the rotation in the Y-axis, so that the neck and head follow through slightly on the turn (see Fig. 4.2.21, right screenshot). The rotation should not be that far as the expected result is a soft Ease Out at this range.

FIG 4.2.21 Extending head and neck rotation to add slight follow through on turn.

Note

The key at frame 22 that was previously the end key of the animation will have broken tangent handles (as the initial key was set with Linear Tangency). Select both keys and hit the "Flat Tangents" shortcut button in the Graph Editor to unify the tangency handles and flatten.

Check the shape of both Rotate Y curves from the Graph Editor – make any necessary edits to the keys and tangency, so that there is a smooth Ease Out (see Fig. 4.2.22).

The head rotation in the local Y-axis may need to extend slightly further than the neck so the motion looks natural (see Fig. 4.2.22, top screen). Additional in-between key at frame 33 may be required to ease out the motion further (see Fig. 4.2.22).

FIG 4.2.22 Ease-out – Rotate Y channel.

For the Rotate X and Rotate Z channels, keys should be set similarly to soften or ease out the turn for the neck and head (see Fig. 4.2.23).

FIG 4.2.23 Ease-out – Rotate X and Rotate Z channels.

Key should also be set at the very end of the animation (frame 45) with the values on the Rotate channels for this key being set with a small incremental change from the last key that was set around frame 33.

Making small adjustments on incremental keys adds light spacing to the animation and is useful for adding "Moving Hold" to the animation. In the case of the head turn, this provides contrast with the fast head turn and ease out and helps to dampen the animation, though still keeping the motion lifelike.

The scene file with the the Ease Out and light damping added to the head turn is included with the project scene files as – **4.2_07_Head_EaseIn_FastTurn_EaseOut.ma**.

Staging – Framing the Action and Setting the Mood

"Staging is the most general principles because it covers so many areas and goes back so far in the theatre … it is the presentation of any idea so that it is completely and unmistakably clear"

The Illusion of Life, Disney Animation – Frank Thomas and Ollie Johnston

Staging is a key principle to understand when working in 3D animation. In traditional animation, the artist is working to the limitation of a 2D plane when drawing and framing the motion. In 3D, we are not restricted to this limitation. This can create additional problems in framing action that is viewable from all angles and in working on key areas of a shot.

The principles of strong staging which we'll cover in this chapter can be applied at all stages in production using the following tools and methodologies.

Storyboarding

Storyboarding is commonly used in pre-production, both in traditional film animation and in 3D animation. Creating strong storyboards that

clearly outline what the major shots will be in a sequence can help in both understanding the work that will be required and making creative decisions for each shot (see Fig. 5.0.1).

FIG 5.0.1 Staging – storyboard layout.

Animatics

Animatics are commonly used in 3D animation in layout for a sequence. They are normally setup with basic models without final lighting and shading. They can be considered as a bridge between a traditional storyboard and final animation (see Fig. 5.0.2). As they are constructed in 3D, they provide advantages in pre-visualizing placement and timing of elements in the scene relative to the camera.

FIG 5.0.2 Staging – animatics (bridge between storyboard and final render).

Framing the Action

In addition to utilizing storyboarding and animatic tools to pre-visualize camera framing and action, we must also consider the readability of individual actions in a particular shot. For example, if the shot is mainly focused on dialog, would a close-up or long shot of the characters be more appropriate? Conversely, if the shot is focused on showing a large VFX explosion, would it be appropriate to frame in on a small part of the environment or specific action? (see Fig. 5.0.3).

FIG 5.0.3 Staging – VFX shot, framing action, and scaffolding collapse.

Thumb-Nailing

Thumb-nails are an ideal tool to work out individual action or shots and can be considered as an extension of the animators thought process as ideas are developed and refined. They are used throughout this book in planning

out individual poses and body motion for the character animation tutorials (see FIG. 5.0.4).

FIG 5.0.4 Staging – thumb-nailing for character animation.

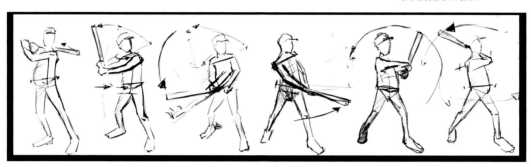

When planning out staging for animation, it is also important to consider the readability of the action from the main camera view you'll use for final render. For example, for the baseball sequences we cover, the animation is primarily worked on from the side view – the posing for the batter character is clearly readable from the side – flowing from left to right with the action line of the bat a strong diagonal (see Fig. 5.0.5). Knowing early on what framing or staging you are working to is critical as it also determines which parts of the animation you need to refine based on the angle the viewer's watching the motion from.

FIG 5.0.5 Staging – animating to the main camera view.

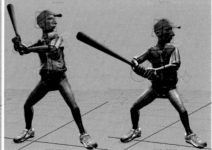

Chapter 5.1 Thumb-Nails and Storyboards

Thumb-nails and storyboards are used widely within production. As a tool, they have their origin in traditional animation and film practice. Their usage allows effective planning for motion and camera framing in a shot or scene, and they can be applied at all phases of production including pre-production, shot layout, camera framing, motion planning, editing, shot revision, and motion editing.

Thumb-Nails

Thumb-nails are quick and simple sketches, which help to establish or layout the motion in a shot. The definition of a thumb-nail sketch is a small (thumb-nail sized) sketch of the motion or framing. You can use traditional media such as pen and paper when creating thumb-nails or alternatively use a graphics tablet on the computer. Using a graphics tablet has the advantage that you can also quickly make revisions to animation through using screenshots or renders of the animation with the action re-drawn as an overlaid layer in painting package.

Let's take a look at a couple of different areas you can apply thumb-nails when animating.

Overall Motion Planning

Thumb-nails can be used to block in animation from Pose-To-Pose in sequence. For example, for the jump animation and run-cycle covered in this book in Chapters 8 and 11, thumb-nails were used to pre-visualize the overall posing and motion.

For the jump animation covered in Chapter 11, the thumb-nails were used to establish both the overall distance of the jump over the sequence (see Fig. 5.1.1, right) as well as specific posing, weighting, and balance at the end of the sequence (see Fig. 5.1.1, left).

FIG 5.1.1 Thumb-nails – jump sequence.

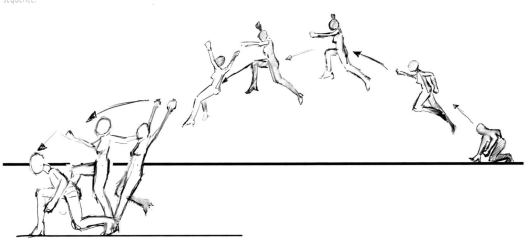

For the run-cycle covered in Chapter 8, thumb-nails were used at a couple of different phases. In the pre-production phase, thumb-nails were used to figure out the basic posing for the character from single side-on view (see Fig. 5.1.2). This helped to establish the overall weight shifts as the character moves from pose-to-pose and was used as reference when animating the key poses in Maya.

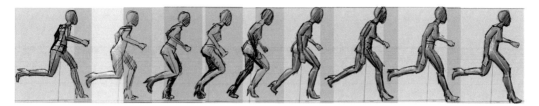

FIG 5.1.2 Thumb-nails – run cycle.

When working on rough thumb-nail sketches to establish overall motion, the sketches can be pretty rough as detail is not required. Simple block figures or "Stick-man" style drawings can be sufficient when blocking out character animation with thumb-nails.

Character Posing – Rig Balance and Weight

Thumb-nails can also be used during the editing and refinement phase of animation. Where more detail is required, they can be used to figure out the pose at a particular frame. Figuring out the line and angle of the shoulders and hips for character animation is critical in planning out poses that look weighted and balanced. Shifts in the shoulders and hips need to correspond with the major weight shifts on the foot plants. For example, for the run-cycle, they were used to figure out the pose and rotations on the character's spine, hips, and shoulders during the major contact poses when the legs and arms are fully extended (see Fig. 5.1.3).

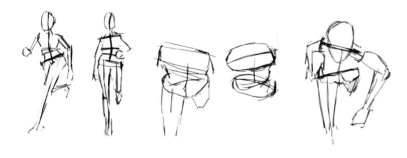

FIG 5.1.3 Thumb-nails – run–cycle – establishing weight/pose.

Overall, thumb-nails should be considered as an extension of your thought processes and are really just a tool to help figure out what work needs to be done or revisions made.

Reference for Animation

When working in 3D, it is important to have a game plan when working out the character pose or shot. For character animation, you can use thumb-nails as reference, to block out and validate the posing as well as to make revisions while animating. This can be really useful when working on the posing of major areas such as the angle or curvature of the spine as well as the rotation of the torso and hips during a run (see Fig. 5.1.4).

197

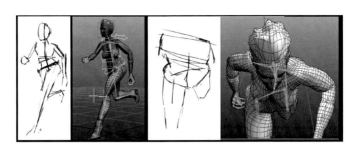

FIG 5.1.4 Thumb-nails – run cycle – spine curve and torso offset. Side and top views.

Roughing out some quick thumb-nails while animating can also be a great aid when you're stuck on the posing for a particular shot or need to make revisions. You can quickly make comparisons and revisions when evaluating the animation in 3D while sketching out the major changes to the pose for the character and rig. For detailed refinement, it can be worth appraising the posing and thumb-nails from several angles to make sure the poses look balanced and poised (see **Figs 5.1.4** and 5.1.5).

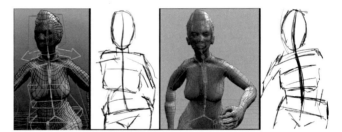

FIG 5.1.5 Thumb-nails – run-cycle – spine curve and torso offset. Front view.

Life-Drawing and Study – Figure and Form

For character animation, it is worth in considering life-drawing classes to study human anatomy and form in more detail. Most life-drawing classes include a warm up section, where you work on a series of shorter sketches. This can really help in sharpening up your drawing and observational skills when it comes to animating (see **Figs 5.1.6** and 5.1.7).

It can also improve your skills when it comes to quickly blocking in a character pose, whether it is as a quick thumb-nail without reference or in 3D in Maya on a complex character control rig.

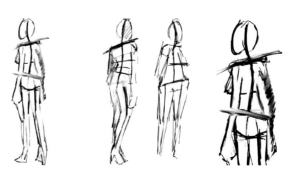

FIG 5.1.6 Life-drawing – quick studies 1.

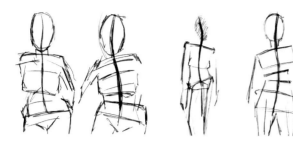

FIG 5.1.7 Life-drawing – quick studies 2.

Video and Photo Reference for Thumb-Nails

When animating, it is important to have as many tools or aids at your disposal as possible to help in analyzing and refining the motion. This is especially true if you are new to animation and particularly true if you are new to computer animation.

When working in 3D animation, it is easy to create animation quickly due to the tools that are available – you can quickly block in a shot and let the computer handle the key interpolation between frames. This isn't the case with traditional Cell Animation, where animators are required to draw each individual frame in sequence. Due to this, it can be easy to forget the traditional skills of thumb-nailing and draughtsmanship when animating in 3D. Sometimes 3D animators feel that they should be able to get quicker results that are more final without the additional prework traditional animators would need to do in planning a shot or motion through thumb-nails.

In addition to using thumb-nails and reference from life-drawing for character animation, it is also worth using Video or Photo Reference in conjunction with thumb-nails to block out major poses for character motion.

Video or photo reference is ideal when working on physical or extreme motion such as animations of characters performing fast actions or sports. For several of the exercises in the book, such as the baseball sequences, video and photo references were used to help in blocking out thumb-nails. This helps in understanding the major poses and contortions of the body, which can be pretty extreme when the motion is fast (see Fig. 5.1.8).

When animating, you need to have a clear understanding of the overall *mood* and *feel* of the motion you're working on. Having great reference and thumb-nails for extreme motion is critical in allowing you to *feel out* where the major shifts in weight and balance are.

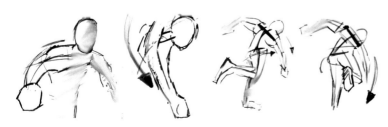

FIG 5.1.8 Video and photo reference in conjunction with thumb-nails – extreme motion.

199

Thumb-nails – Cartooning, Character Detail, and Self Portraits

In addition to the use of thumb-nails as a tool to study extreme or exaggerated body motion, you can also use sketching or cartooning to study more nuanced or detailed areas of human motion. For example, if you're working on secondary motion for hands on a character or want to add more nuance to the performance take a look at the types of poses your own hands can make (see **Fig. 5.1.9**). Quick thumb-nails or cartoons showing the poses can help in the planning and refinement phase for the animation.

FIG 5.1.9 Cartooning – hand poses for animation.

As with other areas of character animation, it's really worthwhile to act out the motion yourself to get a feel for how the body moves and range of motion you can create. Many animators like working with a full-length mirror close by, so that they can perform full-body motion and use this as a mental note for reference when animating the character in 3D space.

For facial animation, a lot of animators recommend to have a mirror beside the monitor to compare the range of facial poses to real life while animating. Studying the facial poses from a mirror can also be used in conjunction with thumb-nailing and cartooning to create a reference sheet for the range of poses you want for the character (see **Fig. 5.1.10**).

FIG 5.1.10 Cartooning – facial poses – full face (see Fig. 5.1.9).

As with full-body motion, cartooning or thumb-nailing can be used to work out specific shapes for facial animation for detailed areas such as the eyes, eyebrows, and cheeks (see **Fig. 5.1.11**).

This really helps when you're working out the range of motion the character will need when creating and refining blend shapes for facial animation. As mentioned before, having a game plan for what you want to achieve at each stage of the work helps clarify what you're doing and the direction the work's headed. For example, will the character's personality demand that he is quizzical, surprised, shocked, or angry? – can acting out these poses in front of the mirror and creating reference thumb-nails help?

FIG 5.1.11 Cartooning – facial poses – detail, eyes.

Skeleton and Rig Design

Another area of production that thumb-nails can be used on that a lot of people overlook is in planning and creating a character skeleton or control rig. In fact, thumb-nails can be used for any rig design or control setup to plan out which controls are needed and where they should be placed for ease of animation.

For a skeleton rig, it is really important to be aware of where the skeleton joints should be created for the character to follow the proportions and form of the character model. Skeletons that are badly placed or misaligned can create bad deformations on the character when animating.

For this, you can use thumb-nailing to draw over a print or screenshot of the character model viewed from several different angles in Maya. Photoshop or any other modern digital painting application allows drawing on layers. You can use this to block out the joint placement relative to the proportions on the character then use this as reference when creating the skeleton rig in Maya (see Fig. 5.1.12).

FIG 5.1.12 Thumb-nailing skeleton proportions and joint placement.

Similar workflow can be used to design effective control rig objects for character rigs. For example, you can quickly thumb-nail out where the control rigs should be placed for the character for logical ease of selection and manipulation (see Fig. 5.1.13).

As with thumb-nailing for animation, you can use this when working on detail areas for the skeleton and rig to figure out how you want the setup to look and work.

201

As mentioned before, the thumb-nailing process should be considered as a visual mental note to help in planning and revision. Time spent working out how you want the rig to look and work will lead to a more effective setup and less time spent making revisions when it comes to actually creating the rig and control object setup in Maya.

FIG 5.1.13 Thumb-nailing control objects and finger joint placement.

Storyboarding

Storyboards could be considered as an extension of thumb-nails. With storyboards, you can use similar processes to work out shot and action for your animation as you would with thumb-nails.

You'd normally use storyboarding, specifically, where you are working on a longer sequence such as a shot or sequence from a feature or a cinematic from a video game. Storyboards are normally laid out similarly to a comic strip and show the summarized action and camera framing in sequential frames (see **Fig. 5.1.14**).

FIG 5.1.14 Storyboard layout – F16 fighter sequence – intro sequence.

When working on storyboards, it's useful to work from a template that has common frame sizes that correspond roughly to the aspect ratio you're going to be working in Maya with. For example, say you're going to be rendering in Maya to a final output of 16 × 9 FullHD resolution (1920 × 1080) For the storyboards, you'd make sure the frame sizes for each shot would be roughly the same so that the camera framing in the storyboards would match what you're going to be setting up in Maya.

For this, you can create a template for the aspect ratio you're working on that can be used throughout for all the storyboards for the project (see **Fig. 5.1.14**). If you are using traditional media, you can make prints or photocopies of the template sheets you can draw on. If using Photoshop or other photo editing software to draw the boards, you can keep a named copy of the template image file that you can use each time.

Storyboards – Shot and Action Notes

When storyboarding, it is useful to add notes to the boards to explain what's going on at each shot. The types of notes that can be useful would include notes on the following:

1. Shot number/camera number – brief description (for example, POV (Point of View) shot/tracking shot/establishing shot).
2. Camera notes (i.e., are FOV/motion blur being used. Are there any changes to focal angle or lens?).
3. Timing notes – how many frames or seconds is the shot?
4. Action notes – which elements are moving in the shot? – is this described through action lines or corresponding text notes or figures?

The notes can be added at the bottom of each panel, if more than one panel is used for a particular shot to show motion and framing, the notes can potentially cover the whole shot (see **Fig. 5.1.15**).

Adding notes on the storyboards makes it easier to communicate what is going on in a particular shot, this is critical if you are working on a team and the storyboards are being passed across to other artists or animators to work on the scene layout.

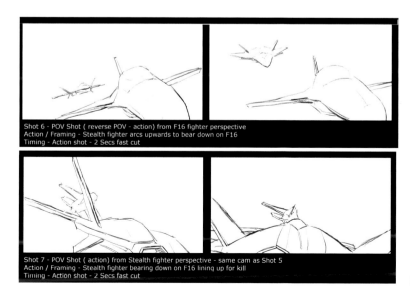

Shot 6 - POV Shot (reverse POV - action) from F16 fighter perspective
Action / Framing - Stealth fighter arcs upwards to bear down on F16
Timing - Action shot - 2 Secs fast cut

Shot 7 - POV Shot (action) from Stealth fighter perspective - same cam as Shot 5
Action / Framing - Stealth fighter bearing down on F16 lining up for kill
Timing - Action shot - 2 Secs fast cut

FIG 5.1.15 Storyboard notes.

Storyboards – Asset and Project Planning

Storyboards that show overall timing and framing for animation can also be a critical aid in managing a project. For example, having a detailed breakdown of how long a particular shot's going to be can help to identify the amount of time it's going to take to animate. Shots that are more complex with multiple elements or effects can then be further broken down when it comes to the asset creation phase of the project or finalization of effects for final render.

The storyboards can be considered as an overall framework for a project and can be used during team presentations to communicate the overall aims of the sequence and breakdown of workload.

Storyboards – Action Lines and Thumb-Nailing

The main purpose of storyboards is to communicate overall camera and action framing for a particular scene or sequence. Where required, the storyboards can be broken down further to communicate more detail where required.

For example, if a particular shot is more complex or it's not really clear what the action is or what needs to be communicated to the viewer, additional thumb-nailing or boards may be required.

As with thumb-nails, action lines can be added to the boards to help convey the action line and motion. Further breakdown frames can be thumb-nailed out at the pre-vis stage to help the animator when it comes to the layout stage or animatic. As with the overall storyboard, these types of breakdowns of the motion through thumb-nails are ideal, where an idea or action needs to be communicated clearly across the team (see Fig. 5.1.16).

FIG 5.1.16 Storyboard breakdown (thumb-nails) – clarifying action.

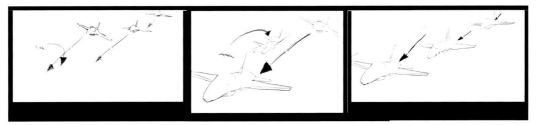

If working in traditional media, layout paper or transparent sheets can be used to rough out the position of elements between frames. Action lines or arrows can be used to show the transitions in the motion for the viewer. For example, is the object moving forward while also rotating from side to side? – adding blur lines around the sketches can help convey this and sell what is trying to be conveyed to the viewer to the other artists working on the project (see Fig. 5.1.17).

Sketching particle effects such as smoke, flames, or camera motion blur can also help convey the mood and tone of the shot and help in planning what effects work is required as well as what types of camera effects or filters will be needed at render time (see Fig. 5.1.17).

FIG 5.1.17 Storyboard breakdown (thumb-nails) – action lines and motion.

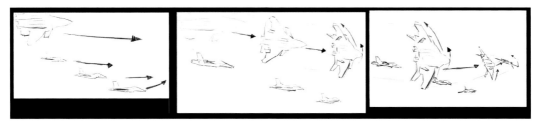

Storyboard and Breakdowns – F16 Fighter Sequence

For the following sections in this chapter and in the online Chapters 5.1 and 5.2, we'll be working on animatic layout as well as taking a look at camera setup and shot sequencing in Maya. For these sections, we'll be working from a storyboard layout that's presented on the next couple of pages for reference.

The storyboard uses some of the tips outlined above as well as some of the methodologies discussed earlier around thumb-nailing. The storyboards and breakdowns are also provided with the project scene files for reference.

F16 Fighter Sequence – Storyboard Sheet 1 – Establishing Action – (See Fig. 5.1.18)

FIG 5.1.18 Storyboard sheet 1 – establishing action.

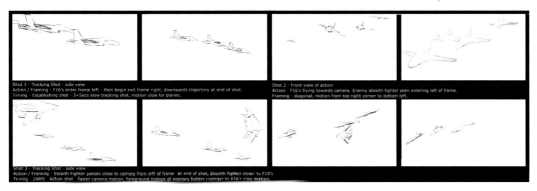

The first storyboard sheet covers the establishing action for the sequence.

- The camera angles in the layout go from standard side-on tracking shot to more dynamic angled shot when the action starts in shot 2.

- The overall timing for the first few shots is slow, giving an Ease In to the action.
- The enemy stealth fighter can be seen entering the frame from shot 2 from behind, the other F16 fighters are not aware and anticipation builds through a series of wide tracking shots in shots 3 and 4, where we see the start of the dogfight as the Stealth fighter darts across the frame.
- At the end of this sheet, two of the F16 fighters have peeled off as the stealth fighter targets the lone leading F16 fighter.

FIG 5.1.19 Storyboard shot 2 – breakdown.

F16 Fighter Sequence Shot 2 – Breakdown— (See Fig. 5.1.19)

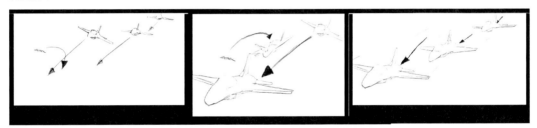

At shot 2, we see the stealth fighter entering quickly from distance in arcing motion to target the lead F16.

FIG 5.1.20 Storyboard shot 3 – breakdown.

F16 Fighter Sequence Shot 3 – Breakdown (See Fig. 5.1.20)

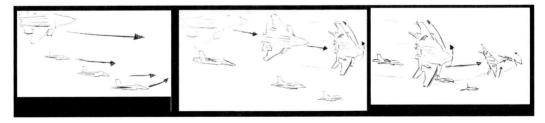

At shot 3, the stealth fighter passes close to the frame twisting round as it chases the F16s. The camera framing starts as a side-on tracking shot clearly showing the action that reads left to right. At the end of the shot, the camera has tracked round slightly to rear of the F16s that are disappearing to horizon point with stealth fighter in pursuit.

F16 Fighter Sequence – Storyboard Sheet 2 – Dogfight Action—(See Fig. 5.1.21)

FIG 5.1.21 Storyboard sheet 2 – dogfight action.

The second storyboard sheet covers the action of the dogfight. The action has moved to 1 × 1 action between the chasing stealth fighter and F16.

- Timing – The other F16s have exited the frame and the shots are close in with quicker cuts to emphasize the action.
- Camera framing – The camera framing used for the main action shots are point of view (POV) shots from the fighter's perspective.
- Movement – The planes are seen tilting and diving during the dogfight with the action culminating in F16 being lined up in the stealth fighter's sights for kill shot.
- Ease out – the last two shots in the sequence show the F16 hurtling toward the ground (shot 8) then the stealth fighter exiting the frame to distance. The timing on the last shot is slower to emphasize lead out in the shot.

F16 Fighter Sequence Shot 7 – Breakdown— (See Fig. 5.1.22)

FIG 5.1.22 Storyboard shot 7 – breakdown.

At shot 7, the camera switches back to POV shot from the stealth fighters perspective. The stealth fighter is positioned above the F16 at this shot, bearing down for kill. The stealth fighter rotates round from right to left to angle itself for kill, with the F16 directly in line of sight.

F16 Fighter Sequence Shot 8 – Breakdown— (See Fig. 5.1.23)

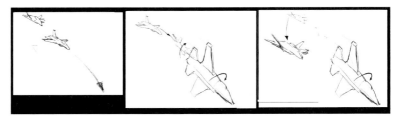

FIG 5.1.23 Storyboard shot 8 – breakdown.

At shot 8, the camera is tracked out to show the motion clearly from side. The F16 has been hit at preceding shot and rotates toward ground spiraling out of control. At the end of the shot, the F16's undercarriage is visible as it passes near the frame of camera. The stealth fighter is seen angling away from the action toward the left of the frame.

Chapter 5.2 Camera – Advanced Settings

In the earlier chapter section, we covered the basic options when working with camera's in Maya (Chapter 5.1, online content). We saw how to work with the different camera types in Maya, including the free camera and camera with aim and how to manipulate the camera's in the scene to frame the action for the animatic appropriately.

We also covered some of the basic settings for the camera's that are accessible from the Attribute Editor in Maya and the different options that are available to switch panel display and framing. In this section, we will take a look at some of the additional controls that are available for camera's in Maya and some of the options that are available for previewing camera effects in Maya with near final render quality (Viewport 2.0).

Areas that we will cover will include the following.

Camera Attributes—(See Fig. 5.2.1, left)

Attributes including camera focal length and depth of field can significantly change the mood or look of the final render and we will cover how to modify these settings from the attribute editor as well as how to preview depth of field through the Viewport 2.0 and offline renderers (mental ray/Maya software):

- Clipping planes
- Focal length/angle of view
- Depth of field (DOF)

FIG 5.2.1 Camera attributes and viewport 2.0

Viewport 2.0 Hardware Rendering (See Fig. 5.2.1, right)

Throughout this chapter section, we'll be working with the additional viewport preview effects implemented in Maya's Viewport 2.0 hardware renderer. Maya's Viewport 2.0 renderer allows real-time preview of many of the effects that you would commonly expect from a final render, greatly improving the speed of workflow for edit and review:

- DOF
- Ambient occlusion/anti-aliasing
- Motion blur
- Hardware rendering (offline) and mental ray/Maya software renderers.

Note

Support for Maya's Viewport 2.0 renderer is dependent on the video card on the system. If your video card does not meet the requirements for Maya's Viewport 2.0 renderer, an error may be displayed on opening the example scenes used in this section.

Clipping Planes

Clipping Planes control what is visible from the camera view in Maya. Objects that are beyond the range of the near or far clip planes may be either not visible or partially clipped.

- Open the start scene for this exercise
 5.2_01_CAM_CLIP_PLANES_00.mb
- Ensure that the current panel is set to display from the camera that's setup, from –
 Panels>perspective>camera1

The scene file includes shot of the three F16 fighters from the animatic we worked on in online Chapter 5.1 (see Fig. 5.2.2, left screenshot).

- From the outliner, expand the "camera1_group" and select "camera1" (see Fig. 5.2.2, top middle screenshot).

209

- Open the attribute editor (Ctrl + A) and, from the "cameraShape1" tab, expand the "Camera Attributes" roll-out to view the Clip Plane settings (see Fig. 5.2.2, bottom middle screenshot).

The scene's camera uses the default clip plane values of

near clip plane = 0.100

far clip plane = 10000.000

The near clip plane value is by default set to a low value (0.100 scene units), this means that everything beyond 0.100 scene units from the camera will be visible. The clipping planes can be imagined as a virtual plane set directly in front of the camera view.

- Modify the Camera's Clipping Plane as follows: near clip plane = 15 (see Fig. 5.2.2, right screenshot).

FIG 5.2.2 Setting near clip plane.

Everything between 0.0 and 15 units from the camera are clipped from view. The nose of the F16 fighter plane seems to be cut off (see Fig. 5.2.2, right screenshot).

Scene file with the near clip plane modified is included with the project scene files as – **5.2_01_CAM_CLIP_PLANES_01.mb**.

Modifying the far clip plane does the opposite; objects beyond the far clip plane will not be visible from the camera view. The scene elements that are visible to the Camera are the objects placed between the near clip plane and far clip plane.

- Open the start scene for this exercise
 5.2_01_CAM_CLIP_PLANES_02.mb

The default setting for far clip plane in the scene is 10000.000 units – all the objects in the distance including the sky objects are visible from the camera view (camera1) (see Fig. 5.2.3, left screenshot).

- From the Outliner, expand the "camera1_group" and select "camera1."
- Open the Attribute Editor (Ctrl + A) and, from the "cameraShape1" tab, expand the "Camera Attributes" roll-out and set the far clip plane as follows:
 - far clip plane = 500

The sky object in the background is no longer visible, as it is beyond the range of the far clip plane (500 units) (see Fig. 5.2.3, middle screenshot) included with the project scene files as – **5.2_01_CAM_CLIP_PLANES_02_02.mb**

- · far clip plane = 75

Along with the sky object in the background no longer being visible as it is beyond the range of the far clip plane (500 units), the back of the F16 at the top right corner of the frame is also clipped (see Fig. 5.2.3, right screenshot). This is because it is placed around 60 to 70 units from the camera view – the back part of the F16 that is more than 75 units from the camera is clipped (as far clip = 75). Included with the project scene files as:

5.2_01_CAM_CLIP_PLANES_02_03.mb

FIG 5.2.3 Setting far clip plane.

The near and far clip planes can be set to extreme values, so that only elements within small range are visible and not clipped from view:

- · From the outliner, expand the "camera1_group" and select "camera1"
- · Open the attribute editor (Ctrl + A) and, from the "cameraShape1" tab, expand the "Camera Attributes" roll-out and set the far clip plane as follows:
 - · far clip plane = 55.000.

All the elements beyond the midpoint on the second F16 from the camera are clipped from view (see Fig. 5.2.4, left screenshot). Included with the project scene files as – **5.2_01_CAM_CLIP_PLANES_02_04.mb**

- · far clip plane = 55
- · near clip plane = 35

The only parts of the scene that are now visible are the elements between 35 units (near clip) and 55 units (Far Clip) from the camera. The tail of the nearest F16 is visible along with the nose of the second F16 from the camera (see Fig. 5.2.4, right screenshot). Included with the project scene files as

5.2_01_CAM_CLIP_PLANES_03.mb

FIG 5.2.4 Setting near/far clip plane to extreme.

Focal Length/Angle of View

The focal length camera attribute in Maya is analogous to angle of lens in real-world cameras. A wide-angle lens equates to a small focal length, whereas a telescopic lens equates to a large focal length. Let's look at modifying the focal length attribute to change the effect

- Open the start scene for this exercise – **04_02_CAM_FOCAL_00.mb**

The scene file includes the same setup as before, the three fighter jets are framed in the camera view using the default settings for clipping plane and focal length.

- From the Outliner, expand the "camera1_group" and select "camera1"
- Open the Attribute Editor (Ctrl + A) and, from the "cameraShape1" tab, expand the "Camera Attributes" roll-out to view the focal length/Angle of View attributes. The default settings are
 - Focal length = 37.000
 - Angle of view = 51.88

This setting for focal length produces a fairly natural camera effect when the camera is placed at mid-distance from the F16s in the scene (see **Fig. 5.2.5**, screenshots 1 and 2 from left).

- From a perspective view, select the camera and with the move tool (W) pull it in closer to the planes, so that it is close to the nose-tip of the closest F16 (see Fig. 5.2.5, third screenshot from left)
- Modify the focal length value as follows:
 - Focal length = 20.000

Note

Both the angle of view and focal length attributes are linked. Reducing the focal length value will increase the angle of view.

- Reducing the focal length widens the lens on the Camera, the angle of view attribute increases to around 84.00 units, so that more can be seen from the extremes of the sides of the camera. More of the scene is visible when the camera is pulled in closer to the objects.

- Similar framing can be achieved with wider angle lens setting when the camera is pulled in close and the lens opened out (see Fig. 5.2.5, fourth screenshot from left).
- Increasing angle of view (or reducing focal length) will also create more exaggerated perspective for the camera. This effect can be pushed too far and can make scene objects look distorted or stretched In the example, the nose-tip of the closest F16 to the camera appears overly elongated (see Fig. 5.2.5, fourth screenshot from left).
- A fish-eye lens type on a real-world camera is equivalent to an extreme low focal length setting in Maya.

Scene file with shot setup with low focal length/wide angle of view is included with the project scene files as

5.2_02_CAM_FOCAL_01.mb

FIG 5.2.5 Setting low focal length = wide angle of view.

If you view the camera object from the Maya perspective or orthographic view, the shape of the camera lens changes when modifying the focal length or angle of view attributes, this gives a visual cue as to how the lens is setup on the camera. Lowering focal length appears to widen the front of the camera lens (see **Fig. 5.2.6**, middle screenshot), whereas increasing focal length stretches the shape of the Camera as if the camera now has a telephoto lens attached (see Fig. 5.2.6, right screenshot).

FIG 5.2.6 Camera icon in perspective view – different focal lengths.

Increasing focal length or reducing angle of view on the camera has the opposite effect to the previous scene file example.

- Open the original start scene for this exercise with the default focal length settings – **5.2_02_CAM_FOCAL_00.mb**

- From a perspective view, select the camera and with the move tool (W) pull it further away from the planes (see Fig. 5.2.7, right screenshot).
- From the outliner, expand the "camera1_group" and select "camera1."
 - Open the attribute editor (Ctrl + A) and, from the "cameraShape1" tab, expand the "Camera Attributes" roll-out to modify the focal length/angle of view attributes to
 - Focal length = 55.000
 - Angle of view = 36.24

This setting for focal length produces a more flattened perspective effect (see Fig. 5.2.7, left screenshot). A narrower angle of view is similar to a zoom lens on real-world camera and would suit a shot like this.

Scene file with shot setup with slightly higher focal length/narrower angle of view is included with the project scene files as

5.2_02_CAM_FOCAL_02.mb

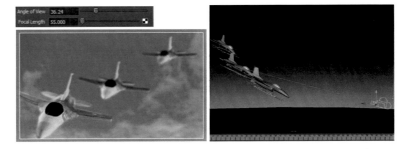

FIG 5.2.7 Increasing focal length = Narrowed angle of view.

The focal length can be increased further to really flatten out the perspective of the camera and create an effect similar to telephoto lens. Test using a high focal length, set to about 120.000 on the scene file setup, the camera will need to be dollied out further (Alt + RMB) to keep similar framing (see Fig. 5.2.8, left screenshot).

Note

Pushing the focal length to really high values can create unnatural looking effects for the camera. An orthographic camera view in Maya is essentially the same as a standard camera with a really high or infinite focal length value – pushing the focal length really highly effectively reduces the appearance of perspective in the camera; objects appeared flattened and will not reduce in scale further from the camera.

Scene file with the focal length pushed to 120.0 on the setup is included with the project scene files as –

5.2_02_CAM_FOCAL_03.mb

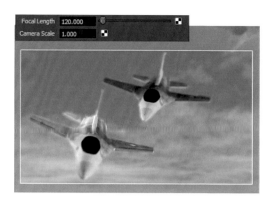

FIG 5.2.8 Ramped up focal length =
very narrow angle of view and flattened
perspective.

DOF

The depth of field (DOF) attribute on Maya cameras also mimics a real-world camera effect. The DOF setting controls what is in focus in the scene based on the focus distance attribute. The attribute is similar to the clipping plane attribute, as it is based on the distance in scene units from the camera object in the scene.

In previous versions of Maya, there was no way to pre-visualize the effect of the DOF attributes without first doing a test render. DOF is not supported in the default Viewport renderer, the high-quality renderer, or Viewport 2.0 in versions of Maya prior to Maya 2012.

From Maya 2012, DOF is supported in Viewport 2.0. This means that the DOF can be adjusted in real-time in the Viewport rather than manually measuring the focus distance from the Viewport, test rendering then making iterative adjustments. Added support for DOF in Viewport 2.0 makes it easy to quickly modify the effect in the Viewport before final renders.

Note

For this section, you will need to install Maya 2012 or newer that supports this feature in Viewport 2.0 to follow along with the tutorials. If you are using older version of Maya, you can still make adjustments to the DOF attributes and validate the effect from off-screen render.

Let's take a look at working with the DOF attribute on our scene setup

- Open the start scene for this exercise – **5.2_03_CAM_DOF_01.mb**

The scene file includes the same setup as before with the camera view set to display the scene elements using the "Default Quality Rendering" mode for the Viewport.

- Set the layout to single panel layout (spacebar toggle) and set the current panel view to show view from "camera1" from
 - Panels > Perspective > camera1 (see Fig. 5.2.9, left screenshot).

215

Note

If the NURBS control objects are displayed (yellow circle/red star shapes), you may want to toggle display of these off from the panel's menu

Show > NURBS Curves

- Go to the renderer menu at the top of the panel and turn on Viewport 2.0 from
 - Renderer > Viewport 2.0 (see Fig. 5.2.9, top middle screenshot)
- From the outliner, expand the "camera1_group" and select "camera1"
- From the attribute editor (Ctrl + A toggle), make sure the "cameraShape1" tab is selected, scroll down to the DOF roll-out, expand the section and turn on- "Depth of Field" (see Fig. 5.2.9, bottom middle screenshot)

With DOF turned on for the Camera using the default settings, all the F16 jets in the shot will appear fuzzy or out of focus (see Fig. 5.2.9, right screenshot).

FIG 5.2.9 Viewport 2.0 – DOF enabled for camera, default settings.

All the scene elements are out of focus because of the following attribute for DOF.

Focus Distance = 5.00 – this setting controls the range in Maya scene units from the Camera that will be in focus. As all the F16 models are more than 5.00 units from the camera, they are blurred or out of focus.

By modifying the DOF attributes, we can control which objects are focused on and how pronounced the effect is:

- From the outliner, expand the "camera1_group" and select "camera1"
- From the attribute editor (Ctrl + A toggle), make sure the "cameraShape1" tab is selected, scroll down to the DOF roll-out, expand the roll-out and set the following (see Fig. 5.2.10, top left screenshot):
 - focus distance = 20.00
 - F stop = 10.000

Focus distance of 20.00 sets focus to around 20 units from the camera – this point is around the cockpit of the F16 fighter model in the foreground (see Fig. 5.2.10).

F stop value of 10.000 reduces the effect, so that there is less overall blurring in the effect. If you reduce the value to around 5.000 – there is more contrast between the area that is focused on and the out of focus areas in the background. Increasing the F Stop value above 30.000 produces a less noticeable effect, with more of the scene appearing to be in focus.

The DOF settings can help to soften areas of the image and draw the viewer toward areas we want them to focus on (see Fig. 5.2.10).

The additional support for DOF in Viewport 2.0 (from Maya 2012) allows for quick edits to be made to the attributes to create and refine the effect.

Edits and refinements to the settings made through the Viewport are pretty consistent with the final render. When finalizing the effect, it is worth doing some test offline renders to make sure the effect is looking how you like.

- Go to the rendering menu set (F6)
- Go to the render menu at the top of the interface and chooseRender > render current frame (see Fig. 5.2.10, test render)

Scene file with the DOF modified to focus on the foreground is included with the project scene files as –

5.2_03_CAM_DOF_02.mb

FIG 5.2.10 Viewport 2.0 and Offline render – DOF modified, foreground focus.

The settings can be modified to change the effect and focus on objects in the mid-ground of the scene or background:

- From the Outliner, expand the "camera1_group" and select "camera1"
- From the Attribute Editor (Ctrl + A toggle), make sure the "cameraShape1" tab is selected, scroll down to the DOF roll-out, expand the roll-out, and set the following (see Fig. 5.2.11, top left screenshot):
 - Focus distance = 55.00
 - F stop = 5.000

F stop value of 5.000 increases the effect, so that there is more overall blurring in the effect. Objects out-with the focus region scale of 1.000 units are more noticeably blurred than in the previous example, where we used F Stop = 10.000.

Focus distance setting of 55.00 units sets the range of focus to around the mid-ground of the scene, the F16 in the middle of the shot is now in focus (see Fig. 5.2.11).

When the F stop or focus region scale values are lowered, the overall blurring in the scene will be more apparent. In some instances such as this example, it may be necessary to do offline test render to make sure the effect is correct (see Fig. 5.2.11, right screenshot).

217

Scene file with the DOF modified to focus on the mid-ground is included with the project scene files as –

5.2_03_CAM_DOF_03.mb

Additional Viewport 2.0 Quality Settings – Ambient Occlusion/Anti-Aliasing

Additional quality features are included with Viewport 2.0 for users running Maya 2012 and newer releases. There include screen-space ambient occlusion and viewport multisample anti-aliasing.

Screen-Space Ambient Occlusion

- From active viewport, go to the renderer menu at the top of the panel and open the Viewport 2.0 [] options from
 - Renderer > Viewport 2.0 [] options (see Fig. 5.2.12, middle screenshot).
- From the hardware renderer 2.0 Setting Window, expand the "screen-space Ambient Occlusion" roll-out and set the following (see Fig. 5.2.12, middle screenshot)
 - Enabled
 - Amount = 0.515
 - Radlus = 17
 - Filter Radius = 20
 - Samples = 32

The amount attribute defines the overall intensity of the effect while the Radius attributes define the sampling area. The samples attribute controls the number of occlusion samples to improve the quality of the effect.

Ambient Occlusion is an effect that controls overall shading of elements in the scene. Elements that are receded or "Occluded" from view are shaded more than objects that are ridged or pushed out on the model. The effect is more noticeable on objects that have sharp definition or edges on the surface. Ambient Occlusion is typically used at render time or baked as a texture onto models to increase the effect of shading – often an "Ambient Occlusion map" for a model is referred to as a "Dirt Map" as it appears to give the model more shading or dirt around the receded parts.

FIG 5.2.12 Viewport 2.0 – enabling screen-space ambient occlusion.

Screen-space ambient occlusion is a Viewport effect implemented in Viewport 2.0 for Maya that replicates the effect of Ambient Occlusion based on the screen-space directly in the Viewport. It can increase the overall quality and shading of models in the Viewport.

In the example above, the screen-space ambient occlusion creates a darkened effect noticeably around the background of the scene (see Fig. 5.2.12, right screenshot). The effect can also create a slight glow around light areas of the model that can help to soften the image and add subtlety.

In the example scene, the models do not have a lot of definition in shape around the body, so the effect is not as pronounced in overall shading (see Fig. 5.2.12, right screenshot).

Multisample Anti-Aliasing

From Maya 2012, multisample anti-aliasing has also been implemented for Viewport 2.0.

This improves overall quality of the Viewport image and is similar to anti-aliasing for offline rendering. Anti-aliasing is an effect that reduces aliasing or edging when viewing hard edges on a model

- From active Viewport, go to the renderer menu at the top of the panel and open the Viewport 2.0 [] options from
 - Renderer > Viewport 2.0 [] Options
- From the Hardware renderer 2.0 Setting Window, expand the "Multisample Anti-Aliasing" roll-out and set the following (see Fig. 5.2.13, bottom left screenshot)
 - Enabled
 - Sample count = 8.0

Increasing the sample count improves the result but may reduce Viewport performance if set too high on very complex scenes. The maximum is 16.0 and performance will also be dependent on the performance of the video card and driver on the system.

The quality improvement from using anti-aliasing in the Viewport will be most noticeable around edges of the model such as the window edges and nose of the F16 models (see Fig. 5.2.13, left screenshots). Without anti-aliasing, the edges appear jaggy, as if each point of the edges is being created by single solid pixel on the screen. The anti-aliasing in the Viewport smooths this effect and creates an effect that is close to render quality with anti-aliasing enabled (see Fig. 5.2.13, right screenshot).

219

FIG 5.2.13 Viewport 2.0 – enabling multisample anti-aliasing.

Scene file with – screen-space ambient occlusion and multisample anti-aliasing enabled for Viewport 2.0 is included with the project scene files as

5.2_04_CAM_ADD_01.mb

Motion Blur

Motion blur is a render effect that simulates the effect of blurring from a camera when objects are moving fast past the camera. Motion blur occurs in real-life cameras due to the change in position of an object as the frame is being captured. The effect is more noticeable in photography or cinema camera's when the film is exposed for a longer period of time. This exposure is referred to as shutter speed.

The longer the shutter is open, the broader the range of movement that is captured. This can create excessively blurred images in photography. In Maya, Motion blur can be enabled for Viewport 2.0 (from Maya 2012) to simulate the effects of camera motion blur. The options accessible from the Viewport 2.0 options for the effect are limited, although they do provide a reasonable approximation of motion blur to help validate the effect and motion in a scene before final render. Let's take a look at motion blur with Viewport 2.0 on an example scene setup using our F16

- Open the example scene setup from the project files directory
 5.2_05_CAM_MBLUR_00.mb

The scene file has F16 model setup with a few frames of animation – the F16 flies past the two camera's setup in the scene to validate the motion blur effect (see **Fig. 5.2.14**, first screenshot)

- From the panels menu, set the view to camera1 from
 - Panels > perspective > camera1
- Open the Viewport 2.0 [] options window from
 - Renderer > Viewport 2.0 [] options
- Expand the motion blur roll-out and set the following (see Fig. 5.2.14, second screenshot)
 - Enabled
 - Shutter open fraction = 1.000
 - Sample count = 8

Scrub the Time Slider from frame 1 to around frame 40. There should be noticeable blurring on the model, a lot of the detail should be lost and the motion blur especially noticeable around the edges of the model (see Fig. 5.2.14, second screenshot).

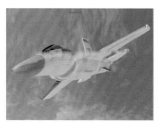

If you dolly in closer to the model, you'll notice that the motion blur effect adds some artifacts in the Viewport – there is a noticeable banding in the colors in the model that looks nasty (see Fig. 5.2.14, third screenshot). This can be resolved by improving the sample count attribute in the options.

FIG 5.2.14 Viewport 2.0 – enabling motion blur and increasing sample count.

- Open the Viewport 2.0 [] Options window
- Expand the motion blur roll-out and set the following (see Fig. 5.2.14, fourth screenshot).
 - Shutter open fraction = 0.5
 - Sample count = 32

Increasing the sample count for motion blur increases the number of samples along the motion vector for each point. A higher sample count improves the quality and reduces the banding effect (see Fig. 5.2.14, fourth screenshot).

The shutter open fraction attribute controls the percentage of the frame time the shutter of the camera is open. A value of 0.5 equates to the shutter being open for 50% of the time instead of the default 1.0 (100%) – this effectively reduces the strength of the effect and is analogous to increasing the shutter speed or reducing exposure on a real camera.

Test the effect from the other camera in the scene

- From the panels menu, set the view to camera2 from
 - Panels > Perspective > camera2
- From the Viewport 2.0 [] Options window, turn off motion blur and scrub the Time Slider from frame 1 to around frame 49 (see Fig. 5.2.15, first screenshot)
- Turn on motion blur and set the following (see Fig. 5.2.15, second screenshot)
 - Enabled
 - Shutter open fraction = 1.000
 - Sample count = 8

Note

You may need to scrub the Time Slider again for the Viewport to update and reflect the changes.

The effect should be really pronounced. The motion blur is overexaggerated, as there is more motion between frames when viewing the action from this camera (see Fig. 5.2.15, second screenshot) test reducing the effect and increasing the quality as follows:

- Shutter open fraction = 0.150
- Sample count = 32

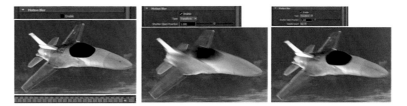

FIG 5.2.15 Viewport 2.0 – reducing effect on fast-moving objects.

The effect is a lot less pronounced and the quality improved (see Fig. 5.2.15, third screenshot).

Scene file with – motion blur setup for camera2 in the scene is included with the project scene files as – **5.2_05_CAM_MBLUR_01.mb**.

Note

As with the other Viewport 2.0 options, enabling motion blur can negatively impact Viewport performance when working on scenes. As with anti-aliasing and Ambient Occlusion, the number of samples used for motion blur can increase quality significantly but will also increase the load on the video card when the effect is turned on. Be aware that the performance is also dependent on the system hardware and video card as well as the general complexity of the scene and geometry.

Maya Software/Mental Ray Motion Blur

Motion blur in Viewport 2.0 produces a reasonable approximation of camera motion blur when setting scenes up for validation. For final render, Maya includes options for motion blur for both the standard Maya software and mental ray renderers. Let's take a look at the settings

- Open the render settings window from Window > rendering editors > render settings
- Set the renderer to Maya software, from Render using = Maya software
- Select the Maya software tab and scroll down and expand the motion blur roll-out (see Fig. 5.2.16, left screenshot)

For the Maya software renderer, the "Use Shutter Open/Close" option is disabled by default. When enabled, this option specifies the length of time in frames the camera's shutter is open – the longer the shutter is open, the more exposed the film is, creating a more pronounced effect.

Note

The Maya software renderer applies motion blur as a post-render effect
and is less accurate than mental ray motion blur.

FIG 5.2.16 Motion blur options –
Maya software and mental ray
renderers.

If you switch the renderer to mental ray – there are additional settings for motion
blur providing more flexibility and quality control (see Fig. 5.2.16, right screenshot).

In addition to the shutter open/close attributes, the mode can be switched
from "No Deformation" to "Full".

- Full mode calculates blur for each vertex on the model that is better
 for deforming models such as skinned character meshes.
- The no deformation mode is fine for models that are rigid and do not
 deform.

Additional settings under the quality roll-out control the displace motion
factor as well as the frame range and number of samples. Refer to the mental
ray for Maya documentation for further information on these settings.

When rendering with motion blur, be aware that the settings can seriously impact
render times depending on the quality settings and complexity of the scene.

Switching the primary renderer to "Rasterizer (Rapid Motion)" when using
mental ray with motion blur can significantly reduce render times when using
motion blur. This can be done from –

Render Settings > Features > Rendering Features > Primary renderer –
Rasterizer (Rapid Motion).

Rendering with Viewport 2.0

In this chapter, we have looked at some of the additional options for Camera's
in Maya including motion blur, DOF, and focal length.

Options such as focal length and clipping planes are handled the same within Maya regardless of whether you are working with the default renderer in the Viewport, Viewport 2.0, or offline renderer.

Some effects, such as DOF and motion blur can also now be previewed in Viewport 2.0 since the release of Maya 2012. The addition of this support now makes it easier to preview and validate scene setups with a quality that is close to final render quality when using the Maya software or mental ray renderers.

FIG 5.2.17 Render settings – Maya hardware 2.0.

Within Maya, you can also now use the Viewport 2.0 renderer to render sequences of animation offline. Using Viewport 2.0 to render produces renders very quickly as the render is being captured from the Viewport using the video card. This is termed as hardware rendering as the video card hardware is being utilized for render instead of a separate Software renderer such as Maya software or mental ray that uses the system's processor to render offline. Using the Maya Viewport 2.0 renderer is ideal when validating scene animation and setup

- Open the Render settings window from
 Window > rendering editors > render settings
- Set the renderer to Maya hardware 2.0, from
 render using = Maya Hardware 2.0

The settings that are available from the Maya Hardware 2.0 options in the render settings window are the same as those found in the Viewport 2.0 [] Options window. The settings are synced with the Viewport 2.0 options, so that the renders are exactly the same as whats seen in the Viewport (see Fig. 5.2.17).

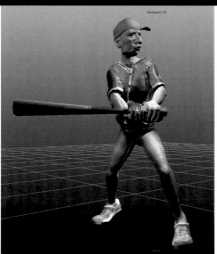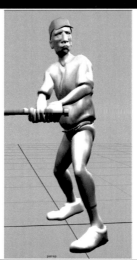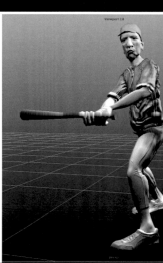

Follow-Through and Overlapping Action

Things don't come to a stop all at once, guys; first there's one part and then another.

> *— The Illusion of Life, Disney Animation — Frank Thomas and Ollie Johnston*

In any animation, follow-through and overlap are critical principles in creating motion that supports and re-enforces the initial main motion. Both principles can be applied to an animation sequence as a theatrical device, although follow-through and overlap are employed more commonly in animation to mimic the effects of object movement in the real world.

The opposite of anticipation, follow-through is commonly seen in natural movement as the release or dispersion of energy after a movement happens. Follow-through and overlap can be seen most clearly in organic character motion where the limbs, appendages (hair clothing), and flesh (i.e., fat stomach) will all move at different phases (overlap) and stop at different points in time (follow-through).

In this section, we'll take a look at follow-through and overlapping action as applied to character motion and cloth simulation in Maya.

Follow-through and overlap need to be applied alongside the other animation principle to create convincing results. We touched on follow-through in Chapter 1 when we looked at the character arm swing animation – changing the posing and timing on the wrist for the animation created follow-through, as the hand followed the motion of the arm swing. This added weight and mass to the animation (see **Fig. 6.0.1**).

FIG 6.0.1 Follow-through – arm swing animation – wrist and hand follow arm.

Follow-through and overlap also need to be applied effectively in detail areas of character animation. For example, for facial animation, the features on the character need to be animated moving at overlapping, different frames in the animation to create believability (see **Fig. 6.0.2**). The expressions tie in with the overall mood being created on the head posing and should either lead or re-enforce the mood in follow-through to the main action.

FIG 6.0.2 Follow-through and overlap – facial animation (Chapter 10).

As an animation principle, follow-through and overlap also tie in closely with secondary motion, which we'll cover in Chapter 7. For the hand animation rig that we'll look at, effective animation on the rig can only be achieved with a firm understanding of how to apply overlap and follow-through (see **Fig. 6.0.3**).

The hand and finger animation should support the main body motion and acting with a lot of overlap in the motion. The finger joints also need to be animated at different timing to create convincing follow-through that either leads or punctuates the body motion with convincing weight and physicality.

For full-body character animation, follow-through and overlap need to be applied throughout the animation, not just at the end or lead out for convincing results.

FIG 6.0.3 Follow-through and overlap – secondary animation on the fingers (Chapter 7).

For example, for the baseball batter animation we looked at in Chapter 2, the separate body parts all moved at different times. Even though the animation that we looked at was for the lead-in anticipation, the hips and leading leg were animated to pose first or lead the action, with the arm swing following the action. In this chapter, we will look at the main follow-through on the pitcher's swing as well as follow-through posing for a baseball batter.

Other examples of follow-through in character animation that we've already touched on so far include the run cycle animation that we looked at in Chapter 1 and the character jump animation and run, of which we analyzed the timing & spacing in Chapter 3.1:

- For the run animation, we saw in Chapter 3.1 how the timing & spacing intervals were different between the body parts, with the limb motion following through on the leading hip and torso motion (see Fig. 6.0.4, left screenshot).
- For the jump animation, which we'll look at in more detail in Chapter 11.0, the hips and upper body lead the motion at the start of the animation up to the mid-point on the jump, with the legs following through.

As the character reaches the mid-point in the jump animation, the trajectory is reversed and the legs lead the action on impact with the hips, then torso, then uppearms following through as the weight is transferrerd (see Fig. 6.0.4, middle and right screenshots).

FIG 6.0.4 Follow-through and overlap – character animation – mass and weight.

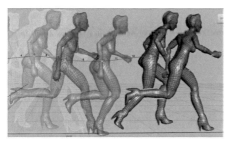
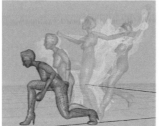
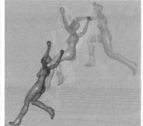

Follow-Through and Overlap – Object Animation, Simulation, and Dyanamics

Follow-through and overlap can also be seen in both object animation and simulation.

In the F16 fighter sequence animatic that we looked at in online Chapter 5.1, there was a reasonable amount of overlap in the motion during the initial phase of the sequence when the fighter planes intercut with one another; this created motion in the sequence and buildup to the action. The main hit on the F16 near the end of the sequence led to extended ease out in the sequence with the F16 pirhouetting to ground and the enemy fighter exiting the screen – both these actions were both a physical follow-through and a dramatic follow-through to the action.

We looked at setup for nParticles in Chapter 2.2. In the setup, there was a buildup of animated elements that followed each action; the rocket reached ready position with the flames starting to emit and then a buildup of smoke enhanced the anticipation for the shot. The follow-through and overlap in the action created believability in the simulation as well as drama.

Soft body and rigid body dynamics are also used in other tutorials in the book where there is an element of natural follow-through and overlap in the physical simulation that adds to the believability of the animation:

Squash and Stretch – Maya Muscle Setup

In online Chapter 11.2, we'll look at a setup for Maya Muscle on one of our character rigs; the setup creates believable dynamic organic squash and stretch in the animation that mirrors how physical muscles work (see **Fig. 6.0.5**). In addition to providing secondary animation to the main character motion, the muscle setup also produces natural dynamic overlapping animation and follow-through. The motion overlaps and follows through on the main body motion with the muscles realistically contracting, expanding, and jiggling after the arm moves.

FIG 6.0.5 Follow-through and overlap – muscle simulation (Chapter 11).

nDynamics – Rocket Smash

In Chapters 8 and 12, on the rocket smash dynamics simulation, again we can see natural overlap and follow-through on the animation. This is partly directed through the decision on the number of mesh elements that are breakable during the simulation though is also a result of the natural forces and physics that are applied during the simulation. The elements break and fall at different stages based on when they are struck, and this creates natural overlap and follow-through as you'd see in the real world (see Fig. 6.0.6).

FIG 6.0.6 Follow-through and overlap – dynamics simulation (Chapters 8 and 12).

Chapter 6.1 – Baseball Pitcher Throw
Pt. 2 – Follow-Through

FIG 6.1.1 Poses 2–5 – swing follow-through.

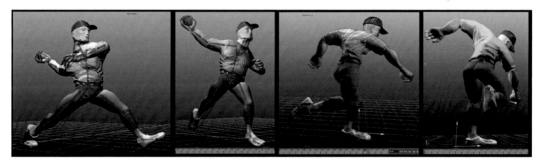

The start scene for this tutorial is the same as the asset we worked with in Chapter 2.1 – Baseball Pitcher Throw. In Chapter 2.1, we blocked in the poses for the baseball pitcher in anticipation of the throw. The pose blocking took us up to the major pre-release pose with the pitcher just beginning to twist back around in direction of throw. In this section, we'll continue blocking in the poses for the throw and follow-through phase of the animation (see Fig. 6.1.1).

Pose Blocking

Thumbnailing has been used to establish the major poses for the throw follow-through animation. The thumbnails are presented in the following illustrations beside screenshots of the animation for the reader to reference while working through the tutorial exercise.

The major phases and posing of the follow-through on the throw are discussed below.

Pose 1 – Step forward with left leg from raised leg pose (lead with feet) – hips beginning to coil or rotate round anti-clockwise, as the left foot leads. Torso is following the coil more slowly (see Fig. 6.1.2).

FIG 6.1.2 Poses 0–1.

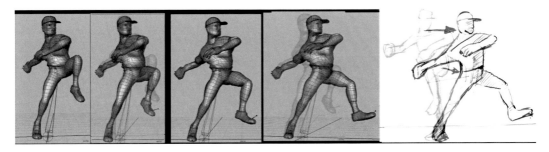

Pose 2 – Left foot planted (lead with left foot) and right foot still planted behind. Hips coiled (or rotated) fully round, perpendicular to direction of travel. Hips evenly weighted between left and right feet. Weight on hips dropping to ground – upper torso still following behind (see Fig. 6.1.3).

FIG 6.1.3 Poses 1–2.

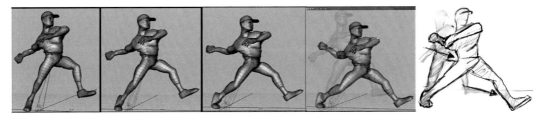

Pose 3 – Left foot fully planted. Weight beginning to transfer over left foot, as torso and right arm swing forward (see Fig. 6.1.4).

FIG 6.1.4 Poses 2–3.

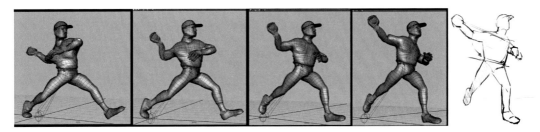

Pose 4 – Right foot raising off the ground, as hips travel forward. Hips weighted fully over left planted foot. Upper torso coiling forward with right arm following through, as ball released (see Fig. 6.1.5).

FIG 6.1.5 Poses 3–4.

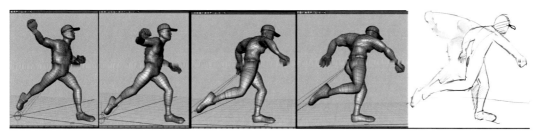

Pose 5 – Ease out. Right foot raised up. Hip motion easing out and torso angled forward, following through on trajectory of throw (see Fig. 6.1.6).

FIG 6.1.6 Poses 4–5.

Work from the same scene file that you were working on at the end of Chapter 2.2 or open the following project scene file from the project scene files directory – **6.1_00_Pre_Throw_Pre_Release.ma**.

The scene file has the last major pose blocked in at frame 15, with the hips raised in anticipation (see Fig. 6.1.7, left). For the throw and follow throw, we'll continue blocking the poses from frame 15. Currently, the Playback end for the scene is set to frame 24. Set it to frame 48, so that there's enough frames in the scene for the new poses we'll key:

- Open the Maya Preferences from Window > Settings/Preferences > Preferences (see Fig. 6.1.7, right).
- From the Preferences, select the Time Slider Category from the left pane and set Playback start/end = 1.00 / 48.00. This will set the animation length to 48 frames, which is equivalent to 2 seconds at 24fps, which is appropriate for the length of the sequence.

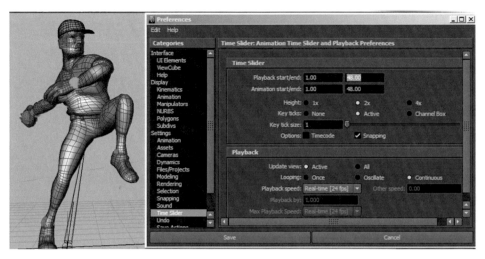

FIG 6.1.7 Start pose at frame 15 and
the Time Slider preferences.

Character Pose Blocking Part 1 – Pre-Release Pose to Step

The first major pose is the pose for the character moving into the step forward. For this, the left foot will lead with the hips following and the torso following later.

- Scrub the Time Slider to frame 22 and orbit around the perspective Viewport until the character is viewed from the front (see Fig. 6.1.8, first screenshot).
- Select the Hips Effector, enable the Move Tool (W), and pull the hips forward in global X-axis and then down slightly in global Y-axis; make sure the back (left) leg is not overextended (see Fig. 6.1.8, second screenshot). Hit Ctrl + F shortcut key to set Full Body IK key for the position at frame 22.

FIG 6.1.8 Posing the hips and left
foot moving forward.

- Select the left Foot Effector (LeftAnkleEffector), enable the Move Tool (W), and pull the foot forward in global X-axis and downward in global Y-axis in readiness for the step (see Fig. 6.1.8, third and fourth screenshots).
- With the effector still selected (LeftAnkleEffector), enable the Rotate Tool (E) and rotate the foot upward in local Z-axis, so that the sole of the foot is facing the floor in readiness to plant on the heel (see Fig. 6.1.8, fourth screenshot). Hit S shortcut key to set a key for the position and rotation at frame 22.

We can continue to finalize the posing, let us first work on the hips rotation. As we discussed earlier, the hips will rotate to follow the direction of travel, so as the left foot steps forward, the hips should also twist round in an anti-clockwise direction.

- The chest end effector currently has rotation pinning enabled. This means that it will be locked in rotation when we rotate any other effectors. We don't need this; we want the chest end effector (or upper torso) to follow the rotation of the hips; we can then make any adjustments manually.
- Select the upper Torso Effector (ChestEndEffector), right-click in the Viewport, and choose Unpin option (see Fig. 6.1.9, first screenshot).
- Select the Hips Effector and enable the Rotate Tool (E) (see Fig. 6.1.9, second screenshot).
- Rotate the hips round in X-axis. The left foot and the rest of the body effectors should rotate round to follow, as they are not pinned. The right foot that is still planted should remain fixed, as pinning is enabled. Hit Ctrl + F shortcut key to set a key for the hip position and rotation at frame 21 (see Fig. 6.1.9, third screenshot).

FIG 6.1.9 Rotating the hips for the pose.

The top Torso Effector should also be rotated round slightly to follow the movement:

- Select the top Torso Effector – ChestEndEffector (see Fig. 6.1.10, first screenshot).

- Enable the Rotate Tool and rotate the effector round slightly in X-axis to follow the motion of the hips. Hit Ctrl + F shortcut key to set a key for the rotation at frame 22 (see Fig. 6.1.10, second screenshot).

While posing, you may need to make additional adjustments to keep the balance solid as well as make the pose strong and dynamic.

- Rotating the head round, so that it is upright will maintain the balance.
- Pulling the top Torso Effector (ChestEndEffector) back slightly (while the hips are temporarily pinned) can help create additional movement in the pose (see Fig. 6.1.10, third screenshot).

Scene file with the first pre-step pose keyed at frame 22 is included with the project scene files as – **6.1_01_Pre-Release_PreStep00.ma**.

FIG **6.1.10** Posing the top torso Effector for the move (ChestEndEffector).

Character Pose Blocking Part 2 – Foot Plant

Next major pose is the actual foot plant on the left foot:

- Scrub the Time Slider to frame 27.
- Select the Hips Effector, orbit round to the side of the character.
- Enable the Move Tool (W) and pull the character forward in global X-axis and down in global Y-axis (the characters right foot should remain planted as pinning is enabled) (see Fig. 6.1.11, second screenshot). The pose should have the free left foot just beginning to touch the ground plane at the heel (see Fig. 6.1.11, second screenshot).
- Hit Ctrl + F shortcut key to key the translation at frame 27.

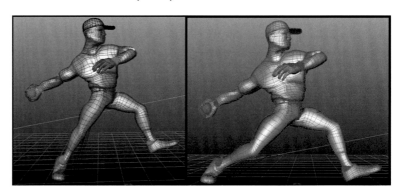

FIG **6.1.11** Posing the hips for the foot plant.

For the left foot plant, we can also make the character stretch out slightly to the side for the throw to make the pose more dynamic (see Fig. 6.1.12):

- Select the Hips Effector, orbit to front view of the character, and pull the hips over to the side.
- Select the left Foot Effector and pull it out to the side as well. Hit Ctrl + F to key the control rig (see Fig. 6.1.12, right screen).

FIG 6.1.12 Tweaking the hip poses and foot plant.

Tweaking the Pose

While animating, you'll typically find that an edit to get the right pose on one element pushes out another element and makes the pose unnatural. To resolve this, you'll typically need to make minor edits. For example, in pulling the hips forward and downward to get the left foot planted, the right foot (trailing) is twisted as the effectors were pinned; the knee is also twisted unnaturally (see Fig. 6.1.13, first and third screenshots)

To resolve this, select the ankle and knee effectors and make any adjustments that are needed (see Fig. 6.1.13, second and fourth screenshots).

FIG 6.1.13 Fixing the foot and knee posing.

For the shoulder posing, we can use the same process as before to rotate round the Torso Effector to pose. For the throw, if you look at video reference of baseball pitchers, the arm throw or and coil movement of the shoulders is usually delayed until after the foot is planted. For this pose, there should only be minor adjustment of the shoulder rotation in readiness.

- Select the Torso Effector – ChestEndEffector and enable the Rotate Tool (E) (see Fig. 6.1.14, left screenshot).
- Rotate round slightly in local X-axis to follow the motion of the throw (see Fig. 6.1.14, middle screenshot).
- Adjust the head pose by selecting the Head Effector (HeadEffector) and rotating back slightly in local X-axis, so that there is a more natural line running from the spine through the neck to the head (see Fig. 6.1.14, right screenshot).
- With effector still selected, hit Ctrl + F shortcut key to set key at frame 27.

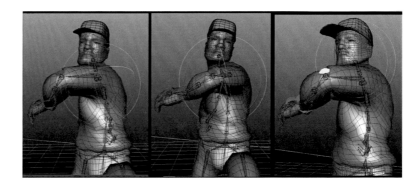

FIG 6.1.14 Posing the torso and head.

Scene file including the anticipation poses into the foot plant pose is included with the project scene files as – **6.1_01_Pre-Release_Step01.ma**.

Re-Timing the Motion

While blocking in poses, it is worth scrubbing the Time Slider to check that the transitions between the poses are natural and fluid. If you playback the animation that we've keyed at frames 21 and 27 (see **6.1_01_Pre-Release_Step01.ma**), you'll notice that the move from the original anticipation animation to the foot plant is a bit slow. We can easily re-time this either by using the Dope Sheet, Curve Window, or simply editing the key timing directly on the Time Slider.

The current timing goes from frame 15 (end anticipation pose) to frame 21 (pre-step) to frame 27 (foot plant). Overall, this move is 12 frames long, which is half a second at 24fps. The timing from the anticipation pose to foot plant should be closer to six frames or a quarter second.

Work from the scene file that you have open or open the project scene file – **6.1_01_Pre-Release_Step01.ma**.

- Open the Outliner from Window > Outliner.
- In the Outliner, select the root of the Full Body IK rig named "Character_Ctrl:Reference."
- Go to Edit > Select Hierarchy (see Fig. 6.1.10, left screenshot).
- In the Outliner, all of the child objects in "Character_Ctrl:Reference" hierarchy should be selected. We want all elements selected for editing the keys (see Fig. 6.1.15, middle screenshot).
- In the Time Slider, click the left-mouse button at frame 18, then click and hold the Shift key, and click drag with the left-mouse button up to frame 30; this selects all the keys between frames 18 and 30. The range is highlight in red (see Fig. 6.1.15, top right screenshot).
- With the range selected, select the small arrow icon >> at the end of the range at frame 30 and drag back to frame 25; this will scale the timing between frames 21 and 27. Scale it to about half, so that there are three frames between the two keys (see Fig. 6.1.15, middle right screenshot).
- With the range still selected, click on the middle area of the range (<> icon) and drag the selected region back a bit, so that the first key is around frame 17 or 18 (see Fig. 6.1.15, bottom right screenshot).

FIG 6.1.15 Re-timing the motion.

Note

The middle <> icons are where to click drag to move the selected range. The < or > arrow icons at either end of the red selection box indicate where you can click drag to scale the keys.

Scene file with the re-timing of the step pose is included with the project scene files as – **6.1_02_Pre-Release_Step02(Re-Timed).ma**.

Weight Shift – Throw Readiness

The major posing from frames 15 to 21 takes the left foot from the raised readiness pose to planted pose. The weight shift is similar to a step, with the waist (or Hips Effector) leading the shift in weight. For the throw, the motion continues onto the left foot with the body and hips weighted on the left foot, which also raises the right leg off the ground, as it trails behind.

For this pose, we can use the effector pinning and IK to switch the pinning from the right foot to left foot:

- Scrub the Time Slider to frame 26 to work on the new pose.
- Select the left Ankle Effector (LeftAnkleEffector).
- Right-click in the Viewport and choose Pin Both option to turn on effector pinning (see Fig. 6.1.16, left screenshot).
- Select the effector for the right foot's ball (RightFootEffector).
- Right-click in the Viewport and choose Unpin option to turn off effector pinning (see Fig. 6.1.16, right screenshot).

FIG 6.1.16 Switching pinning on for right foot, turning off for right foot.

With the pinning switched from the right foot to left, now when we manipulate the Hips Effector, the right foot will remain planted, but the right foot will rise from the floor to follow the hip movement. This is what we need for the step, and the workflow is similar to what you'd use for a character walk cycle or run.

- Select the Hips Effector and enable the Move Tool (W) (see Fig. 6.1.17, left screenshot).
- With the Move Tool enabled, pull the hips forward in global X-axis and upward slightly in global Y-axis (see Fig. 6.1.17, middle screenshot). Hit Ctrl + F shortcut key to set key at frame 26.
- The right foot (trailing) is still in the same pose as when it was planted, with the toe curled in. As the foot is now raised, this looks unnatural; select the Toe Effector, adjust the rotation (with E Rotate Tool), and adjust the Ankle Effector rotation, so that there is a more natural line running along the leg to the toe (see Fig. 6.1.17, right screenshot).

FIG 6.1.17 Shifting hip pose onto left leg and adjusting the right leg and foot pose.

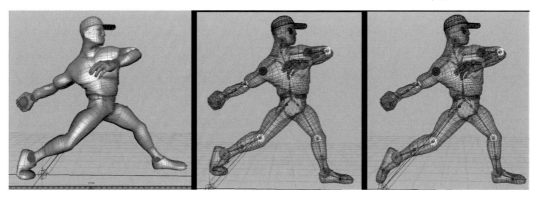

As we saw before, making adjustments to one body part can push out another part. While animating, it is important to view the character rig from several different angles to check that the posing is natural. For example, the Knee Effector on the trailing leg may need minor adjustment; to resolve this while keeping the foot placement the same, enable pinning for the foot and then adjust the Knee Effector position (see Fig. 6.1.18, left and middle screenshots).

For the final pose, the trailing right leg should be posed in more of a straight line; this is more dynamic and creates more motion in the pose (see Fig. 6.1.18, right screenshot).

FIG 6.1.18 Revising the pose for the right leg.

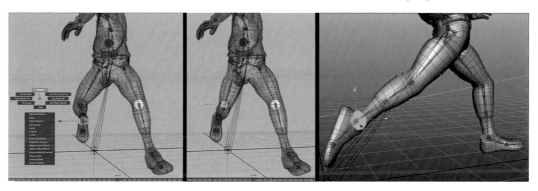

For this pose, the shoulders and right arm should also be beginning to twist round for the throw.

- Still at frame 26 – In the perspective Viewport, orbit round to the front of the character.
- Select the Head Effector (HeadEffector) and turn on Pin Rotate from right-click menu (see Fig. 6.1.19, left screenshot).
- Select the upper Torso Effector (ChestEndEffector) and rotate anti-clockwise in local X-axis to rotate the upper torso around for the throw; the arms should follow the movement, but the head rotation will remain locked as pinning was enabled in the last step (see Fig. 6.1.19, middle screenshot).
- Make any necessary minor adjustments to the head posing by rotating the Head Effector back (see Fig. 6.1.19, right screenshot). Hit Ctrl + F shortcut key to key the pose at frame 26.

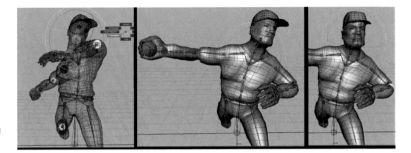

FIG 6.1.19 Rotating the upper torso for the throw follow-through.

Scene file with the poses from frames 1–26 with the last pose being the weight shift to the left foot is included with the project scene files as – **6.1_03_Plant_Cork01.ma**.

Throw Pose– Corkscrew Follow-Through

The pose at frame 26 has the weight shifting onto the left foot and the upper torso and right arm beginning to corkscrew round. This corkscrew motion is a great example of follow-through. The hip movement is nearly at full extension over the left foot with torso about to twist round in a corkscrew type movement for the throw. The next pose should be more extreme, with the body twisted quite far round but not fully extended.

- Work from the scene file that you have open or open the project scene file – **6.1_03_Plant_Cork01.ma**.
- Scrub the Time Slider to frame 30 to work on the new pose.
- Select the Hips Effector and enable the Move Tool (W) (see Fig. 6.1.20, left screenshot).
- Pull the hips forward in global X-axis and up slightly in global Y-axis, so that the hips are fully weighted over the left foot, with the leg being pretty straight (see Fig. 6.1.20, middle screenshot).

- Select the right Foot Effector and pull it in a bit in global X-axis, so that it is slightly bent (see Fig. 6.1.20, right screenshot).
- With effector still selected, hit Ctrl + F shortcut to set a key. We'll refine the hip position and rotation and foot pose later.

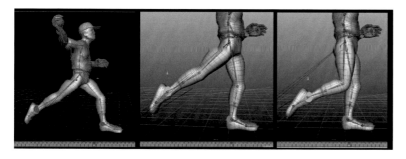

FIG 6.1.20 Hip placement, weight shifted fully over left foot.

Let us take a look at the torso twist and arm posing. The torso should be rotating round for the throw, with the right arm beginning to follow through:

- The Head Effector should still have rotation pinning enabled; this will keep the head rotation the same while modifying the upper torso pose.
- In perspective Viewport, orbit round to the front of the character, and select the upper Torso Effector (ChestEndEffector) (see Fig. 6.1.21, left screenshot).
- With the effector still selected, rotate the upper torso round in local X-axis and down in local Z-axis, so that it is rotating down and across toward the characters planted left foot (see Fig. 6.1.21, middle and right screenshots).

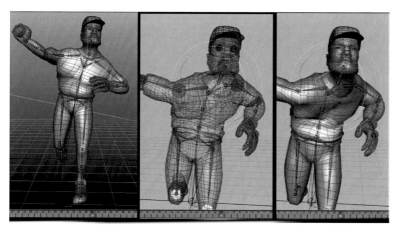

FIG 6.1.21 Chest rotation, corkscrew follow-through.

The arm posing now looks odd, the upper torso is rotating across the body, but the arm is still in the same pose.

- Still at frame 30, select the RightWristEffector (see Fig. 6.1.22, left screenshot).
- Enable the Move Tool (W) and pull the wrist down in Y-axis and in toward the body in X-axis (see Fig. 6.1.22, middle screenshot).

241

- The angle of the arm should match the angle of motion across the body; to solve this, with the RightWristEffector still selected, enable Pin translate from right-click menu (to maintain position), then select the Elbow Effector (RightElbowEffector), and then pull up in Y-axis to get the angle looking right (see Fig. 6.1.22, right screenshot).

FIG 6.1.22 Arm pose and angle.

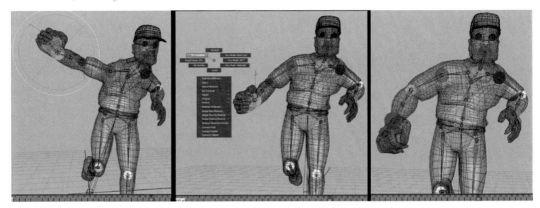

The left arm should swing back as the shoulders rotate round for the throw-opposite to the right arm swing forward for the follow-through.

- Select LeftWristEffector (see Fig. 6.1.23, left screenshot).
- With the Move Tool enabled (W), pull the hand back in global X-axis (see Fig. 6.1.23, middle screenshot).
- Preview the pose from different angles to make any final adjustments, hit Ctrl + F shortcut to set key (see Fig. 6.1.23, right screenshot).

FIG 6.1.23 Left arm, swing back on throw.

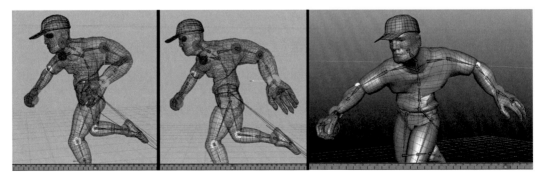

If you preview the pose from the front of the character, the legs and hips are still pretty straight from the previous pose. To resolve this, the hips should be rotated slightly to create more motion in the pose.

- We want to keep the left planted leg position the same, so select the Knee Effector and turn on translation and rotation pinning from right-click > Pin Both (see Fig. 6.1.24, first screenshot).
- With the Knee Effector pinned, select the Hips Effector and rotate it round slightly in local X-axis across the body (see Fig. 6.1.24, second screenshot).
- The right leg pose looks unnatural now and doesn't follow the line across the torso; the knee needs to be adjusted – select the Ankle Effector (RightAnkleEffector) and enable Pin Translate.
- Select the Knee Effector and pull it out slightly from the body, so that the character looks less cramped (see Fig. 6.1.24, third and fourth screenshots). As always, orbit round the character to validate the pose and make any necessary final refinements (see Fig. 6.1.24, fourth screenshot).

FIG 6.1.24 Refining the hips and right leg pose.

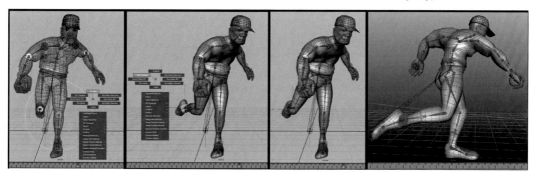

Scene file with the poses from frames 1–30 with the last pose being the weight shift fully over the left foot with the torso and arm following through is included with the project scene files as – **6.1_03_Plant_Cork02.ma**.

Throw Pose – Corkscrew Follow-Through 2

The shoulders and arms are midway through the follow-through for the throw with the corkscrew pose keyed at frame 30. We need to add a final pose a couple of frames after this pose for the full corkscrew extension and throw follow-through on the shoulders and arms.

Work from the scene file that you have open or open the project scene file – **6.1_03_Plant_Cork02.ma**.

- Scrub the Time Slider to a few frames after the last pose, around frame 33.
- Select the upper Torso Effector (ChestEndEffector) (see Fig. 6.1.25, left screenshot).
- Enable the Rotate Tool (E) and rotate the upper torso further round in local X-axis for the full follow-through extension for the pose (see Fig. 6.1.25, right screenshot).
- Hit S shortcut key to key the pose.

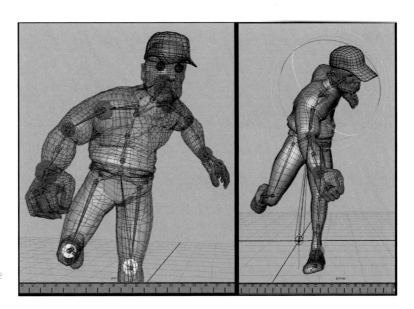

FIG 6.1.25 Full follow-through pose for the shoulders.

If you look at video reference of baseball pitchers, the trailing leg (right leg) also swings out to follow through last after the torso swings round for the throw. The leg raises outward and adds weight to the hip motion that also continues forward slightly:

- Select the right Foot Effector (RightAnkleEffector).
- With the Move Tool (W), pull the foot out to the side (see **Fig. 6.1.26**, middle screenshot).
- Use the Rotate Tool to make any adjustments to the pose that are needed, make sure to validate the pose from a few different angles in the Viewport before setting key (S) (see Fig. 6.1.26, right screenshot). Hit S shortcut to key the pose at frame 33.

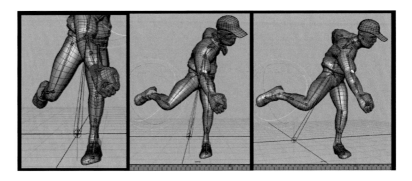

FIG 6.1.26 Leg swing follow-through for the pose.

For the hips, these should be pulled forward slightly for the full extension. This adds weight, as the upper torso leans forward:

- Select the Hips Effector.

- With the Move Tool (W), pull hips forward, so that they are slightly in front of the planted left foot (see Fig. 6.1.27, middle and right screenshots). Hit Ctrl + F shortcut to key the pose.

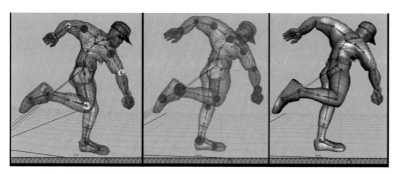

FIG 6.1.27 Hip extension follow-through.

Scene file with the poses keyed from frames 1–33 with the last pose being the full extension corkscrew follow-through pose over the left foot is included with the project scene files as – **6.1_03_Plant_Cork03.ma**.

Chapter 6.2 – nCloth – Cape Follow-Through

Dynamics simulations in Maya are a great way to create natural and realistic follow-through in animation.

Follow-through can naturally be seen in real life during motion on characters with appendages or secondary elements connected to the body. For example, you should see follow-through when studying motion of a character with a long ponytail, loose clothes, or cape. Each of these elements will move based on the natural motion of the character and, if the elements are large or loose, there will be lots of follow-through or extended motions after each action on the character. Think of a character with a flowing robe, as they swing round – the motion of the robe will drag behind the motion of the character, as they come to sudden stop; the motion of the robe will continue to follow through after.

Animating these elements succesfully will help to increase the believability of the motion in your character sequences. Using traditional animation processes, you can animate these elements by hand to create the effect. This can be done quite effectively using joint rigs and skinning to animate elements such as clothing and hair; in fact, using this type of workflow is common in some game animations.

Creating secondary follow-through animation by hand keying in Maya can, however, be laborious. It can also be dificult to get convincing final results that have believable weight, volume, and timing without a lot of hard work, time, and dillegence.

Fortunately, Maya includes a robust dynamics system to help create these types of effects. The nCloth system in Maya allows us to realistically simulate cloth for characters that reacts convincingly to the body and natural forces in the real world.

In this tutorial, we'll take a look at the setup for nCloth in Maya. We'll be working with a character asset setup with run cycle animation. We'll look at the technical aspects of setting up an nCloth cape for the character that interacts realistically with the character and run cycle animation (see **Fig. 6.2.1**).

FIG 6.2.1 nCloth cape simulation.

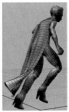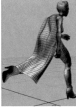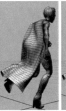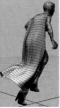

Technical areas covered in the tutorial will include:

- Nucleus physics solver and attributes (gravity and global forces).
- nCloth attributes and presets – creating, modifying, and finalizing the effect.
- nRigid passive colliders – creating collision objects for cloth.
- nConstraints – connecting nCloth to the character.
- Geometry caching-baking the simulation for playback.

Modeling the Base Mesh for the nCloth Cape

Open the start setup scene from the project scene files directory – **6.2_00_nCloth_Start_CharMesh.ma**.

The scene file includes the character mesh in the stance pose at the global origin (0,0,0). The model is a static mesh without any control rig setup, skin binding, or animation. We'll use geometry cache later in the tutorial to load a run cycle animation to work in combination with the nCloth simulation. In this first section, we'll model the cape for the nCloth simulation with the base polygon modeling tools in Maya.

Note

If you wish to skip this section, go to the nCloth basic section that is next and open the scene file with the cape ready modeled from the project directory – **6.2_01_nCloth_Cape_Mesh.ma**.

- From the Create menu at the top of the user interface, select Create > Polygon Primitives > Plane (see **Fig. 6.2.2**, left screenshot).
- Drag in the perspective Viewport at the origin to create a new plane object.

- Scale the object, so that it is roughly the same height as the character from shoulders to ankle.
- From the Channel Box (Ctrl + A toggle), set INPUTS = Suibdivisions Width = 16 / Height = 15 (see Fig. 6.2.2, left and middle screenshots).
- From the Outliner, name the object as Mesh_Cape.
- With the Move Tool active, move the Mesh_Cape up in global Y-axis and back in global Z-axis, so that it sits at the mid-point in the character's neck (see Fig. 6.2.2, right screenshot).

FIG 6.2.2 Poly-primitive plane, subdivided and positioned at character shoulders.

Enter CV selection mode (F9) and double-click the Scale Tool in the toolbox to open the tool options (see Fig. 6.2.3, left screenshot).

- From the Scale Tool options, enable Soft Selection and sculpt the cape shape by selecting and scaling sections of the mesh, so that the shape is tapered from the neck to the base (flared out) (see Fig. 6.2.3).

FIG 6.2.3 Sculpting the cape's shape using CV selection and soft scaling.

Continue to refine the shape of the model, so that it tapers smoothly along the length and is sculpted to fit round the character's neck and shoulders:

- Turn off Soft Selection for the transform tools, select groups of CVs around the edge of the cape, sculpt these close to the neck on the character mesh using the move (W), and scale (R) tools (see Fig. 6.2.4, left and middle screenshots).

247

- When you're happy with the shape, freeze the mesh transforms and delete history from – Modify > Freeze Transforms and Edit > Delete By Type > History. The Channel Box should show all channels zeroed out (see Fig. 6.2.4, right screenshot).

FIG 6.2.4 Refining the cape mesh around the shoulders and neck.

Scene file with the cape mesh sculpted to match the character mesh is included with the project scene files as – **6.2_01_nCloth_Cape_Mesh.ma**.

nCloth – Basic Setup and Nucleus Solver

When working on the nCloth setup, it is important to set the Playback speed to "Play every frame." This is so that, when running the simulation, every frame is evaluated on playback. Using the "Real-time" option on playback will force the software to attempt to play the simulation in real-time, which will cause frames to be skipped and the simulation not to be evaluated correctly:

- Click the Animation Preferences button at the bottom right of the UI or open the preferences from Window > Settings/Preferences > Preferences > Settings > Time Slider. Set the Playback start/end and Animation start/end to frames 1/100 (see **Fig. 6.2.5**, left screenshot).
- In the Animation Preferences window, Playback section, set Playback speed to Play every frame from the drop-down menu (see Fig. 6.2.5, left screenshot).

FIG 6.2.5 Setting playback rate and creating new nMesh (nCloth) in scene.

The options for setup of new nMesh objects (nCloth) are included within Maya's nDynamics menu set. Let us take a look at converting the cape mesh to an nCloth object:

- From the Outliner or Viewport, select the cape mesh (Mesh_Cape).
- Enable the nDynamics menu set from the drop-down menu on the left of Maya's status line at the top of the UI (see Fig. 6.2.5, top middle screenshot).
- With the mesh still selected, go to the nMesh menu at the top of the UI and select nMesh > Create nCloth [] options (see Fig. 6.2.5, lower middle screenshot).

The options for creating new nCloth objects in the scene include a drop-down to select the Solver.

Currently, as there is no solver in the scene, leave this at the default "Create New Solver" option and hit "Create Cloth" button (see Fig. 6.2.5, right screenshot); leave the other option for Local Space Output at the default.

If you look in the Outliner, a new nCloth1 node is created, double-click and rename this as nCloth_Cape for ease of selection (see Fig. 6.2.6, first screenshot). A couple of other things to be aware of to aid in selecting and working with the nCloth node and attributes:

- From the perspective view, the mesh is highlighted in purple when selecting this node to show that the Mesh_Cape model has input connection from nCloth. A small circular icon is also displayed in the Scene View for ease of selection of the nCloth node (see Fig. 6.2.6, second screenshot).
- When either the nCloth node (nCloth_Cape) or source mesh (Mesh_Cape) is selected in the Outliner or Scene View, the Attribute Editor will automaticaly display the shape node tab (named nCloth_CapeShape for our cape).
- The nClothShape tab is where all of the attributes for the nCloth properties are displayed for edit during setup (see Fig. 6.2.6, third screenshot).
- To the right of the nClothShape tab in the Attribute Editor the nucleus1 tab is shown (see Fig. 6.2.6, fourth screenshot). From here, the attributes for the nucleus solver that the nCloth is evaluated within can be modified. This includes base properties for the scene gravity and solver quality.

FIG 6.2.6 nCloth scene node, nCloth, and nucleus properties display in the Attribute Editor.

If you playback the animation in the scene, not much seems to happen with the default settings, the new nCloth object appears to fall very slowly in space (hit Alt + Shift + V to go to first frame and then hit Alt + V for playback from frames 0–100).

From the Animation Preferences window, set the Playback and Animation end frame to frame 500 (see Fig. 6.2.5, for Animation Prefs).

By playing back the full range of the animation (frames 0–500), you can more clearly see the simulation and how the cloth is reacting to the forces in the scene. The cape falls and unfurls, as it floats toward the ground.

FIG 6.2.7 nCloth reacting to gravity
on nucleus solver.

Although the nCloth cape is reacting to the default gravity settings in the nucleus solver, it is not interacting with the character mesh or ground. It floats through both (see Fig. 6.2.7).

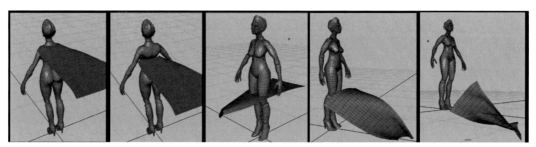

Nucleus Space Scale Attribute

The reason the nCloth cape appears to float so slowly is due to the scene units scaling. The nucleus solver considers each Maya scene unit equivalent to 1 meter in real life. If scene objects are not modeled to this scale, nCloth objects will not react appropriately to the nucleus forces in the scene.

Fortunately, there is a Scale Attribute on the nucleus solver that can be set to compensate for this:

- With the nCloth node selected from the Outliner or Scene View (nCloth_ Cape), open the Attribute Editor and go to the nucleus1 tab at the top (see Fig. 6.2.8, first screenshot from left).
- Expand the Ground Plane section and enable Use Plane; this will set the nucleus solver to evaluate the Ground Plane (at Y = 0) as a part of the simulation. nDynamics objects will interact with the Ground Plane as if it is a rigid object in the scene (nRigid).
- Expand the Scale Attributes section and set Space Scale = 0.100 (see Fig. 6.2.8, first screenshot from left).
- From the playback controls, go to the start of the playback range (Alt + Shift + V) and then start playback to view the simulation (Alt + V). The cloth will fall at a more convincing rate due to the nucleus gravity; this is due to the Space Scale being set appropritately. The cloth will also interact with the ground plane, sliding across the suface at around frame 100.

FIG 6.2.8 nCloth space scale and creating passive collider in scene.

nRigid – Adding the Character Mesh to the Simulation

For our cloth simulation, we want the nCloth cape to interact with our character mesh. The cape mesh should deform and react when it collides with the character model. Within nDynamics setup, objects can be setup as nRigid objects within the nucleus solver. As long as nRigid objects are evaluated as a part of the same nucleus solver as the nCloth objects, the simulation should work as expected. Let us look at the setup for our scene:

- Select the character mesh from the Scene View or Outliner (Mesh_Space_ Heroine). It should highlight green in the perspective Viewport (see Fig. 6.2.8, second screenshot from left).
- With the mesh selected, make sure that the nDynamics menu set is active and select nMesh > Create Passive Collider [] – options from the top of the Maya user interface (see Fig. 6.2.8, third screenshot from left). Make sure that the new nRigid object is added to the same Solver in the scene, as used by the nCloth (nucleus1).

Note

As there is only the one nucleus solver in scene, it should be added to this by default (nucleus1).

- Hit "Make Collide" to create the new nRigid node from the selected character mesh.

When new nRigid objects are added to the scene, a new nRigid1 node will be visible from the Outliner. As with the nCloth node, it can be selected from the Outliner or from the Scene View (small sphere placed at the center of the mesh (around where the character mesh's hips meet).

- From the Outliner, select the new nRigid1 node and rename as nRigid_ Space_Heroine to aid selection (see Fig. 6.2.8, fourth screenshot from left).

As with the nCloth node, the properties for the new nRigid will display by default in the nRigid_Space_HeroineShape Attribute tab in Attribute Editor when selecting either the original mesh or the nRigid node (see Fig. 6.2.8, fourth screenshot from left).

The main attributes for edit include whether or not the nRigid is enabled and thickness of collision. The default properties are fine for the simulation and are not covered any further in this tutorial. Refer to the Maya documentation for further information on nRigids.

Preview the simulation by going to the start frame (Shift + Alt + V) then hitting play (Alt + V).

The nCloth cape will slide over and off the character's shoulders, as it falls toward the ground. The nCloth behaves correctly in interacting with the nRigid character mesh in the simulation (see Fig. 6.2.9). Scene file with the

nCloth and nRigid nodes setup is included with the project scene files as – **6.2_02_nCloth_nMesh_nucleus01.ma**.

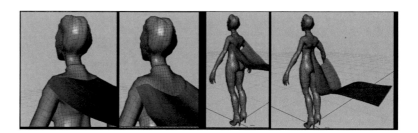

FIG 6.2.9 Previewing the simulation, nCloth interaction with nRigid.

nConstraint – Connecting the Cape to the Character

For our nCloth setup, we want to connect the cloth cape to the character mesh to mimic the connection of the fabric on the cape to the character's costume. As we've seen already, the nCloth reacts convincingly to gravity and reacts correctly in interaction with the character mesh (nRigid).

nDynamics in Maya include a constraints system, which allows connection between components on nMesh's to mimic this.

In the setup, we can connect the CVs at the edge of the nCloth cape to our character mesh's shoulders; this will cause the nCloth to drape over the character's back convincingly to get to the rest pose for our nCloth simulation.

- Make sure object selection mode is active (F8/Q shortcuts) and select the cape mesh from the Scene View or Outliner (Mesh_Cape).
- With the mesh selected, right-click with the mouse and choose Vertex from the marking menu (see **Fig. 6.2.10**, first screenshot from left).

Note

Although object selection mode is active, vertex subcomponents can also be selected in this mode; this allows us to add the character mesh to the selection in next steps.

- In a perspective view, select the CVs around the open edge of the cape where it meets the character mesh (see Fig. 6.2.10, second screenshot from left).

Note

Toggle wireframe display to aid in selection of occluded vertices (shortcut = 4).

- Hold Shift shortcut and select the character mesh in the Scene View (Mesh_Space_Heroine).

Note

The original CVs on the cape should still be selected and the character mesh highlighted in green to show that it is also selected (see Fig. 6.2.10, third screenshot from left).

Note

For nConstraints, the object that we are constraining to (Mesh_Space_ Heroine) needs to be selected last.

- Make sure the nDynamics menu set is still active and select nConstraint > Point to Surface from the top of the Maya user interface (see Fig. 6.2.10, fourth screenshot from left).

This command creates a new dynamic constraint between the CVs on the cape and the character mesh. The constraint is visible from the Outliner, named dynamicConstraint1. The constraint is shown in the Scene View as a dotted green line between the Points and Surface.

Rename as dynamicConstraint_Cape from the Outliner.

FIG 6.2.10 Creating dynamic constraint – point to surface.

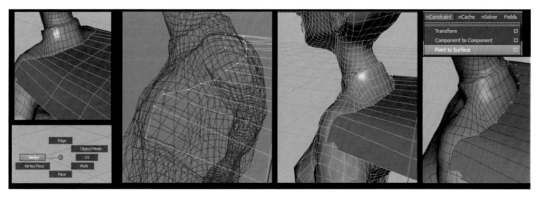

Previewing the Simulation – nCloth Rest Pose

Scene file with the nConstraint added to connect the cape to the character is included with the project scene files as – **6.2_03_nCloth_nConstraint.ma**.

Let's preview the simulation. Return to the first frame of the animation and hit play (Alt + V) to preview the nCloth simulation.

- At frame 1, the cape is at it's original default shape (see Fig. 6.2.11, first screenshot from left).
- As the simulation plays, the nCloth falls toward the ground, connected at the shoulders through the nConstraint (see Fig. 6.2.11, screenshots from left to right).

- As the cloth falls, it interacts convincingly with the character mesh through the nRigid setup. The cloth unfurls, bounces in reaction to the character mesh, and creases realistically.

FIG 6.2.11 nCloth simulation to rest state (frames 1–100).

- The nCloth simulation plays from frame 1, with the cloth reaching a relaxed state at around frame 100 (see Fig. 6.2.11, screenshots on far right).

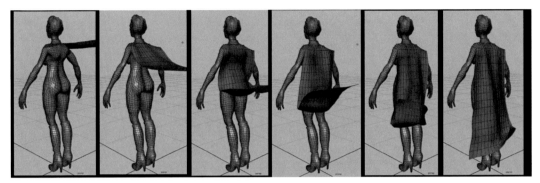

When working with nCloth, the cloth should typically be simulated with a pre-animation roll-up until the cloth reaches a relaxed state.

The rest pose for the cloth is dependent on the original position for the cloth mesh and the forces of gravity in the nucleus solver.

As the mesh for the cape has been modeled in a flat pose, it takes a few seconds for the cloth to drop and relax against the character mesh. If working with cloth mesh that is already modeled in a relaxed pose, the amount of frames to reach the rest pose will be shorter.

When adding dynamic forces to act on the nCloth, this should happen after the cloth has settled to the rest pose. For our simulation, the character animation should be animated after frame 100, as this is the cloth at its relaxed state with force of gravity fully applied.

Collision Thickness Attribute

Previewing the simulation, we can see that there are interpenetration issues between the nCloth cape and the nRigid character mesh. At around frame 38 of the simulation, the cloth interpenetrates with the character mesh; this can be seen around the shoulders and nape of the back where the character mesh is visible (see Fig. 6.2.12, first screenshot from left).

This is partially due to the amount of detail on the model but is also due to the collision and quality settings for the nCloth and nucleus solver. We'll take a look at the attributes for the nCloth and nucleus solver in more detail later, for now, we can quickly resolve the interpenetration by modifying the collision thickness attribute for the nCloth:

- With the nCloth cape selected, open the Attribute Editor (Ctrl + A) to display the nCloth_CapeShape tab to view the attributes.

- Under the Collisions section, turn on Solver Display = Collision Thickness. This will display the Collision Thickness in the perspective view (see Fig. 6.2.12, middle screenshot).

The Solver Display color can be changed from the Display Color swatch. The default color is yellow.

The collision thickness is displayed around the mesh.

- For the initial setup, increase the thickness attribute to around Thickness = 0.17 with the slider. The attribute slider can be modified interactively with the thickness display in yellow updating in the Viewport (see Fig. 6.2.12, third screenshot from left).

By replaying the simulation from frame 1, the interpenetration should be resolved (see Fig. 6.2.12, far right screenshot).

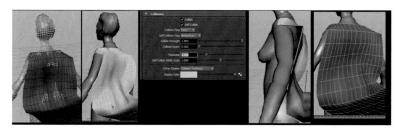

FIG 6.2.12 Collision thickness – fixing interpenetration on nCloth.

Save the scene file setup at this stage, so that we can work on the next phase of the setup and reload this setup file at a later stage.

Scene file with the Collision Thickness modified on the setup is included with the project scene files as – **6.2_04_nCloth_CollisionThickness.ma**.

Geometry Cache – Adding the Character Animation to the nCloth Setup

Let's take a look at adding animation for our character to interact with the cloth simulation that is set up. Open the character animation scene file we'll use for this step – **6.2_05_CtrlRig_Anim.ma**.

The scene file includes the same character mesh as we've been working on for the nCloth setup (see Fig. 6.2.13, first screenshot from left).

The main differences in the scene file are that the character mesh is:

- Bound to the skeleton with Maya smooth bind.
- Control rig setup and animated (see Fig. 6.2.13, first screenshot from left).

The control rig setup is covered in online Chapter 9.1, and the animation is the character run cycle that is covered in Chapter 8.1.

The run cycle has been looped from frames 0 to 128 (0–16 = one cycle) and a pre-animation has been created, going from the idle pose at frame –100 to the start pose for the run at frame 00.

The pre-animation for the rest pose (100 frames) has been created, so that there is a roll-in at the start to work in conjunction with the initial nCloth simulation, as the cloth settles to the rest pose before the run cycle starts (see Fig. 6.2.11). The animation has been keyed on the control rig.

We want to get this animation onto our nCloth setup scene without any of the extraneous scene elements including the control rig and skeleton. The simpler the scene setup we're working on with the nCloth simulation, the faster and more responsive the edits and preview will be with nCloth.

FIG 6.2.13 Saving and loading geometry cache on the character.

Fortunately, Maya includes Geometry Caches that allow us to save out a cache file that stores the vertex position on a mesh that can be reloaded in other scene. This will allow us to save out the base underlying vertex animation on the skinned character that can be reloaded in our nCloth setup scene. Let us look at the setup:

- With the scene file open (**6.2_05_CtrlRig_Anim.ma**), select the character mesh from the Outliner (Mesh_Space_Heroine) (see Fig. 6.2.13, second screenshot from left).
- Switch to Maya's Animation Menu Set from the status line drop-down menu (F2 shortcut) (see Fig. 6.2.13, second screenshot from left).
 - From the Animation Menu Set, the menu item "Geometry Cache" that we need to work with should be visible from the top of the UI.
- With the mesh still selected, go to the Geometry Cache menu and select Geometry Cache > Create New Cache [] Options (see Fig. 6.2.13, second and third screenshots from left).

In the Create Geometry Cache Options window, set the following:

- Cache Directory: By default, this will be set to the current Maya Project Directories – Data folder. If you've already set this correctly, this can be left as is. The path to the cache file is displayed in the Attribute Editor when loaded.
- Cache Name: Name the cache appropriately – Mesh_Space_HeroineShape.
- File Distribution: Set this option to "One file"; this will save single file for the geometry cache rather than individual cache file for each frame of the animation.

- Cache Time Range: Set this to "Time Slider"; this will generate cache based on the current settings on the Time Slider. This is the full animation range from frames –100 to 128.
- Hit "Create" – Maya will run through the animation and generate the cache file in the specified Cache Directory.

With the Cache file generated, we can reload our nCloth setup scene and use the cache file to animate our character.

- Reopen the previous nCloth setup scene that we were working on or open the project scene file – **6.2_04_nCloth_CollisionThickness.ma**.
- From the Outliner or Scene View, select the character mesh – Mesh_ Space_Heroine.
- With the mesh selected, make sure the Animation Menu Set is active (F2) and go to:
- Geometry Cache > Import Cache (see Fig. 6.2.13, far right screenshot).
- From the Import Cache File dialog, choose Files of Type = All Files, then browse to the directory that the .mc cache file was saved in from previous step and choose.

Note

If saved in the default Project File > Data directory, the Import Cache file dialog should automatically point to the correct directory.

Note

The cache file is included with the project as – Mesh_Space_HeroineShape. xml.

- Hit "Open" to open and load the cache file onto the character mesh.

With the geometry cache loaded, you'll notice that the nCloth simulation is out of sync with the character run cycle (see **Fig. 6.2.14**, first screenshot from left).

FIG 6.2.14 Setting the nCloth scene to sync with the cache animation.

The Time Slider is set to run from frames 1–100 in the scene. At this frame range, the character is already in the run cycle, while the nCloth simulation is still performing the pre-evaluation to get to the rest pose (see Fig. 6.2.14, first screenshot from left).

This can be resolved by setting up the playback frame range and start frame for the nucleus solver to sync:

- Open the Animation Preferences from the shortcut button at the bottom right of the UI or from Windows > Settings/Preferences > Preferences > Settings > Time Slider.
- Set the Playback start/end and Animation start/end frames to−100 (minus 100) to 128 (positive 128) (see Fig. 6.2.14, second screenshot from left).
- In the Playback section, make sure Playback Speed = "Play every frame," so that the nCloth simulation is evaluated correctly on playback.
- Select the nCloth mesh (Mesh_Cape) or nCloth node (nCloth_Cape) from the Outliner or Scene View.
- With the node selected open the Attribute Editor and go to the nucleus1 tab at the top to view the attributes for the nucleus solver.
- Scroll down and expand the "Time Attributes" section in the Attribute Editor and set Start Frame = −100 (minus 100) (see Fig. 6.2.14, second screenshot from left).

Go to the Start Frame, which is now frame = −100 (Shift + Alt + V shortcut) and hit Play (Alt + V) to playback the animation.

The nCloth now evaluates correctly and is in sync with the character animation (see Fig. 6.2.14, screenshots 3–5).

- The nCloth evaluation starts at frame = −100 (minus 100) and reaches the rest pose at around frame 00 (100 frames). During this phase, the character mesh animation is at the stance pose before the run.
- From frames 00 to128, the character run cycle loops and the cloth interacts with the run, going from the rest pose at frame 00 folding, creasing, and reacting to the character's body movements during the animation (see Fig. 6.2.14, screenshots 4–5, from left).

nCloth Attributes and Presets
Pt. 1 – Leather

On playback of the nCloth simulation, the cloth appears quite light and shows a lot of movement. The parts of the cloth mesh appear to stick and interpenetrate. This is due to the attribute settings for the nCloth and nucleus solvers in the scene that we'll take a look at here.

nCloth attribute presets provide a good starting point in the setup and allow you to try out different effects while working (see Fig. 6.2.15).

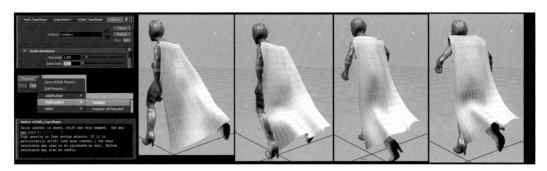

FIG 6.2.15 nCloth – space scale attribute and thickLeather preset.

- With the nCloth selected, go to the nucleus tab in the Attribute Editor.
- Expand the Space Scale Attribute and set Space Scale = 0.03 – this scale setting is appropriate for the scene scale and the attribute presets we'll work with on the preliminary setup (see Fig. 6.2.15, left screenshot).
- With the nCloth still selected, go to the nCloth_CapeShape tab in the Attribute Editor to work on the attributes for the nCloth.
- At the top right of the nCloth_CapeShape tab is "Presets" button. Click and hold the Presets button with the left-mouse button to view the nCloth attribute Presets. From the menu, scroll down and select the thickLeather preset and choose "Replace" option to replace the current nCloth presets with the thickLeather preset (see Fig. 6.2.15, left screenshot).

Note

If you scroll down to the bottom of the Attribute Editor window for the nCloth_CapeShape node, there are some notes displayed on the preset settings for reference (see Fig. 6.2.15, left screenshot).

Go to the start frame and playback the simulation to preview the nCloth effect with the thickLeather preset setting (see Fig. 6.2.15, Viewport screenshots). The nCloth reacts quite differently when compared with the default settings that we used before. The cloth appears more thick and heavy and has less movement when interacting with the character mesh during the run cycle. This is due to the nCloth attributes that have been set by the preset. Select the nCloth and check the nCloth_CapeShape tab in the Attribute Editor to see the settings. The main settings that affect the simulation are discussed in the following sections:

Dynamic Properties

Stretch Resistance/Compression Resistance/Bend Resistance – These attributes are set quite high in the preset (50/50/30). This means that the cloth will have less motion and compression and bend when reacting during the simulation.

Mass – This attribute is also set high (3.0); the cloth mass gives it a weighty feel.

Damp – This attribute controls how damped or muted the motion is (set high at 8.0), ideal for heavy or weighty cloth.

Scene file including the thickLeather preset loaded onto the nCloth is included with the project scene files as – **6.2_06_nCloth_Preset01_Leather01.ma**.

nCache

During playback of the simulation, the nCloth is evaluated in real-time by the Solver. The performance during playback can be impacted by the amount of detail in the simulation, and this can make it hard to validate the effect. As with the character mesh animation, we can use a cache to store the nCloth's vertex animation to a file to improve playback on the scene (see Fig. 6.2.16).

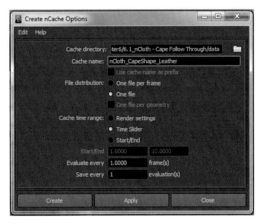

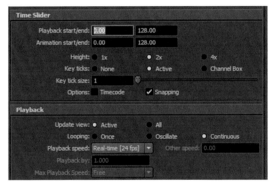

FIG 6.2.16 Creating nCache for the cloth to preview the animation in real-time.

- Select the nCloth mesh from the Outliner or Scene View (Mesh_Cape).
- Select the nDynamics menu set from the drop-down menu at the top left of the Maya status line. This will change the menu items at the top of the UI to show the nCache menu (see Fig. 6.2.16, top left screenshot).
- Select nCache > Create New Cache [] Options.
- The options in the "Create nCache Options" window are the same as the options in the "Create Geometry Cache Options" window that we covered earlier (see Fig. 6.2.16, left screenshot and Fig. 6.2.13). The options should be set to generate the cache from the Time Slider (frames −100 to 128) ensure that the directory the cache is saved to is valid and that the cache file is named logically.

Once generated, the cache file will automatically be loaded for the mesh. The Time Slider can be scrubbed and the animation will play correctly. The nucleus solver can be disabled as the nCloth simulation has been "baked" at the vertex level onto the mesh.

Note

With the mesh selected, the settings for the cache file and directory can be modified from the nCloth_CapeShapeCache1 – tab. To get to this tab, select the cape mesh and scroll right > or use the right arrow keys on the keyboard to get to to the node connection. The cache file can be reloaded from here and you can also remove the cache connection or replace the cache file (which will re-simulate the nCloth) from the nCache menu options.

Note

On playback, the animation may play too quickly now. This is because the nCloth is no longer being evaluated on playback, and the Playback Speed is still set to "Play every frame" – The Play every frame Playback option will play the animation at a speed relative to the complexity of the scene and processing power of the system. From the Animation Preferences window, set the Playback Speed to "Real-time [24fps]" to force the system to match the playback speed to the frame rate of the animation (see Fig. 6.2.16, right screenshot).

nCloth Attributes and Presets Pt. 2 – T-Shirt

FIG 6.2.17 nCloth simulation – Tshirt preset and properties.

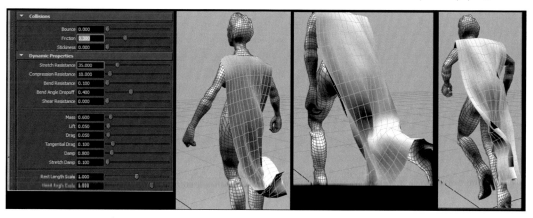

The nCloth simulation with the leather preset that we've setup acts convincingly for a very heavy and thick leather cape. This is not really the effect that we're looking for on the cape, which would look more natural as a lighter and more maleable cloth surface. With more motion in the cape, the

animation follow-through will be more dynamic and realistic looking for the viewer. We can use another nCloth preset as a starting point to refine and finalize the simulation.

- Reload the scene file from the previous step before the Cache file was generated for the nCloth – **6.2_06_nCloth_Preset01_Leather01.ma** (included with the project scene files).

Note

Ensure that the character mesh animation cache file is loaded correctly and plays back. It needs to be referenced from correct directory; this can be confirmed after selecting the model –Mesh_Space_Heroine – and checking from the Attribute Editor – "Mesh_Space_HeroineShapeCache1" tab. The cache file included with the project is called Mesh_Space_HeroineShape.xml.

- Select the nCloth cape from the Outliner or Scene View (nCloth_Cape).
- From the Attribute Editor – nCloth_CapeShape tab, click the Presets button and choose Tshirt > Replace to replace the current thickLeather preset in the scene with the Tshirt cloth preset.

Go to the start frame and playback the simulation with the new Tshirt preset. The nCloth simulation looks quite different with this preset; the cloth has a lot more movement and reacts more when interacting with the nRigid character mesh during the run cycle (see **Fig. 6.2.17**, Viewport screenshots). The difference in the effect is due to the attribute settings in the presets (see Fig. 6.2.17, left screenshot).

Collisions
Friction – The friction attribute is set at 0.3 for the nCloth using the Tshirt preset. This is half the value used on the leather preset (0.6).

Dynamic Properties
Stretch Resistance/Compression Resistance/Bend Resistance – The values used here on the Tshirt preset are significantly lower than those used on the leather preset (Tshirt = 35 / 10 / 0.1 – Leather = 50 / 50 / 30). The cloth is more malleable and stretches and deforms significantly more than previously.
Mass – This attribute is set at 3.0, half of the value used on the leather preset (6.0); the nCloth feels less dense and heavy.
Damp – This attribute is set at 0.8 a tenth of the value used on the leather preset (8.0); the motion of the cloth is significantly less damped or muted.

Scene file with the default Tshirt preset applied to the nCloth is included with the project scene files as – 6.2_07_nCloth_Preset02_Tshirt01.

The presets for nCloth provide a great starting point for realistic simulations. It is worth taking some time to review the presets in depth, comparing the attribute settings between the different presets. The presets show that there are a significant number of different effects that can be achieved with nCloth. Many of the effects that can be achieved may be different from the base simulations that you'd think possible from a cloth simulation system. The software also includes a number of nCloth example setups for reference; these can be accessed from the nDynamics Menu Set > nMesh > Get nCloth Example (see Fig. 6.2.18).

FIG 6.2.18 nCloth example scenes included with the software.

nCloth Attributes – Refining the Simulation to Improve Quality

Although the Tshirt preset that we setup in the previous section suits the cloth effect for the cape better, there are still a number of refinements we can make to the simulation to improve the quality.

The cloth appears to interpenetrate on itself, with polygons intersecting noticeably (see Fig. 6.2.19, first screenshot from left). The mesh is also probably not detailed enough for the simulation, as there is not enough detail on the model; it doesn't deform smoothly and this also contributes to the issues in bad collisions and interpenetrations on the cloth. Let us look at some of the settings to resolve this in the following sections.

nCloth Quality Settings (see Fig. 6.2.19, second screenshot from left, top)
- Select the nCloth cape to view the nCloth attributes from the "nCloth_CapeShape" tab in the Attribute Editor.
- Increase the following from the Quality Settings heading:
 - Max Iterations = 12,000.
 - Max Self Collide Iterations = 8.0.

Note

These settings will increase the following:

Max Iterations – Amount of iterations per simulation step each nCloth dynamic property is evaluated by the nucleus solver (for example, stretch/compression resistance).

Max Self-Collide Iterations – Amount of iterations per simulation step each self-collision is calculated for the nCloth within the nucleus solver.

Increasing both these values will not only increase the quality but also increase the calculation time.

• Enable both Trapped Check and Self-Trapped Check.

Note

Both of these options will track collisions during the simulation and resolve interpenetration issues where the surface mesh is sticking during interpenetration. On our simulation, this improves the issue where we can see areas sticking together during self-collision.

FIG 6.2.19 Increasing quality settings on the nCloth and nucleus solver.

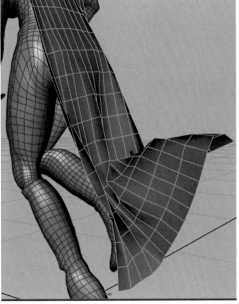

nCloth Collisions (see Fig. 6.2.19, second screenshot from left, middle)

- Expand the Collisions section and set Self Collision Flag = Full Surface.

Note

This option controls which of the nCloth's components are evaluated when the nCloth self-collides. Full Surface option evaluates the meshes – vertices, edges, and faces on collision during the simulation.

Nucleus-Solver Attributes (see Fig. 6.2.19, second screenshot from left, bottom)

The nucleus solver includes a couple of attributes that control the overall quality of the nucleus solver:

- With the nClothShape node still selected, go to the nucleus1 tab in the Attribute Editor (the tab to the right of the nCloth_CapeShape tab at the top of the Attribute Editor).
- Expand the "Solver Attributes" section and set the following:
 - Substeps = 8.
 - Max Collision Iterations = 12.

Note

The Substeps attribute sets how many times the Solver calculates per frame. The default value of 3.0 may be too low for fast-moving objects. Setting the value higher (to 8.0) increases the quality of the simulation. The Max Collision Iterations attribute sets how many times collisions are evaluated per simulation step. As with the other settings, increasing this attribute not only will increase the overall quality of the Solver but also increase the calculation time.

Playback the simulation to validate the changes; the quality of the Solver will be significantly improved due to the quality settings being increased on the nCloth node and nucleus solver.

Note

Playback performance of the simulation will be impacted due to the additional calculations required. Generate a new cache file from nCache > Create New Cache menu and switch playback mode to "Real-time [24 fps]" to view the animation in real-time.

Note

If you have already created nCache file in the current scene that you are working on, you will need to either disable the cache file to view any changes that have been made to the attributes or regenerate the nCache file for the cloth. When working on iterative changes to the attributes, a common workflow is to make the edit, then choose nCache > Replace Cache from the nDynamics menu set to overwrite the previous cache file.

Increasing nCloth Mesh Resolution and Fixing Collision Thickness

FIG 6.2.20 Subdividing the input mesh.

Although the simulation is significantly improved due to the increase in the nCloth and nucleus quality settings for the Solver, the mesh deformation for the nCloth is still fairly rough looking. This is due to the base resolution of the input mesh used when creating the nCloth. The quality of the nCloth effect is very dependent on the quality and detail of the mesh used. The less detail on the mesh, the less smoothly the cloth will deform.

- With the nDynamics Menus Set active, select the cape from the perspective view and choose nMesh > Display Input Mesh (see Fig. 6.2.20, first screenshot from left, top).

Note

This will display the source mesh in the Scene View, i.e. the original cape mesh without the nCloth effect applied.

- Activate Maya's Polygon Menu Set (from the status line drop-down, or F3 shortcut) (see Fig. 6.2.20, first screenshot from left, middle).
- With the mesh still selected, choose "Mesh > Smooth" from the top menu in Maya (see Fig. 6.2.20, first screenshot from left, bottom).

- Switch back to the nDynamics Menu and set and choose nMesh > Display Current Mesh.
 - The nMesh (nCloth) should be displayed as smoothed in the Viewport; the number of edge loops and rings on the mesh should be approximately doubled (see Fig. 6.2.20, second screenshot from left).

Playback the simulation after replacing the nCache – the deformations on the nCloth will be significantly improved (see Fig. 6.2.20, third and fourth screenshots from left).

At some phases of the simulation, interpenetrations may be visible between the nCloth and character mesh (see Fig. 6.2.21, left screenshot). At around frame 54, the character's left leg can be seen clipping through the cape. This is due to the Collision Thickness attribute that we covered earlier (see Fig. 6.2.12). As we loaded the Tshirt preset as a starting point to refine the nCloth, this attribute has been reset.

Use the same steps as before to select the nClothShape node and set the Collision Thickness to around 0.6–0.7 to fix the interpenetration (see Fig. 6.2.21, middle screenshot).

Note

If you have already cached the animation replace the nCache from nCache > Replace to validate the fix (see Fig. 6.2.21, right screenshot).

FIG 6.2.21 Fixing collision thickness.

Scene file with the nCloth cape and nucleus quality improved and the mesh smoothed is included with the project scene files as – **6.2_08_nCloth_Preset02_Tshirt02_SmoothQual.ma**.

Note

The example scene file references the geometry cache for the character animation. The cache for the nCloth cape will need to be regenerated after opening the file to view playback in Real Time [24fps]. Follow the above-mentioned steps to regenerate the nCache.

Final Tweaks to the nCloth Simulation

The quality of the nCloth simulation and deformations are improved using the steps in the last section. When working on nCloth animations, you can make almost endless tweaks and modifications to the attribute settings to change the effect. The changes to the setup are a matter of personal preference and the type of effect you're trying to replicate and achieve.

On playback of the cached simulation, the motion on the nCloth is still fairly weighty or rigid looking. Let us take a look at settings that we can use to add a bit more motion and fluidity to the simulation.

Collision Attributes (see Fig. 6.2.22)

- With the nCloth mesh selected, go to the nCloth_CapeShape in the Attribute Editor.
- Scroll down to the Collisions rollout to view the Bounce, Friction, and Stickiness attributes.
- Increase these to *Bounce = 0.350* – this defines the springiness of the nCloth or how much reacts in collision with itself or the nRigid (character mesh).

Increasing this attribute gives more natural follow-through to the motion. For example, when the legs kick back and interact with the cloth, it will travel more (see Fig. 6.2.22, right Viewport screenshot).

- *Stickiness/Friction = 05/0.3* – Both these attributes work in conjunction; increasing the Stickiness attribute will cause the nCloth to more naturally stick or drag when colliding with other nucleus objects including the nRigid character mesh. Friction is relative to the Stickiness attribute, with a low friction nCloth being similar to smooth silk.

An increased Stickiness value works with the simulation creating a more realistic drag from the feet pulling the cloth back during the run cycle (see Fig. 6.2.22, left and middle Viewport screenshots).

FIG 6.2.22 Tweaks to the collision attributes.

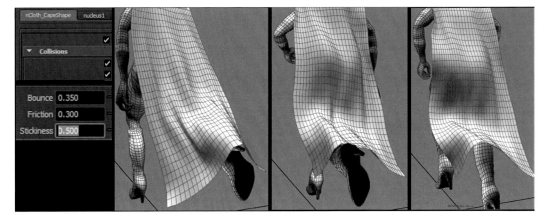

Dynamic Properties (see Fig. 6.2.23)

- With the nCloth mesh selected, go to the nCloth_CapeShape in the Attribute Editor (see Fig. 6.2.23, first screenshot from the left-top).
- Scroll down to the Dynamic Properties rollout and set the following:
 - *Bend Resistance = 0.04 (from 0.1).*
- Lowering this attribute allows the nCloth to bend more across its edges when strained (compressed or stretched); this adds more movement to the simulation.
 - *Mass = 0.4 (from default for the Tshirt preset = 0.8).*

This attribute controls the mass of the cloth relative to the gravity being exerted by the nucleus solver. A value of 1.0 would be equivalent to felt, while a mass of 0.0 would be equivalent to sheer silk. For the cape, a relatively low mass attribute suits the cloth effect we're looking for.

Nucleus-Solver Attributes (see Fig. 6.2.23)

- With the nCloth mesh selected, go to the nucleus1 tab in the Attribute Editor (see Fig. 6.2.22, first screenshot from the left-bottom).
- Scroll down to the Scale Attributes section and set the following:
 - *Space Scale = 0.015 (halved from previous setting = 0.030).*

As discussed earlier, space scale is relative to the scene units and scaling of the objects in the scene. Nucleus evaluates single centimeter units in meters, which can cause issues. The attribute should be reduced if objects are being evaluated by the Solver as if they were huge in the scene. The attribute can also be tweaked or changed to create different effects with the cloth. For our cloth setup, reducing the setting further adds additional overall motion to the nCloth simulation.

FIG 6.2.23 Dynamic properties and nucleus-solver attributes.

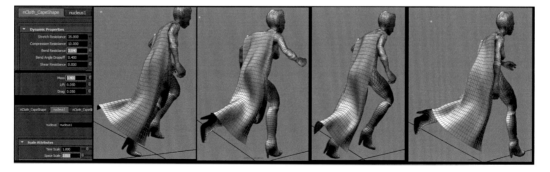

Scene file with the tweaked nCloth and nucleus-solver attributes is included with the project scene files as – **6.2_09_nCloth_Preset03_CapeTweak.ma**.

As before, ensure that the geometry cache for the character run animation is loaded:

- Re-cache the nCloth cape simulation from nCache > Replace and set Playback speed to Real-time [24fps] from the Animation Preferences.
- From the Animation Preferences, after cahing the nCape, set the start frame to frame 00 for playback, so that only the run cycle animation plays (i.e., the pre-simulation for the nCloth from stance pose is truncated).

Chapter 6.3 – Prop Follow-Through and Overlap – Character Baseball Swing

Characters holding prop objects or appendages can show considerable follow-through in motion. For example, when viewing a character swinging a golf club or chain, you will see a lot of follow-through on the motion of both the body (torso and arms) and the object. As the object has weight and mass, it will add additional follow-through to the motion and will continue to travel after being moved by the body.

In this section, we'll take a look at the pose blocking for the baseball swing animation that we looked at in Chapters 2 and 3. In the earlier chapters, we looked specifically at re-timing the motion and adding ease in & ease out to the motion. In this section, we will focus specifically on the posing of the body parts for the sequence to create natural and fluid follow-through in the animation.

As with the baseball throw sequence that we've already worked on, reference material should be used to analyze and appraise the body posing and timing for the sequence. There are plenty of video references available for this type of motion; analyzing video or photos of the motion can help in the pre-planning stage before laying down the key poses for the animation.

From thumbnail outline of the motion, we can see a couple of major areas of movement that can be used to help create effective poses when working on the animation.

Full Body – Major Weight Shifts on Swing and Arc of Bat (see Fig. 6.3.1)

- Looking at the full-body motion on the swing, the weight on the character hips is typically weighted on the back leg at the start of the animation. This weight shifts forward, as the bat is swung. Occasionally, the leading foot will be raised from the ground and will do pre-step forward that is sometimes called "Testing the water" before shifting back and then forward as the leading foot takes the weight.
- The main force comes initially from the hips shifting forward onto the leading leg; the upper torso follows through on the hip motion with the leading left arm and elbow following through to lead the direction of the swing. The bat will typically follow the arm angle and should produce a natural arc on the swing.

- At the mid-point in the sequence, the hips reach full rotation extension; this forces the feet and legs to extend, as the hips rotate. At mid-point, once the spine is fully rotated, the arms continue traveling around with the bat, and at the end of the sequence, the bat continues swinging slightly further as the wrist stops.

FIG 6.3.1 Thumbnails – major weight shifts and arcs.

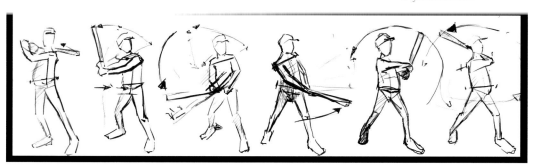

Upper Body – Torso Coil Rotation and Arm/Bat Follow-Through (see Fig. 6.3.2)

Appraising the motion through thumbnails of the spine shows a couple of things:

- Spine rotation – The major motion on the swing comes from the rotation on the spine. Although the hips lead in the motion and rotate slightly counter-clockwise into the swing. The main element leading the motion is the spine. The shoulders follow the spine motion, carrying the arms round with the left arm leading.
- Arm Swing Leads Bat – The left arm leads the swing with the bat following through; the bat should be angled backward on the swing, as it follows through on the swing. At the contact point, there should be an almost straight line along the leading left arm to the bat, with both at 90° to the legs.
- Near the end of the motion, when the arms fully swing round, the bat will continue swinging beyond the wrist and the motion will follow through. Throughout the animation, the bat swings and pivots based on the position of the wrists. The bat needs to be animated with follow-through to create convincing weight and mass to the animation.
- S-coil in swing Look at the start and end poses for the motion. The arms are coiled tightly in toward the body, with the angles between the arms, elbows, and bat being tight; the pose here is similar to a snake coiled around a log (log being the body). This pose at the start is needed to build the momentum or energy for the swing; as the body coils out and the bat is swung, the s-line curve on the arms and bat is less pronounced and more straight, as the energy is released.

271

FIG **6.3.2** Thumbnails – spine coil and follow-through motion.

The tutorial will work through the six major poses for the swing, moving from the start pose through full swing extension and follow-through. The body parts will be keyed through individual keying of the controls for the character at regular 5× frame intervals (see **Fig. 6.3.3**). Do not be concerned about the timing between the poses, as this was covered in the earlier exercices. The poses should be animated from the side or ¾ front side view as shown in the screenshots in Fig. 6.3.3.

FIG **6.3.3** Start pose (pose 0/frame 15) through to final pose (pose 5/frame 40).

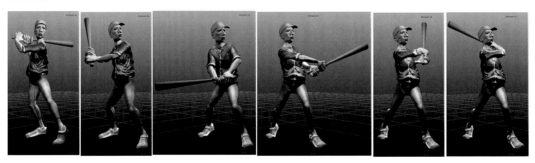

Start Pose to Swing Pose 1

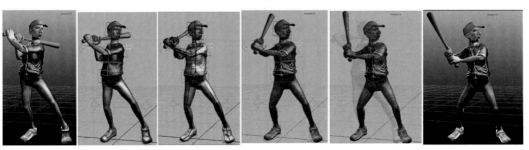

FIG **6.3.4** Start pose (pose 0/frame 15) through to swing pose 1 (frame 20).

Note

Please refer to Chapter 3.2 for information on the scene setup and display layers for this character rig while working through the exercise.

The first move in the swing animation goes from the readiness Start Pose (bat held behind right shoulder/neck) to pre-swing pose (see Fig. 6.3.4). The hips are

leading in the motion with the upper torso and arms following. The left elbow leads the arms with the bat still angled behind, following the motion. Let us look at the posing on the character setup:

- Open the start file for the tutorial – 6.3_00_Start_Pose.

The start pose is keyed at frame 15 on the Time Slider (see Fig. 6.3.4, first screenshot). For the tutorial exercise, we'll block the poses in at regular five-frame intervals. Re-timing the poses for this sequence was covered previously in Chapter 3.2.

Note

It is important to consider the final camera that you are animating to while working; for this exercise, the final animation should be viewed from the side or ¾ front/side view.

- Scrub the Time Slider to frame 20.
- In perspective view, tumble (Alt + LMB) around, so that the full character is viewed from front side with direction of swing to right (see Fig. 6.3.5, first screen).
- From the Outliner or perspective view, select the main Hip control object and left Foot control object (BBALL02_RIG_BASE_FSP_COG_CTRL and BBALL02_RIG_BASE_FSP_Foot_L_CTRL).
- With the control objects selected, enable the Move Tool (W) and pull both controls forward slightly in global X-axis (see Fig. 6.3.5, second screen). Hit Shift + W shortcut to key the translation.
- De-select the left foot control and, with Move Tool active, pull the hip control forward a bit more in global X-axis (see Fig. 6.3.5, third screen). Hit Shift + W shortcut to key.

The foot is angled at the start pose, with weight on the ball of foot (frame 15). At frame 20, the foot should be flat.

- With the control selected (BBALL02_RIG_BASE_FSP_Foot_L_CTRL), open the Channel Box and set the following: Ball Roll = 0 // Toe Roll = 0. Hit S shortcut to key the attributes (see Fig. 6.3.5, fourth screen).

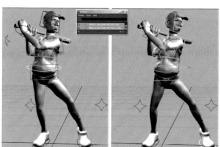

FIG 6.3.5 Swing pose 1 – weight shift on hips.

The hips are keyed moving forward at this pose (frame 20). At this frame, the upper torso should also be beginning to rotate around into the swing. The torso should be angled backward slightly, as the hips are leading the motion.

- Still at frame 20, select the green-colored base spine control object from the Outliner or perspective view (BBALL02_RIG_BASE_FSP_Spine01_CTRL).
- With the control selected, tumble around to vew the character from a ¾ front/top view (see **Fig. 6.3.6**, first screen).
- Enable the Rotate Tool and rotate the spine round slightly forward in local Y-axis (see Fig. 6.3.6, second screen). Hit Shift + E shortcut to key the rotation and make any additional adjustments to the secondary spine controls, so that the pose looks natural from this angle (see Fig. 6.3.2, second screen).

The spine controls should also be angled backward slightly to suggest that the hips are leading.

- Tumble around to view the character from the front (see Fig. 6.3.6, third screen).
- Select each of the spine controls, rotate back slightly in local Z-axis, and key to pose (see Fig. 6.3.6, fourth screen).

FIG 6.3.6 Swing pose 1 – spine angle on pose.

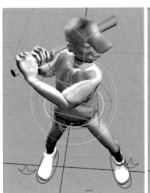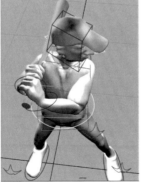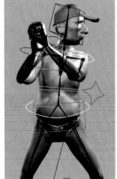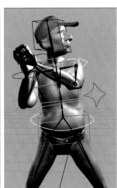

At this pose, the left hand should begin to swing forward with the bat angled as it's following through. The angle of the upper arm and elblow should remain the same (see **Fig. 6.3.7**).

- Still at frame 20, select the left-hand control (BBALL02_RIG_BASE_FSP_Hand_L_CTRL).
- From a front perspective view, pull the control forward (in Z-axis) and down slightly (in Y-axis).
- Rotate the control forward in local Z-axis and round slightly in local Y-axis (see Fig. 6.3.7). Set key for the translation and rotation (Shift + W/Shift + E).

FIG 6.3.7 Swing pose 1 – arm and hand posing.

Scene file with the posing keyed from the start pose to the first swing pose at frame 20 is included with the project scene files as – **6.3_01_Pose_Swing01.ma**.

Swing Pose 1 to Swing Pose 2

FIG 6.3.8 Swing pose 1 (frame 20) through to swing pose 2 (frame 25).

The next major pose is the contact pose as the bat hits the ball (see Fig. 6.3.8, far right screenshot). There is less overall movement in the hips and lower spine at this pose. The main motion is starting to come from the upper spine, as the left forearm and wrist rotate to swing the bat.

- Scrub the Time Slider to frame 25 to work on the next major pose.
- View the character from the front (see Fig. 6.3.9, first screen).
- Select the main hip control (BBALL02_RIG_BASE_FSP_COG_CTRL), and with Rotate Tool active (E), rotate the hips forward and down slightly in the direction of the swing (see Fig. 6.3.9, second screen). Hit Shift + E to key the rotation (see Fig. 6.3.9, second screen).
- In perspective view, tumble around to view the character from ¾ front/top view (see Fig. 6.3.9, third screen).
- Rotate the upper spine controls round slightly into the direction of swing (see Fig. 6.3.9, fourth screen).
- Hit Shift + E to key the rotation.

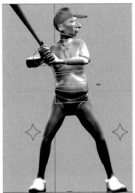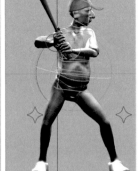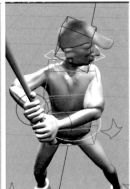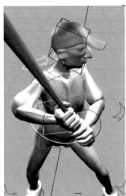

FIG 6.3.9 Swing pose 2 – hips and upper spine.

The upper spine controls should be rotated back slightly at this pose, so that there is a smooth curve in the spine, even with the hips rotated downward (see Fig. 6.3.10, screenshots on left and right).

When viewed from the top, the angle of the shoulders should be at around 45° to the angle of the hips (see Fig. 6.3.10, middle screenshots).

FIG 6.3.10 Swing pose 2 – spine and shoulder angle and curve.

The main motion on the arms at this pose is coming from the left forearm and wrist. The left upper arm is at full extension already; the forearm swings from angled inward pose (at frame 20) to full extension at frame 25. The wrist is also controlling the swing angle, bringing the bat round and in, so that it is in line with the body.

- Still at frame 25, select the left wrist control (BBALL02_RIG_BASE_FSP_Hand_L_CTRL).
- In perspective view, tumble around to the side of the character (see Fig. 6.3.11, first screen).
- With the Move Tool, pull the wrist control down in Y-axis and out slightly in Z-axis. Use the Rotate Tool to rotate the wrist down in local X-axis and forward slightly in local Y-axis (see Fig. 6.3.11, second screen).
 - If you tumble around to the side of the character, the angle of the bat should be at around 90° to the angle of the legs, so that the bat will connect directly with the ball.

- When posing the left wrist control, both arms are also posed automatically (as the right wrist is linked to the left, it follows the motion). Extreme poses for the wrist position and rotation can push out the pose on the elbows on the character.
- To resolve these issues, the pole vector controls for the elbows can be used to tweak the pose. The shoulder controls can also be used to rotate the shoulders inward to reduce the length between the wrist and the shoulder and reduce any hyperextension on the arms.
- Select the right shoulder control (BBALL02_RIG_BASE_FSP_Calvicle_R_CTRL) and rotate it in toward the body and key as needed to resolve any issues (see Fig. 6.3.11, third screen).
- For the elbow posing, these should be angled roughly in line with the arms, so that the posing looks natural. Select, move, and key both of the star-shaped pole vector controls to resolve any issues with the elbow twisting (see Fig. 6.3.11, fourth screen).

FIG 6.3.11 Swing pose 2 – hand pose, shoulder, and pole vector tweak.

As the body rotates round at this pose, the angle of the feet and knees should also rotate round slightly to follow the twist in the upper torso. As the weight is distributing forward, the heel can also lift slightly off the ground:

- Still at frame 25, tumble around to view the characters right leg from the front (see Fig. 6.3.12, first screen).
- Select the right foot control (BBALL02_RIG_BASE_FSP_Foot_R_CTRL), and from the Channel Box, set the following:
 - Ball Roll = −17 and Toe Pivot = 24 (see Fig. 6.3.12, second screen).
 - The heel should lift slightly and the foot pivot round slightly on toe (see Fig. 6.3.12, third screen).
- Select both Channels and choose Right-Click > Key Selected.
- Select the star-shaped pole vector object for the knee (BBALL02_RIG_BASE_FSP_Leg_R_Pole) (see Fig. 6.3.12, fourth screen).
- With the Move Tool, pull the control forward slightly in global X-axis to angle the knee forward slightly (see Fig. 6.3.12, fifth screen). Hit Shift + W to key the translation.
- The left foot control – BBALL02_RIG_BASE_FSP_Foot_L_CTRL – can also be rotated forward slightly and keyed at this pose to follow the action line (see Fig. 6.3.12, fifth screen).

FIG **6.3.12** Foot and knee poses.

FIG **6.3.13** Validating the pose – perspective views, shaded and textured/lit (Viewport 2.0).

Validate the pose from a few different angles; the bat should be roughly at right angle to the line of the legs at the contact point. The shoulders should be roughly at the same angle as the bat. The left arm should be almost straight on, but not fully extended at the mid-point of the swing. The weight should be fully distributed between both legs, but the hips angled down slightly as the action line is downward in the swing (see Fig. 6.3.13).

Scene file with the posing keyed from the start pose through to the second swing pose is included with the project scene files as – **6.3_01_Pose_Swing02.ma**.

FIG **6.3.14** Swing pose 2 (frame 25) through to swing pose 3 (frame 30).

Swing Pose 2 to Swing Pose 3

The next couple of poses in the sequence are the main follow-through poses for the swing. There should be less motion on the upper spine twist. The spine has twisted round to full extension, at around 90° to the legs at previous pose (frame 25 – see Fig. 6.3.14, first screen).

The main motion in the next couple of poses is in the follow-through position and angle of the wrist. The bat continues to travel and follow through in the motion. There is less inertial motion on the rest of the body, as the weight and momentum of the bat on the swing carries the wrist round (at frame 30 – see Fig. 6.3.14, screenshot on far right).

- Scrub the Time Slider to frame 30 to work on the next major follow-through pose.
- Select the main hip control object (named BBALL02_RIG_BASE_FSP_ COG_CTRL).
- Enable the Rotate Tool and rotate the control round slightly in local Y-axis, so that the arms are more in front of the body (see Fig. 6.3.15, second screenshot from left). Hit Shift + E to key.
 - If you tumble around to the front of the character, the head rotation will look off (see Fig. 6.3.15, third screenshot from left); this is because the neck and head follow the spine rotation. Select the neck and head controls, and with Rotate Tool active, rotate back round slightly and key (Shift + E), so that the head pose counters the body and stays solid, as the torso swings round slightly (see Fig. 6.3.15, fourth screenshot from left).

FIG 6.3.15 Swing pose 3 – hip and upper torso pose/head angle counters.

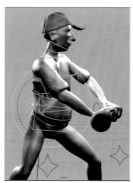 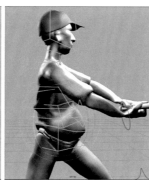

For the wrist and arm posings at this pose, we want the wrist to twist round at this pose, so that at frame 30, the angle of the bat is almost directly opposite the angle from frame 25 (see Fig. 6.3.16).

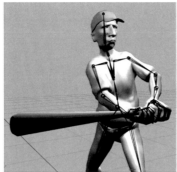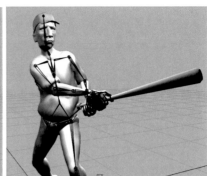

FIG 6.3.16 Swing pose 3 – wrist rotation and bat angle – frame 25 (left) and frame 30 (right).

The previous pose changes on the spine and upper torso were not that extreme on this pose. The main pose differences at this pose are in the position and angle of the wrist. This creates the natural follow-through on the swing as the wrist travels across the body angling the bat (see Fig. 6.3.16).

- Still at frame 30, select the main left wrist control object (named BBALL02_RIG_BASE_FSP_Hand_L_CTRL).
- With the Move Tool active, pull the wrist over and across the front of the body in global Z-axis, so that it is moving to other side of the character and set key (Shift + W).
- Rotate the wrist control, around local Y-axis, so that the bat is angled across the body at roughly 45° to the straight legs (see Fig. 6.3.17, left screen).
 - You'll notice that extreme pose difference on the wrist may create some funky looking posing on the elbows (see Fig. 6.3.17, left and middle screen). This is because the raised elbow pose from frame 25 does not fit, posing the wrist rotation right round "breaks" the wrist and forces the elbow up.
- Select the star-shaped left elbow control object and pull the control downward and out to the side to pose the elbow correctly (see Fig. 6.3.17, right screenshot).

FIG 6.3.17 Swing pose 3 – posing the left wrist and fixing elbow angle.

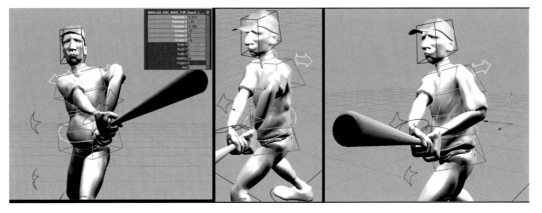

As before, the right arm may be extended beyond limit at this pose, with the arm too straight (see Fig. 6.3.18, left screenshot). Rotate the arrow-shaped right shoulder control forward slightly and key to soften the pose if needed (see Fig. 6.3.18, middle screenshot). For the feet, modify the Ball and Toe Pivot attributes on the right foot control to extend the reach and rotate the left foot control round slightly to match the rotation.

FIG 6.3.18 Swing pose 3 – clavicle posing and feet pivot and rotation.

As before, validate the posing from a few angles to make sure it feels right. The major pose change between this pose (frame 30) and the previous pose (frame 25) is on the wrist and arm angle. The angle of the bat should be rotated almost 90° round from the previous pose, directly across the body. Make sure that the angle looks consistent with the type of arc that would naturally be on the bat (see Fig. 6.3.19).

Scene file with the posing keyed from the start pose through to the third swing pose is included with the project scene files as – **6.3_01_Pose_Swing03.ma**.

FIG 6.3.19 Validating the pose – perspective views, shaded and textured/lit (Viewport 2.0).

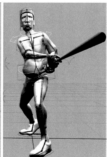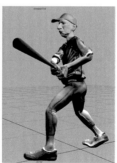

Note

By scrubbing the Time Slider, you'll probably notice that there are inconsistencies on the arc of the bat as it arcs between frames 25 and 30. Additional in-between key is required at this pose to make the arc appear natural. The final example scene file includes additional pose keyed at around frame 27 to resolve this.

While working on the animation, you may wish to use the previous workflow of creating Motion Trail or Editable Motion Trail (Maya 2012) to refine the major arcs on the swing.

Swing Pose 3 to Swing Pose 4

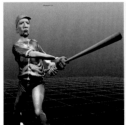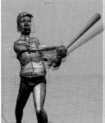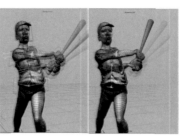

FIG 6.3.20 Swing pose 3 (frame 30) through to swing pose 4 (frame 35).

The next pose, at frame 35, is the main follow-through on the wrist on bat. The wrists are up over the left shoulder at this pose, as the bat swings back. There is limited or no motion on the rest of the body, as the swing follows through (see **Fig. 6.3.20**, far right screenshots).

- Scrub the Time Slider to frame 35 to work on the next major follow-through pose.
- Select the left wrist control object (named BBALL02_RIG_BASE_FSP_Hand_L_CTRL) (see **Fig. 6.3.21**, left screenshot).
- With the control selected, tumble around to view the character from the front, and with the Move Tool active, pull the control upward in global Y-axis and over slightly in Z-axis, so that the wrists are roughly in line with the shoulders (see Fig. 6.3.21, middle and right screenshots and **Fig. 6.3.22**). Hit Shift + W to key the translation on the control.
- For the rotation on the wrist/bat, the wrist control should be rotated backward in local X-axis, so that it is angled upward, as if arcing over the shoulder (see Fig. 6.3.21, right screenshot).

FIG 6.3.21 Swing pose 4 – posing the hands and angle on bat.

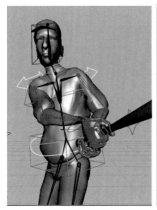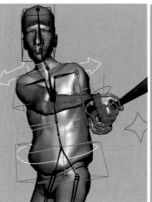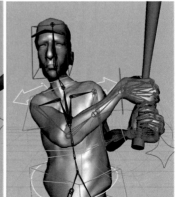

As we saw in the previous pose setups, the angles of the elbows can get pushed out when making gross pose changes to the wrist pose and rotation (see Fig. 6.3.22, left screenshot).

- Select the star shaped right elbow control (named BBALL02_RIG_BASE_FSP_Arm_R_Pole).
- Pull the control object up slightly in global Y-axis, so that the elbow is raised and the right arm follows a straight line from the shoulder to wrist (see Fig. 6.3.22, middle screenshot).

Note

The left elbow control may also need to be adjusted slightly if it is interpenetrating into the body. Make any iterative adjustments to the wrist and elbow posing while validating the final changes (see Fig. 6.3.22, right screenshot).

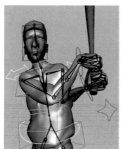 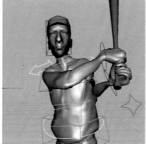

FIG 6.3.22 Swing pose 4 – refining the arm and elbow poses and finalization.

For the lower body, the hips can be pushed forward slightly at this pose to suggest the weight and effort in the second part of the swing animation:

- Still at frame 35, select the main hip control (named BBALL02_RIG_BASE_FSP_COG_CTRL).
- Tumble around to the side of the character in perspective view (see Fig. 6.3.23, first screen).
- With the Move Tool, pull the hips forward slightly in global X-axis and key (see Fig. 6.3.23, second screen).
- Select the right foot control – BBALL02_RIG_BASE_FSP_Foot_R_CTRL, and from the Channel Box, set the Toe Pivot attribute = 49 to rotate the foot round a bit further and set key (see Fig. 6.3.23, second screen).
- Tumble around to a ¾ front/side view of the legs and make any further adjustments to the star-shaped leg pole vector controls, so that the leg angle matches the angle of direction on the feet and hips (see Fig. 6.3.23, third and fourth screens).
- Make some final adjustments to the hip height pose and key to reduce the hyperextension on the rear right leg (see Fig. 6.3.23, fourth screen).

FIG 6.3.23 Swing pose 4 – hip posing and leg adjustment.

As with the previous key poses, review the character pose and skeleton from a number of angles to check that the pose looks natural and dynamic. Use the different shading and display modes to check the diagonal action line running along the left leg and bat looks solid (see **Fig. 6.3.24**).

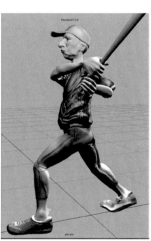

FIG 6.3.24 Validating the pose – perspective views, shaded and textured/lit (Viewport 2.0).

FIG 6.3.25 Swing pose 4 (frame 35) through to swing pose 5 (frame 40).

Scene file with the posing keyed from the start pose through to the fourth swing pose is included with the project scene files as – **6.3_01_Pose_Swing04.ma**.

Swing Pose 4 to Swing Pose 5

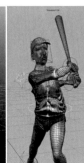

The final pose in the animation sequence is the full follow on pose for the bat swing. The bat and wrists are coiled fully round, back at the opposite side of the head and neck to the original start pose. At this pose, there is a gross movement on the angle of the bat due to the weight and gravity on the bat. The length of the bat drops to around 45° behind the neck due to the weight and swing, forcing the angle of the wrists inward. The arms are pulled more tightly in toward the body due to the coil, and there is a strong diagonal line running across the body from the rear right leg up to the hands. There is also a strong diagonal line on the angle of the bat that makes the pose dynamic and fluid (see Fig. 6.3.25, far right screenshot).

Looking at the spine on the character over the two poses shows that the major pose difference on the wrist is in the placement and rotation. The wrist is fairly low on the existing pose 4 (frame 35); at the new pose 5 on frame 40 that we'll key, the wrist is higher up, closer to the ear on the neck with both wrists directly behind the shoulder. The left wrist is rotated inwards to angle the bat behind the head at around 45°. Adding the new pose after the existing pose will create the follow-through animation mainly on the bat, which is pivoting directly on the wrist through the posing (see Fig. 6.3.26).

FIG 6.3.26 Comparing the pose – pose 4 (frame 35 – existing pose, left screens) – final pose 5 (frame 40 – intended new pose, right screens).

Let us take a look at keying this pose to finalize the pose blocking for the shot:

- Scrub the Time Slider to frame 40 to key the final pose.
- Tumble around to the front of the character and select the left-hand control (named BBALL02_RIG_BASE_FSP Hand L_CTRL) (see Fig. 6.3.27, first screen).
- With the Move Tool active (W), pull the control up, so that it is roughly in line with the left shoulder (see Fig. 6.3.27, second screen). Hit Shift + W shortcut to key the translation.
- With the control still selected, activate the Rotate Tool and rotate the wrist back in local X-axis and in toward the body slightly (see Fig. 6.3.27, third screen).

Note

Rotating the wrist control inward to the body should modify the angle on the arms, so that the pose looks more natural. Make any additional adjustments as needed to the pole vector controls and set key to finalize the pose. Check the pose from the side and ensure that the left elbow angle looks natural for the pose, with both elbows raised at around 45° (see Fig. 6.3.27, fourth screen).

FIG 6.3.27 Swing pose 5 – posing the wrist, bat, and arm angles.

The main motion between this pose (frame 40) and the preceding pose (frame 35) is the wrist rotation on swing. At this pose, there should be minimal movement on the rest of the body; very minor adjustments can be made to the hip height and spine rotations to create a moving hold at the pose (see Fig. 6.3.28, left screens). Validate the pose from a number of angles and different shading modes to make sure the pose looks dynamic and natural (see Fig. 6.3.28, textured screens).

FIG 6.3.28 Swing pose 5 – moving hold on hips/spine and finalization.

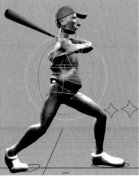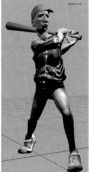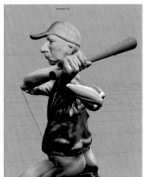

Scene file with the posing keyed from the start pose through to the final fifth swing pose is included with the project scene files as – **6.3_01_Pose_Swing05.ma**.

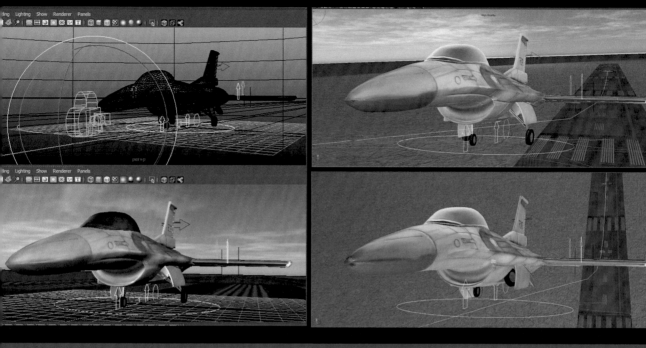

Secondary Action – Enhancing the Shot

Often, the one idea being put over in a scene can be fortified by a subsidiary action within the body.
Secondary Actions will add richness to the scene, naturalness to the action, and a fuller dimension to the personality of the character.

The Illusion of Life, Disney Animation – Frank Thomas and Ollie Johnston

Secondary action is the motion in a scene that is supportive of the main action or statement; it is usually separate, although related to the primary motion. Its application in animation is most effective when it is considered alongside the primary motion and other secondary motions in providing a unified statement to the action.

It can be implemented most effectively in an animation workflow alongside another key animation approach – blocking and pose-to-pose animation. In traditional animation practice, animators would commonly draw the key poses or primary actions of the character, including body movement, arms, legs, and head. The secondary elements that would be animated after

the primary elements are blocked in could include facial animation, hand gestures, props, background elements, cloth, appendages, etc.

In the tutorials, we looked at in earlier chapters; there were elements that could be classified as a secondary motion or a detail motion in the examples.

nCloth Simulation/nDynamics

The cloth simulation for the character cape that we looked at in the last chapter is an example of strong secondary action. The cloth setup was applied after the main run cycle animation for the character was blocked in. The simulation of the cloth is supporting of the main run animation and helps to strengthen and re-enforce the animation as it reacts convincingly to gravity and the character (see **Fig. 7.0.1**).

FIG 7.0.1 Secondary animation – nCloth cape.

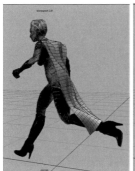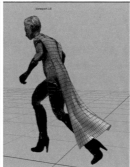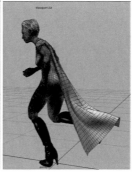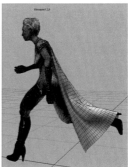

Typically cloth and other dynamics simulations will be added on top of the main animation to support and re-enforce the shot. This was also illustrated in Chapter 2, where we looked at the setup for nParticles for the rocket launch. The smoke that was added to the rocket flame could be classed as secondary to the main rocket flame as it helped to enhance the anticipation in the simulation.

Layered Animation and Supporting Action

In setting up dynamics simulation, often the effect will be layered to create more believability or nuance in the simulation. As in other areas of animation practice, this will be an iterative process in production as the simulation is refined and enhanced as more detail is added.

For example, in Chapter 8, we'll take a look at a rigid body dynamics simulation for a rocket strike on a building and military compound. At the start of the tutorial, the wall section is blocked in as a single breakable section; this is replaced with smaller pieces that break before the main building is struck – this and the preceding motion provide a lead into the main action, which is supportive or secondary (see **Fig. 7.0.2**, left screens).

FIG 7.0.2 Secondary animation – layered dynamics.

In Chapter 12, we will enhance the sequence through the use of another key animation principle – exaggeration; the sequence will be exaggerated through the addition of multiple secondary elements to the simulation including scaffolding, which collapses at the start of the animation. The addition of this secondary element creates additional anticipation for the sequence and pleasing overlap to the timing of the sequence (see Fig. 7.0.2, right screens).

Detail Animation

Secondary action should be considered supportive of the main motion and should not be overdone or else it can become primary to the action or distracting. Secondary motion should also be considered alongside staging or framing of an animation sequence – if the secondary motion is framed in close-up, it will become the primary motion.

FIG 7.0.3 Secondary animation – facial rig animation.

For example, for the facial head turn animation, we blocked in in Chapter 4, the main motion was the head turn (see Fig. 7.0.3, left screens). In Chapter 10, we'll look at how the animation can be enhanced to create performance appeal through different timing and spacing of both the head turn and the supporting motion of the facial expressions. As the face is framed in close-up, the main head turn is the primary action with the facial expressions being secondary, though also primary in the frame – if the head and facial animation were part of a full body performance on the character, both the facial animation and head gestures may become secondary depending on the framing and emphasis on the body motion (see Fig. 7.0.3, right screens).

Chapter 7.1 – Hand Animation Rig Setup

In this section, we'll take a look at setup for an animation rig for hands in Maya. As with any character setup, you should gather reference from life before designing the rig.

For humanoid control rigs, the types of reference you can pull on would include:

1. Anatomical reference, studies showing skeletal structure and muscle groups.
2. Photographic reference of the body in motion to study posing and anatomy in motion.
3. Video reference of the body in motion to study anatomy and motion timing.

First, let's take a look at some anatomical reference to understand how the joints and tendons in the hand are connected together. You can find this type of reference through online image search or by purchasing an anatomical reference guide (see Fig. 7.1.1).

FIG 7.1.1 Anatomy drawings – hand and major joint structure.

Looking at the structure, the major joints in the fingers are called the phalanges. There are three phalanges on each finger. The longest phalange is called the proximal phalange, the middle phalange is called the intermediate phalange, and the small, end phalange joint at the end of each finger is called the distal phalange. The phalanges are connected in socket by the distal interphalangeal joints. All the finger joints (excluding thumb) are connected to the wrist by the joints named the metacarpals (see Fig. 7.1.1, right screenshot).

If we take a look at some photographic reference of the hand in motion, we can study the range of movement in the hand and fingers as a reference for our setup and animation in Maya (see Fig. 7.1.2).

FIG 7.1.2 The hand and fingers in motion.

Studying from life, we can see that the three phalange joints in the fingers have a range of movement to curl inward and outward along single axis (see Fig. 7.1.2, first and second screenshots). This allows the fingers to curl inward to form fist or curl outward independently to create all manner of expressive shapes.

The second and third phalange joints (intermediate phalange and distal phalange) are restricted to rotate along only a single axis, whilst the main root phalange joint (proximal phalange) is not restricted to rotate along single axis. We can see this in the range of movement where the fingers can spread outward from the root phalange joint or inward to clasp each finger together (see Fig. 7.1.2, third and fourth screenshots).

We can apply what we've learnt by looking at a joint rig setup in Maya. Open the example scene file from the project folder – **7.1_00_Hand_Skeleton_Bind.ma**.

The scene file includes the base skeleton setup bound to the mesh with smooth skin bind. The hierarchy of the joints for the hand and fingers can be seen from the hypergraph in Maya (Window>Hypergraph: Hierarchy) (see **Fig. 7.1.3**).

FIG 7.1.3 Skeleton hierarchy – hand and fingers.

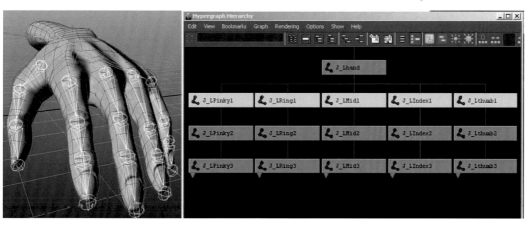

The three phalange joints for each finger are in a separate single joint chain. The main root phalange joint in each finger chain (proximal phalange) is a child of the hand joint in the hierarchy.

The main range of motion for each phalange in the finger joints is around the local Z-axis (highlighted blue when rotate tool is active) (see **Fig. 7.1.4**, left).

291

The second and third joints in the finger joint chain (intermediate phalange and the distal phalange) have restricted motion and should only really rotate around the local Z-axis to curl inward and outward (see Fig. 7.1.4, right).

FIG 7.1.4 Finger joints (phalanges) range of motion (Z-axis only for intermediate/distal phalange).

The root joint in each of the finger joint chains (proximal phalange) has a broader range of motion and can also rotate outward and inward, to spread the fingers or join together. The axis of rotation for the spread on the root proximal phalange joint is visible as the Y-axis local rotation (highlighted green) when the rotate tool is visible in Maya (see Fig. 7.1.5).

FIG 7.1.5 Root finger joint (proximal phalange) can rotate around local Y-axis to spread or clasp.

When animating, we would not want to rotate the joints in the axis they should not, if we were animating on the base skeleton setup in example, we would need to set rotation limits for the joints, so that we are not breaking the model – this can be done from the Attribute Editor (Ctrl + A) >Limit Information>Rotate. To more easily access the joint rotations, we work with for the hand whilst animating – it would be better to setup connections or a control rig, so that we can select and modify the rotations more easily – this will make it easier for the animator to select and modify the finger posing without selecting individual joints on the fingers to rotate and pose.

Introducing the Hand Rig

The final control rig for this tutorial is included in the project folder and is named as – **7.1_01_Hand_Rig.ma**. Open the scene file to get familiar with the controls. The setup includes a mesh for the forearm and hand that's skinned to the joint rig ready for animation.

Controls – Hand Placement, Elbow Placement, and Rotation

The basic controls to manipulate the hand, wrist and elbow are the same as we worked with back in Chapter 1. The main control for the hand placement is the circle named Ctrl_Hand that's highlighted green in the viewport. Translating the control with the move tool (W hotkey) moves the hand in the viewport (see Fig. 7.1.6).

FIG 7.1.6 Circular hand control (Ctrl_Hand) can be transformed to place hand in space.

The yellow cross-shaped locator in the scene (named Ctrl_Elbow) controls the angle of the elbow on the rig and is setup with Pole Vector Constraint for the IK arm joint chain. As with the hand control, translating the control will allow you to pose the elbow appropriately (see Fig. 7.1.7).

FIG 7.1.7 Cross-shaped locator control (pole vector) to control elbow position (elbow raised from Fig. 7.1.6).

The hand can be rotated in the viewport with the rotate tool (E) using the same circular Ctrl_Hand control that's used for placement in the scene (see Fig. 7.1.8).

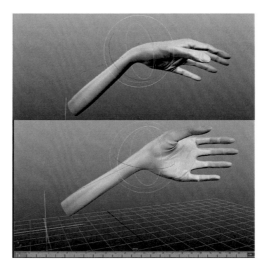

FIG 7.1.8 Circular hand control (Ctrl_Hand) controls hand rotation.

Note

The hand rotation is setup through an Orient Constraint in Maya. The root hand joint (that the mesh is bound to) is Orient Constrained to follow the rotation of the circular controller (Ctrl_Hand).

Attribute Connections for Finger Joint Rotation

The controls for the fingers have been added as custom attributes to the same circular Ctrl_Hand object that's used to place and rotate the hand. For reference, I'll quickly outline the process that was used to add the attributes and setup the controls. You can use similar setup on your own rigs or work from the base skeleton setup file with hand control setup to practice setting up the connections.

- Open – **7.1_01_Hand_Rig_StartConnection.ma**
- Controller selected in the Outliner or Viewport (Ctrl_Hand).
- Go to Modify>Add Attribute (at the top of the user interface).
- From Add Attribute window add a Displayable attribute to use as category name for each finger joint. Click Add to add Attribute.
- From Add Attribute window add a Keyable attribute for each joint in each finger (numbered 01>03). Go through same steps for the Index/Middle/ Ring/Pinky and Thumb fingers to add attributes. This attribute will control the main finger rotation inward and outward along the local Z-axis (see preceding section and Fig. 7.1.4).
- Once the attributes are added, they are viewable from the Channel Box (Ctrl + A) when the Ctrl_hand control object is selected (see Fig. 7.1.9).

FIG 7.1.9 Adding finger control attributes to the hand controller.

Using this process puts all the controls for the finger rotations in one place. This means that when animating, all you need to do is drag the sliders from the Channel Box to control the rotations of the fingers.

Note

When selecting the order to add attributes, you should consider which control you will need access to the quickest whilst animating. The main control we need is for only the Z-axis rotation on the fingers; individual attributes are added here for each phalange (finger joint). This means it is easy to group select all the joints to rotate inward or modify single attribute to offset individual joint or phalange rotation.

Additional attribute controls have also been added for the spread and twist on the root phalange for each finger. These are listed last in the Channel Box as they will not be modified as regularly (see Fig. 7.1.5 and preceding section for explanation of spread Y-axis rotation on root proximal phalange joint).

The process of linking the newly added attributes to the finger joint rotation is done through the connection editor in Maya (Window>General Editors> Connection Editor). The direct connections are setup by loading the Cntrl_Hand controller as a driver and the selected joint as a driven. Each of the added attributes is set to drive rotation on the joint through connection (see **Fig. 7.1.10**).

FIG 7.1.10 Connection editor – connecting the attributes to the joint rotation.

Each of the 01/02/03 attributes that were added on Ctrl_Hand control the Z rotation on each finger. As previously mentioned, this controls the rotation inward (curl) or outward (extension) for each finger. Connection is made between each of the attributes and rotation for each joint.

Working With the Finger Controls

To pose the rig, you simply need to select the hand control (Ctrl_Hand), and then either group selects the attributes by click dragging downward on the attribute name or Ctrl + Click the attributes you wish to modify. This allows you to quickly pose the fingers together or individually.

Example – Posing finger pointing

- Open the setup file – **7.1_01_Hand_Rig.ma**.
- Select the circular hand controller (Ctrl_Hand) in the Viewport. Open the Channel Box with Ctrl + A shortcut.
- In the Channel Box, select Index 01 attribute with Left Mouse Button held down (it will highlight in blue) and then drag downward with Left Mouse Button still depressed to also select Index 02 and Index 03 attributes.

Note

You can also use Shift + Click to select the group of attributes from first to last selected.

- With the attributes still highlighted, move the mouse pointer over the Viewport, hold down the middle mouse button (it will turn into a left–right arrow pointer), and drag right.

This will increase the value of the attribute, which controls the rotation upward of the three finger joints.

- Modify the value by dragging the mouse until you are happy with the posing (see **Fig. 7.1.11**).

FIG **7.1.11** Attribute sliders – posing the index finger.

The posing can be strengthened further by rotating up the root index joint (proximal phalange) on its own (Index 01).

- Select Index 01 attribute in the Channel Box and use the same process to modify the rotation on the joint by middle mouse dragging in the Viewport (see Fig. 7.1.12).

FIG 7.1.12 Attribute sliders – posing the index finger.

The other fingers can be curled inward to finalize the pose.

- With Ctrl_Hand still selected, go to the Channel Box, select "Middle" attribute with left mouse button and drag downward with the mouse still de-pressed to select all the Middle, Ring, and Pinky attributes.
- As before, move the mouse pointer over the viewport and middle mouse drag to curl the fingers; you'll need to drag left with the mouse to decrease the value to around −70 (see Fig. 7.1.13).

FIG 7.1.13 Attribute sliders – posing the other fingers, curl inward.

The final pose is included with the project scene files as
7.1_02_Finger Point.ma.

Tip

When modifying highlighted attributes by middle mouse dragging in the Viewport, you can increase the speed of the value change when dragging. To do this, use Ctrl + middle mouse button to slow the rate or Shift + middle mouse button to increase the rate the value changes whilst dragging.

Animating With the Rig Clenching Fist

Now that we've had a look at the basic controls and connections setup for the hand and fingers. Let's work on blocking out some more strong hand and finger poses before we get into refining the animations.

Idle Pose to Clench Fist (Punch)

- Open the project scene file – **7.1_03_Idle Pose.ma**.

The scene file has the hand posed as if at the side of the body in a rest position (see Fig. 7.1.14).

FIG 7.1.14 Idle pose.

- Select the circular hand control (Ctrl_Hand) and scrub the Time Slider to frame 0 and set a keyframe for the control at frame zero with S shortcut key.

Note

For objects with custom attributes stored and viewable from the Channel Box, hitting S shortcut key will key all the attributes at the same time. Attributes that are keyed are highlighted in red in the Channel Box. If you want to only key selected attributes at the current frame, right click on the highlighted attribute in the Channel Box and choose Key Selected option.

- Scrub the Time Slider to frame 7 and with the Move Tool (W shortcut) translate the hand up in Y-axis and out in X-axis, so that it is leveled with the elbow. After placing the hand, use the rotate tool (E shortcut) to rotate the hand up, so that it runs parallel with the forearm (see Fig. 7.1.15) with the hand control still selected, set a key at frame 7 for the pose.

FIG 7.1.15 Posing the hand for fist clench.

We'll use the same process as in the previous exercise to rotate all the fingers (excluding thumb) inward to clench.

- With the Hand Control (Ctrl_Hand) still selected, open the attribute editor and Ctrl + Click drag to select all the listed 01/02/03 attributes for each finger joint (see Fig. 7.1.16, left).
- Middle mouse drag in the Viewport to rotate the joints in until they are posed with the first joint in each finger roughly at right angle to the palm of the hand (see Fig. 7.1.16 right).
- Make sure that you are setting keys (S shortcut) at frame 7 for any modifications you're making to the attributes you've modified whilst posing.

FIG 7.1.16 Blocking in the finger poses.

You'll notice that the pose needs further refinement. Orbit round the model to view from the other side (inner palm), the fingers are spread out, and there's some overlap on the pinky from group rotating the joints from the idle pose (see Fig 7.1.17, left).

To resolve this, there are a couple of additional controls to control the root finger joints (proximal phalange) rotation inward and outward as well as the twist along their axis. These are listed at the bottom of the Channel Box under the headings Spread and Twist (see Fig. 7.1.17, middle). Use these to fix the overlap on the fingers, bring them in closer together, and make the twist axis consistent (see Fig. 7.1.17, right).

FIG 7.1.17 Fixing the finger spread
and twist on the pose.

We need to finalize the pose by bringing the thumb joints in to clench with the fingers.

- To do this, first use the thumb Spread and Twist controls to rotate the thumb outward, so that it is leveled with the index finger root joint.

Note

The Thumb Spread and Twist controls are listed directly under the Thumb 01/02/03 controls in the Channel Box when Ctrl_Hand is selected.

- Select the controls and modify the spread and twist to pose (see Fig. 7.1.18).

FIG 7.1.18 Rotating the thumb
outward with thumb spread and twist
controls.

Once the thumb's spread to the right pose, use the base joint controls (Thumb 01/02/03) for the Thumb to curl inward to clench into the fingers. You can use the same process as previously to Ctrl + Click to select and rotate all three joints at the same time before refining the individual posing for each joint by selecting and modifying the attributes individually (see Fig. 7.1.19). The final scene file is included with the project files as – **7.1_04_Idle Pose_Clench.ma**.

FIG 7.1.19 Final pose for the fist clench.

Punch Pose to Karate Chop

Let's say we're animating an action hero for a fighting game. We've already blocked out a major pose for a punch for the hand. We can work on other fight poses for the hand such as an outstretched chopping pose with the fingers and thumb flat and extended from the palm.

We'll work from the punch pose and block out some animation for the hand position going from the coiled punch pose where it is leveled to the elbow up to where the right shoulder would be on the character. Start from the previous file you were working on or open the included project file – **7.1_04_Idle Pose_Clench.ma**.

We'll create some anticipation for the move from the clenched fist fight pose to the karate chop pose.

* Go to frame 11, select the hand control (Ctrl_Hand) orbit, the Viewport round to the front of the hand, and move the hand control downward and out to the side (down in Y-axis and back in Z-axis). Once happy with the pose, set a key (S Shortcut). This'll create anticipation for the movement of the hand upward as the direction of movement is opposite to the following motion (see **Fig. 7.1.20**, right).

FIG 7.1.20 Anticipation pose for the hand.

301

• Scrub the timeline to frame 16 to work on the next pose for the hand and elbow. This is the major pose for the hand raised level with where the shoulder would be on the character in anticipation of the karate chop action.

For this pose, we want the hand raised up and rotated and we also want the elbow raised up, so that it is almost leveled with the hand.

• From the side view, move the hand control (Ctrl_Hand) up with the move tool (W), so that it is leveled with the shoulder (see Fig. 7.1.21).

FIG 7.1.21 Hand placement from side.

• Go to a front view (see Fig. 7.1.22, left screenshot).
• Move the hand control with the move tool (W) toward the opposite shoulder in Z-axis forearm (see Fig. 7.1.22, middle screenshot).
• Rotate the wrist round with the rotate tool (E), so that the hand runs parallel to the forearm (see Fig. 7.1.22, right screenshot).
• With the hand control (Ctrl_Hand) still selected, set a key at frame 16 for the pose.

FIG 7.1.22 Hand placement from front (steps from left to right).

For the karate chop pose, we want to lift the elbow up slightly. For this, we can use the elbow locator controller (yellow cross in Viewport).

• First, go to frame 11 in the Timeline, and select the locator (named Ctrl_Elbow) and set a key for the locator at the current position with Ctrl + W shortcut (see Fig. 7.1.23, left).

- Then go to frame 16 and move the locator up in Y-axis and out in X-axis to position the elbow correctly; at this step, you may also need to re-orient the hand control with the rotate tool, so that the hand runs parallel to the forearm (see Fig. 7.1.23, right) and set a key for the locator at frame 16 (S shortcut).

FIG 7.1.23 Raising the elbow with the pole vector locator (yellow cross).

We'll work on the posing for the fingers now.

- Select the circular hand control (Ctrl_Hand). Then at frame 16, click select the first value attribute for the finger controls and then drag down with the mouse button still de-pressed to select all the values for the attributes (see Fig. 7.1.24, left).
- Enter a value of 0 from the numeric keypad. This sets all the attributes for the fingers to the default rest pose, which we'll work from for the karate chop pose (see Fig. 7.1.24, right).

FIG 7.1.24 Resetting the control attributes for the fingers to return to the default rest pose.

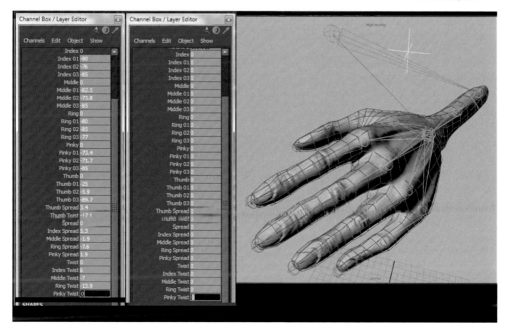

We can use the spread attribute on the Hand control (Ctrl_Hand) to bring the fingers closer together. You can Ctrl + Click to select the Index Spread and Middle Spread controls to rotate inward then the Ring Spread and Pinky Spread controls to bring them in to meet (see Fig. 7.1.25).

FIG 7.1.25 Using the spread attribute to rotate the fingers inward.

The base 01/02/03 attribute controls for the finger joint rotations can be used to group rotate the fingers upward, so that the fingers are tensed in the chop pose. Individual attributes can be modified to get the pose right. In example, I've rotated the fingers in exaggerated upward pose similar to the finger point pose covered earlier (see Fig. 7.1.26). For the thumb joint, the spread attribute is also used to bring the joint in to clasp the index finger with the end thumb joint (Thumb 03) rotated outward.

When finalizing the pose, you may need to modify the rotation of the wrist to keep a strong action line running from the tip of the fingers along to the palm and wrist. In example, the wrist has been rotated downward slightly (on Ctrl_Hand) to match the arc of the extended fingers (see Fig. 7.1.26 for final pose and attribute settings).

FIG 7.1.26 Final karate chop pose, fingers extended and clasped, with strong action line from wrist.

The final pose for the karate chop is included with the project files and is named as – **7.1_05_ClenchPose_Chop.ma**.

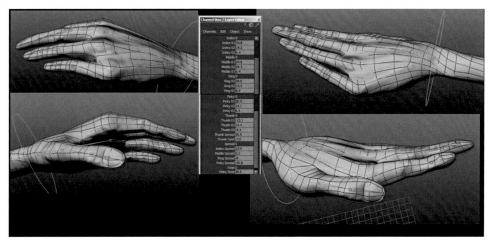

Joint Rotation Limits – Attribute Minimum and Maximum

Whilst working with the attribute controls to rotate the joints, you'll notice that there is a minimum and maximum amount that you can rotate the fingers by modifying the attributes, this is so that the fingers cannot be rotated beyond the natural limits of the joints.

The setup that controls this is done from the Edit Attribute window when the Ctrl_Hand object is selected (Modify>Edit Attribute). Minimum and maximum values can be set for the attributes from the Edit Attribute window (see Fig. 7.1.27, left screenshot). As the attributes have direct connections setup with the rotation values on the joints, the setup here limits the rotation of the joints.

For example, the root index joint attribute (proximal phalange = Index 01) cannot be set above maximum value of 40.0. This means that the index joint itself (J_LIndex1) cannot rotate above a maximum of 40.0 in Z-axis (see Fig. 7.1.27, right screenshot). You can modify these values from the Edit Attribute window if you find that you need to push the joint rotation beyond their limits.

FIG 7.1.27 Attribute minimum and maximum values limit rotation.

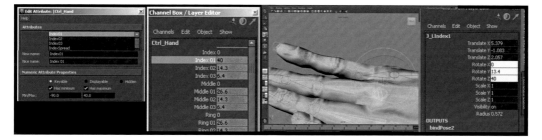

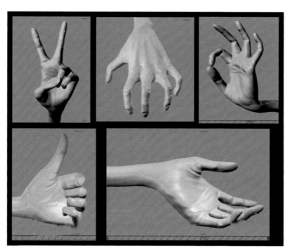

FIG 7.1.28 Variety of poses achievable from the attribute controls.

As we've seen, the attribute controls setup for the hand provide a high level of control when posing the fingers. We have group control over the overall cupping, clenching, and extension of the finger joints (phalanges). Group control of the attributes is easy to work with through Ctrl + Click and multiselection of the attributes from the Channel Box.

We also have a high level of individual control for the joints as each joint (or phalange) on the finger has an individual attribute; we can quickly and easily modify the finger posing to create poses that are unique and varied. The spread control attribute can be used to quickly spread out the fingers, and the additional twist attributes allow us to twist in the thumb and other joints.

Spend some time working with the attribute sliders and controllers to pose the hand in a variety of different poses. Included with the project scene files is a scene setup with main poses keyed for the hand to show the variety you can achieve – **7.1_06_Finger_Posing.ma** (see Fig. 7.1.28, above).

Refining the Hand Animation – Overlapping Action and Follow Through

So far, we've worked with the finger control attributes to create a variety of dynamic hand poses for the rig. We've found that the control setup is easily accessible, and multiple edits to the finger posing can be made quickly from the Channel Box attributes.

In the previous exercises, we used process of keying on the main hand control after setting each major pose for the fingers. This meant that all the keys for the finger pose attributes were set at same frame. This would be the process you would use to block out a pose when using a pose-to-pose type workflow.

As with any organic movement, not all joints or elements on the body move at exactly the same time. In keying the attributes at same frame in the previous exercises, the animation moves directly from one pose to the next without any overlapping motion or follow through.

In hand motion, the fingers naturally move like a coil. For example, going from a clenched pose to relaxed pose, the base joint on the index finger (proximal phalange) would naturally move first to full extension before the secondary finger in the joint (intermediate phalange) then the small joint at the end (distal phalange) (see Fig. 7.1.29, screenshots from left to right).

FIG 7.1.29 Finger moving from coiled position to full extension – root joint motion leads (proximal phalange) with appendage joints at the end of chain following through after (intermediate and distal phalange).

Similarly, not all the fingers will move at same time; typically the index finger joints will lead before the rest of the joints, which will follow through later. The motion of the fingers is organic and will naturally follow through from the wrist motion.

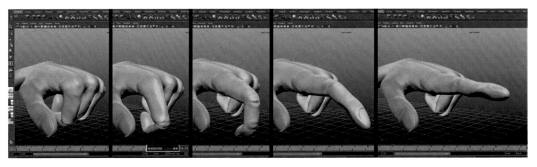

Let's take a look at an example scene file with poses blocked in to see how we can easily create natural overlap and follow through on the fingers by modifying the timing.

- Open the scene file – **7.1_07_Overlap_Follow_Through_Start.ma**.

The scene has two poses keyed at frame 1 and frame 24 for the hand and fingers. The hand rotates round from rest pose at from 1 to open welcome pose for the hand and fingers at frame 24 (see Fig. 7.1.30).

FIG 7.1.30 Two key poses in scene – frame 1 (relaxed) frame 24 (open/welcome).

As all of the hand and finger attributes have been keyed at same frame, there is no overlapping motion or follow through. We can make edits to the timing of the motion through the Dope Sheet to make the animation more organic and believable.

- Select the circular hand control (Ctrl_Hand) and open the Dope Sheet from Window>Animation Editors>Dope Sheet at the top of the user interface.
- Expand the Crtl_Hand heading at the left of the Dope Sheet window to display the keys for the additional finger attributes. From the Dope Sheet, we can see that the keys are currently blocked in and set at frame 1 and frame 24 for all finger attributes (see Fig. 7.1.31).

FIG 7.1.31 Keys visible in Dope Sheet window for hand control (Ctrl_Hand) and finger attributes.

We'll offset the timing of the index finger motion, so that it extends before the other fingers.

- In the Dope Sheet window, select the keys at frame 24 for Index 01, Index 02, and Index 03 and activate the move tool (W).

- With the Middle Mouse Button Depressed, drag the keys back to frame 11.
- Offset the frames for Index 02 and Index 03 to frames 17 and 19, respectively, so that they extend slightly later (see Fig. 7.1.32).

FIG 7.1.32 Keys offset for Index finger, so that it coils out before other fingers extend.

Use a similar process to offset the motion of the middle finger.

- Select (Q) and move (W) the start keys for Middle 01/02/03 attributes, so that the start frame is frame 6, set the end frames for the motion to frames 15/19/21, respectively (see Fig. 7.1.33).

FIG 7.1.33 Keys offset for middle finger attributes. Finger coils out after index.

The middle finger now starts moving after the index finger and stops later – as with the index finger, the motion for the individual joints on the middle finger are offset, so that the end joint coils out last (Middle 03 – at frame 21).

We can use the same workflow to add follow through for the ring and pinkie fingers.

- Offset the start key at frame 1 for Ring 01/02//03 to frame 9, so that they start moving after the index and middle fingers (which start at frame 1 and frame 5), offset the end frames for the ring 01/02/03 joints to frame 20, 23, and 25.

- The pinkie attributes should be set to move last, for example; not starting until frame 14 and ending at frame 32.
- The thumb motion can be offset, so it overlaps with the index finger motion; typically, the thumb joint will match timing of the index finger in leading the motion (see Fig. 7.1.34).

Note

Shifting the keyframes will set end time for the animation to frame 32 – the previous end frame was frame 24. To modify the end frame for playback, open and set Playback and Animation End from the Animation Preferences (Button at bottom right of the user interface).

FIG 7.1.34 Keys offset for ring, pinkie, and thumb. Screenshot from mid frame in the animation (frame 16) shows the motion offset as the fingers coil open.

The final animation is included with the project files as **7.1_08_Overlap_Follow_Through_FIN.ma**.

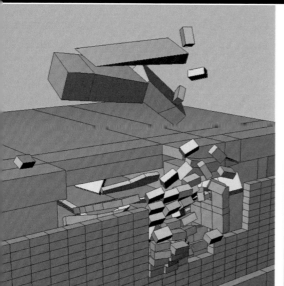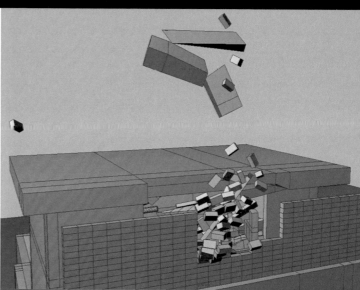

Straight Ahead Action and Pose to Pose

There are two main approaches to animation.
The Illusion of Life: Disney Animation – Frank Thomas and Ollie Johnston

"Straight ahead" and "pose to pose" are considered as distinct, different approaches to animation. With pose-to-pose animation, the animator will block in the key poses for the animation prior to working on the animation refinement. In traditional cell animation, a key animator would typically work on the key poses, while an "in-betweener" would work on the poses in-between the main poses.

In computer animation, the computer interpolates between motions through the motion curves or F curves (Graph Editor window in Maya). The traditional pose-to-pose technique has most in common with the current workflows used in computer animation, particularly with reference to character animation.

A traditional pose-to-pose-based approach to blocking animation is typically considered more methodical or worked out.

Throughout this book, we've worked primarily with a pose-to-pose-based workflow for the majority of the character animation exercises. For example, both the baseball batter and pitcher animations were blocked in using a pose-to-pose workflow.

In Chapter 6.3, with the baseball batter swing animation, preplanning and thumbnails were used to work out the major poses needed for the sequence as the animation was blocked (Fig. 8.0.1).

In previous chapters, we worked on refining both the timing & spacing (Chapter 3.2) and ease in/ease out (Chapter 4.1) for the same sequence.

This is similar to the typical workflow when working with a pose-to-pose-based workflow.

- The major poses are planned out and keyed.
- In-between poses are added to the animation and other iterative adjustments are made to refine and finalize the animation.

In 3D animation, as the software interpolates the motion between keyframes, there is less need to create each in-between frame manually as there would be if using traditional media such as cell or stop motion animation. However, the methodology is similar as iterative refinements are still made to timing & spacing posing and occasional in-between poses added to finalize the motion.

FIG 8.0.1 Pose to pose – baseball batter animation.

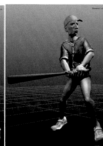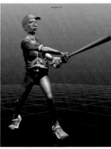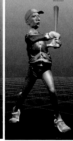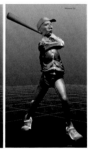

Pose to Pose – Walk and Run Cycles and Video Game

One area where a pose-to-pose workflow is commonly used is when creating gameplay animations for video games. For "in-gameplay" animation; typically a large number of animation clips are required for the main character that is controlled by the player. The playable character has to respond to a number of inputs by the player through the controller that are interconnected. The following are some examples of how the animations are interconnected:

- Idle animation – Character in stance pose (typically 1–2 seconds and looped).
- Idle to walk animation – Character goes from idle pose animation to walk animation).

- Walk or run loop animation – Character walk (around 1 second – looped).
- Character action – For example, character kick punch or shoot. This may use idle pose as the starting point or blend with the walk or run loop.

As the animations are interconnected, the poses typically need to match exactly at the end/start point where the motions may connect. More recent advances in game animation engines are more flexible in that they allow IK blending between different animation clips, but the principle is largely still the same.

For loopable animations such as runs and walks, which we'll look at in this chapter, following a pose-to-pose workflow is key to achieving great results. As we saw in Chapter 3.1, when we looked at timing & spacing for walks and runs, even posing and spacing for walks and runs is required so that the steps or paces on the motion look natural. To achieve this, pose copying as well as pose mirroring are required to match the spacing on the strides on the body as well as the spacing of individual elements.

In the first chapter tutorial, we will look at how the workflow can be broken down as we focus on creating loop on each major body part through the hips, legs, arms, and overall motion (Fig. 8.0.2).

FIG 8.0.2 Pose to pose – run cycle tutorial.

Straight Ahead Action and Combining Both Methodologies

In contrast to pose-to-pose animation, a straight ahead approach to animation is more fluid and organic. With a straight ahead workflow, an animator would work from the first frame of animation straight ahead through the sequence without blocking poses or considering framing. Although considered more fluid, a straight ahead approach to animation has disadvantages where clear planning and framing are required. For example, a character animation sequence requiring the character to travel a set distance within the scene and interact with a number of elements or characters would be difficult to plan with the straight ahead approach to the sequence.

By understanding the strengths of both approaches and how they can be applied within Maya, we can choose the most appropriate method to suit the current shot. In 3D animation, a number of areas including dynamics and simulation are primarily calculated by the software after setup by the animator or technical director.

For example, the nParticle rocket and nCloth cape setup we looked at in earlier chapters were setup to simulate the natural effect of particles and cloth. Although the animator has control over the effect of the simulation through the settings in Maya, the quality and believability of the results are partly down to the calculations made in the software.

For the rigid body dynamics setup, which we'll look at in the second tutorial in this chapter, the effect is partly directed through setting up which elements are breakable within the scene during the simulation – this could be classed as "pose to pose." However, although the simulation is partly directed through planning each major collision in the simulation, elements of the simulation are not directed and could be classified as "straight ahead." Knowing when to let the software direct the action through the simulation and knowing where to direct the action to make adjustments to the effect or direction of the collisions is key to getting the right results (Fig. 8.0.3).

FIG 8.0.3 Straight ahead and pose to pose – dynamics.

Chapter 8.1 – Pose-to-Pose Run Cycle

In this section, we'll take a look at a pose-to-pose workflow for animating a character run cycle. Pose-to-pose animation is typically defined as a workflow whereby the major or key poses are blocked in first for the animation and then the in-betweens for the animation (or refinements) are added.

In previous chapters focussing on character animation, we've used a similar workflow to establish the major poses for the animation. For character walk and run cycles, pose to pose is a great fit as the poses are quite broad and repeat across the cycle. If we take a look at video or photo reference of a run cycle, we can see that during the cycle there is mirroring in the posing and that broad motions on the legs and arms are countered.

Breaking the major poses down through thumbnails shows that poses are identically mirrored during the run at the major poses where the legs are fully extended at the start and midpoint of the run (Fig. 8.1.1 – first pose – left leg fully extended, end pose – right leg fully extended).

As the legs fully extend, the opposite arm extends fully to keep the pose weighted and balanced. As the major poses are effectively mirrored from the start to the half way midpoint in the run, we can effectively reuse poses throughout. From the mid-point in the animation to end, the poses are effectively mirrored again with the final pose being identical to the first.

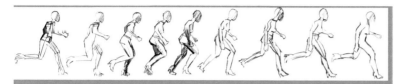

FIG 8.1.1 Thumbnails — run cycle poses — start frame to mid frame on cycle.

For the tutorial, we will be working with the same female character mesh as used in the nCloth cape tutorial in Chapter 6.2. We worked with the same animation setup back in Chapter 1.4, where we looked specifically at the motion arc for just the hips on the run.

In this tutorial, we'll go into a bit more detail in working with the control rig setup for the character. In this tutorial, we will focus on posing for localized body part elements to create the run cycle. We'll also look at how to pose the body part elements for the foot placements on the run as well as how to create the arcs on the torso and mirroring posing on other localized body elements (Fig. 8.1.2).

FIG 8.1.2 Character pose mirroring and torso posing.

Leg and Hip Pose

Open the start setup scene from the project scene files directory – **8.1_01_Run_Start.ma**.

The scene file uses the character setup from online Chapter 9.1 for the exercise. The character and control rig are in the default stance bind pose facing forward (in the +Z-axis, (Fig. 8.1.3, first screenshot)). As we're working on a run cycle, the scene frame length is set appropriately for the run cycle at 16 frames. For a run, the typical length will be around two-thirds of a second; as the frame rate is set to 24fps, this is correct.

For a run cycle, the overall character posing will be identical at the first and last frames (frames 00 and 16). The legs will be extended in the run pose, with the pose mirrored at the midpoint in the animation to create the cycle. Let's take a look at blocking in the leg and hip poses for the run.

- Scrub the Time Slider to frame 00.
- Set the current view to a side orthographic view from Panel menu > Panels > Orthographic > side (Fig. 8.1.3) when working on posing for a run or walk cycle it helps simplify the workflow by doing the initial pose blocking in a side orthographic view.
- At frame 00, select the main hips control object from the Outliner (named FSP_COG_CTRL) or Viewport (the red cube-shaped control) (Fig. 8.1.3, second screenshot).
- With the control selected, enable the move tool (W) and pull the control object downward along the global Y-axis to lower the hips position. The feet should remain planted as IK is enabled for the feet. We want to lower the hip position so that the legs can be extended on the ground plane for the run. The hips should be lowered to around Y = −0.092 (Fig. 8.1.3, second screenshot).

Note

IK is also setup for the hands which will also remain locked in space, without movement during these initial edits. Do not worry about this for now as the hand posing and animation will be worked on later in the tutorial.

FIG 8.1.3 Initial hips and leg poses for run.

- With the control still selected, set key at frame 00 for the translation with the Shift + W shortcut key.

For the leg and feet pose, we'll set up the left foot so that it is still planted on the ground with the right leg raised behind. This is a midpoint in the run, with the weight passing onto the leading left leg.

- Select the left foot control from the Outliner (named FSP_Foot_L_CTRL) or Viewport (the blue circular-shaped control at the sole of the left foot).
- With the control selected, enable the move tool (W) and pull the foot forward in the +Z-axis (around 0.471) and raise it slightly in the Y-axis

(around 0.008 units). Rotate the foot upwards slightly with the rotate tool (E) to suggest that the heel is making initial contact with the ground (Fig. 8.1.3, third screenshot). Set key for translation and rotation by hitting Shift + W and then Shift + E, respectively.

- The right foot should be posed back, trailing the leading left foot. Select the right foot control (FSP_Foot_R_CTRL) and translate backward (in the –Z-axis) and upwards (in the +Y-axis) with the Move tool. The values used in the final example scene are

 Translate Y = 0.381
 Translate Z = −0.502

- The foot needs to be rotated round to follow the line of the leg, with the control selected, enable the rotate tool (E) and rotate back in the local X-axis to around rotate X = 94.063

- Once you're happy with the pose, set key for the translation and rotation using the Shift + W and Shift + E shortcut keys (Fig. 8.1.3, fourth screenshot), respectively.

Mirroring the Pose across the Character (Left <> Right)

For a run cycle, the pose should be mirrored at the midpoint of the cycle. For the hips and legs on our run, this means that the extended left leg at frame 00 should be mirrored with the right leg extended at frame 8 (midpoint of run) and the raised trailing right leg at frame 00 should be mirrored with the left leg trailing the opposite leg at frame 8.

We can use a simple workflow to mirror the poses between the frames. This workflow works as the translations on the control objects for the character have been frozen prior to animation. This means that the initial translation values are X = 0/Y = 0/Z = 0, with any subsequent translations for the posing being offset from this. As the translations are frozen for the feet controls, the values we've used when posing can be easily copied across from the left to right controls and vice versa on the character.

- At frame 00, select the right foot control (FSP_Foot_R_CTRL) and open the Channel Box to view the translation and rotation values (Ctrl + A) (Fig. 8.1.4, second screenshot).

- From the Channel Box, double-click each of the numeric fields in turn for Translate Y/Translate Z/Rotate X and use the Ctrl + C shortcut key to copy the values to the Windows Clipboard.

> **Tip**
>
> Double-clicking in the numeric input field will highlight the current value number. This is the number shown to the right of the channel name.

FIG 8.1.4 Mirroring the leg pose.

Note

You can use Windows Notepad or any other typing application as an intermediate to note these values (with Ctrl + V [paste shortcut]).

- Scrub the Time Slider to frame 8. This is the frame we want to mirror the leg poses across on.
- Select the opposite foot control (FSP_Foot_L_CTRL) and from the Channel Box (Ctrl + A toggle) double-click in the numeric input fields and with the paste shortcut key (Ctrl + V), paste the numeric values for Translate Y/Translate Z/Rotate X that were copied from the opposite foot (Fig. 8.1.4, second screenshot, bottom).

The copy/paste of the values has to be done separately in turn for each channel value (X/Y/Z).

- The left foot should be trailing in the same position as the right foot control (Fig. 8.1.4, third screenshot). With the left foot control still selected (FSP_Foot_L_CTRL), hit the Shift + W and Shift + E shortcut keys to set key for the translation and rotation, respectively.

Use the same process to mirror the left foot pose across to the right foot.

- Scrub the Time slider back to frame 00 and select the left foot control object (FSP_Foot_L_CTRL).
- From the Channel Box (Ctrl + A), double-click in the numeric input fields to copy the values for Translate Y/Translate Z/Rotate X and use the Ctrl + C shortcut key to copy the values to the Windows Clipboard. Paste the values in Windows Notepad or other typing utility (Fig. 8.1.4, third screenshot, top).
- Scrub the Time Slider to frame 8 and select the right foot control object (FSP_Foot_R_CTRL).
- From the Channel Box, use the Ctrl + V shortcut key to paste the values for Translate Y/Translate Z/Rotate X in the Channel Box. Hit the Shift + W and Shift + E shortcut keys to set key for the translation and rotation respectively at frame 8 (Fig. 8.1.4, third screenshot, bottom).

- The right foot should be fully extended and planted on the ground plane at frame 8 (Fig. 8.1.4, fourth screenshot), mirroring the pose on the left foot at frame 00 (Fig. 8.1.4, first screenshot).

Copying Pose from Frame to Frame

To loop the animation, we need the pose at frame 16 to exactly match the initial pose at frame 00 (left leg extended). We can easily do this by doing the following:

- Scrub the Time Slider back to frame 00.
- Hover the mouse cursor over frame 16 and click with the middle Mouse button exactly on frame 16.
- Doing this updates the current frame to frame 16, but keeps the animation for the elements in the Viewport same as it was at frame 00. The animation isn't updated. This allows us to key the control objects at frame 16 with the same values as were used at frame 00.
- After clicking on frame 16, select each of the following and set a key for translation and rotation with the Shift + W and Shift + E shortcuts, respectively.
 - FSP_COG_CTRL
 - FSP_Foot_L_CTRL
 - FSP_Foot_R_CTRL

If you playback the animation (Alt + V), the leg poses should cycle correctly from frame 00 to frame 16. Looking at the animation, it is still pretty blocky and needs further refinement. The leg motion is floaty, and the hips do not rise and fall naturally as you'd expect.

Foot Plant

Scrub the Time Slider to frame 03, here you can see that the left foot is raised of the ground where it shouldn't be (Fig. 8.1.5, first screenshot). It should really still be planted on the ground at this section of the animation. We can add an in-between key to keep the foot planted.

- At frame 03, select the left foot control object (FSP_Foot_L_CTRL).
- From the side orthographic view, enable the Move tool (W) and move the foot down in the Global Y-axis and back a bit in the global Z-axis (Fig. 8.1.5, second screenshot).
- Use the Rotate tool (E) to rotate the foot control so that the foot is posed correctly, planted on the ground plane (Fig. 8.1.5, second screenshot).

The Ball Roll attribute can also be used to compress the foot in toward the toe to suggest the weight compression on the foot plant. Click the Ball Roll attribute name in the Channel Box so that it is highlighted in blue (Fig. 8.1.5, second screenshot). With the attribute selected, move the mouse cursor over

the Viewport and hold the Ctrl key and the middle Mouse button and then drag slightly to decrease the attribute to around − 24.9 to compress the toe. With the attribute still selected in the Channel Box, right-click on the attribute name and choose Key Selected to key the attribute.

Note

You will need to also key the attribute at value 0 at frame 00 where the toe pose isn't compressed.

- The other values for translation and rotation for the foot control at frame 03 should be
 Translate Y = 0.003
 Translate Z = −0.188
 Rotate X = 0.436
- Key the translation and rotation at frame 3 for the left foot control with the Shift + W and Shift + E shortcut keys (Fig. 8.1.5, second and third screenshots), respectively.

FIG 8.1.5 In-between foot pose, foot plant.

The in-between foot plant pose should be mirrored across to the opposite frame at the same corresponding part of the animation sequence. This plant pose at frame 3 is three frames after the initial left foot plant pose at frame 00. For the right foot, the initial foot plant pose is at frame 8, so the mirrored pose should be at frame 11. Use the same process as before to copy the Channel Box translation and rotation values from the left foot control (FSP_Foot_L_CTRL) at frame 3 across to the right foot control (FSP_Foot_R_CTRL) at frame 11. The value for the Toe Roll attribute should also be duplicated at this frame (Fig. 8.1.5, third and fourth screenshots).

Centre of Mass – Weight Rise and Fall

Playback the animation, the feet plants now look more natural, but there is no corresponding weight shift on the hips during the feet plant shift between the feet. We can key the translation for the hips and use the Graph Editor to edit the curves for the motion so that it looks more fluid and natural.

- Select the main Centre of Mass control for the character's hips (FSP_COG_CTRL).
- The value we keyed at frame 00 for the translation Y is −0.092. This value is constant throughout the animation as no other keys have as yet been set.

If you playback the animation, the major weight shifts are at or around the key poses we've already blocked in.

- At frames 00, 08, and 16, the left and right feet are planted on the ground with the heel leading. The full weight plant and shift downwards on the hips should be a couple of frames after (at frames 02 and 10).
- There should be another in-between pose for the hip height three frames before the main poses to indicate the main rise on the hips where the body is fully off the ground in the run. This pose should be keyed at around frame 5 (three frames before frame 8) and frame 13 (three frames before frame 16).
- At frame 5, select the COG control (FSP_COG_CTRL), enable the Move tool, pull the hips up in the global Y-axis to around Translate Y = −0.032, and hit Shift + W to key the translation (Fig. 8.1.6, first screenshot).
- Still at frame 5, move the mouse cursor over frame 13 in the Time Slider and then click the middle Mouse button to go to frame 13 but maintain the same posing as in the Viewport from frame 5. Again, hit Shift + W to key the translation (Fig. 8.1.6, first and second screenshots).

FIG 8.1.6 Centre of mass, hip raise pose, and Graph Editor.

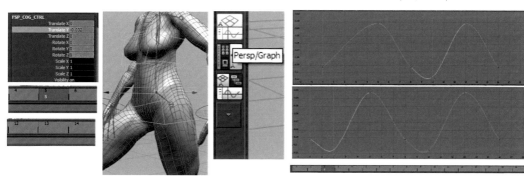

The translation on the hips should dip slightly after the pose at frames 00, 08, and 16.

- Scrub the Time Slider to frame 2, and with the hip control still selected, enable the Move tool (W) and pull the hips down slightly in the Y-axis. To around Y = −0.105. Hit the Shift + W shortcut to key the translation.

The pose can be copy/pasted by using the same process as before.

- Still at frame 2, click the middle Mouse button on frame 10 to update the frame number but keep the posing in the Viewport the same as at frame 2. Hit Shift + W to key the translation for the hips.

Editing the Motion Curve Through the Graph Editor

We can use the Graph Editor to refine and finalize the motion curve for the hips Y-translation.

- With the hips centre of mass control still selected, go to the Maya Tool Box on the left of the User Interface and select the Perp/Graph layout screen from the icon button to split the panels into a Perspective (top) and Graph Editor (bottom) two-pane layout (Fig. 8.1.6, third screenshot).
- From the left pane of the Graph Editor window, select the Translate Y channel to view the motion curve (Fig. 8.1.6, fourth screenshot).

Tip

If the translation channels are not listed for selection, go to Show > Attributes > Translate from the top of the Graph Editor.

- Select the keys to display the tangent handles in the Graph Editor. The key tangent handles should be adjusted so that there is a smooth motion curve for the hips translation up and down in the Y-axis (Fig. 8.1.6, fourth screenshot, bottom).

Cycling the Motion Curve

Maya includes a tool to cycle a motion curve beyond the start and end frames of the curve. This is especially useful when working on animation cycles such as a run.

With the Graph Editor window still open and the Translate Y channel selected and curve displayed,

- Go to the Curves menu at the top of the interface and select and enable the following:
 Curves > Pre Infinity > Cycle
 Curves > Post Infinity > Cycle

This cycles the motion curve to infinity before and after the existing motion.

- Go to the View menu at the top of the interface and enable "Infinity" option.

This displays Pre Infinity and Post Infinity motion curve as a dotted line before and after frames 00 and 16. The dotted line curve cannot be modified, though it will be updated as you make edits to the keys on the curve that it references. Use this display to make edits to the Key tangent handles on the first and last keys (at frames 00 and 16) so that the curve cycles smoothly (Fig. 8.1.7).

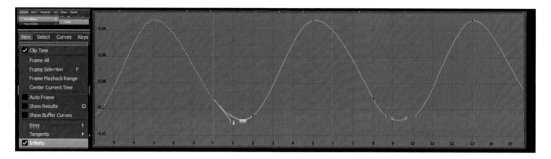

FIG 8.1.7 Pre infinity and post infinity cycle in Graph Editor.

Hip Rotation

If you preview the animation (Alt + V), the weighting on the hips looks more convincingly combined with the foot plants. On a walk or a run, the hips also rotate considerably during the foot plants. As the weight is transferred to the leading leg, the hips naturally drop on the side of the trailing leg (Fig. 8.1.8, third screenshot). The hips also rotate forward and backward a lot, with them rotating forward on the side of the leading leg that is planted (Fig. 8.1.8, first and second screenshot). The character setup uses an individual control for just the hips rotation; the control object is the yellow circular shape around the hips and is named FSP_Hip_CTRL. Let's pose the hip rotation with the control to finalize the hip motion for the run cycle:

- Select the Hip sway control object from the Viewport (yellow circular control) or Outliner (named FSP_Hip_CTRL).
- With the control selected, change the Viewport to a Perspective view from Panels > Perspective > persp.
- In the Perspective view, use the Camera Tools to tumble, track, and dolly around to a front view of the character with the view slightly above the character so that we can pose the hips around the local Y-axis rotation (Fig. 8.1.8, first and second screenshot).
- With the hip sway control selected, scrub the Time Slider to frame 00 and, with the rotate tool (E) enabled, rotate the left hip forward around the local Y-axis to follow the motion of the leading leg (Fig. 8.1.8, first screenshot). The rotation should be around Rotate Y = −20 in the Channel Box. Hit Shift + E to set a key for the rotation at frame 00.
- Take a note of the Rotate Y value from the Channel Box at frame 00 that you've keyed so that we can use this value in the next step.
- Scrub the Time Slider to frame 8; at this frame, the hips rotation in the Y-axis should be exactly mirrored; the right leg is leading and planted at this frame, whereas at frame 00, the opposite is true. Double-click in the Rotate Y channel in the Channel Box to numerically input the Rotate Y value. Put in the number that is the negative of the value that was noted from the last step. In the final example scene, Rotate Y value was −20 at frame 00, with the Rotate Y being set to +20 at frame 8 (Fig. 8.1.8, second perspective screenshot). Hit Shift + E to set a key for the hip rotation at frame 08.

323

FIG 8.1.8 Hip rotation pose at the major pose points, frames 00 (and 16) and 08.

Use the same process as in previous steps to copy the Hip Y-rotation from frame 00 to frame 16 and set key.

The hips also rise and fall depending on the planted leg to show the weight shift.

- With the hip sway control selected, enable the rotate tool (E) and scrub the Time Slider to frame 00.
- Rotate the hips upward around the local Z-axis to raise the left side of the hips upwards (Fig. 8.1.8, third perspective screenshot). The rotation should be around Rotation Z = +10 in the Channel Box. Set a key for the rotation with Shift + E at frame 00 and also set a key at frame 16 for the same value (Fig. 8.1.8, second Channel Box screenshot).
- Mirror the rotation shift at frame 8 by copy pasting the value for Rotate Z and changing to negative value (Fig. 8.1.8, fourth perspective screenshot). In the final example scene, Rotate Z = +10 at frame 00/16 and Rotate Z = −10 at frame 8. Set another key for the rotation at frame 8.

The scene file with the foot plant poses and hip weight shift poses blocked in is included with the project scene files as – **8.1_02_Run_Lwr_Block01.ma**.

Upper Torso – Main Pose

With the feet planting and hip posing blocked in, we can take a look at blocking in the posing for the upper torso. If you look at the pose as it is from the scene file, you're working on, to the included project scene file – **8.1_02_Run_Lwr_Block01.ma**. The upper torso is upright in the default pose, this doesn't look natural for a run cycle animation (Fig. 8.1.9, first screenshot).

Normally, the upper body will be leaning forward slightly to follow the motion of the run and balance the weighting on the body during a run.

- Scrub the Time Slider to frame 00 and use the Viewport navigation controls to tumble around to a side view of the character.
- Select the main centre of mass control object from the Viewport (the red cube-shaped control at the base of the hips) or Outliner (named FSP_COG_CTRL).
- With the rotate tool active (E), rotate the hips forward around the positive local X-axis to bend the torso forward. The value for Rotate X in the

Channel Box should be around +15 units (Fig. 8.1.9, second screenshots from left). Hit Shift + E to set key at frame 00.

The other torso control (FSP_Spine02_CTRL) can also be rotated forward slightly and keyed to make the pose more natural (at around Rotate X = +10) (Fig. 8.1.9, third screenshot from left).

FIG 8.1.9 Posing the torso rotation forward for the run.

For the neck and head controls (FSP_Neck01_CTRL and FSP_Head_CTRL), these can be rotated back slightly and keyed to keep the pose balanced (Fig. 8.1.9, fourth screenshot from left).

Torso and Head Follow Through

The main pose we've keyed for the torso and head looks more natural. We can refine the animation by adding some follow through to the torso and head rotation to emphasize the weight on the foot plants. For this, the control objects from the base of the spine down to the head can be keyed and rotated forward slightly just after the foot plant. Moving down from the spine to the head, the motion should be offset by 1–2 frames for each subsequent joint in the chain to create the follow-through motion.

- Select the main centre of mass control – FSP_COG_CTRL – scrub the Time Slider to frame 3 and rotate the control forward slightly in the local X-axis, set key (Rotate x = around 18 units), and copy the key to frame 11, which is the mirrored foot plant on the opposite leg.

For the shoulder spine control, we can animate this rotating forward 1–2 frames after the hips.

- Select the main upper torso control – FSP_Spine03_CTRL – first, set key at frame 0, then scrub the Time Slider to frame 4 and rotate the control forward slightly in the local X-axis, set key (Rotate x = around 6 units), and copy the key to frame 12, which is the mirrored foot plant on the opposite leg.

For the head control, we can animate this rotating forward 1–2 frames after the upper torso to create a nice bobbing motion on the head.

- Select the head control – FSP_Head_CTRL – scrub the Time Slider to frame 5 and rotate the control forward slightly in the local X-axis, set key (Rotate x = around 5 units), and copy the key to frame 13, which is the mirrored foot plant on the opposite leg.

Note

Make sure that the initial key set at frame 00 is copied to frame 16 to create a perfect loop.

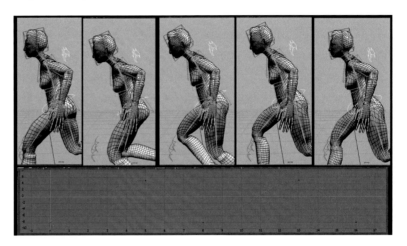

FIG 8.1.10 Torso and head follow through and bob on run.

The follow-through motion can be validated by playing back the animation (Alt + V). In the example, the rotation for the torso and head bob is quite pronounced to emphasize the follow through on the motion (Fig. 8.1.10). The motion curves for the torso elements can be further refined from the Maya Graph Editor.

Tip

When working on a walk or a run cycle, the Graph Editor can be used to soften or exaggerate the motion by scaling the motion curve. To do this, select the keys on the curve and with the scale tool enabled (R shortcut), click and drag up and down with the middle Mouse button to scale the curve (Fig. 8.1.10).

The scene file with the follow-through motion on the torso and head blocked in for the run is included with the project scene files as – **8.1_03_Run_Uppr_Folw01.ma**.

Torso Counterbalance Rotation – Part One

The torso rotation should counter the hips rotation that was keyed in the previous steps. Tumble around the character in the Perspective Viewport to work on the posing. At frames 00 and 16, the left side of the hips is raised

slightly to show the weight shift onto the planted left leg (Fig. 8.1.11, first screenshot). The torso should be posed in a curved S-shape to give a natural flow to the pose, with the left shoulder naturally dropping downward to counter the weight shift when the left side of the hips rises (Fig. 8.1.11, third screenshot).

- At frame 00, select the first spine control – FSP_Spine01_CTRL – and rotate down around the local Z-axis with the rotate tool to around Rotate Z 1.5, set key (Fig. 8.1.11, second screenshot). Also, set key at frame 16 for same pose.
- At frame 00, select the second spine control – FSP_Spine02_CTRL – and rotate in the opposite direction around the local Z-axis to counter the hip rotation. With Rotation Z = −5, set key (Fig. 8.1.11, third screenshot). Also, set key at frame 16 for same pose.
- At frame 00, select the third spine control – FSP_Spine03_CTRL – and rotate in the opposite direction to the hips around the local Z-axis to counter the hip rotation. With Rotation Z = −6, set key (Fig. 8.1.11, third screenshot). Also, set key at frame 16 for the same pose.

FIG 8.1.11 Torso and hips counterbalance.

Use the same process as used previously to mirror the rotation on these poses at frame 8. As before, the rotation values should be mirrored from negative to positive values and keyed. For each of the spine controls, these should be keyed as follows:

FSP_Spine01_CTRL – @ Frame 8 = Rotate Z = −4.5
FSP_Spine02_CTRL – @ Frame 8 = Rotate Z = +5
FSP_Spine03_CTRL – @ Frame 8 = Rotate Z = +6

Validate the counter rotation by scrubbing the Time Slider and playing back the animation (Alt + V). The animation should look more balanced when viewed from the front or back of the character, with a nice bobbing motion on the head. This can be toned down a bit as described in the following section to dampen the motion and add more counterbalance.

The scene file with the torso rotation in the local Z-axis counterbalanced with the hip rise is included with the project scene files as – **8.1_04_Run_ Uppr_CounterRot01.ma**.

Torso Counterbalance Rotation – Part Two

The upper torso rotation should also counter the hips rotation around the way in a corkscrew motion. If you look at the existing pose blocking (from **8.1_04_Run_Uppr_CounterRot01.ma**), the hips rotate around the local Y-axis to follow the leading leg (Fig. 8.1.8, first and second perspective screenshots). In a walk or a run cycle, the opposite shoulder should rotate round to counter the leading leg to create balance and weight. The rotations should follow a natural S-shape curve and be distributed gradually from the base hip joint down to the neck (Fig. 8.1.12). When working on this counter rotation, it's best to view the animation from a three-fourth top/down view in a perspective Viewport (Fig. 8.1.12, first and second screenshot).

FIG 8.1.12 Shoulder and hips counterbalance.

- At frame 00, select the first spine control – FSP_Spine01_CTRL – and rotate around the local Y-axis with the rotate tool to around Rotate Y = −3, set key (Fig. 8.1.12, second and third screenshots). Also, set key at frame 16 for the same pose.
- At frame 00, select the second spine control – FSP_Spine02_CTRL – and rotate around in the opposite direction in the local Y-axis to counter the hip rotation. With Rotation Y = +8, set key (Fig. 8.1.12, second and third screenshots). Also, set key at frame 16 for same pose.
- At frame 00, select the third spine control – FSP_Spine03_CTRL – and rotate around in the opposite direction to the hips in the local Y-axis to counter the hip rotation. Rotation Y = +13, set key (Fig. 8.1.12, second and third screenshots). Also, set key at frame 16 for the same pose.

Use the same process as used previously to mirror the rotation on these poses at frame 8. As before, the rotation values should be mirrored from negative

to positive values and keyed (Fig. 8.1.12, first and fourth screenshots). For each of the spine controls, these should be keyed at the following values in Channel Box.

FSP_Spine01_CTRL – @ Frame 8 = Rotate Y = +3
FSP_Spine02_CTRL – @ Frame 8 = Rotate Z = −8
FSP_Spine03_CTRL – @ Frame 8 = Rotate Z = −13

Head Counterbalance

If you playback the existing animation, you'll notice that the head motion looks a bit odd. As the upper torso has been rotated around to counter the hip rotation corkscrew, the head is following the motion, so it looks as if the character is looking from side to side while running (Fig. 8.1.12, first and second screenshots). This can be resolved by countering the rotation, which also creates a more natural S-curve shape on the spine (Fig. 8.1.13, third and fourth screenshots).

- At frame 00, select the base neck control (FSP_Neck01_CTRL) and rotate back around slightly in the local Y-axis (to around Rotate Y = −6). Set key for the rotation and copy the key to frame 16.
- Mirror the key to frame 8 with the control keyed at around Rotate Y = +6.

FIG 8.1.13 Head rotation offset to counter torso corkscrew motion.

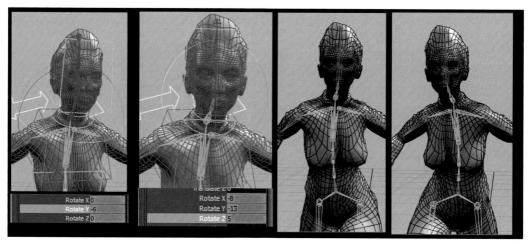

- At frame 00, select the head control (FSP_Head_CTRL) and rotate back around slightly in the local Y-axis (to around Rotate Y = −13). Set key for the rotation and copy the key to frame 16.

The head can also be tilted over slightly in the local Z-axis rotation to counter the spine and create a nice S-curve.

- Select the head control (FSP_Head_CTRL) and rotate back around slightly in the local Z-axis (to around Rotate Z = +5). Set key for the rotation and copy the key to frame 16.

Mirror the key to frame 8 (Fig. 8.1.13, fourth screenshots). With the head control keyed at

Rotate Y = +13
Rotate Z = −5

The scene file with the torso counter corkscrew rotation and head counter rotation is included with the project scene files as – **8.1_05_Run_Uppr_ CounterRot02.ma**.

Arm Swing on Run

The pose blocking we've established has blocked in the posing for the legs, hips, upper torso, and head. The arms and hands are still locked in space as IK is enabled, so they aren't following the motion on the run (Fig. 8.1.14, first screenshot). The arm posing on a run should follow the motion of the upper torso, and the arms will typically follow through with the posing following the corkscrew motion of the upper torso. Therefore, the arm poses should be the opposite of the posing on the legs, so when the left leg moves forward, the left arm swing backward to counter the weight (and vice versa). Let's take a look at posing the left arm on the run:

- In the Perspective Viewport, tumble around to a front view of the character (Fig. 8.1.14, first and second screenshots). Scrub the Time Slider to frame 00.
- Select the left-hand control object (named FSP_Hand_L_CTRL in the Outliner, it's the blue circular control in the Viewport).
- With the move tool (W) enabled, pull the hand inwards a bit toward the body in the global negative −X axis. (Fig. 8.1.14, second screenshot).
- In the Perspective Viewport, tumble around to a side view of the character (Fig. 8.1.14, third and fourth screenshots).
- Pull the hand control back a bit in the global negative −Z axis and down slightly in the global Y-axis so that it is fairly straight and extended (Fig. 8.1.14, fifth screenshot). Rotate the hand control back slightly around the local Rotate X-axis (around 24 units). Hit Shift + W/Shift + E to set key at frame 00.

FIG 8.1.14 Blocking in the first pose for the left arm.

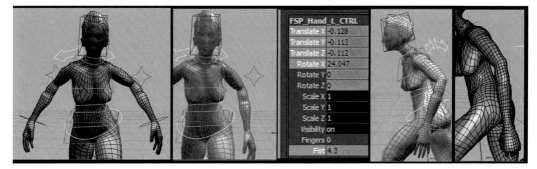

For the run, the fingers can be posed in a more clenched fist pose, which will look more appropriate on the run.

- With the control object still selected (FSP_Hand_L_CTRL), go to the Channel Box (Ctrl + A) and double-click on the Fist attribute. Enter a value of roughly 4.3, which will clench in the fingers (Fig. 8.1.14, fifth screenshot). From the Channel Box, select and highlight the "Fist" attribute and choose Right-Mouse-Click > Key Selected to key the attribute.

Note

The Channel Box values for the Translation/Rotation/Fist attribute are shown in Fig. 8.1.14.

The posing of the left hand should be opposite of this pose at frame 8. Scrub the Time Slider to frame 8; at this frame, the left leg is swinging backward, so the left arm should swing forward.

- Scrub the Time slider to frame 8 and tumble the perspective viewport to a side on view (Fig. 8.1.15, first screenshot).
- With the control object for the left hand selected (FSP_Hand_L_CTRL), enable the Move tool (W) and move the hand control forward in the global Z-axis and upwards to around the midpoint on the torso in the global Y-axis (Fig. 8.1.15, second and third screenshots).
- Hit Shift + W/Shift + E to key the hand control at frame 08.
- If you tumble around the Viewport to a front on view of the character, the elbow posing may look a bit off. We can resolve this by using the pole vector control for the elbow posing on the character.
- Select the purple star-shaped pole-vector control for the left elbow (named FSP_Arm_L_Pole, located behind the character in the Viewport).
- With the control selected at frame 08, pull it out a bit in the global X-axis, which will pose the elbow outwards from the body so that the pose looks more natural (to around Translate X = 0.18) (Fig. 8.1.15, fourth screenshot).
- Press Shift + W/Shift + E to key the pole vector control at frame 08.

FIG 8.1.15 Blocking in the second pose for the left arm and elbow.

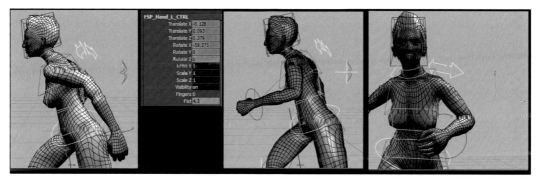

Mirroring the Arm Pose

The arm and hand pose should be mirrored for the right arm and hand. So, at frame 00, the right arm will be swung forward, in the same pose used by the left arm at frame 08. And, at frame 08, the right arm will swing backward, in the same pose used by the left arm at frame 00.

The same process we used previously to mirror the leg posing across from the Channel Box values can be used for this.

- Scrub the Time Slider to frame 00 and select the left-hand control (FSP_ Hand_L_CTRL) (Fig. 8.1.16, first screenshot).
- From the Channel Box (Ctrl + A), double-click on each of the channels for Translate X/Y/Z and Rotate X and Fist. Take a note of the values by Copying (Ctrl + C) and Pasting (Ctrl + V) the attributes for each channel in Windows Notepad or other note application.
- Scrub the Time Slider to frame 08 and select the right-hand control (FSP_Hand_R_CTRL).
- From the Channel Box (Ctrl + A), double-click on each of the channels for Translate X/Y/Z and Rotate X and Fist in turn and paste the values from the previous step. Click drag select each of the Translate X/Y/Z and Rotate X channels and Ctrl + Click select the Fist channel then choose right-Mouse-Click>Key Selected to key (Fig. 8.1.16, second screenshot).
- The right arm and hand pose at frame 8 should be downwards and swinging backward (Fig. 8.1.16, third screenshot) mirroring the left-hand pose that was keyed at frame 00 (Fig. 8.1.16, first screenshot).
- Repeat the above steps to mirror the raised arm swing pose from the left-hand control at frame 08 to the right-hand control at frames 00 and frame 16 (Fig. 8.1.16, third and fourth screenshots).

FIG 8.1.16 Mirroring the pose on the right arm and hand.

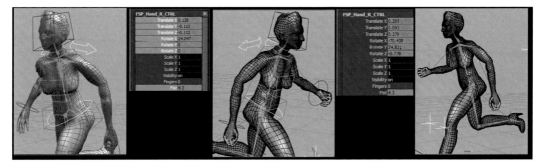

Additional follow through can be added to the arm swing by keying the hand control rotation in the local X-axis a couple of frames after the full extension on the backward and forward swing. For this, a keying process similar to what we used earlier for the torso follow through and head bob can be used (Fig. 8.1.10).

The scene file with the base poses blocked in for the left and right arm swing is included with the project's scene files as – **8.1_06_Run_Uppr_ArmSwing01.ma**.

If you preview the animation that's blocked in so far, the motion on the upper torso and arms is looking solid. For the hip and lower torso poses that were blocked in at the start, we can add some further refinement to the posing and a couple more in-betweens to finalize the run.

Hip Weight Shift

Looking at the hip motion, the up and downward motion of the center of mass (in the global Y-axis) was established to strengthen the weighting on the feet plants (Fig. 8.1.6). As the character run cycle is fixed "on the spot," we don't need to animate the translation in the global Z-axis. If we look at the character's legs and hips from a front view (Fig. 8.1.17, first screenshot), we can see that there isn't any side-to-side weight transfer on the hips, and the motion still looks a bit unnatural.

On a run or walk cycle, the center of mass should typically shift or sway from side to side (viewed from a front or rear view). This weight transfer is normally at full extension to the side on whichever foot is currently planted. Let's add this motion to the run cycle:

- Work from the existing scene file you have open or open the project scene file – **8.1_06_Run_Uppr_ArmSwing01.ma**.
- Scrub the Time Slider to frame 00 and select the main centre of mass control on the character (named FSP_COG_CTRL, the red square-shaped control around the hips).
- From a front on view, enable the move tool (W) and pull the control over to the side in the global X-axis so that the center of mass is positioned over to the side, with the hips more clearly weighted over the left planted foot (Fig. 8.1.17, second screenshot). The Translate X value should be set to roughly X = 0.05 in the Channel Box (Fig. 8.1.17, third screenshot, top).
- Set a key at frame 00 for the translation with Shift + W. Scrub the Time slider to frame 16 and set key for same translation value.

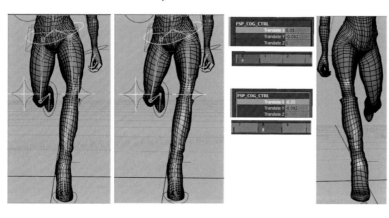

FIG 8.1.17 Mirroring the pose on the right arm and hand.

At frame 08, the weight shift should be exactly mirrored to the side across the X-axis.

- Scrub the Time Slider to frame 08, and with the control selected (FSP_COG_ CTRL), double-click in the Channel Box > Translate X value field and type in value that is the opposite of the value at frame 00/16. In the final example, Translate X = 0.05 units at frame 00, so the value at frame 08 that's used is Translate X = −0.05 (negative) (Fig. 8.1.17, third screenshot, bottom).
- Set a key at frame 08 for the translation with Shift + W.

When viewed from the front, the shift of the hips across the body should be exactly mirrored at frame 08, with the weight directly over the planted right foot (Fig. 8.1.17, fourth screenshot).

The scene file with the weight shift keyed for the hips on the run is included with the project scene files as – **8.1_07_Run_Lwr_WieghtShift.ma**.

Chapter 8.2 – Dynamics Rocket Smash

Rigid body dynamics simulations in Maya in unedited form are a great example of a straight-ahead animation workflow. As with the nCloth cape setup we worked with in Chapter 6.2, the animation is created primarily by the software, which evaluates the collisions and physics of the objects in the scene based on how physics are applied in the real world.

Although the effects can be directed and refined by the animator, a major factor in the quality of results you get are down to how the software evaluates the physics and collisions in the scene. The animator does not have complete control over the result, and as with the best applications of a straight ahead workflow in animation, the results can be quite different from what you'd initially planned, which can lead to different creative decisions and directions in the work.

In this tutorial, we will cover the following:

Rigid Body Dynamics – Scene Setup and Attributes
(Fig. 8.2.01)

- How to create passive (static) and active rigid bodies (which react to force and collision) for simulation.
- Animating passive rigid body elements that can be switched to active (rocket).
- Attributes – editing the rigid bodies mass/friction/bounciness to change the effect.
- Adding fields (gravity) to act on the rigid bodies in the scene.
- Caching dynamics simulations to memory for playback and validation.

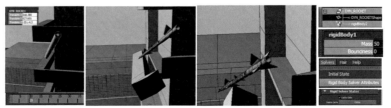

FIG 8.2.01 Scene setup, rigid body collision, attributes, and Solver cache.

Rigid Body Dynamics – Refining and Directing the Effect (Fig. 8.2.02)

- Modeling – Creating effective elements for collision and destruction (brick and concrete smash).
- Swapping geometry/visibility on collision and destruction to make the effect more believable.
- Optimizing the simulation – Proxy models and collision layers.

FIG 8.2.02 Scene refinement – breakable geometry and render proxies.

Dynamics – Scene Setup and Elements

Open the start scene file for this section from the Project scene files directory – **8.2_00_Dynamic_Setup_Start.ma**.

The scene file includes simplified geometry for the elements we'll setup as rigid bodies using Maya's dynamics system (Fig. 8.2.1).

FIG 8.2.1 Scene setup – base geometry and breakable elements.

The main elements in the scene are a couple of large buildings – a large tower block building sits in front of a flat square military compound building (Fig. 8.2.1, left screen).

The cylindrical-shaped object represents a rocket that is angled to fire toward both buildings (Fig. 8.2.1, middle screens).

The angle of trajectory of the rocket takes it through the tower block toward the military compound – separate elements have been modeled to break off from the tower and military compound using the dynamics setup (Fig. 8.2.1, third/fourth screens from left).

- Select the following elements from the Viewport or Outliner (Fig. 8.2.2, left and middle screens):
 - DYN_GROUND_pass (the ground plane)
 - DYN_ROCKET (the cylinder)
 - DYN_BUILD01_BODY_pass (the main tower block model)

335

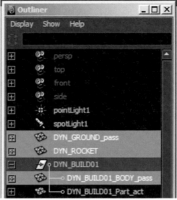
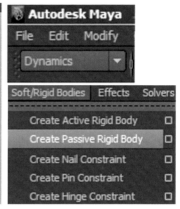

FIG 8.2.2 Selecting elements to add to simulation as rigid bodies.

• With the elements still selected, switch to Maya's Dynamics menu set using either the drop-down menu on the left of the Status line or F5 shortcut (Fig. 8.2.2, top right screen).

Note

Switching to the Dynamics menu set will display the appropriate menus for working with Dynamics across the top of the Maya user interface.

• With the elements still selected, go to the "Soft/Rigid Bodies" menu at the top of the user interface and select Soft/Rigid Bodies > Create Passive Rigid Body (Fig. 8.2.2, lower right screen).

In Maya, there are two types of Rigid Body objects you can create – Passive and Active.

• Passive rigid bodies participate in the simulation but are static in the scene – they will not react or move when forces in the scene such as collisions or fields such as gravity act upon them.
• Conversely, Active rigid bodies will move when they collide with other objects in the scene or are acted on by fields.
• The Passive rigid body type is typically used for ground object or static objects such as the ground plane or main building parts in our scene setup. The other Active rigid body objects in the scene will react with these Passive rigid body objects during the scene.

Note

Although the options for creating rigid body can be set prior to creation (from [] box on creation), the settings are not critical – the default settings for the rigid body (mass/friction/damping, etc., can be modified through the Attribute Editor, which is covered later in the tutorial).

- From the Outliner, select the Display menu at the top left corner and select Display > Shapes (Fig. 8.2.3, top left screen).
 - Turning on Shapes display will show the rigid body element in the Outliner; the element is displayed as a small bowling pin/ball icon linked to the geometry (Fig. 8.2.3, lower left screen). If you need to remove rigid bodies from Objects in scene, display the rigid body shape element in the Outliner, select then delete.
- With the obejct selected, the base rigid body attributes can be displayed by expanding the SHAPES section from the Channel Box (Fig. 8.2.3, middle screen) (or by selecting the rigid body node in the Outliner).

FIG 8.2.3 Displaying rigid bodies in Outliner and viewing attributes in Channel Box.

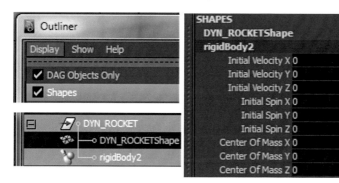

- The "Center of Mass" attribute refers to where the Center of Mass is on the object. This is by default based on the center of the object and can greatly affect the simulation. The Center of Mass is placed at the same point in the scene as the Rigid Body node, which is visible as a small green cross in the Viewport (Fig. 8.2.3, right screen).

Note

The default setting for Center of Mass is used in this tutorial. However, you may wish to modify the Center of Mass attribute in some situations – for example, if you were simulating an object with the main mass at the base of the object (imagine a large heavy box with objects at base), you would shift the Center of Mass downwards.

- Select the small cube-shaped balcony object from the Viewport or Outliner (named DYN_BUILD01_Part_act in the Outliner, child of DYN_BUILD01 (Fig. 8.2.4, left screen and top middle screen).
- Go to the Soft/Rigid Bodies menu and select Soft/Rigid Bodies > Create Active Rigid Body (Fig. 8.2.4, lower middle screen).

Note

This part is set as an Active rigid body, as it's setup to react to collision from the rocket.

- With the object still selected, go to the Fields menu at the top of the interface and select Field > Gravity (Fig. 8.2.4, top right screen).

Note

When adding Fields to the scene, any currently selected objects are added to the field on creation.

FIG 8.2.4 Creating active rigid body and gravity field.

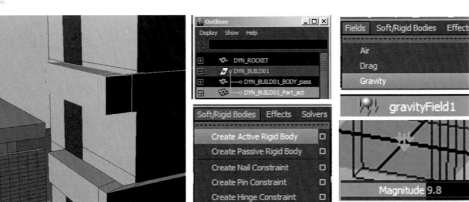

The Gravity Field is visible from the Outliner as a small circular icon with downwards arrows – the element is also visible from the Perspective view, by default created at the origin (Fig. 8.2.4, right screens).

Note

The location for the Gravity Field is not important as it applies force of gravity throughout the scene (for objects added to the field).

When the element is selected, the attributes are visible from the Channel Box (Fig. 8.2.4, lower right screens). The main attributes creating the gravity effect are as follows:

> *Magnitude* – This is the force of the field in units – the default value of 9.8 is the same as the force of gravity on the earth. You should not modify this value unless you want to reduce or increase the natural effect of gravity.
> *Direction* – This is the direction the force is applied in. The default value is Direction Y = −1.

The force is applied downwards, the same as Gravity is in the real world.

- Select the cylindrical object from the Viewport or Outliner (named -DYN_ ROCKET) (Fig. 8.2.5, left screen).

Note

This is a proxy object representing our rocket. In the following steps, we'll setup the rocket so that it flies toward the balcony and collides.

- From the Toolbox, double-click the Move tool icon to open the Move settings. Set the following
 - Move Axis = Object (Fig. 8.2.5, top left screen).
- With the object selected, scrub the Time Slider to frame 1 and hit S to set key.
- Scrub the Time Slider to frame 10.
- With the Object still selected and the Move tool active, move the object along the +Y Object axis toward the balcony (Fig. 8.2.5, middle screen). The values for Translate X/Y/Z can be set manually as
 - Translate X = 318.388
 - Translate Y = 527.855
 - Translate Z = −351.413
- Hit S to set key for the Cylinder at frame 10 – the object should move toward the balcony between frames 1–10 (Fig. 8.2.5, middle screen).
- With the Object selected, open the Channel Box, and from the SHAPES-rigid body section set
 - Mass = 50.00
 - Bounciness = 0

Note

This increases the weight on the object and prevents it from bouncing on collision.

FIG 8.2.5 Animating rigid body and switching passive − active.

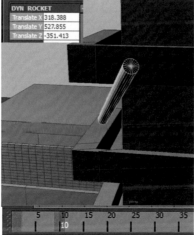

- From the SHAPES-rigid body section in Channel Box, scroll down to the "Active" heading.
- Right-click the attribute at frame 10 and choose "Key Selected" (Fig. 8.2.5, middle right screen).
- Scrub the Time Slider to frame 11, double-click in the attribute input field (where it says "off") and type in 1, hit "enter," and then right-click the attribute and "Key Selected" (Fig. 8.2.5, right lower screen). This switches the obejct from being a Passive to Active rigid body between frames 10 and 11. Passive rigid bodies can be animated in scene, when switched to Active rigid body, they react to forces in the scene.

The velocity in the animation from frames 1 to 10 is continued from frame 11 onwards.

From Frame 11, the object acceleration is calculated using the rigid body solver and physics in the scene. As the object is now an Active rigid body, it can react to other object collisions and forces.

Playing Back the Simulation

- Open the Animation Preferences from Window > Settings/Preferences > Preferences > Settings > Time Slider
- From the Playback section set – Plaback speed = Play every frame (Fig. 8.2.6, lower left screen).

Note

Playback speed needs to be set to Play every frame when working with Dynamics to correctly evaluate the simulation. When you playback the simulation using this setting, the simulation will evaluate correctly, but the playback speed will be incorrect. To correctly validate the effect, you need to either render a Playblast or Cache the simulation.

- Go to the "Solvers" menu at the top of the interface and select Solvers > Rigid Body Solver Attributes (Fig. 8.2.6, top right screen).
- From the Attribute Editor, expand the Rigid Solver States section and enable the following checkbox – Cache Data = On (Fig. 8.2.6, lower right screen).

FIG 8.2.6 Playback and rigid solver cache.

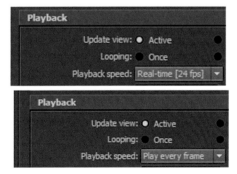

- Go to the Start frame (Alt + Shift + V) and hit play (Alt + V) – during playback (at play every frame rate), the simulation is cached to memory.
- From the Animation preferences, set Playback speed to "Real-time [24 fps]."

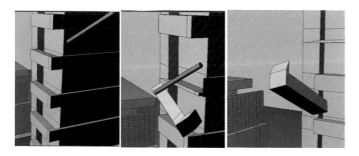

FIG 8.2.7 Playing back the cached animation.

The cached animation will playback at the correct frame rate. The Time Slider can also be scrubbed forward to validate the simulation (Fig. 8.2.7).

Previewing the simulation, the rocket object collides with the balcony part knocking it away from the building. As both objects are active rigid bodies, they interact with each other and the passive rigid bodies in scene. The balcony part collides with both the tower building and ground plane, and it also falls convincingly to the ground as the force of the Gravity Field object is acting on it.

The scene file with rigid body simulation for the rocket strike on balcony with default settings is included with the Project scene files as – **8.2_01_Dynamic_Setup_Collision01_00.ma**.

Modifying the Simulation – Mass, Bounciness, and Friction
If you playback the simulation, you'll notice that the balcony part starts to fall from frame 1 – this is because it is an active rigid body reacting to gravity. This can be resolved as follows:

- Scrub the Time Slider to frame 10 and select the balcony part (DYN_ BUILD01_Part_act) (Fig. 8.2.8, left screen).
- From the Channel Box > Shapes > rigidbody, set "Active = off" and Key selected (Fig. 8.2.8, top right screen).
- Scrub the Time Slider to frame 11.
- From the Channel Box > Shapes > rigidbody, set "Active = on" and Key selected.

The object is now passive from frames 1 to 10 and does not react to forces in world – from frame 11, just before the rocket hits, it is active and will react as needed.

Also on playback of the unedited scene, you'll notice that the balcony part looks a bit weightless after being hit by the rocket, it appears to float through the scene as it reacts and falls to the ground. This is due to the "Mass" attribute.

The object also appears to bounce unrealistically as it connects with the building and ground on collision. This is due to the "Bounciness" attribute.

341

- Scrub the Time Slider to frame 12 and Key both the Mass/Bounciness attributes.
- Scrub the Time Slider to frame 15 and Key the Mass/Bounciness attributes at −Mass = 500/Bounciness = 0.05 (Fig. 8.2.8, right screens).
- Scrub the Time Slider to frame 19 and Key the Mass/Bounciness attributes at −Mass = 5000/Bounciness = 0 (Fig. 8.2.8, right screens).

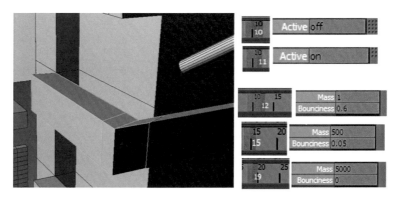

FIG 8.2.8 Keying rigid body attributes for the balcony.

To validate the edits to the rigid bodies, the Cache needs to be deleted and re-created.

- Go to – Solvers > Rigid Body Solver Attributes > Rigid Solver States.
- Delete Cache.
- From Animation preferences, set Playback speed = Play every frame.
- Go to Start frame (Alt + Shift + V), and hit Play (Alt + V) to resimulate animation and record new Cache.
- From Animation preferences, set Playback speed = Real-time [24 fps] (so that the change can be validated on playback).

On playback, the balcony model part collides with the building and ground more convincingly. The object has more weight and mass as it falls and does not bounce against the ground as if made of rubber. This is due to the edits to the attributes that were keyed (Fig. 8.2.9).

A minor issue you'll notice with the simulation is that the rocket part is now deflected upwards on collision (Fig. 8.2.9) – this is due to the change in mass of the balcony part that takes it away from target of the other building.

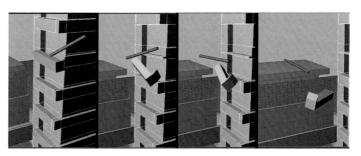

FIG 8.2.9 Validating the attribute edits for mass/bounciness.

The scene file with rigid body simulation for the rocket strike on balcony with modified settings for the balcony mass and bounciness is included with the Project scene files as – **8.2_02_Dynamic_Setup_Collision01_01.ma**.

The issue in deflection of the rocket object is due to the Friction attribute on both objects, this can be fixed by turning off Friction for the Rocket and keying the friction on the balcony model.

- Select the Balcony model piece and open the SHAPES > rigidbody section in the Channel Box to view the attributes.
- With the model slected, scrub the Time Slider to frame 15 and key the following attributes.
 - Static Friction = 0 (Fig. 8.2.10, left screen)
 - Dynamic Friction = 0 (Fig. 8.2.10, left screen)
- With the model slected, scrub the Time Slider to frame 19 and key the following attributes.
 - Static Friction = 0.5 (Fig. 8.2.10, middle screen)
 - Dynamic Friction = 0.5 (Fig. 8.2.10, middle screen)

The balcony does not react to friction from other objects or gravity at frame 15 (prior to collision from rocket). This would make the object float unnaturally if applied throughout the simulation, however, turning back on friction at frame 19 (to 0.5 value) lets the object drop naturally.

- Select the rocket model piece and open the SHAPES > rigidbody section in the Channel Box to view the attributes.
- With the model slected, set the following attributes (Fig. 8.2.10, right screen)
 - Static Friction = 0
 - Dynamic Friction = 0

Note

As these attributes are not keyed, the setting applies throughout the simulation.

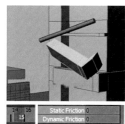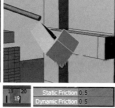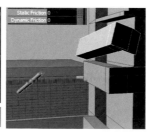

FIG 8.2.10 Keying rigid body attributes for the balcony.

After re-creating the cache and playing back the simulation (Fig. 8.2.6), the rocket is no longer deflected after impact with the balcony because of the change made to the Friction attributes for both objects. The trajectory of the

rocket is largely the same and it continues flight after collision toward the next part it'll collide with.

Although Dynamics setup is an example of straight-ahead animation where the simulation is dictating the direction of the animation (which is slightly random due to forces), it is possible as we've seen to modify the effect and direct objects toward goals – animating the rocket provided the initial impetus to the simulation. Alongside the placement of the objects that are breakable in the scene, we are able to direct the effect or major poses.

The scene file with rigid body simulation for the rocket strike on balcony with modified settings for the balcony and rocket friction is included with the Project scene files as – **8.2_02_Dynamic_Setup_Collision01_02.ma**.

Rigid Body Collision Part Two – Breakable Wall

The next collision area for the simulation is the wall section in front of the military compound. A section of the wall has been broken away to be smashed by the rocket on impact. The standard modeling tools in Maya can be used to subdivide models to create breakaway pieces to use as rigid body objects.

For the smaller wall section (named DYN_WALL1_act), you'll notice that it has been modeled with a slight gap between the edges and edges of the larger section (DYN_WALL1_pass) – this is necessary as models cannot have overlapping edges if they're going to be used in Dynamics simulation – during simulation, playback will stop or grind to a halt as these collisions cannot be correctly evaluated. Errors related to collision calculation will also be displayed in the Maya Script Editor.

- Select the larger wall section part (DYN_WALL1_pass) and from the Soft/Rigid Bodies menu, select Soft/Rigid Bodies > Create Passive Rigid Body (**Fig. 8.2.11**, left screen).
- Select the smaller wall section part (DYN_WALL1_act) and from the Soft/Rigid Bodies menu, select Soft/Rigid Bodies > Create Active Rigid Body (Fig. 8.2.11, right screen).

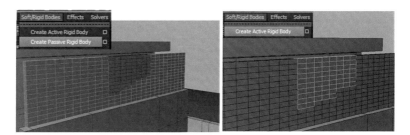

FIG 8.2.11 Creating passive/active rigid bodies for wall smash.

- With the smaller wall section selected (DYN_WALL1_act), open the "Dynamic Relationships" window fromWindow > Relationship Editors > Dynamic Relationships (**Fig. 8.2.12**, left screen).

Note

The Dynamic Relationships Editor window allows us to check and modify which Fields are acting upon the selected scene elements (Fig. 8.2.12, right screen).

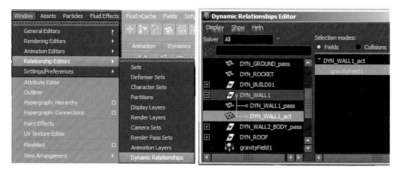

FIG 8.2.12 Dynamic relationships editor window.

- From the Dynamic Relationships Editor window, make sure that the DYN_WALL1_act object is still selected in the left pane and then from the right pane select and highlight "gravityField1."

The Dynamic Relatonships Editor is similar to the Maya Connection Editor and allows us to set the connection between the model and the existing Gravity Field in the scene – the object will now react to gravity during the simulation (Fig. 8.2.12, right screen).

Using the same workflow as before, delete and then re-create the Rigid Solver cache for the scene (at Play every frame rate) and then switch playback to "Real-Time" to validate the simulation (Fig. 8.2.13).

FIG 8.2.13 Validating the cached rigid simulation – breakable wall.

The scene file with rigid body simulation for the basic wall break is included with the Project scene files as – **8.2_04_Dynamic_Setup_Collision02_01.ma**.

The simulation is pretty basic looking. It might be the type of thing you'd see when blocking out a sequence or creating extended animatic. To refine the effect and create more interest, the wall can be broken into more parts to create a more realistic effect:

- Select the Active wall section (DYN_WALL1_act) and hit "delete".
- Go to File > Import and import the following File of type = Maya ASCII from the project directory – **8.2_05_.ma** – The imported file is the wall broken into more separate sections (Fig. 8.2.14, left).

After Import, you'll notice new Group in the Outliner (named as – _05__DYN_ WALL1_BRICKS_ac) (Fig. 8.2.14, top middle screen).

This group contains all of the separate wall and brick parts to keep the scene organized.

- In the Outliner, click on the new Group with the middle Mouse button and then drag the group on top of the – DYN_WALL1 group. This makes the Active wall group a child of the main DYN_WALL1 group to keep things organized (Fig. 8.2.14, lower middle screen).
- Make sure that the DYN_WALL1 group is expanded in the Outliner so that the new "05__DYN_WALL1_BRICKS_ac" group is listed.
- Click on the small + icon beside the group name in Outliner "05__DYN_WALL1_BRICKS_ac"

This expands the Group to show all the elements.

- Select the first pCube element that's listed in the group and then scroll down to the bottom of the Outliner and with the Shift key held down, select the last listed pCube element in the group.

This multiselects all of the pCube elements in the group (Fig. 8.2.14, right screen).

Note

The reason the separate elements and not the master group need to be selected is due to how rigid bodies are applied on creation – the rigid body is created for each selected element – and we need to create individual rigid body for each pCube element to be used in our simulation.

With the pCube elements selected, go to the Soft/Rigid Bodies menu at the top of the UI and select – Soft/Rigid Bodies > Create Active Rigid Body (Fig. 8.2.15, top left screen). This creates new Active Rigid Body for each element.

As before, the new rigid body elements need to be connected to the Gravity Field.

- With the pCube elements still selected, open the Dynamic Relationships Editor – Window > Relationship Editors > Dynamic Relationships (Fig. 8.2.15, lower left screen).
- From the Dynamic Relationships Editor, make sure that Selection Modes = Fields and then, from the right pane, select and connect the gravityField1 to the first element and scroll to the bottom of the window and Shift + Select the last element to connect gravityField1 (Fig. 8.2.15, right screen).

FIG 8.2.15 Creating active rigid bodies for the new wall cubes – linking to gravity field.

Using the same workflow as before, delete and then re-create the Rigid Solver cache for the scene (at Play every frame rate) and then switch playback to "Real-Time" to validate the simulation.

The simulation is a lot more interesting to look at – The elements deform gradually as the rocket object first intersects with the wall (Fig. 8.2.16).

FIG 8.2.16 Breakable wall simulation – initial impact.

As the brick objects are Active rigid bodies, they react naturally to gravity and the forces in the scene and interact with each other believably.

They also collide correctly with the main wall section and ground plane as these parts are Passive rigid body elements.

There is a natural crumpling effect on impact, with each brick element gradually breaking away from the wall as they interact with the rocket and with each other (Figs 8.2.16 and 8.2.17).

The force pushes the bricks upward on impact and they then fall naturally because of gravity at the end of the simulation (Fig. 8.2.17).

FIG 8.2.17 Breakable wall simulation – object interaction and gravity.

The scene file with rigid body simulation for the enhanced wall break is included with the Project scene files as – **8.2_06_Dynamic_Setup_Collision02_02.ma**.

Rigid Body Collision Part Three – Breakable Wall 2
On playback of the cached simulation, the rocket rigid body object knocks the balcony object and then passes through the brick wall. The brick wall shatters into separate brick pieces on impact. For the next phase of the simulation, the rocket passes through the secondary wall into the military compound building. For this simulation, we can use a different approach in modeling and simulating the breakable elements.

- With the previous scene file open (**8.2_06_Dynamic_Setup_Collision02_02.ma**), open the Outliner and select both of the following Groups:
 - DYN_WALL2_BODY_pass
 - DYN_ROOF

Both the main building and roof should be selected (**Fig. 8.2.18**, left screen).

- With both Groups selected, hit Ctrl + G or go to Edit > Group to group both into a new Group (Fig. 8.2.18, middle screen, top).
- Rename the new Group– UNDYN_WALL2_ROOF (Fig. 8.2.18, middle screen).
- Go to the Display menu and select – Hide > Hide Selection (Fig. 8.2.18, middle screen).

Both objects should now be hidden from the scene (Fig. 8.2.18, middle screen).

The reason for grouping both elements is to make it easier to select and key the visibility of the elements in a later section.

FIG 8.2.18 Grouping and hiding original geometry – importing breakable parts.

- With the new Group hidden, go to the File menu and choose File > Import – Import the following File of type = Maya ASCII from the project directory – **8.2_07_.ma** (Fig. 8.2.18, right screen, top).

The new geometry is imported into the scene – the geometry is the wall section and roof shattered into multiple pieces (Fig. 8.2.18, right screen).

Some forethought has gone into modeling the separate sections for the wall and roof break; larger circular sections on the inside of the wall part (where the rocket will connect first) have been modeled, with some smaller shard sections on the outside being modeled to break away last. This will create a nice reaction in the simulation and will simulate the natural effect of the wall smashing on impact.

To model the parts, the standard Poly modeling tools were used in Maya – Edge Loops were added to base Poly plane and the Split Polygon tool used to subdivide the model into sections. The poly sections were then extruded to create solid sections (Fig. 8.2.19, left and right screens).

Note

When modeling breakable parts for Rigid Body Dynamic simulations, the parts need to be modeled with gaps so that there are no intersections during the simulation. The edge selection and modify tools were used to model gaps between the geometry (Fig. 8.2.19, left and right screens).

FIG 8.2.19 Modeled geometry – wall shatter and Maya poly modeling toolset.

349

Note

Maya also has a tool within the Dynamics menu set, which will automatically shatter a model into pieces that can be used for Dynamic simulation. This tool can be accessed from Dynamics > Effects > Shatter.

Although the tools will automatically break a model into sections, as described above, the sections will need to be separated to work as rigid bodies correctly within the simulation. Although useful, the Shatter tool also does not offer much control in how the model is sub-divided and additional work may be required using the standard Poly modeling tools in Maya to get the desired affect.

Adding the New Elements to the Simulation

The same workflow as before should be used to create rigid bodies for the new elements to add them to the simulation:

- From the Viewport or Outliner, select the main building model part (named _07__DYN_WALL2_BODY_pass) (child of the _07_:DYN_WALL2_ ROOF group in Outliner).
- Go to the Soft/Rigid Bodies menu and choose Soft/Rigid Bodies > Create Passive Rigid Body (Fig. 8.2.20, left screen).

Note

This part is setup as Passive rigid body as, although it is not breakable, other objects should be able to collide with it.

- From the Outliner, select and expand the following group: _07__DYN_WALL2_CONCRETE_act
- With the Group expanded, select the first "polySurface" object, scroll down the bottom of the Outliner and then Shift select the last listed "polySurface" object in the group to multiselect all of the breakable concrete Wall poly objects (Fig. 8.2.20, middle and right screens).
- Go to the Soft/Rigid Bodies menu and choose – Soft/Rigid Bodies > Create Active Rigid Body.

FIG 8.2.20 Creating rigid bodies for the passive wall section and active breakable parts.

Use the same workflow to create new Passive/Active rigid bodies for the static and breakable roof sections:

- Select Element = "_07__polySurface58" > Create Passive Rigid Body.
- Select Element = "_07__DYN_ROOF_PARTS_act" (Note: As before, the seperate poly elements need to be Selected from the Group, the broken poly pieces) – > Create Active Rigid Body.

For the breakable wall and roof sections, the Gravity Field needs to be connected to the selected poly parts using the Dynamic Relationships Editor. Refer to the preceding section for this workflow (Fig. 8.2.15).

Using the same workflow as before, delete and then re-create the Rigid Solver cache for the scene (at Play every frame rate) and then switch playback to "Real-Time" to validate the simulation.

During the initial phase of the simulation, the rocket rigid body smashes through the brick wall section and then continues on trajectory to the main wall section of the building (Fig. 8.2.21).

- The elements break apart convincingly because of the modeling of the breakable parts; the circular section in the middle breaks away on the first impact, with the other parts shattering as the rigid bodies interact with each other.
- There is a nice contrast in this part of the simulation compared with the consistent size and shape of the bricks being smashed before. The variation in the breakable shapes creates interest when viewing the simulation.
- As the parts shatter from impact outwards, there is also a nice follow through and overlap in the simulation as the reactions occur at different points in time.

FIG 8.2.21 Previewing the simulation – initial shatter – overlapping action.

When dollied out from the simulation, we can also see that there is a nice upward effect on the breakable parts during the second part of the simulation. (Fig. 8.2.22).

- The brick and roof sections are forced upward on impact as the rigid bodies react to the collisions and gravity. The contrast in the large breakable roof sections creates impact in the sim.
- As the simulation plays out, the broken parts fall convincingly toward the ground reacting the Gravity Field and collide with the ground plane.

FIG 8.2.22 Previewing the simulation – follow through – forces pushed outwards and drop.

The scene file with the rigid body simulation setup for the main wall smash is included with the Project scene files as – **8.2_08_Dynamic_Setup_ Collision03_01.ma**.

Note

Do not be too concerned if the simulation appears to playback a bit slow. These types of issues can sometimes be due to the scene scaling or issues in playback evaluation. Problems such as these can typically be resolved by keying the Solver Current Time attribute, modifying the Gravity effect, or scaling the scene frame rate after baking the simulation to Geometry Cache.

Rigid Body Collision Part Three – Breakable
Wall 2 – Refining the Effect

On playback of the simulation, you'll notice that all of the secondary wall parts break away. This is because the breakable parts have been modeled from cube section removed from the main wall. This looks a bit unconvincing as the whole of the wall would not break. For this type of collision, typically there would be some sections still connected to the wall and also possibly some shards or variation along the edges of the wall break. To make the simulation more convincing, additional shards or variation along the edges of the Passive wall part and Active parts could be added. As a quick fix, some of the breakable parts on the wall can be switched off from being Active rigid bodies so that they do not react to the forces, but still provide collision for other object interactions.

- With the scene still open (**8.2_08_Dynamic_Setup_Collision03_01.ma**), go to the start frame (Alt + Shift + V) and dolly in close to the breakable wall parts (Fig. 8.2.23, left screen).
- Select a few of the breakable sections that run along the bottom of the section – the parts that are near the base of the wall (Fig. 8.2.23, left screen).
- Scrub the Time Slider to around frame 23 and, from the Channel Box, right-click on the "Active" channel and select – Key Selected. This sets key for the active state for all of the selected parts (Fig. 8.2.23, left screen).
- Scrub the Time Slider to frame 25 and, from the Channel Box, double-click on the "Active = on" field/type 0 (which sets Active = off)/Hit " Enter," then

right-click on the "Active" channel, and select – Key Selected. This sets key for the active state to be "off" for all of the selected parts (Fig. 8.2.23, middle screen).

Note

The key is set for Active = off for the elements at this frame as it is just after the impact of the rocket with the wall (Fig. 8.2.23, middle screen).

FIG 8.2.23 Switching simulation off for active rigid bodies.

This causes the parts to stop reacting to collisions of the other parts (as active = off) just after the break starts. As the simulation runs for a few frames before this, it allows the parts to still shatter slightly, while keeping them static for the later part of the sim. The effect is a trick that makes the wall break a bit more convincingly (Fig. 8.2.23, right screen).

The scene file with Active attribute keyed off for a few selected wall parts is included with the project scene files as – **8.2_08_Dynamic_Setup_Collision03_02.ma**.

Rigid Body Collision Part Three – Breakable Wall 2 – Switching Models (Pre-/Postbreakage)
If you playback the simulation in the current scene (**8.2_08_Dynamic_Setup_Collision03_02.ma**), the simulation looks a bit unconvincing as the wall and roof sections are already broken before impact. Do you remember the original main building section seen earlier that was hidden before importing the separate parts for the breakable wall and roof? (Fig. 8.2.18). These parts were kept in the scene because they are the original parts before the rocket collides and breaks away the parts.

The original parts can be used to swap between the models from the original solid building and roof model to the broken parts at the point of impact. This can be keyed at the point of the collision of the rocket, which will act as a visual trick to increase the believability of the simulation.

- Scrub the Time Slider to frame 23 and select the following group from the Outliner – _07_DYN_WALL2_ROOF (Fig. 8.2.24, left screen).
- With the Group selected, open the Channel Box and enter 0 (off) for the Visibility channel. Right click on the Channel and choose Key Selected to set key (Fig. 8.2.24, left screen).
- Still at frame 23, select the following group from the Outliner – UNDYN_WALL2_Roof (Fig. 8.2.24, middle screen).

- With the Group selected, go to the Display menu and choose Display > Show > Show Selected.
- With the Group still selected, open the Channel Box. Right-click on the Visibility Channel and choose Key Selected to set key for Visibility = On (Fig. 8.2.24, middle screen).
- Scrub the Time Slider forward a single frame to frame 24, and from the Channel Box key, the Visibility is as follows for both groups (Fig. 8.2.24, right screen):
 - UNDYN_WALL2_Roof – Visibility = Off
 - _07_DYN_WALL2_ROOF– Visibility = On

FIG 8.2.24 Switching visibility – models pre-collision/broken models at collision.

Keying the Visibility attribute means that:

- The unbroken building and roof are visible from frame 1 to frame 23 (UNDYN_WALL2_Roof) (Fig. 8.2.24, middle screen).
- From frames 1 to 23, the separate parts for the simulation are hidden from view (_07_DYN_WALL2_ROOF).
- At frame 24, the exact point of collision, the models visibility are swapped, so the unbroken building and roof are hidden (_07_DYN_WALL2_ROOF), and the broken parts are displayed in the scene (_07_DYN_WALL2_ROOF) (Fig. 8.2.24, right screen).

Using the same workflow as before, delete and then re-create the Rigid Solver cache for the scene (at Play every frame rate) and then switch playback to "Real-Time" to validate the simulation.

The scene file with visibility keyed between the pre- and post-collision models is included with the project scene files as – **8.2_08_Dynamic_Setup_Collision03_03.ma**.

On playback of the scene, the simulation looks a lot more realistic. The trick of swapping the models through keying the visibility at the collision frame is a neat visual trick to help increase the believability of the animation (**Fig. 8.2.25**).

FIG 8.2.25 Validating the simulation – swapped model visibility – pre-/ post-collision.

Proxy Collision Models and Dynamics Performance

The simulation we've setup uses fairly low-poly geometry for the rigid bodies. When setting up Rigid Body Dynamics, it's important to be aware of the complexity of the scene geometry you'll use as it can really impact on performance when evaluating and caching the simulation.

For rigid bodies, elements can be placed on separate Collision Layers, and the evaluation mode for rigid body collisions can also be switched, which can help improve performance (Fig. 8.2.26).

FIG 8.2.26 Collision layer and apply force at modes.

Both of these attributes can be set from the Channel Box after selecting the objects SHAPES > rigidBody node.

> Collision Layer – Objects are evaluated by the Dynamics solver based on which Collision Layer they are part of. Setting rigid bodies onto separate collision layers can improve performance – Elements on the same collision layer will interact with each other as required, and elements on separate collision layers will not interact with objects set to other Collision Layer. This can be useful if you are working on a larger scene file with many elements with parts that do not need to interact with other parts.

Note

Setting Collision Layer = −1 will cause objects on Layer −1 to interact with elements on every layer. This setting is useful for Passive rigid body objects such as a ground plane.

Apply Force At – This attribute controls how collisions are evaluated for the rigid body. The default boundingbox option is fine for most situations. Occasionally, you may need to switch this to verticesOrCVs to improve the quality of the collisions and simulation.

Note

Switching to verticesOrCVs will impact on performance as the simulation is calculated on a per vertex basis. This option may be useful if working with lower polygon models, but may not be an option if your source model is really high polygon.

If using more complex geometry, it can be a good idea to use stand-in proxy models as collision objects. These can be modeled using the standard Poly modeling tools in Maya and should be modeled as a close approximation of the size and form of the high-poly model. Using a lower polygon model as the collision object will allow you to speed up performance when working with Dynamics and will also allow you to control the detail required from the collision object:

- Open the completed scene file from the previous section – **8.2_08_Dynamic_Setup_Collision03_03.ma**.
- With the scene file open, go to the File menu and choose File > Import. Import the following File of type = Maya ASCII from the project directory – **8.2_09_.ma**.
- After importing the scene, open the Outliner and select the new element named – 09__Rocket_FIN.
- Hit F to frame the new object in the Perspective view. The new object is the high poly version of the Rocket model (Fig. 8.2.27, left screen).
- From the Outliner, select the Rocket collision model (DYN_ROCKET) and then with the Shift key depressed, select the new high poly Rocket model (_09__Rocket_FIN) (Fig. 8.2.27, middle screen).

Note

The high-poly rocket model should be highlighted in green to indicate that it was selected last.

- Activate the Animation menu set from the Status Line drop-down (or press F2 shortcut).
- Select the Constrain menu at the top of the user interface and select Constrain > Parent [] Options.
- From the Parent Constraint Options window, turn on "Maintain offset" option and hit "Add."

New parent constraint node should be visible from the Outliner for the model (Fig. 8.2.27, right screen).

The high-poly rocket model will inherit the animation of the original low-poly collision rocket model due to the Parent Constraint. The original collision model can be hidden from the scene:

- Select the original low-poly cylinder rocket collision model from the Viewport or Outliner – DYN_ROCKET

Note

The model will be highlighted in green to show selection. The high-poly rocket will be highlighted in purple wireframe as it is constrained to the model (Fig. 8.2.28, left screen).

- With the model selected, open the Attribute Editor and scroll down, expand the "Object Display > Drawing Overrides" section (Fig. 8.2.28, middle screen), and set the following:
 - Turn On = Enable Overrides
 - Turn Off = Visible

FIG 8.2.28 Turning on drawing override for the collision proxy visibility.

Playback the simulation – The high-poly rocket model follows the motion of the original collision proxy through the constraint. With the proxy hidden, the animation looks more visually appealing with the higher resolution model (Fig. 8.2.29).

Although the low-proxy collision model does not exactly match the size and shape of the high-poly model (noticeably there are no fins on the proxy), the effect is still convincing.

FIG 8.2.29 Validating the final animation – proxy collision model hidden.

The major collisions and rigid body reactions still act correctly and there is added appeal in the animation with the rocket fins spinning after the collision.

The scene file with final high-resolution rocket model added to the final simulation is included with the project scene files as – **8.2_10_Dynamic_ Standin_GEO.ma**.

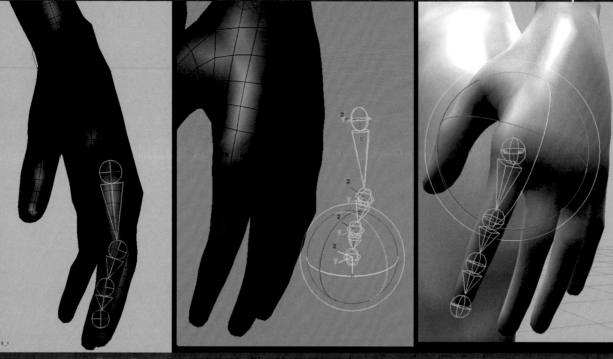

Solid Drawing and Design – Form Meets Function

Grim Natwick – You should learn to draw as well as possible before starting to animate.
Marc Davis – Drawing is giving a performance; an artist is an actor who is not limited by his body, only his ability and, perhaps, experience.
The Illusion of Life: Disney Animation – Frank Thomas and Ollie Johnston

Strong draughtsman skills and an ability to convey weight and form through drawing are the key fundamentals in traditional animation practice. A flair for drawing fluidly helps to convey life and vitality in traditional cell animation. The principle can also be applied to computer animation, without the ability to create solid and pleasing shapes and forms in 3D modelling and animation; your sequences will appear lifeless and will lack the vitality of the best animation. In 3D animation, solid drawing is most easily compared with character posing or object and element framing in the scene.

Thumbnailing, Draughting, and Traditional Modeling

In Chapter 5, we looked in detail at thumbnailing and storyboarding. Clear and well thought out thumbnails and storyboards, which clearly convey the motion and forms of the action are critical reference for animation (see Fig. 9.0.1, left).

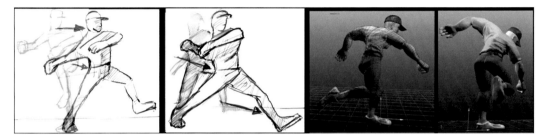

FIG 9.0.1 Solid drawing – thumbnails through to sculpting the form and pose in 3D.

For character animation, strong draughting skills are carried across from the thumbnail pre-production sketches through to the character posing (see Fig. 9.0.1, right). Character posing in 3D can be considered analogous to other forms of traditional animation practice such as stop-motion animation or claymation. As such, traditional skills in sculpting or modeling the form are important to achieve believable results when posing the character. In previous chapters, we touched on breaking down the poses for a sequence and the process of posing the character rig through edits to individual controls. In the first two tutorials of this chapter, we will look in more detail at how to apply the fundamentals of solid drawing to Dynamic Character Posing and how to spot and resolve issues with Twinning in posing and animation.

Dynamic Posing

In the first tutorial of this chapter, we will focus on the animation posing for fluidity and poise. The tutorial will use the same female character rig we worked with in the run animation tutorial in the last chapter. In the tutorial, we will cover in detail how to study specific poses for the character and make itterative adjustment to the poses to achieve fluid and natural results.

The tutorial will start with a single specifc pose (idle) being broken down and analyzed, with small adjustments in the posing being used to create more natural weight and balance on the character. Examples will also be provided for you to compare different action poses on the control rig to see where strong dynamic posing and fluid action lines have been applied to make the poses look more believable (see Fig. 9.0.2).

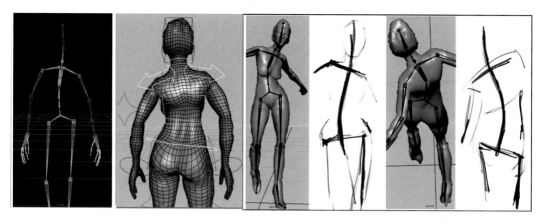

FIG 9.0.2 Solid drawing – dynamic pose.

Twinning

This is the unfortunate situation where both arms or legs are not only parallel but doing exactly the same thing.

The Illusion of Life: Disney Animation – Frank Thomas and Ollie Johnston

In the second tutorial of this chapter, we will look in detail at a short animation sequence of a character stepping into an arms outstretched pose.

The initial starting point for the tutorial will show both the animation timing and posing blocked in and twinned (see Fig. 9.0.3, left). Twinning in animation is a common pitfall that many animators fall into, which can cause the illusion to break down as the character pose looks rigid and symmetrical, with even timing. The twinned posing and the animation timing can often look robot or mechanical and are contrary to the principle of solid drawing.

The exercise will step you through how to pose the character fluidly with dynamic poses that are asymmetrically posed and timed to create more natural and fluid animation (see Fig. 9.0.3, right).

FIG 9.0.3 Solid drawing – twinning.

Character Rigging

> *Animation rigs are at their best when they are optimized for the specific personality and motion of the character. Pay attention to silhouettes when aligning characters to the camera.*
>
> *Applying the 12 Principles to 3D Animation – Isaac Kerlow, Wednesday, July 23, 2003 – CGTalk – excerpt from "The Art of 3D Computer Animation and Effects."*

Solid drawing (or design) can also be applied to more technical aspects of computer animation including character rig design. Understanding how to create a character skeleton rig that follows the flow of the character model is key. A rig that is solidly designed in terms of usable controls will also enable the animator to create more pleasing forms and poses that are solidly drawn (see Fig. 9.0.4).

Strong technical skills in designing character control rigs in Maya are also important in the success of the character animation. Without a control rig that is well designed and fits the needs and intent of the character, the animator will struggle. The tutorial in online Chapter 9.1 will cover in more detail the setup of a full character control rig through each step of the rigging process in production.

FIG 9.0.4 Solid design – character design.

Chapter 9.1 – Dynamic Posing

Open the start scene file for this tutorial: – **9.1_00_Idle_Start.ma**; the character is in the bind pose with control rig setup.

We'll work on the hip posing first. The character's center of mass, hips, and foot placement are critical to create weight and mass in the pose. The bind pose looks weightless, with the hips floating between both legs, with both legs in "twinned pose." Typically, weight is not distributed evenly between the legs, this makes the pose looks rigid; we can fix this by shifting the hips over so they are weighted over one leg.

- From the Outliner, Select the center of mass control FSP_COG_CTRL and then Ctrl + Select both the hand controllers FSP_Hand_L_CTRL and FSP_Hand_R_CTRL (see Fig. 9.1.1, first screenshot).
- With the Move Tool (W) enabled, move the center of mass and hands over to the side (global X-axis), so that the hips are weighted over the characters left leg (see Fig. 9.1.1, second screenshot).

FIG 9.1.1 Posing the center of mass and offsetting right leg pose.

- Orbit round the character in the perspective view to check the weighting over the left leg; the hips may need to be pulled forward slightly (in + Z-axis) to make the weight plant convincing (see Fig. 9.1.1, third screenshot).

For the leg posing, we can offset the right leg slightly to make the pose less rigid.

- Select the right foot control FSP_Foot_R_CTRL.
- With the Move Tool (W) enabled, move the foot slightly back (in the global Z-axis).
- With the control still selected, go to the Channel Box and modify the foot control attributes to change the foot pose; select the Toe Rool or Ball roll attribute (highlighted in blue) and with Middle Mouse Button selected drag left–right to modify the attribute until the heel and knee are posed slightly forward, suggesting the weight is moving forward (see Fig. 9.1.1, fourth and fifth screenshots).

Leg/Foot Angle and Pose

If you look at the legs and feet from the front, the pose is still pretty rigid looking, both feet are pointing forward at same angle and the knees are also "twinned" (see Fig. 9.1.2, first screenshot).

This can be fixed by modifying the angle of the feet and knees by using the pole vector controls.

- Select the left foot control (FSP_Foot_L_CTRL) and rotate it out slightly around the local Y-axis, so that the toe is pointing out slightly. Translate it out a bit as well (in + X-axis) (see Fig. 9.1.2, second screenshot).
- Select the left knee pole vector control (FSP_Leg_L_Pole) and pull it out in the X-axis slightly, so that the knee follows the angle of the foot.
- Repeat the same steps as above to angle the right foot out slightly, do this by modifying the rotation of the right foot control (FSP_Foot_L_CTRL) and position of the right leg pole vector object (see Fig. 9.1.2, third and fourth screenshots).

FIG 9.1.2 Modifying the foot and knee pose.

Hip Tilt

If you look at the hip pose, we've established the position looks better with the center of mass positioned over the left leg (see Fig. 9.1.1, second screenshot). The pose still looks a bit rigid and un-natural; this is because the hips are perfectly aligned with the ground plane; when weight is distributed onto either leg, the hips typically tilt to the side, the side that holds the weight should be higher than the relaxed side.

- From the Outliner or Viewport, select the yellow circular Hip swivel control, named – FSP_Hip_CTRL.
- From front or back view of character, with the rotate tool active (E), rotate the hip control up slightly around the local Z-axis to raise the left hip (see Fig. 9.1.3, first and second screenshots).

The weight is planted on the left leg, which is posed slightly forward from the right leg that is trailing. The hips should also be rotated or twisted round slightly to follow the angle:

- With the control still selected, enable the rotate tool (E) orbit round to the side of the character and rotate in the local Y-axis, so that the left side of the hip is posed forward (see Fig. 9.1.3, third and fourth screenshots).

FIG 9.1.3 Hip tilt – weight distribution on left leg.

Scene file with the hips and legs posed for the weight shift on the idle pose is included with the project scene files as – **9.1_01_Idle_HipPose.ma**.

Spine = S-Curve

When posing on the character rig, it's important to consider how each element works together to achieve balance and weight. The hip and leg posing we've established is more natural, with the hips offset to suggest the weight planted on the left leg.

If you shift your weight, there's typically a counter weight on other parts of the body to achieve the balance; this is usually pronounced on the spine and the shoulders, with the shoulders usually offset at angle the hips are at. The spine will also typically have an organic curve to suggest the weight shift and will commonly form an S-curve type shape from the tip of the head to the waist (see Fig. 9.1.4, third screenshot). If the spine is straight and does not follow a curve to suggest the weight shift, the pose looks rigid and un-natural (see Fig. 9.1.4, first and second screenshots). Let's see how to fix this:

- Work from the existing scene file or open the project scene file named – **9.1_01_Idle_HipPose.ma**.
- Select the base Spine control – FSP_Spine01_CTRL and rotate to follow the angle of the hip control, but slightly offset, in the local Z-axis (see Fig. 9.1.4, fourth screenshot).
- Select the mid spine control FSP_Spine02_CTRL and rotate, so that it's offset slightly from the base spine control in the local Z-axis (see Fig. 9.1.4, fourth screenshot).

- For the upper torso control FSP_Spine03_CTRL, rotate it in the opposite direction (around the local Z-axis), the pose of the shoulders should be the opposite of the hips, with the right shoulder raised slightly to mirror the left hip raise (see Fig. 9.1.4, fourth screenshot).

FIG 9.1.4 Spine offset – S-curve shape.

Tip

When working on the posing, it's worthwhile toggling on/off the skeleton display to check the line of the spine. Viewed from the front, the spine should follow a reverse S-shape from the tip of the head to the waist. Use the Display Layer toggles to turn of the character mesh and control objects to appraise the posing on the spine (see Fig. 9.1.4, third screenshot). Toggling shaded (5)/textured (6) display for the mesh can also help to appraise the posing along with changing the background color in the Viewport for clarity (Alt + B toggle).

Scene file with the S-pose established for the spine is included with the project scene files as **9.1_02_Idle_SpineS.ma**.

Spine Twist

When working on character posing, it's a good idea to work through the major poses while appraising the pose from different angles in the Viewport. If you look at the spine pose in the project scene file **9.1_02_Idle_SpineS.ma**, the pose has been established to look natural from the front Viewport, with the rotation offsets in the local Z-axis being readable from the front view to create the S-curve. The rotations on the spine along the other angles can also be offset to create a more natural pose. The hip pose we've established has the left hip rotated round slightly to suggest the weighting. The upper torso

and spine can also be offset in rotation to create a counter weight, with the left shoulder weighted backward slightly to counter the left hip forward pose.

- To work on the shoulder/hip counter twist posing, orbit around the character to the top/back view in the perspective Viewport (see Fig. 9.1.5, first screenshot).
 - Work through rotating the spine controls to create the offset.
- FSP_Spine01_CTRL should be rotated back slightly to follow the twist of the hips in the local Y-axis. FSP_Spine02_CTRL should be rotated slightly to counter the hip rotation in the local +Y-axis, and the top spine control FSP_Spine03_CTRL should be rotated more in the +Y-axis, so that the right shoulder is slightly forward to counter the left hip forward motion (see Fig. 9.1.5, second screenshot).

Be sure to appraise the spine and hip pose from different angles; from a three-fourth side view, the pose should look natural and balanced, with the spine following a natural curved angle (see Fig. 9.1.5, third and fourth screenshots). From a straight side view, the spine control objects should also be rotated slightly to create a natural curve along the local X-axis for the control objects.

FIG 9.1.5 Spine twist – S-curve shape.

Scene file with the spine posing finalized is included with the project scene files as – **9.1_03_Idle_SpineS_Twist.ma**.

Hand Posing and Finalization

If you look at the posing we've established, the legs/hips/spine poses have been refined and each works in combination to create a natural and balanced pose with weight. When working on the posing, we work on the major areas and then make any necessary refinements while working. The hands still look slightly rigid; as they are outstretched and straight in the pose, it makes the character looks like she is about to go into an action or move, is anxious, or is gesturing as if talking (see Fig. 9.1.6, first screenshot).

367

To resolve this, the pose for the hands should be more relaxed in toward the body, with the weight from the hands resting in a relaxed state at the side of the hips.

- Select the left hand control FSP_Hand_L_CTRL.
- With the control selected, go to the Channel Box and set the "Fist" attribute to around 5.0, so that the fingers are clasped inward slightly in a more relaxed pose (see Fig. 9.1.6, second screenshot).
 - The arm pose may still look slightly un-natural with the elbow angled as if she's about to punch (see Fig. 9.1.6, third screenshot).
- With the Hand control still selected FSP_Hand_L_CTRL, enable the move tool (W), and pull it down slightly along the global Y-axis and rotate slightly, so that the wrist is angled to suggest weighting on the arm (see Fig. 9.1.6, fourth and fifth screenshots).

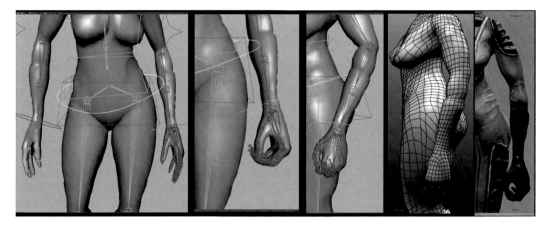

FIG 9.1.6 Refining the left hand posing.

Use the same workflow to refine the right hand pose

- Select the right hand control FSP_Hand_R_CTRL.
- From the Channel Box, set the Fist attribute to around 1, so that the fingers are in slightly relaxed pose (see Fig. 9.1.7, second screenshot).
- With the control selected, enable the move tool (W) and pull it in toward the body slightly, so that it looks more relaxed; check the posing from the side view and rotate the wrist slightly, so that the weighting looks right (see Fig. 9.1.7, second and third screenshots).
 - For the hand posing, the shoulders can be adjusted slightly, so that they look more natural and follow the curve of the spine and arms.
- Rotate the left clavicle control (FSP_Calvicle_L_CTRL) down slightly and back to follow the arc of the shoulders and arm (see Fig. 9.1.7, fourth and fifth screenshots).
- Rotate the right clavicle control (FSP_Calvicle_R_CTRL) up slightly and forward to follow the arc of the shoulders and arm (see Fig. 9.1.7, fourth and fifth screenshots).

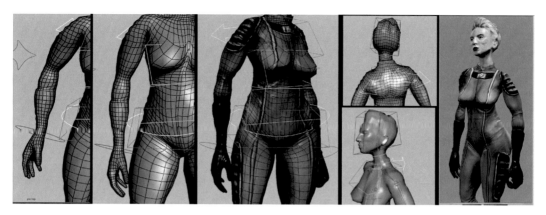

FIG 9.1.7 Refining the right hand posing and shoulders.

Finalizing the Pose

When finalizing the character posing, it's important to validate the pose from different angles to ensure that the pose is weighted, dynamic, and the lines running along the form are flowing and natural (see Fig. 9.1.8). After establishing the major poses, orbit round the character to validate the lines and make any necessary adjustments. This process is iterative, and you may find that making adjustments to one part of the pose throws out the lines on other body parts that require additional adjustment. Finalized scene file with idle pose for the character is included with the project scene files as – **9.1_04_Idle_Final.ma**.

FIG 9.1.8 Finalizing the pose.

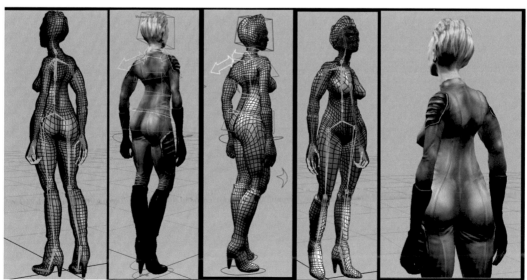

Action Pose – 01 Gunplay – Blocked in Posing

When working with character posing, it's important to consider the action lines of the character alongside the weighting, balance, and curves across the body.

For the idle pose we've worked on, the hips were offset to the side creating more natural balance on the stance; the S-line curve of the spine also helped to make the character pose look more natural, organic, and believable. Although a strong action line was not used on the pose, slight offset on the shoulder rotation relative to the hips helped to suggest a line of action for the body.

For more dynamic action poses, the principles of weight and balance alongside smooth S-curves can be exaggerated to create stronger action lines on the body to add more impact to the animation.

- Open the start scene file for this section – **9.1_06_SHOOT_BLOCKED.ma**.

The scene file uses the same character asset, with pose set up for character aiming to shoot (see Fig. 9.1.9/9.1.10).

Note

Toggle on/off the display layers for the control objects and skeleton to validate the action lines on the skeleton and posing on the control objects used to establish the pose.

- From the side of the character, we can see that the pose uses mainly straight lines to describe the action. Slight diagonal running from the head down across the bent left leg suggests forward motion.
- From the side, straight line on both the right arm holding the gun and right thigh suggests strength/concentration, straight lines in animation typically indicate power or action. In animation, you can contrast straight line motion with curved motion for impact.
- From the front, slight diagonal can be seen running from top of the head down to the base of the bent left knee. Again, the diagonal contrasts with the straight lines on the pose.

FIG 9.1.9 Action pose 01 – blocked in pose.

Although the pose is solid looking, it does not explicitly suggest dynamic action. The pose looks balanced and controlled, as if the character is composed or even slightly nervous.

If we look more closely at the spine on the pose, we can see that the spine looks fairly rigid or upright. There is no curvature on the spine as there was on the idle pose we worked on. Checking the rotation on the control objects shows this – the only offset between the shoulder and hip rotation is visible from the top of the character, with the left shoulder rotated slightly forward.

The hips are also positioned directly between both planted feet – there is little offset on the hip weighting suggesting which leg is carrying the majority of the weight (see Fig. 9.1.10).

Although the pose looks technically correct, it lacks real dynamism or action.

FIG 9.1.10 Action pose 01 – blocked in pose – blocky hip posing.

Action Pose – 01 Gunplay – Refined Posing

- Open the following scene file from the project files directory – **9.1_06_SHOOT_DYNAMIC.ma**.

The scene file uses a modified version of the pose we've just looked at. The pose has been modified and exaggerated in a few areas to create a more dynamic action pose- ideal for this type of character asset (see Fig. 9.1.11).

FIG 9.1.11 Action pose 01 – refined pose – dynamic action.

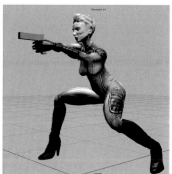

Let's take a look at the refinements that have been made to enhance the pose (see Fig. 9.1.12).

- The feet spacing has been increased to give the character a more commanding stride.
- The angles running along the legs through the back are stronger with more defined diagonals.
- The hips have been offset to the side slightly more, weighting the torso to the side.
- The spine controls have been rotated to create a nice diagonal offset between the shoulders and the hips; when viewed from the back, you can see the lower spine controls have been rotated upward at one side, whereas the shoulder control has been rotated downward to compress.
- The curve along the spine is now a nice S-curve shape, running from the head down to base of spine. This looks far more natural, fluid, and organic (see Fig. 9.1.12, right).

 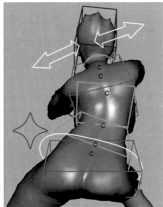

FIG 9.1.12 Action pose 01 – refined pose – dynamic action lines – fluid curve.

The pose has a lot more movement to it due to both the strong diagonals and S-curves running through the spine and legs (see Fig. 9.1.13). Pulling the stride further apart on the stance increases the distance between the feet and the torso when viewing the pose from the side, making the diagonals sharper across the body (see Fig. 9.1.13, right).

The curvature on the spine is a lot more natural and organic looking compared with the "blocky" spine rotation on the original un-edited pose (see Fig. 9.1.9/9.1.10).

There is also stronger contrast between the curves on the pose (spine, left leg) and the solid straight posing on the right thigh and gun arm.

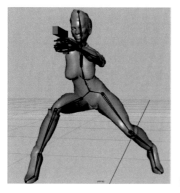

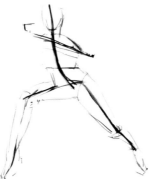

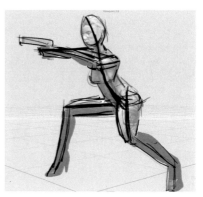

FIG 9.1.13 Action pose 01 – refined pose – dynamic action lines and contrast.

Action Pose – 02 Swing – Blocked in Posing

• Open the start scene file for this section – **9.1_07_SWING_BLOCKED.ma**.

The scene file includes the same character rig, posed in upright pose leading into a light swing. If you look at the pose, there's some obvious issues that make the pose look blocky and lifeless (see Fig. 9.1.14).

• The hips are weighted evenly between both feet – there is no mass or weight to the pose because of this. The hips also do not have any off-axis rotation – both sides of the hips are at same height.
• Both legs are in roughly similar pose – there is twinning apparent in both the angles of the knees and feet rotations.
• The spine looks rigid – possibly the character has a back condition – there isn't any difference in the angle of the shoulders and hips when viewing the character from the front.
• From the top view, there is slight rotation offset on the shoulders for the trailing, swinging arm; however, the offset isn't dynamic looking and the arm posing also looks a bit lifeless.

FIG 9.1.14 Action pose 01 – blocked in pose.

With thumbnails overlaid on the screen-grabs, you can clearly see the issues with both this and the original blocked in gunplay pose. Straight lines run across the body at all the major areas. The spines are straight, making the character look robotic and lifeless – where there are diagonal's to denote the action lines, they are not overt enough to be readable and there is a lack of contrast between the pose. Both poses have limited weight and the forms are not appealing to look at (see Fig. 9.1.15).

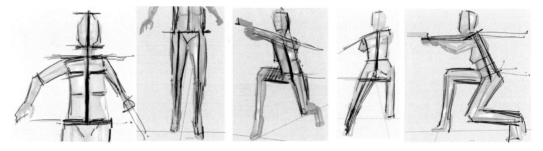

FIG 9.1.15 Blocked in poses – lifeless and un-appealing.

Action Pose – 02 Swing – Refined Posing

- Open the following scene file from the project files directory – **9.1_07_SWING_DYNAMIC.ma**.

The scene file uses a modified version of the pose we've just looked at. The pose is not as exaggerated as the previous refined action pose we looked at (**9.1_06_SHOOT_DYNAMIC.ma**). As there is less movement in the swing, more subtle modifications have been to the pose to make it look more fluid and organic (see Fig. 9.1.16).

FIG 9.1.16 Action pose 02 – refined Pose – dynamic action.

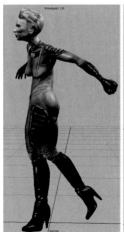

- As with the idle pose we worked on, the pose has been edited to make sure that there's a nice smooth natural looking S-curve shape on the spine (see Fig. 9.1.17).
- There's a nice contrast between the angles on the shoulders and the hips, which creates a lot of motion in the pose (see Fig. 9.1.17).

If you look at the pose from the front and top, there's also a nice contrast between the curves in the pose and the straight lines indicating weight and balance (see Fig. 9.1.18).

FIG 9.1.17 Action pose 02 – refined pose – spine S-curve and rotation

- The left planted leg, which the hips are weighted over, forms a straight line that contrasts with the spine curvature.
- Although not as exaggerated as the gunplay pose, the solid diagonal line of the left arm suggests action and contrasts with the angle of the opposite arm which is posed to give the character balance.
- There is contrast between the posing on the legs, the straight left planted leg leads, with the trailing leg forming a nice curved shape as it is slightly bent.
- There is a nice diagonal to the arms when viewed from the top – the arm posing is light and graceful. Although the arm posing looks similar from the top view, there is contrast on the angles when viewed from the front which prevents the arms looking twinned.

FIG 9.1.18 Action pose 02 – refined pose – contrast in action line/curve and grace.

Chapter 9.2 – Twinning

Twinning in character animation is considered as contrary to solid drawing. Posing or timing that is "twinned" lacks vitality and looks un-natural.

Twinning is typically noticeable either in rough blocked in animation or in work by in-experienced animators. Typically, it will make the character look either blocky, rigid, square, or robotic in motion.

Twinned posing is where both elements are in an exact mirrored symmetrical pose of each other; for example, the arms or hands are in exact mirored pose or the angles of the legs, feet, and knees are exactly the same. The principle can also apply to facial animation, for example, where both sides of the face such as the eyebrows or lip corners are in exact matched pose (see Fig. 9.2.01).

FIG 9.2.01 Eye poses – twinned and mirrored (left) un-symmetrical, natural looking (right).

In the previous section, we looked at dynamic posing for our character rig to create fluid and believable anmation. As we saw, studying the curves, posing, and balance on the character can add life, vitality, weight, and fluidity to the animation. Dynamic posing can be applied to both sublte animation poses such as our character idle or more exaggerated poses such as the arm swing or gunplay pose we looked at in the previous section.

In this section, we will take a look at an extended animation sequence for character doing a subtle arm raise animation. Although the animation has the character raising both arms pretty much simultaneously, we will see how subtle edits to the posing of the character in combination with offset edits to the timing helps to make the animation more believable and natural (see Fig. 9.2.02).

FIG 9.2.02 Arm raise – twinned and symmetrical (left) balanced (right).

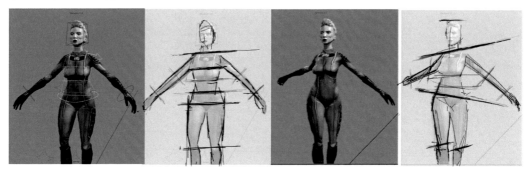

Twinned Motion – Gestural Step

- Open the following scene file from the project files directory – **9.2_01_Step_Gesture_Twinned.ma**.

The scene file includes the same character asset we worked with in the previous section.

- Playback the animation (Alt + V).

The character takes a step forward from closed idle pose at frame 06 to open, arms outstretched pose at frame 18 (see Fig. 9.2.1).

The step takes 12 frames (06–18), this timing is fairly even for a step and would be at regular march pace in a walk cycle.

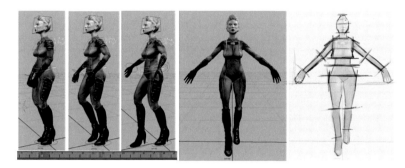

FIG 9.2.1 Twinned animation sequence – gestural arm raise.

If we look at the animation, we can see that it's pretty blocky looking and un-natural. The character is not weighted or balanced during the step and looks fairly upright. This would be normal for a blocked in animation that hasn't been refined. Let's look at the first pose at frame 8.

Pose 1 – Idle Pose – Frame 6
The pose at this frame has the body perfectly straight with the weight distributed perfectly evenly between the legs. This would be fine except that there is absolutely no rotation on the torso. The evenness between the poses on the arms also looks un-natural, and overall, the character looks lifeless or static (see Fig. 9.2.2).

FIG 9.2.2 Twinned animation – pose 1 (idle).

377

Pose 2 – Mid-Step Pose – Frame 12

At the mid-step pose on the animation, we can see similar problems.

The body is still perfectly upright, with the hips weighted perfectly between both legs (see **Fig. 9.2.3**, first and second screens from left).

This looks un-natural from the front at this frame, as there is no weight shift or distribution to the side onto the planted left leg (see Fig. 9.2.3, second screen from left).

- From the side, the pose looks slightly better as there is variation between the poses on the legs (as the right foot moves forward (see Fig. 9.2.3, third screen from left).
- The arm poses are also rigid and too even; the angles of the arms are perfectly twinned or mirrored when viewed from the front or side (see Fig. 9.2.3, fourth and fifth screens from left).

FIG 9.2.3 Twinned animation – pose 2 (mid-step pose).

Pose 3 – Final Step Pose – Frame 18 – Arms Fully Outstretched

At the final pose in the animation, the arms are fully outstretched, as if gesturing, again the same issues as the previous two poses can be seen. There is absolutely no weight shift on the hips, the torso is perfectly straight and the arm poses are perfectly twinned (see **Fig. 9.2.4**).

FIG 9.2.4 Twinned animation – pose 3 (full extension on arms).

In addition to the twinning on the poses in the animation, there are issues with the timing; every element on the character has been keyed at the exact same frame, which makes the motion look robotic and lifeless.

Refined Motion and Posing – Gestural Step

- Open the following scene file from the project files directory –
 9.2_02_Step_Gesture_Refined01.ma.

Pose 1 – Idle Pose – Frame 6

For the idle pose at the start of the animation, subtle adjustments have been made to the pose to remove the issues with twinning on the pose and make the pose look more natural, balanced, and weighted (see Fig. 9.2.5).

Scrub the Time Slider to frame 6 to validate the edits that have been made.

Pose 1 – Idle Pose – Frame 6 – Arm Posing

- The arms have been posed slightly offset from each other, the angles of both arms are not perfectly identical and the twinning has been resolved.
- Right arm – The right arm has been posed hanging freely at the character's side; the wrist is angled slightly to suggest the weight of the hand pulling the arm (see Fig. 9.2.5, third screen from left).
- Left arm – The left arm has been posed slightly forward, resting in front of the body, the pole vector constraint has been used to pose the elbow out slightly, so that the arm is closed in toward the body. The forearm pose looks natural, as if the character is resting the arm, wrist, and hand on the hip and thigh (see Fig. 9.2.5, fourth screen from left).
- The angles of the arms complement the angle of the overall pose of the body (see Fig. 9.2.5, first and second screens from left).
- The arms are posed to complement the angles of the legs:
 - The leading right leg has right arm trailing.
 - The trailing left leg has right leg trailing.

FIG 9.2.5 Refined pose – pose 1 – idle.

Pose 1 – Frame 6 – Hip and Torso Counter Balance

If we look at the torso, there are subtle adjustments that have been made, which are similar to the idle pose we worked on in the previous section.

- Weight shift – the main hip control has been shifted over the left leg to balance the weight.
- The hips have also been rotated up on the left side to straighten the left leg (see Fig. 9.2.6, first/second screen from left).
- The torso controls have been counter rotated, so that the right shoulder is back from the leading right hip (see Fig. 9.2.6, screens on right).
- There is a nice curve on the spine running down the body when viewing the pose from the back.

FIG 9.2.6 Refined posing – pose 1 – hip and torso balance.

Pose 2 – Frame 12 – Mid-Step Pose

Similar adjustments have been made to the mid-step pose at frame 12 of the animation (see Fig. 9.2.7).

- At the mid-pose, the arm angles are broken up, the right arm is trailing the leading right leg more (see Fig. 9.2.7, middle screenshot).
- The right arm is straighter than the left, with the leading left hand being slightly more open in anticipation (see Fig. 9.2.7, middle and right screenshots).

FIG 9.2.7 Refined posing – pose 2 – overall pose and arms offset.

Pose 2 – Frame 12 – Mid-Step Pose – Hip and Torso
Counter Balance and Poise

At this pose, the character is now moving in a more diagonal line (to the characters left side – see Fig. 9.2.8). This overall direction of the character makes the animation more dynamic and fluid. The hip and torso rotation is also exaggerated as the character reaches the mid-step.

- The hips are rotated round in the Y-axis to match the leading right leg (see Fig. 9.2.8, left screenshot).
- The hips are rotated round slightly more in the Z-axis to straighten the planted left leg and distribute the weight (see Fig. 9.2.8, middle screenshot).
- There is a nice line and curve running from the legs through the back (see Fig. 9.2.8, right screenshot).

FIG 9.2.8 Refined posing – pose 2 – hip and torso counter balance.

- The torso is curved back slightly, so that the chest is pushed forward more (see Fig. 9.2.9).
- The shoulder controls are rotated back slightly to make the character appear poised (see Fig. 9.2.9).

FIG 9.2.9 Refined posing – pose 2 – chest and shoulder rotation.

Pose 3 – Frame 18 – Final Step Pose – Arms Fully Outstretched

At the full extension pose on frame 18:

- The arms are fully outstretched (see Fig. 9.2.10).
- There is a clear diagonal line running from the tip of the left hand up across the body, which complements the angle of the hips.
- The left fingers are outstretched, which gives a nice gesture as the hand opens out to this pose (see Fig. 9.2.10, right screen).

FIG 9.2.10 Refined posing – pose 3 – final arm extension pose.

- The hips have been counter rotated from the previous pose; the right hip has now been raised, straightening the right leg. The contrast between this and the previous pose makes the animation look punchy (see Fig. 9.2.11, left screens).
- The torso is rotated further back at the chest, exaggerating the lean inward from the previous pose (see Fig. 9.2.11, third screen from left).
- The right shoulder control is rotated really far back, making the pose more dynamic (see Fig. 9.2.11, fourth screen from left).

FIG 9.2.11 Refined posing – pose 3 – hip, torso, and shoulder balance.

- Playback the full sequence to validate how the pose edits work in combination (Alt + V).

The contrasts between the poses create a far more fluid and natural animation (compared with the original twinned animation – **9.2_01_Step_Gesture_Twinned.ma**).

The shifts in the hips and spine rotation create weight and balance in the pose, and the offset posing on the arms create a more natural and dynamic action line (see Fig. 9.2.12).

Although all the body controls are keyed at same frame (frame 0/6/12/18), the animation poses are not twinned; this helps to break up the motion and to prevent it looking like everything is moving at the same time. To further enhance and finalize the animation, additional follow through, overlap and offsets to the timing can be added to reduce the appearance of evenness or twinning in the timing & spacing.

FIG 9.2.12 Refined posing – validating the pose edits in combination.

Pose 4/5/6 – Frame 18 to Frame 33 – Follow Through and Overlap – Pt.1

- Open the following scene file from the project files directory – **9.2_03_Step_Gesture_Refined02.ma**.

The scene file includes an additional 15 frames from frame 18 to 33, where the character returns to idle pose (see Fig. 9.2.13). Playback the sequence (Alt + V) to see how the edits enhance the sequence.

FIG 9.2.13 Follow through and ease out.

Pose 4/5/6 – Frame 18 to Frame 24 – Arm Follow Through and Overlap

The arms return to the idle stance pose after the foot plant–

- There is contrast in the timing; the motion from idle to the full arm raise pose was 12 frames, the return to the idle is half this (six frames); the motion is punchier.
- The left arm begins to drop first, with the spacing being more even. The right arm drop is faster as the drop is delayed – the spacing is broader (see Fig. 9.2.14, middle screens).

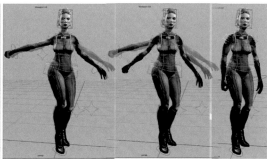

FIG 9.2.14 Ease out (frame 18–24) – arm follow through to idle.

Pose 4/5/6 – Frame 18 to Frame 33 – Idle Ease Out and Foot Follow Through/Overlap

There is a prolonged ease out as the body returns to idle

- The hips dip slightly after the move (frames 18–24) and then return back to more upright rigid idle at frame 33 (see Fig. 9.2.15, left screens). The motion is subdued as the pose spacing is close.
- The left foot pivots round after the foot plant, the foot rotates round from the heel, with the Heel Pivot channel keyed on the control object between frames 18–24. This motion overlaps with the rest of the motion as the foot follows through to reach more natural pose for idle (see Fig. 9.2.15, right screens).

FIG 9.2.15 Idle ease out (frame 18-33)/foot follow through.

Additional Edit – Timing Offset on Arm Swing

Further edits can be made to the timing and posing to change the mood, weight, and balance on the animation. Looking at the animation (in the scene file **9.2_03_Step_Gesture_Refined02.ma**), the timing on the arm swings still look a bit "twinned"; the difference between the arm drop spacing creates a nice offset (see Fig. 9.2.14), but overall, the arm raise timing is pretty consistent on both arms.

- With the project scene file still open (**9.2_03_Step_Gesture_Refined02.ma**), open the Outliner, and select the following control object:
 - FSP_Hand_L_CTRL (see Fig. 9.2.16, left screen).
 - With the control selected, click with the left mouse button at frame 5 on the Time Slider, and then with the left mouse button and Shift key on the keyboard de-pressed, drag past frame 27 to highlight and select the key range between frames 6 and 27 (see Fig. 9.2.16, lower screen).
 - With the range selected and highlighted click with the left mouse button at the <> icon in the middle, and drag the key range back 1 frame (see Fig. 9.2.16, bottom screen).

FIG 9.2.16 Timing edit 1 – left arm raise earlier.

This edit modifies the timing so that the left hand starts to move slightly ahead of the right hand.

Additional edits can be made to the overall timing for the left hand, for example,

- Left wrist to full extension on arm raise can be moved slightly forward, from frame 17 to frame 16 or frame 15.
- Left wrist drop can be delayed by moving the in-between key at frame 20 to frame 18.
- The in-between poses on the hand drop can be modified, so that the drop eases out more at the end.

385

Editing the timing & spacing for the hand can enhance the animation. Additionally, be aware that edits may also be needed for the left shoulder control (FSP_Calvicle_L_CTRL) and other elements to keep the motion balanced. For example, the left shoulder should naturally lead the motion, so the keys should be shifted forward and pose adjusted for them as well.

For the right wrist control, the timing can also be adjusted for it, so that the right arm begins to move slightly after the left arm at the start of the animation.

- With the project scene file still open, open the Outliner and select the following control object – FSP_Hand_R_CTRL (see Fig. 9.2.17, left screen).
 - With the control selected, click with the left mouse button at frame 4 on the Time Slider, and then with the left mouse button and Shift key on the keyboard de-pressed, drag past frame 27 to highlight and select the key range between frames 4 and 27 (see Fig. 9.2.17, lower screen).
 - With the range selected and highlighted click with the left mouse button at the <> icon in the middle and drag the key a couple of frames later (see Fig. 9.2.17, bottom screen).

Moving the keys ahead a couple of frames for the control object delays the swing on the right arm. The twinning on the timing is less apparent (see Fig. 9.2.17, right viewport screen).

Note

As with the edits to the left wrist control, additional adjustments to the timing & spacing of the other control rig elements may be required to keep the animation balanced and weighted.

FIG 9.2.17 Timing edit 2– right arm raise delayed.

Further edits that could be made to the timing & spacing could include – Delay upper torso and arms, this would be a global edit to all the top torso and hand controls, the motion could be delayed by 1–2 frames; the top torso control (FSP_Spine03_CTRL) and hand controls could be delayed further to create additional follow through.

Note

Additional work may be required to edit the overall posing on the animation. Edits to timing can significantly change the overall mood of the animation and in some cases soften the motion.

Scene file with the minor offset edits to the arm swing timings is included with the project scene files as – **9.2_03_Step_Gesture_Refined03.ma**.

Appeal

[Appeal]... often misinterpreted to suggest cuddly bunnies and soft kittens.
The Illusion of Life: Disney Animation – Frank Thomas and Ollie Johnston

Appeal is sometimes misinterpreted as a traditional animation principle that applies only to stylized, cartoony, or cute Disney characters. This is incorrect as appeal in animation can also equally be applied to animation design or performance that is dark or fits a more adult tone and mood.

It can equally be applied to design or performance for a striking heroic character or villainess. The best designed features and animations will appeal to a wide range of viewers and will typically appeal across a broad audience and age range.

Appeal is a term that can also be applied generally to all aspects of Computer Animation & VFX Production. Is the character design appealing? Does the production design for the environment fit the mood of the feature? Is the VFX shot exciting and appealing to the audience? The success of recent Pixar features is testament to great design in appeal – both the mood of the feature and the design of the characters in Pixar films appeal to a wide age range and demographic.

In this chapter, we'll be looking at appeal in 3D production design, lighting design, and animation through character performance.

Appeal in Character Design and Animation

A strong character design informs the animation. The believability of the character as well as the basic shape, weight, and form of the body has a large influence on the way the character will be animated. Understanding what is appealing in the character design helps when making creative decisions about how the characters should hold themselves and move in the scene.

For example –

- The female character model we've worked with in previous chapters is athletic and toned. The character is bright and strong. The animation appeal comes from the character being posed and animated as poised, balanced, and graceful, which matches the characterization (see Fig. 10.0.1, left).
- The baseball pitcher character is heavy set and muscly. The character is gruff and tough. The character should be animated with more mass and weight to match the characterization (see Fig. 10.0.1, right).

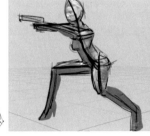

FIG 10.0.1 Appeal – production design and characterization.

Production Design – Lighting

The Lighting TD is typically responsible for the lighting setup in an animation feature. Creating effective lighting rigs that naturally mimic the effects of real-world lighting is an art form in itself. For animation production, the setup of the lights in the scene is critical in tying the scene together and creating an overall feeling or mood that's appropriate for the individual shot or sequence.

The setup of the lights has to also be considered against both the production design for the set and characters as well as for the camera framing in the shot.

- Is the keying and color of the lights appropriate for the scene?
- Are the subjects lit clearly, with the lights modeling the forms convincingly?
- Does the lighting enhance the staging and make the action readable?

In this tutorial, we'll start by looking at the basic setup for the most common lighting setup, the 'three-point' lighting rig. This rig is typically the starting point for lighting a single character or subject in a scene (see Fig. 10.0.2, left).

We will also consider how the setup and tone of the lights in the scene can help enhance the overall feel of the animation and create different moods that can tie in to the performance appeal (see Fig. 10.0.2, right).

FIG 10.0.2 Appeal – lighting and mood.

Performance Appeal

In the third tutorial in this chapter, we'll take a look at how to create appeal through character performance. Character animation that is appealing creates empathy with an audience and holds its attention throughout the feature. This appeal can be created through either broad theatrical performance by the character or the most subtle gestures that are highly nuanced.

From the examples provided in Chapter 10.3, we will show how using the previously taught animation principles in a combined and considered manner creates appeal (see Fig. 10.0.3).

FIG 10.0.3 Appeal – nuanced performance.

Chapter 10.1 – Production Design – Character

A strong and clear design intent is critical in animation production. For character animation, it's important for a character artist to have a clear idea of what the character's personality and mood will be when designing an effective character mesh for production.

The appeal of the character is defined at the design phase, which really informs the work of the animator:

- What is the personality of the character? – are they gruff, strong willed, louche, or evil? – is the personality overly exaggerated to create stronger appeal for the viewer?

- What is the build of the character? – are they bulky or heavy, light, athletic or fleet of foot?
- Is the character stylized or do they have exaggerated proportions?
- Is the character to be photo-realistic for the needs of the project or should they fit a more illustrative or cartoon style?

Appealing character design will help to inform the animation. Great designs that have strong personality will help to make the animator's job more enjoyable and effective and will imbue the animation with more life, vitality, and appeal.

In production, typically the character design will be defined during the pre-production phase on the basis of the project needs. Clear communication between the project leads on what the character design appeal and the animation appeal are is important in defining the direction of the work.

In a production pipeline, the character design will typically begin with production sketches and model sheets being completed (see **Fig. 10.1.1**, first screen from left).

Depending on the project's size, the character design and execution may pass through several phases before rigging and animation (see Fig. 10.1.1, left to right screens). These major phases can include the following:

- Look development – pre-production, character design, and model sheets
- Base mesh modeling (Maya) and detail sculpting (Mudbox or Z-Brush)
- Surface painting – typically done in Mudbox/Z-Brush or surface painting tool
- Character rigging and animation

FIG 10.1.1 Character design – look development through detailing to final animation.

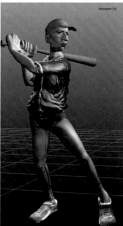

In this section, we'll take a look at the major phases in designing the look and feel for the main characters used within the book. The major design decisions in creating the character appeal will be discussed and presented alongside the pre-production sketches and model shots showing the characters moving through the main production phases prior to rigging and animation.

Female Heroine

The female heroine character model is your typical toned athletic female archetype – the sort of character that's common in action films, sci-fi, and video games.

Pre-production sketches help to define the proportions, forms, and mood for the character (see Fig. 10.1.2).

The character has classical female proportions, with well-defined hips and smaller shoulders. The character is fairly tall, and the overall forms for the shape of the character are curved and feminine, though not overly full figured or overly womanly (see Fig. 10.1.2).

The overall design intent for the character was poised, athletic, and commanding.

FIG 10.1.2 Pre-production sketches – female heroine.

The character mesh was roughed out in Maya, with a medium-resolution polygon count of a few thousand polygons. When modeling, it's critical to look at the overall forms and silhouettes of the character, and using flat shading on the model can help when checking the forms in relation to the pre-production sketches to ensure that the shapes are proportionally correct (see Fig. 10.1.3).

FIG 10.1.3 Base character mesh and silhouettes – female heroine.

Female Heroine Detail Modeling and Texturing – Mudbox

Mudbox was used to finalize all the project models with additional detail. The base medium-resolution Maya meshes were imported to Mudbox, sub-divided to around a million+ polygons, and detail sculpted through the Mudbox brush sculpting tools (**Fig. 10.1.4**).

Sculpt Details

For the female heroine character, the Mudbox sculpting tools were used to add both definition to the form as well as close detail for the costume and face. The character is wearing a close fitting "jump suit". The sculpt and pinch tools were used in Mudbox to add fine line wrinkles for the cloth as well as detail for the costume ribbing. The additional wrinkles and creases in the costume were added around the main areas where the cloth bunches up around the body parts such as the groin, hips, and elbows (Fig. 10.1.4). The amount of crease detail on the cloth is appropriate for the cloth – which is fairly thin and silk like; thicker creasing on the leather boots and gloves provides contrast in the design. Ribbing detail was added for the shoulder and thigh pads, which provides extra detail that breaks up the costume.

FIG 10.1.4 Detail sculpt, Mudbox – female heroine.

The mesh was detail painted in Mudbox. For the character, clean primary colors were used for the costume – with bright silk blues used for the jump suit with gold and silver detail areas. Overall, the color tones for the costume were clean and synthetic. The face and hair color tones are also clean, with primary natural flesh tones used to give the character a warm hue and golden yellows used to give the hair a teutonic look (see Fig. 10.1.5).

FIG 10.1.5 Detail painting, Mudbox – female heroine.

Male Athlete 1 – Baseball Pitcher

The baseball pitcher character is your typical muscle-bound athlete.

The proportions for the character were defined through pre-production sketches (see Fig. 10.1.6).

The character is proportioned with heavy muscle mass on the upper torso and shoulders, which is in contrast to the tapered thin hips. The proportions are slightly exaggerated from the norm, with the character being almost ape like in proportion. The forms on the character are solid looking with the face being chiseled, giving a tough masculine look to the character, and the jaw line is fairly square with a straight flat nose making the character look a bit gruff or angry.

FIG 10.1.6 Pre-production sketches – male athlete 1.

The character mesh was roughed out in Maya. Basic primitive shapes were used at the initial phases of modeling to get the overall form and silhouette for the character right (see Fig. 10.1.7).

FIG 10.1.7 Base character mesh and silhouettes – male athlete 1.

Male Athlete 1 – Detail Modeling and Texturing – Mudbox

As with the other character meshes, detail sculpting was done in Mudbox. For the baseball pitcher, different levels of sculpt detail were applied to the mesh to enhance the overall mood for the character.

Clothing – For the character's shirt, the muscle forms were clearly defined on the upper torso through overall sculpt. The fabric is fairly light and loose around the torso, so the folds around the forms were more loosely sculpted.

The character's trousers are a tight silk fabric, so less detail is applied through sculpt for the creases and folds on the fabric, with detailing being used only on the major creases around the forms and fabric seams and belt (see Fig. 10.1.8).

Skin – The sculpt tools in Mudbox were used to enhance the forms on the character face, the jawline was clearly defined and masculine, and additional chisel marks were used around the mouth and cheeks to suggest the character is slightly rough or Jaded (see Fig. 10.1.8). Detail was also applied around the fingers to make them look rougher or more worn.

FIG 10.1.8 Detail sculpt, Mudbox – male athlete 1.

The color tones used in painting the mesh use off primary blues and grays and cooler skin tones. The cold color tones used for the cloths and skin on the character help enhance the overall mood of the character, who is aloof, tough, cold, and hard. The skin tones are slightly off-white, with more purple tones on the cheeks used to give the skin tone a cold bloodless feel, enhancing the overall mood and appeal (see Fig. 10.1.9).

FIG **10.1.9** Detail painting, Mudbox – male athlete 1.

Male Athlete 2 – Baseball Batter

The baseball batter character uses similar costume to the pitcher character. However, the character design and overall proportions are in contrast to the pitcher model.

The pre-production sketches defined the character as noticeably less athletic than the pitcher. The character is a lot thinner and less athletic, and the overall shape of the body is thin and sinewy. The character is slightly out of shape, with a slightly paunched belly and double chin. The character is also slightly caricatured, with the overly large nose and protruding mouth making the character look a bit goofy (Fig. 10.1.10).

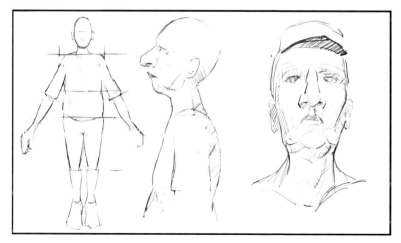

FIG **10.1.10** Pre-production sketches – male athlete 2.

The base character mesh used for modeling is the same mesh as that used for the more athletic baseball batter. Commonly in production meshes are re-used on projects – this is especially true if the models are of similar types – as both models use similar costume and detailing, there is no point in creating a new model from scratch. The baseball batter model was modified from the original pitcher model, with the mesh being scaled around the major areas to change the proportions significantly before importing to Mudbox. As before, the mesh forms and silhouettes were worked on in Maya at the initial phase with reference to the original production drawings (see Fig. 10.1.11).

FIG 10.1.11 Base character mesh and silhouettes – male athlete 2.

Male Athlete 2 – Detail Modeling and Texturing – Mudbox

As with the other character meshes, the base model was imported from Maya to Mudbox and sub-divided to higher resolution for the detail sculpting. Similar sculpting methodologies to that of the chiseled baseball pitcher were used for the costume as the fabric types are the same.

For the character, major creases were sculpted around the gutline with the angles on the creases pulled down to create more noticeable sagging in the fabric. This helps to create additional emphasis in the characterization as the batter is not athletic and toned like his counterpart. Saggy creases were also used around the detail areas for the flesh around the face, with the saggy jaw and cheeks enhancing the overall mood and appeal of the character (see Fig. 10.1.12).

FIG 10.1.12 Detail sculpt, Mudbox – male athlete 2.

The color tones used in painting the character are brighter and less subdued than that used for the baseball pitcher character (see Fig. 10.1.13). Bright warm greens, beiges and warm skin tones are used – making the viewer empathize with the character as protagonist (see Fig. 10.1.13).

FIG 10.1.13 Detail painting, Mudbox – male athlete 2.

Chapter 10.2 – Lighting and Mood

Viewport Renderer and Lights

- From the project files, open the start file for the tutorial – **10.2_01_Head_3Point.ma**.

The scene file includes the character face mesh we've worked with in the previous tutorials (see Fig. 10.2.1, left screen).

- Make sure that the active Panel is set to Perspective view:
 - Panels > Perspective > Persp (see Fig 10.2.1, left screen).
- From the active Panel, go to the Renderer menu at the top and switch to 'Viewport 2.0' (see Fig. 10.2.1, top middle screen).
- From the active Panel, go to the Lighting menu at the top and toggle on 'Use All Lights' option (Fig. 10.2.1, center middle screen).

Note

The 'Use All Lights' option can also be toggled on by hitting the shortcut key '7' or by pressing the small yellow icon shortcut along the top row of the panel (see Fig. 10.2.1, lower middle screen).

By toggling on the 'Use All Lights' option, the lights that are active in the scene are used to shade the model (see Fig. 10.2.1, right screen).

This is in contrast to the 'Use Default Lighting' option (see Fig. 10.2.1, left screen) – 'Default Lighting' option lights the model uniformly from single light in the scene that is not visible, but essentially follows the Perspective view so that the model is always clearly lit while working.

Default lighting can be toggled back on from the Lighting menu or by toggling off the 'Use All Lights' button or by pressing the shortcut key '5'.

Note

While animating, modeling, or working on the scene setup, you may find it preferable to shade the model with default lighting.

Viewport 2.0 and Lighting

With any of the Viewport renderers active (Default/High Quality/Viewport 2.0), the effect of the scene lights that have been added can be previewed in the Viewport. The High Quality and Viewport 2.0 renderers provide several benefits over the default renderer in terms of both quality of the renderer and preview of scene lighting. The Viewport 2.0 renderer provides more realistic shading of the model as well as additional quality features for previewing the camera effects, which we covered in Chapter 5.2.

FIG 10.2.1 Viewport renderer – default lighting (5) and scene lights enabled (7).

Lighting – Three-Point Lighting

- From the active Perspective Panel, go to the Show menu at the top and select the 'Lights' option:
 - Show > Lights (see **Fig. 10.2.2**, first screen from left).

The main lights in the scene are Spot Lights – these are displayed as cone-shaped icons in the Viewport (see Fig. 10.2.2, second screen from left). The shape of the light icons are dependent on the light type.

The light type can be switched from the Attribute Editor 'Type' drop-down, when each light is selected (see Fig. 10.2.2, third screen from left top). The additional attributes that display in the Attribute Editor are dependent on the light type (see Fig. 10.2.2, third screen from left bottom), with each light providing benefits in different situations.

FIG 10.2.2 Lights visible in Viewport – three-point lighting rig.

The scene uses a standard three-point lighting rig. Three-point lighting is a standard used in traditional photography and film. It is a natural lighting scheme where the object is lit realistically with the following:

1. Key light – This is the main light that illuminates the subject. This is the light pointing to left side of the character's face (see Fig. 10.2.3).
2. Fill light – This light provides additional illumination on the subject, typically used to light any harsh shadows. This is the light pointing to right side of the character's face (see Fig. 10.2.3).
3. Rim light (or back light) – The rim light is typically placed at the back of the object. It is used to both mimic the reflected light and help separate the object from the background. This is the larger light pointing to the back of the character's face (see Fig. 10.2.3).

FIG 10.2.3 Three-point lighting rig.

Three-Point Lighting – Key Light

Let's take a look at the three-point lighting setup in more detail. We can add each light separately to the scene to see how the attributes work in combination to create the effect. Let's start with the main Key Light in the scene.

- From the project files, open the start file for this section – **10.2_00_Head.ma**.
 - The scene is the head model, without the setup of the lights.
- Choose File > Import – from the Import dialog, set Files of Type = Maya ASCII and import – **10.2_00_Light01.ma**.

401

- Enable the Viewport 2.0 renderer and turn on 'Use All Lights (7)' (see Fig. 10.2.1).

The key light is shown as as a cone-shaped icon in the Viewport (Fig. 10.2.4, left screen).

The light illuminates the left side of the character due to the angle and position of the light. The light is set above the character pointing downward – this produces natural lighting effect, which you'd get from both the sun or an artificial indoor light (see Fig. 10.2.4).

With the light selected, we can check the attributes from the Attribute Editor (Ctrl + A) to check the setup in more detail (see Fig. 10.2.4, right screen).

Color – The light color is set to a slightly off-white yellow – this color is appropriate for light that mimics daylight or natural light outdoors.

Intensity – The intensity is set quite high, at around 1.35 – this makes the light quite strong on the focused area around the left temple (see Fig. 10.2.4, middle screen).

Cone Angle/Penumbra/Dropoff – The Cone Angle is the main attribute that controls the size of the light (or spread), and modifying this attribute modifies the width of the light cone in the Viewport. The Cone Angle is set quite small for the light – this creates a focused light, which fades around the extreme edges of the neck on the model. The Penumbra Angle and Dropoff control the softness of the contrast on the light at the extremes (Penumbra) and the overall dropoff before the light fades.

FIG **10.2.4** Key light – isolated effect and attributes.

Viewport Shadows – Key Light
- With the scene file still open, go to the Lighting menu at the top of the Panel and select
 - Lighting > Shadows (Fig. 10.2.5 – left screen).

Note

This is a global toggle, which turns on Shadows in the Viewport for all lights that have shadows enabled. The option is not accessible when using the Default Renderer for the Viewport.

- With the Key light selected, open the Attribute Editor (Ctrl + A) and set the following (see Fig. 10.2.5, right screen):
 - Shadows > Depth Map Shadow Attributes =
 - 'Use Depth Map Shadows'
 - Resolution = turn up to 4096 or maximum of 8192

Note

Shadows can only be turned on for lights that are set as either 'Spot Light' or 'Directional Light' type in the scene.

The light casts realistic shadow in the Viewport – a strong shadow can be seen cast from the nose across the top lip and from the chin across the neck and the character's right shoulder (see Fig. 10.2.5, middle screen).

When lighting, you will typically only want a single light casting shadows on the subjects; this will look more natural and will mimic natural lighting more realistically. Multiple shadow casting lights can make the subject harder to read and reduce clarity.

FIG 10.2.5 Enabling Shadows in scene and turning on Depth Map Shadows for Key Light.

Depth Map Shadows can be rendered off-line, as well as previewed in the Viewport (with Viewport 2.0 and High Quality renderers). The two main types of shadows used for lights in 3D are Depth Map Shadows and Ray Traced Shadows.

Depth Map Shadows are rendered using a calculation of the distance (or depth) from the light source to the model, with a map being produced, which creates the shadow. The resolution of the map (which can be set from the Attribute Editor) controls the overall quality of the effect.

Depth Map Shadows are not as physically accurate as Ray Traced Shadows, which calculate shadows on the basis of tracing rays from the light source. However, Depth Map Shadows are not as computationally expensive as Ray Traced Shadows; that is, they render more quickly using the off-line renderer (Maya Software or mental ray). Thus, owing to time/cost constraints on projects, Depth Map Shadows are commonly used in production instead of Ray Traced Shadows for rendering. Because Ray Traced Shadows are more computationally expensive, it is also not currently possible to preview their effect using either the Viewport 2.0 or High Quality rendering modes in Maya.

Three-Point Lighting – Fill Light

With the scene file still open, import the next light, the Fill Light, to see how it enhances the lighting in the scene. Go to File > Import and import the following Maya ASCII file – **10.2_00_Light02.ma**.

The light is positioned directly opposite the Key Light, illuminating the opposite side of the face (right side of the face) (see Fig. 10.2.6, left screen).

The fill light does as you'd expect; it helps to fill in areas that are too dark on the subject. If you compare the effect with that of the previous setup with single key light (Fig. 10.2.5), the effect is a lot more natural, with the shadows appearing less harsh (see Fig. 10.2.6).

Fill lights are typically used in 3D animation to mimic the effect of bounced or reflected light. In the real world, light will typically reflect or dissipate across a wider range, producing more natural effect. Using fill lights around areas of the subject will help to create an effect that, to the viewer's eye, is believable and natural. The fill light in the scene uses the following setting, which can be confirmed from the Attribute Editor:

Color – The color of the light is set to an off-purple tone. This tone provides contrast with the key light color and is a natural tone for lighting facial skin tones. Using colored lights selectively can help to make the lighting appear more dynamic.

Intensity (0.89) – The intensity is set lower than that of the key light, though not so low that the shadows still look harsh.

Cone Angle/Penumbra/Dropoff – The light spreads over a broader range than does the key light. This is appropriate as the light is illuminating the shadow areas across the subject (at lower intensities).

FIG 10.2.6 Fill light – softening the key light effect.

Note

In 3D animation, there are additional effects that are available to more realistically mimic how real light bounces and dissipates – these include global illumination, radiosity, and caustics. These features can be enabled through the off-line mental ray renderer; however, as with ray tracing, the additional quality benefits they provide come at a cost in terms of scene complexity and render times. Because of this, you may find that it is preferable to use fill lights in scenes, even for off-line rendering.

Three-Point Lighting – Rim Light

With the scene file still open, import the next light, the rim light, to see how it enhances the lighting in the scene. Go to File > Import and import the following Maya ASCII file – **10.2_00_Light03.ma**.

The rim light (or back-light as it is sometimes called) is positioned directly behind the subject (Fig. 10.2.7).

The rim light produces a rim-like effect around the subject, brightly illuminating the subject around the edges. The rim light helps to separate the subject from the background and can produce a halo-type ring around the edges. As the light is angled slightly diagonally from the back of the subject, the bright light also dissipates slightly across the form with the light also illuminating the side edge of the nose and right cheek (see Fig. 10.2.7, right screen).

FIG 10.2.7 Rim light – separating the subject from the background.

405

Check the attributes for the light from the Attribute Editor (see Fig. 10.2.7, middle screen).

Color – The color of the light is again set to a slightly off-purple tone, shading the character naturally. This provides a slight contrast to the key light color and mimics both the natural translucence of skin and effect of cast light.

Intensity (3.5) – The intensity is set a lot higher than those of the key light and main fill light. This produces good contrast in the image with the rim light separating the face from the background (when viewed from the front of the character) (see Fig. 10.2.7, right screen).

Cone Angle/Penumbra/Dropoff – The light spreads over a far broader range than both the key light and main fill light. This illuminates the back of the head, neck, and shoulders evenly, creating a strong effect. The wide Cone Angle is reflected in the Viewport icon, which is a broad fanned cone.

Three-Point Lighting Setup – Additional Fill Lights

Lighting your characters and subjects effectively is an iterative process. When adding key lights and additional fill lights in the scene, it is a matter of modifying the light's position, intensity, and other attributes so that the effect of the lighting is natural, and the lights complement one another. When lighting your subjects, it is also critical to consider how the lighting affects the forms on the subject and whether these are subdued or enhanced by the lights. Lighting can be considered analogous to modeling, with the lights helping to bring out or better define the forms on the subject.

With the scene file still open, import the final lights for the setup and the additional fill lights to see how they enhance the lighting in the scene. Go to File > Import and import the following Maya ASCII file – **10.2_00_Light04.ma**.

The imported file includes a couple of additional fill lights.

Prior to importing the lights, the shadows around the character's neck still appeared quite dark (see Fig. 10.2.8, first screen from left).

Although this may be appropriate in some situations, small point lights can be used in the scene to pull up the tones around the selected areas.

The placement of the fill lights is set up appropriately for the area they're being used on – both the lights are placed diagonally out from the neck and lower jaw, as the light will dissipate outward from the source (see Fig. 10.2.8, second screen from left).

Let's look at the effect of the additional fill lights based on the Attributes used in Maya (see Fig. 10.2.8, third screen from left).

Light Type = Point Light – The Point Light type in Maya is represented as a small spherical icon in the Viewport (see Fig. 10.2.8, second screen from left). The Point Light is not a directional light (as the Spot Light is), and, therefore, light is dissipated in all directions outward from the light in the scene.

Note

The Point Light type does not include the additional attributes for Cone Angle/Dropoff, etc., that the Spot Light does. The Point Light typically provides more localized light in the scene with a smaller dropoff.

Light Intensity (0.28) – Both the fill lights have low intensity, set at around 25%–30%. The light intensity is set low as they are only being used to pull up the tone of the shadows around the chin and lower jaw slightly (see Fig. 10.2.8, fourth screen from left).

FIG 10.2.8 Additional fill lights – localized softening of the shadows.

Lighting and Mood

The three-point lighting setup is typically used for portraiture, both in physical portraiture (with a camera in the real world) and in 3D, where the same principles are applied or mimicked. A similar process in using key, fill, and rim lights can be applied to create different effects, including more exaggerated theatrical effects or subtle subdued lighting.

- Open the scene file for this section – **10.2_02_Head_Contrast_Mood1_01.ma**.

The scene file includes a similar setup to the three-point light rig we discussed earlier. The main difference in the setup is in the color tones of the lights as well as the overall brightness and contrast in the image.

RimLight2_point1 – This light's color tone is bright green, with strong intensity. This gives strong contrast across the back of the head and the side of the face (see Fig. 10.2.9, left screen).

FillLight2_point1 – This light's color is light bluish, complementing the garish green tone of the main rim light (see Fig. 10.2.9, middle screen). Turning down the intensity of the fill light (to around 0.14) increases the contrast between the high-impact rim light and the shadowed areas on the face (see Fig. 10.2.9, right screen).

FIG 10.2.9 Mood lighting 01 – cast light (neon).

The light setup is closer to something you'd see on the stage or theatre. The light colors are really synthetic looking on the setup, the type of effect you might use in lighting for a science fiction show.

Although the light setup is dramatic, it looks a bit unnatural – the lighting on the right side of the face looks as if the subject is lit normally, while there is strong dramatic synthetic cast light on the left side of the face (see Fig. 10.2.10).

FIG 10.2.10 Mood lighting 01 – cast light (neon).

Dusk Lighting

Open the scene file for this section – **10.2_02_Head_Contrast_Mood1_02.ma** (see Fig. 10.2.11, left screen).

The scene file has the same light setup with the light colors, contrast, and intensities tweaked to produce a more natural dusk lighting effect.

KeyLight1_spot1 – The intensity of the key spot light pointing to the character's right side has been reduced. The color tone has also been changed to give a more bluish hue, improving the overall mood (see Fig. 10.2.11, second screen from left).

Note

The color for the light has been changed slightly. The value for the Color (from HSV on color swatch) has been reduced, while the Intensity has been increased – reducing the value is similar to reducing the intensity (see Fig. 10.2.11, fourth screen from left).

RimLight1_spot2 – The color and intensity of the main rim spot light pointing at the back of the head has been changed. A more natural 'moonlight' effect has been achieved (see Fig. 10.2.11, third screen from left).

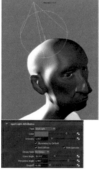

The color tones for the key light and the fill lights are better matched than before. The more subdued blueish tone of the key light is more in fitting with the cast yellow and green light from the rim lights at the back of the subject. Adjusting the intensity and color of the key, rim, and fill lights, so that it's better matched, produces a more realistic light setup.

FIG 10.2.11 Mood lighting 02 – dusk lighting.

Spooky Lighting

- Open the scene file for this section – **10.2_02_Head_Contrast_Mood3_Spooky.ma** (see Fig. 10.2.12).

The setup is almost identical to the previous setup we looked at, except for a couple of key additions.

The cyan-colored rim light has been duplicated and pulled out to the front of the character (named RimLight2_point2).

- The light is positioned underneath the character's chin (see Fig. 10.2.12, second screen from left).
- The light intensity is set at 0.65 (65% Intesity), and the light has fairly strong effect.

Note

The existing rim and fill lights have also been moved downward slightly (in the global Y-axis).

Lighting your characters with light source placed below the subject creates a fairly unnatural effect. Typically, light sources (both sunlight and artificial light) are directed from above, downward onto the character.

Using a light source pointing upward from below onto the character creates a more sinister or spooky effect in the lighting.

FIG **10.2.12** Mood lighting 03 – spooky lighting.

As with the previous lighting setup, this effect looks fairly unnatural. However, the effect may be appropriate depending on the mood you're trying to create in the animation.

Chapter 10.3 – Character Performance

In this section, we'll take a look at how to combine the different animation principles together with creative judgment to create effective appeal in the character performance.

As appeal is the most general animation principle, it can be difficult to quantify. Sometimes, appeal is misinterpreted as meaning that the viewer finds the character or animation attractive, cute, or fun. This is incorrect; appeal can also be applied to the most gross, shocking, or horrific character or animation. For example, a villainous or grotesque character or performance can also be considered to have appeal if the character or the performance strikes an emotional response or resonance with the viewer. The performance in the animation doesn't always need to be exaggerated or over the top to create the emotional response and connection with the viewer.

Understanding how to create effective animation performance that supports and re-enforces the mood of the character or emotion being conveyed is critical to understanding how to effectively create appeal.

FIG 10.3.01 Character performance – appeal.

We will use a series of four practical character performance examples in this section to demonstrate how the animation has been put together to create an appealing sequence. The sequences are a series of short animations using the character head model we worked on to create the head turn animation in Chapter 4. The four examples we will look at will be the following:

1. Surprise/Shock (see Fig. 10.3.01, first screen from left)
2. Austere/Aloof (see Fig. 10.3.01, second screen from left)
3. Dejected/Subdued (see Fig. 10.3.01, third screen from left)
4. Bright (see Fig. 10.3.01, fourth screen from left)

In most of the examples, the same initial head turn animation from Chapter 4 has been used as a starting point for the animation, with the character animation conveying an emotional response or overall mood to demonstrate appeal in action (see Fig. 10.3.01, left to right).

Lighting rig – In each of the example scenes, the base lighting rigs that were introduced in the previous section have been used as a starting point. The lighting has been modified to slightly support the mood being conveyed in the animation. This helps re-enforce the appeal in the animation and could be exaggerated further by pushing either the light color, intensity or placement in the scenes.

Camera setup – The perspective camera has been framed to support the animation. In the examples, the character has been animated with reference to the viewer.

Scene Setup and Rig

The scene file examples we'll be looking at in this section are set up as follows:

- Renderer = Viewport 2.0 (see Fig. 10.3.02)

The Viewport 2.0 Renderer is enabled for the Viewport to take advantage of the following features.

- Multi-sample Anti-aliasing
- Camera – DOF enabled (setup on Persp camera)
- Real-time depth-mapped shadows (setup on the scene lights – typically single key light)

FIG 10.3.02 Scene setup – Viewport 2.0.

To preview the final animations, enable the Viewport 2.0 renderer and ensure that Shadows and Use All Lights (7) are enabled from the Panel's Lighting menu.

To preview the animation with the control objects displayed, refer to the following section:

- Control object setup (see **Fig. 10.3.03**)

We worked with the main animation controls for the head and neck in Chapter 4. The setup for the facial controls is covered in more depth in the online Chapter 11.1, next.

- The Default or High Quality Rendering Modes should be enabled to preview the animation with the controls visible to validate the animation timing and posing. Shadows should be disabled.

FIG 10.3.03 Scene setup – control objects, groups, and display modes.

- The Controls are hidden and grouped under the following two groups in the Outliner Ctrls // Cntrl_Neck (see Fig. 10.3.03). Expand the groups to select the elements from the Outliner.
- Select the groups and choose Display > Show > Show Selection to unhide them in the Viewport.

Surprise/Shock

- Open the scene file for this section from the Project scene files directory – **10.3_01_Surprised.ma**.
- Playback the animation from the Perspective view to see how the animation principles are used in combination to create appeal (see Fig. 10.3.1).

Overall Posing/Mood

If we look at the overall posing of the head and face, the poses support the mood being conveyed. The head is in a relaxed pose facing away from the camera at the start of the animation, which contrasts with the reasonably

FIG 10.3.1 Surprised/shocked facial animation.

fast head turn and extreme poses with the mouth and eyes wide open (see Fig. 10.3.1, left to right screens).

Appeal is created in the animation due to combining effective use of timing & spacing as well as exaggerated posing for the shocked expression.

Head Turn – Timing & Spacing

If we look specifically at the head turn at the start of the animation (see Fig. 10.3.2),

- There is a slow turn at the start as if the character is reacting to motion or sound and then a double take as he turns back and then around again quickly from frames 15 to 24 (see Fig. 10.3.2).
- The slow 'ease-in' at the start contrasts with the close spacing and timing on the quick head turn – making the motion punchy. This motion is based on the exercise we worked on from Chapter 4.
- The long 'ease-in' to the main motion (frames 0–frame 15) creates anticipation of the action.

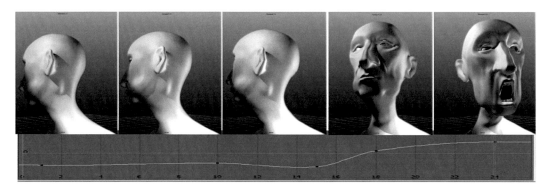

FIG 10.3.2 Head turn – ease-in (double take) to punchy turn.

Eye Posing – Secondary Motion

The setup for the facial rig controls are covered in more detail in online Chapter 11.2. The eyebrow and cheek controls move up and down (in the local Y-axis) to squash and stretch the brow and cheeks. The circular eye controls are scaled inward and outward to open and close the eyes. Base key poses are blocked in between frames 20–40 to support the motion on the head turn (see Fig. 10.3.3).

- The left eyebrow extends further than the right (to prevent the motion being twinned on the eyes).
- The brows reach almost full extension slightly after the head turns at frame 24 (the secondary motion follows through and overlaps with the main motion of the head turn).
- There are a series of small movements between the brow poses between frames 24 and 50, the brow is at its fullest extension at frame 40 as the head pulls back.
- The brow motion supports and re-enforces the mood for the animation.

f0175

FIG 10.3.3 Eye extension (shock) – secondary motion.

Coil Back – Moving Hold

Between frames 24 and 50, the head and face maintain largely the same shape and pose. This contrasts with the posing at the start (from the head turn to shock).

Between these frames, the neck, head, and facial controls use a series of smaller movements to maintain the pose but still keep the viewer's interest – this is a moving hold.

During this frame range, the neck rotates backward slightly in the local X-axis to coil the head back to exaggerate and push the pose slightly to support the appeal of the shock/surprise (see Fig. 10.3.4).

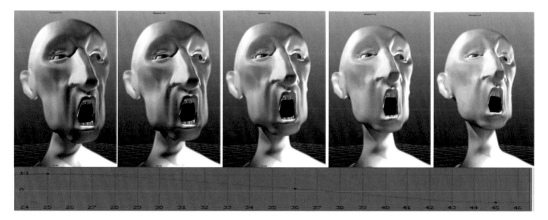

FIG 10.3.4 Neck coil back – moving hold.

Mouth Motion – Moving Holds

For the mouth during the main shock expression (frames 24–40), there is a slight movement in the width of the mouth as well as in the corners of the mouth (blue controls).

- This helps add additional life to what would otherwise potentially be a stilted looking motion.
- The slight quiver on the mouth also suggests an intake of breath as the mouth is opening and closing slightly.
- The timing of these motions is offset and supports the main motion of the head (see Fig. 10.3.5).

FIG 10.3.5 Mouth motion – moving hold (shock move).

Later in the sequence, there are additional moving holds for the mouth, with the mouth opening and closing slightly, and these use similar timing to suggest nervousness or quiver on the mouth (see Fig. 10.3.6).

- The top and bottom controls on the mouth move inward and outward slightly to suggest pursing of the lips.
- The width control object scales inward and outward suggesting slight intake of breath and exhale.

FIG 10.3.6 Mouth motion – moving hold (quiver).

Austere/Aloof

- Open the scene file for this section from the Project scene files directory – **10.3_02_Austere.ma**.
- Playback the animation from the Perspective view to see how the animation principles are used in combination to create the appeal (see Fig. 10.3.7).

Overall Posing/Mood

FIG 10.3.7 Austere/Aloof facial animation.

If you look at the overall posing of the head and face for the animation, you can see that the head is predominantly tilted backward to the viewer. The head poses have been animated to the camera with the character looking downward toward the viewer. This creates the impression that the character is aloof, austere, or slightly arrogant (see Fig. 10.3.7).

Ease-In

The main motion on the head and neck at the start of the animation leads into the animation. The head does not turn quickly as in the previous example, but instead cranes forward slightly, as if inspecting the viewer.

- This motion runs from frames 1 to 15 at around two-third of a second; the animation is poised and composed at this timing & spacing and supports the mood, creating the appeal (see Fig. 10.3.8).
- Between frames 15 and 45, there is a moving hold, where the head and facial features compress back slightly (see Fig. 10.3.8, right screens).

FIG 10.3.8 Ease-in – poised lead-in to sequence.

Shake – Dismissive

There is contrast in the timing & spacing on the 10 frame head shake at frames 45–55 compared with the long lead-in and moving hold at the start (frames 1–45).

- The head still looks fairly poised as the rotation is limited to side-to-side motion.
- The timing & spacing is fairly even between the three poses, makng the motion look composed.
- The expression on the mouth during the shake turns to a slight grimace to support the main motion (see Fig. 10.3.9).

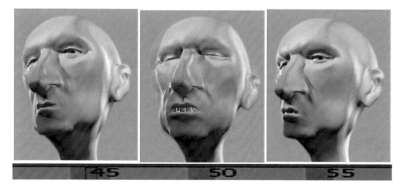

FIG 10.3.9 Dismissive head shake (frames 45–55).

Head Shake – Dismissive – Eye Follow-Through

Although the eyes close at the same moment as the shake (at frame 50):-

- The eyes do not fully open again until a few moments after the head turns back round (at frame 55) (see Fig. 10.3.10).
- This creates natural follow-through and weight to the animation.
- The other eye controls are also offset slightly so that the animation overlaps nicely and looks natural.

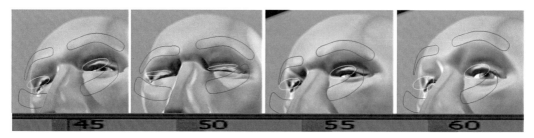

FIG 10.3.10 Dismissive head shake (frames 45–55) – eye follow-through.

Mouth Posing – Pursed/Closed/Snarl

If we look at the mouth posing throughout the sequence, the mouth is mainly pursed, making the character appear more aloof, which supports the mood. There are a series of small, subtle movements on the mouth, which change the characterization slightly and support the head animation. These are difficult to visualize through the screenshots below but are more noticeable on playback, and they include the following:

- Frame 150 – mouth fully closed (see **Fig. 10.3.11** – first screen)
- Frame 75 – cheeks sucked in (see Fig. 10.3.11 – second screen)
- Frame 50/110 – top lip curl (snarl) (see Fig. 10.3.11 – third screen)
- Frame 15 – slight snarl (see Fig. 10.3.11 – fourth screen)

FIG 10.3.11 Mouth poses – frames 150/75/110/15.

Lead-Out – Acknowledgment to Inspection

At the end of the sequence is an extended lead-out section (frames 80–150). This is divided into two main phases:

- Phase 1 – Acknowledgment (Frames 80–90): Between these frames the character does a fairly straight or even head rise (from frames 80 to 85) and then nod (frame 90). This suggests acknowledgment of a thought or action (see **Fig. 10.3.12**, left screens).
- Phase 2 – Inspection
 - Frames 90–100: At this phase, the head tilts back and around in a circular motion. The pose at frame 100 is fairly exaggerated.
- Frames 100–110: The head again tilts forward at this point – the angle of the head begins to face the viewer straight on.
- Frames 110–150: The head continues moving slightly at this phase. The motion is pretty slow and gives a slow ease-out to the animation. Creating longer pauses or very slow motion to the sequence helps make the animation feel uneasy, enhancing the appeal of the sequence.

FIG **10.3.12** Lead-out – frames 80–110.

Dejected/Subdued

- Open the scene file for this section from the Project scene files directory – **10.3_03_Dejected.ma**.
- Playback the animation from the Perspective view to see how the animation principles are used in combination to create the appeal (see Fig. 10.3.13).

Overall Posing/Mood

For this sequence, the head is mainly tilted forward, suggesting the character is subdued or dejected during the motion. The head is also predominantly tilted to the side, which suggests that the character is not as composed or poised as in the other examples. The facial expressions on the character are mainly closed, supporting the main motion, suggesting that the character is anguished (see Fig. 10.3.13).

FIG **10.3.13** Dejected/subdued facial animation.

Head Turn – Timing & Spacing

There is a head turn at the start of the animation that leads into the sequence (see Fig. 10.3.14).

- The turn starts very slowly, suggesting the character is labored.
- The neck leads the slow turn (at frame 40) with the head following through from frames 50 to 80. This suggests effort and weight on the character, supporting the appeal.

419

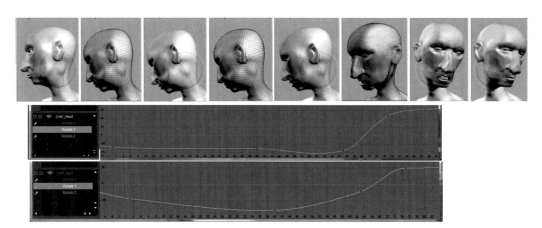

FIG **10.3.14** Head turn – slow labored ease-in.

Subdued Head Shake – Resignation

After the main extended lead-in to the animation (frames 1–80), the next main motion is a series of slightly resigned head shakes.

- Again, the motion is more subdued on these.
- The turns are quite slight and are composed, with the motion being along the main side-to-side axis.
- Main turn back around is from frames 105 to 125 (see **Fig. 10.3.15**, left screens).
- Series of shorter head shakes from frames 125 to 145/145 to 155/165 to 175.
- Timing of these after the initial turn (125–145) is even at around 10 frames, consistent with the mood being conveyed (see Fig. 10.3.15, right screens).

FIG **10.3.15** Resignation – subdued head shake.

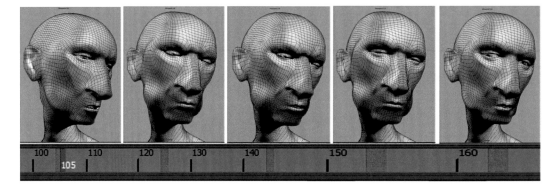

Again, the eye motion supports the main mood of the sequence and enhances the appeal.

- The eyes are in mainly compressed poses on the brows, cheeks, and eyelids.
- The timing of the eye and brow compressions is fairly slow and supports the main head motion.

- There is slight follow-through; for example, the motion follows through with the eyes fully closed at frame 130 after the first head shake at frame 125 (see Fig. 10.3.16).
- The eyes punctuate the motion.

FIG 10.3.16 Resignation – slow eye close.

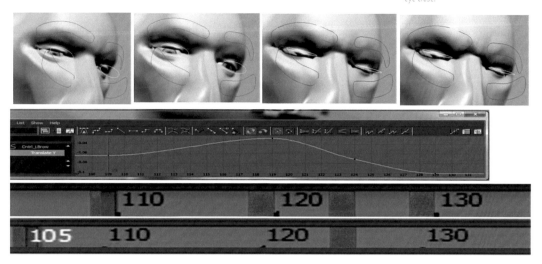

Bright/Chatty

- Open the scene file for this section from the Project scene files directory – **10.3_04_Bright.ma**.
- Playback the animation from the Perspective view to see how the animation principles are used in combination to create the appeal (see Fig. 10.3.17).

Note

Although the character has not been animated to voice-over track-Timing and posing has been used that would be appropriate for lip-sync of a bright or chatty character performance.

Overall Posing/Mood

In this sequence, the head is mainly posed straight on to the camera, engaging with the viewer. The head is angled between the fairly neutral straight pose to poses with the head tilted slightly upward. The bright key light supports the overall mood in the animation (see Fig. 10.3.17).

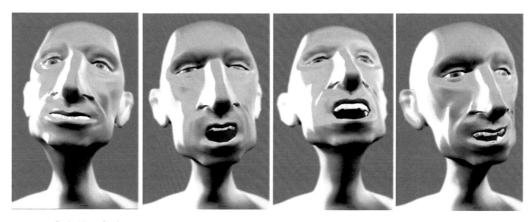

FIG 10.3.17 Bright/chatty facial animation.

Head Turn Lead-In – Timing & Spacing

The lead-in to the sequence is around a second (20 frames). In combination with the straight pose to the camera; this gives the impression the character is composed and attentive. The first reaction or nod of the head is fast and punchy at 5 frames (see **Fig. 10.3.18**).

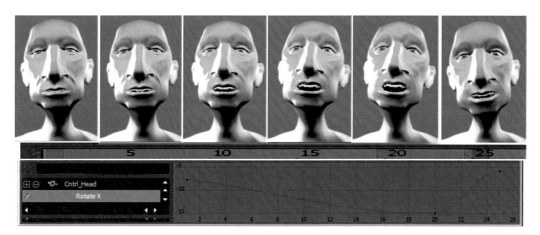

FIG 10.3.18 Head turn – punchy ease-in.

Head Nods – Punchy Action

Throughout the sequence, there are a series of short head nods or acknowledgments (see **Fig. 10.3.19**).

The timing & spacing of these are fairly crisp and punchy, supporting the overall bright mood and enhancing the appeal. The timing of these is typically:

- Lead-in 10 frames – head goes from the down pose (frame 90) back to the raised pose (frame 85/100).
- Nod action 5 frames – head goes from the raised pose (frame 85/100) to nod (frame 90/105).

The nods are fairly punchy at around a fifth of a second (5 frames at 24 fps). The lead-in is twice this (10 frames at 24 fps), so the motion still looks composed and deliberate.

As the spacing between the poses is fairly broad, the action is readable. Compare this with the timing & spacing on the head shakes in the dejected animation to see how the overall mood is quite different.

FIG 10.3.19 Bright head nods – punchy action.

Squash and Stretch

Anything composed of living flesh, no matter how bony, will show considerable movement within it's shape in progressing through an action.
The Illusion of Life: Disney Animation – Frank Thomas and Ollie Johnston

Many would consider squash and stretch to be an animation principle solely for use in traditional cartoon animation. Although squash and stretch can be over exaggerated in traditional cartoon cell animation, it is still applicable to modern computer animation.

The principle is based on the need to represent the change of mass and weight on soft-bodied organic objects. It can clearly be seen in most motions in the real world such as the squashing and stretching of the human face or expansion and contraction of other living tissue including muscles. As an animation device, it can also be applied less literally in instances where an object will contract in shape before expanding to release energy, for example in a rocket explosion.

In this section, we will take a look at some examples of where you could apply squash and stretch in Maya.

Manual Squash and Stretch and Deformation

Squash and stretch can be applied in 3D animation using either manual scaling, scaling of weight influences, clusters, or deformers. In the first tutorial in this chapter, we'll look at how to use manual scaling on the model to reproduce the effect of squash and stretch.

Although creating the effect manually can be laborious, it does help in appraising and understanding how an objects weight and mass should change and deform when squash and stretch are applied. The start exercise will use the Flour-Sack animation test which was a common animation line test for traditional animators (see **Fig. 11.0.1**).

FIG 11.0.1 Squash and stretch – Flour-Sack animation test.

Character Posing and Squash and Stretch

In earlier chapters in the book, we looked at posing the character rig to anticipate an action or build up of energy before release. For example, both the Baseball pitcher and Batter animations we've worked with have an element of squash and stretch, both in the build up to the action and in release or swing.

- The initial posing for both sequences displayed both characters compressing, twisting, and contracting the body to build energy – this is squash (see **Fig. 11.0.2**).
- In the second half of both sequences, the overall posing for the character's showed a release of energy in the body posing – with the arms and other body parts outstretched as the energy is released – this is stretch (see Fig. 11.0.2, second, fourth, and fifth screenshots from left).

FIG 11.0.2 Squash and stretch – character posing – anticipation and release of energy.

In the second tutorial in this chapter, we will look at the pose blocking for an extended sequence of a character jump. The motion is slightly exaggerated to fit the mood of the character, which helps in analyzing the major squash and stretch on the body poses, as the character compresses at start and end of the shot and releases to full stretch on the mid-point on the jump.

Facial Animation – Blend Shapes Setup

In the last chapter, we looked at creating appeal in performance animation through applying the different animation principles together on a series of short facial animation sequences. Nuance and characterization in the shots were achieved through effective animation of the detail areas on the face (eyes, mouth, brows, etc.).

In setting up an effective facial rig, it's important to understand how the face compresses, contracts, and stretches around the major muscles and bones on the face. For blend shape animation, traditional sculpting or modeling skills are required to create effective target shapes for animation. Creating effective facial animation is dependent on creating both convincing shapes and animation controls for the character; both will be covered in online Chapter 11.1 (see **Fig. 11.0.3**).

FIG 11.0.3 Squash and stretch – facial animation – blend shape setup and controls.

Dynamics

Dynamics in 3D animation can also be utilized to mimic the effect of natural squash and stretch or deformation. The nParticles and dynamics simulations we worked on in earlier chapters illustrate this. For example,

- On the rocket lift of animation we looked at back in Chapter 2 – there was a build up or expansion of the nParticles and smoke into the scene, as the flames and smoke built up anticipation for the rocket launch. The particle and nDynamic effect reproduced what would happen in real life as flames or smoke expand or contract (see **Fig. 11.0.4**, left screens).
- The nCloth simulation for the character cape we looked at in Chapter 6 is another example of natural squash and stretch that can be achieved through dynamics or simulation in 3D. For example, as the cloth deforms based on interaction with other objects in the scene, it can appear to

427

compress or to expand the overall shape of the character as it reacts to the body swinging or pushing the cloth away from the body (see Fig. 11.0.4, right screens).

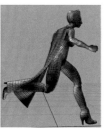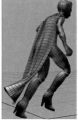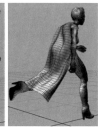

FIG 11.0.4 Squash and stretch – dynamics – nParticles, fluid effects (smoke), and nCloth.

Dynamics – Maya Muscle

In online Chapter 11.2, we will focus on another area of dynamics simulation that can be utilized to effectively mimic natural organic squash and stretch. Maya's muscle system allows animation riggers to set up effective muscle simulations that act as real muscles would (see **Fig. 11.0.5**). As with cloth or hair simulation, this adds another layer of believability to the animation as the muscles react to the body motions naturally and re-enforce the other animation principles including follow-through, overlap, and secondary action.

FIG 11.0.5 Squash and stretch – Maya muscle setup.

Chapter 11.1 – Animation Test – Flour-Sack

The Flour-Sack animation test was used at Disney to test the animator's ability to represent change in mass and shape of an object through squash and stretch. The test took the form of a series of line drawings the animator had to complete – each drawing in the sequence represented the Flour-Sack in different states of squash and stretch.

The purpose of the exercise was to test whether the animator could convincingly convey a sense of volume and weight through the drawings by using squash and stretch. In this exercise, we'll be working with a basic 3D model for the Flour-Sack setup with some simple controls to control squash and stretch.

The tutorial asset is included with the project scene files as –
11.1_01_FlourSack_Start.ma.

Let's take a look at the scene file to get familiar with the setup and controls:

1. The model for the Flour-Sack is lo-polygon and includes diffuse texture and normal map (for the creases that are visible in Viewport). The normal map is visible when either High-Quality Rendering or Viewport 2.0 is enabled from the Viewport Panel > Rendering menu (see Fig. 11.1.1, first screenshot).
2. The Flour-Sack model is connected to standard Maya joints with a smooth bind. The scaling, rotation, and translation of the joints deform the Flour-Sack model (see Fig. 11.1.1, second screenshot – joint weighting for middle section highlighted in white).
3. NURBS control objects are setup in the scene to control the joints – these are the simple transparent colored cube shapes that are visible on the model. These are parented to the joints to control the scaling, rotation, and translation of the different parts of the model. Posing and scaling the cube control the squash and stretch and twist of the Flour-Sack model (see Fig. 11.1.1, third screenshot).

FIG 11.1.1 Flour-Sack model, joints setup, and controls.

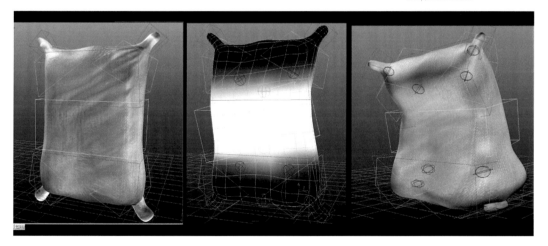

The main controls are the large cube shaped controls for the base (Cntrl_BTM), middle section (Cntrl_MID), and top of the sack (Cntrl_TOP); these are highlighted in red for the bottom and top controls and yellow for the mid-section control.

In addition to the main controls, there are a couple of secondary controls for the corner sections of the Flour-Sack. These allow for localized squash and stretch and twisting for model. These controls are labeled with suffix as _L/_L2/_R/_R2 and are visible as the green and blue cube-shaped controls in the Viewport (see Fig. 11.1.2).

FIG **11.1.2** Flour-Sack setup,
secondary controls.

The controls have been added to a Character Set in Maya. Character Sets can be used to help organize keyframing of controls for both character- and object-based animation. Character Sets are created by selecting the controls in scene and creating a new set from F2 (Animation Menu set) > Character > Create Character Set.

In the setup scene (**11.1_01_FlourSack_Start.ma**), a new Character Set has been created which includes all the control objects. The Character Set is named Flour-Sack and is visible from the Outliner Window. When the Character Set is selected from the drop-down at the bottom of the user interface – setting keyframe for any of the control objects will also set key for all other control objects included in the set (see Fig. 11.1.3). This helps to keep initial keyframes for the character organized in the scene.

FIG **11.1.3** Creating Character Sets, viewing contents from Outliner, and selecting set from drop-down.

Squash

Let's take a look at working with the controls to create squash on the Flour-Sack.

- Open the setup scene file (**11.1_01_FlourSack_Start.ma**) and Scrub the Time Slider to frame 5.
- Select the main control object at the bottom of the model (Cntrl_BTM – highlghted in red).
- Make sure that the "Flour_Sack" character set is selected from the drop-down (see Fig. 11.1.3) – this will ensure that keys set on any of the controls will key all.

- With the control object selected, enable the Scale Tool (R shortcut) and scale the controller outward (in X/Z-axis) and downward (in Y-axis) to squash the shape down and outward (see Fig. 11.1.4).

FIG 11.1.4 Squashing the shape at bottom of the Flour-Sack.

The amount of control object scaling in each axis should be considered in keeping the volume consistent. For example – scaling the object down in the Y-axis by 10% (0.9) would result in the other axis increasing by similar amount as the volume is maintained (i.e., X-axis and Z-axis would scale by 5% each, respectively).

- Set key for the scaling with S shortcut key at frame 5

We can squash the mid-section of the model in as well by scaling the mid-control object highlighted in yellow in the Viewport (Cntrl_MID). The scale can be set numerically from the Channel Box if needed. Scale values for the Cntrl_MID object should be roughly $X = 1.15$, $Z = 1.15$, and $Y = 0.8$. Scale the main top control (Cntrl_TOP) by similar amount to squash in the volume of the Flour-Sack. With any of the controls selected, set key with S shortcut to key the character set at frame 5.

We can also create localized squash and stretch on the model around the corner areas of the Flour-Sack. At the base of the model, the corners should be pushed inward and shape compressed slightly to suggest the weight.

- Select each of the small blue-colored bottom corner controls in turn (Cntrl_BTM_L2/Cntrl_BTM_L2) enable the translate tool (W shortcut) and push the controls in slightly to the body of the Flour-Sack (see Fig. 11.1.5, first and second screenshots). Squash the shape in slightly by scaling in the local X-axis.
- The larger cube controls for the corner sections of the model can also be scaled outward to suggest more mass at the bottom of the Flour-Sack – select each of the green control objects at the bottom corners in turn (Cntrl_BTM_L/ Cntrl_BTM_L). Compress the shape down slightly with the scale tool (R shortcut) in the X-axis and outward slightly in local Y- and Z-axes (see Fig. 11.1.5, third and fourth screenshots). We don't want the scaling to be identical on either side (or twinned), so scale either the left or right corner controls more than the other side. With any of the controls selected, set key with S shortcut to key the Character Set at frame 5.

431

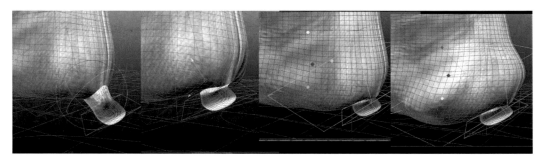

FIG 11.1.5 Squashing in the bottom corners of the Flour-Sack with the controllers.

The main middle and top control objects (Cntrl_MID/Cntrl_TOP) can also be rotated inward and round slightly to suggest slump in the Flour-Sack due to the weight and volume.

- Select the mid-controller highlighted in yellow in the Viewport (Cntrl_MID) and rotate downward in the local X-axis.
- Select the main top controller highlighted in red in the Viewport (Cntrl_TOP) and rotate downward in the local X-axis (see Fig. 11.1.6, first screenshot).
- To create some twist on the Flour-Sack and to create a more natural pose, select the top controller (Cntrl_TOP) and rotate round in the local Y- and Z-axes, so that the posing is offset with the sack twisted at the top with right corner pointing to left (see Fig. 11.1.6, second and third screenshots). With any of the controls selected, set key with S shortcut to key the Character Set at frame 5.

Final scene file with the default Flour-Sack pose at frame 1 and the squash pose at frame 5 is included with the project scene files as – **11.1_02_FlourSack_Start_SQ1.ma**.

FIG 11.1.6 Creating twist at the top of the model to suggest weight slump.

Stretch

Continue with the scene file you're working on or open the project scene file – **11.1_02_FlourSack_Start_SQ1.ma**.

We'll work on posing and keying a stretch pose with the Flour-Sack. Currently, the scene has the default pose keyed at frame 1 and the squash pose at frame 5. We want to key the controls at frame 10 from the default pose.

- First, make sure that the "Flour_Sack" Character Set is selected from the drop-down (see Fig. 11.1.3) – this will ensure that keys set on any of the controls will key all.
- Select any of the control objects, then – Hold the Shift key and drag with the left mouse button at frame 1 to select the keyframe. It should be highlighted in red on the Time Slider (see Fig. 11.1.7, left screenshot).
- Right-Click with the mouse over the highlighted keyframe and choose Copy from the menu to copy the keyframe (see Fig. 11.1.7, left screenshot).
- Make sure that Flour_Sack Character Set is selected from the Character Set drop-down menu at the bottom right of the interface (see Fig. 11.1.7, middle screenshot).
- Scrub the Time Slider to frame 10. Right-Click with the mouse at frame 10 and choose Paste > Paste to paste the keyframe that was copied from frame 1. As the character set is selected – keyframe for all control objects is copied and pasted from frame 1 to frame 10. (see Fig. 11.1.7, right screenshot).

FIG 11.1.7 Copying and pasting the default pose for the Flour-Sack using the character set and key pasting.

We can now work from the default pose at frame 10 to create stretch on the Flour-Sack model –

- Select the main middle control object that's highlighted Yellow in the Viewport (Cntrl_MID – see Fig. 11.1.8, left screenshot).
- With the scale tool enabled (R Shortcut) – scale the control up in the Y-axis to stretch the Flour-Sack. Scale the control inward in the X- and Z-axes to compress in the shape of the model and maintain the volume. The values to scale can be set numerically from the Channel Box for accuracy (Ctrl + A) and can be set to $X - 0.7$ (70%), $Z - 0.7$ (70%), and $Y - 1.5$ (150%) (see Fig. 11.1.8, middle screenshots).
- As in the squash example, we can rotate the control backward or forward to suggest that the Flour-Sack is being pulled in a direction. With the Cntrl_MID object still selected, enable the Rotate Tool and rotate the control back slightly in the local X-axis (see Fig. 11.1.8, right screenshot). With the control object still selected, set a keyframe at frame 10 to key the Character Set.

433

FIG 11.1.8 Creating stretch and
slight twist on the mid-section
of the model.

For the top section of the model, use the same workflow to select (Q)/Rotate
(E), and Scale (R) the Cntrl_TOP control object. As with the Cntrl_MID control
object, the top control object can be rotated backward in the X-axis to suggest
movement in the stretch and give a more natural arc to the posing (see
Fig. 11.1.9, middle screenshot). The top control should be scaled up in the local
Y-axis to stretch and compressed in the X- and Z-axes to compress (see Fig.
11.1.9, right screenshot). When scaling, check the values from the Channel
Box, so that the volume is roughly consistent on the stretch. With the control
object still selected, set a keyframe at frame 10 to key the character set.

FIG 11.1.9 Stretching out the top
Cntrl_TOP control for the Flour-Sack.

For the stretch, we can create localized stretch and twist on the corner
sections of the model using the corner controls (Cntrl_TOP_L/Cntrl_TOP_L).

- Select the Cntrl_TOP_L controller at the top right of the Viewport.
- Stretch out the controller in the local X-axis to stretch the main corner of
 the Flour-Sack posing (see Fig. 11.1.10, first screenshot) – scale the controller
 slightly in the Y- and Z-axes to maintain the volume.
- Select the Cntrl_TOP_L2 end controller and scale it out slightly to stretch
 in the local X-axis and suggest that the sack is being pulled from the
 extreme corner (see Fig. 11.1.10, second screenshot).

- The main top and middle controllers can also be rotated round slightly to suggest that the sack is being pulled backward and diagonally. Select the Cntrl_TOP and Cntrl_MID controls and rotate back in the local Y-axis and over to the side slightly in the local Z-axis (see Fig. 11.1.10, third and fourth screenshots). Once you're happy with the pose, set a keyframe at frame 10 to key the Character Set.

FIG 11.1.10 Stretching out the corner on the Flour-Sack and rotating the mid/top sections to suggest the sack is being pulled from the corner.

Final scene file with the stretch pose keyed (at frame 10) along with the squash (frame 5) and Default pose (frame 1) is included with the project scene files as – **11.1_03_FlourSack_SQ1_ST1.ma**.

Twist

Continue with the scene file you're working on or open the project file – **11.1_03_FlourSack_SQ1_ST1.ma**.

Use the same steps as at the start of the stretch section of the tutorial to copy/paste default key pose from frame 1 in the scene to frame 15 (see Fig. 11.1.7 on the previous page). We'll work at frame 15 setting up a base twist pose for the Flour-Sack.

- At frame 15, select the main middle controller – Cntrl_MID (see Fig. 11.1.11, first screenshot).
- Rotate the control in the local + Y-axis to twist the mid-area of the model around (see Fig. 11.1.11, second screenshot).
- Select the main top controller – Cntrl_TOP and Rotate in the same + Y direction to twist the Flour-Sack further. The shape formed should be a diagonal running from the top of the model to base (see Fig. 11.1.11, third screenshot).
- With any of the controls selected and Flour-Sack Character Set active, hit Shift + E shortcut at frame 15 to set key for the object rotations.

435

FIG 11.1.11 Twist base pose.

The Flour-Sack model has a strong diagonal from the twist base pose. To make this type of pose more dynamic, the main top and bottom controls should be rotated in opposite direction to create more of an S shape to the pose. The principles shown in Chapters 8 and 9 around posing and solid drawing can equally be applied here to the Flour-Sack model.

- At frame 15, Select the main top controller – Cntrl_TOP and Rotate downward in the local X-axis to create a more natural S-shaped twist (see Fig. 11.1.12, left screenshot).
- The local controls for the corners can also be rotated to follow the action line and exaggerate the S-shape. Select the main right top corner control Cntrl_TOP_R and rotate downward in the local Y-axis and round in the X-axis to extend the twist. The controller can also be pulled forward slightly with the Move Tool (W) to exaggerate the pose. Select the smaller controller on the corner and rotate further in the X/Y-axis to follow the action line (see Fig. 11.1.12, middle and right screenshots). Once you're happy with the pose, set a keyframe at frame 15 to key the character set.

FIG 11.1.12 Exaggerating the twist through the lower level appendage controls.

The process can be repeated for the other corner controls. Select each and rotate to follow the curved S-shape in the twist (see Fig. 11.1.13, left screenshots). The direction of the twist on the corner controls should be opposite of the line followed between the top and bottom corners. For example, the bottom left controls would be rotated forward and inward, whereas the top left controls would be rotated back and out (see Fig. 11.1.13, right screenshot).

FIG 11.1.13 Twisting in opposite direction around the corners and final twist pose.

The final scene file including the twist pose keyed at frame 15 along with the squash (frame 5) and stretch Poses (frame 10) is included with the project scene files as – **11.1_04_FlourSack_SQ1_ST1_TW1.ma**.

In this tutorial, we've taken a look at how to create natural squash and stretch on an organic object through manually scaling box controls linked to a skeleton bound to our model. Through scaling the controls, we have an understanding of how to maintain the volume and the mass in an organic object that is critical to conveying convincing squash and stretch. In the tutorial, we have also looked at creating natural twist in our poses with appendages following through an organic S-line shape.

Squash and stretch are commonly over exaggerated in traditional cell-animated cartoons for comic effect. Spend some time working with the setup to see how far the effect can be pushed with the controls and animation. As in the examples we worked with earlier, it's important to make sure that the overall volume of the object looks consistent – this is applied even when you're pushing the squash and stretch to extremes.

To explore the setup and effect further, you may want to consider creating a longer animation sequence to further explore how the principle can be used in conjunction with the other principles we've covered-

Follow-Through and Overlapping Action

In the exercise, we worked on blocking out the major base poses for the effect. Long-form animation sequence could be enhanced by adding follow-through to the motion to create animation that enhances and strengthens the effect. For example,

437

- For stretch effect, the sack could stretch out from the base of the model, with the areas that are more stretched and further away from the squash moving after to create convincing follow-through.
- For the twist pose we worked on – animation for this could have the mid-area rotating round first with the top area and local controls following on later. See Chapter 6 and the section in Chapter 7 covering the Hand Animation Rig setup (7.1) for further information on the techniques to use.

Ease In & Ease Out and Timing

If we were working on a long-form animation with the asset, we could use ease in and ease out to more convincingly convey the weight and volume on the Flour-Sack as it moves from a squashed pose to stretched or twisted. We could also use exaggerated timing for the sack falling quickly to ground to create squash and then settling very slowly to the rested state. Timing and Ease In and Out are covered in Chapters 3 and 4.

Appeal and Performance

The original test used at Disney Studios encouraged the artists to draw the Flour-Sack in almost human type poses. This style of anthropomorphic animation is very common in traditional animation and particularly at Disney. Inanimate objects or animals are animated as if they are human. Think of Disney's Fantasia where all of Mickey's background (such as mop/bucket) comes to life and dances in time to the music. A long-form animation could be created with the asset dancing or jumping across the screen as if alive. The test would be an opportunity to test your ability to create appeal in a character and convincing performance. Similar techniques are used in animated production today for feature commercials for products such as household goods. Refer to Chapter 10 for further information on appeal for animation.

Chapter 11.2 Character – Hero Jump

The human body naturally compresses and extends in motion. This is most noticeable on extreme actions or in sports and athletics. The squashing and stretching in the body shapes can be seen on localized elements, such as the muscles, which are covered in online Chapter 11.2, and in the general body shape and form during action.

Squash and stretch can be seen naturally in general body motion as the body's limbs and torso change shape to build and release energy-

- Squash – Coiled Readiness

Think of a runner who begins the run in a coiled or squashed position on the ground at the starting blocks – this pose allows the athlete to build energy

before the race starts. Weight is typically transferred backward as well during the motion and helps to build the momentum.

• Stretch – Jump Extension

The converse of the coiled squash pose for the body can be seen on the high jump or long jump in athletics – the body is fully stretched or extended as the body reaches through the air to reach maximum extension. Similar stretching can be seen on an extended run cycle where the legs are fully outstretched.

In this section, we'll look at pose blocking for an extended character jump to help to study the squash and stretch we can achieve through a full body character animation. There is a broad range of squash and stretch motion on the body, which can be observed when looking at video reference of extended jumps.

Working from video reference, thumbnailing can help to establish the range of squash and stretch in the motion as well as the overall arc in the body as it moves through the air. The thumbnails for the key jump poses and trajectory are provided in Fig. 11.2.01, which were used to establish the key poses for this tutorial.

Note

Depending on the style of animation you're going for, the poses and squash and stretch can be exaggerated as you work through the tutorial.

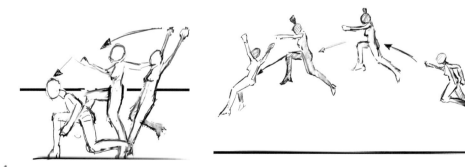

FIG 11.2.01 Thumbnails – jump poses and trajectories.

For this tutorial, we will be working with the same female character rig as used in previous chapter sections. Similar workflow as we used in the run cycle tutorial (Chapter 8) of iteratively modifying individual body part posing with the control rig to achieve the poses will be used throughout the tutorial to complete the animation (see Fig. 11.2.02).

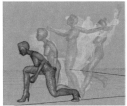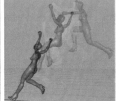

FIG 11.2.02 Maya – jump pose blocking and editing control rig elements.

FIG 11.2.1 Idle pose to ready pose.

The first move in the jump animation goes from the upright standing idle pose to the compressed ready pose with the character in a ready pose with the body compressed to the ground. The initial move for the jump shows a lot of compression or squash in the body in compressing to the crouch pose to gain momentum for the jump (see Fig. 11.2.1).

• Open the start file for the tutorial – **11.2_00_Idle.ma**.

The scene file includes the same female hero character we worked with in the previous chapter.

The character is at the idle pose we worked on in Chapter 9.1 – Dynamic Posing.

For blocking the animation for the jump, we'll work mainly from a side perspective view, a side on view is ideal for blocking character motion for walks, runs, and the jump animation.

There are several Camera Bookmarks setup to work on the edits for the animation and preview the sequence.

- From a Single Pane layout, from the panel menus, go to View > Bookmarks > FULL_SIDE to set the perspective view to show the character from full side on (see Fig. 11.2.2, first screenshot).
- Activate the Auto keyframe Toggle (small red icon at the bottom right) and scrub the Time Slider to frame 4 to work on the first pose.
- From the Outliner, select the following control objects:
 - FSP_COG_CTRL
 - FSP_Hand_L_CTRL
 - FSP_Hand_R_CTRL
- Activate the Move Tool (W) and pull the controls forward in global Z-axis to pull the character's body and hands forward (see Fig. 11.2.2, second screenshot).

Note

If the Move Tool is not moving globally, open the Tool Settings and Hit "Reset Tool" to Set Move Axis = World.

- From the Outliner, select the following control objects:
 - FSP_Foot_R_CTRL
 - FSP_Leg_R_Pole
- Activate the Move Tool (W) and pull the controls forward in global Z-axis and up in global Y-axis to pose the right foot forward as if stepping forward (see Fig. 11.2.2, third screenshot).
- To finalize the pose, select the main torso control (FSP_COG_CTRL) and rotate forward in the local X-axis to lean the body forward in toward the step (Note: the hand control position may need to be adjusted after rotating the torso) (see Fig. 11.2.2, fourth screenshot).

FIG 11.2.2 Idle pose to mid-step pose.

The pose keyed at frame 4 is a mid-pose for the move from the idle into the crouched ready pose.

- Scrub the Time Slider to frame 8 and make sure that the Auto keyframe toggle is still active.
- Select the following control objects from the Outliner (see Fig. 11.2.3, middle screenshot):
 - FSP_Hand_L_CTRL
 - FSP_Hand_R_CTRL
 - FSP_Arm_L_Pole
 - FSP_Arm_R_Pole
 - FSP_Foot_R_CTRL
 - FSP_Leg_R_Pole
 - FSP_COG_CTRL

Note

This selects all the control objects except the controls for the left foot (FSP_Foot_L_CTRL) and left-leg pole vector (FSP_Leg_L_Pole). We want to leave the left foot in its existing position and pose the body and right foot stepping forward to ground.

> ### Tip
>
> Group selecting all the control objects allows us to make simultaneous edits to their position. This is ideal when working with a control rig using IK – as the hands use IK controls – we want to move them along with the torso when posing the step, that is why multi-selection is used. If you click-drag in the Outliner, you can multi-select the objects at once. Ctrl + Click selecting the hip control (FSP_COG_CTRL) last makes the transform tool visible over it when making the edit (see Fig. 11.2.3, middle screenshot).

- With the controls selected, activate the Move Tool (W) and pull the controls forward in global Z-axis slightly and downward in the Y-axis slightly until the right-foot control is flat with the ground plane (see Fig. 11.2.3, middle screenshot).
- De-select the right-foot control (FSP_Foot_R_CTRL) and right-leg pole vector (FSP_Leg_R_Pole).

Only the main torso control (FSP_COG_CTRL) and hand controls should now be selected (see Fig. 11.2.3, top right screenshot).

- With the controls selected, activate the Move Tool (W) and pull the character downward in the Y-axis toward the ground, so that the character looks like she's almost kneeling on the ground (see Fig. 11.2.3, right screenshot).

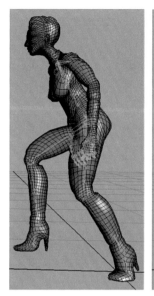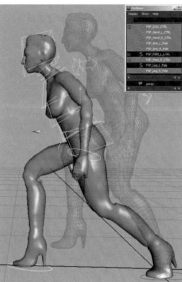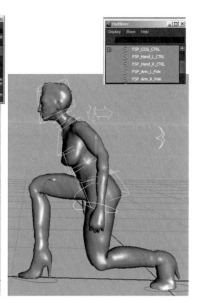

FIG 11.2.3 Mid-step pose to ready pose-torso position.

To finalize the pose, the arm pose should be edited along with the angle of the torso; currently the torso is upright and the arms straight out at sides (see Fig. 11.2.3, right screenshot). The pose would look more dynamic with the arms swung out further and the torso leaning forward slightly in readiness.

- Still at frame 8, select the left-hand control (FSP_Hand_L_CTRL) and with the Move Tool (W) active, pull the hand forward in the Z-axis and upward slightly in the Y-axis. The angle of the arm should be around 90° between the forearm and upper arm (see Fig. 11.2.4, second screenshot).
- Still at frame 8, select the right-hand control (FSP_Hand_R_CTRL) and with the Move Tool (W) active, pull the hand back in the Z-axis and upward slightly in the Y-axis. The angle of the arm should be almost straight out behind the body (see Fig. 11.2.4, third and fifth screenshots).

Note

Both the arms posing should mirror what's going on with the legs, this is similar to the run or walk cycle with the arms swinging backward or forward to mirror the pose on the legs. This provides balance in the pose.

- For the torso, select the main control (FSP_COG_CTRL) and rotate forward in the local X-axis to lean the character in toward the body (see Fig. 11.2.4, third screenshot). The additional torso controls can be rotated to keep the spine curve looking natural. The head should be rotated backward slightly to counter the spine rotation and keep the pose balanced (see Fig. 11.2.4, third and fifth screenshots).

443

For the left foot, the foot should be compressed inward on the ball of the foot as the character crouches and leans forward.

- Still at frame 8, select the left-foot control (FSP_Foot_L_CTRL) and open the Channel Box (Ctrl + A toggle).
- Select and highlight the "Ball Roll" channel and middle-mouse drag in the Viewport to increase the value to around −50 to compress the foot into the ball (see Fig. 11.2.4, fourth and fifth screenshots).

Scene file with the pre-animation from the idle pose to the ready pose is included with the project scene files as – **11.2_01_Idle_PreJump.ma**.

FIG 11.2.4 Finalizing the ready pose.

For the animation for the jump, the character posing that's blocked from frame 0 to frame 8 has the character going from the idle stance pose to the ready pose for the jump. For the jump, we can add some anticipation to the animation by having the character hold this pose for a few frames. What would also add further to the anticipation would be to have the character coil back slightly – with the body pulling back slightly further into a coiled pose to build momentum and energy for the jump (see Fig. 11.2.5). This is another Moving Hold, which we covered previously.

- Select all the control objects from the Outliner.

> **Tip**
>
> You can also select all the control objects at once, by going to the Display Layer and Right-Clicking on the "Curve_CNTRLS" layer and choosing "Select Objects" option, which will select all objects that are included in the Display Layer.

- With all the animation control objects selected, scrub the Time Slider to frame 8 and hit S to set key on all elements.
- With the control objects still selected, scrub the Time Slider along a bit further (to around frame 14) and hit S shortcut key again to set key. For this interim pose, you may also want to modify the pose slightly.

FIG 11.2.5 Ready pose to coiled pose.

For the Pre-Coil pose, the timing for this is a matter of personal preference, you may want this immediately after the ready pose (a few frames), so that the motion is pretty quick. For the example, I've keyed the pose at around frame 24, which creates a slow ease in (frames 14 – 24 = 10 frames) from the ready pose to the coiled pose (see Fig. 11.2.5). This creates contrast with the fast motion in the jump that follows immediately after

- Scrub the Time Slider to frame 24 and select the following control objects (see **Fig. 11.2.6**, first screenshot) –
 - FSP_Hand_L_CTRL
 - FSP_Hand_R_CTRL
 - FSP_COG_CTRL
- With the controls selected at frame 24, ensure "Auto keyframe toggle" is active. Enable the Move Tool (W) and pull the character torso and hands back and down toward the left heel (see Fig. 11.2.6, second screenshot).

FIG 11.2.6 Posing – coiled pose.

With the torso pulled back slightly, the spine controls can be rotated slightly to tilt the body in toward the right leg, creating more compression.

- Select the main torso control FSP_COG_CTRL, and with the Rotate Tool active (E), rotate the spine in to the right leg (in local X-axis), use the additional spine control objects to rotate the spine so that the pose looks natural.

The head and neck controls can also be adjusted to pull the head inward to match the pose (see Fig. 11.2.6, third screenshot).

For the feet, these should naturally pivot and compress based on the weight shift, the right foot that is planted would naturally swivel on the heel as the body pushes back.

- Select the right-foot control object (FSP_Foot_R_CTRL) and from the Channel Box, set the following attribute value to pivot the foot on the heel-Heel Roll = −20 to −25.

Note

You may need to set key for the Heel Roll = 00 at the preceding keyframe if this channel hasn't already been keyed.

Scene file with the animation from the idle pose to the ready pose to the coiled pose is included with the project scene files as – **11.2_02_PreJump_PreCoil.ma**.

FIG 11.2.7 Coiled pose to pre-launch pose.

For the launch from the coiled pose, the motion should be fairly quick between the poses. The animation is similar to the first move (**11.2_01_Idle_PreJump.ma**) but reversed. The character steps forward, pushing the weight onto the leading right leg and raises the body off the ground (see Fig. 11.2.7).

- Scrub the Time Slider forward 2–3 frames from frame 24 (to around frame 27).
- Select both the hand controls (FSP_Hand_L_CTRL/FSP_Hand_R_CTRL) and the main hip control (FSP_COG_CTRL) (see Fig. 11.2.8, first screenshot).

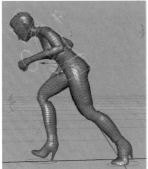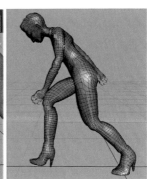

FIG 11.2.8 Coiled pose to first pre-launch pose.

- With the controls selected and "Auto keframe toggle" active, activate the Move Tool (W) and pull the torso upward in the Y-axis and forward slightly in global Z-axis to shift the weight toward the leading right leg (see Fig. 11.2.8, second screenshot).
- For the right foot, the heel pivot should be rotated slightly to flatten the foot and re-enforce the weight shift. Select the right-foot control object (FSP_Foot_R_CTRL) and from the Channel Box, set the attribute value to pivot the foot on the heel back – Heel Roll = 0 (see Fig. 11.2.8, third screenshot).
- To finalize the pose, select each of the hand controls in turn (FSP_Hand_L_CTRL/FSP_Hand_R_CTRL) and straighten the arms out slightly (see Fig. 11.2.8, fourth screenshot). For the pose, the back should be kept tilted forward to delay the motion, the following poses bring the back straight to lead the jump.

On the next pose, continue moving the character forward to shift the weight onto the right leg. The trailing right leg should start to rise from the ground, with the motion delayed slightly to add follow-through to the animation.

- Scrub the Time Slider forward another couple of frames to work on the next pose (around frame 29).
- Select the following control objects from the Outliner (see Fig. 11.2.9, first screenshot):
 - FSP_COG_CTRL
 - FSP_Hand_L_CTRL
 - FSP_Hand_R_CTRL
 - FSP_Foot_L_CTRL
- With the controls selected, enable the Move Tool and pull the torso forward and upward, so that the weight is shifting forward onto the right leg, but not fully weighted over the foot yet (see Fig. 11.2.9, second screenshot). The left foot should also lift from the ground as it has been selected and moved at same time.

For the left foot, the foot should be pivoting from the toe with the compression into the ball of the foot removed:

- Select the left-foot control (FSP_Foot_L_CTRL) and from the Channel Box set and key the following channels (see Fig. 11.2.9, third screenshot).
 - Ball Roll = 0
 - Toe Roll = −55

FIG 11.2.9 First pre-launch pose to second pre-launch pose.

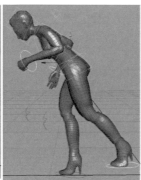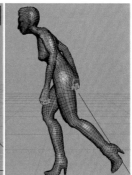

- Finalize the pose by rotating the torso and head controls to straighten out the back and head (see Fig. 11.2.9, fourth screenshot).

Scene file with the animation from the coiled pose to the second pre-launch pose is included with the project scene files as – **11.2_03_PreCoil_PreLaunch.ma**.

For the launch section on the jump, the body poses should be more dynamic and fluid. The previous poses (coiled pose- to pre-launch) were deliberately muted with the body "easing in" to the following section, which will be faster with more contrast between the pose timing & spacing (see **Fig. 11.2.10**).

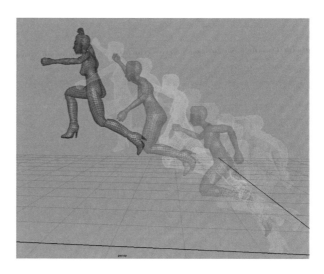

FIG 11.2.10 Jump – launching into air.

At the two poses immediately before the body lifts off the ground, the body posing should look as if the character is almost moving into a run with the body taking on a more dynamic diagonal pose (see Figs. 11.2.11 and 11.2.12).

- Scrub the Time Slider forward a couple of frames (to around frame 31) and make sure that the "Auto keyframe toggle" is still active
- Select the following control objects from the Outliner:
 - FSP_COG_CTRL
 - FSP_Hand_L_CTRL
 - FSP_Hand_R_CTRL
 - FSP_Foot_L_CTRL
- With the control objects selected, activate the Move Tool and pull the torso forward (in global Z-axis) and upward slightly (in global Y-axis). The hips should be almost directly over the right foot with the right leg straightened (see Fig. 11.2.11, second screenshot).
- The left foot should be following movement, select the control object (FSP_Foot_L_CTRL) and pull it up and forward slightly (see Fig. 11.2.11, third screenshot).
 - For the right foot, the weight shift onto the foot can be emphasized by compressing the foot in toward the ball of the foot.
- Select the right-foot control (FSP_Foot_R_CTRL) and, from the Channel Box, set the following:
 - Ball Roll = −30 to −31 (see Fig. 11.2.11, fourth screenshot)
- Finalize the pose by pulling the left hand (FSP_Hand_L_CTRL) back slightly and moving the right hand (FSP_Hand_R_CTRL) forward slightly to follow the line of the pre-run pose. Also rotate the wrist round slightly so that there's a nice line along the arm (see Fig. 11.2.11, fifth screenshot).

FIG 11.2.11 Pre-Jump – moving to launch.

The next pose a couple of frames on should be far more dynamic, with the left leg straight out and arms launching into the jump (see Fig. 11.2.12, fifth screenshot).

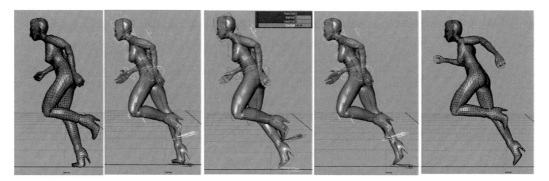

FIG 11.2.12 Start-Jump –
launching off the ground.

- Scrub the Time Slider forward a couple of frames (to around frame 33) and make sure that the "Auto keyframe toggle" is still active.
- Select the following control objects from the Outliner:
 - FSP_COG_CTRL
 - FSP_Hand_L_CTRL
 - FSP_Hand_R_CTRL
 - FSP_Foot_L_CTRL
- With the Move Tool active (W) pull the torso forward so that the hips are weighted in front of the right toe (see Fig. 11.2.12, second screenshot).

Note

You may need to also pull the pole vector controls forward for the legs to stop the knees from flipping (if the foot control pushes the joint chain in front).

- As the character lifts off the ground, the weight on the right foot should shift onto the toe (from the ball).
- Select the right-foot control (FSP_Foot_R_CTRL) and from the Channel Box set the following:

Ball Roll = 0 (see Fig. 11.2.12, third screenshot)

Toe Roll = −50 to −55 (see Fig. 11.2.12, third screenshot)

Note

Modifying the Toe Roll for the foot will also bend the knee slightly from the previous pose (compare Fig. 11.2.12, second/third screenshot).

- Select the main torso controls (FSP_COG_CTRL), the hand controls and left-foot control and pull upward and forward slightly, so that the right leg is straightened more (see Fig. 11.2.12, fourth screenshot).

- Finalize the pose by extending the arms into a swing to match the dynamic posing in the launch. Select the left-hand control (FSP_Hand_L_CTRL) and pull backward, then select the right-hand control (FSP_Hand_R_CTRL) and pull forward and upward slightly (see Fig. 11.2.12, fifth screenshot).

Scene file with the animation from the pre-launch pose to the Start Jump Pose is included with the project scene files as – **11.2_04_PreLaunch_StartJump.ma**.

The previous selection mode was used to select and translate all the control objects *except* for the planted foot; this method is commonly used when animating character walk, run, or other body motion along ground.

For the launch on the jump, multi-selection/translation of *all* the control objects can be used to move the whole of the character into the air. The action line for the overall motion on the jump should match the lines of the pose, with the diagonal pose matching the diagonal action line during the first half of the jump (see Fig. 11.2.13).

FIG 11.2.13 Launching into the air.

- Scrub the Time Slider forward a couple of frames (to around frame 36) and make sure that the "Auto keyframe toggle" is still active
- Select the following control objects from the Outliner (see Fig. 11.2.13, second screenshot):
 - FSP_COG_CTRL
 - FSP_Hand_L_CTRL
 - FSP_Hand_R_CTRL
 - FSP_Arm_L_Pole
 - FSP_Arm_R_Pole
 - FSP_Foot_L_CTRL
 - FSP_Foot_R_CTRL
 - FSP_Leg_L_Pole
 - FSP_Leg_R_Pole
- With the Move Tool active (W) move the controls up in global Y-axis and forward slightly in global Z-axis – this will move the whole character as all the controls are selected at same time. The character should be

traveling diagonally forward/upward – the amount of travel is a matter of preference and can be modified depending on how exaggerated you want the jump to be (see Fig. 11.2.13, second screenshot).

- Pull the left foot back and up slightly (FSP_Foot_L_CTRL) and rotate a bit to suggest the foot is trailing on the jump (see Fig. 11.2.13, third screenshot-top). Move the right foot down a bit also.
- The torso can also be rotated slightly to follow the action line (see Fig. 11.2.13, third screenshot – bottom).
- To finalize the pose, the arms can be pushed forward to lead the motion. The right-hand control (FSP_Hand_R_CTRL) should be pulled upward, so that the arm is outstretched (see Fig. 11.2.13, fourth screenshot). The left-hand control can also be pulled forward slightly and rotation adjusted to suggest that the arms are swinging (see Fig. 11.2.13, fourth screenshot).

Note

Use the pole vector controls for the arms to fix the pose if the elbow angle looks off.

Scene file with the animation from the Start Jump Pose to the first pose mid-flight is included with the project scene files as – **11.2_05_StartJump_JumpUp01.ma**.

For the jump, we can extend the height on the jump as far as we need. If the aim of the shot was to show cartoon character or superhero flight, you might want to add further in-betweens to extend the jump far into the air. For a superhero, you may want the last pose we worked on to extend into a straight out full body with the legs straight back and body flat like Superman. For our shot we're working on, the character is jumping about 5–6 m distance.

The next pose for the animation will, therefore, be the character at full height on the jump.

During the jump, the angle of the character's body and posing should match the direction they're traveling in.

At the start of the jump, the character's body is angled forward, with the left arm and head leading the action (see Fig. 11.2.13, far right screenshot).

For the next pose, the character is at full height, so the body should be changing direction as the body is about to fall. At the next phase of the animation (fall from full height to ground), the character's leg's should lead the action with the body direction reversed (see Fig. 11.2.15).

- Scrub the Time Slider forward a few frames (to around frame 39) and make sure that the "Auto keyframe toggle" is active.
- Select all the parent control objects from the Outliner (check previous step for list of control objects).

• With the control objects selected, enable the Move Tool and pull the character forward (in global Z-axis) and upward into the air (in global Y-axis). The character should be traveling around 4–5 ft in same diagonal trajectory (see Fig. 11.2.14, second screenshot).

During the jump, the character should look like it's almost doing a "run in the air" if you look at sports video of athletes doing the long jump, you'll see the same phenomenon:

• Select the left-foot control (FSP_Foot_L_CTRL) and, with the Move Tool active, pull the foot back and down, so that it is roughly in the same pose as the opposite right foot. From the Channel Box, set the "Toe Roll" attribute back to 0 to straighten out the foot (see Fig. 11.2.14, third screenshot).
• Select the right-foot control (FSP_Foot_R_CTRL) and, with the Move Tool active, pull the foot forward (see Fig. 11.2.14, fourth screenshot).

Note

Switching the posing for both feet from the poses on the previous keyframe will make the character look as if they're using the feet to "run forward" in the air to add momentum.

FIG **11.2.14** Mid-flight pose.

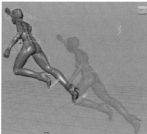

As the character is in mid-flight at the top of their trajectory on the jump, the torso should start to rotate and straighten up. The arms should also lead upward as the character is propelling themselves forward –

• Select the main torso control (FSP_COG_CTRL) and rotate the torso round slightly in local X-axis to straighten the spine. Use the additional spine controls to add a natural curve to the spine (see Fig. 11.2.14, fifth screenshot).
• Move the left arm upward by selecting, moving, and rotating the left-hand control (FSP_Hand_L_CTRL) to pose (see Fig. 11.2.14, fifth screenshot).
• Move the right arm back slightly by selecting, moving, and rotating the right-hand control (FSP_Hand_L_CTRL) to pose (see Fig. 11.2.14, fifth screenshot).

453

Note

For the arms, the posing here suggests almost a wind-mill motion played from the previous poses. When posing the arms, make any necessary edits to the arm pole vector controls (FSP_Arm_L_Pole and FSP_Arm_R_Pole) to edit the angle of the arm and elbow pose.

Scene file with the animation up to the full height on the mid-jump is included with the project scene files as – **11.2_06_ JumpUp01_JumpUp02.ma**.

During the next phase of the sequence, the character begins to fall toward the ground. The feet lead the action, and the direction and angle of motion is changed to match this trajectory. As the legs are leading the motion, the arms trail behind due to gravity – the arms will follow through last after landing. The posing of the character just before landing will be fully extended or stretched out (see **Fig. 11.2.15**).

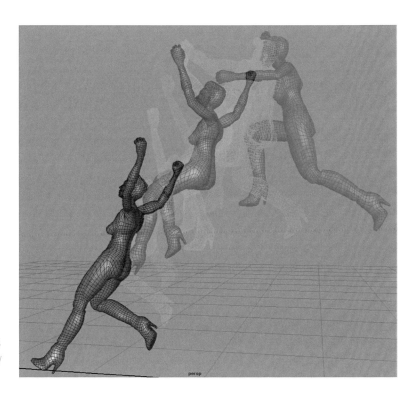

FIG 11.2.15 Second phase of jump, falling to ground – trajectory of body reversed.

For the fall phase of the jump, the same process as before can be used to multi-select the control objects and translate to move the character forward. For this section, the character will also be dropping downward and the spine will be rotated.

- Scrub the Time Slider forward a few frames (to around frame 42) and make sure that the "Auto keyframe toggle" is active.
- Select the following control objects from the Outliner –
 - FSP_COG_CTRL
 - FSP_Hand_L_CTRL
 - FSP_Hand_R_CTRL
 - FSP_Arm_L_Pole
 - FSP_Arm_R_Pole
 - FSP_Foot_L_CTRL
 - FSP_Foot_R_CTRL
 - FSP_Leg_L_Pole
 - FSP_Leg_R_Pole
- With the controls selected, enable the Move Tool and pull the character forward (in Z-axis) and downward toward the ground (in Y-axis). The direction of travel should be around 4 ft on the hips (see Fig. 11.2.16, second screenshot, and Fig. 11.2.15, middle screenshot).
- At this pose, the feet posing should be switching again to suggest the character is "wind-milling" to try and balance the body and propel forward.
- Select the left-foot control (FSP_Foot_L_CTRL) and pull it forward with the Move Tool and Rotate slightly with the Rotate Tool, so the foot is almost flat with the ground plane (see Fig. 11.2.16, third screenshot).
- Select the right-foot control (FSP_Foot_R_CTRL) and pull it backward with the Move Tool and Rotate slightly with the Rotate Tool, so the foot is angled (see Fig. 11.2.16, fourth screenshot, and Fig. 11.2.15, middle screenshot).

FIG 11.2.16 First fall pose for jump, torso, and feet position.

At this pose, the arms should also travel upward due to gravity on the fall and follow the "wind-mill" type motion on the legs:

- Select the left-hand control (FSP_Hand_L_CTRL) and pose it above and in front of the head with the Move and Rotate Tools. Use the Pole vector control to edit the elbow angle (see Fig. 11.2.17, first screenshot, and Fig. 11.2.15, middle screenshot).

455

- Select the right-hand control (FSP_Hand_R_CTRL) and pose it above and just behind the head with the Move and Rotate Tools. Use the Pole vector control to edit the elbow angle (see Fig. 11.2.17, first screenshot, and Fig. 11.2.15, middle screenshot).

Note

For the arm raise on the fall, you may want to also use the clavicle controls to raise up the shoulders. For this, select and rotate the following controls in local Z-axis – FSP_Clavicle_L_CTRL and FSP_Clavicle_L_CTRL.

Select and rotate the main torso control (FSP_COG_CTRL) back slightly in the local X-axis to finalize the pose. Make any final adjustments to the additional spine controls and check the hand posing as well (see Fig. 11.2.17, third and fourth screenshots on right, and Fig. 11.2.15, middle screenshot).

FIG 11.2.17 First fall pose for jump, arm posing, and torso rotation.

Scene file with the animation up to the first pose on the Jump Fall is included with the project scene files as – **11.2_07_ JumpUp02_JumpFall01.ma**.

At the next major pose, the character is hitting the ground. The legs are leading the motion, with the left leg outstretched in anticipation of the landing (see Fig. 11.2.15, left screenshot).

- Scrub the Time Slider forward a few frames (to around frame 45) and make sure that the "Auto keyframe toggle" is active.
- Select the following control objects from the Outliner:
 - FSP_COG_CTRL
 - FSP_Hand_L_CTRL
 - FSP_Hand_R_CTRL
 - FSP_Arm_L_Pole

- • FSP_Arm_R_Pole
- • FSP_Foot_L_CTRL
- • FSP_Foot_R_CTRL
- • FSP_Leg_L_Pole
- • FSP_Leg_R_Pole
- With the controls selected, enable the Move Tool and pull the character forward (in Z-axis) and downward toward the ground (in Y-axis). The direction of travel should be around 4–5 ft on the hips (see Fig. 11.2.18, second screenshot, and Fig. 11.2.15, left screenshot). The left foot should almost be hitting the ground plane (see Fig. 11.2.18, second screenshot).
- Select the left-foot control (FSP_Foot_L_CTRL) and pull it downward in global Y-axis to straighten out the left leg – the heel of the foot should be at the same level as the ground plane. If necessary, select the hip and hand controls to edit the height of the torso, so that the foot touches the ground (see Fig. 11.2.18, screenshots on right).
- The right leg should be traveling backward at this pose to counter the motion on the left leg, select the right-foot control (FSP_Foot_R_CTRL) and pose it backward with the Move and Rotate Tools (see Fig. 11.2.18, screenshots on right).

FIG 11.2.18 Second fall pose for jump, torso, and leg posing.

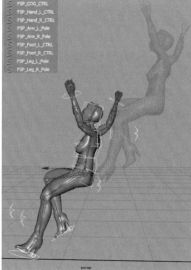

The left arm should be pulled further back at this pose to continue the wind-mill motion and strengthen the angle of fall (see Fig. 11.2.19, fourth screenshot from left). The character should be at full extension or stretched out at this point, just before landing.

The torso control (FSP_COG_CTRL) and additional spine controls can also be rotated backward slightly to follow the angle of the leading left leg better (see Fig. 11.2.19, screenshots on right).

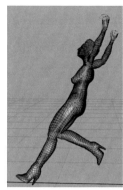

FIG 11.2.19 Second fall pose for jump, arm posing, and torso trajectory.

> **Tip**
>
> You may find that the hand and arm joints appear to flip when going from the previous poses. This is because the motion is fairly extreme, and the software is automatically interpolating the motion. If necessary, add additional in-between keyframes at 1–2 frame intervals for the hand controls and arm pole vector controls to fix any issues.

Scene file with the animation up to the second pose on the Jump Fall (first landing pose) is included with the project scene files as – **11.2_08_ JumpFall01_JumpLand01.ma**.

For the landing, the poses can be quite extreme. The arms are following through after the feet and flail forward. The posing is an extreme version of the first pose we worked on at the start for the jump sequence (see Fig. 11.2.1, idle pose to ready pose) with the body compressing from an extreme "stretched" pose just before landing to compressed "squash" pose on the ground (see **Fig. 11.2.20**).

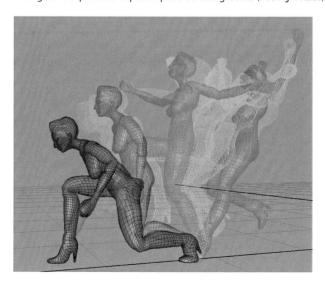

FIG 11.2.20 Landing – extreme "stretch" to "squash" pose.

Let's look at the first pose directly after the left foot connects with the ground:

- Scrub the Time Slider forward a few frames after the last pose – to around frame 48, three frames after the first pose where the left foot connects with the ground (see Fig. 11.2.21, first screenshot).
- Select the following control objects from the Outliner:
 - FSP_COG_CTRL
 - FSP_Hand_L_CTRL
 - FSP_Hand_R_CTRL
 - FSP_Arm_L_Pole
 - FSP_Arm_R_Pole
 - FSP_Foot_R_CTRL
 - FSP_Leg_L_Pole
 - FSP_Leg_R_Pole

Note

The left-foot control (FSP_Foot_L_CTRL) isn't selected as it remains planted as the body travels forward at this pose.

- With the Controls selected, enable the Move Tool and pull the character forward, so that the hips are just passing over the planted left foot (see Fig. 11.2.21, second screenshot).

For the left foot, the heel should be pivoting onto the ball of the foot at this pose as the weight shifts.

- Select the left-foot control (FSP_Foot_L_CTRL) and, from the Channel Box, set the following:
 - Heel Pivot = 0.0 (see Fig. 11.2.21, third screenshot).

As the hips travel forward, the right foot can be posed out in front, in anticipation of the character attempting to balance with both feet in the following pose:

- Select the right-foot control (FSP_Foot_R_CTRL) and pose it in front using the Move and Rotate Tools (see Fig. 11.2.21, fourth screenshot).

FIG 11.2.21 Second landing keyframe, torso, and leg posing (frame 48).

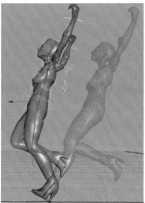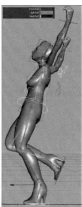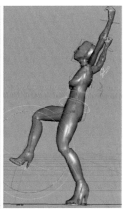

The arms should be starting to fall at this pose.

Note

You may want to delay the arms falling at this pose to increase the sense of follow-through for this part of the sequence. In the example, the arms are animated at about the mid-point on drop toward the rest pose (at side of body) (see **Fig. 11.2.22**, fifth screenshot).

- Select the right-hand control (FSP_Hand_R_CTRL) and with the Move Tool pull the hand down slightly in front of the body, use the Rotate Tool to fix the rotation and make any necessary edits to the angle of the arm and elbow with the Pole Vector Control (FSP_Arm_R_Pole) (see Fig. 11.2.22, second screenshot).

Note

For the example, the right arm is swinging in an anti-clockwise direction (from side view), whereas the left arm is swinging in opposite clockwise direction.

- Select the left-hand control (FSP_Hand_L_CTRL) and with the Move Tool pull the hand down and back behind the body, use the Rotate Tool to fix the rotation and make any necessary edits to the angle of the arm and elbow with the Pole Vector Control (FSP_Arm_L_Pole) (see Fig. 11.2.22, third screenshot).
- The torso can also be rotated slightly forward at this pose by rotating the main torso control (FSP_COG_CTRL) forward slightly in the local X-axis (see Fig. 11.2.22, fourth screenshot).

FIG 11.2.22 Second landing keyframe, finalizing the arm poses.

Scene file with the animation up to the second landing pose is included with the project scene files as – **11.2_09_ JumpLand01_JumpLand02.ma**.

The posing between the landing keyframes is similar to a walk, with the weight starting to distribute at the next pose onto the outstretched right leg. This and the previous pose could be exaggerated if you wanted to make the character look as if they were landing clumsily.

For the example, the landing is fairly balanced, with the character using the arms to remain poised. In the example sequence, the spacing between the key poses on the land is also extended from between 3 and 6 frames to create a natural ease out to the sequence. Let's take a look at keying the next major pose for the jump land.

- Scrub the Time Slider forward a few frames after the last pose – to around frame 51, three frames after the last pose at frame 48, where the left foot was fully planted on the ground (see Fig. 11.2.22, fifth screenshot).
- Select the following control objects from the Outliner –
 - FSP_COG_CTRL
 - FSP_Hand_L_CTRL
 - FSP_Hand_R_CTRL
 - FSP_Arm_L_Pole
 - FSP_Arm_R_Pole
 - FSP_Foot_R_CTRL
 - FSP_Leg_L_Pole
 - FSP_Leg_R_Pole

Note

The left-foot control (FSP_Foot_L_CTRL) isn't selected as it remains planted as the body travels forward at this pose.

- With the controls selected, enable the Move Tool (W) and pull the character forward and down. The torso should be around the mid-point in step, about two feet in front of the planted left foot (see Fig. 11.2.23, second screenshot), The hips should also be shifted to the side slightly to show change in balance.

At this pose, the left foot looks unnatural – as the weight starts to distribute over the foot, the heel should lift off the ground and push forward to shift the weight onto the ball of the foot to look balanced

- Select the left-foot control (FSP_Foot_L_CTRL) and from the Channel Box, set the following:
 - Heel Roll = −40 (see Fig. 11.2.23, third screenshot).

The right foot should be posed connecting with the ground at this key –

- Select the right-foot control (FSP_Foot_R_CTRL) and with the Move Tool, position the foot so that the heel is just touching the ground plane (see Fig. 11.2.23, fourth screenshot).

Note

If the foot cannot reach the ground plane, reduce the height of the torso by moving the main hips control in Y-axis. Make any necessary refinements, so that the leg and hip positions looks right (see Fig. 11.2.23, fifth screenshot).

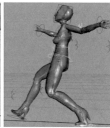

FIG 11.2.23 Third landing keyframe, torso, and leg posing (frame 51).

For the arms, these should naturally begin to swing into the body as the character starts to come to rest after the jump landing (see Fig. 11.2.24, fourth screenshot).

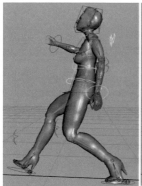
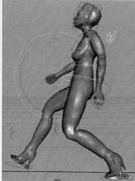
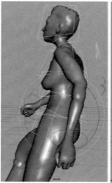
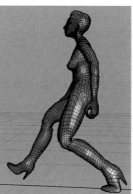

FIG 11.2.24 Third landing keyframe, finalizing the arm poses.

- Select the left-hand control (FSP_Hand_L_CTRL) and pose the arm closer into the side of the body with the Move and Rotate Tools (see Fig. 11.2.24, first screenshot).

Note

The hand control will also need to be pulled in global X-axis to bring it into the side of the hip (check from front of character while keying the pose). Use the Pole vector control (FSP_Arm_L_Pole) to fix any bad deformations on the arm rotation and elbow.

Select the right-hand control (FSP_Hand_R_CTRL) and pose the arm closer into the side of the body with the Move and Rotate Tools. The angle of the arm should be around half way toward the full rest pose (see Fig. 11.2.24, second screenshot). Use the Pole vector control (FSP_Arm_R_Pole) to fix any bad deformations on the arm rotation and elbow.

The arms are at fairly relaxed pose at this key, the swing down could be delayed or the keys for the hand controls offset a few frames after frame 51 if you wanted to add more natural follow-through to the landing section of the animation.

Scene file with the animation up to the third landing pose is included with the project scene files as – **11.2_10_ JumpLand02_ JumpLand03.ma**.

For the final pose for the jump landing, in the example I've used a similar pose to the one used at the start of the animation prior to the jump (see Fig. 11.2.20, left screenshot, and Fig. 11.2.26). As the character lands, the body is pushed forward after the feet due to gravity on the jump. This could be emphasized in the animation by having the character to take a couple of steps, leant forward to regain balance.

For the final pose, In the example, I've chosen to make the weight fully distributed onto the right leg which is now planted with the body lowered into "squash" pose and torso leaning forward. Let's take a look at the posing for the final pose on the jump animation.

FIG 11.2.25 Final landing keyframe, posing the torso, right foot, and left arm.

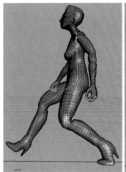

- Scrub the Time Slider forward a few frames after the last pose – to around frame 58, 6–7 frames after the last pose at frame 51 where the right foot first connects with the ground (see Fig. 11.2.24, fourth screenshot).
- Select the following control objects from the Outliner
 - FSP_COG_CTRL
 - FSP_Hand_L_CTRL
 - FSP_Hand_R_CTRL
 - FSP_Arm_L_Pole
 - FSP_Arm_R_Pole

Note

Neither of the foot controls (FSP_Foot_L_CTRL and FSP_Foot_R_CTRL) is selected, as they are already planted from previous pose. The torso is being posed at this key to give follow-through on the shot.

- With the controls selected, activate the Move Tool (W) and pull the hips down toward the ground. The pose should push the left knee down so that the character is almost in a kneeling position (see Fig. 11.2.25, second screenshot).

463

At this pose, the weight will be distributed over the right foot. From the previous pose (frame 51) to this pose (frame 58), the foot will pivot over the heel. Use the Channel Box control to plant the right foot (see Fig. 11.2.25, third screenshot):

- Select the right-foot control (FSP_Foot_R_CTRL) and from the channel box, set the following:
 - Heel Roll = 0.0.

The arms should also swing forward at this pose as the torso rotates forward. When rotating the torso controls, the arms may become locked. First, pull the left-hand control (FSP_Hand_L_CTRL) forward to pose the left arm before posing the torso in next step (see Fig. 11.2.25, fourth screenshot).

With the left hand placed, the torso can be posed following through after the legs. As we're keying with "Auto keyframe" enabled the keys will be set on same frame. When finalizing the animation, you may want to offset the keys for the arms swinging a few frames after the torso comes to rest to create more natural follow-through in the animation.

- Select the main torso control (FSP_COG_CTRL) and with the Rotate Tool (E) active, rotate the upper body forward in the +X-axis (see Fig. 11.2.26, first and second screenshots).

The right arm should swing backward at this pose, so that it is opposite to the leading right leg and left arm.

Select the right-hand control (FSP_Hand_R_CTRL) and with the Move and Rotate Tools, pose the hand outstretched behind the back, close into the body (see Fig. 11.2.26, third and fourth screenshots).

FIG 11.2.26 Final landing keyframe, Torso rotation, and right-arm swing.

Scene file with the full jump animation from the idle pose (frame 1) to the final rest pose (at frame 58) is included with the project scene files as – **11.2_11_ Jump_Final_Sequ.ma**.

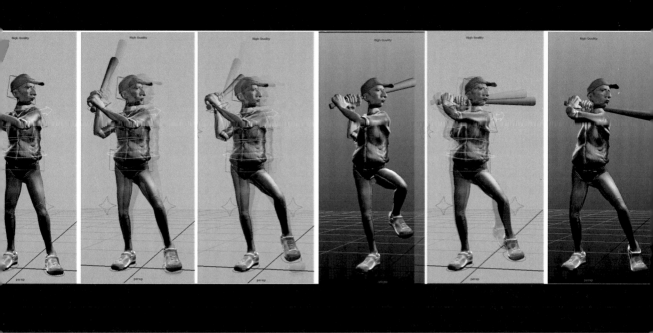

Exaggeration

There was some confusion among the animators when Walt first asked for more realism then criticized the result because it was not exaggerated enough.
The Illusion of Life: Disney Animation – Frank Thomas and Ollie Johnston

Exaggeration is an important principle to understand and apply in your animations and VFX shots. It is typically used alongside the other animation principles to provide additional impact and readability to a sequence. As a device, it can be clearly seen in every action movie made, with ramped up action and effects increasing the audience excitement and suspension of disbelief. For animation, it can equally be applied to provide additional clarity to a character performance or simulation.

Exaggeration should be considered at all stages in animation practice and can be interpreted as boldness or strength.

In this section, we will take a look at some of the sequences covered in the earlier chapters of this book. We will find out how pushing the character posing, timing & spacing, secondary animation, and other principles with exaggeration can improve both the readability and success of the animation.

Baseball Batter Animation

In the baseball bat swing animation we worked on in previous chapters, the pose blocking was established alongside timing edits to create a fluid swing with natural ease in and ease out. Although the animation timing and motion looked natural and fluid, the action lacked vitality and impact for what should be a strong move.

This is an ideal example of where exaggeration can be considered and applied throughout the work. Can the posing be exaggerated to create stronger action lines? Can the timing & spacing be edited to exaggerate both the anticipation and ease in and ease out on the swing? (see **Fig. 12.0.1**).

FIG 12.0.1 Exaggeration – baseball swing, posing.

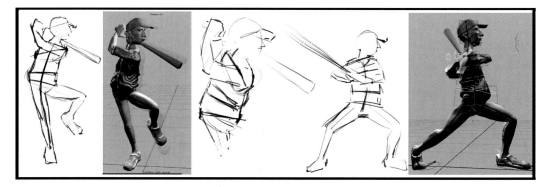

Walk Cycle Animation

In Chapter 3.1, we looked at timing & spacing for animation and studied timing and pose intervals for both walk and run cycle animations. In the tutorial, we looked at even posing and timing for a standard march time walk cycle (see **Fig. 12.0.2**, left screenshots).

People do not all walk perfectly upright with even timing, and this is an ideal example of where exaggeration can be applied to create more appeal in the animation to fit the mood and characterization.

Often a standard posed and timed walk or run cycle will be used as a starting point in production; this is especially true of gameplay animation for video games, where a large number of different walk and run cycles are required for both the main gameplay characters and background characters. A common workflow to edit base motion in Maya and other 3D packages is to use animation layering to add offsets to the motion posing to change the characterization or mood. In the second tutorial in this chapter, we will use a motion capture walk sequence as a starting point: Maya's HumanIK retargeting will be utilized to map the motion to our character for further edit and refinement. The animation layers will be used to change the mood of the walk, with pose edits also changing the timing & spacing to create a dejected and labored motion (see Fig. 12.0.2, right screenshots).

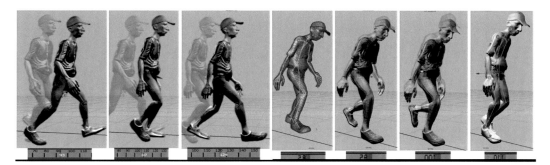

FIG 12.0.2 Exaggeration – original walk motion and layer edited dejected walk.

VFX Dynamics

Visual effects and dynamics are an ideal example of where exaggeration can be applied. In the third tutorial in this chapter, we'll work from the initial dynamics simulation of the rocket smash we blocked in Chapter 8.2. The addition of more elements to the simulation will help to ramp up the viewer interest in the simulation through both secondary and overlapping action. Once again, edits to the timing & spacing will also be used to create exaggerated anticipation to the main impact (see Fig. 12.0.3).

FIG 12.0.3 Exaggeration – dynamics simulation, additional secondary elements and follow-through.

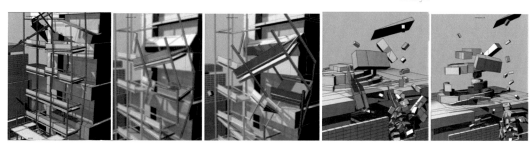

Chapter 12.1 – Exaggeration – Character Baseball Swing

In this section, we'll take a look at strengthening the baseball batter sequence we worked on in previous chapters through effective use of exaggeration. The project scene files for this chapter section include the original unedited animation alongside the sequence with exaggeration applied for comparison:

- **12.1_00_Exaggeration_Pre-Edit.ma**
- **12.1_01_Exaggeration_Final-Edit.ma**

For animation sequences that focus on fast motion or athleticism such as the baseball shots in this book, it is critical that the motion is pacy, fluid, and the action readable by the viewer. When animating action, it can be difficult to judge the timing and posing correctly to represent the action for the viewer.

Even when the posing and timing look correct, the animation may still feel stilted or lifeless.

For these types of sequences, it's often necessary to exaggerate the timing, spacing, and posing – this can often be an iterative process to get something that looks and feels right.

Note

When working on enhancing these types of shots, it can often be necessary to push the Character Rig and posing beyond the natural limits that the body would normally be able to hit, and this can sometimes, as in areas of this example appear as if the character is "breaking." Although this may seem unnatural at first, on playback of the animation, the exaggerated poses will only be seen for a fraction of a second and will overall enhance the readability of the motion.

If we take a look at the original sequence, we can see several areas that can be enhanced through effective use of exaggeration on the animation:

Animation Lead-In

From the project scene files folder, open the original unedited animation – **12.1_00_Exaggeration_Pre-Edit.ma**.

On the lead into the swing (frame 00–15), the batter raises his left foot from the ground as the weight on the hips shift backward in anticipation of the swing. This is termed as "testing the water" in baseball technique as the batter gathers himself. This move builds anticipation for the swing that follows.

On the preswing, the body rotates round in corkscrew motion in anticipation to gather momentum.

Although the poses look solid and natural, there isn't much drama in the animation. This is because the poses and timing are not exaggerated enough to be clearly readable by the viewer (see **Fig. 12.1.1**). The lead-in can potentially also be enhanced by extending the frame length, which would provide more anticipation and contrast with the fast swing that follows.

FIG 12.1.1 Animation lead-in – idle to preswing (frame 00–15).

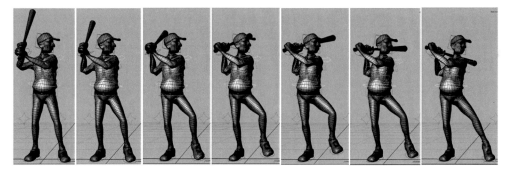

Swing Animation

On the unedited animation (**12.1_00_Exaggeration_Pre-Edit.ma**), there is a reasonable amount of movement on the hips and upper torso as the body leans into swing.

However, several areas can be enhanced:

There is a slight shuffle on the left foot as the character steps forward, which is not particularly readable (step into swing after testing the water).

The contrasts between the readiness swing pose and full extension on the swing are also not particularly strong. Although the poses look natural, exaggerating the poses (or spacing) could add extra dynamism and movement to the animation.

Extremes between the poses will make the motion more powerful.

For the swing animation, we can also look at exaggerating the follow-through on the bat swing by offsetting the timing on the animation so that the upper torso follows through slightly after the hips travel forward. As it is, the move looks slightly soft or stilted (see Fig. 12.1.2).

By exaggerating the animation through the pose contrasts and timing, we can add more drama to the animation.

FIG 12.1.2 Swing animation – preswing to midpoint follow-through (frame 15–24).

When making edits to any animation, it's worthwhile making revised thumbnails of the character posing for reference. These can be made roughly as overlays on screenshots taken of the existing animation. For the two main pose edits for the sequence, thumbnails were utilized to rough out poses that had clearer action lines, S-curves, and diagonals, which were more readable (see Fig. 12.1.3).

These were used as reference for the pose edits on the rig in Maya, which are covered in more detail in this chapter.

469

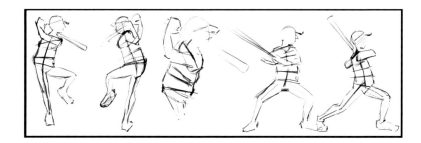

FIG 12.1.3 Thumbnails –
exaggerated preswing pose
(anticipation) and swing follow-
through.

Pose Edits 01 – Preswing Pose

- Open the original unedited animation – **12.1_00_Exaggeration_Pre-Edit.ma**.
- The preswing pose directly before the bat swing at frame 15 on the original animation is reasonably dynamic, with diagonals running across the shoulders and body. It shows a solid action line for the animation (see Fig. 12.1.4, left screenshot).
- Open the edited animation with the pose modified – **12.1_01_Exaggeration_Final-Edit.ma**.
- To add dynamism to the animation, the pose has been exaggerated slightly. The following edits have been made to the keyed pose at frame 15.

Exaggerated Torso Rotation

The spine controls have been twisted round slightly further on the pose to exaggerate the corkscrew on the swing. Each of the following controls has been rotated round slightly further in local Y-axis (see Fig. 12.1.4, middle screenshot).

> BBALL02_RIG_BASE_FSP_Spine01_CTRL – Control rotated slightly in local Y-axis.
> BBALL02_RIG_BASE_FSP_Spine02_CTRL – Control rotated slightly in local Y-axis.
> BBALL02_RIG_BASE_FSP_Spine03_CTRL – Main upper torso control rotated slightly more in local Y-axis.

Note

The neck and head controls have been rotated back slightly to counter the offset on the spine.

Bat Angle Edited

Both the angle of the bat and the position of the wrists have been exaggerated on the pose.

BBALL02_RIG_BASE_FSP_Hand_L_CTRL – the Control object has been pulled further round to back of right shoulder and rotated.

Pulling the wrists further around exaggerates the "corkscrew" effect on the swing as the wrist and bat have further to travel (in following motion). Angling the bat so that it is sloped at a more diagonal angle to the body creates a more dynamic pose while giving the bat more of an angle to swing on the ease in phase (see Fig. 12.1.4, right screenshot). Compare the thumbnail for this pose (see Fig. 12.1.3, left) to the original unedited pose (see Fig. 12.1.4, left screenshot).

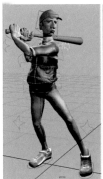
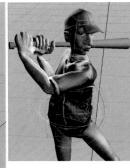
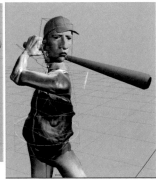

FIG 12.1.4 Edited preswing pose – torso rotation and bat angle exaggerated.

Timing Edit 01 – Additional Lead-In – Anticipation

- Open the original unedited animation – **12.1_00_Exaggeration_Pre-Edit.ma**.
- The lead-in on the unedited animation before the swing starts plays from frame 00 to frame 15, which is just over half a second at 24 fps.
- Although this adds some anticipation for the swing, the lead-in can be extended to add additional anticipation for the sequence.
- Open the edited animation with the lead-in timing modified – **12.1_01_Exaggeration_Final-Edit.ma**.

To add additional anticipation on the sequence, the overall playback range has first been extended to 60 frames (see Fig. 12.1.5, top screenshot).

The start frame for the swing has then been offset from frame 16 to frame 22. This has been done simply by selecting all the control objects and offsetting the key range on the Time Slider (see Fig. 12.1.5, middle and bottom screenshots).

FIG 12.1.5 Playback range extended and swing animation offset (+6 frames).

The original preswing pose at frame 15 has been copied to frame 21 by selecting all of the control objects and duplicating the key. This has been done simply by scrubbing the Time Slider to frame 15, then clicking with middle mouse button at frame 21 before setting key (S shortcut).

This creates additional static animation for six frames of the character standing idle in the preswing ready pose (see Fig. 12.1.6, screenshots 1–4 from left). This allows blocking out the time intervals and allows viewing of the new overall timing interval. In extending the range before the swing, there is additional contrast on the short frame range on swing. Edits are made to the new idle frame range to create additional pre-step or double-take before swing.

Note

Middle mouse click on Time Slider will update the current frame but will not update the viewport or transforms on the selected elements. This makes it possible to quickly copy/paste pose, even when there isn't existing key to copy.

FIG 12.1.6 Additional pre-lead-in (frame 15–27 – two-frame intervals).

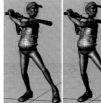

Pose Edits 02 – Pre-step (Test the Water)

• Open the original unedited animation – **12.1_00_Exaggeration_Pre-Edit.ma**.

The batter raises his left foot from the ground (from frame 0 to frame 10) and then connects with the ground lightly at frame 15 before the swing starts (see Fig. 12.1.7, gray-shaded screenshots). This move is called "testing the water" in baseball technique and is used by the batter to gather himself before the swing. In the animation, it also adds some anticipation to the sequence as there is a shift back in the hips to gather momentum before the body moves forward.

• Open the edited animation with the pre-step pose modified – **12.1_01_Exaggeration_Final-Edit.ma**.

Pre-Step Pose1 – Left Foot Raise Exaggerated

The foot control has been raised slightly further from the ground at frame 10. This makes the step more readable as the poses are exaggerated (see Fig. 12.1.7, second screenshot from left).

Pre-Step Pose2 – Hips Shift Forward Slightly

The hips have been shifted slightly forward as the foot connects with the ground when the batter "tests the water" before the swing. Slightly exaggerating the pose at this frame again makes the step more readable as there is more difference between the two key poses (see Fig. 12.1.7, fourth screenshot from left).

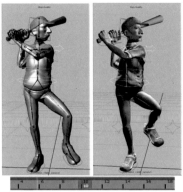
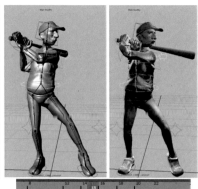

FIG 12.1.7 Pose Edits – frame 10 and frame 15.

On playback, the exaggerated poses make the "test the water" step more readable (see Fig. 12.1.8).

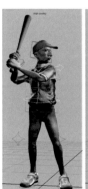
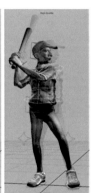
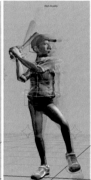
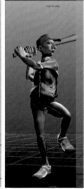
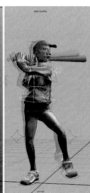
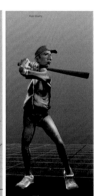

FIG 12.1.8 Test the water step – validating pose edits on playback.

Pose Edits 03 – Exaggerated Anticipation on Swing

• Open the edited animation – **12.1_01_Exaggeration_Final-Edit.ma**.

The original pose that's been copied from frame 15 to frame 21 has been edited to exaggerate the anticipation on the swing (see Fig. 12.1.9, gray-shaded screenshots, pre-edit/textured screenshots – after edit). The pose provides contrast with the preceding readiness pose (frame 15) as well as contrast with the poses that follow as the baseball batter steps forward into the swing.

Note

On the exaggerated poses, you may see issues with the wrist, elbow, or shoulder skinning appearing to "break" on the character – this is not apparent when viewing the character from the front which is where we've animated to – the breaking is necessary to push the pose and is not apparent on playback from the front three-fourth side view.

Exaggerated Action Line

The action line has been exaggerated on the pose at frame 21, with the following edits:

> BBALL02_RIG_BASE_FSP_COG_CTRL – The main hip control has been pulled back further and rotated downward in local Z-axis to tilt the upper torso forward. This creates a stronger diagonal line across the body and increased sense of anticipation for the coiling motion of the swing (see Fig. 12.1.9, textured screenshots).
>
> BBALL02_RIG_BASE_FSP_Spine01_CTRL >> ##_Spine03_CTRL – The upper torso spine controls have also been rotated slightly further from the new pose edited at frame 15 (see Fig. 12.1.4).
>
> BBALL02_RIG_BASE_FSP_Foot_L_CTRL – As with the "test the water" pose, the left foot control has been raised. On this pose, the raise has been exaggerated further to heighten the anticipation and make the step more overt on the frames that follow. The knee control pose has also been edited to ensure that the angle of the leg and knee is dynamic (see Fig. 12.1.9, screenshot on far right).

FIG 12.1.9 Pose edit – frame 21 – preswing anticipation pose.

On playback, there is a more overt anticipation on the step back before the swing at frames 15–20 (see Fig. 12.1.10).

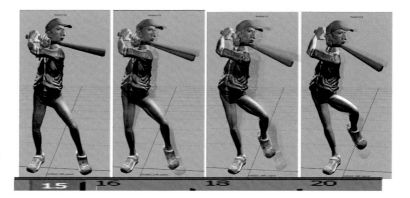

FIG 12.1.10 Playback – frame 15 to frame 21 – exaggerated anticipation preswing.

Curve Edit – Offset Hips/Feet on Stance – Exaggerated Lean into Swing

- Open the original unedited animation – **12.1_00_Exaggeration_Pre-Edit.ma**.
- On the swing phase of the animation after both feet are planted and weight distributed evenly between the legs (frame 21 onward), the legs are fairly upright in the stance, with the knees only slightly bent (see Fig. 12.1.11, screen on far left).
- Open the edited animation – **12.1_01_Exaggeration_Final-Edit.ma**.
- On the swing phase of the animation (from frame 27 forward) after both feet are planted, the hips are lowered and the feet are spread further apart, creating a more squat pose.

This is achieved through edits from the curve window on the following animated elements:

BBALL02_RIG_BASE_FSP_COG_CTRL – The keys for Translate X, from frame 25 onward, have been marquee selected and offset downwards in +X (see Fig. 12.1.11, second screen from left).
BBALL02_RIG_BASE_FSP_COG_CTRL – The keys for Translate Y, from frame 25 onward, have been marquee selected and offset downward in –Y (see Fig. 12.1.11, third screen from left).
BBALL02_RIG_BASE_FSP_Foot_L_CTRL – The keys for Translate X, from frame 25 onward, have been marquee selected and offset slightly in +X (see Fig. 12.1.11, fourth screen from left).

FIG 12.1.11 Curve edit – offset hip and foot pose – squat during swing.

The offset on the channels on the key range creates a more dynamic squat during the swing phase of the animation. As the posing is more exaggerated, there is also more contrast during the lead-in from the preswing pose (from frame 21 to frame 26). At full extension on the swing (frame 30+), the posing is more dynamic with a strong diagonal running across the body and right leg (see Fig. 12.1.12, fourth screen from left). When exaggerating poses, this could be pushed even further, which can help to strengthen the animation. Bear in mind that even if the pose looks grossly overexaggerated when seen in isolation, it will only be visible to the eye for a couple of frames and can really help strengthen the move.

FIG 12.1.12 Curve edit – comparing edits (gray-shaded before edit – textured after edit).

Pose Edits 04 – Exaggerated Step

* Open the edited animation – **12.1_01_Exaggeration_Final-Edit.ma**.

The previously outlined edits to the preswing pose (frame 21) and curve edits to the squat pose on swing (frame 26+) create more contrast on the step into the swing. For the in-between frames between these two poses, additional edits have also been made to the following elements to exaggerate the step:

BBALL02_RIG_BASE_FSP_Foot_L_CTRL – The left foot control has been keyed with the rotation modified. The foot has been posed with the angle shifted so that the heel is leading rather than the toe.

This creates a more exaggerated lunge or step into the swing than the previous soft slide or shuffle on the unedited animation (see Fig. 12.1.13, second and third screens from left).

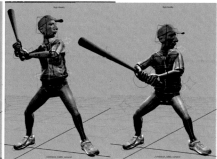

FIG 12.1.13 Pose edits – exaggerated step.

Timing Edit 02 (Dope Sheet) – Arm Swing – Follow-Through

* Open the original unedited animation – **12.1_00_Exaggeration_Pre-Edit.ma**.

At the swing phase of the animation, the posing of the upper torso and wrist/bat is appropriate for follow-through on the swing. However, all of the elements on the upper body and arms are keyed at the same frame (from

the pose blocking phase – covered in Chapter 6.3). The swing follow-through also happens at the same time that the feet are fully planted and weight distributed between legs (frame 21 onward).

 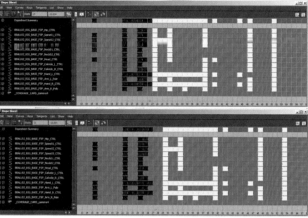

- Open the edited animation – **12.1_01_Exaggeration_Final-Edit.ma**.

FIG 12.1.14 Dope sheet – spine/ arms – keys offset for exaggerated follow-through.

To add additional exaggeration to the swing follow-through, edits have been made to the key timing through the dope sheet to offset the keys by a couple of frames on the spine, shoulders, and arms. This causes the elements to follow through more naturally as each element is not moving at same time.

The following elements have been selected, and keys offset through the dope sheet from frame 27 to frame 29 (see Fig. 12.1.14).

 BBALL02_RIG_BASE_FSP_Spine01_CTRL //
 BBALL02_RIG_BASE_FSP_Spine02_CTRL //
 BBALL02_RIG_BASE_FSP_Spine03_CTRL
 BBALL02_RIG_BASE_FSP_Hand_L_CTRL //
 BBALL02_RIG_BASE_FSP_Hand_R_CTRL
 BBALL02_RIG_BASE_FSP_Arm_L_Pole //
 BBALL02_RIG_BASE_FSP_Neck01_CTRL //
 BBALL02_RIG_BASE_FSP_Neck02_CTRL
 BBALL02_RIG_BASE_FSP_Head_CTRL

The following elements have been selected, and keys offset through the dope sheet, an additional one frame from frame 21 to frame 22 (see Fig. 12.1.15).

 BBALL02_RIG_BASE_FSP_Spine03_CTRL
 BBALL02_RIG_BASE_FSP_Hand_L_CTRL //
 BBALL02_RIG_BASE_FSP_Hand_R_CTRL
 BBALL02_RIG_BASE_FSP_Arm_L_Pole //
 BBALL02_RIG_BASE_FSP_Neck01_CTRL //
 BBALL02_RIG_BASE_FSP_Neck02_CTRL
 BBALL02_RIG_BASE_FSP_Head_CTRL

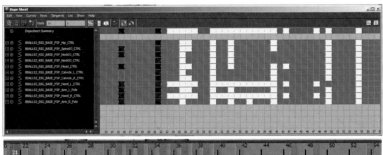

FIG 12.1.15 Dope sheet – upper spine (shoulders)/arms – keys offset for exaggerated follow-through.

All of the torso and arms keys are offset a couple of frames while only the top spine control keys are offset an additional frame. This exaggerates the follow-through as the spine rotation on the swing is delayed until after the hips are fully compressed into the squat for the swing animation. This makes the swing animation more weighted as the follow-through is more natural and fluid (see Fig. 12.1.16).

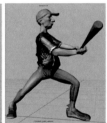
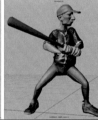
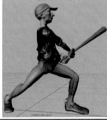
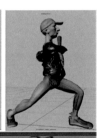

FIG 12.1.16 Dope sheet edits – playback – offset spine follow-through on swing.

Chapter 12.2 – Exaggeration – HumanIK Retarget and Edit

In this tutorial, we'll take a look at Maya's HumanIK system for animation retargeting and edit.

The HumanIK setup and retargeting in Maya allow animators to easily remap animation between different character setups.

The system is typically used in production to retarget motion capture data onto character rigs for edit, though it can also be used as a starting point to remap and repurpose animation onto different characters that can be further edited or exaggerated to meet the needs of the character and animation.

The first part of the tutorial will provide an introduction to the HumanIK setup, controls, and retargeting workflow. We will be working with some of the sample motion capture data that ships with Maya as a starting point. We will look at how to transfer this motion onto our baseball batter character using

the retargeting workflow. In addition to covering the base workflow, we will also look at the editable attributes for HumanIK retarget to modify and refine the result (see Fig. 12.2.01).

FIG 12.2.01 HumanIK – retargeting Mocap to character rig.

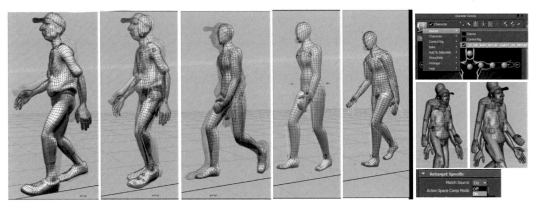

In the second part of the tutorial, we'll look at workflows for editing the retargeted animation using Maya's animation layers. The layers will be utilized to add cumulative offsets to the animation to exaggerate the body posing and timing to change the mood and feel of the animation (see **Fig. 12.2.02**).

FIG 12.2.02 HumanIK – exaggerating the motion – animation layers.

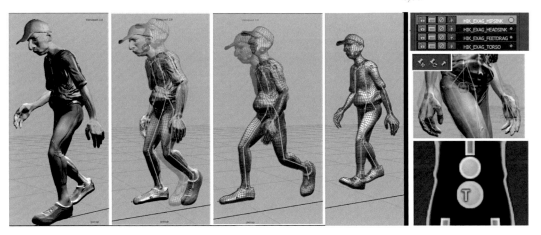

Character Rig – HumanIK

· Open the start scene file for this section from the Project scene files directory – **12.2_01_HIK_RIG_BBALL02.ma**.

The scene file includes the baseball batter character model we worked with in previous chapters (see Fig. 12.2.1, left screenshot).

The character is set up with a different type of rig to the one we worked with before for the character, the character uses the HumanIK Rig in Maya.

The HumanIK Rig was introduced in Maya 2011 and is an enhanced version of the Full Body IK Rig we worked with previously on the baseball pitcher character from Chapter 2.1.

Interaction with the HumanIK Rig is similar to the Full Body IK Rig, with pinning available for the Control Rig elements.

- Select the small red-shaped icon for the left wrist effector (named HIK_BBALL02_Ctrl_LeftWristEffector).
- With the effector selected, right-click on the Viewport and choose "HIK Mode: Full Body" from the marking menu (see Fig. 12.2.1, top right screenshot).
- With the Move tool active (W), pull the control downward (in global Y-axis).

The feet remain locked to the floor with the left arm stretching the upper torso as the wrist moves (see Fig. 12.2.1, middle screenshot).

The feet remain locked during interaction because pinning is enabled.

The body stretches to the wrist position as Full Body manipulation mode is enabled.

As with the Full Body IK Rig, Pin Translate and Pin Rotate can be enabled from the right-click context menu (see Fig. 12.2.1, top right screenshot).

TR icons display over the effector in blue to indicate whether or not pinning is enabled for the effector.

T = Translate/R = Rotate (see Fig. 12.2.1, bottom right screenshot).

FIG 12.2.1 HumanIK Rig – interaction and pinning.

HumanIK – Character Controls Window

Additional enhancements for working with HumanIK rigs were introduced in Maya 2012. A visual interface for working with the setup was introduced. This system uses the same implementation as Autodesk MotionBuilder 2012 and includes similar functionality and user interface.

- With the scene file open, enable the Animation menu set from the status line drop-down menu or F2 shortcut (see Fig. 12.2.2, left screenshot).

- Go to the Skeleton menu at the top of the Maya user interface and select – Skeleton > HumanIK > Character Controls (see Fig. 12.2.2, middle screenshot).

The Character Controls window will open (see Fig. 12.2.2, right screenshot).

The Character Controls window provides an easy-to-use interface for working with HumanIK.

FIG 12.2.2 HumanIK – Character Controls window.

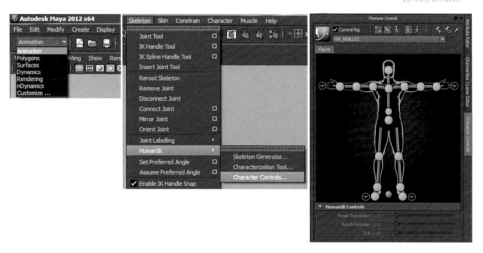

The display type for the HumanIK Control Rig can be switched between three different display modes. This can be done from the Blue "Character Menu Button" at the top left of the Character Controls window. Test switching between the three different display modes from:

- Character Menu Button > Control Rig > Rig Look > Wire/Stick/Box (see Fig. 12.2.3).

FIG 12.2.3 Control Rig – rig look – wire/stick/box (left-to-right screens).

Note

Toggling rig look does not modify the rig and is only used to aid in display and interaction.

481

The main window in the Character Controls window is called the Figure Representation area and allows easy selection of the Control Rig effectors. Effectors can be selected by clicking on the circular icons in the Character Controls > Figure Representation area, which also selects the elements in the scene.

The toolbar icons along the top of the Character Controls window provide easy access to common workflow tools.

- Full Body/Body Part Keying Mode and Manipulation
 - Full Body Mode will set key on all HumanIK Effectors when setting key. When in Full Body Mode, manipulation is also slightly different as the Full Body will reach when manipulating end effectors such as the hands and feet (see Fig. 12.2.4, first screen from left).

Note

Some animators may find Full Body Manipulation mode counterintuitive as elements are automatically being moved to stretch to the limb position. In these cases, you may prefer to consider Body Part Mode.

- Body Part Mode will set key only on the body part the effector is part of. For example, setting key on wrist effector will set key on the wrist, shoulder, and elbow elements only. The elements that are keyed in the current mode are highlighted with white outline in the Character Controls window as visual aid (see Fig. 12.2.4, second screen from left).

Note

When in Body Part Mode, the rig solving is slightly different with the IK only solving on the element. For example, translating the Wrist Effector will only modify the HumanIK Rig up to the shoulder; the rest of the rig will not reach as it would when in Full Body mode.

FIG 12.2.4 Character Controls window – toolbar toggles.

- Pin Translation/Pin Rotation
 - The small pin icons at the top right of the Character Controls window allow to quickly toggle on/off pinning for the currently selected effector (see Fig. 12.2.4, third screen from left – top).
 - In the main Character Controls window, the circular icons for the effector will update with TR icon to show whether or not pinning is enabled (see Fig. 12.2.4, third screen from left – bottom).

Note

Effector pinning as well as mode can also be switched from the right-click context menu in the Viewport (see Fig. 12.2.1).

- Show/Hide FK – IK – Skeleton
 The three toolbar icons at the top left allow you to toggle between the HumanIK elements that are visible in the Viewport (see Fig. 12.2.4, right screen).
 The red circular IK effectors can be toggled on/off as well as the yellow-stick-shaped FK effectors and underlying skeleton. Hiding the FK effectors is the most useful mode when animating with the IK rig.

HumanIK – Character Retargeting

One of the most powerful features in HumanIK is the ability to retarget animation data between HumanIK characters. Character skeletons first need to be characterized with HumanIK for this, and the system allows control over how the animation data is retargeted. Any standard bipedal character skeleton can be converted to HumanIK setup for retargeting.

- With the Baseball HumanIK setup scene still open, go to the File menu in Maya and choose – File > Import.
- From the Import dialog window, ensure that "Files of type = Maya ASCII" is set and Import the following Maya scene file from the Project directory – **12.2_02_HIK_ANIM_MOCAP_Walk02.ma**.

Playback the animation – The Imported file is one of the Maya Mocap samples (Walk02) setup with HumanIK. The character should import into the scene with walk animation with the character walking toward the baseball character (see Fig. 12.2.5, left screenshot)

- With the animation imported, open the Character Controls window, from – F2 > Skeleton > HumanIK > Character Controls.
- From the drop-down menu at the top of the Character Controls window, select the new character – _02_ HIK_ANIM_MOCAP_Walk02_HIK_MOCAP (see Fig. 12.2.5, top right screenshot).

Note

This drop-down menu is called the "Current Character" menu and allows you to select the currently working character within the scene through the Character Controls Window.

FIG 12.2.5 Importing walk animation and toggling current character.

- Select any of the effectors for the new character from the Character Controls Window.
 - The keys will be visible on the Time Slider for the effector. Each element on the Control Rig has a keyframe on every frame (at 60 fps).

Note

The data is dense because it has been transferred from motion capture data captured at a key per frame (see Fig. 12.2.5, middle right screenshot).

- From the Range Slider, set the end time of the animation and end time of playback to frame 488 from the numeric input fields (see Fig. 12.2.5, lower right screenshot).

Note

The full range of the animation is 488 frames (at 60 fps). Playback the animation (Alt + V) to view the full walk animation on the new character.

- From the Character Controls window, switch back to the baseball batter character from the "Current Character Menu" (see Fig. 12.2.6, top left screenshot). The Current Character should be listed as "HIK_BBALL02."
- Go to the Blue "Character menu button" at the top left of the Character Controls window and select – Source >_02_HIK_ANIM_MOCAP_Walk02_ HIK_MOCAP (see Fig. 12.2.6, bottom left screenshot).

Switching source to another HIK character in the scene activates retargeting. The baseball character no longer accepts input from its own control rig, instead it will appear to follow the walk animation of the imported character during playback (see Fig. 12.2.6, right Viewport screenshots).

FIG 12.2.6 Character source-switching to the animation retargeted from walk.

Scene file with the walk animation imported and retargeted onto the BBALL02 character with default settings is included with the project scene files as – **12.2_03_HIK_Retarget01_SourceInput.ma**.

- With the HIK_BBALL02 character set from the Current Character menu, select the small circular icon between the feet in the Figure Representation area.

This selects the Character Reference, which is a parent node that can be used to offset the overall animation (see **Fig. 12.2.7**, first screen).

The character reference is named – HIK_BBALL02_Ctrl_Reference.

- With the Character Reference selected, enable the Move tool (W) and move the reference locator from the default Origin position out to the side so that the character animation is offset, with both of the characters now side by side (see Fig. 12.2.7, screenshots on right).

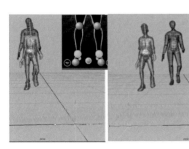

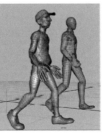

FIG 12.2.7 Offsetting the animation – "Ctrl_Reference" locator object.

- With the HIK_BBALL02 character still set from the Current Character menu, select the Blue "Character menu button" at the top left of the Character Controls window and choose – Character > Edit Properties (see **Fig. 12.2.8**, first screen from left).

- This will open the Attribute Editor, showing the properties for the current character.
- From the Attribute Editor, go to the "Retarget Specific" heading and turn on – Match Source = On (see Fig. 12.2.8, second screen from left).

The character will pop back to position (see Fig. 12.2.8, third screen from left). The Match Source option allows the character retarget to solve more closely to the actual position of the source animation in space. This allows us to work with the Reach settings in the next steps to match the wrist position.

FIG 12.2.8 Edit character properties – retarget specific and reach.

- Expand the "Reach" section from the Attribute Editor and set the following:
 - Left Wrist = 1.00
 - Right Wrist = 1.00

Setting Reach to 1.00 (100%) will force the effector to reach to the exact position of the source effector (see Fig. 12.2.8, fourth screen from left).

This option is commonly used when retargeting between similarly proportioned character rigs. For example, let's say you have source motion capture data where character will connect with hands or feet in exact positions in space (i.e., handshake between characters or picking up an object). When retargeting the animation, you will possibly need the new character to hit the exact same points in space with the hands and feet. For our data, this is not critical as the motion being retargeted is a walk, also this option is not appropriate as the proportions on the character are quite different, so setting this will cause the arms to reach unrealistically (see Fig. 12.2.8, fourth screen from left).

- Set the Reach back to 0.00 for both wrists and turn back Off the Match Source option (see Fig. 12.2.9, first screen from left). Alternately, reload the scene file – **12.2_03_HIK_Retarget01_SourceInput.ma**.
- From the Attribute Editor, set the following:
 - Retarget Specific > Hips Level Mode = User/Hips Level = –20.00.
 - This will offset the height of the hips on the retargeted motion (see Fig. 12.2.9, second screen from left).

- From the Attribute Editor, set the following:
 - Retarget Specific > Feet Spacing Mode = User/Feet Spacing = 10.00.
 - This will offset the spacing between the feet, with the feet spread out more on retarget (see Fig. 12.2.9, third screen from left).

FIG 12.2.9 Edit character properties – retarget specific options – offset motion.

Note that the rest of the motion still looks correct on the retargeted animation. Although the hip height and feet spacing have been offset, the foot position and IK still look correct and the rest of the motion is unaltered. The options available in the Character Properties allow the motion to be tweaked on retarget.

HumanIK – Retargeting Data to Control Rig – Bake to Rig and Cleanup after Retarget

When the Source is switched for character, the Retarget is live and can be tweaked as shown in the preceding section. There is no actual keyframe data on the character that is accepting the source input while the retarget is live. In fact, the Control Rig is deactivated, hidden from Viewport, and cannot be edited.

When retargeting animation data, some work can be done in tweaking the effect with the Character Property settings while the Source retarget is "live." Typically, additional work will be required after retarget to "massage" or edit the animation on the target character to get the results you need. In this section, we'll take a look at transferring the key data onto the target character for further edit.

- Reopen the original scene file with the retarget setup with default options – **12.2_03_HIK_Retarget01_SourceInput.ma** (see Fig. 12.2.10, first screen from left).
- Open the Outliner and click-drag with the left mouse button to select the following elements:
 - _02_HIK_ANIM_MOCAP_Walk02_HIIK_SkelLocator_MOCAP
 - _02_HIK_ANIM_MOCAP_Walk02_HIIK_SkelLocator_MOCAP
 - _02_HIK_ANIM_MOCAP_Walk02_MOCAP_MESH

487

- Go to Edit > Select Hierarchy – This will select all of the Mocap character hierarchy and control rig – the elements will highlight in green/white to show they're selected (see Fig. 12.2.10, second screen from left).
- Go to Display > Hide Selection – This hides the original Mocap character and rig so that only the retargeted character is visible in scene for edit (see Fig. 12.2.10, third screen from left).

FIG 12.2.10 Hiding the source character from view.

- From the current Character drop-down, make sure that the HIK_BBALL02 character is active (see **Fig. 12.2.11**, top screen).
- From the Character menu button, select Bake > Bake To Rig (see Fig. 12.2.11).

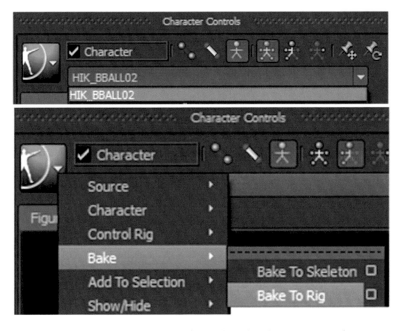

FIG 12.2.11 Character controls – bake to rig.

- From the Character Controls window, select the Character menu button and choose – Character Menu > Source.

From the Source menu, you should see that the Source has switched from the Mocap character back to the Original Control Rig for the HIK_BBALL02 character.

After Baking the retargeted animation across to the BBALL02 character, the source input is automatically switched back to the Control Rig (see **Fig. 12.2.12**). The Control Rig is now driving the animation as the key data has been transferred (or baked) if you select any of the control rig effectors, the keys will be visible from the Time Slider (see Fig. 12.2.12).

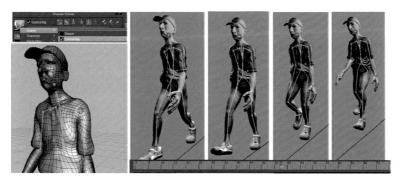

FIG **12.2.12** Retarget baked and control rig reactivated as source.

Scene file with the animation baked onto the BBALL02 character Control Rig for further edit is included with the project scene files as – **12.2_04_HIK_Retarget02_Bake_Rig.ma**.

Playback the baked animation. On Playback, we can see that there are some general edits that can be made to refine the animation. This can be considered as a first pass after the retarget to fix some issues. The elbows are too close into the body, and the hand poses look unnatural (as no finger animation was captured from the source animation [see **Fig. 12.2.13**, left Viewport screens]).

FIG **12.2.13** Viewing the retargeted animation and adding new animation layer for edit

We can use Maya's animation layers to make the edits. This will allow us to make overall edits to the posing on the rig. Using this in conjunction with the pinning features on the HumanIK Rig allows iterative edits to be made while retaining the overall animation from the source.

- From the Character Controls window, select the blue Character menu button and choose – Control Rig > Add to new animLayer (see Fig. 12.2.13, top right screenshot).

- This option adds all of the current character's Control Rig elements to a new animation layer for edit.
- Open the Channel Box/Layer Editor (Ctrl + A toggle).
- Select the Anim tab at the bottom to show the Anim layers.
- Double-click in the name section of the new animation layer to rename.
- Rename the new animation layer as – HIK_ARM_TWEAK (see Fig. 12.2.13, middle right screenshot).

When any of the Control Rig elements are selected, the animation layer will show a small green dot to identify that the layer is active (with current object in layer contents) (see Fig. 12.2.13, bottom right screenshot).

Editing Animation on Animation Layer with Effector Pinning – Elbow Posing

If we look at the retargeted and baked animation, the main issue is in the elbow positioning, which is far too close into the body. We can use the Anim layer to fix this. Although the elbow posing looks out, the hand position is roughly correct for the arm swing on the walk. To retain this during edit, use pinning, which will lock the wrists:

- From the Character Controls window – Figure Representation area, select the left wrist effector and then with Ctrl key depressed, select the right wrist effector to add to selection.

Note

Ctrl + left mouse button is used to add to selection in the Character Controls window, if selecting the elements from the Viewport use Shift + left mouse button to add to selection. The selection should update with the circular effector icon highlighted in the Character Controls window and the elements highlighted in white/green in the Viewport (see Fig. 12.2.14, left screenshot).

FIG 12.2.14 Selecting wrist effectors and enabling pinning.

With both wrist effectors selected, pinning can be enabled either from the right-click marking menu in the Viewport or from the icon in the Character Controls toolbar (see Fig. 12.2.14, middle screenshot).

- Enable "Pin Translate" for both the selected wrist effectors.
- After enabling Pin Translate for the effectors, a small "T" icon will display over the effector in the Viewport – this is also synced with display in the Character Controls – Figure Representation area (see Fig. 12.2.14, right screenshot).
- Scrub the Time Slider back to frame 0 and tumble around to view the character from the front (see Fig. 12.2.15, first screenshot from left) – make sure that the new Anim layer is selected and highlighted in blue to show that it is currently active.
- Select the left elbow effector, either from the Viewport or Character Controls window.
- Enable the Move tool (W) and pull the control effector out from the body slightly in X-axis so that the elbow pose looks more natural.

Note

The yellow FK effectors may not update immediately as the blue IK effector for the elbow is moved. This is normal and is a minor update issue during manipulation. The yellow FK effectors will update once the effector has been moved (see Fig. 12.2.15, second/third screenshot from left).

- Press the S shortcut key to key the elbow effector at frame 0.

Scrub the Time Slider or playback the edited animation (Alt + V). The elbow position looks more natural.

Note

You can compare the Anim layer edit to the original unedited animation by muting/unmuting the new animation layer. To do this, click the small "Stop sign" icon on the layer to mute/unmute the layer (see Fig. 12.2.15, fourth/fifth screenshots from left).

The edit made to the elbow position does not modify the wrist position as pinning was active during keying.

The edit to the elbow position is applied across the whole of the animation sequence. As the key offset was made at frame 00, the cumulative offset for the elbow is visible throughout all of the animation. This is as needed for this edit as we want to make an overall modification to the animation.

FIG 12.2.15 Keying left elbow offset on animation layer.

The same process can be used to make edit to the right elbow effector. As pinning is also active for the right wrist effector, the right elbow can be pulled out slightly so that the pose looks more natural. As before, make sure that the Time Slider is set at frame 00 and that the effector is posed then keyed at frame 00. Use the animation layer Mute feature to compare the layer edits on both elbows (see Fig. 12.2.16).

FIG 12.2.16 Comparison — layer offset — right and left elbows (middle/right screenshots — layer active).

If we look at the hand posing, we can see that the hand rotation looks slightly off. For example, the left wrist is rotated too far round as if the hand is open (see Fig. 12.2.17, blue wireframe-shaded screens). This is because of a combination of the offsets when editing the elbows and the source data not working correctly on the character.

This can be fixed easily by using same workflow as before to pose the wrists at frame 00 and set key on layer to offset the pose through the animation.

- Scrub the Time Slider to frame 00.
- Select each of the wrist effectors in turn and rotate round slightly in local X-axis so that the wrist is aligned better with the forearm. Set key after making each adjustment (S shortcut).

Note

When aligning these elements, orbit round to the front or back of the character to check the pose alignment with forearm (see Fig. 12.2.17, purple wireframe-shaded screens).

FIG 12.2.17 Offsetting wrist pose on animation layer — alignment.

The source Mocap skeleton, which the data has been retargeted and baked from, did not have any skeletons setup for the fingers. Motion Capture data is sometimes not captured for fingers which explains this, however, full body capture of fingers is becoming more common.

To work around this limitation in the data that's been captured, the fingers can be animated by hand as a separate animation layer pass. The process is not covered in detail in this section, but similar workflows to those used in Chapter 7.1 could be applied to the setup. For this example, we'll simply pose the fingers and set base keyframe at frame 00 on the layer so that the hands look more natural throughout the walk.

If we look at the hand posing, the fingers are outstretched throughout, which looks quite unnatural (see Fig. 12.2.18, shaded Viewport screens).

- From the Character Controls window > Figure Representation area, click on the small circular down arrow icon, which appears after the last arm effector, near the tips of the fingers in the window (see Fig. 12.2.18, second screen from left-top).
- The Figure Representation window will change to show the controls that are selectable for the fingers (see Fig. 12.2.18, second screen from left-bottom).
- Select all of the four finger FK effectors for the left hand, except for the thumb (the thin rectangular icons). Tip: To add to selection to select all four main fingers, use Ctrl+ to add selection.

Each of the effector icons will highlight in blue, and the finger FK controls will also highlight in the Viewport (see Fig. 12.2.18, third and fourth screen from left).

FIG 12.2.18 Character Controls window — finger controls and selection.

- Make sure that the Time Slider is scrubbed back to frame 00 and that the animation layer is set to HIK__ARM_TWEAK.
- With the Rotate tool active (E), rotate the four finger controls inward in local Z-axis to cusp the fingers more naturally (see Fig. 12.2.19, second screen from left).

Set key on the FK finger controls at frame 00 with S shortcut.

Note

For relaxed hand pose, the fingers from the middle finger through to pinky finger should be rotated or cusped in slightly more.

Select each FK effector element in turn and make any additional iterative adjustments as required before keying (see Fig. 12.2.19, third screen from left-textured and lit).

Repeat the process to pose the right-hand's fingers more naturally at frame 00 and set key (see Fig. 12.2.19, right screens – textured and lit).

The overall pose edit will apply throughout the animation to the finger pose as the key is adding offset across the sequence. Additional animation can be keyed on a separate layer to add further refinement.

FIG 12.2.19 Posing and keying the fingers on animation layer – relaxed finger pose.

If you look at the posing at frame 00 of the left wrist, the hand is raised quite high and the wrist is rotated updward. It looks like the character is gesturing off-screen, which looks unnatural (see Fig. 12.2.20, first screen from left). This can be resolved by pulling the wrist effector downward slightly and also rotating back at frame 00 then setting key (S shortcut) (see Fig. 12.2.20, second screen from left).

These types of global edits to the animation layer can occasionally push out the HumanIK Rig at other points in the animation (see Fig. 12.2.20, third screen from left).

To resolve this, either a zero-weighted key can be used before/after the edit or minor adjustment made to the effector pose. In the final example, additional key is added at frame 65 to push the wrist back up slightly, fixing the hyperextension on the arm (see Fig. 12.2.20, fourth screen from left).

Scene file with the animation layer edits made to the elbow posing, wrist pose and additional finger pose is included with the project scene files as – **12.2_05_HIK_Edit_01_Arm_Tweak.ma**.

FIG **12.2.20** Offset wrist pose at frame 00 and fix at frame 65.

Toggling on/off the animation layer can help to validate the animation edits and see where additional refinements can be made.

- In the unedited animation, the motion looked quite unnatural with the elbow's forced inward and hands out-stretched, as if the character was a zombie (see **Fig. 12.2.21**, pre-edited animation in blue wireframe screenshots).
- The edits for the arms, hands, and fingers make the character walk look a lot more natural and lifelike (see Fig. 12.2.21, edited animation shown in shaded/textured screenshots).

FIG **12.2.21** Comparing layer edits (pre-edits in flat-shaded/blue wireframe screenshots).

If you playback the full sequence (Alt + V), the motion fits the character reasonably well. Walk is a half-stumble across the ground with the character looking slightly fatigued. Between frames 60 and 110, the character pauses and then half lurches to the side on the left foot plant, as the body dips (see **Fig. 12.2.22**).

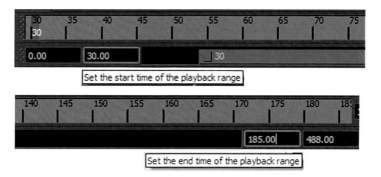

FIG 12.2.22 Previewing the edited retarget — stumble on walk.

For additional edits to the motion, we can focus on a specific frame range, including this section, this will help hone in on a specific area for edit.

Animation Edit – Exaggerated Walk – Dejected

When editing the motion, we can make slight adjustments in the posing to change the mood or feel of the walk. The source animation is a slow moving walk with a slight lurch. We can exaggerate the overall posing on the walk to turn the animation into more of a dejected or resigned walk animation. These types of edits to base animations are common in production when the animation has to be modified slightly to fit the needs of the project.

Within game animation, this process is commonly used to create derivative motions to fit different characters. Along with editing the posing, the timing can also be adjusted slightly to fit the mood. This phase of editing should normally be done after any cleanup phase once the base motion looks appropriate.

With the previous scene file open (**12.2_05_HIK_Edit_01_Arm_Tweak.ma**), go to the Range Slider at the bottom of the user interface and set the following:

- Set the start time of the playback range = 30.00 (see Fig. 12.2.23, top screenshot).
- Set the end time of the playback range = 185.00 (see Fig. 12.2.23, lower screenshot).

FIG 12.2.23 Changing playback range — start = 30.00/end = 185.00.

- Open the Channel Box/Layer Editor and go to the Anim layers tab.
- Click the "Create Empty Layer" icon at the top right (see Fig. 12.2.24, top left screenshot).

- Double-click on the new layer and rename as – HIK_EXAG_TORSO (see Fig. 12.2.24, lower left screenshot).
- Make sure that the new animation layer is highlighted in blue to show it's active and, from the Character Controls window (F2 > Skeleton > HumanIK > Character Controls), choose Character Menu > Control Rig > Add to Anim Layer: HIK_BALL_TORSO (see Fig. 12.2.24, right screenshot).

FIG 12.2.24 Adding new animation layer to exaggerate walk.

The frame range is set to the range that we're going to make the edit refinements on to the walk. The new layer will be used to make adjustments to the overall spine and neck posing to exaggerate the walk and create more of a dejected feel to the animation.

Note

When working with the animation layers (for HumanIK rigs and standard character rigs), you should keep the layers organized and named appropriately. It is also a good idea to separate out the edits onto separate layers. The source clean-up edits are on the first layer, with any subsequent layers above.

- With the new layer selected and active, scrub the Time Slider to the start playback frame (30.00).

We can see that the character is fairly upright at this pose, the spine is fairly straight at the start of the animation and remains pretty much solid throughout the walk (see Fig. 12.2.25, first screen from left).

We can exaggerate the mood of the character by making simple edit to the spine rotation to lean the character more forward.

- From the Character Controls main "Figure Representation" area (which has the icons and figure background), select the FK Spine control icon, the upright rectangular icon between the circular hips and chest icon (see Fig. 12.2.25, second screen from left).

The FK joints for the spine and upper torso should highlight in green in the Viewport to reflect the selection (see Fig. 12.2.25, third screen from left).

- Enable the Rotate tool (E) and rotate the upper torso forward slightly in local Z-axis to lean the character down (see Fig. 12.2.25, fourth screen from left).
- Press S shortcut to key the offset at frame 30.

Playback the animation, we can see that the offset changes the mood of the character a bit, the walk is exaggerated with him slumped forward, leaning into the walk. As with the previous layer edits, the offset applies across the whole walk (see Fig. 12.2.25, fifth screen from left).

FIG 12.2.25 Layer offset on torso rotation – dejected walk.

If you playback the animation with the layer offset, you'll notice that the neck rotation doesn't really match the angle of the spine (see Fig. 12.2.26, first screen from left).

When rotating the Spine FK controls, the rotation is propagated from the root downward (unless end IK effector is locked). The end elements may not rotate as much as needed.

An additional tweak can be added for the neck posing to fix this.

- Scrub the Time Slider back to frame 30 and make sure that the new animation layer is still active – HIK_EXAG_TORSO
- Go to the Character Controls > Figure Representation area and select the circular head effector at the end of the neck – both the circular icon and the effector in Viewport should highlight to show they're selected (see Fig. 12.2.26, second screen from left).
- With the Move tool active (W), pull the head effector forward slightly to angle the neck, and with Rotate tool (E), rotate the effector forward so that the head tilts downward slightly more, adding to the exaggerated dejected feel of the pose (see Fig. 12.2.26, third/fourth screen from left).
- Press S shortcut to key the offset on the layer at frame 30.

FIG 12.2.26 Layer offset on neck rotation – dejected walk.

If you playback the animation, you'll notice that there is an issue with the left arm extension at around frame 85 (see Fig. 12.2.27, first screen from left). This hyperextension on the arm is because of the edit made to the torso rotation

earlier. Rotating the torso forward has extended the distance from shoulder to wrist, causing the join to lock at extension.

This can be fixed easily by keying offset at this frame. First, a "Zero" key needs to be set before and after the edit.

- Scrub the Time Slider to frame 55 and, with the left wrist effector selected, press S shortcut to key on the layer (see Fig. 12.2.27, second screen from left).
- Scrub the Time Slider to frame 105 and, with the left wrist effector selected, press S shortcut to key on the layer (see Fig. 12.2.27, third screen from left).
- Scrub the Time Slider to frame 75 and, with the left wrist effector selected, pull it up slightly in Y-axis to fix the hyperextension (see Fig. 12.2.27, fourth and fifth screen from left). Press S shortcut to key on the layer.

FIG 12.2.27 Layer offset – fixing left arm hyperextension.

Scene file with the animation layer edits made to exaggerate the posing for the dejected walk is included with the project scene files as – **12.2_06_HIK_Edit_02_Torso_Exag.ma**.

Additional Edits 01 – Feet Drag

Additional edit refinements can be made to the animation using the layers. So far, the layer edits that have been made have largely been single edits that apply across the whole sequence. Specific frames of the animation can also be edited through an animation layer to change and exaggerate the timing of the animation to enhance the mood of the walk.

If we look at the edited walk animation (**12.2_06_HIK_Edit_02_Torso_Exag.ma**), the character looks fairly dejected with the torso and neck edits, we can enhance this by exaggerating the timing on the foot plants. By changing the timing & spacing on the walk, we can create the impression that the character is dragging his feet more, with the foot motion being less deliberate than the current normal timing in the scene.

- Open the Channel Box/Layer Editor (Ctrl + A) and from the Anim layers tab, add new empty layer. Name the layer – HIK_EXAG_FEETDRAG (see Fig. 12.2.28, left screen).
- Go to the Character Controls window and select Character Menu button > Control Rig > Add to Anim Layer: HIK_EXAG_FEETDRAG (see Fig. 12.2.28, right screen).

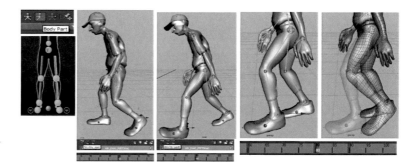

- From the Character Controls window, enable Body Parts Keying Mode (see Fig. 12.2.29, first screen from left).

We want to make an edit to the timing & spacing of the left foot step. From farme 60 to frame 90, the left foot lifts from ground, travels forward, and then reconnects with ground as the weight is transferred (see Fig. 12.2.29, second/third screens from left).

For the edit, we want to set a "Zero" key before and after the edit so that the rest of the animation is not modified (before and after frames 60 and 90, respectively).

- Select the left foot effector and scrub the Time Slider to frame 60.
- Ensure that the new layer is active and press the "Zero Key" shortcut button in the Anim layer window. Note: This is the small "Key" icon with 0 under it at the top left of the Anim layer window (see Fig. 12.2.29, second screen from left).
- With the left foot effector still selected, scrub the Time Slider to frame 90.
- Ensure that the new layer is active and press the "Zero Key" shortcut button in the Anim layer window (see Fig. 12.2.29, third screen from left).
- Scrub the Time Slider to frame 80 and, with the left foot effector selected, enable the Move tool and pull the foot back from the position it was at so that the foot has traveled less far forward at frame 80 (see Fig. 12.2.29, fourth screen from left before edit – fifth screen from left after edit).
- Press S shortcut to key the offset on the foot at frame 80.

If you playback the animation with the layer edit (Alt + V), the timing on the left foot step between frame 60 and frame 90 is quite different.

- Between frame 60 and frame 80, the foot travels a lot less than before and the motion is delayed – making the character look like he's dragging his heels in exaggerated walk (see Fig. 12.2.30, screenshots from right to left).
- Between frame 80 and frame 90, the spacing on the foot is opened more, causing the foot to accelerate into the step more (see Fig. 12.2.30, screenshots from right to left – final three screenshots on left).

There is quite a lot of contrast between the ease out at start and accelerate out as the foot plants. Further in-betweens could be added to smooth this out more or exaggerate the spacing.

FIG 12.2.30 Validating the timing & spacing – layer edit on the left foot (frames 60–90, right to left screens).

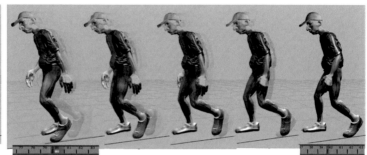

Similar edits can be made to the right foot step between frame 95 and frame 125 –

- Zero key set on layer at frame 95 – right foot effector (see Fig. 12.2.31, left screenshot).
- At frame 115, right foot effector pulled back slightly in Z-axis, key set on layer (see Fig. 12.2.31, middle screenshot).
- Zero key set on layer at frame 125 – right foot effector (see Fig. 12.2.31, left screenshot).

FIG 12.2.31 Timing/spacing edit – right foot plant (frame 95–125).

The final left foot step between frames 130 and 155 can have similar delay pose added to the foot on layer at frame 145 to finish the edits.

501

Scene file with the animation layer edits added to exaggerate the timing & spacing on the feet drags is included with the Project scene files as **12.2_07_HIK_Edit_03_FeetDrag_Exag.ma**.

Additional Edits 02 – Head Lull

If we look at the edited motion, we can see that the edits to the torso posing and timing on the foot drags add to the overall dejected mood of the character. Between frame 80 and frame 110, there is a natural dip in the body motion as the left foot plants (see **Fig. 12.2.32**). There is also a noticeable bob on the head at around frame 100 just after the left foot plants (see Fig. 12.2.32, textured screenshot).

FIG 12.2.32 Appraising the animation work (frame 90–110 – five-frame intervals).

We can exaggerate both of these motions slightly to emphasize the mood of the character. The head can sway slightly more from side to side to suggest despaired headshake, and the dip on the hips can be empahasized to make the foot falls more stompy or leaden.

Let's take a look at the head motion.

- Create a new animation layer, named – HIK_EXAG_HEADSINK (see **Fig. 12.2.33**, top left).
- Use the same workflow as before to add the Control Rig to the new layer (see Fig. 12.2.28, right screen).
- From the Character Controls window > Figure Representation area, select the head effector control (see Fig. 12.2.33, bottom left).
- The control can be both translated and rotated to either change the angle of the neck (through IK position) or rotate the head in all three X-axis (see Fig. 12.2.33, middle and right screens).

FIG 12.2.33 Adding new animation layer for the exaggerated head motion.

502

- With the head effector selected, scrub the Time Slider to frame 75, and on the new animation layer, set "Zero Key Layer" (see Fig. 12.2.34, left screenshot).
- Scrub the Time Slider to frame 85 – at this frame, the head has rotated slightly to the character's right shoulder, rotate the head round slightly more to exaggerate this so that the head rotates slightly more to the side and set key (S shortcut) (see Fig. 12.2.34, middle screenshot).
- Scrub the Time Slider to frame 95 and set Zero key to get the head back in original position. Then, rotate the head round slightly more toward the opposite left shoulder and rotate down toward the body and set key (S shortcut) (see Fig. 12.2.34, right screenshot).

FIG 12.2.34 Setting zero key and offset for head rotation on layer.

Playback the animation to validate the edits (Alt + V).

The head dip and sway from side to side is more pronounced, slightly exaggerating the posing at frames 85 and 95 changes the mood quite a bit (see Fig. 12.2.35, left to right screens). The sway looks more like a disconsolate shake of the head. Additional keys can be added at the end of the shot to keep the head locked downward and to the side after the major dip (see Fig. 12.2.35, right screens).

As the layer edit exaggeration has been layered on top of existing motion that is already there, it looks reasonably natural and fluid. The head swayed slightly from side to side in the original Mocap as the body shifted weight on the foot plants.

Analyzing the motion capture data for areas of motion that can be enhanced is critical in making edits, making layer edits to the motion that go against the existing motion can make the animation look unnatural or break the sense of weight in the animation.

When editing motion capture, it is critical to fully analyze and appraise the existing weight and timing & spacing on the motion.

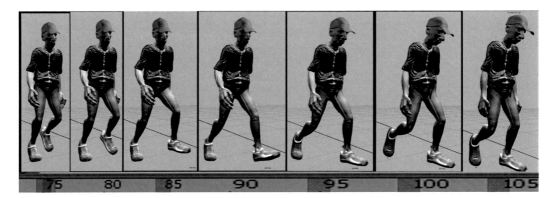

FIG 12.2.35 Appraising the layer edits for the head dip and sway.

Scene file with the animation layer edit added to exaggerate the head dip, and shake is included with the Project scene files as – **12.2_08_HIK_Edit_04_HeadLull_Exag.ma**.

When making layer edits to animation, it's important to consider how the edits tie together to enhance the animation. If we look at the edits made to the motion so far in the scene – **12.2_08_HIK_Edit_04_HeadLull_Exag.ma** – the head dip along with the feet drags look quite snappy and exaggerate the walk.

However, the overall walk timing & spacing still look a bit floaty – although the spine has been rotated forward to make the character look dejected – there isn't really any purpose to the foot falls, and he looks a bit as though he's gliding across the ground.

Further edits to the overall timing & spacing of the dip and raise of the hips can change the weighting on the character and exaggerate the mood further, giving the character more purpose and mass. These additional edits can also help to emphasize and enhance the mood created on the foot drags and head dips.

Additional Edits 03 – Hip Dip – Weight a Mass

- Create a new animation layer, named – HIK_EXAG_HIPSINK (see Fig. 12.2.36 top left).
- Use the same workflow as before to add the Control Rig to the new layer (see Fig. 12.2.28, right screen).
- From the Character Controls window > Figure Representation area, select the main hips effector control (see Fig. 12.2.36, bottom left screen).

The hips effector on the HIK Rig is the main centre of mass control, which moves the hip and torso around.

- Select each of the Wrist effectors from the Character Controls > Figure Representation area and turn OFF Translation/Rotation Pinning (see Fig. 12.2.36, second screen from left).

Note

Make sure that translation/rotation pinning is enabled for the foot effectors.

Test moving the hips effector up and down – this shifts the position of the upper torso and can be used to change the weighting on the foot falls. The arms will move with the upper torso when moving the hips effector as pinning is turned off. The feet should remain planted as pinning is still enabled for them (see Fig. 12.2.36, third and fourth screen from left).

FIG 12.2.36 Adding new animation layer, unpinning wrists and testing motion.

Note

Make sure that Full Body keying mode is enabled when making the following adjustments on the layer. There may be issues with the wrist pinning not being respected when keying the hips on the layer if body parts keying mode is used.

- Scrub the Time Slider to frame 50
 - At this frame, the left foot is slightly raised – about to plant on the ground and transfer the weight.
- With the hips effector selected, set "Zero-Key" on the new HIK_EXAG_HIPSINK animation layer.
 - The "Zero-Key" is set at this frame as it is preframe just before the edit we'll make (see Fig. 12.2.37, first screen from left).
- Scrub the Time Slider to frame 55
 - At this frame, the left foot is planted, and weight is beginning to shift downward.
- With the hips Effector selected, enable the Move tool (W) and pull the hips slightly downward in global Y-axis (see Fig. 12.2.37, second screen from left). Set key with S shortcut.

Note

The feet should remain locked because of pinning, with the hands following the movement of the hips as pinning is turned off.

- Scrub the Time Slider to frame 60
 - This frame is slightly after the foot first plants on ground – as with other areas of the animation, the weight shift will follow through on the leading motion. The hips should naturally dip a few frames after the foot first plants.
- With the hips effector selected, enable the Move tool (W) and pull the hips downward slightly further in global Y-axis (see Fig. 12.2.37, third screen from left). Set key with S shortcut.

Note

Pulling the hips down slightly further after the foot plant exaggerates the weight and mass on the character as he steps.

- Scrub the Time Slider to frame 70
 - This frame is a bit after the foot has planted. The hips should begin to rise at this frame as the weight transfers over the leg.
- With the hips effector selected, set "Zero-Key" on the new HIK_EXAG_ HIPSINK animation layer.
 - The "Zero-Key" set at this frame returns the hips posing to the original position based on the layer underneath (see Fig. 12.2.37, fourth screen from left). This raised position is in contrast to the exaggerated layer edit dip between frame 55 and frame 60 and adds a bit of exaggeration to the weighting on the foot plant and following rise.

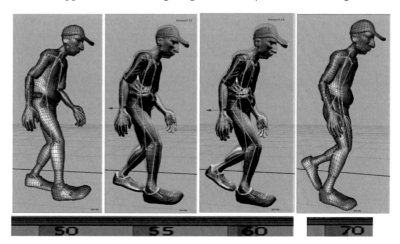

FIG 12.2.37 Offset on hips on Anim layer – hip dip at frame 55–60/zero key frame 50/70.

Similar edits can be made on the hip pose on same layer for the major foot falls throughout the animation. For example,

Left Foot Plant – frame 160–185.

- Frame 160 – Zero key on hips effector (pre-edit lock).
- Frame 165 – Hips keyed slightly down.
- Frame 170 – Hips keyed slightly further down (follow-through dip on step).
- Frame 185 – Zero key on hips effector (pre-edit lock).

More exaggerated edits for the hip dip can also be made at selected points in the animation. This can help break up the animation and add emphasis to the other edits that have been made for the motion.

For example, the head dip and shake layer edit (HIK_EXAG_HEADSINK) exaggerated the motion between frame 85 and frame 95 (see Fig. 12.2.34) the head dips noticeably at around frame 100 with the edit. The weight and mass on the character can be exaggerated by pushing the dip on the hips further down during this range, which will tie in nicely with the exaggerated head motion.

- Frame 85 – Hips keyed with zero key on HIK_EXAG_HIPSINK layer (see Fig. 12.2.38, first screen from right – locking pose pre-edit).
- Frame 95 – Hips pulled down slightly in the global Y-axis (around 5–6 in.). Key set on layer (S) to offset motion – this is beginning of hip weight shift on foot plant (see Fig. 12.2.38, second screen from right).
- Frame 100 – Hips pulled down further in the global Y-axis (around 8–10 in.). Key set on layer (S) to offset motion – this is the hip weight shift after foot plant – follow through (see Fig. 12.2.38, third screen from right).
- Frame 115 – Hips keyed with Zero key on HIK_EXAG_HIPSINK layer (see Fig. 12.2.38, first screen from left).

Note

The end Zero key is set a bit after the final edit (frame 115). This gives slightly longer between the exaggerated edit (100) and return to the previous pose. This smooths out the transition a bit.

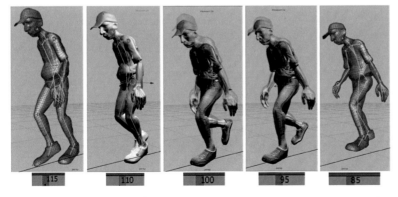

FIG 12.2.38 Exaggerated offset on hips on Anim layer – hip dip at frame 95–100/zero key frame 85/115.

Other areas where the hip dip can be exaggerated on the foot falls include the following frame ranges:

Left Foot Plant – Frame 20–35
Right Foot Plant – Frame 125–150

Scene file with the animation layer edit added to exaggerate the weight shift on the hips is included with the Project scene files as – **12.2_09_HIK_Edit_05_HipSink_Exag.ma**.

Chapter 12.3 Exaggeration – Dynamics Explosion

Dynamics – Scaffolding Setup Part 1 – Scene Setup

- Open the Start scene file for this section from the Project scene files directory – **12.3_01_Dynamic_Scaffolding1.ma**.

The scene file is based on the Dynamics rocket smash we worked with in Chapter 8.2 (see Fig. 12.3.1, right screen). The setup we'll look at in this chapter includes a number of additional elements, which will be set up to add additional emphasis to the Dynamics sequence through exaggerated secondary animation, overlap, and follow-through.

The first setup we'll look at is the additional collapsible scaffolding, which will exaggerate the rocket penetration on the tower building at the start of the sequence (see Fig. 12.3.1, left screen).

FIG **12.3.1** Scene setup – additional scaffolding model (left screen).

The simulated wall and building smash we worked on in Chapter 8.2 has been baked to the objects. Baking simulation improves performance as the dynamics are no longer evaluated on playback. This is fine when working on segmented animation where the elements do not need to interact. The process to bake the animation is fairly straightforward. The simulation is cached to memory, and then the selected elements are baked from – Edit > Keys > Bake Simulation. After baking, the objects have a keyframe on every frame, and the Rigid Body elements can be deleted from the Outliner (see Fig. 12.3.2).

FIG **12.3.2** Baked dynamics – wall and building smash.

Basic Rigid Bodies Setup – Collapsible Scaffolding

Let's take a look at the basic setup for the collapsible scaffolding in the scene.

Similar to the breakable wall we worked on in the initial setup in Chapter 8.2, the scaffolding is made from a number of separate parts. For the simulation, the decision was made that only a section of the scaffolding nearest to the top of the building would be collapsible. Therefore, the scaffolding ladders and main body of the scaffolding are made from single parts that are set up as Passive Rigid Bodies. These elements are grouped in the Outliner as UNDYN_SCAFF_02 – this is the scaffolding ladders (see Fig. 12.3.3, middle screen).

UNDYN_SCAFF_01 – this is the main body of the scaffolding model (see Fig. 12.3.3, right screen).

FIG 12.3.3 Scaffolding – passive rigid bodies.

From the setup we have already seen in Chapter 8.2, Passive Rigid Bodies are static and do not react to fields or forces in the scene.

Conversely, the scaffolding elements that are separate model parts that are set up to collapse during the simulation are Active Rigid Bodies (see Fig. 12.3.4).

These elements are grouped in the Outliner as DYN_SCAFF_01 (see Fig. 12.3.4, first and second screens from left).

The model sections vary in size to give the simulation some variety.

- On some sections, the scaffolding poles are connected to the platforms as single breakable piece (see Fig. 12.3.4, third screen from left).
- Other parts are single scaffolding platform or connected part (see Fig. 12.3.4, fourth screen from left).

FIG 12.3.4 Scaffolding – active rigid bodies (breakable elements).

- Playback the simulation to preview the cached, unrefined simulation (Alt + V).

Note

Do not worry about interpenetrations between the baked elements or glitches during playback of the unrefined simulation. The simulation can be re-cached as in the final example provided later in the tutorial.

At the initial phase of the simulation:

- The rocket still connects with the tower block balcony at the start (see **Fig. 12.3.5**, left screen).
- Instead of flying away from the building (as it did in the setup in Chapter 8.2), the balcony part now collides with the scaffolding elements – pushing the parts nearest to the balcony away quickly during the collision (see Fig. 12.3.5, middle screen).
- The rocket continues through the scaffolding, knocking away the platform part nearest to the edge (see Fig. 12.3.5, right screen).

FIG 12.3.5 Rocket collision – initial impact.

After the initial collision of the Rocket > Balcony > Scaffolding (see **Fig. 12.3.6**, first screen from left):

- The main scaffolding parts at the top right side fly away (see Fig. 12.3.6, second screen from left).
- After this initial collision, the underlying parts begin to fall (see Fig. 12.3.6, third screen from left).
- The two separate platform parts at the top left fall toward the ground (see Fig. 12.3.6, third/fourth screens from left).

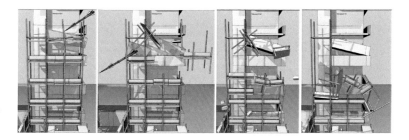

FIG 12.3.6 Rocket collision – initial impact to scaffolding collapse.

Planning in breaking up the model parts for the simulation is critical in getting a decent effect during the first pass of the animation.

Dynamics – Scaffolding Setup Part 2 – Rigid Bodies – Hinge Constraint

Although the effect looks alright, the dynamics simulation can be enhanced. For scaffolding, the separate elements would be interconnected; the parts should break away together or more gradually during the simulation to create something more convincing.

Fortunately, Maya has additional controls that allow you to create constraints or connections between the rigid body elements. Let's take a look at the setup on a simple example scene:

- Open the start scene file for this section from the Project scene files directory – **12.3_02_Dynamic_Scaff_Hinge1.ma**.
- From the Outliner or Perspective view, select the Cube object named – Hinge1 (see Fig. 12.3.7, first screen from left).
- From the Dynamics menu set (F5), go to the "Soft/Rigid Bodies" menu and, with the Cube object still selected, choose Soft/Rigid Bodies > Create Active Rigid Body.
- With the Cube object still selected, go to the "Fields" menu and choose Fields > Gravity.
- With the Cube object still selected, go to the "Soft/Rigid Bodies" menu and choose Soft/Rigid Bodies > Create Hinge Constraint.

A new Hinge Constraint will be created for the object – the Hinge Constraint should be listed as "rigidHingeConstraint1" in the Outliner. The Hinge Constraint is visible as a small green line icon, which by default is placed at the rigid bodies center of mass (see Fig. 12.3.7, second screen from left).

The Hinge Constraint effectively acts as a pivot point for the rigid body, allowing it to swing around the position.

- With the new Hinge Constraint selected ("rigidHingeConstraint1"), enable the Move tool (W) and pull the hinge out to the long side of the Cube (see Fig. 12.3.7, third screen from left).
- With the new Hinge Constraint still selected ("rigidHingeConstraint1"), open the Attribute Editor (Ctrl + A) and set the following from the "Rigid Constraint Attributes" roll-out –
 - Initial Orientation – X = 0.00/Y = 90.00/Z = 0.00 (see Fig. 12.3.7, third screen from left).

FIG 12.3.7 Active rigid body, gravity field, and hinge constraint.

511

Changing the Initial Orientation so that the Constraint is rotated 90° around Y-axis changes the Constraint pivot so that it is aligned with the long side of the cube.

- Playback the simulation (Alt + V).

The Cube swings downward toward the ground due to the Gravity Field and Active Rigid Body, the Hinge Constraint "pins" the cube in space and causes it to swing around the pivot point.

In the last example, the Hinge Constraint was applied between the Rigid Body object and "World Space." This is because no other Rigid Body elements were selected when creating the Constraint. Rigid Body Constraints can also be applied between Active and Passive Rigid Bodies:

- From the Outliner or Perspective View, select the T-shaped cube object named – "Hinge2_Pass" and from the Soft/Rigid Bodies menu, choose Soft/Rigid Bodies > Create Passive Rigid Body (see **Fig. 12.3.8**, first screen from left).
- From the Outliner or Perspective View, select the rectangular cube object named – "Hinge2_Act" and from the Soft/Rigid Bodies menu choose Soft/Rigid Bodies > Create Active Rigid Body (see Fig. 12.3.8, second screen from left).
- With the rectangular cube object named – "Hinge2_Act" still selected, open the Dynamic Relationships Editor (from Window > Relationship Ediors) and select gravityField1 from the right pane to add the object to the Gravity Field (see Fig. 12.3.8, third screen from left).

FIG 12.3.8 Passive rigid body and new active rigid body added to gravity field.

- Select both objects ("Hinge2_Pass"/"Hinge2_Act") and create a new Hinge Constraint from Soft/Rigid Bodies > Create Hinge Constraint (see Fig. 12.3.9, first screen from left).

The new Hinge Constraint is created between both objects. The position for the Constraint is set as the midpoint between the Center of Mass on both Rigid Bodies. A small green line can be seen connecting both objects (see **Fig. 12.3.9**, second screen from left).

- Select the new Hinge Constraint (named – "rigidHingeConstraint2") and with the Move tool (W) pull the constraint icon in nearer toward the edge point where both the objects meet (see Fig. 12.3.9, third screen from left).

FIG 12.3.9 Hinge constraint – connecting passive and active rigid bodies.

- Playback the simulation (Alt + V).

As in the previous example, the Active Rigid Body falls due to gravity but pivots around the Hinge Constraint position (see Fig. 12.3.9, fourth screen from left). The Active Rigid Body also connects with the passive part and collides convincingly – the Mass and Bounciness of the Active Rigid Body can be modified to change the effect.

As we saw earlier in Chapter 8.2, Passive Rigid Bodies can be animated by hand-keying.

Connecting Passive to Active Rigid Bodies through the Hinge or other Rigid Body Constraints can allow you to create automatic connected or follow-through motion that wouldn't otherwise be possible:

- Dolly out in the scene so that the five cube-shaped objects in a row and sphere object are visible.
- With Shift + LMB, select both the cubes at either end of the chain (named pCube8/pCube2).
- From the Soft/Rigid Bodies menu, choose Soft/Rigid Bodies > Create Passive Rigid Body (see Fig. 12.3.10, top left screen).
- Use Marquee select or Shift + LMB to select the three cube-shaped objects and sphere in the middle of the chain (named pCube6/pCube6/pCube7/pSphere1).
- From the Soft/Rigid Bodies menu, choose Soft/Rigid Bodies > Create Active Rigid Body (see Fig. 12.3.10, bottom left screen).
- With the three cube-shaped objects and sphere in the middle of the chain still selected (named pCube6/pCube6/pCube7/pSphere1), go to the Dynamics Relationships Editor and add them to the Gravity Field (named gravityField1) (see Fig. 12.3.10, top right screen)
- Multiselect each of the following cube links in the chain in turn and then choose Soft/Rigid Bodies > Create Hinge Constraint to create hinge cosntraint link between each.
 - pCube8 + pCube7 – Create Hinge Constraint
 - pCube7+ pCube6 – Create Hinge Constraint
 - pCube6+ pCube3 – Create Hinge Constraint
 - pCube3+ pCube2 – Create Hinge Constraint

The four new Hinge Constraints should be visible from the Outliner (see Fig. 12.3.10, bottom right screen).

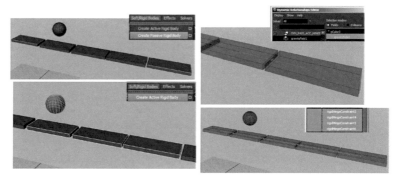

FIG 12.3.10 Hinge constraint – active rigid bodies connected in chain.

- Playback the simulation (Alt + V).
 - The two passive Rigid Body cubes at either end of the Hinge Constraint linked chain keep the chain locked in place during playback (see Fig. 12.3.11, top screen).
 - The passive Rigid Body cube (named pCube8) at the right-hand side has been animated moving inward.

Note

Passive Rigid bodies can be hand-keyed and Active Rigid Bodies cannot (unless baked), this is because Active Rigid Bodies react to forces in the scene.

- As the Passive Rigid Body cube moves inward, the Hinge-Connected Active Rigid Bodies in the midsection change their position and sag in the middle, reacting to the forces of gravity.
- The Active Rigid Body sphere drops and rolls along the cubes as they are also evaluated as part of the simulation (see Fig. 12.3.11, lower screen).

Scene file with the three different Hinge Constraint setups is included with the Project Scene files as – **12.3_02_Dynamic_Scaff_Hinge2.ma**.

FIG 12.3.11 Hinge constraint – connecting passive and active rigid bodies.

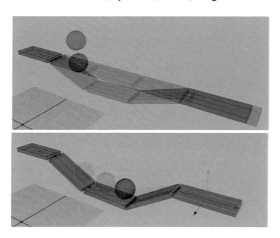

As we can see, the Hinge Constraint for Rigid Bodies is fairly flexible and allows the user to make a variety of different connections between both Passive and Active Rigid Body elements.

- Passive Rigid Bodies with Hinge-Connected Active Rigid Bodies can be hand-keyed to create effect.
- Active rigid bodies can be connected together to create chains.
- Using the settings for the Initial Orientation on the Hinge Constraint allows control over the direction of the hinge pivot.
- The effect of the Hinge Constraint can be further refined through the Attributes that are accessible from the Channel Box and Attribute Editor (after selecting the Hinge Constraint).
- The setting for the rigid bodies mass and other attributes, along with the forces and fields in the scene, allow further control over how the connected elements will act and react to other elements in the setup.

Dynamics – Scaffolding Setup
Part 3 – Hinge-Connected Elements

The setup we've looked at with the Rigid Body Hinge Constraint can be applied to the final scene setup with the collapsible scaffolding.

- Open the modified scene file from the Project scene files directory to see how the Hinge Constraints have been used in the setup – **12.3_03_Dynamic_Scaffolding_Final.ma**.
- Playback the Cached simulation (see **Fig. 12.3.12**).
 - The three main scaffolding elements at the top right-hand side of the scaffolding assembly are connected with Hinge Constraints.
 - The Hinge Constraints have been placed at the connecting points on the scaffolding poles between the models. The connection between the elements can be seen through the thin line connection between each elements centre of mass (see Fig. 12.3.12, left screen).
 - As the elements are Active Rigid Bodies, they react to the collisions and gravity field in the scene and break away (see Fig. 12.3.12, screens on right).
 - As they are connected with the hinge constraints, they break away convincingly with connection at the poles (see Fig. 12.3.12, screens on right).

FIG 12.3.12 Hinge constraint – connected scaffolding (active rigid bodies).

For the scaffolding platforms visible from the front left of the assembly (see Fig. 12.3.13),

- Hinge constraint has been placed at the left side (at the pole intersections).
- On playback, each of the platforms collapses convincingly (see Fig. 12.3.13, left to right).
- The attributes for the rigid bodies have been modified to change the effect.
 Mass – Increased to make the platforms heavier as they fall.
 Bounciness – Reduced so that the platforms appear less bouncy as they drop and intersect.

FIG 12.3.13 Hinge constraint – connected collapsible scaffolding platforms (active rigid bodies).

Dynamics – Roof Smash – Fields

The collapsible scaffolding that's been added to the scene adds a lot to the simulation. As the elements break away after the initial collision with the tower block platform, there is now a lot of exaggerated follow-through and overlap in the animation. This could be considered as secondary or supporting animation for the main impact of the rocket on the wall and building that follow. For the rocket impact, we can look at adding further breakable elements to the rigid body simulation to exaggerate the end of the sequence.

- Open the start scene file for this section from the Project scene files directory – **12.3_04_Dynamic_RoofBlast_Field1.ma**.

The scene file includes the roof geometry from the main compound building (see Fig. 12.3.14).

- The main roof section (named UNDYN_ROOF2) is a Passive Rigid Body.
- The breakable sections in the middle (grouped as __DYN_ROOF2) are Active Rigid Bodies.
- The Active Rigid Body sections are keyed going from Passive-to-Active at frame 55. Therefore, they do not react to the Gravity Field or the other forces/fields in the scene until after frame 55 (see Fig. 12.3.14, right screen).

FIG 12.3.14 Roof smash – passive/ active rigid bodies.

- From the Outliner, select the group named – __DYN_ROOF2 (see Fig. 12.3.15, top left screen).
- With the Group selected, go to the Edit menu at the top of the Maya UI and select – Edit > Select Hierarchy (this selects all of the separate elements that will be added to the field in the next step) (see Fig. 12.3.15, left screen).
- With the elements still selected and Dynamics menu set active (F5), go to the Fields menu at the top of the UI and select – Fields > Uniform (see Fig. 12.3.15, middle screen).

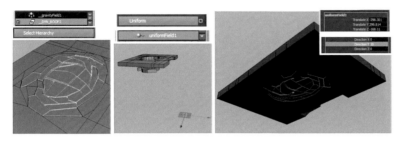

FIG 12.3.15 Roof smash – adding uniform field to scene.

A new Uniform Field is added to the scene. As with the Gravity Field we worked with in Chapter 8.2 (that's also used in this setup scene), the Uniform Field is applied to the selected objects on creation. The connection can also be managed through the Dynamics Relationship editor.

The new Uniform Field is named as uniformField1 and is visible from the Outliner and perspective Viewport. By default, the new field is created at the origin (X = 0/Y = 0/Z = 0) (see Fig. 12.3.15, middle screen).

- With the Uniform Field selected, enable the Move tool (W) and move the field so that it is placed just underneath the breakable roof elements (see Fig. 12.3.15, right screen). You can also position this using the following numeric values for Translation in Channel Box –
 - Translate X = −298.301/Y = 298.814/Z = −168.11 (see Fig. 12.3.15, right screen).
- With the new Uniform Field still selected, open the Channel Box and set the following:
 - Direction X = 0
 - Direction Y = 10 (see Fig. 12.3.15, right screen).

Note

The default setting for the Uniform Field direction is Direction X = 1 with Y and Z direction set to 0. By default, the field will exert force to the side along the positive X-axis with this setting.

- Remember that the Gravity Field has Direction Y = −1, which exerts force downward in negative Y-axis (as gravity does).

517

- The Uniform Field is essentially the same as the Gravity Field except Gravity Field by default has the direction set to force objects downward (in Y-axis). The Uniform field applies a Uniform force or field on the scene objects
- Setting our field to exert force in +Y direction will force the Active Rigid Bodies upward, which is what we want for the roof smash simulation.
- With the Uniform Field still selected, set the following from the Channel Box.
 - Attenuation = 0.1 (see Fig. 12.3.16, left screen).
- With the Uniform Field still selected, set the following value for Magnitude from the Channel Box at each frame and then right-click on the channel and choose Key-Selected.
 - Frame 55 – Magnitude 0 – Key Selected (see Fig. 12.3.16, left screen).
 - Frame 59 – Magnitude 500 – Key Selected (see Fig. 12.3.16, left screen).
 - Frame 64 – Magnitude 0 – Key Selected (see Fig. 12.3.16, left screen).

Note

If you check each of the breakable roof elements, you'll notice that the Mass attribute for the Rigid Body is set to different values for the pieces. This is so that the elements will break away differently when the Uniform Field is active (see Fig. 12.3.16, right screen).

- Open the Rigid Body Solver Attributes window (from Dynamics menu (F5) > Solvers >).
- From the Rigid Solver Attributes window, expand the Rigid Solver States section, ensure that Cache Data is enabled and press "Delete" to delete the existing cache (see Fig. 12.3.16, middle screen).

FIG 12.3.16 Roof smash – setting attenuation/keying magnitude and caching simulation.

- Make sure that Playback Speed = Play Every Frame (from Animation Preferences) and playback the cached simulation (Alt + V – see Fig. 12.3.17).
 - The separate Active Rigid Body elements for the roof are blown away from the roof.
 - They are blown upward as the Uniform Field has Direction Y = +10.
 - The effect doesn't start until after frame 55 as the Magnitude attribute for the Field was keyed.

- The effect of the Uniform Field stops after frame 64 (as Magnitude keyed at 0), and the objects aren't pushed up any further but begin to drop to the ground due to the Gravity Field in scene.

FIG **12.3.17** Roof smash – playing back the cached simulation (uniform field).

Although the effect looks alright, it looks a bit, well, uniform. The different Mass setting for the elements and low attenuation forces the elements upward from the middle, which looks convincing, but they all move straight up due to the Uniform field. The effect can be broken up a bit using another Field influence:

- Select the separate elements using the previous workflow (see Fig. 12.3.15, left screen).
- With the elements selected, go to – Dynamics (F5) Fields > Turbulence.

A new Turbulence Field will be added to the scene, listed as turbulenceField1 in the Outliner and visible at the origin.

- Move the Turbulence Field up above the breakable roof objects so that they pass through the field during the simulation (see Fig. 12.3.18, left screen).
- With the Turbulence Field selected, test modifying the Magnitude attributed from the Channel Box (to around 1000 to 2000, re-cache the simulation (see Fig. 12.3.16, middle screen) and then playback to validate the effect (see Fig. 12.3.18, middle and right screens).

FIG **12.3.18** Roof smash – uniform and turbulence field and modified magnitude.

Scene file with the breakable roof elements setup with the Uniform and Turbulence Fields is included with the Project Scene files as –
12.3_04_Dynamic_RoofBlast_Field2.ma.

Viewing the Additional Simulated Effects in Combination

As mentioned at the start of this tutorial, dividing up or baking selected parts of your dynamics simulation can help to improve performance while working. As we've seen with the hinge scaffolding setup and breakable roof, working on isolated elements for the simulation can also make things clearer and more focused when testing out the components that are going together to make up the final shot. For the final shot, the breakable roof rocket smash has been merged into the scene using Maya's File > Import functionality. File Referencing could also be used to reference in external baked elements that make up the shot.

Note

If merging in elements that have not been prebaked, you may find that you end up with duplicate fields such as the Gravity Field that are acting on separate elements. If this is an issue, use the Dynamics Relationships Editor to establish the correct connections between the Fields or Emitters that are set up in the scene.

Let's take a look at the final scene setup with the breakable scaffolding and smashed roof elements added to the original setup.

- Open the finalized scene file from the Project scene files directory – **12.3_05_Dynamic_Scaffolding_RoofBlast_Final.ma** (see Fig. 12.3.19).

FIG 12.3.19 Rocket smash – finalized rigid bodies simulation.

Note

Viewport 2.0 along with multisample antialiasing and DOF for the perspective camera is enabled in the screenshot.

- Playback the cached simulation (Alt + V) for the scene to see how the additional elements that have been added to the scene help exaggerate and reinforce the action.

Follow-Through and Overlapping Action

The additional elements that have been added to the simulation create exaggerated follow-through and overlapping action to the animation. The additional elements collapse, collide, and blow up at different phases of the animation (see Fig. 12.3.20/21, right to left screens).

1. The scaffolding breaks away in sections after the initial rocket collision at the start of the animation. The motion overlaps and follows-through.
2. The wall section breaks away next, then the main compound wall.
3. The Roof section explodes upward last, there is a slight pause to create exaggerated anticipation of this (the field was keyed at frame 59 to act on the scene).
4. Each part of the simulation overlaps with the other, as one collision is at midpoint or fading, the next part starts. This creates additional interest when watching the motion.

FIG 12.3.20 Overlap and follow-through – scaffolding collapse.

FIG 12.3.21 Overlap and follow-through – walls smash to compound and roof smash.

Secondary Action and Exaggeration

The sheer number of elements that have been added to the simulation really exaggerates the action (see Fig. 12.3.22/23, left to right screens).

1. Elements such as the collapsible scaffolding could be classified as secondary or tertiary to the main rocket smash on the building.
2. A large number of smaller bricks that smash away from the wall are secondary to the main wall smash and roof explosion.
3. The roof explosion is exaggerated, with larger breakable elements flying into the air.
4. The timing on the animation has been exaggerated slightly, small pre-lead-in has been added by framing the animation from frame −100 to frame 00 – this creates exaggerated anticipation, the slight pause before the roof explodes also adds anticipation to the main motion.

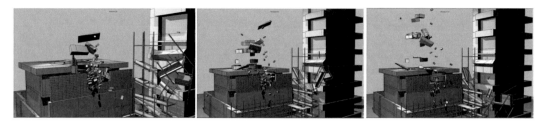

FIG 12.3.22 Secondary, supporting action – scaffolding collapse and brick smash.

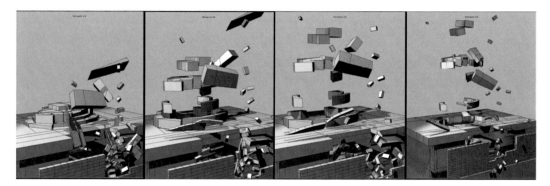

FIG 12.3.23 Exaggerated rocket smash – larger breakable roof elements.

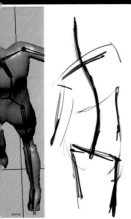

Conclusion

Chapter 13.1 – Recap – The Principles and Application

As we've seen throughout this book, the traditional principles of animation have a broad application within computer animation in Maya.

These principles are fundamental to a number of different areas including both creative and technical applications.

Pre-visualization, Scene Layout, and Revision

Creative usage of traditional media for animation reference and revision is a fundamental that can be applied throughout animation practice when applying the 12 fundamental principles. Using solid drawing to plan how the character should be posed through thumbnails is key, as is knowing how to effectively stage your animation sequence through storyboarding or shot layout.

As we've seen, traditional media should also be utilized throughout animation practice when analyzing where revisions can be made to the animation. In Chapter 12, we saw how effective thumbnails helped in planning the revisions that needed to be made to exaggerate the character posing, so the baseball

swing had more impact through increased anticipation, follow-through, and better contrast in timing & spacing.

Character Animation

The traditional principles of animation are a fundamental for all character animators working in Maya. As we've seen throughout this book, understanding the fundamentals of timing & spacing and how to effectively apply the other principles including, for example, ease in & ease out or anticipation together, are necessary to create believable character animation. Believability in animation can only be created through a thorough understanding of how the principles can be applied to effectively represent mass, weight, gravity, and natural locomotion from the real world.

For character performance, general principles including staging, solid drawing, anticipation, and exaggeration are also a necessity to create compelling performance for the viewer alongside emotional resonance or appeal. Being able to analyze both exactly where the principles should be applied and how they can be used in conjunction effectively for character animation is something that only the best animators are capable of.

Dynamics and Simulation

For animators and technical artists working specifically in dynamics and simulation, an understanding of the fundamentals of how things should move and interact from the original principles are a key element in creating believable results for the viewer. As we've seen in the chapters, the ability to enhance your animations through dynamics and simulation adds a lot to the overall appeal in the animation. Traditional principles, including adding secondary animation elements as well as follow through with dynamic elements that interact believably with scene elements, have been demonstrated throughout.

Although VFX and dynamics are an increasingly specialized area of computer animation, an understanding of the technical application of dynamics and simulation in Maya is critical for all animators, even those specifically focused on character animation. For animators working specifically as VFX Technical Directors, an understanding of the traditional principles is useful as a device to understand how to effectively direct performance in the VFX shot through understanding of theatrical principles including staging, anticipation, and exaggeration.

Chapter 13.2 – Industry Trends Moving Forward

In recent years, a number of trends have been seen within the computer animation industry. Although a solid grounding in animation and traditional practice is expected across production, both the technical and creative specializations are constantly evolving as the industry grows.

Industry Specialization

As audience expectation increases with each new film or game release, both the technical complexity of film and game animation as well as the quality required by the animation or VFX artist is ramped up. The size of production crews required for film and game animation has increased exponentially over the past 10 years. Because of the expected increase in quality and practical increase in budgets and team sizes, production skills are becoming increasingly specialized within the industry.

Previously, roles within the industry were more generalized, with an animator being expected to work on a number of different areas of production with broad technical knowledge. Within film or game production, different roles and specialization can now include a multitude of different positions, both technical and creative as well as managerial – Character Rigger TD, Visual Effects Supervisor, VFX Artist, Technical Director or Technical Animator, Animation Director, Character Animator, Facial Animator, Motion Capture (Motion Edit/Capture).

Digital Pre-visualization

Computer graphics are becoming increasingly important in pre-visualization for film. This extends across CG features, visual effects, and live action features. The ability to accurately pre-visualize shot framing, story flow, character, and set interaction is critical in allowing the director and production crew to get an early feel for how the shots will work in terms of the overall production and what changes are required.

Pre-visualization is a key tool used in production planning that is analogous to animatics, which we looked at in the online Chapter 5.2. Pre-visualizing which elements, both physical and digital, will be required in a particular shot is important as it allows the production team to plan what the complexity and cost will be at each stage.

Virtual Cinematography and Performance Capture

Increasingly, motion capture is being used in film and video games as a means to accurately capture performance. In film, the recent trend has been toward full-body performance capture to capture increasingly detailed performances, which are translating into ever more believable characters in the feature.

For film and game, real-time performance capture is also being utilized onset by the director to direct the performance and visualize how the performance will translate onto the CG character. Recent examples of this include the *Pirates of the Caribbean* features, which captured performance onset for the Davey Jones character. This allowed the actor to perform onset with the other actors as normal as the body and facial motion was captured, with the digital enhancements being made to the capture later in postproduction. For *Avatar*,

performance was captured from the actor on the motion capture stage, with the director able to direct and pre-visualize the final action through real-time camera capture as well as real-time mapping of the motion to CG model in Autodesk MotionBuilder.

Performance capture is also increasingly being utilized for facial and full-body capture (fingers and other appendages); a number of different technologies including traditional marker capture as well as capture from scan of the face are being employed. Recently released titles such as the *LA Noire* video game have pushed the level of quality in facial performance capture producing far more nuanced results that are more immersive and engaging for the viewer.

Although a range of technical skills and technologies are required for virtual cinematography and performance capture, traditional skills are required to direct the performance and map and edit the capture performance to get great results on the final character model.

Video Games – Real-Time Animation and Run-Time Blending

The tools available to animators working within video game development are becoming increasingly complex and nuanced, delivering better character performance and gameplay to gamers. Increased interoperability between software has improved production workflows for animators working with Motion capture data for game across MotionBuilder, Maya, and 3ds Max.

In addition to the multitude of in-house tools that the majority of Game Development studios use for animation in production, a number of full production tools as well as application and run-time solutions for game animation have sprung up in the past few years.

Autodesk HumanIK/Natural Motion Endorphin

- Middleware solutions such as Autodesk's HumanIK allow studios to implement real-time IK for characters in game. This increases believability in the gameplay as characters are able to connect realistically with static objects as well as interactive elements when the player is moving the character through the environment. For example, in a game, a character can now grab a specific ledge on a wall to pull themselves up from without the need for the animation to be pre-calculated or baked on the character, this is because the IK for the hand is able to connect with the ledge in real time in the game using the HumanIK middleware solution. Natural Motion's Endorphin solution allows animators to create virtual stuntmen that react convincingly to physics and dynamics in-game, this allows for more believable and compelling gameplay for the player.

Run-Time Animation Authoring

- Modern game engines have increased in both the complexity of the number of different animation clips in the game as well as in how the animation clips are combined together or authored by the artist for game. The increase in complexity in production as well as the increase in audience expectation has necessitated more complete solutions for animation authoring and edit.
- Modern game engine authoring tools now include tools for animators to control which animation clips are blended together as the player interacts in the game. These authoring tools typically allow more control for the animator as they are able to visualize the animation tree for the character as well as how the animations will blend in real time. This allows for both faster creation of animation assets as well as higher quality gameplay interaction as edits can be made visually by the artist without input from a technical programmer.

Chapter 13.3 – Selected Reading and Additional Reference

There are a number of reference guides for traditional animation, also published by Focal Press, that are equally as applicable to 3D animation as they are to cell animation (see Fig. 13.0.1). These typically cover a lot of similar ground to what we've looked at throughout this book and are recommended reference for animating in Maya. Here is some background on the other titles available from Focal Press.

Timing for Animation, Second Edition by Harold Whittaker and John Halas (Authors), Tom Sito (Editor)

ISBN 9780240521602

- This title focuses specifically on timing & spacing, which we looked at in Chapter 3. Timing & spacing is an animation principle that underpins all others, and the book includes numerous well-illustrated examples of how to apply it effectively. A must-have reference.

Animation: The Mechanics of Motion by Chris Webster

ISBN 9780240516660

- This title is a more general guide to animation practice. Although it covers the main animation principles really clearly, it also includes a wealth of other information including information on character design and animating to audio.

Drawn to Life: 20 Golden Years of Disney Master Classes, V1 by Walt Stanchfield and Don Hahn

ISBN 9780240810966

- This collection is an indispensable series of lectures delivered by one of the original key Animators from Disney responsible for work including *Sleeping Beauty, 101 Dalmatians, and Peter Pan*.

Character Animation: 2D Skills for Better 3D by Steve Roberts
ISBN 9780240520544

- This book was published recently and bridges the gap between traditional fundamentals and 3D animation practice. Descriptions of the fundamentals of what is animation and how exactly do things move are clear and well thought out.

FIG 13.0.1 Focal press – suggested reading.

Other standard texts for animators by other publishers that should find shelf space on most aspiring animator's book shelves are the following:

The Illusion of Life: Disney Animation by Ollie Johnston and Frank Thomas

Publisher: Disney Editions; Rev Sub-edition

ISBN-13 978-0786860708

The original source of the 12 fundamental principles of animation, although the principles are outlined in short chapter section, they are the basis for a lot of the other topics discussed in the book, which have become the framework for animation. The book is a mixture of historical anecdotes about

the early years of Disney and discussion around animation practice, and the book is beautifully illustrated throughout. It gives a fascinating insight into the practices of animators at the studio as well as inspiration to modern animators.

The Animator's Survival Kit (Paperback) by Richard Williams

Publisher: Faber & Faber

ISBN-13 978-0571238347

This book is a great resource for animators, which explains several fundamental principles of animation such as timing & spacing and arcs through great illustrations. The examples are really clear and practical examples of posing and timing for standard animations such as actions, walks, and runs make this an indispensable reference guide.

Acting for Animators: A Complete Guide to Performance Animation by Ed Hooks

Publisher: Heinemann Drama

ISBN-13 978-0325005805

It is a great reference book that focuses on acting and animation theory. This book is less graphic or practical based than a lot of other animation references as it draws connection between acting and character performance and animation. It is a standard reference for character animators.

Cartoon Animation (The Collector's Series) by Preston Blair

Publisher: Walter Foster

ISBN-13: 978-1560100843

Although mainly focused on cartoon animation, Preston Blair's title provides insight into a number of the traditional principles of animation.

The Human Figure in Motion by Eadweard Muybridge

Publisher: Dover Publications

ISBN-13 978-0486202044

Animals in Motion by Eadweard Muybridge

Publisher: Dover Publications

ISBN-13 978-0486202037

Aspiring character animators should also consider reference guides on both traditional drawing skills and anatomy. Photographic reference of the body in motion is also invaluable, and Eadweard Muybridge's reference guides of humans and animals in motion, which were published over a century ago, are considered as a standard reference for animators.

Industry Periodicals, Websites, and Training

There are a number of periodicals, industry websites, and other training resources available for both traditional animators and computer animators. Below is a list of resources that are useful for both training and staying abreast of what is going on in the industry. In terms of industry conferences, the main two for computer animators are ACM Siggraph, which covers film, VFX, and game, and the Game Developers Conference (GDC), which focuses solely on video game development.

Industry Periodicals – Animation
Animation World Network/Animation World Magazine
http://www.awn.com/magazines/animation-world-magazine
http://www.awn.com/
Animation Magazine
http://www.animationmagazine.net/

Industry Periodicals – Computer Graphics/VFX
Computer Graphics World
http://www.cgw.com/
3D World
http://www.3dworldmag.com/
Cinefex
http://www.cinefex.com/
ACM Siggraph
http://www.siggraph.org/

Industry Websites – Computer Graphics
CG Society
http://www.cgsociety.org/
The AREA
http://area.autodesk.com/

Video Training – Learning
The Gnomon Workshop
http://www.thegnomonworkshop.com/
Digital Tutors
http://www.digitaltutors.com
Animation Mentor
http://www.animationmentor.com/

Game Development

Game Developer's Conference (GDC)

http://www.gdconf.com/

Gamasutra

http://www.gamasutra.com/

Develop

http://www.develop-online.net/

Index

Page numbers followed by *f* indicates a figure and *t* indicates a table.

Printed and bound by CPI Group (UK) Ltd, Croydon, CR0 4YY

23/10/2024

01778267-0002